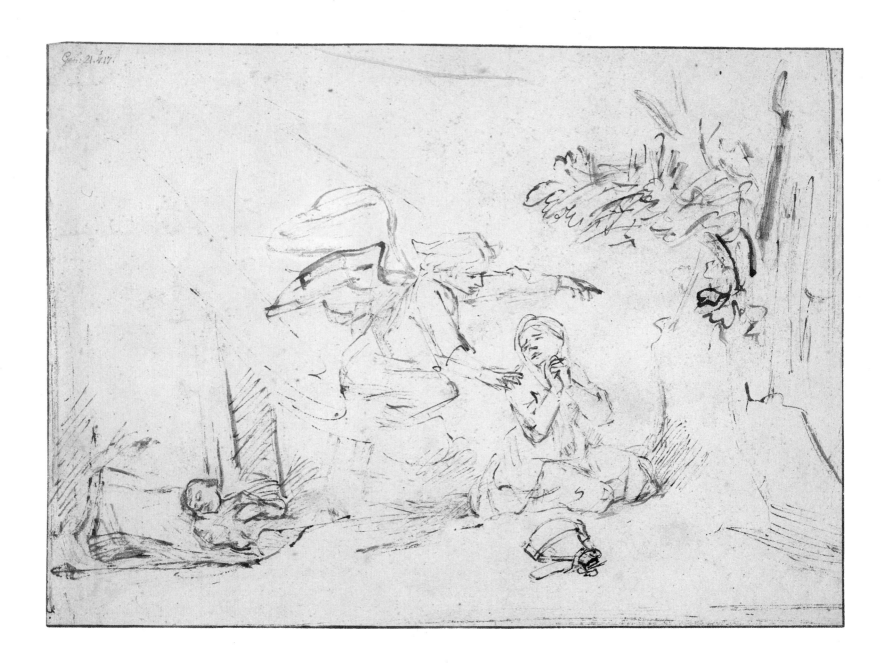

Holm Bevers, Peter Schatborn & Barbara Welzel

Rembrandt: the Master & his Workshop

Drawings & Etchings

Yale University Press, New Haven and London
in association with
National Gallery Publications, London

Exhibition dates:

Kupferstichkabinett SMPK at the Altes Museum, Berlin: 12 September 1991–27 October 1991
Rijksmuseum, Amsterdam: 4 December 1991–19 January 1992
The National Gallery, London (Etchings only): 26 March 1992–24 May 1992

Exhibition Organiser: Uwe Wieczorek

Edited by Sally Salvesen

Designed by Derek Birdsall RDI

Translators: Elizabeth Clegg, Fiona Healy, Josine Meijer, Paul Vincent

Typeset in Monophoto Van Dijck by Servis Filmsetting Ltd, Manchester
Printed in Italy by Amilcare Pizzi, s.p.a., Milan on Gardamatt 135 gsm

Library of Congress Catalog Card Number 91–65961

British Library Cataloguing-in-Publication Data

Bevers, Holm
 Rembrandt: the master & his workshop: drawings and etchings.
 I. Title II. Schatborn, Peter. III. Welzel, Barbara
 769. 924

ISBN: 0–300–05151–4
ISBN: 0–300–05152–2 (paperback)

Frontispiece: Rembrandt,
The Angel appearing to Hagar and Ishmael in the Wilderness
Hamburg, Kunsthalle, Kupferstichkabinett

Cover illustration: Rembrandt,
Portrait of Saskia van Uylenburgh (detail).
Berlin, Kupferstichkabinett SMPK.

Contents

Patrons

Her Majesty Queen Elizabeth II

Her Majesty The Queen of the Netherlands

His Excellency Dr Richard von Weizsäcker
President of the Federal Republic of Germany

Directors' Foreword

Rembrandt has changed in the last twenty years. A steady flow of documentary research has combined with unprecedented stylistic and technical examination, carried out for the most part by the Rembrandt Research Project, to give us a view of the artist and his work materially different from that presented by the Rembrandt exhibition in Amsterdam in 1969. Many works long loved and admired are now believed to have been painted by other artists. Berlin's *Man with the Golden Helmet*, the Frick Collection's *Polish Rider* and the Chicago *Girl at the Door*, along with many other paintings previously attributed to him in museums around the world, are now questioned as the work of Rembrandt, or, by many scholars, rejected outright.

If we exclude these pictures, some previously revered as the summits of his achievement, we have to ask what sort of Rembrandt we are now left with. Who, in short, is Rembrandt in the 1990s? And, no less important, who are the other artists that we have been unwittingly admiring for so long? If Dou, Drost and Hoogstraten are the true creators of paintings that have for years delighted and inspired us, it is clearly time that we took another look at them as well. Rembrandt remains a giant, even if not quite the one we thought we knew; but he is a giant surrounded no longer by pygmies, but by artists of real stature, whom we ought to know better.

The investigation of this new Rembrandt and of his contemporaries are the two main purposes of this exhibition. There is, however, a third. We wanted to show the public how decisions about attribution are made. Paintings, drawings and prints we believe to be definitely by Rembrandt are therefore shown with works definitely by other artists. With them are exhibited paintings once given to Rembrandt, now attributed to one of those others. In the same way drawings by Rembrandt and his pupils and followers are exhibited in two sections, which also take account of the recent research in this area. Visitors to the exhibition will therefore be in a position to examine the Paintings and Drawings, weigh the evidence and decide for themselves whether the conclusions drawn in this catalogue are sound.

However, in the etchings section of the exhibition we encounter the authentic Rembrandt with absolute certainty. Forty outstanding examples provide clear evidence that Rembrandt's use of the print medium was as original as his approach to painting and drawing.

The Kupferstichkabinett, the Rijksmuseum and the National Gallery are all fortunate in having rich Rembrandt holdings. The curators who look after them, all distinguished Rembrandt scholars, have between them written most of this catalogue. Other distinguished scholars of Rembrandt and of Dutch art and society in the seventeenth century have contributed essays and catalogue entries. Yet we could not have thought of organising an exhibition like this one, an exhibition able to address these very particular questions, without the support of lenders, both private and institutional, throughout the world. And no less could we have embarked on so ambitious a venture, had not American Express Foundation supported us financially with generosity and encouraged us throughout with its enthusiasm for the project.

We hope that both sponsors and lenders will find their generosity of spirit repaid not only by our thanks, but by the enjoyment of hundreds of thousands of visitors.

We are particularly indebted to Simon Levie, former General Director of the Rijksmuseum, who was a driving force behind the exhibition in its early stages.

Alexander Dückers
Director
Kupferstichkabinett SMPK
Berlin

Henk van Os
General Director
Rijksmuseum
Amsterdam

Neil MacGregor
Director
National Gallery
London

Lenders

Private collections, 2, 23, 27, 28, 29, 30, 31, 47

Amsterdam, Rijksmuseum, Rijksprentenkabinet, 1, 12, 16, 19, 34, 37, 40, 41, 43, 44, 51
Berlin, Staatliche Museen Preußischer Kulturbesitz, Kupferstichkabinett, 3, 4, 5, 7, 11, 24, 36
Birmingham, The Barber Institute of Fine Art, 8
Bremen, Kunsthalle, 45
Chicago, The Art Institute, 38
Cleveland, The Cleveland Museum of Art, 18
Dresden, Kupferstich-Kabinett der Staatlichen Kunstsammlungen, 10, 48
Haarlem, Teylers Museum, 6
Hamburg, Kunsthalle, Kupferstichkabinett, 25, 32
Munich, Staatliche Graphische Sammlung, 39, 50
New York, The Pierpont Morgan Library, 9, 14, 46
Oxford, The Ashmolean Museum, 33
Paris, Institut Néerlandais, Fondation Custodia (F.Lugt collection), 20, 21
Paris, Musée du Louvre, Département des arts graphiques, 15, 26
Rotterdam, Museum Boymans-van Beuningen, 17, 42, 49
Stockholm, Nationalmuseum, 35
Wroclaw, Library of the Ossolinski Institute of the Polish Academy of Arts and Science, 22
Vienna, Graphische Sammlung Albertina, 13

Introduction

Rembrandt was a draughtsman of originality and versatility. This catalogue aims to reflect these qualities in a balanced way. Although only forty of the large number of extant drawings are included, they provide a representative selection of the finest examples of the most important subjects depicted by Rembrandt. The choice was limited by a restriction in the number of drawings that could be included, and the impracticability of arranging the loan of some important sheets. Nevertheless, it is a particular pleasure that lenders' generosity has enabled such a varied survey to be offered, showing Rembrandt at his best.

As the Kupferstichkabinett in Berlin and the Rijksprentenkabinet in Amsterdam have organised this exhibition, it is only natural that a large selection has been made from their collections. Requests for the loan of drawings have been limited to one or two from other collections in Europe and the United States. The British Museum, which has an extremely important collection, was excluded from participation from the outset because drawings from its own collection, accompanied by a separate catalogue, will be exhibited simultaneously with the exhibition at the National Gallery. The length of the exhibitions in Berlin and Amsterdam is also restricted because the fragility of the drawings makes it impossible to exhibit them for more than three months.

The catalogue testifies to the unique quality of Rembrandt's draughtsmanship. During its making, the author has been grateful for the use of earlier publications, and the advice of experts. In the descriptions, special emphasis has been placed on the quality of draughtsmanship, and the individual way in which Rembrandt depicted his subjects. Extensive discussion of the literature on the drawings has not been included.

As Rembrandt's pupils imitated his work, and since there is uncertainty of attribution in respect of various drawings, the exhibition has been supplemented by a small group of drawings previously attributed to Rembrandt, but now accredited to pupils. In each case, an undisputed drawing by the pupil is included and the comparison of these drawings with those previously attributed to Rembrandt is intended to clarify the new attributions. These new attributions, which are mainly fairly recent, are in most cases generally accepted. In a few cases, the comparative work in the exhibition may support the new attribution. That confrontation with the original drawings will still provide surprises makes the inclusion of this group particularly exciting, not least for the author of the catalogue who, although familiar with the drawings, has never before had the opportunity to study them side by side.

The introduction outlines the issues concerning authorship. In addition, a number of the most important aspects of Rembrandt's draughtsmanship are discussed, and it is hoped that the particular nature of Rembrandt's masterly and individual manner of representation is illuminated. My thanks go to the many people who have helped me in the completion of the catalogue of drawings.

In the first place are my colleagues at the Rijksprentenkabinet and the other departments of the Rijksmuseum, and also in the Kupferstichkabinett in Berlin. I also received assistance at exactly the right moment from Nina Wedde from Geneva, who greatly relieved my workload. Without mentioning them all by name, I am of course also greatly indebted to the collectors, and my colleagues the curators of the collections of drawings. Were it not for their willingness and kind help, this exhibition could never have taken place.

Peter Schatborn
Rijksprentenkabinet
Rijksmuseum, Amsterdam

Aspects of Rembrandt's Draughtsmanship
Peter Schatborn

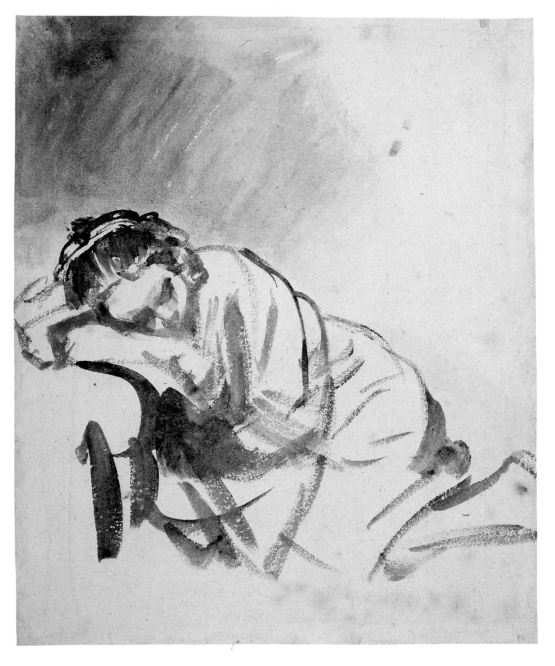

1: Rembrandt, *Hendrickje asleep*,
London, British Museum.

Rembrandt's drawings are strikingly individual. As with his paintings and etchings, their style sets him clearly apart from his contemporaries. Within his œuvre as a draughtsman there is also considerable variety. This is due in equal measure to Rembrandt's artistic development, to his use of different materials and to the different functions that drawings served. Rembrandt was extremely versatile and his work contains virtually all the subjects current in his day.

Rembrandt's pupils imitated his style and produced paintings in his manner for the market, and therefore one finds many Rembrandtesque features in their works, albeit to a lesser extent. The result of this is that many works have been attributed to Rembrandt when they are in fact by pupils. Now that much more material has become available and more research has been carried out, it has been possible in many cases to distinguish the work of the master from his pupils' imitations. However, the process of defining the body of his drawings is by no means complete.

The authentic Rembrandts

In order to be able to make the necessary distinction one must first establish which drawings can be regarded as Rembrandt's work with any degree of certainty. These will then represent the core of the œuvre. With the exception of a few borderline cases there is a fair degree of unanimity among specialists on this group. The authenticity of drawings from this core group is determined by signatures and inscriptions in Rembrandt's hand and in addition by the function of drawings used as preliminary studies for authenticated paintings and etchings. It comes as something of a surprise to find that the group of 'definite' Rembrandt works that can be isolated in this way is small, comprising no more than some seventy drawings.

The drawings are rarely signed. In his Leiden period Rembrandt signed a number of figure studies with the monogram he used at the time (Cat. No. 2). He did this not because the drawings were actually intended for sale, but probably by analogy with paintings and etchings which were put on the market. Later he occasionally signs a piece in full, as in the case of the drawings for Jan Six in the Album Pandora (Cat. No. 31). A monogram or signature gives the drawing a guarantee of authenticity, making it more a work of art in its own right, on a par with paintings and etchings. It may also have been a guarantee of quality, both for Rembrandt himself and for his pupils who used his works as a model. Rembrandt also sometimes wrote texts on drawings, probably with an eye to his pupils, for whom this provided extra information about the subject.

Initially there was insufficient awareness that so many pupils had painted and drawn in the style of the master. Limiting Rembrandt's œuvre as a draughtsman to the core group and those drawings directly associated with it, and querying the attribution of the remaining drawings hitherto regarded as Rembrandt's made it possible to take a fresh look at the body of Rembrandt's work and that of his pupils. In the case of the paintings this led to the setting up of the Rembrandt Research Project in 1968. In the case of the drawings, the starting point was the comprehensive catalogue by Benesch from the 1950s. In reviews of Benesch, in museum and exhibition catalogues and articles, considerable progress was made on a more precise demarcation of the œuvre. The series of comprehensive catalogues of the drawings of pupils by Werner Sumowski which has been appearing since 1979, has proved of inestimable value. As a result of these publications a fairly large number of drawings still regarded as authentic by Benesch, are now attributed by Sumowski or other authors to known or unknown pupils. For example, Benesch lists nearly one hundred Rembrandt drawings in the Printroom of the Rijksmuseum, whereas the Collection's 1985 catalogue contains only sixty authentic works.[1] A somewhat smaller percentage of the drawings in the Louvre in Paris has been discarded,[2] but of the drawings in the Museum Boymans-van Beuningen in Rotterdam half of those included by Benesch are no longer regarded as authentic.[3]

A new view of Rembrandt's draughtsmanship

The revision of what constitutes the body of Rembrandt's drawings has considerable implications for our view of Rembrandt's art. The drawings in the core group differ quite widely from each other, but have nevertheless long been regarded as authentic Rembrandts. Now that other drawings originally considered authentic have been eliminated, the œuvre as a whole has come into sharper focus, with a smaller number of drawings displaying more varied extremes. At various points in his catalogue of the drawings Benesch had placed works as transitions or links between two definite drawings or groups of drawings, and these are precisely the works which have disappeared from the œuvre. Rembrandt was probably not such a prolific draughtsman as has always been assumed.

Rembrandt seldom made preliminary studies for paintings and etchings. There exist only four preliminary drawings that he indented with a sharp instrument for transfer onto the copper plate, including one of the two studies for the *Portrait of Jan Six at the Window* (Fig. 23b). In addition there are a few preliminary drawings that were never indented (Cat. No. 23 and 26). Next there are drawings, mainly of figures, made as preliminary studies for details of a work. These were done by Rembrandt before he began an etching or while work was in progress. In the latter case he was searching for the appropriate form for a particular detail which was giving him some difficulty. For the same reason he also drew on early states of unfinished etchings in preparation for the completion of the print.

Preliminary studies for the composition of paintings are even rarer than for etchings. A few such drawings are based on a composition by another artist, as with the preliminary study for the *Rape of Ganymede* (Cat. No. 10). A number of figure studies, mainly from the Leiden period, were used in paintings. Drawings were also made after Rembrandt had begun a painting, although the precise point in the process cannot always be determined with any certainty. These are also compositional drawings (Cat. No. 40) and figures (Cat. No. 7).

Drawings in Rembrandt's style

Numerous drawings, though not preliminary studies and unsigned, were nevertheless attributed to Rembrandt by virtue of their style. There is at present no unanimity on these attributions. If after thorough comparison drawings can be convincingly shown to be connected with the core group, they can indeed be regarded as genuine Rembrandts. However, in a case of doubtful authenticity, there is always a chance that it is the work of a pupil. If there are sufficient correspondences with the 'definite' drawings of one of the pupils, an attribution to that pupil can be considered. A great deal of misunderstanding surrounds such attributions. Specialists concerned with problems of attribution are guided in the first instance by a kind of visual intuition. Their attributions can be subsequently tested in all kinds of ways. Whatever the outcome of the research, however, pronouncements of necessity retain a hypothetical character.

Rembrandt's drawings under the magnifying glass

Every drawing is different. Constantly changing factors are involved in its creation and every drawing could be seen as the final stage in a process of development. The example of other artists, the function of the drawing and the choice of medium all affect the end result. The style of the drawing is the most obvious aspect. Generally speaking, this is determined by the nature of the forms being depicted. The development of an individual style is a function of the artist's personality. That can be described in general terms, but what is in fact being described in such a case is the overall impression made by the drawing. It makes more sense to distinguish the constituent elements which determine style and to study them separately. In this way it will be possible to establish what elements are most characteristic of Rembrandt. The most important components in the study of a drawing are the medium, the technique and the stylistic features.

The drawing materials used by Rembrandt and his method of working provide information which may prove specific to him. This also applies to the link between the material and what is being depicted with that material. Technical aspects, such as the way Rembrandt constructed his drawings, where he began, and how he made changes and corrections, can be studied separately. In determining authenticity the stylistic traits are the most important aid. Every drawing has many stylistic features, including for example, division of the picture surface, the structure of the composition, the types of figures, the character and expression of the faces and finally the treatment of space and light. The interpretation of the subject being depicted by Rembrandt is sometimes also regarded as a part of the style. Other aspects, such as the nature of the handling of line in pen or chalk, the way in which brush strokes and washes are applied, also help determine the style. Since pupils were attempting to imitate Rembrandt's method of working, stylistic characteristics alone are often not a reliable enough indicator. In such cases it is the combination of such characteristics and the degree to which they are used which must provide the key. This is the most difficult aspect to define and articulate.

Subjects and types of drawing

Once research into his drawings has made further progress, it will probably emerge that Rembrandt actually produced far fewer drawings than has always been assumed. Presumably there were periods when he either drew nothing at all or very little. That may have been the case at the beginning of the 1630s when he worked in the studio of Hendrik Uylenburgh and painted a large number of portraits. Occasionally he produced a portrait drawing (Cat. Nos 3, 4 and 17). Beside the drawings Rembrandt produced in connection with other, works he repeatedly produced groups of drawings on the same or related subjects. These are historical, especially Biblical scenes, genre scenes, figure and animal studies and also model drawings, made especially for teaching

2: Pieter Lastman, *Half-length study of a nude Man*,
Amsterdam, Rijksprentenkabinet.

3: Rembrandt, *Man pulling on a rope*,
Munich, Graphische Sammlung.

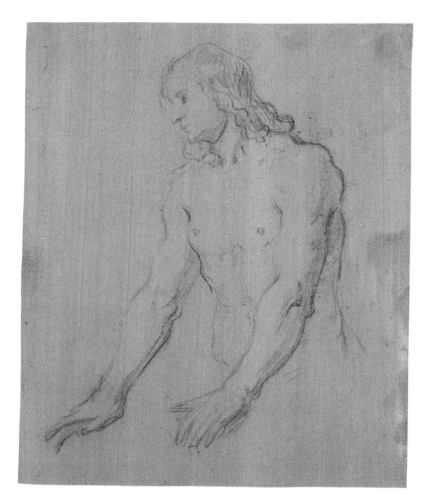

purposes. Then there are landscapes and nude studies, both subjects which were drawn by Rembrandt together with his pupils. Copies from other masters, including Lastman (Cat. No. 11) and from Indian miniatures (Cat. No. 37), form separate categories.

It was customary to produce drawings in groups or series. In a series the same subjects were depicted in different ways or from different perspectives, with variations on the same theme or motif. This was of course a way of familiarising oneself with the subject. Moreover, artists with this kind of experience found it easier to produce similar themes from memory. But such groups of drawings were also instructive exemplary material, as they showed pupils different possibilities.

Of course Rembrandt also drew for his own benefit as a form of practice. His drawings, however, were intended for a collection of his work which served himself and his pupils as a pool on which they could draw. The drawings were kept in albums. In the art collection of which they formed part there were all kinds of works by various artists and in addition natural objects. Rembrandt probably began the collection in Leiden and it was further expanded at the beginning of his Amsterdam period.

Subject and material

In a number of cases there is a clear connection between the choice of material used and the function or subject depicted. For example, all designs for etchings, the outlines of which he transferred to the copperplate with a sharp instrument, were executed in red or black chalk (Fig. 23b); on the other hand, preliminary drawings which were not transferred were done in ink. (Cat. Nos 23 and 25). Nor does his choice of material to depict animals seem coincidental. Rembrandt naturally captured the elephant best in black chalk (Cat. No. 13), while pen strokes were best suited to the birds of paradise (Cat. No. 15). The supple coat of the lions was best conveyed by a wash applied with the brush (Cat. No. 25), and pigs were of course drawn with the pen in order to be able to render their flabby skin.

For most drawings Rembrandt used pen and ink. Chalk tended to be reserved more for those drawings used as instructional material. The chalk figure studies from the Leiden period (Cat. No. 1 and 2), the copies from paintings by Lastman (Cat. No. 11), the group of small landscapes (Cat. No. 22) and the figure and genre studies, may have more the character of practice and preparation than the comparable pen-and-ink drawings.

Rembrandt and his teacher

Rembrandt's second teacher was Pieter Lastman; his influence is clearly evident in the early paintings, and the same applies to the early drawings. Lastman's œuvre of drawings is small, consisting of no more than some fifteen known works. It is the various drawing techniques used by Lastman that we find in Rembrandt's early work.[4] The drawings which are closest to Lastman show Rembrandt following his teacher's formal language, but already adding to it and using different emphases. In the first place Rembrandt is more concerned with the clear rendering of light. Moreover, his approach is freer, more expansive, if necessary at the expense of detail. An example of the difference between teacher and pupil is provided by two chalk drawings, the first by Lastman, a *Half-length male Nude* (Fig. 2)[5] and the second by Rembrandt, *A Man pulling on a rope* (Fig. 3).[6] Rembrandt's figure is freely, almost crudely drawn with strong accents and contrasts, showing a clear awareness of the effect of light. In some places shadows have not been added to drawn shapes as in Lastman, but play an autonomous shaping role. Rembrandt derived his preoccupation with the representation of light from the most avant-garde movement in the Netherlands in the 1620s, the Utrecht Caravaggists.[7]

Rembrandt's early pen-and-ink drawings are also very close to Lastman's work at first. The earliest is probably an *Seated Old Man*,[8] which shares a number of stylistic features with a preliminary drawing by Lastman for a window in the Zuiderkerk in Amsterdam.[9] Later in the 1620 drawings appear using a very evocative pen-and-ink technique, in which the effect of light and dark predominated. One of these is the *Seated Man with a tall hat* (Fig. 4).[10] From the outset Rembrandt used the difference in strength of line to convey the effect of light. The shadow to the left of the head and in the eye socket, as well as the powerful outline and shadow of the shoulder and arm make it clear which direction the light is coming from. It is seldom a single line which defines the shapes, but the figure is made up largely from a combination of various parallel and intersecting lines. Some are very characteristic of Rembrandt, such as the twisting line near the bottom of the leg. The contours of legs and arms are often enlivened in this way by Rembrandt. It is not only light that Rembrandt takes great care over, a number of details have been accurately reproduced. The eye in shadow is very subtle but has been made visible and the row of buttons riding up a little over the stomach indicates the shape of the shirt. Besides a powerful feeling for

4: Rembrandt, *Seated Man with a tall hat*, Rotterdam, Museum Boymans-van Beuningen.

the effect of light, it is the combination of such carefully evoked details with boldly and schematically drawn shapes which is characteristic of almost all Rembrandt's drawings. Generally it is the faces which are carefully drawn, while the rest of the figure is more schematic, depending on how far Rembrandt had worked out the rest of the composition. The *Seated old Man* (Cat. No. 2) is an example of this from the Leiden period.

Outline and elaboration

It was general practice first to draw in fine lines and subsequently to elaborate using heavy lines. These were therefore usually applied last to the composition and also serve to correct the preceding fine lines. When Rembrandt draws landscapes he also first uses fine lines and then proceeds from back- to foreground with darker lines, drawing the foreground last. The countryside and the buildings in *View over the IJ near Amsterdam* (Cat. No. 28) clearly show how subtly and delicately Rembrandt's pen creates the background while the closeness of the foreground motifs is brought out by the dark washes. A nice example of Rembrandt's method of beginning a drawing is afforded by the sketch on the back of *The Entombment* (Cat. No. 19, verso). This sketch was made in connection with an etching, *The Beheading of John the Baptist* of 1640. The kneeling John sits with his hands folded on his knees while the executioner prepares to strike. John is depicted with carefully drawn thin lines and not worked up. The executioner is sketched with equally thin lines, but subsequently retraced with slightly darker lines. This second version improves on the first in several places. The shift in the position of the head, from upright to inclined forward, is the most obvious change, and a clear example of Rembrandt's correction with a darker pen. In addition this sketch shows that Rembrandt's line is more assured when there is a first preliminary version, which can then serve as a starting point and guide for the second version.

This applies in a different way when Rembrandt follows the model of another artist. The copy made for example of a painting by Lastman was largely set down directly in fairly bold lines (Cat. No. 11). It looks therefore as though Rembrandt, especially when starting to draw a figure or composition from memory, begins carefully with fine lines. In numerous drawings this first version can be detected beneath and alongside the subsequent development. However, this is not a characteristic of Rembrandt's drawings alone. Probably all pupils were instructed to make a point of starting with fine lines and subsequently elaborating the composition in darker lines.

The position of the knee in the *Washing of the Feet* is another example of a correction with darker lines drawn over a previous version (Cat. No. 34). By themselves these extra lines would not have the required effect, but added to the existing lines they convincingly suggest the position of the leg, without outlining it precisely. The method, whereby a number of lines which, in themselves are not precisely defining, combine to suggest the forms convincingly, is very characteristic of Rembrandt's drawing, and helps to determine the style.

Rembrandt corrected not only his own drawings, but also those of his pupils. There are a number of examples, especially of the drawings of Constantijn van Renesse, which show beautifully how Rembrandt is able to give his pupil's often pinched forms a new allure. The best example is probably *The Annunciation*, in which Van Renesse's kneeling, static angel is overshadowed by Rembrandt's dynamically drawn figure (Fig. 5).[11]

There are drawings to which Rembrandt made alterations, but without removing the earlier version. He sometimes did this in such a way that the earlier version only becomes visible on closer inspection. This applies for example to the elephant which advances on us with raised trunk, while the earlier lower position of the trunk is integrated into the figure of the elephant's attendant (Cat. No. 13). Another, more immediately recognisable example is found in the drawing of *Saskia in Bed* (Fig. 6).[12] Her right arm was first drawn resting on the covers and subsequently supporting her chin. In this case Rembrandt did not bother to paint out the lines over which the arm was drawn in white, though he did use a heavier line for the arm.

Various examples show that Rembrandt did not abandon a drawing once he had started, not even, for example, when he had made a blot or one part had not worked. If he had used to much ink or made a mistake with the pen or brush he used white paint to cover the offending lines or spots. We find this masking wash in countless drawings, although because of wear and tear it is often not immediately detectable. The white paint has often oxidised because of the lead in it, producing a darker colour, the opposite of what Rembrandt intended. Sometimes Rembrandt simply whited out a number of misplaced lines, such as on the back of the *Man standing with a Stick* (Cat. No. 1), sometimes a whole area is covered in white to soften the tone (Fig. 31a). White could also be used to throw certain sections into relief, or highlight them, as can be seen in the *Seated female Nude as Susanna* (Cat. No. 24).

When a section was clearly beyond redemption, Rembrandt took a knife and cut a hole in the paper. Sometimes he stuck a new piece of paper over the hole from behind and completed the drawing on it (Cat. No. 6), sometimes he covered it with a patch and redrew the figure (Cat. No. 16). Such procedures show that Rembrandt was determined to preserve the successful parts of the drawing. It also sometimes happens that Rembrandt began a drawing and afterwards realised that the paper was not big enough. An example of this is the landscape *The Bend in the Amstel near Kostverloren* (Cat. No. 30), where the right-hand side of the paper has been stuck on.

The hand of the master

In his Leiden period Rembrandt made mostly figure studies and only a few historical drawings are known from that period. In the mid-1630s he produced a group of drawings which are characterised by a very free handling of line (Cat. No. 5 and 12). It is again the faces particularly which have been more carefully executed and elaborated. The remaining lines indicate the form in a seemingly disconnected rhythm. The direction of the hatching lines representing shadows, like the cursory outlining of the shapes are in no way arbitrary but contribute greatly to the plasticity of the figures and the effect of depth in the compositions. If it were possible to examine the pattern made by the hatching separately from the rest of the drawing, it would be clear that the hatching and the direction in which it runs form a balanced pattern which focuses attention on the most important section of the drawing. One example from a group of drawings of actors and actresses is the *Seated Actor in the Role of Capitano* (Cat. No. 12). The actor's head, drawn in profile, is the central point in the composition and given all the more prominence by the way in which the lines and hatching are placed around it.

A drawing from a small group of Biblical scenes, *Christ falling beneath the Cross* is also a characteristic example of Rembrandt's pen-and-ink drawing style of the 1630s (Cat. No. 5). The longer one looks the more sharply the image comes into focus as it were, the more clearly the figures stand out, and the more emphatic a part the individual lines and shading play in the whole composition.

The brush is used not only to add a figure in the foreground, but also to create a darker area above the fallen figure of Mary. This patch suggests shadow and depth, but optically also has another effect: placed centrally between the figures this area emphasises the oval shape of the composition. Rembrandt used such optical effects

5: Constantijn van Renesse and Rembrandt, *The Annunciation*, Berlin, Kupferstichkabinett SMPK.

6: Rembrandt, *Saskia in bed*.
Groningen, Museum voor Stad en Lande.

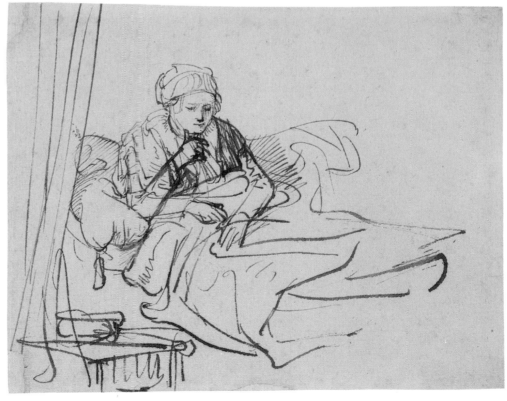

quite often, which particularly enhance the composition as a whole and do not necessarily represent anything definite. As the drawing progressed the composition that emerged under Rembrandt's hand naturally began to assume a proportionally greater significance for what he had yet to draw. The elaboration consisted of correction and emphases, including such optical effects. We also find them in drawings in places where the paper was originally too much like a white empty surface. In such cases Rembrandt simply draws a short line or a number of scribbles, which do not stand out in the overall composition but which counteract the flat impression made by the blank paper. He did something similar when in a small charcoal landscape he placed some zigzag shading at the top of the sheet, which, rather than representing a canopy of leaves, helps to fill the empty space somewhat (Cat. No. 22). In a figure study, *Seated female Nude* (Cat. No. 38) such 'auxiliary lines' are found, which do not appear to represent any direct form in themselves (the short line on the breast), but which have a definite effect (the line through the calf).

Among the group of fine pen-and-ink drawings from the 1630s there is a sheet with three scenes depicting *The Prodigal Son and a Woman* (Fig. 7).[13] Unfortunately one of the scenes has been partially cut off at the top of the sheet. The other two are done in an equally schematic pen technique, with the faces characterised tellingly and carefully. And it was these which counted in the three aspects of the same event. In the first scene at top centre the young man's hands begin wandering, in the scene on the left his behaviour is punished with a furious gesture by the woman. On the right the woman is seen finally to have relented and the young man to have got his way: Rembrandt's ability to impart expression to their faces with just a few lines was probably unprecedented in the history of drawing. The triumphant pleasure of the young man in the right-hand sketch and the acquiescent pleasure of the woman he is petting, are perfect examples of Rembrandt's capacity to represent human feelings in the most succinct form. In drawings from all periods we find examples of this special quality of Rembrandt's drawing and it is often in this respect that the work of pupils is exposed as lacking conviction.

For a group of drawings from the late 1630s Rembrandt used gall-nut ink, often on paper treated with light yellow colour. In this group we find the same astonishing style of characterisation, whether of figures and facial expressions or, for example, animals. It is as though Rembrandt's plastic language has become more resonant than

ever, and he has also become more confident. The way in which he depicted his wife *Saskia at the open window* is extraordinarily direct (Fig. 8).[14] Producing a likeness with so few lines—compare the portrait in silverpoint of 1633 (Cat. No. 3)—requires extreme sureness of touch. An important aspect of this drawing is the use of washes. These give relief to the subject and have been applied with particular care in the figure itself: the fine, almost transparent brushstroke on Saskia's collar, for example, follows the line of her right arm to bring her shoulder a little forward and the slightly curved brushstrokes above her right hand exactly indicate the curve of her breasts beneath the collar. The brush-strokes in the background are transparent and use different tones to indicate the darkness in the room. This transparency of the wash is characteristic of Rembrandt's use of the brush. Much later, when he drew Hendrickje at the window, he added an equally transparent wash in the background of a much bolder pen-and-ink drawing (Cat. No. 35).

Occasionally Rembrandt drew with the brush alone and one of his most famous drawings, *Hendrickje asleep* (Fig. 1),[15] was produced in this way. The secret of this drawing's unequalled expressiveness is in the well-considered pattern of lines produced with transparent brush-strokes. By imposing this limitation on himself and particularly by carefully separating light and dark Rembrandt has produced a evocative portrait of his wife.

Rembrandt's brush is just as effective in depicting light and dark in an interior, whether he is drawing from life as in the case of *Seated Nude in the studio* (Cat. No. 33), or as in one of the drawings from memory in the Album Pandora (Cat. No. 31). In a completely different way from the sleeping Hendrickje every stroke counts. Not only does the brush create a sense of space, but the atmosphere is made tangible. Finally Rembrandt occasionally creates a background with the brush in which shapes are scarcely distinguishable, but where an abstract pattern of lines evokes the space surrounding a seated figure (Cat. No. 38).

Rembrandt as a narrator

In numerous drawings Rembrandt reveals himself as a narrator of Biblical or other historical scenes. His feeling for drama is apparent, for example, from the way he depicts *Christ falling beneath the Cross* (Cat. No. 5). But in less dramatic stories too he is able to convey human feelings poignantly. Sometimes he depicts one moment in a story, sometimes he adds motifs which refer to earlier or later moments. For example, the figure of Simon

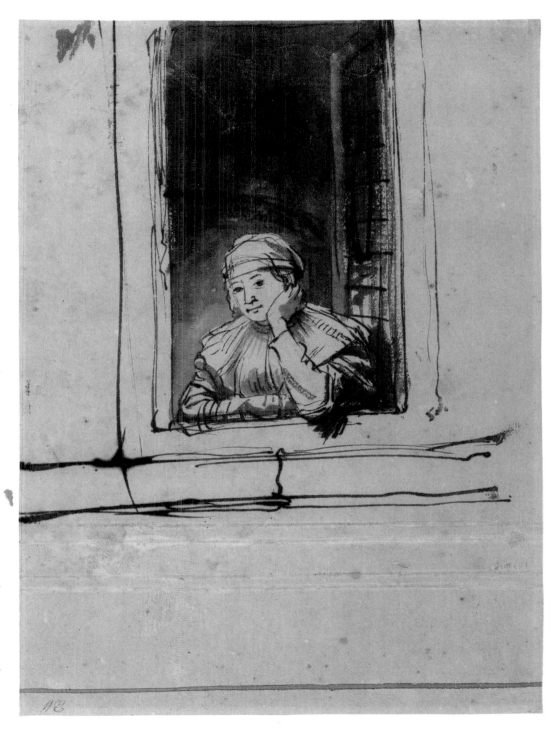

8: Rembrandt, *Saskia at the open window*, Rotterdam, Museum Boymans-van Beuningen.

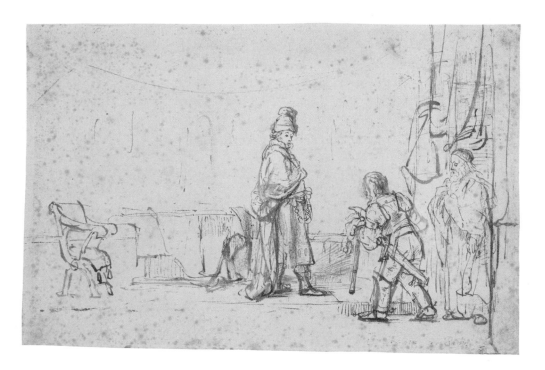

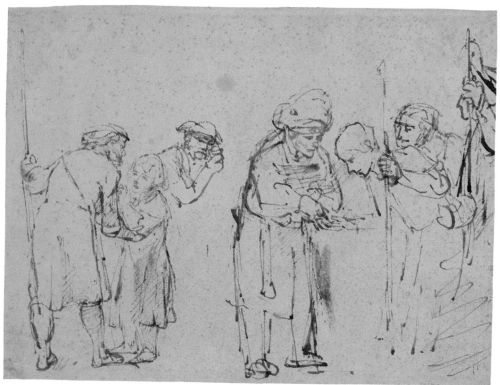

of Cyrene on the left in the drawing of *Christ falling beneath the Cross* represents the later moment at which he will take over the cross from Christ (Cat. No. 5); and Sarah enters the story of Tobit only after his blindness is cured and is not a witness, as Rembrandt has depicted her (Cat. No. 18). The custom of depicting more than one moment at a time dates from the Middle Ages and Rembrandt is one of the last artists to work in this way.

It is not only the faces which allow one to read the feelings of the figures, sometimes it is the composition as a whole which helps make the content of a story particularly vivid. A perfect example of this is a drawing of an episode from the story of King David.[16] The composition depicts him receiving the news that Uriah has been slain (Fig. 9). David had made Uriah's wife Bathsheba pregnant after he had seen her bathing from a window of his palace. Afterwards David sent Uriah into battle knowing that he was almost bound to die. In the drawing we see in the background the windows which look out onto the garden in which Bathsheba was bathing, a reference to the beginning of the story. On the left is the chair from which David rose when he heard the messenger approaching. The latter stands on the right with Uriah's armour over his arm, as a sign of Uriah's death. However, David has not gone straight to meet him, but as if to avoid the message he bears, he has turned towards the background. The drawing depicts the moment when he turns his head and looks at the messenger. By arranging things in this way, Rembrandt emphasises David's sense of guilt. The feeling of guilt is also conveyed by David's look, which expresses fear of hearing the truth. At a later moment in the story God sends the prophet Nathan to David. In the drawing the prophet is already standing as though in the wings ready to admonish the king. From his rendering of this story it is clear how Rembrandt has empathised with the situation. In the broad sweep of his composition he narrates events from left to right, referring both to earlier and later events. The disposition and the attitudes and expressions of the figures show Rembrandt as a director who has his actors express aspects of humanity in all kinds of ways.

Not all the Biblical scenes in Rembrandt's drawings are narrated in such depth, but there is always great intensity. An excellent example of this is the concentration with which Tobias heals his father's eyes (Cat. No. 18). Rembrandt was so taken with the powerful profile of the young Tobias, who is carrying out the operation, that he later used it again in a drawing in which the

young Joseph is being sold by his brothers (Fig. 10).[17] Here the sharp profile expresses the brother's intentness on the money, as he stares at it to ensure that he receives the full amount. In this drawing the finely drawn face of Joseph expresses the uncertainty and pain of the little child about to be taken away by strangers in a masterly way. The gentle pressure with which the man urges the child to come with him is also wonderfully conveyed.

No less explicit is the depiction of the contact between Hagar and the angel, in a particularly 'open' drawing using very few lines (Cat. No. 32). The positioning of the figures in the picture space and the way the gestures and the contact between Hagar and the angel are rendered, make the drawing not just an illustration of what happens in the story, but also a personal interpretation by Rembrandt of how the figures experience the event. Even when he draws more schematically he characterises both the story and the various facial expressions just as powerfully (Cat. No. 34 and 36).

The picture space

There are a number of bold and opulent pen-and-ink drawings dating from the 1640s. The *Entombment* (Cat. No. 19) is an example from the beginning of the decade, and the preliminary drawing for the *Portrait of Jan Six at the window* (Cat. No. 23) a similar work from 1647. Here and there Rembrandt appears to draw messily, but on closer inspection his pen is always single-minded in its pursuit of the desired form. The drawing of *Three women and a child at a door* from the mid-1640s shows a characteristic combination of features, (Fig. 11).[18] The old woman in the centre is the focus of the composition, even though she is not placed in the middle of the arch of the doorway. She is the most fully elaborated figure and the most carefully shaded. Her face is the most striking, the more so because she is wearing a bonnet. The figures in the foreground are mainly done with very free strokes of the pen. Their particularly lively interplay gives a very convincing sense of space and plasticity, without defining the shapes precisely. The figures are located within a strict framework. If we look only at those lines outside the figures which indicate the architecture, we see a composition in which every line contributes to the balance: if we take away the horizontal line at bottom right there is a gap; if we take away the vertical lines at bottom left, the composition threatens to veer to the right. Finally, if we remove the arch of the door the figures seem to be outlined against the sky. In short, Rembrandt underpins his freedom of line

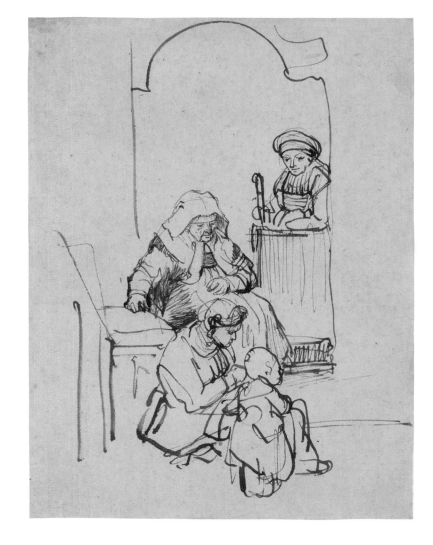

11: Rembrandt, *Three Women and a child at the door*, Amsterdam, Rijksprentenkabinet.

12: Rembrandt, *View of the Omval near Amsterdam*. Private collection.

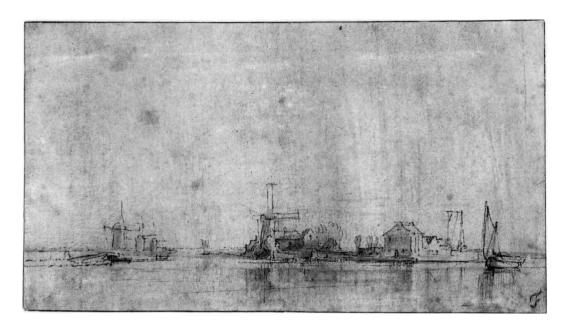

brandt, but many of them were cut up into small sketches by later dealers.

Space and atmosphere

In the 1640s particularly Rembrandt concerned himself with drawing landscapes. However, a few small landscapes done in silverpoint on parchment were produced as early as the beginning of the 1630s. These have a certain linear, graphic character (Fig. 3a). Later landscape drawings were done in chalk, or pen and ink with a wash applied by brush. The expressiveness which Rembrandt was able to impart to all natural forms and buildings in the landscape has the same intensity as that of the figures and faces.

Whether it is the stone walls of the old town gate at Rhenen (Cat. No. 29) or the tall grass on the dyke with the wind blowing through it (Cat. No. 27), every form is characterised with equal accuracy. Of course light plays an extraordinarily important role in the landscapes too, as its treatment determines the effect of space and depth. How impressively Rembrandt could achieve this is shown by the drawings he made on the IJ and along the Amstel. In the Rhenen drawing we can see how he makes the cool atmosphere in the gateway tangibly present. The gateway and the gatehouse are drawn with exceptional care and precision, while the buildings to the left are executed in a balanced rhythm of separate pen strokes. Through leaving the houses on the left out of focus, as it were, Rembrandt directs our eye towards the gateway.

With landscapes he is able to evoke atmosphere in various ways. Sometimes he used cartridge paper, a fairly coarse, grainy type of paper which ensured that, for example, the sky and other areas left open did not have a flat and empty effect (Cat. No. 28). The atmospheric effect could also be obtained by applying a coloured wash to the paper. There are examples where Rembrandt has conjured up a misty atmosphere by combining a wash with fine pen lines (Fig. 12).[19] He seldom represents clouds in his landscapes, though they do occur occasionally (Cat. No. 21). Atmosphere was also created in landscapes by drawing the horizon and the most distant trees and houses in faint, broken lines: a way of rendering what in reality can only be seen by peering intently. In the first instance this technique was a way of achieving depth, but Rembrandt's pen gave it an added atmospheric effect.

Drawings by pupils in Rembrandt's style

All the features of Rembrandt's drawings which have been briefly described here—and there are

with a tight framework. Most of his drawings are based on a compositional scheme which gives balance or direction to the scene. The background of the *Portrait of Jan Six at the window* (Cat. No. 23) and of the *Seated woman with an open book on her lap* (Cat. No. 17) has a clear division of picture area. The depiction of *Jacob and his sons* (Cat. No.16) for example is virtually symmetrical as regards both the figures and the background.

Differences in the position on the sheet and the division of the picture surface can sometimes be explained by the function. With sketches of figures which served as preliminary studies, the division of the picture area emerged as the artist drew, because Rembrandt was concerned only with finding the right form (Cat. No. 7). With sheets intended as examples the composition is very well thought-out. In these cases variation and alternation of motives were conscientiously introduced. The model sheet with heads and figures (Cat. No. 8), one of the most splendid examples of its kind, shows how one head is finished with a brush, another is only cursorily indicated in ink, while in a small sketch is again done in red chalk; one head is drawing from the side, another more frontally. Quite a number of model sheets were probably produced by Rem-

many more besides—were imitated by pupils. This was why drawings in Rembrandt's style by pupils were previously attributed to the master. The appearance of Benesch's authoritative catalogue would seem to have stopped the process of attribution to pupils. However, the body of drawings by a number of these pupils has been further expanded by publications which have appeared since Benesch. The most spectacular expansion is the œuvre of Willem Drost; Sumowski has attributed numerous drawings to this artist, of which there are no less than sixteen in the Rijksprentenkabinet of the Rijksmuseum alone.[20] An attempt has also been made to attribute drawings to Carel Fabritius; this group can be enlarged without much difficulty by a number of drawings still regarded as Rembrandts by Benesch.[21]

Several examples of recent attributions are discussed in this catalogue. These are a small group of drawing by five of Rembrandt's pupils, namely Ferdinand Bol, Nicolaes Maes, Willem Drost, Aert de Gelder and Johannes Raven. The newly attributed drawings are preceded in all cases by a drawing which has long been ascribed to the pupil in question and whose attribution is undisputed. The new attributions have been made by various authors. While they know the drawings at first hand, they have never yet been able to study the originals side by side. The attributions discussed here appear well-founded, but not everyone will necessarily agree immediately. Our intention is that the juxtapositions may bring the hoped-for clarification.

1. Schatborn 1985.
2. Paris 1988/1989. Starcky has accepted 72 of Benesch's 109 catalogued drawings.
3. Giltaij 1988.
4. Schatborn 1989, pp. 118–20.
5. Amsterdam, Rijksprentenkabinet, Inv. No. RP-T-1983–437. Red and white chalk on yellow prepared paper. Peter Schatborn, 'Een figuurstudie met rood krijt van Pieter Lastman', *Bulletin van het Rijksmuseum* 32 (1984), pp. 25–26.
6. Munich, Graphische Sammlung; Red and white chalk, 273 × 176 mm; Benesch 5.
7. Albert Blankert, Leonard B. Slatkes *et al.* ed: *Nieuw licht op de Gouden Eeuw. Hendrik ter Brugghen en zijn tijdgenoten*, Utrecht/Brunswijk 1986/1987 (exhibition catalogue).
8. Paris, Louvre, Département des arts graphiques, Benesch 49; Paris 1988–1989, No. 1.
9. Berlin, Kupferstichkabinett SMPK; Bock-Rosenberg 1930, No. 5284; Lugt 1931, pp. 79–80; Schatborn 1989, pp. 118–19.
10. Rotterdam, Museum Boymans-van Beuningen; Benesch, no. 29; Giltaij 1988, No. 1.
11. Berlin, Kupferstichkabinett SMPK; Benesch, No. 1372; Sumowski Drawings, No. 2191-XX.
12. Groningen, Museum voor Stad en Lande; Benesch, No. 282.
13. Berlin, Kupferstichkabinett SMPK; Benesch 100 verso. On the front of the sheet there is a very freely drawn *Lamentation*.
14. Rotterdam, Museum Boymans-van Beuningen; Benesch 250; Giltaij 1988, No. 8.
15. London, British Museum; Benesch 1103.
16. Amsterdam, Rijksprentenkabinet; Benesch 890; Schatborn 1985, No. 37.
17. Berlin, Kupferstichkabinett SMPK; Bock-Rosenberg 1930, No. 1119; Benesch 876.
18. Amsterdam, Rijksprentenkabinet; Benesch 407; Schatborn 1985, No. 27.
19. *View of the Omval*, sale London, 6 July 1987, No. 16; Benesch 1321.
20. Schatborn 1985–I, pp. 100–3.
21. Schatborn 1985, Nos 61–66.

I

Man standing with a stick
verso: *Man seen from behind*

Black chalk, brush in white, 290 × 170 mm
Inscription: below right, part of letter *R*
Amsterdam, Rijksmuseum,
Rijksprentenkabinet

Provenance: Jacob de Vos Jbzn. (L. 1450), sale
Amsterdam, 22–24 May 1883, in lot No. 412;
acquired by the Vereniging Rembrandt in 1889
(L. 2135); Inv. No. RP-T-1889 A3172.

Literature: Henkel 1942, No. 1 and 2; Benesch
1954–1957 and 1973, No. 30; Schatborn 1985,
No. 2 (with other previous literature and
exhibitions).

1a: Rembrandt, *A standing Archer.*
Dresden, Kupferstich-Kabinett.

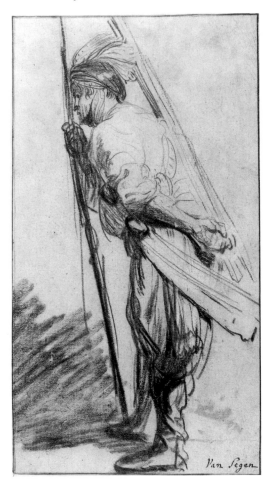

After Rembrandt had been a pupil with Jacob
van Swanenburg in Leiden and thereafter with
Pieter Lastman in Amsterdam, he set up as an
independent master in 1625 in his birthplace,
Leiden. The drawings from this early period
are mainly figure studies. Rembrandt's
ambition was to become a history painter, a
painter of biblical and mythological subjects,
and the depiction of figures was therefore of the
utmost importance. These figure studies were
made in red and/or black chalk on fairly large
sheets of paper; smaller drawings of figures
were usually done in pen and brown ink.

From the very beginning these figure studies
have an individual, robust style, which is
clearly different from the style of Lastman, who
also drew red and black chalk figures that he
used in his paintings.[1]

Rembrandt's early chalk figure studies can
be divided into groups on the basis of differing
styles. The first group, from c. 1627, consists of
three drawings in red chalk, which are
extremely sketchily and loosely executed (Fig.
1a).[2] The *Man standing with a stick* belongs to a
series of six which date from a little later and
are executed in black chalk.[3] Characteristic of
these drawings are the heavy, sometimes
angular, lines which broadly outline the forms.
In this case the profile consists of six small lines
and a dot which indicates the eye. Rembrandt
was sitting fairly close to the model when he
drew these and other figures, as we are looking
up at the man.

It was usual to begin drawings in light lines
and to elaborate with increasingly darker lines.
In the left leg of the man it can be seen how
the darker lines emphasise the outline while
simultaneously correcting the earlier ligher
lines.

Rembrandt always took the fall of light into
account. The brightly lit sections are simply
left blank. In contrast, the slightly later group
of red chalk studies are almost entirely
executed in chalk without blank areas (Cat.
No. 2).

The vertical lines beneath the belt of the
man indicate the area in shadow. Rembrandt
had apparently not determined the division
between light and dark satisfactorily at the
outset, as he painted over the three right-hand
lines with white in order to make them
invisible. These lines have now become visible
again as a result of oxidisation of the lead in the
white paint. This kind of correction, which
occurs repeatedly in Rembrandt's drawings,
indicates the importance he placed on the
precise rendering of lightfall. The most effective
method of achieving plasticity and depth was
an accurate depiction of light and dark.

The drawing of figures was, in the first

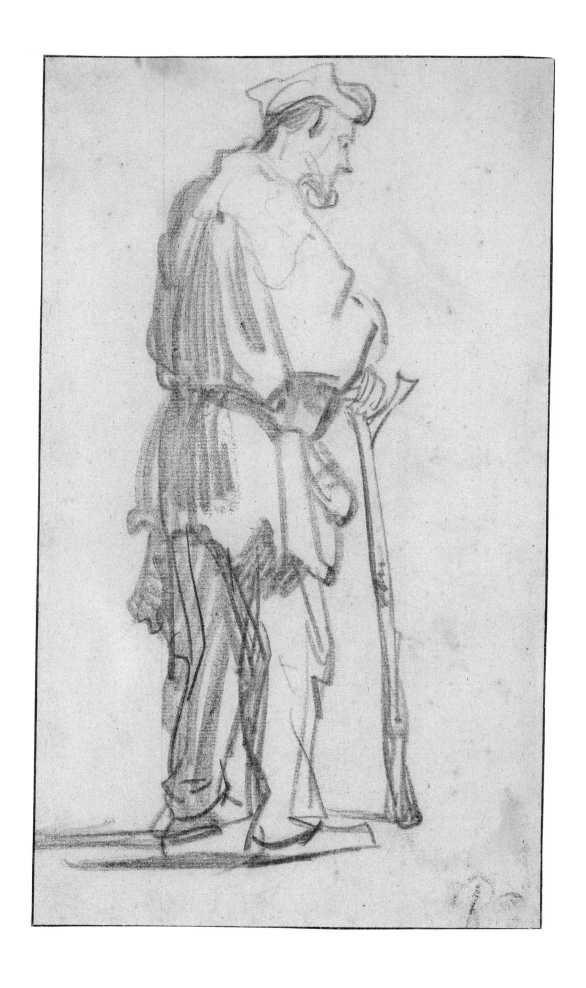

place, an exercise in learning to represent the human form realistically and it also served as preparation for the portrayal of all manner of types in paintings and etchings. Although Rembrandt usually worked from imagination or from life, the drawings could also be used as preparatory studies. One of the studies in black chalk served as a model for the figure of Peter in the etching[4] of *Peter and John healing a cripple at the Temple Gate*.[5] The other drawings in the group relate specifically to etched and painted figures which appear in his work dating from approximately the 1630s. Through practice in drawing from life, Rembrandt was also able to depict figures in a lifelike way in paintings and etchings.

The influence of the French artist Jacques Callot can be seen in these figures, and in particular from his series of prints *Les Gueux* (*The Beggars*).[5] This is especially noticeable in the shadows with parallel lines. A comparable etching of a *Man standing with a stick* (Fig. 1b)[7] from c. 1629 has more the style of a drawing. Rembrandt was one of the first artists to exploit the possibilities of the technique of etching in this manner.

Rembrandt used paper made in Italy with a watermark of a bird in a circle[8] for the *Man standing with a stick* and the other drawings of the group in black chalk. This paper must have been available in Leiden around 1630 as it was also used by his friend and fellow townsman Jan Lievens,[9] and his pupil Joris van Vliet.[10] Dated paper with this watermark appears in documents from 1629 and 1630, the same time as Rembrandt made his figure studies in black chalk. The three drawings of the group in Amsterdam all have an inscription with Rembrandt's initial at the bottom right. The chalk in which these letters are written is of a slightly different colour from that in which the drawing is made. If these inscriptions are indeed by his own hand, then Rembrandt possibly added them to the drawings at a later date.

The small sketch on the reverse of the *Man standing with a stick* perhaps represents a horseman who, however, is only partly depicted.

P.S.

1. Oxford, Ashmolean Museum; Schatborn 1981, No. 63, p. 48–49. Among the work by his teacher that Rembrandt owned, according to the inventory of 1656, was *[Een boeckie met schetsen] van Lasman met root krijt* ([A small book with sketches] by Lastman in red chalk). *Documents* 1656/12, No. 264.
2. Munich, Graphische Sammlung; Benesch, Nos. 4 and 5; Dresden, Kupferstich-Kabinett, Benesch 3.
3. Benesch 12, 30–32, 45 and 196. Schatborn 1989, p. 125–26.
4. *Man standing with outstretched arms*. Dresden, Kupferstich-Kabinett, Benesch no. 6.
5. B. 95.
6. The series *Les Gueux* appeared in 1622; J. Lieure, *Jacques Callot, Catalogue de l'Oeuvre gravé*, Paris, 1924–1929, nos. 479–503.
7. B. 162.
8. J.H. de Stoppelaar, *Het papier in de Nederlanden gedurende de Middeleeuwen, inzonderheid in Zeeland* (Paper in the Netherlands during the Middle Ages, especially in Zeeland), Middelburg 1869, pl. VIII, No. 15 (1630).
9. *Hermit in a Cave*, etching (B. 6), impressions in Rotterdam, Museum Boymans-van Beuningen and Amsterdam, Rijksprentenkabinet.
10. *St Jerome in a Cave*, etching (B. 13) dated 1631, after a painting by Rembrandt, now lost; Amsterdam, Rijksprentenkabinet.
11. Schatborn 1989.
12. Benesch 30–32.

1b: Rembrandt, *Beggar leaning on a stick*. Amsterdam, Rijksprentenkabinet.

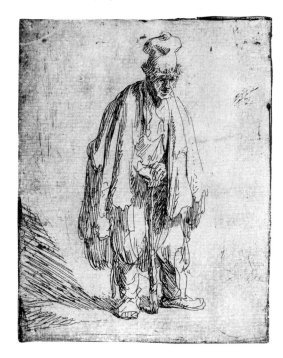

2

Seated old man

Red and black chalk on pale yellow prepared paper, 233 × 160 mm
Inscription: centre below, monogram *RHL* and *1631*
Paris, collection A. Delon

Provenance: J.H. Hawkins, sale London, 29 April 1850, No. 1027, W. Mitchell, London, sale Frankfurt a/M, 7 May 1890, No. 84; Stephan von Kuffner, Vienna; Von Kuffner family, Zurich; sale London, 29 November 1970, No. 16.

Literature: Benesch 1954–1957 and 1973, No. 20 (with other previous literature and exhibitions); J. Giltaij, 'Een onbekende schets van Rembrandt', *De Kroniek van het Rembrandthuis* (1977) 1, pp. 1–9; *Corpus* II, under A66; Jeroen Giltaij, 'The Function of Rembrandt Drawings', *Master Drawings* (1989), vol. 27/2, pp. 111–17.

Exhibitions: 20 ans de passion, Paris (Didier Imbert Fine Art) 1990, No. 23.

At the end of the Leiden period and before he went to work in Amsterdam in the early 1630s Rembrandt drew a number of figure studies in red chalk of an old man. This model also posed for paintings and prints. The red chalk studies are less linear than the figure studies in black chalk (Cat. No. 1), which probably date from a little earlier. The figure is now almost entirely worked in chalk and executed with abundant variations of light and dark. This drawing style is characteristic of the period around 1630–1631, during which time Rembrandt's paintings were executed in an especially fine manner and the etchings were conceived in tone rather than line (Etchings Cat. No. 4).

Three of the extant figure studies of the old man show him full-length, sitting on a chair—originally a folding chair—which often appears in Rembrandt's work. Rembrandt possessed such a chair himself (Cat. No. 20).[1] In the exhibited drawing the old man is seen somewhat from below and from the side and he is looking sideways.

The drawing is almost entirely executed in red chalk. Rembrandt emphasised the outline of the figure on the right-hand side with short lines in black chalk and he also drew the chair in that medium. The use of line within the drawing is extremely varied: the figure was first begun in fine lines, shaded with transparent areas of red chalk and thereafter elaborated with broader and longer lines. Only the face, beard, hands and fur collar were left blank.

The almost horizontal line beneath the chair could indicate a higher level, a sort of low podium which existed in the studio.[2] The foot of the right leg rests on the ground in front of this podium and the man is seated near a wall on which his shadow falls.

It is rather strange that the knee of the right leg is shown in two positions. In the higher position only the top is visible, while the contour of the knee below it appears to have been erased. Traces of red chalk can be seen in the space between the two versions of the knee, possibly a remainder of the partly-erased lower knee. This must then have been the earlier version.

Rembrandt used the drawing of the old man as a preliminary study for the figure of Jacob in a grisaille in the Rijksmuseum, *Joseph telling his dreams* (Fig. 2a)[3] and he appears again in a sketch in red chalk in Rotterdam (Fig. 2b)[4] and in an etching (Fig. 2c),[5] both of the same subject.

The grisaille, painted on paper, is signed and carries a date from the 1630s of which the last figure is missing. The writing of the signature in full indicates a date of 1633 at the earliest.[6]

2a: Rembrandt, *Joseph telling his Dreams.* Amsterdam, Rijksmuseum.

2b: Rembrandt, *Sketch for Joseph telling his Dreams.* Rotterdam, Museum Boymans-van Beuningen.

2c: Rembrandt, *Joseph telling his Dreams.* Amsterdam, Rijksprentenkabinet.

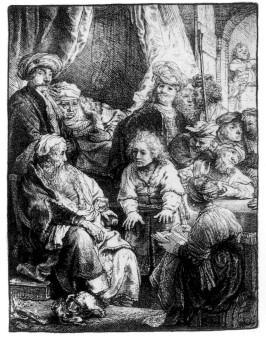

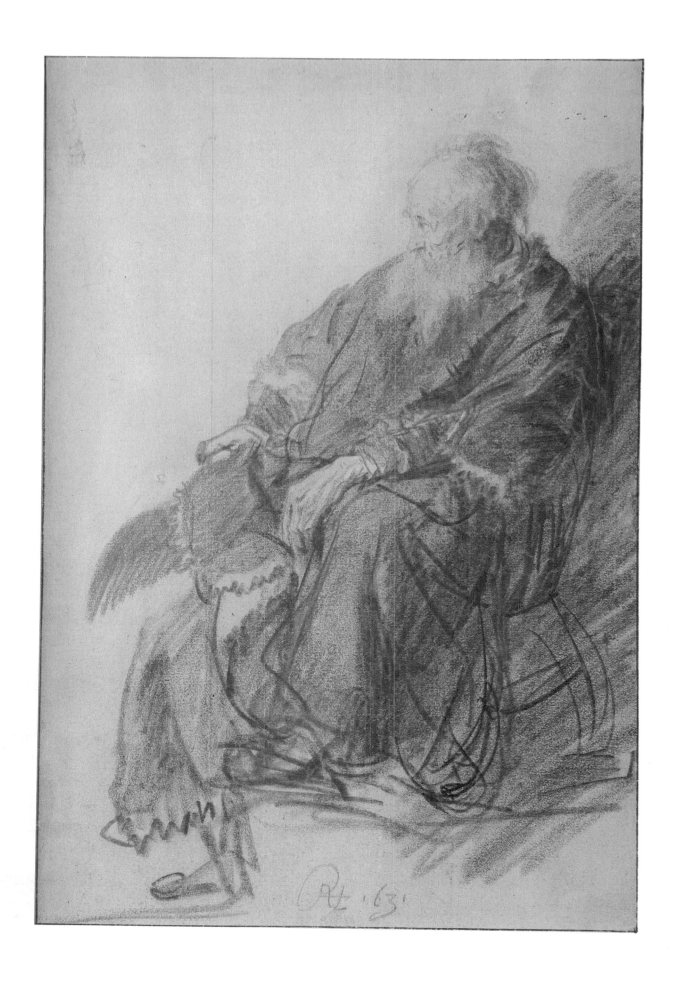

This means that the drawing dated 1631, from the Leiden period, was not made intentionally as a preliminary study, but was only adopted in the grisaille two years later. Another argument for this is the differing viewpoint: the drawn figure is seen from slightly below, as is often the case with drawings made from the life. The figure is seen from a higher viewpoint in the grisaille. Rembrandt probably reworked the drawing in order to adapt the figure to a composition with a higher viewpoint before he used it for the grisaille. This is suggested by the dark lines which have been added mainly to the lower part of the body. As a result the folds of drapery fall somewhat differently. This modification was in part adopted in the grisaille.

The height difference of the feet also posed a problem in the drawing. To solve this, the motif of a brazier was introduced into the grisaille. From a comparison of the depiction of the feet—seen from the side in the drawing and slightly more from above in the grisaille— it becomes clear that the viewpoint has been altered.

The grisaille was probably made as a design for an etching, which, however, was never realised in this form. It was only in 1638 that Rembrandt made the much smaller etching of the same subject, in which the old man appears in mirror-image. The uneven positioning of the feet was avoided in the etching by hiding them behind a step and the brazier was placed next to Jacob's chair. His leg, painted at a down-ward angle in the grisaille, appears a little straighter in the etching. In order to explain the two positions of the leg we could suppose that the drawing was again reworked in 1638, that Rembrandt erased the outline of the right leg and drew a new version on top of it. The position of the leg in the etching is somewhere between the two positions in the drawing.

The figure of Jacob in the sketch in Rotter-dam, which was made as a preparatory study for the composition of the etching, originates in the grisaille. In the sketch, the right leg is not only drawn with one oblique line, but underneath this the higher position is perhaps already indicated with a vertical and a short horizontal line.

According to the above assumption, Rembrandt reworked the drawing of 1631 before he adopted it for the grisaille and then used it again in 1638, after he had first tried out the higher position of the knee.

Rembrandt prepared the paper with a pale yellow wash, leaving the reverse white. In this he was following Lastman's example, and Jan Lievens, also a pupil of Lastman, probably also used the same sort of paper. Rembrandt made drawings in pen and brown ink on similarly prepared paper at the end of the 1630s.
P.S.

1. Benesch 20, 40 and 41. A fourth study of the same old man, probably also originally full-length, was cut off below the knees; Benesch 37.
2. The motif of a podium also occurs in a number of paintings and etchings, see: Schatborn 1985, No. 5.
3. Corpus II A66.
4. Giltaij 1988, No. 13 verso.
5. B. 37.
6. In the Corpus (A66) this is considered to be the most likely dating.
7. Schatborn 1989, pp. 118–19.

3

Portrait of Saskia van Uylenburgh

Silverpoint on white prepared parchment, arched at the top, 185 × 107 mm
Inscription: dit is naer mijn huijsprou geconterfeijt | do sij 21 jaer oud was den derler | dach als wij getroudt waeren | den 8 junijes 1633 (this is drawn after my wife, when she was 21 years old, the third day of our betrothal, the 8th of June 1633
Berlin. Staatliche Museen Preussischer Kulturbesitz, Kupferstichkabinett

Provenance: Jeronimus Tonneman, sale Amsterdam, 21 October 1754, Konstboek N, No. 67; A.G. Thiermann, Berlin; KdZ. 1152 (1861).

Literature: Bock-Rosenberg 1930, No. 1152, p. 230; Benesch 1954–1957 and 1973, No. 427 (with other previous literature and exhibitions); D.J. van der Meer, 'Ulenburg', *Genealogysk Jierboekje* 1971, pp. 98–99; F. Anzelewsky e.a., *Kupferstichkabinett SMPK, Kunst der Welt in der Berliner Museen*, Stuttgart/Zurich 1980, no. 33.

Exhibitions: Bilder vom Menschen in der Kunst des Abendlandes, Berlin (Nationalgalerie) 1980, pp. 280–81, No. 62.

3a: Rembrandt, *Landscape with two cottages.* Berlin, Kupferstichkabinett SMPK.

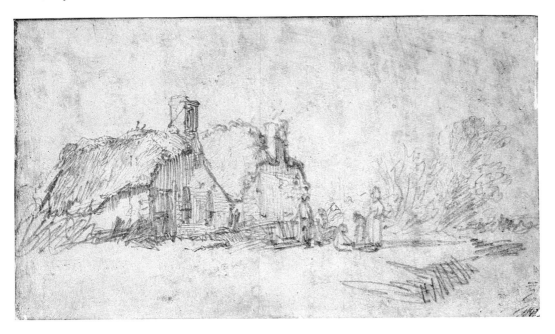

The portrait of Saskia was acquired by the museum in Berlin in 1861 from the widow of the collector A.G. Thiermann with a large collection of etchings by Rembrandt.[1] When Carel Vosmaer visited the Kupferstichkabinett shortly afterwards for his monograph on Rembrandt the drawing was catalogued as 'in the style of Rembrandt'.[2] Vosmaer recognised the likeness of Saskia and saw that Rembrandt was the creator.[3]

Saskia van Uylenburgh was born in 1612, the youngest daughter of Rombartus van Uylenburgh, government attorney and Mayor of Leeuwarden in Friesland. She was a niece of Hendrick van Uylenburgh, the art dealer with whom Rembrandt had worked since 1631. It was through him that Rembrandt became acquainted with his future wife.

Rembrandt made the drawing on costly parchment on the occasion of his engagement to Saskia on 5 June 1633. The word 'married' in the inscription means that the couple had exchanged betrothal vows.[4] The marriage took place more than a year later, on 22 June 1634.[5]

Saskia became an orphan in 1624, at the age of twelve. Thereafter she probably lived in Sint Annaparochie with her sister Hiske and her brother-in-law Gerrit van Loo, who was appointed as her guardian in 1628.[6] It is not improbable that Rembrandt travelled to Friesland to discuss the wedding with Saskia's guardian in June 1633, the date on the drawing. This would mean that the drawing was made in Friesland.[7] On 10th June 1634, when Rembrandt and Saskia's nephew Johannes Cornelis Sylvius, who signed on her behalf, signed the registry in Amsterdam, Sint Annaparochie is still given as her place of residence and this is where the marriage took place.[8]

The drawing was made in a period in which Rembrandt painted many portraits, including one of Saskia from the same year.[9] In 1633 Rembrandt made an etched portrait of the clergyman Sylvius.[10] Since the fifteenth century it was not unusual to draw portraits in silverpoint on parchment, which was first prepared with white or another colour. Immediate examples for Rembrandt were Hendrick Goltzius and Jacques de Gheyn, by whom a series of similar, mainly small, portraits are known. Rembrandt rarely used this medium. Two other parchment sheets have a drawing on both sides: on the verso of a representation of two separate small farms is landscape (Fig. 3a),[11] and on the verso of a drawing of a number of heads (Fig. 3b) is one single small farm.[12] These four drawings probably date from the same time as the portrait of Saskia. The farms which Rembrandt

drew are of a particular type found in the Gooi, in the area around Zwolle and Kampen and also in Friesland.[13]

Saskia wears a straw hat with a wide brim, decorated with flowers. Women with similar hats appear in a number of seventeenth-century representations of shepherds and shepherdesses.[14] These pastoral scenes often contain an amorous element and Rembrandt probably wanted to express this is in his betrothal portrait.[15]

The straw hat in connection with marriage also occurs in the work of Rubens of this period. In the early 1620s this Flemish artist painted Suzanna Fourment dressed as a shepherdess and with a straw hat, possibly on the occasion of her marriage to Arnold Lunden in 1622.[16] In the painting in Munich of *Rubens and Hélène Fourment in a garden*, the young bride is dressed as for gardening and also wearing a straw hat with flowers. The painting is believed to be an allegory on the marriage between Rubens and Hélène, which took place on 6 December 1630.[17]

In contrast to Suzanna Fourment and other 'shepherdesses', Saskia does not hold a shepherd's crook but a flower, perhaps a rose, an allusion to love and marriage which occurs often in literature and art.[18]

The drawn portrait of Saskia has a special place in Rembrandt's œuvre. The precision and care with which he portrayed his beloved make the drawing one of his most personal testimonies.

P.S.

3b: Rembrandt, *Model sheet*.
Rotterdam, Museum Boymans-van Beuningen.

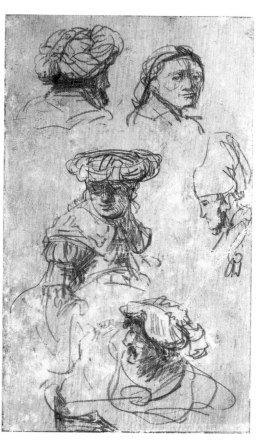

1. In the Kupferstichkabinett in Berlin is an old handwritten catalogue in which these etchings, the portrait of Saskia and three other drawings, are mentioned. This catalogue, written on paper with a watermark of 1838, is mentioned by Lugt (in L. 2434) and belonged to the English art dealer S. Woodburn (1786–1853).
2. Carel Vosmaer, *Rembrandt Harmens van Rijn, sa vie et ses œuvres*, The Hague 1868, p. 52; 'enveloppe contenant des dessins dans le goût de Rembrandt'; changed to 'un carton avec des dessins apocryphes' in the edition of 1877.
3. Peter Schatborn, 'Vosmaers magnum opus over Rembrandt', in: *De verzameling van Carel Vosmaer*, The Hague/Amsterdam 1989, ed. J.F. Heijbroek, p. 180.
4. H.F. Wijnman, 'Rembrandt en Saskia wisselen trouwbeloften', *Maandblad Amstelodamum* 56 (1969). For the details about Saskia and Rembrandt see: Broos 1981, pp. 253 ff.
5. *Documents* 1634/5. The Julian calendar was still used in Friesland in the seventeenth century. It ran ten days behind the Gregorian calendar which was used in Holland, where it was therefore 2 July on the wedding day: J.F. Jacobs, 'Notities voor een toekomstige Rembrandt-biografie', *Tableau* 8 (1986), p. 99.
6. On 14 June 1628. *Documents* Add. 1628/3. Saskia's new guardian was appointed on 20 July 1633, six weeks after the engagement, as she would come of age as a result of the forthcoming wedding. *Documents* Add. 1633/5.
7. Broos also believes that it is by no means certain that the drawing was made in Amsterdam.
8. Saskia had by then moved to Franeker, where her sister Antje had lived until her death, shortly before, on 9 November 1633.
9. Amsterdam, Rijksmuseum; *Corpus* II A75.
10. B. 266.
11. Berlin, Kupferstichkabinett SMPK, Benesch 341.
12. Rotterdam, Museum Boymans-van Beuningen, Benesch 341. A further two landscapes on parchment date from a later period, Benesch 844 and 1288; various prints of the etchings were then also printed on parchment by Rembrandt.
13. According to Boudewijn Bakker, in: Washington 1990, Intro. p. 55 and under No. 1.
14. Alison McNeil Kettering, *The Dutch Arcadia, Pastoral Art and its Audience in the Golden Age*, Montclair 1983, p. 33.
15. The first Dutch portraits in the guise of shepherds and shepherdesses were made around 1630; see Kettering 1983, p. 63 (n. 14). See also Etchings Cat. No. 17.
16. Hans Vlieghe, *Rubens Portraits of identified sitters painted in Antwerp, Corpus Rubenianum . . . XIX*, London 1987, No. 101.
17. Vlieghe 1987 (n. 16), No. 139.
18. E. de Jongh, *Portretten van Echt en Trouw, Huwelijk en gezin in de Nederlandse kunst van de zeventiende eeuw*, Zwolle, Haarlem 1986, under No. 33.

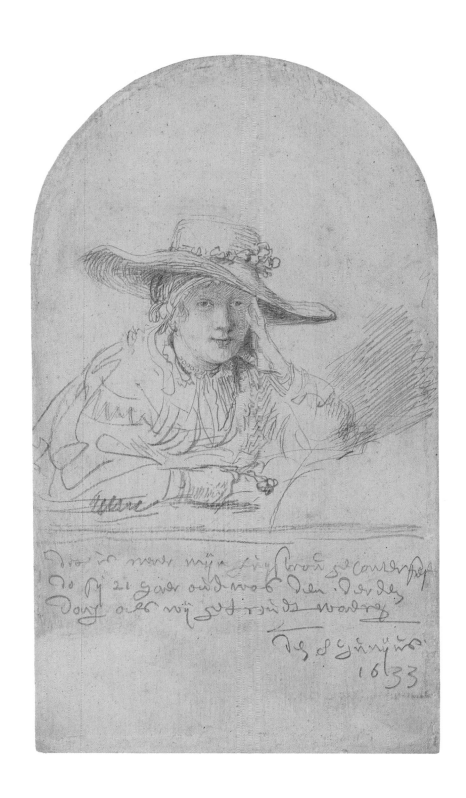

4

Self-portrait as an artist

Pen and brown ink, brown and white wash,
123 × 137 mm
Berlin, Staatliche Museen Preussischer
Kulturbesitz, Kupferstichkabinett

Provenance: Jonkheer Joh. Goll van Francken-
stein (not in the Amsterdam sale of 1 July
1833), mentioned in Cat. Woodburn 1835; Sir
Thomas Lawrence (L. 2445), London; Gallery
S. Woodburn, London, Cat. 1835, No. 72;
William Esdaile, sale London, 17 June 1840,
No. 107; Andrew Geddes, sale London, 8–14
April 1845, No. 334?; Sir Charles Robinson
(L. 1433), not in the sale, London, 7–8 May
1868; KdZ. 1553 (1880).

Literature: Bock-Rosenberg 1930, No. 1553,
p. 230; Benesch 1954–1957 and 1973, No. 432
(with other previous literature and
exhibitions).

There are not many seventeenth-century artists
who depicted themselves so often and in so
many different ways as Rembrandt. His face
already appears among the bystanders in an
early history painting of 1626.[1] In the Leiden
period Rembrandt not only made a number of
paintings of himself but also a number of
etchings which show him with various facial
expressions. Rembrandt made these in order to
depict all sorts of emotions. That self-
portraiture was exactly right for this is
apparent from a comment by Samuel van
Hoogstraten, a pupil of Rembrandt during the
1640s: 'Dezelve baet zalmen ook in 't
uitbeelden van diens hatstochten, die gy
voorhebt, bevinden, voornaemlijk voor een
spiegel om tegelijk vertooner en aenschouwer
te zijn' (the same benefit will accrue from the
depiction of the emotions which you can find
before you, namely in a mirror, where you can
be exhibiter and viewer at one and the same
time).[2] Such etchings (Cat. No. 1 and 2) were
thus made as a form of practice in the depiction
of expressions for the artist and could be used
as examples for figures in history paintings.
Moreover, they were examples for students.

Two drawn portraits from the Leiden period
(Fig. 4a)[3] were made at the same time as the
first painted and etched self-portraits. These
drawings were made as preliminary studies for
another sort of portrait, Rembrandt's first
representative etched self-portrait from 1629
(Fig. 4b).[4] The self-portraits in brown ink and
grey wash are direct precursors of the exhibited
drawing, which is in pen and brush in brown
only.

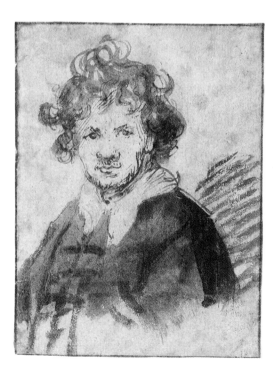

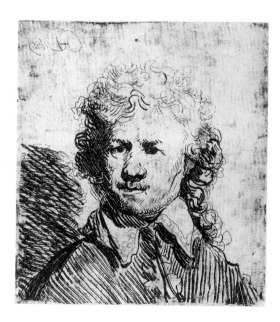

4a: Rembrandt, *Self-portrait*.
Amsterdam, Rijksprentenkabinet.

4b: Rembrandt, *Self-portrait*.
Amsterdam, Rijksprentenkabinet.

We see Rembrandt sitting at a table, his left hand on the arm of a chair. The hand in which he is holding the pen and brush is not shown. A piece of paper is perhaps lying on the table next to the sheet on which the drawing was made. In contrast to the two earlier drawings, Rembrandt wears his shirt open under his dark jacket. In all three drawings he is looking directly out at us—and himself in the mirror. His hair which was long in the early portraits is now short, the eyebrows show he is frowning slightly and the expression is serious. Rembrandt's palette is hanging on the wall. Thus the self-portrait has become that of the artist, a painter who takes his work seriously, judging by the grave expression.

During his Leiden period, Rembrandt made a small painting of himself in his studio, standing before the easel. As before, a palette hangs on the wall (Fig. 4c).[5] This painting is the first in which Rembrandt depicts himself as an artist. It probably dates from 1629, the same year as he etched his first self-portrait. It is evidence of his self-awareness as an artist.

The drawn *Self-portrait as an artist* probably dates from the beginning of the Amsterdam period, a time when Rembrandt mainly painted portraits. It had previously been supposed that the drawing dates from the late 1620s[6] or alternatively from the mid 1640s.[7] In comparison to drawn self-portraits from the Leiden period Rembrandt seems older, but it is not easy to estimate by how much. A painted *Self-portrait* in the Louvre in Paris, dated 1633, perhaps provides the best comparison for the face and the hairgrowth, although here it is longer at the back (Fig. 4d).[8]

The style of the drawn *Self-portrait as an artist*, with its lively, sometimes sharp penlines in the face and the broad brushstrokes in parts of the clothing, is comparable to that of the drawn self-portraits made in the Leiden period. If the drawing was made in or around 1633, it would have been made at the same time as the *Portrait of Saskia* (Cat. No. 3) which was executed in silverpoint and which has a finer handling of line.[9]

We do not know for what purpose the *Self-portrait as an artist* was made. It could have been as practice or as a preparatory work, but no directly comparable painted or etched self-portrait is known from this time. Drawings of this type were also intended as examples for pupils' most of whom also drew self-portraits during their apprenticeship.[10]

P.S.

1. *Corpus* I A6.
2. Hoogstraten 1678, p. 110.
3. London, British Museum; Benesch 53. Amsterdam, Rijksprentenkabinet; Benesch 54; Schatborn 1985, No. 1.
4. B. 338.
5. Boston, Museum of Fine Arts; *Corpus* I A18.
6. Lilienfeld 1914, No. 88.
7. HdG 1906, No. 98; Valentiner II 1934, No. 1934, No. 663. Benesch dates the drawing c. 1634, Bock-Rosenberg c. 1635.
8. Paris, Musée du Louvre; *Corpus* II A71.
9. In 1634 Rembrandt drew the *Bust of an old man with clasped hands*, a figure which is reminiscent of biblical figures and saints. This drawing, in the album of the German merchant Burchard Grossman, was executed in pen and brush and shows the same combination of sharp, lively lines and broad areas of wash. Moreover, the areas of light and dark are similarly distributed over the figure. The Hague, Koninklijke Bibliotheek; Benesch 257.
10. See for example Exhib. Cat. Amsterdam 1984–1985, Nos. 3–6.

4c: Rembrandt, *Self-portrait as a Painter*. Boston, Museum of Fine Arts.

4d: Rembrandt, *Self-portrait*. Paris, Musée du Louvre.

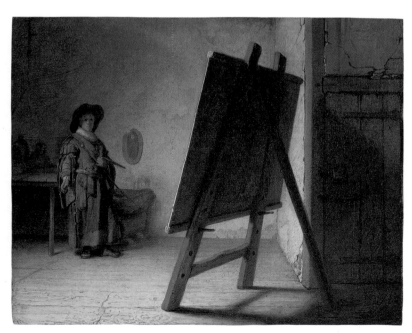

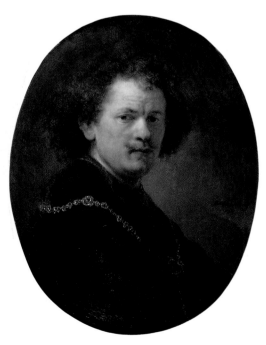

Christ carrying the Cross

Pen and brown ink, brown wash, mounted,
145 × 260 mm
Inscription: below left *Rembrant.*
Berlin, Staatliche Museen Preussischer
Kulturbesitz, Kupferstichkabinett

Provenance: Sir John Charles Robinson (L. 1433),
not in sale London, 7–8 May 1868; KdZ 1554
(1880).

Literature: Bock-Rosenberg 1930, No. 1554,
p. 227; Benesch 1954–57 and 1973, No. 97
(with other previous literature and
exhibitions).

Exhibitions: Amsterdam 1969, No. 40; Berlin
1970, No. 98.

Rembrandt has depicted the moment from the
Passion when Christ falls to the ground (Luke
23: 26–27). One of the soldiers behind him has
taken over the Cross to pass it on to Simon of
Cyrene. The latter stands in the left
foreground, having come in from the fields,
with a spade, from which a basket hangs, over
his shoulder. Mary has fallen backwards and a
figure, perhaps John, kneels beside her. From
behind him a woman rushes forward, her arms
outstretched. Another woman behind the cross,
jumps back startled. Between these two, we see
another head. It has recently been suggested
that the woman with outstretched arms might
be Veronica holding the cloth with the imprint
of the face of Jesus before her.[1] However,
Veronica's cloth is not clearly apparent and
the small head could also belong to a figure
situated further in the background.

Behind the soldiers is a rider on a horse,
but because the picture has been cut off at the
top at a later date, this is not immediately
apparent. The lower part of the horse's head, of
which the eyes are only just on the paper, is to
the right of the cross. Next to this the hands,
an arm and a section of the rider's cloak have
been drawn. The vertical stripes beneath the
rider represent the horse's saddlecloth.

The horizontal composition is inspired by a
print by Martin Schongauer, which Rembrandt
probably owned (Fig. 5a).[2] The placing of
Jesus under the cross and the position into

which he has fallen support the supposition that Rembrandt knew Schongauer's print. Rembrandt has replaced the soldier seen from behind, to the left of the Cross on the print, with the figure of Simon. He is not often depicted in the representational tradition and Rembrandt has added him to the scene in an original way, as a farmer with a spade and basket.[3] The man who takes over the cross and the horseman in the background appear in both works but, where Schongauer had placed a soldier with a whip in the middle foreground, Rembrandt has drawn the fallen Mary. In his composition the heads of the figures form an oval, which is even further accentuated by the direction of the various pen lines. By interpreting this story as a human drama, the drawing has become one of the most moving depictions of the suffering Jesus.

The style of the drawing is particularly sketchy, the figures are only broadly indicated, yet, in their summary treatment, almost all their movements are clear. The face of Jesus is the most highly finished and forms the central motif of the drawing, while the anxious face of the fallen Mary is also more worked out than the others. Finally Rembrandt added the figure of Simon with the brush and his shadow in the foreground forms the basis of the composition.

How a pupil used a drawing such as this as a model is apparent from a drawing in Amsterdam (Fig. 5b) of a fallen man. A woman kneels by him while an old man rushes towards him. It is not clear what the subject is, but the sheet is a kind of paraphrase of the right side of the Berlin drawing.[4]

Christ carrying the Cross is dated to the mid-1630s, when Rembrandt was occupied with the series of paintings of the Passion commissioned by Frederik Hendrik. A number of drawings from this time display the same stylistic characteristics (e.g. Cat. Nos 7, 9, 12).
P.S.

1. Information kindly supplied by Stephan Kemperdick.
2. B. 21; mentioned in the inventory of 1656 detailing Rembrandt's possessions is 'A cardboard box with prints by Hubse Marten [Schongauer], Holbeen, Hans Broesmer [Brosamer] and Israel van Ments' [Meckenem]; *Documents* 1656/12, No. 237.
3. This figure is identified by L.C.J. Frerichs, in Amsterdam 1969, No. 40.
4. Schatborn 1985, No. 88.

5a: Martin Schongauer, *The Great Ascent to Calvary*.

5b: Rembrandt, *Scene with a fallen man*. Amsterdam, Rijksprentenkabinet.

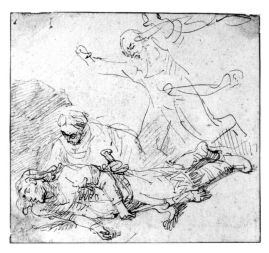

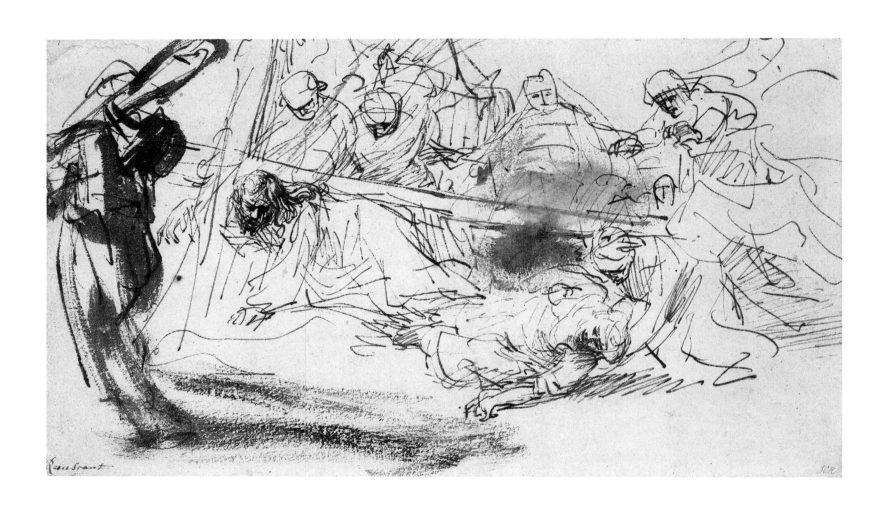

6

Christ and the Apostles on the Mount of Olives

Pen and brown ink; brown, grey, white and some green wash; black and red chalk; to the left of Christ a vertical fold; a piece of the paper cut out and the hole covered with a piece of paper glued to the back; a cut in the paper about 2 cm from the top, 357 × 478 mm
Inscription: centre right *Rembrandt f 1634*
Haarlem, Teylers Museum

Provenance: E. Valckenier-Hooft, sale Amsterdam, 31 August 1796, No. A4; Inv. No. O* 74.

Literature: Benesch 1954–1957 and 1973, No. 89; Hoekstra 1981, N.T. 2, pp. 68–69; M. Plomp, *Catalogue of the Dutch Drawings in Teylers Museum, Artists born Between 1575–1630,* to appear in 1992 (with other previous literature and exhibitions).[1]

Exhibitions: Rotterdam/Amsterdam 1956, No. 28; *Höllandische Zeichnungen der Rembrandt-Zeit,* Brussels and Hamburg 1961, No. 47; catalogue by K.G. Boon and L.C.J. Frerichs, introduction by Frits Lugt; Amsterdam 1964/1965, No. 108.

Christ and his disciples are sitting together in a circle in the darkness of the night. They are lit by the halo of Christ, who is seated above the others, holding his right hand to his chest. Nine disciples are clearly visible and the tenth has been indicated only as an initial sketch, on the left in the background. The figure with closed eyes to the left of centre can be identified as the young John and the bald, bearded figure in the background next to Christ is Peter. In the left foreground a disciple is yawning while looking out at the viewer.

The drawing was made on a large piece of paper, which has been folded down the centre. Rembrandt probably began with black chalk, as can be seen in the figure of Christ, and then added brown, grey and black wash. Thereafter he used red chalk, with which he drew over the wash in parts of the left foreground and background, including the face of the unfinished tenth disciple. Rembrandt then used black chalk again over the wash to draw the small gate behind and to the right of Christ and to sign his name and give the date. Finally, areas were enhanced with pen and dark-brown ink, including the head of the yawning man. Areas were also heightened with white, such as the profile of the disciple in the right fore-ground. The disciple with the turban in the centre apparently caused difficulties at first, as Rembrandt cut him out of the paper, redrew him on another piece of paper and glued it on from behind. At the top there is a cut in the paper, the presence of which cannot be explained. Up to a certain point the drawing therefore gives a clear idea of the working process.

There are a number of works by Rembrandt where the subject cannot be precisely determined in accordance with the Bible or the tradition of representation. In the case of the Haarlem drawing the question is whether it represents one particular moment. A number of varying interpretations have been suggested for the subject of the drawing.

It is true that Rembrandt sometimes depicts various moments from a story in one picture, as in the *Hundred Guilder Print* (Etchings Cat. No. 27), but such an amalgamation does not seem very plausible here.[2] It has also been suggested that the scene represents one of the miracles of Christ,[3] but there is not enough evidence for this either. A more plausible suggestion is that it represents 'The first appearance of the risen Christ' (John 20: 19–23).[4] This does take place at night but not out of doors as shown in the drawing. The presence of ten disciples does accord as Judas was then no longer alive and Thomas only appeared a few minutes later. But the two

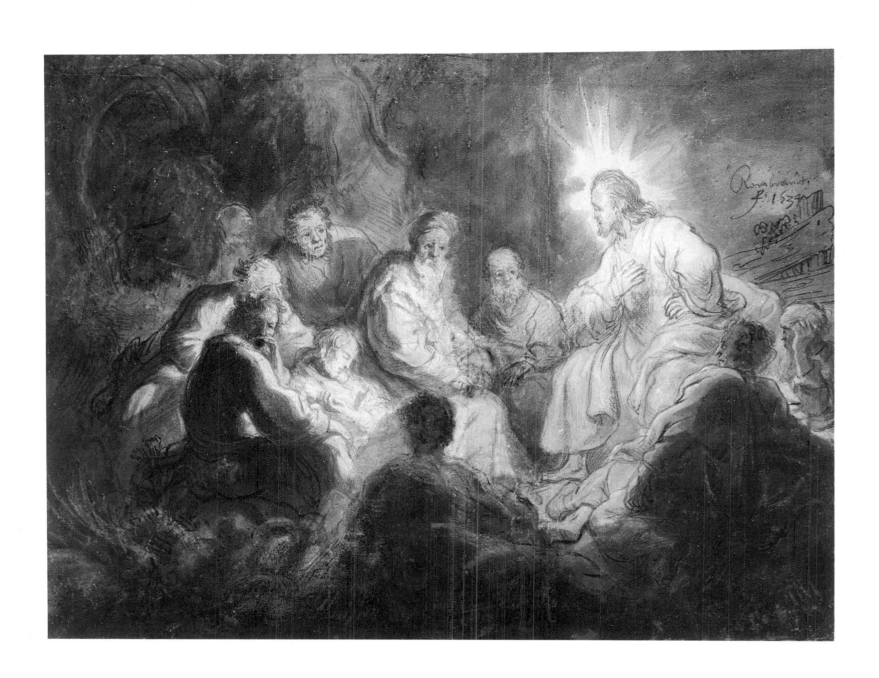

apostles sleeping and yawning does not fit here.

It has also been suggested that the subject is 'Christ's Prophecies and Warnings' in which he is sitting on the Mount of Olives with his disciples (Matthew 24).[5] Since this scene does not take place at night, the argument is not supported.

The most recent identification is 'Christ's return to the Apostles from Gethsemane'.[6] This does take place at night, but in most representations only three of the disciples are present, according to the gospels of Matthew and Mark. In the gospel of Luke all the disciples are present when Christ discovers them asleep: 'Why sleep ye? rise and pray, lest ye enter into temptation' (Luke 22: 46).[7] With this interpretation, not only the darkness is explained, but also the sleeping John and the yawning man. Only the number of ten is actually one too few, but it is uncertain whether this should count as an argument against this identification. The gesture of the seated Christ, with his hand on his chest and heart is, however, different from the pose in other drawings of the return from Gethsemane, where Christ is shown standing with outstretched arms.[8]

As it is so difficult to pinpoint the subject, it does not seem improbable that there is an amalgamation of subjects. The drawing could then in the first instance represent 'Christ's Prophecies and Warnings' with motifs from 'Christ's Return from Gethsemane', in particular the darkness and the yawning man.

The same amalgamation was drawn by Rembrandt's pupil, Philips Koninck, and here also Christ is holding his hand to his chest (Fig. 6a).[9] Moreover, there are only ten disciples present, John is sleeping and another disciple is yawning.

Only a few of Rembrandt's drawings are so elaborately worked. There is a drawn portrait from the same year, which probably represents Willem van der Pluym and was made as an independent drawing, finished in the same media,[10] so it is not improbable that the *Christ and his Disciples* had a similar function.[11] Both works are signed and dated.

P.S.

1. Michiel Plomp was so kind as to make available his as yet unpublished catalogue text, of which use has gratefully been made.
2. Panofsky suggested that it concerns 'The calling of the first Disciples and the first Healed' (Matthew 4: 18–25) and the 'Sermon on the Mount' (Matthew 5: 1–12), in: Brussels/Hamburg 1961 (German edition).
3. Mentioned are the *Raising of Lazarus* (Van Regteren Altena, in Rotterdam/Amsterdam 1956, p. 20) and *The Healing of the epileptic Boy* (F. Wickhof, *Einige Zeichnungen Rembrandts mit biblischen Vorwürfen*, Innsbruck 1906, p. 25).
4. W. Weisbach, *Rembrandt*, Berlin-Leipzig 1926, pp. 141–42, *Corpus* III A90, p. 473.
5. Amsterdam 1964–1965 and Hoekstra 1981.
6. By Michiel Plomp, op. cit.
7. Plomp gives as an example a painting in Braunschweig by Orazio Borgianni in which eleven disciples appear.
8. Benesch 613, 940 and 941.
9. Paris, Ecole des Beaux-Arts; Benesch A53; Sumowski *Drawings*, 6, No. 1525–xx. The drawing is dated by Benesch and Sumowski to the first half of the 1640s.
10. New York, private collection; Benesch 433. I.H. van Eeghen, 'Willem Jansz. van der Pluym en Rembrandt', *Amstelodamum* 64 (1977) 1, pp. 6–13.
11. Plomp does not rule out the possibility that the drawing was begun as a design for an etching and then later changed hands as a work of art in its own right.

6a: Philips Koninck, *Christ and the Apostles*. Paris, Ecole des Beaux-Arts.

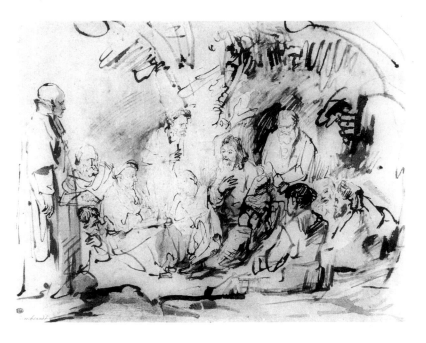

7

Sketches of figures for John the Baptist preaching

Pen and brown ink, 167 × 196 mm
Berlin, Staatliche Museen Preussischer
Kulturbesitz, Kupferstichkabinett.

Provenance: Sir Thomas Lawrence (L. 2445),
London; Samuel Woodburn, not in 1835
London Cat.; William Esdaile (L. 2617), sale
London 17 June 1840, No. 35 (to Brondgest);
KdZ 3773 (1884).

Literature: Bock-Rosenberg 1930, No. 3773,
p. 235; Benesch 1954–1957 and 1973, No. 141
(with other previous literature and
exhibitions); *Corpus* III under A. 106, p. 83,
Fig. 14.

Exhibition: Berlin 1970, No., 71.

The *John the Baptist preaching* (Fig. 7a), a
grisaille formerly in the collection of Jan Six
(see Cat. No. 23) and now in Berlin, is one of
Rembrandt's ambitious compositions from the
1630s.[1] This painting, like other works
executed in the same technique, is probably a
design for an etching, which was, however,
never made.

In this picture countless figures in all
manner of poses and stances are depicted
around John as he preaches. Rembrandt made
a number of preparatory drawings for the
grouping and characterisation of these figures
in approximately 1634–1635 when the initial
design of the monochrome painting had
probably already been completed.

There are two sheets of sketches with
different versions of the group of scholars in the
centre of the composition, the exhibited draw-
ing and one at Chatsworth with sketches on
both sides of the sheet (Figs. 7b and 7c).[2] On
one side two figures are conversing while a
third leans on a stick listening to them. This is
presumably the first version of this group,
which was elaborated further in the exhibited
drawing.

On the left-hand side Rembrandt drew the
same two scribes and the listening man but in
between them he placed a third figure with a
tall hat. This additional figure was also
included full-length on the lower right, while
another, separate drawing exists of just the
head.[3] The face of the same man is also drawn
on the verso of the Chatsworth sheet, cut off
below centre and partly at the edge (and
possibly above it as well). The group of three
appears again in the centre of the Berlin
drawing, but now without the listening figure.
Rembrandt tried out the heads of these figures
once more above these sketches.

The scribe seen from the side has undergone
the most interesting development: in the
Chatsworth sketch he is wearing a long cloak
and holding a stick. In the two sketches in the

7a: Rembrandt, *St John the Baptist preaching*
(detail). Berlin, Gemäldegalerie SMPK.

7b: Rembrandt, *Sheet of studies* (recto).
Chatsworth, The Devonshire Collection.

7c: Rembrandt, *Sheet of studies* (verso).
Chatsworth, The Devonshire Collection.

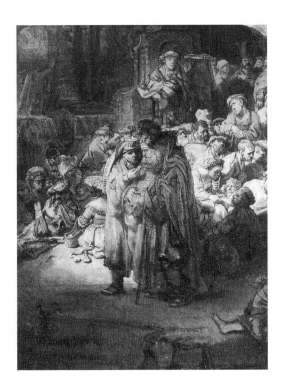

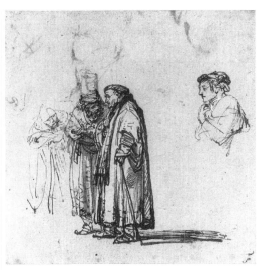

lower part of the Berlin drawing, where he is wearing the same sort of headdress as the man above left,[4] he has taken on the form of Willem Ruyters, an actor with plump cheeks and a fat stomach, who Rembrandt drew more than once (Fig. 7d).[5] In the painted version the figure is dressed in such a way that very little of his face remains visible. The actor, drawn from life, was therefore used as a type for one of the scholars, but Rembrandt eventually abandoned this idea. This illustrates the rôle played by drawings from life in a sketch created from the imagination.

A number of other sketches can be seen at the top of the Berlin drawing. The man leaning on his arms at the top right-hand side is comparable to the figure at the feet of John who is leaning on the ground. So, when Rembrandt drew this sketch the spatial structure the composition had already been determined. This may also be the case in another pen drawing in Berlin showing a group of listening figures (Fig. 7e).[6] In the painting similar figures sit and stand at the feet of John. The foliage at the top of this drawing could be compared to the foliage in the painting next to and behind John. It is true that the figures in the drawing are different from those painted, but we do encounter similar motifs. Rembrandt here especially tried to depict various ways of listening, from sceptical to sympathetic and from empathetic to uncomprehending. From the innumerable sketches we can understand a little of the way in which Rembrandt tried out different versions and built up shape in the painting, which in the end still differs from the drawings.

Two other drawings are also connected with the painting: one in Stockholm shows three studies of the figure of a negro with a plumed hat and a quiver. A similar figure lies on the ground listening to the left of centre in the painting, while another such figure stands in the right foreground.[7] Finally, there is a red chalk drawing which twice shows the figure of *John preaching* (Fig. 7f)[8] The bearing and position are roughly the same, but in the painting John's face is depicted from the side, not diagonally from the front, and with outstretched arm and fingers spread. The exhibited drawing is a typical example of a sketch, in which Rembrandt, while drawing, sought solutions for the expression and bearing of various figures and the relationship between them, in this case during work on a particular painting, bearing its progress in mind. Such a sheet therefore had a preparatory function for Rembrandt, although the figures were not necessarily incorporated into the painting. A comparable drawing was made as an example for pupils and can be regarded as a model sheet (Cat. No. 8).

The sketchy drawing style, with its occasionally rather scratchy use of line, is in keeping with various other drawings of this period (Cat. Nos 5, 9 & 12). The dating of the painting to 1634–1635 also applies to the drawings which Rembrandt made in preparation for it. P.S.

1. Berlin, Gemäldegalerie SMPK; *Corpus* III A106.
2. Chatsworth, The Devonshire Collection; Benesch 142, recto and verso.
3. New York, Pierpont Morgan Library; Benesch 336.
4. Rembrandt wears a similar headdress in a *Self-portrait* ascribed to him in Washington, National Gallery of Art; Bredius/Gerson 39.
5. Dudok van Heel 1979–I; Albach 1979, pp. 19–21; the drawings of this actor which could have been made from the life or from memory are in London, Victoria and Albert Museum, Benesch 235; in Rouen, Musée des Beaux-Arts, Benesch 230; Chatsworth, The Devonshire Collection, Benesch 120.
6. Berlin, Kupferstichkabinett SMPK; Benesch 140.
7. Stockholm, Nationalmuseum; Benesch A20. This drawing is inscribed on the back, possibly in Rembrandt's hand, [schi] *lderij 2-0-0/3* [Changed to] *5-0-0.*
8. London, The Princes Gate Collection, Courtauld Institute Galleries; Benesch 142A.

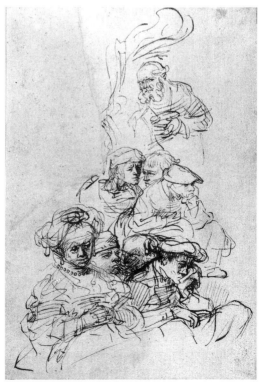

7d: Rembrandt, *The Actor Willem Ruyters.* London, Victoria and Albert Museum.

7e: Rembrandt, *Sketches of listening figures.* Berlin, Kupferstichkabinett SMPK.

7f: Rembrandt, *Two sketches of St John preaching.* London, Princes Gate Collection, Courtauld Institute Galleries.

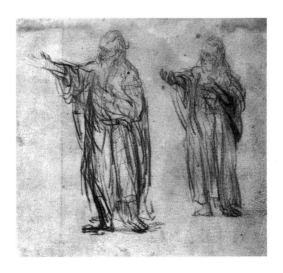

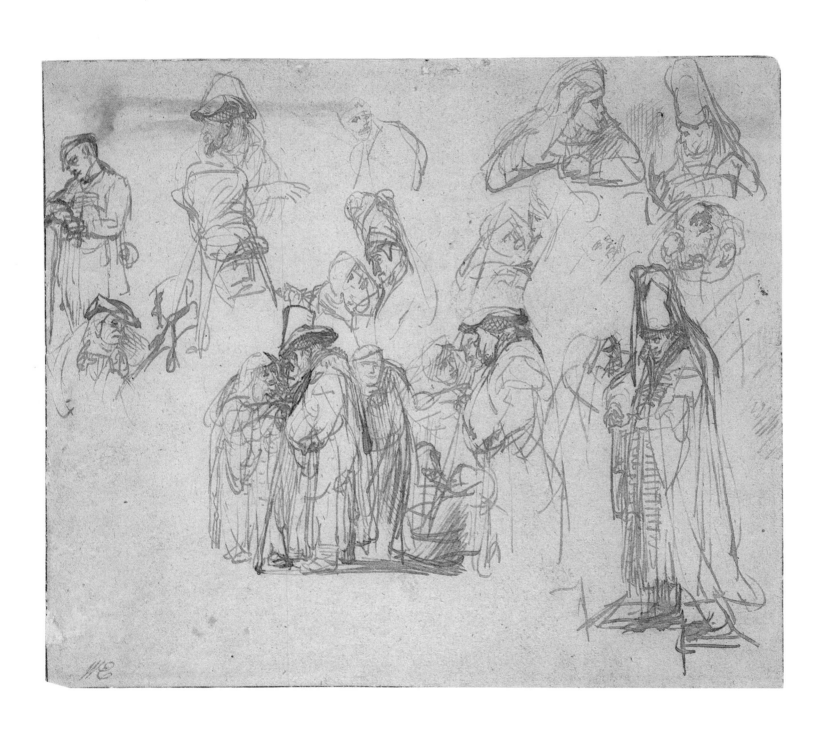

8

Model sheet with male heads and three sketches of a woman with a child

Pen and brown ink, brown wash, red chalk,
220 × 233 mm
Birmingham, The Barber Institute of Fine Arts

Provenance: R.P. Roupell (L. 2234), sale London,
12–14 July 1887, No. 1109; J.P. Heseltine
(L. 1507), London; H. Oppenheimer, London;
O.F. Oppenheimer, sale London, 17 June 1949,
No. 27.

Literature: Benesch 1954–57. No. 340; Bruyn
1983, pp. 55, 58.

Exhibitions: Amsterdam 1969, No. 37; Hamish
Miles and Paul Spencer-Longhurst, *Master
Drawings in the Barber Institute*, London (Morton
Morris & Company) 1986, No. 12 (with other
previous literature and exhibitions).

8a: Rembrandt, *Model sheet.*
Berlin, Kupferstichkabinett SMPK.

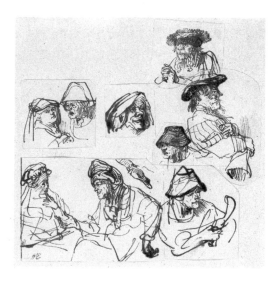

There is a difference between sheets with
sketches of various heads and figures made in
preparation for a painting or etching, and the
so-called model sheets. To the first group
belong, for example, the sketches for *The
Preaching of John the Baptist* (Cat. No. 7), where
Rembrandt appears to have experimented with
all sorts of versions of figures and groups in
order to hit upon the right shape. In contrast,
the exhibited drawing shows deliberation in the
placing of the sketches: it is not a preliminary
study. Model sheets have a less sketchy style
than sheets with sketches and are more
finished. They gave the artist the opportunity
to draw various characteristic heads and figures
on the same sheet and were intended as
examples for pupils.

Since time immemorial such sheets belonged
to model books which were at the disposal of
artists and their pupils in the studio. These
model books originally consisted of drawings,
but later there were also editions of prints, as a
result of which the examples of course achieved
a wider circulation.

Rembrandt made a number of etchings in
the tradition of such model books. In the
eighteenth century there is even a mention by
Dézalier d'Argenville of a model book by
Rembrandt, which probably consisted of
etchings of heads and figures as well as studies
of the nude.[1] We do not know for certain
whether this *livre à dessiner* of his etchings was
assembled by Rembrandt himself or by a later
collector or dealer.

The man with plumes on his headdress
wears a cloak with an ermine collar. His left
hand constitutes the centre of the sheet. The
other heads and figures have been placed in a
circle around it. At the left are two male heads,
one seen from the side and one who is looking
at us over his shoulder. To the right are three
sketches of a woman breastfeeding her child.
Two sketches show the woman with the child
in her arms, the central sketch only shows the
sleeping child against the breast. At the above
left there are two small turbaned heads. At the
bottom right Rembrandt drew a man wearing a
fur-trimmed hat who leans on a table and
seems to be listening.

This latter figure is the only one executed in
red chalk, while his features have been streng-
thened with the pen. The underside of the pen-
drawn arm of the man in the middle is
heightened with red chalk. This combination of
various media on the same sheet also occurs in
a drawing in Amsterdam of *Sketches of grieving
Marys.*[2]

The combination of exotic heads with
sketches of a woman and child does not seem
to have any particular significance. We see, for

example, similar male heads in etchings of
oriental heads, which Rembrandt made in 1635
after the example of Jan Lievens.[3] Rembrandt
also drew Saskia with a child in her arms and
the sketches on the model-sheet could be
inspired by these. In an etching of 1636 by
Rembrandt various heads of Saskia are again
combined with the head of a man wearing a
turban.[4] The variety of motifs was probably
deliberate.

Not all of these drawings have remained in
their original form. Dealers cut up some of
the sheets in order to earn more from the
individual drawings. In Rembrandt's œuvre,
we therefore come across all sorts of small
drawings, which were originally parts of larger
sheets. A drawing in Berlin consists of sketches
on small pieces of paper which have been
pasted onto a new sheet of paper to form a
whole (Fig. 8a).[5] Some pieces however are
missing, as the head of a goose in the centre
has been cut off. The exhibited drawing is, in
contrast, the finest model sheet in Rembrandt's
œuvre that has remained intact. The drawing
dates from the mid 1630s.

I.J. de Claussin (1795–1844) made a print
after Rembrandt's drawing, in which he
omitted the sketch in red chalk. However, in
the centre he added a head which derives from
another drawing.[6]

P.S.

1. Dézalier d'Argenville, *Abrégé de la vie des plus fameux
peintres . . .*, II, Paris 1745; 'son livre à dessiner est de
dix à douze feuilles'; J.A. Emmens, *Rembrandt en de regels
van de kunst*, Utrecht 1968, pp. 155–58; Bruyn 1983,
p. 57.
2. Made in 1635–1636 in preparation for *The Entombment*
in Munich; Benesch, No. 152; Schatborn 1985, No. 7.
3. B. 286–89.
4. B. 365.
5. Berlin, Kupferstichkabinett SMPK; Benesch,
No. 219.
6. Giltaij 1988, in No. 16; Benesch, No. 190.

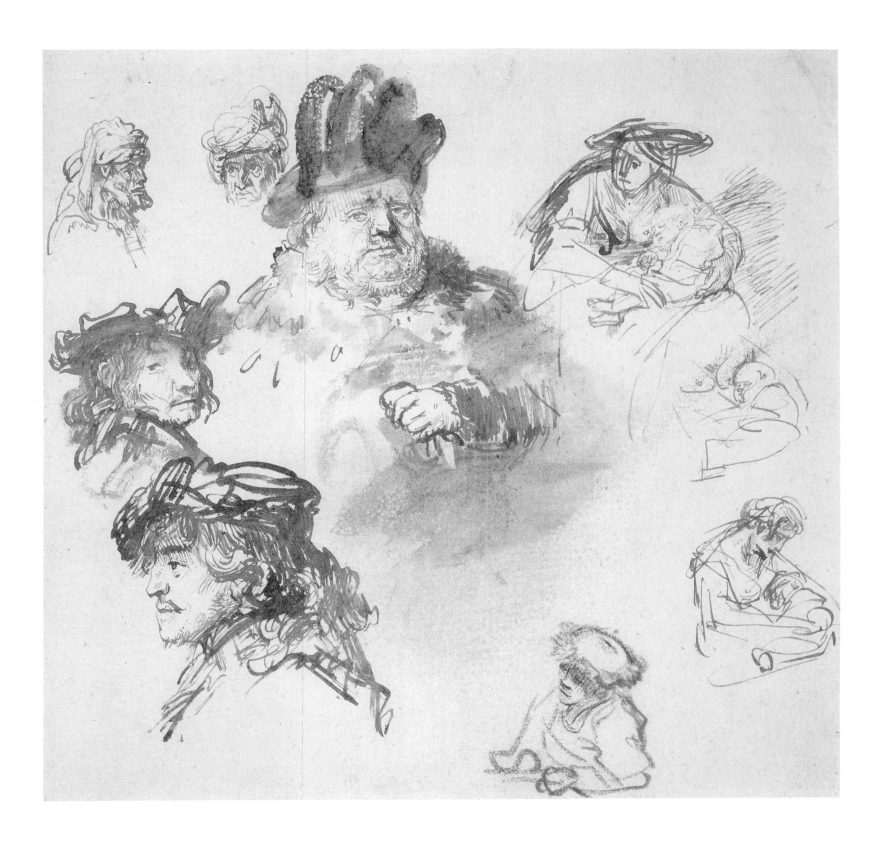

9

Woman with a Child descending a staircase

Pen and brown ink and wash, 187 × 132 mm
Inscription: bottom right, unidentified sign
New York, The Pierpont Morgan Library

Provenance: Charles Fairfax Murray, London;
John Pierpont Morgan, New York (1910);
Inv. No. I. 191.

Literature: Benesch 1954–1957 and 1973,
No. 313.

Exhibitions: New York/Cambridge 1960, No. 23;
Amsterdam 1969, No. 44; Paris/Antwerp/
London/New York 1979/1980, No. 68 (with
other previous literature and exhibitions).

One of the many subjects which Rembrandt drew is called *The Life of Women with Children* in the inventory of 1680 of Jan van de Cappelle.[1] The latter, a painter of seascapes, owned approximately 500 drawings by Rembrandt and 135 of these were representations of women and children. Although this title does not appear in the inventory of Rembrandt's own collection of 1656, the album of drawings as acquired by Van de Cappelle was probably put together by Rembrandt.[2] Drawings of women and children occupy an important place in the œuvre, especially among the drawings of the 1630s and 1640s.

The drawing of the woman descending a staircase with a child in her arms probably originates from the album of Van de Cappelle. One of the later owners added a letter (*R?*) or a sign at the lower right, which also appears on other drawings, particularly those of women and children.[3]

The young woman is wearing a small cap on her head and a cord with a tassel (or a purse?) hangs from her dress. She is shown in movement, the visible leg bent, while her dress is dragging on the stairs. The spiral staircase is certainly not depicted in the correct perspective, but it is still clearly recognisable. The young woman clasps the little boy to her, with his face touching hers.

The genesis of Rembrandt's drawings can often be read in the work itself. The fine lines were gradually supplemented by and replaced with stronger lines. The back of the boy is, as it were, expanded backwards and in comparison with the first version the legs hang more vertically. The contour of the woman's hair has been moved further out in order to obtain a better form for the head. On the other hand, the profile and the face of the child seem to have been set down correctly from the outset. Characteristic of Rembrandt is the transparent wash, through which light constantly shines and flat areas and hard contours hardly ever appear.

It is uncertain to what extent such a drawing was made from life. There is no doubt that the scene was observed, but it is likely that it was put onto paper from memory. This method of working was called 'van onthoudt' (from recollection) in the seventeenth century.[4] The similarity of the child's features with others in Rembrandt's drawings indicates that he based them on an existing model, as can be seen in the depiction of Ganymede (Cat. No. 10) and other drawings. It is clearly more likely that an existing type served as a model when he was drawing from imagination or 'from memory' rather than that he drew directly from the life.

The subject comes of course from Rembrandt's immediate surroundings. It used to be thought that Rembrandt used his wife Saskia and their children as models for his drawings, but we now know that all his children, with the exception of Titus born in 1641, only lived for a short time, and this is no longer a possibility (see Cat. No. 20).[5] However, after 1631 Rembrandt worked for a considerable time with Hendrick Uylenburgh, who became his brother-in-law in 1634. Uylenburgh had married Maria van Eyck in 1624 and by 1634 they had six children with whom Rembrandt was of course acquainted. When he married Saskia in that year these children of all ages became his nephews and nieces. They were probably an important source of inspiration for the images of the life of women and children mentioned in Van de Cappelle's inventory.[6]

The style of the drawing with its fine pen lines and transparent wash is typical of the mid-1630s. Comparable is for example the *Model sheet with heads* (Cat. No. 8).
P.S.

1. A. Bredius, 'De schilder Johannes van de Cappelle', *Oud-Holland* 10 (1892), pp. 26–40 and 133–136; Schatborn 1982, pp. 1–12.
2. In Rembrandt's inventory of 1656 these drawings are probably included among the 'sketches'. We also come across 'histories' in his inventory, which are also not mentioned individually in Rembrandt's inventory. In addition Van de Cappelle owned numerous landscapes: 277 in total.
3. Exhib. Cat. Paris, Antwerp, London & New York 1979–80, No. 68.
4. Alison McNeil Kettering, *Drawings from the Ter Borch Studio Estate*, I/II, *Catalogue of the Dutch and Flemish Drawings in the Rijksprentenkabinet, Rijksmuseum, Amsterdam*, The Hague 1988, No. H51.
5. Van Eeghen 1956.
6. Amsterdam 1984–1985, p. 8.

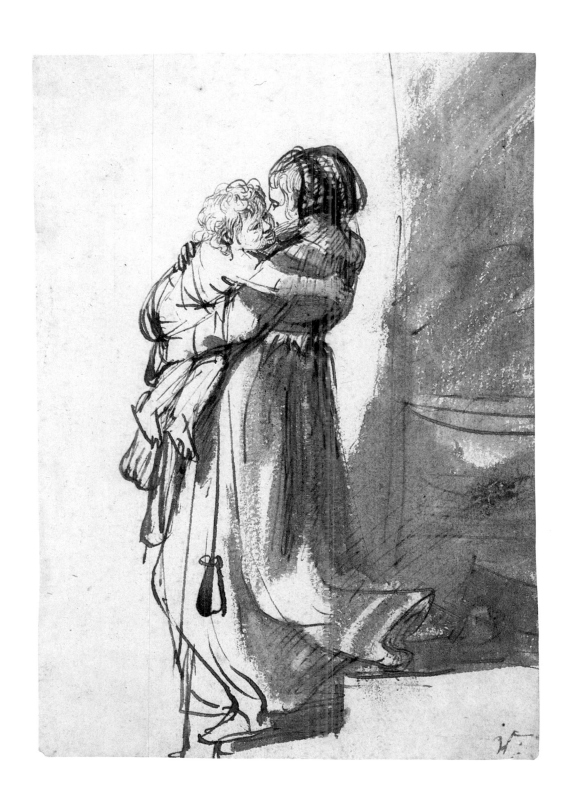

The Rape of Ganymede

Pen and brown ink and wash, 183 × 160 mm
Dresden, Kupferstich-Kabinett der Staatlichen
Kunstsammlungen

Provenance: Gottfried Wagner, Leipzig (1728);
The Electors of Saxony (L. 1647), Dresden;
Inv. No. C 1357.

Literature: Benesch 1954–1957 and 1973,
No. 92 (with other previous literature
and exhibitions); Margarita Russell,
'The Iconography of Rembrandt's Rape
of Ganymede', *Simiolus* 9 (1977), 1,
pp. 5–18; *Corpus* III under A 113.

10a: Rembrandt, *The Rape of Ganymede*.
Dresden, Staatliche Kunstsammlungen.

10b: Nicolas Beatrizet after Michelangelo,
The Rape of Ganymede. Amsterdam,
Rijksprentenkabinet.

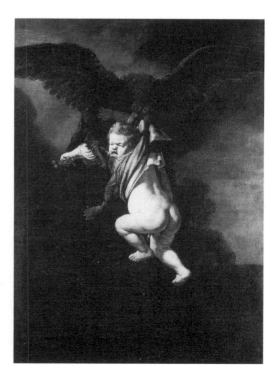

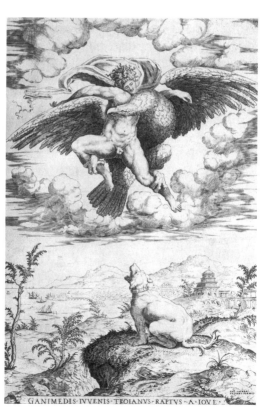

GANIMEDIS·IVVENIS·TROIANVS·RAPTVS·A·IOVE·

The art and literature of antiquity held a well-
established place in European culture. The
stories belonged to the popular repertoire of
writers and artists and were widely-known in
the seventeenth century. Among Rembrandt's
narrative representations biblical subjects hold
the most important place, but in addition to
these there are a considerable number of
mythological representations.

Ganymede, described in *The Iliad* as the
'divine' son of the Trojan king Tros and the
most beautiful of all mortals[1] was, because of
his beauty, abducted by Zeus who had taken
on the form of an eagle, to become cup-bearer
to the gods. In 1635 Rembrandt made a
painting of this abduction (Fig. 10a).[2] The
exhibited drawing is a preliminary sketch for
the composition.

With wings outstretched the eagle holds the
arms of the little boy in his claws and beak in
such a way that the little tunic has been pulled
up leaving him almost completely naked. In the
lower left of the drawing the despairing parents
watch their little boy disappear. These figures
do not appear in the painting, but they are
mentioned in Karel van Mander's *Explanation* of
the much-read *Metamorphoses*. Moreover, Van
Mander says that Ganymede was taken from
them at an early age by death; that is, while he
was still a child.[3] By depicting him as a child,
Rembrandt has placed less emphasis on the
erotic aspect of the story. In the drawing the
child is not peeing as he is in the painting.
In the latter this refers to Ganymede's trans-
formation into the constellation Aquarius, as
Van Mander relates. It is plausible to suppose
that the telescope, through which Ganymede's
father is looking, has a connection with this
astrological aspect.[4]

The features of the child, particularly as
depicted in the painting, are of a classic type,
based on examples by other artists.[5] We come
across the same child crying in Rembrandt's
drawing which has long been known as *The
naughty Child*,[6] and again as a *putto* in
Rembrandt's *Danaë* from 1636.[7] A drawing
which is more directly based on observation
also has these classic features (Cat. No. 9).

For the composition of the drawing
Rembrandt probably made use of a print by
Nicolas Beatrizet, after Michelangelo (Fig. 10b)
in which Ganymede is however represented as
a young man and not as a child.[8] Rembrandt
usually made the initial design for his compo-
sition directly onto the canvas, panel or etching
plate and he very rarely drew a design for a
painting. The studies which relate to paintings
either work out an alteration to the first design
or serve to elaborate a section of the
composition. The print by Beatrizet served the

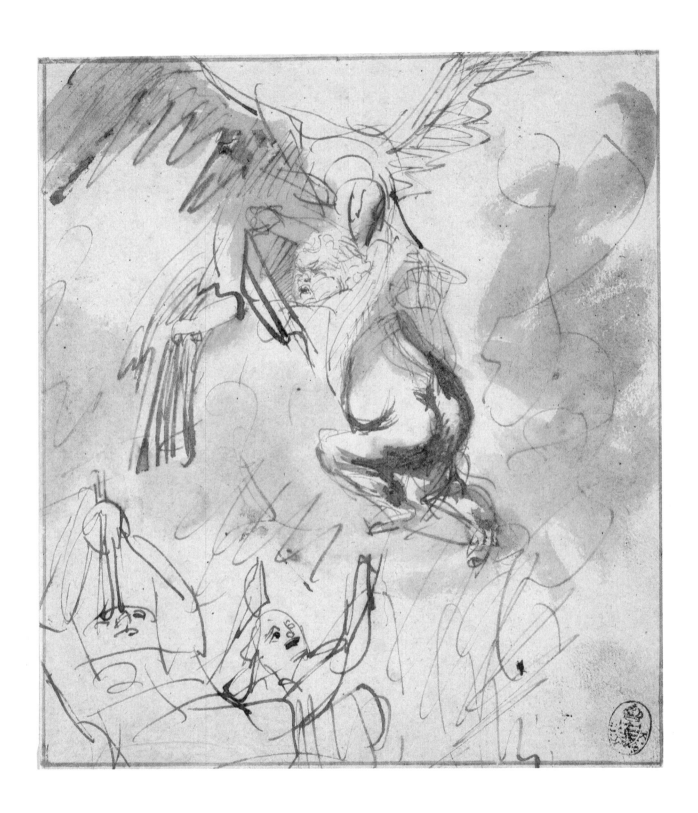

purpose of a first design and the drawing developed alterations to the print which Rembrandt then incorporated in the painting.[9] By omitting the parents in the painting he has placed all emphasis on the principal motif and thereby weakened the narrative and incidental aspects of the event in favour of the broader symbolic character. In the place where the parents were, there is now a section of a building, which does not distract the attention from the event.

The drawing is exceptionally sketchy. The classic features of the child are already visible and Rembrandt therefore did not base it on a drawing made from life.[10] There is enormous variety in the use of line: the face and figure of the child are executed with small fine lines, whereas the eagle on the whole is depicted in broad strong lines. The way in which the repeated contours of the lower half of the child are drawn shows the search for the right shape. The figures of the parents, seen from below, are rudimentarily and summarily indicated. Rembrandt indicated the background with loose zig-zag lines, whereas in the painting he depicted trees and the sky. Finally the shadow on the eagle and under the tunic of the child was added and the background was also in part lightly shaded.

This drawing style is in keeping with that of other drawings from the mid 1630s (Cat. No. 5 and 12).[11]

P.S.

1. Homer, *The Iliad*, E232.
2. Dresden, Staatliche Kunstsammlungen, Inv. No. 1558.
3. Karel van Mander, 'Uitleggingh op den Metamorfosis Pb. Ovidij Nasonis', in the *Schilderboeck*, 1604, fol. 87.
4. *Corpus* III under A113.
5. Peter Schatborn, 'Over Rembrandt en kinderen', *De Kroniek van het Rembrandthuis* 27 (1975), pp. 8–19.
6. Benesch 401.
7. J. Bruyn, 'On Rembrandt's use of Studio-Props and Model Drawings during the 1630s', *Essays in Northern European Art presented to Egbert Haverkamp-Begemann on his sixtieth birthday*, Doornspijk 1983, pp. 52–60.
8. Clark 1966, p. 15, Fig. 13.
9. The composition of an Italian print, in this case by Sisto Badalocchio after Raphael similarly provided the source for the drawing *Isaac and Rebecca Espied by Abimelech*, New York, private collection, Benesch 988, which was the basis for *The Jewish Bride* in the Rijksmuseum.
10. In another instance he did use a small drawing, *A Child frightened by a Dog*, Budapest, Szépmüvészeti Múzeum, Benesch 477 is the finished version of a study made from life in Paris, Fondation Custodia (coll. Lugt), Benesch 403 recto.
11. Particularly related is also *The Lamentation* in Berlin, Benesch 110 recto.

I I

Susanna and the Elders

Red chalk, grey wash, 235 × 354 mm

Inscriptions: below right *Rf* on the verso an inscription in Rembrandt's hand, in red chalk:; in black chalk: '*verkoft syn vaendraeger synd 15—— | en flora verhandelt——6—| fardynandus vaa sijn werck verhandelt | aen ander werck van sijn voorneemen | den Abraham een floorae | Leenderts floorae is verhandelt tegen 5 g'*. (sold, his standard-bearer for 15—— | a flora sold——6—| sold work by ferdynandus / another work by him / the Abraham / a flora / Leendert's flora was sold for 5 guilders).
Berlin, Staatliche Museen Preussischer Kulturbesitz, Kupferstichkabinett.

Provenance: Court Andreossy, sale Paris, 13–16 April 1864, in No. 356; Jan-François Gigoux, not in sale Paris, 6 May 1862 and 20 March 1882; Adolf von Beckerath, Berlin; KdZ 5296 (1902).

Literature: Bock-Rosenberg 1930, No. 5296, p. 224; Benesch 1954–57 and 1973, No. 448 (with other previous literature and exhibitions); Broos 1981, p. 257; Broos 1983, p. 40 and 44; Paris 1986, in No. 41, Fig. 2; *Documents*, p. 594–595.

Exhibitions: Berlin, 1970, No. 35; New York 1988, No. 30.

Susanna and the Elders has been a common biblical subject since the Middle Ages and it had not lost its popularity by the seventeenth century (Daniel 13: 15–21). The moment usually depicted is when the bathing Susanna is being spied on and blackmailed by the two old men who were, moreover, judges: they threaten that if she does not agree to have sexual relations with them they will accuse her of infidelity with someone else. Susanna refuses and is finally acquitted with the help of Daniel. Thereafter the two old men are executed.

Rembrandt's teacher, Pieter Lastman, painted the subject in 1614 (Fig. 11a),[1] and Rembrandt made a copy in red chalk, which differs in a number of details from the original. To begin with the proportion of the dimensions of the paper differ from the painting. Rembrandt's composition is wider and there is more space around the figures. This makes it all the more noticeable that one of the elders is standing nearer to Susanna in the drawing than in the painting, while stretching out his arm behind her. In this way Rembrandt has strengthened the menace that emanates from this man.[2] Other motifs have similarly been altered. The peacocks on the righthand side have been reduced in scale and the water-spewing stone sculpture and the building in the background have been enlarged. The most striking difference between Rembrandt's drawn copy and Lastman's painting is the position of Susanna's hands: Rembrandt moved the right hand, held up in shock in Lastman's painting, to her lap where the other hand rests.[3]

Susanna and the Elders is not the only copy which Rembrandt made after a painting by his teacher. He made a drawing in black chalk[5] of the principal group in *The Dismissal of Hagar*.[4] The figures of Abraham, Hagar and Ishmail in this copy provided the basis for an etching and a number of drawings by Rembrandt and by his pupils.[6] Rembrandt made two other copies after Lastman, in red[7] and black chalk[8] respectively, after *Paul and Barnabas at Lystra*[9] and *Joseph distributing Corn in Egypt*.[10] These subjects were not depicted by Rembrandt himself.

Rembrandt twice depicted the bathing Susanna in paintings, once as an isolated seated figure—here only the heads of the elders are visible through the bushes—(Fig. 24a) and once standing in a larger composition of which the elders also form a part (Fig. 24b).[11] Rembrandt depicted the seated Susanna in the painting in the Mauritshuis with her right hand in her lap and the left hand at her breast in a gesture of shock and defence. The painting is dated 1636 and it is possible that the copy

drawn after Lastman predates it and served as a source of inspiration. Thus, the position of Susanna's hand in Rembrandt's painting may already have been prepared in the drawn copy.

Rembrandt made notes concerning the sale of work of pupils on the back of the drawing (Fig. 11b). There are two names, 'fardynandus', Ferdinand Bol, and 'Leendert' van Beyeren, by whom a *Flora* is sold. A *Vaandeldrager* (Standard-bearer) and a *Sacrifice of Isaac* are also mentioned. Paintings by Rembrandt of these subjects date from 1634,[12] 1635[13] and 1636.[14] From the latter year there is also a *Sacrifice of Isaac* in Munich by a pupil.[15]

If the works mentioned on the reverse of the drawing were made after Rembrandt or inspired by him, then the notes can be dated, at the earliest, to 1636. This would then be an argument for the assumption that Bol was working with Rembrandt from that year on.[16] We know of no work by Leendert van Beyeren but at a sale in 1637 he is mentioned as a '*disipel van Rembrandt*' (pupil of Rembrandt).[17]

The relationship between the drawing and the notes raises a number of questions which cannot be answered with certainty. We could assume that the notes were written at the same time that the drawing was made. A large gap in timescale does not seem likely. It is also possible that the painting by Lastman and the recorded works by pupils were sold at the same time. Moreover, as the drawn copy after Lastman precedes Rembrandt's painting dated 1636 in the Mauritshuis, the drawing could also be dated to the same year of 1636.[18]

The style of the signature *Rf* at the lower right of the drawing is fairly unusual. One of the other copies after Lastman is signed in full,[19] as are the three known copies after Leonardo's *Last Supper* from the same period.[20] Rembrandt therefore provided the composition of another artist with his own name and so his signature refers to the execution and not to the invention.

Typical of the difference between an original drawing and a copy is the uniformity of the handling of line. The genesis of a drawing, which can often be so clearly read in Rembrandt's work, is different when working after a model. Because of this the drawing has a different character from those which are made from the imagination or from life.
P.S.

1. Berlin, Gemäldegalerie SMPK, Inv. No. 1719; K. Freise, *Pieter Lastman*, Leipzig 1911, p. 48, No. 44, pp. 135 ff. and pp. 249 ff.
2. Taking note of the differences between the drawing and the painting Broos spoke of a 'critical commentary' by Rembrandt; Paris 1986, No. 41.
3. Broos pointed to the resemblance to the classical *Venus Pudica*; Paris 1986.
4. Hamburg, Kunsthalle; Inv. No. 191.
5. Vienna, Albertina; Benesch, No. 447.
6. Hamann 1936; Amsterdam 1984–1984, Nos. 68–75.
7. Bayonne, Musée Bonnat; Benesch, No. 449.
8. Vienna, Albertina; Benesch, No. 446.
9. Previously in Russia, Court Stetzki; Freise 1911, No. 88.
10. Dublin, National Gallery of Ireland; Freise 1911, No. 20.
11. The Hague, Mauritshuis; *Corpus* III A117 and Berlin, Gemäldegalerie SMPK; Bredius/Gerson, No. 516. This last painting is dated 1647, but originated in the 1630s; see Cat. No. 24.
12. *Flora*, Leningrad, Hermitage, dated 1634; *Corpus* II A93.
13. *Sacrifice of Isaac*, Leningrad, Hermitage, dated 1635; *Corpus* III A108.
14. *A Standard bearer*, Paris, private collection, dated 1636; *Corpus* III A120.
15. *Sacrifice of Isaac*, Munich, Alte Pinakothek, dated 1636; *Corpus* III, in A108.
16. In December 1635 Bol is still mentioned as painter in Dordrecht; the drawing was previously dated to between 1630 and 1637; Blankert 1982, pp. 17 and 71: after 1635.
17. *Documents* 1637/2. In the estate of his father of 7 May 1638 four copies after Rembrandt are mentioned; *Documents* 1638/5.
18. An argument against this has been advanced, that red chalk was used for the drawing and the undeciphered inscription on the verso, and black chalk for the inscriptions concerning the work of the pupils.
19. Benesch, No. 446.
20. Benesch, Nos. 443, 444 and 445, the last is dated 1635.

11a: Pieter Lastman, *Susanna and the Elders*. Berlin, Gemäldegalerie SMPK.

11b: Verso of Cat. No. 11.

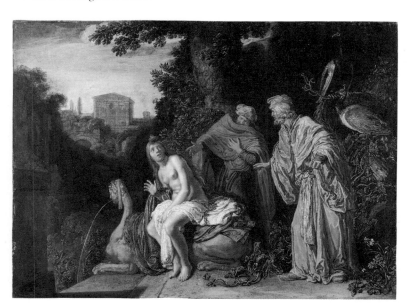

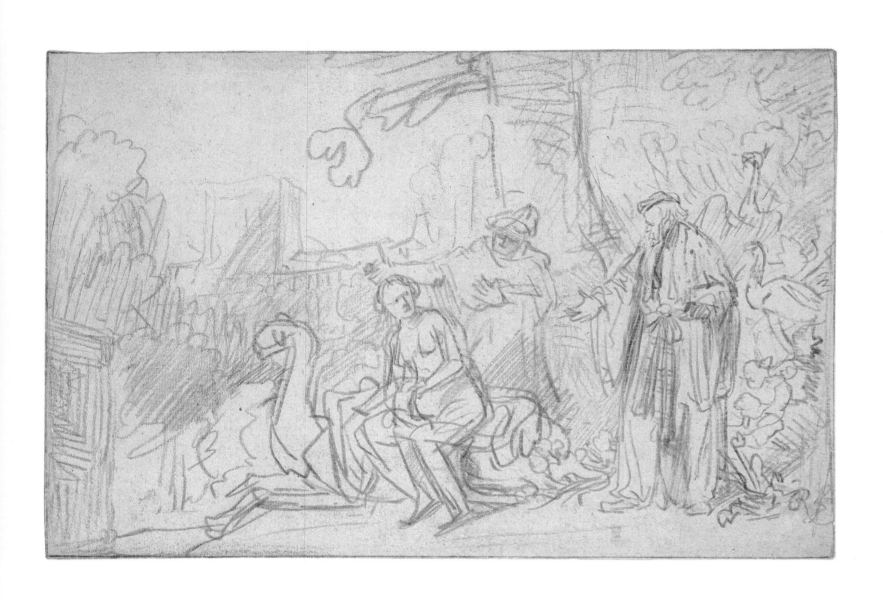

12

Seated Actor in the rôle of Capitano

Verso: *Actor in the rôle of Pantalone in Conversation.*

Pen and brown ink, brown wash; verso: pen and brown ink, 182 × 153 mm
Amsterdam, Rijksmuseum, Rijksprentenkabinet.

Provenance: Art dealer Dunthorne, London (1909); Cornelis Hofstede de Groot, sale Leipzig, 4 November 1931, No. 168; I. de Bruijn-van der Leeuw, Spiez, gift made in 1949 to the Rijksprentenkabinet, in usufruct until 28 November 1960; Inv. No. RP-T-1961-76.

Literature: Benesch 1954–57 and 1973, No. 293; Albach 1979, pp. 8–15; Schatborn 1985, No. 8 (with other previous literature and exhibitions).

Exhibition: Amsterdam 1969, No. 38.

12 verso.

12a: Jan Steen, *The Village Fair* (detail). The Hague, Mauritshuis.

When Rembrandt devised compositions of narrative subjects he employed the same techniques as a director who places his actors on stage in the *mise en scène*. Director and painter both give their own interpretation of the story. Just as with actors, Rembrandt's models were dressed up for the biblical, mythological or allegorical representation. Moreover patrons dressed themselves up as historical figures and had their portraits painted thus.

One or two actors in drawings by Rembrandt are recognisable as characters from Joost van den Vondel's *Gijsbrecht van Amstel*, a play which had its première in Amsterdam in 1638. Other drawings show players from the *Commedia dell'Arte*, such as Capitano and Pantalone: the characters on each side of the Amsterdam drawing. The actors are probably Dutch as there are no indications that Italians were acting in Amsterdam at the time that Rembrandt made the drawings.[1] He depicted quacks trying to sell their medicines in the same way as the comic characters from the *Commedia del'Arte*.

The man with the feathered hat is sitting with legs wide apart on the edge of his chair, his right hand at his side and a stick in the other hand. The long, wide cloak is draped over the back of the chair. The costume and stance characterise him as Capitano, a type which not only appears in the *Commedia dell'Arte*, but also in Bredero's *The Spanish Brabanter* of 1617, for example. Behind the Capitano hangs a cloth which was used as a simple backdrop when appearing at a fair or market. The stage was situated on an platform which explains why the scene is seen from such a low viewpoint. How such a play took place can be seen in a painting by Jan Steen (Fig. 12a),[2] among others.

A figure kneels at the left, holding a bag open for the Capitano. This bag could be the key to recognising the depicted scene. The word bag was in fact also used in the seventeenth century to denote a woman of loose morals and moreover for the female sexual organ. The open bag perhaps illustrates symbolically a scene in which the Capitano has been offered medication by a procuress. A bag also appears in Rembrandt's *Flute Player* (Etchings Cat. No. 17) where it has an erotic meaning.[3] If this interpretation is correct, the expression on the face of the Capitano could be interpreted as one of satisfaction as he listens to the proposal.

The figure of Pantalone on the verso, was drawn more often by Rembrandt. On a sheet in Groningen[4] (Fig. 12b) he is shown laughing slyly, depicted from the front and in the same

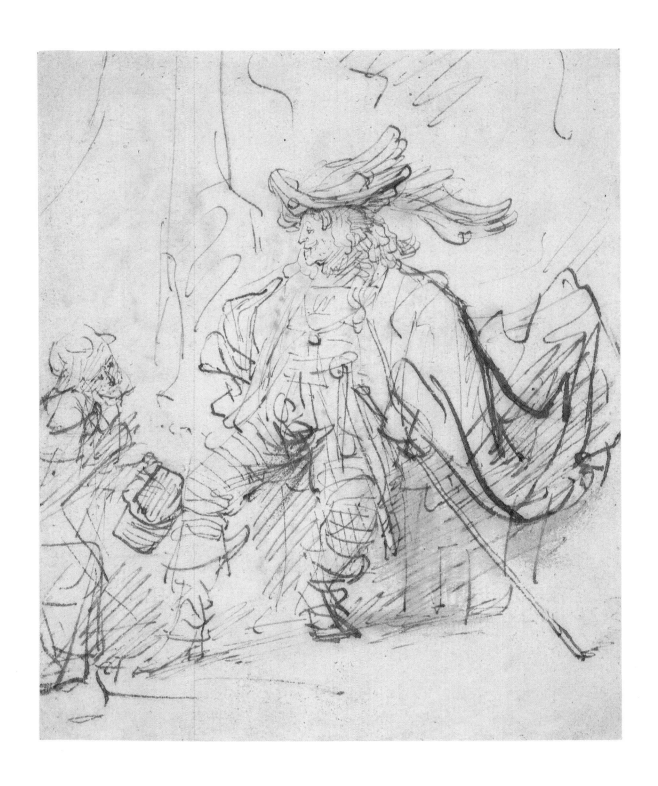

pose as in a print by the French artist Jacques Callot,[5] whereas he is seen from the side in drawings in Frankfurt[6] and Hamburg,[7] but he always displays his characteristic laughing mouth. In the Amsterdam drawing Pantalone is laughing in the direction of an unidentified man in a tall hat, who stares intently at him; only the upper half of his body is depicted. It seems that Pantalone is telling him something, all the while gesticulating, but the summarily drawn face and the stance of the other man convey incomprehension and disbelief.

It is plausible to suppose that in both drawings the figures depicted are from the same play and from the fact that Rembrandt used both sides of the paper it can be surmised that the drawing was made during the play and not in the studio.

Rembrandt's fine pen has drawn the figures in a loose and sketchy manner, whereas the faces of the Capitano and Pantelone are executed with the utmost care. Stronger accents have been added in a few places. The contours of the cloak over the back of the chair have been strengthened with a few strong lines and the space between the legs of the Capitano has also been clearly accentuated. Shadow has not only been indicated with hatching but also with the brush, particularly in the section of the chair under the Capitano's cloak.

The rhythm of the penline with its sweeping, almost scratchy, hatching is comparable to that of drawings from the mid-1630s (Cat. Nos 5, 7, 10).[8]

P.S.

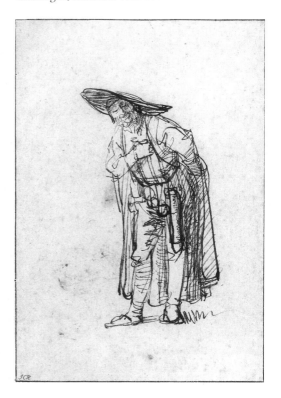

12b: Rembrandt, *Pantalone*.
Groningen, Museum voor Stad en Lande.

1. Albach 1979, p. 9.
2. Jan Steen, *The Village Fair*, The Hague, Mauritshuis. Karel Braun, *Jan Steen*, Rotterdam 1980, No. 81.
3. Alison McNeil Kettering, 'Rembrandt's Flute Player: a unique treatment of pastoral', *Simiolus* 9 (1977), 1, p. 37 and note 72.
4. Groningen, Museum voor Stad en Lande; Benesch, No. 295.
5. J. Lieure, *Jacques Callot, Catalogue de l'œuvre gravé*, No. 288.
6. Frankfurt a/M, Städelsches Kunstinstitut; Benesch, No. 297.
7. Hamburg, Kunsthalle; Benesch, No. 296.
8. The signed and dated 1635 drawing after Leonardo's *Last Supper*, Berlin, Kupferstichkabinett SMPK; Benesch, No. 445 is also comparable in style.

13

Three studies of an elephant with attendant

Black chalk, 239 × 354 mm
Vienna, Graphische Sammlung Albertina

Provenance: Archduke Albert of Saxe-Teschen
(L. 174), Vienna; Inv. 8900.

Literature: Benesch 1954–57 and 1973. No. 458;
L.J. Slatkes, 'Rembrandt's Elephant', *Simiolus* 2
(1980), pp. 7–13.

*Exhibitions: Die Rembrandt-Zeichnungen der
Albertina*, Vienna (Albertina) 1969–70, No. 13.

In one of Willem Goeree's manuals for artists which appeared in 1670 he gives the following advice: 'Voornamentlijk moet men sijn kans waernemen omtrent de vremdigheden, als van Leeuwen, Tygers, Beeren, Olyphanten Kameelen ende diergelijke Dieren, diemen selden onder oogen krijght, en somtjds evenwel hebben moet om in sijn Inventien toe te passen.'[1] (One should especially take the opportunity to observe the exotic, such as lions, tigers, bears, elephants, camels and such like creatures, which one rarely can set eyes on and which one sometimes must have in order to use in one's inventions). With this the author gave the reason why artists made drawings of exotic animals, although in the case of Rembrandt these were usually not used directly as preliminary studies.[2] His method of working generally meant that, having gained experience from drawing from the life, he was able to depict animals in a convincing way from his imagination.

A second drawing of an elephant, also in the Albertina in Vienna, is signed and dated 1637 (Fig. 13a).[3] Rembrandt depicted an elephant in the background of his etching of *The Fall of Man* of 1638 (Fig. 13b).[4] This elephant, in mirror-image, bears the closest resemblance to the walking elephant in the exhibited drawing, although in the etching he is carrying his trunk rather higher. The depiction of an elephant in the fall of man has a long tradition in art. In Rembrandt's etching the animal represents virtuousness as a counterbalance to the evil of the serpent.[5] A third, undated, drawing of an

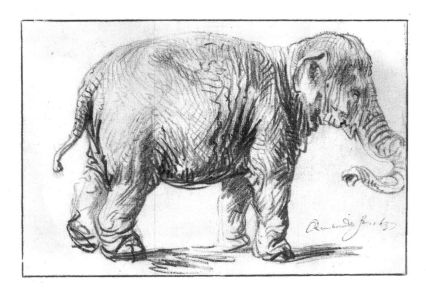

13a: Rembrandt, *Study of an Elephant.*
Vienna, Albertina.

13b: Rembrandt, *The Fall of Man.*
Amsterdam, Rijksprentenkabinet.

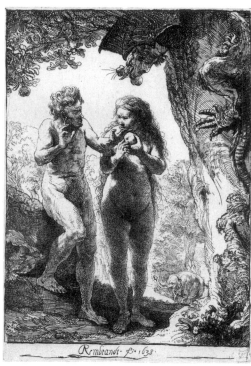

elephant is in the British Museum in London.[6] The medium which Rembrandt used for all these drawings, black chalk, is extremely effective for the characterisation of the rough skin.

The exhibited drawing is the only one which shows three studies of the same animal in various poses: lying, standing and in movement. He placed figures and heads together on a sheet in the same way.[7] The drawing of the elephant lying down is the least finished, and his rump, in so far as it is visible, is barely indicated. As in the two drawings of a single elephant, the standing elephant is seen from the side. He has just put something in his mouth with his trunk. This animal is partly shaded and rather more finished. The entirely visible elephant is stepping forward at an angle, while the attendant is perhaps guiding him with his unseen hand. The trunk has been given in two positions. The figure of the attendant has been drawn over the trunk in the lower position. This elephant is the most finished; the shadows are indicated with dark chalk lines. The hatching to the right of the animal is drawn across the man's body and the raised trunk and therefore belongs to the first version.

When an exotic animal such as this was exhibited it was obviously an exceptional event which was sometimes recorded in prints in the sixteenth and seventeenth centuries. In 1629 Wenzel Hollar depicted a ten-year-old elephant with small tusks,[8] but this image is based on a sixteenth-century print:[9] so there are instances where an older example was used as a prototype. Another print bears an inscription stating that the elephant, called Hanske, was born in Ceylon in 1630.[10] This animal died in 1655, having made many journeys through Europe. We know from many sources that this was a female elephant.[11]

Rembrandt drew the elephants from life and none of them seem to have tusks. In 1646 Herman Saftleven also made a print of an elephant without tusks and this could have been the same elephant—possibly Hanske— immortalised by Rembrandt.[12] Female Asiatic elephants do have tusks, but in contrast to those of male elephants, they are not visible, or only so with certain movements of the trunk. The walking elephant in the exhibited drawing does appear to have a tusk, but it is in the wrong place and if Rembrandt did see a tusk, then he drew it wrongly. It is clear from both of the other drawings by Rembrandt that the elephant does not have externally visible tusks. In addition, it should be noted that the tusks of the female Asiatic elephants are extremely fragile so that they appear in various lengths.

The way in which an elephant was exhibited to the public can be seen from a drawing by Jan van Goyen in the Getty Museum in Malibu.[13] Here two large, high tents are depicted and around them are standing and seated figures. Above the coach in the left foreground hangs a sign with an elephant (detail, Fig. 13c). The public could thus view the animal inside the tent and if one wanted to see the tricks the animal performed then, of course, an entry fee had to be paid. Van Goyen's drawing is dated 1653 and it is possible that it is again Hanske who is being shown to the public.

P.S.

1. Willem Goeree, *Inleydingh tot de Practijck der algemeene Schilderkonst*, Middelburg 1670, p. 121.
2. An exception is the drawing with two sketches of the head of a camel (Benesch, No. 454), of which one probably served as model for the animal in the background of *The Hundred Guilder Print* (Etchings Cat. No. 27).
3. Benesch, No. 457.
4. B. 28 (Etchings Cat. No. 11).
5. Slatkes 1980.
6. Benesch, No. 459. A fourth elephant recorded by Benesch is in the Pierpont Morgan Library, Benesch, No. 460. This is a counter-proof after a drawing probably made by one of Rembrandt's pupils.
7. For example in the etchings of heads of Saskia, B. 365, 367 and 268.
8. G. Parthey, *Wenzel Hollar*, Berlin 1853, No. 2119. Apart from the scene in the centre, there are also ten small pictures in which the elephant is performing various tricks.
9. This print by P. van Groeningen is from 1563; FM 462.
10. Slatkes 1980, fig. 2. It is improbable that this image was based on observation. It is possible that use was made of one of the elephants in the print by Hollar. This could also be the case with the anonymous print, FM 1854.
11. The details given here were provided by Prof. Dr. L. Dittrich, Zoological Gardens, Hannover, for which our special thanks.
12. Holl. 40.
13. George Goldner *et al.*, *European Drawings*, I, *Catalogue of the Collections*, The J. Paul Getty Museum, Malibu, 1988, No. 108.

13c: Jan van Goyen, *A Village Festival* (detail). Malibu, The J.Paul Getty Museum.

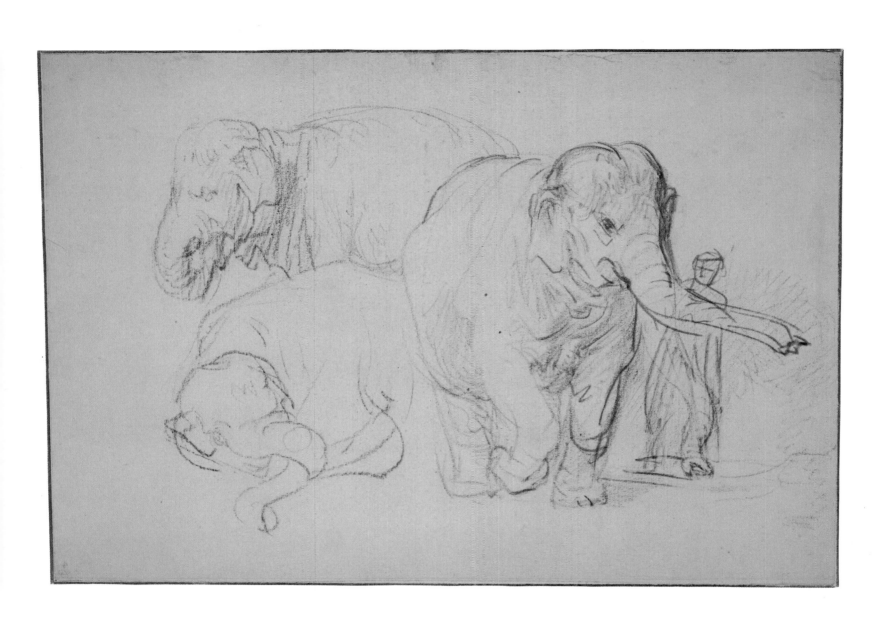

14

Two riders on horseback

Pen and brown ink, brown and white wash, red and yellow chalk, 212 × 153 mm

Inscription: on the old mount, above left *81*, on the reverse *6* and *J C Robinson/July 18 1893/from Lrd Aylesford Colln.*
New York, The Pierpoint Morgan Library

Provenance: Jonathan Richardson (L. 2184), sale London, 22 January–8 February (in fact 11 February) 1747; Thomas Hudson (L. 2432), sale London 15–26 March 1779, in lot No. 52; Henneage Finch, 5th Earl of Aylesford (L. 58), sale London, 17–18 July 1893, No. 265; Sir John Charles Robinson, sale London 12–14 May 1902, No. 355; Charles Fairfax Murray; J. Pierpont Morgan; Inv. No. I 201.

Literature: Benesch 1954–57 and 1973, No. 368; Konstam 1978, p. 27.

Exhibitions: Rotterdam/Amsterdam 1956, No. 74; New York/Cambridge 1960, No. 31; Chicago/Minneapolis/Detroit 1969; No. 112; Paris/Antwerp/London/New York 1979–1980, no. 71 (with other previous literature and exhibitions).

Four drawings which show related figures and which are executed in the same style and technique were still together in the eighteenth century in the collection of Jonathan Richardson. On one drawing are *Two negro drummers mounted on mules* (Fig. 14a),[1] and on another we see *Four negroes with wind instruments*.[2] Dutch horsemen are depicted on the other two sheets: one wears a tall hat and is seated on a horse;[3] on the other sheet there are two riders. In both drawings the horses are only summarily indicated.

It is not absolutely certain where and for what purpose Rembrandt made the four drawings. It has been suggested that he saw the horsemen when he attended the celebration of the marriage of Wolfert van Brederode and Louise Christine of Solms which took place in The Hague on 11 February 1638. On 19 February and the days following processions and competitions took place. According to an old description nobles and moors in costume were present.[4] Unfortunately, there are no other depictions of this event which could confirm this identification.

Another suggestion assumes that Rembrandt executed the four drawings in the studio and that the models were placed in front of a mirror.[5] In the New York drawing the figure behind the first would then be his mirror-image, while Rembrandt drew two different headdresses for variety. In this case the four drawings would also have been made after life.

The two horsemen are seen at an angle from the front and slightly from below. The one is wearing a tall hat, the other a flat beret with a feather. The heads have been characterised concisely in strong pen lines. The collar of the man in front has simply been indicated with a zig-zag line, while the horse has been depicted in loose pen lines and strokes of the brush.

The technique of the drawing is rather unusual as Rembrandt added red and yellow chalk to the pen and brush. This combination of materials does not often appear in his œuvre of drawings. Only the drawings after Mughal miniatures from the 1650s can serve as a comparison in this respect (see Cat. No. 37).

Both groups of drawings were formerly together in the collection of Jonathan Richardson. He may have acquired these drawings simultaneously, as they were originally sold in groups organised by subject in Rembrandt's albums.

P.S.

1. London, British Museum; Benesch, No. 365.
2. New York, collection Eugene Thaw; Benesch, No. 366.
3. London, British Museum; Benesch, No. 367.
4. I.Q. van Regteren Altena, 'Retouches aan ons Rembrandt-beeld, De Eendracht van het Land', II, *Oud Holland*, 67 (1952), pp. 60–63.
5. Konstam 1978.

14a: Rembrandt, *Two negro Drummers mounted on Mules*. London, British Museum.

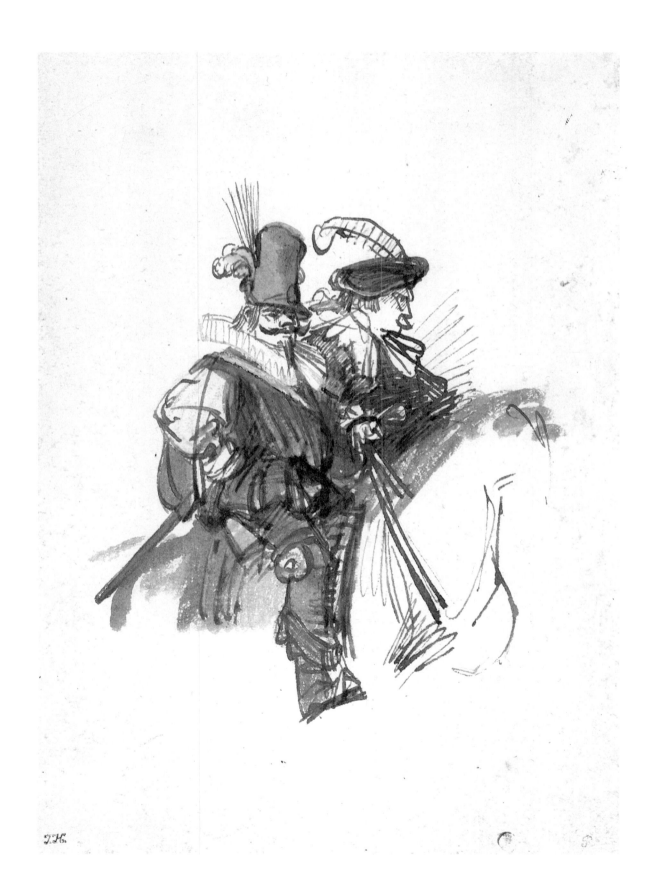

15

Two studies of a Bird of Paradise

Pen and brown ink, brown and white wash
181 × 151 mm

Inscriptions: below left *Rembrand*; above right *46*
(album Bonnat).
Paris, Musée du Louvre, Départment des arts
graphiques

Provenance: U. Price (L. 2048), sale London, 3
May 1854, No. 187; L. Bonnat, Paris (L. 1714),
presented to the Louvre in 1919; Inv. No. RF
4687.

Literature: Lugt 1933, No. 1195; Benesch 1954–
57 and 1973, No. 456.

Exhibitions: Amsterdam 1969, No. 33; Paris
1988–1989, No. 26 (with other previous
literature and exhibitions).

15a: Rembrandt, *Oriental and a Bird of Paradise*.
Paris, Musée du Louvre, Département des arts
graphiques.

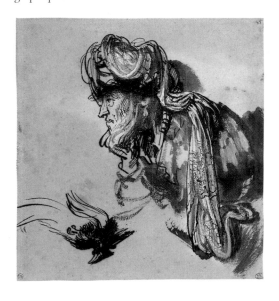

Rembrandt had a good instinct for the best
medium to use for drawing various kinds of
animals. Elephants were made in black chalk
(Cat. No. 13), lions in chalk but also in pen
and wash (Cat. No. 25). Rembrandt drew the
two birds of paradise in pen; with this medium
he could most aptly capture the characteristics
of the bird. The head and body were made in
strong lines placed very close together in some
places. The display feathers, which are usually
mistaken for a tail, are drawn in fine lines that
fan out. Rembrandt added some wash in white
in order to suggest the yellow-gold colouring of
the feathers and he achieved their full spendour
with long zig-zag lines and transparent strokes
made with a half dry brush. He added a few
fine hatching lines of shadow in order to bring
the section of feathers left white in the lower
drawing into relief.

Rembrandt drew the bird twice, in the same
way in which he filled sheets with various
figures and heads (Cat. No. 8). Such study
sheets had the function of models and were also
made in order to elaborate and complement
Rembrandt's collection of drawings and prints,
by his own hand and other masters, which
together formed a survey of the visible world.
To such a collection also belong, for example,
shells (Etchings Cat. No. 29), other natural
objects and casts from statues, creating a so-
called encyclopaedic collection, which artists
had at their disposal for their work.[1]

Among the objects mentioned in
Rembrandt's inventory of 1656 is 'een
paradijsvogel en ses wayers' (a paradise bird
and six fans) which he kept in a drawer.[2] As
can be seen in the drawing, the bird has no
legs: these were cut away in its country of
origin (New-Guinea) with the innards and
underbelly. For this reason Linnaeus had called
the bird '*Paradisia apoda*' (without legs).[3]

When Rembrandt drew another such bird,
he did give it legs (Fig. 15a).[4] He added it to a
sheet with a beautifully-finished head of an
oriental, motifs which were probably combined
because of their exotic nature. Even though the
drawing in Paris was made from a carcass, the
animal by no means gives the impression of
being dead. However, this clearly is the case in
the other drawing. There is absolutely no
indication of space around the birds—perhaps
Rembrandt had secured the bird of paradise on
a white surface—and this gives the impression
that the bird is still alive, in addition to which
the background can almost be seen as the open
air.

Birds rarely appear in the work of
Rembrandt, although we repeatedly see them
in the sky in the landscape drawings and
etchings. In a painting in the Rijksmuseum two
dead peacocks are depicted in the window next
to a girl[5] and there is a painting in Dresden,
dated 1639, in which a hunter with the features
of Rembrandt is holding up a dead bittern.[6]
In the latter case the bird has an allegorical
significance and the figure probably represents
a lover.[7] These birds were almost certainly
painted from life.

The drawing of the two birds of paradise
were made at the end of the 1630s, when
Rembrandt frequently used dark gall-nut ink
for his drawings.
P.S.

1. R. Scheller, 'Rembrandt en de Encyclopedische
kunstkamer', *Oud Holland*, 74 (1969), pp. 1–81.
2. *Documents* 1656/12, No. 280.
3. Schatborn 1977, pp. 15–16.
4. Paris, Musée du Louvre, Département des arts
graphiques; Benesch, No. 158.
5. *Corpus* III A134.
6. *Corpus* III A133.
7. E. de Jongh, 'Erotica in vogelperspectief',
Simiolus 3 (1968/1969), p. 41, n. 46.

46

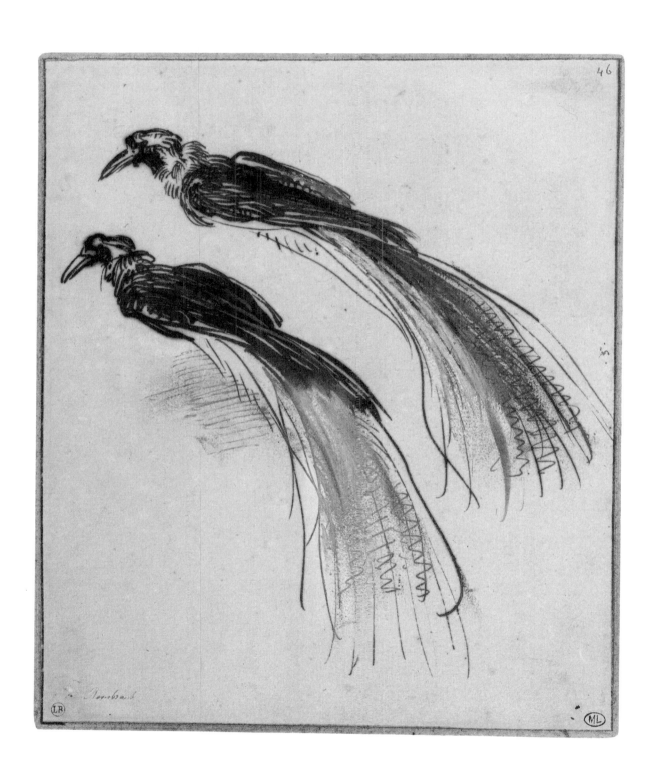

Tourbais

LB ML

Jacob and his Sons

Pen and brown ink, brown and white wash,
the seated man on the left added on a separate
piece of paper, laid down, 176 × 230 mm
Amsterdam, Rijksmuseum,
Rijksprentenkabinet

Provenance: H. Croockewit, sale Amsterdam,
16–17 December 1874, No. 143; Berthold
Suermondt (L. 415), sale Frankfurt, 5 May
1897 and following days, No. 128; William
Pitcairn Knowles (L. 2643), sale Amsterdam,
25–26 June 1895, No. 522; acquired by the
Vereniging Rembrandt in 1901; Inv. No.
RP-T-1901 A4518.

Literature: Benesch 1954–57 and 1973, No. 541;
Schatborn 1985, No. 17 (with other previous
literature and exhibitions).

Exhibitions: Rotterdam/Amsterdam 1956, No.
90; Amsterdam 1964–1965, No. 61; Amsterdam
1969, No. 68.

Rembrandt repeatedly depicted the story of the
patriarch Jacob and his son Joseph, especially in
prints and drawings. Joseph was one of Jacob's
twelve sons, who was sold as a slave by his
jealous brothers, but eventually managed to
rise to the position of viceroy of Egypt. During
a time of famine, the brothers travelled there to
buy food. Joseph did not let them know who
he was, and imprisoned them as spies. He
demanded that they fetch the youngest brother
Benjamin, who had remained at home, while he
held Simon with him in Egypt.

When the brothers were leaving for Egypt
for the second time they begged their father to
let Benjamin accompany them. It has been
suggested that this is the scene represented in
the drawing, but this is probably not the case.[1]
Jacob is sitting in the centre on a platform
under an arch, while the young Benjamin
stands next to him holding a cup. Judah is
speaking and gesticulating while the other
brothers are listening attentively. The cup,
however, only appears later in the story. When
the brothers have set out on the return journey
from Egypt with Benjamin, and laden with
food, Joseph has secretly hidden his silver cup
in Benjamin's knapsack. When this is disco-
vered, having put his brothers to the test once
again, Joseph can no longer restrain himself and
unmasks himself as the brother they sold. After
their return to Canaan the brothers tell their
father that Joseph is still alive and that he is
viceroy of Egypt, but Jacob does not believe
them.

This moment in the story is more likely to
be the subject of the drawing. There has after
all been no previous mention of the cup in
Benjamin's hand. Moreover, the hat in
Benjamin's other hand is a sign that he has
returned from the journey.[2]

There is a second drawing of the same
subject by Rembrandt in the Louvre in Paris
(Fig. 16a) in which the scene is viewed more
from the side and in which the backs of the
figures at the left and right do not symmetri-
cally enclose the composition.[3] Here, Benjamin
does not hold a hat in his hand and there are a
greater number of brothers. A drawing in
Rotterdam shows an earlier moment in the
story, when Judah or another brother is
begging Jacob, who is in a dilemma about the
decision to let Benjamin go with them. Here,
the child stands next to his father Jacob
without cup or hat (Fig. 16b).[4]

Rembrandt's depiction of biblical stories was
in the main determined by the iconographic
tradition, the way in which predecessors and
contemporaries had depicted the subject. There
is no direct example that can be pointed to in
this tradition in the case of the Amsterdam and
Paris drawings. Rembrandt drew his
understanding of the story from the biblical
text and he particularly liked to depict the
events in which human emotions played an
important role. Consequently both drawings
concern an emotional confrontation between
the father and his sons.

Rembrandt has expressed variety in the

16a: Rembrandt, *Jacob and his Sons*. Paris, Musée
du Louvre, Département des arts graphiques.

16b: Rembrandt, *Jacob, Benjamin and an older Son*.
Rotterdam, Museum Boymans-van Beuningen.

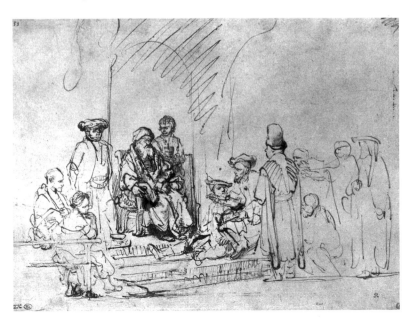

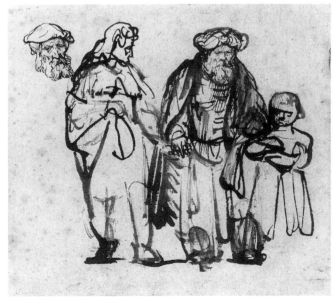

balanced composition, especially in the stances of the figures and the expressions on their faces. The seated figure to the left has been redrawn on a separate piece of paper to cover an unsuccessful version. There is also a correction in the right leg of the seated brother, which was at first stretched out. Rembrandt painted over this version in white.

The two drawings of *Jacob and his sons* are executed in the same style and date from the same period, about 1640. Rembrandt often drew different versions of the same subject. Jacob and Benjamin from the Rotterdam drawing appear again on a sheet in Stockholm, where the figure of the son has been cut off (Fig. 16c).[5] These two drawings were made later in the 1640s.[6]

P.S.

1. For the various opinions on this subject, see Schatborn 1985, No. 17 and Paris 1988–89, No. 31.
2. If it is the earlier moment that is depicted then the hat would indicate that Benjamin is prepared for a journey, which is illogical, as it is just that which Jacob still has to decide.
3. Benesch, No. 542; Paris 1988–89, No. 31.
4. Benesch, No. 190; Giltaij 1988, No. 16. as *The Dismissal of Hagar*. Luijten and Meij 1990, No. 35, as 'Biblical representation'.
5. Benesch, No. 189. Tümpel believes that the moment depicted is that in which Jacob sends his sons to Egypt the first time without Benjamin as he is afraid that something will happen to him; Christian Tümpel, 'Iconografische verklaring van de voorstelling op twee tekeningen van Rembrandt', *De Kroniek van het Rembrandthuis*, 3 (1972), pp. 67–75. The gesture of the son's hand under his father's, suggests an attempt to persuade him—of which there is however no question before the first journey. See also Luijten 1990, No. 35.
6. Benesch dates the drawings in Rotterdam and Stockholm too early, 1637–40; Giltaij approximately 1642–43, but a slightly later date, around or after the mid-1640s, is more probable; compare for example Benesch, Nos. 763 and 767. Luijten (note 4) dates the drawing to approximately 1642.

16c: Rembrandt, *Jacob and Benjamin*. Stockholm, Nationalmuseum.

Seated old woman, with an open book on her lap

Pen and brown ink, brown wash,
126 × 110 mm
Rotterdam, Museum Boymans-van Beuningen

Provenance: J. Richardson Sr. (L. 2183); Sir
Joshua Reynolds (L. 2364); Benjamin West;
Jhr. Johan Goll van Frankenstein, sale
Amsterdam, 1 July 1833, *Kunstboek* I, No. 13;
Sir Thomas Lawrence (L. 2445); W. Esdaile (L.
2617), sale London, 17 Junes 1840, No. 62; C.S.
Bale, sale London, 1 June 1881, No. 2416; J.P.
Heseltine, sale Amsterdam, 27 May 1913, No.
16; M. Kappel, Berlin; P. Cassirer, Berlin; F.
Koenigs, Haarlem; presented to the Stichting
Museum Boymans by D.G. van Beuningen
(1940); Inv. No. R10.

Literature: Benesch 1954–57, No. 757; Giltaij
1988, No. 15 (with other previous literature
and exhibitions).

Exhibitions: Rotterdam/Amsterdam 1956, No.
84; Amsterdam 1969, No. 55.

Portraits are rare in Rembrandt's œuvre of
drawings. Apart from the self-portraits
(Cat. No. 4) and the portraits of members of
Rembrandt's family (Cat. No. 3 and 35)
there are a few preliminary studies for etched
portraits.[1] There is also one large finished
portrait drawing extant, which represents
Willem van der Pluym. This drawing hung
on the wall in the sitter's home.[2]
 Around 1639 Rembrandt drew two female
portraits in the same style and technique. The
portrait of Maria Trip in the British Museum
in London (Fig. 17a)[3] gives a clue to the date,
as the drawing was made in connection with
the painting dated 1639 in the Rijksmuseum,[4]
not as a preliminary study but in preparation
for an alteration in the composition. The *Seated
old woman* is related in a number of respects to
this drawing of Maria Trip.
 The woman is sitting on a chair with a low
armrest. On her lap lies an open book with two
clasps. The middle finger of the left hand has
been placed between the pages and in the right
hand she is holding her glasses between thumb
and index finger. She is wearing rather old-
fashioned clothing which indicates that she is
not so very young.

17a: Rembrandt, *Portrait of Maria Trip*.
London, British Museum.

Rembrandt started this drawing with fairly fine pen lines and then added wash with a brush which has somewhat obliterated the lines. He then took up the pen again and completed the drawing in strong lines and accents. The distribution of light and dark has been made with fewer or more transparent brushstrokes, especially in the background. The head of the woman is placed exactly on the border of the light area of the background and the dark curtain. This positioning on the border of light and dark contributes to the three-dimensional effect of the picture.

It is not known who the woman is.[5] If it were a preparatory study for a painting the sheet would be an exception in the œuvre. It is possible that the drawing, like that of Maria Trip, was a preparation for an alteration in the composition of a painting which is now lost.

The drawing gives the impression of having been made from life. This is also the case with a drawing dated 1639 of Rembrandt's sister-in-law Titia van Uylenburgh who is busy with some needlework (Fig. 17b).[6] Although this is really more of a genre-portrait and the space around her has not been indicated in much detail, this drawing is affiliated in style to the portraits of Maria Trip and the unknown woman. Lastly, this also applies to the drawing of a *Seated old man* (Fig. 17c) which, on the basis

of subject, had been attributed to Salomon Koninck, but it is so closely related in style and technique that it must be by the hand of Rembrandt.[7] It is not necessarily the case that this sheet was also drawn from life.
P.S.

1. B. 271 and Benesch, No. 758, Cornelis Claesz. Anslo; B. 285 and Benesch, Nos. 767 (Cat. No. 23) and 768, Jan Six; B. 280 and Benesch, Nos. 762, 762a nd 763, Jan Corneslisz. Sylvius.
2. New York, private collection; Benesch, No. 433. I.H. van Eeghen, 'Willem Jansz. van der Pluym and Rembrandt', *Amstelodamum* 64 (1977), 1, pp. 6–13.
3. London, British Museum; Benesch, No. 442.
4. Amsterdam, Rijksmuseum, *Corpus* III A31.
5. It has been noted that in a portrait in the National Gallery, London, there is a similarity to Magaretha de Geer, but this painting is from 1661, a date which is too late for the drawing. Gerson 1968, No. 385, pp. 130 and 503.
6. Stockholm, Nationalmuseum; Benesch, No. 441.
7. Paris, Fondation Custodia (coll. F. Lugt), inv. 4502. Amsterdam 1973, No. 56. Sumowski *Drawings*, No. 1529.

17b: Rembrandt, *Portrait of Titia van Uylenburgh*. Stockholm, Nationalmuseum.

17c: Rembrandt, *Seated old Man*. Paris, Fondation Custodia (F. Lugt Collection).

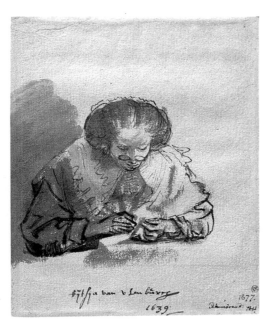

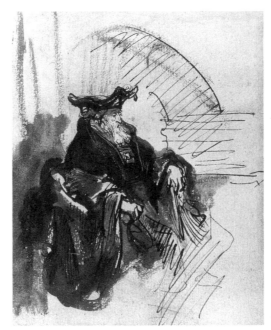

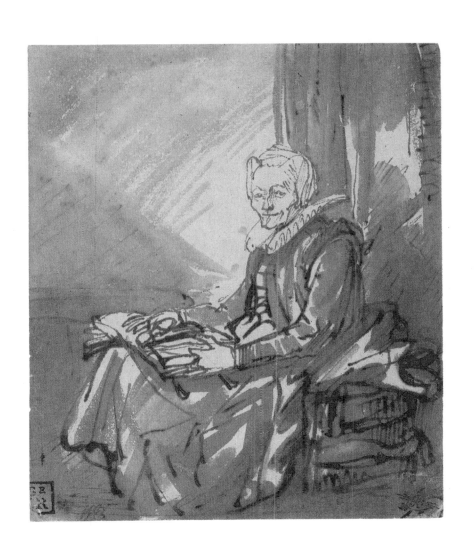

18

The Healing of the blind Tobit

Pen and brown ink, white wash, 210 × 177 mm
Cleveland, The Cleveland Museum of Art,
J.H. Wade Fund

Provenance: I.J. de Claussin, sale Paris, 2 December 1844, No. 53; G.J.J. van Os; N. Revil, sale Paris, 24 February 1845, No. 48 (?); Pierre Defer and Henri Dumesnil, sale Paris, 10 May 1900, No. 87; Joseph Reinach; Mme Pierre Goujon; Wildenstein & Co.; Inv. No. 69.69.

Literature: Benesch 1954–57 and 1973, No. 547 (with other previous literature and exhibitions); J.S. Held, *Rembrandt and the book of Tobit*, Northampton (Mass.) 1964, p. 17 (reprinted in *Rembrandt's Aristotle and Other Rembrandt Studies*, Princeton 1969); Louise S. Richards, 'A Rembrandt Drawing', *Bulletin of the Cleveland Museum of Art*, February 1970, pp. 68–75; *Het boek Tobias, met etsen en tekeningen van Rembrandt en zijn leerlingen*, Zeist 1987, pp. 43 and 55–66; preface by Christian Tümpel, commentary by Peter Schatborn.

Exhibitions: Seventeenth Century Dutch Drawings from American Collections, Washington (National Gallery of Art), Denver (The Denver Art Museum), Fort Worth (Kimbell Art Museum) 1977, No. 34; catalogue by Franklin Robison (with other previous exhibitions).

The story of Tobit belongs to the apocryphal books of the Old Testament. It describes the story of the old Tobit who has become blind and who is healed by his son Tobias with the help of the angel Raphael. This healing is the climax of the story and the drawing convincingly depicts the tension of the moment.

Old Tobit is seated, hands clasping the armrests of the chair. The young Tobias resting his right hand on his father's head, raises the eyelid with his thumb and performs the operation with a knife which is in his left hand.[1] Tobias's face, drawn from the side, betrays great concentration. The angel behind him is not looking at the operation but at Tobias, as if to invest him with confidence and courage. One of the angel's wings is poking out of the window and the other is stretched out behind Tobias and his mother Anna. The latter is looking with curiosity over her son's shoulder and she holds a small bowl in her hand. In the right foreground Tobias's wife Sarah stands with clasped hands, looking on. According to the story she was not present at this event, as Tobias was to fetch her only later from the gate of Nineveh where he had left her. By depicting her Rembrandt has expanded the scene to include the next moment in the story and created a link with the viewer of the drawing who is looking on in suspense, just as she is.

The faces of the figures are carefully depicted: the expression of anticipation of Tobit, whose head is bent slightly back—his mouth fallen slightly open as a result—the fixed and tense attention of Tobias, the friendly, encouraging expression of the angel and the curiosity of Anna peering through her glasses; all these facial expressions testify to Rembrandt's astonishing manner of characterisation. Sarah's eyes are not visible but the position of her head, bent slightly forward, displays her full attention for the operation.

In addition to the use of mainly fine pen lines for the contours, Rembrandt used various hatched lines, sometimes cross-hatched, to indicate shadow. The figure of the seated Tobit has thereby been brought into relief and the head of Tobias in particular has been accentuated as a result. The figure of Sarah is depicted in a slightly looser drawing style, with occasional strong strokes of the pen. Rembrandt painted over the whole of the head of the angel with white which makes him less noticeable and draws all the attention to Tobit and his son; the hand on the windowsill was also painted over with white.

The drawing in Cleveland is certainly one of the finest which Rembrandt made of the story

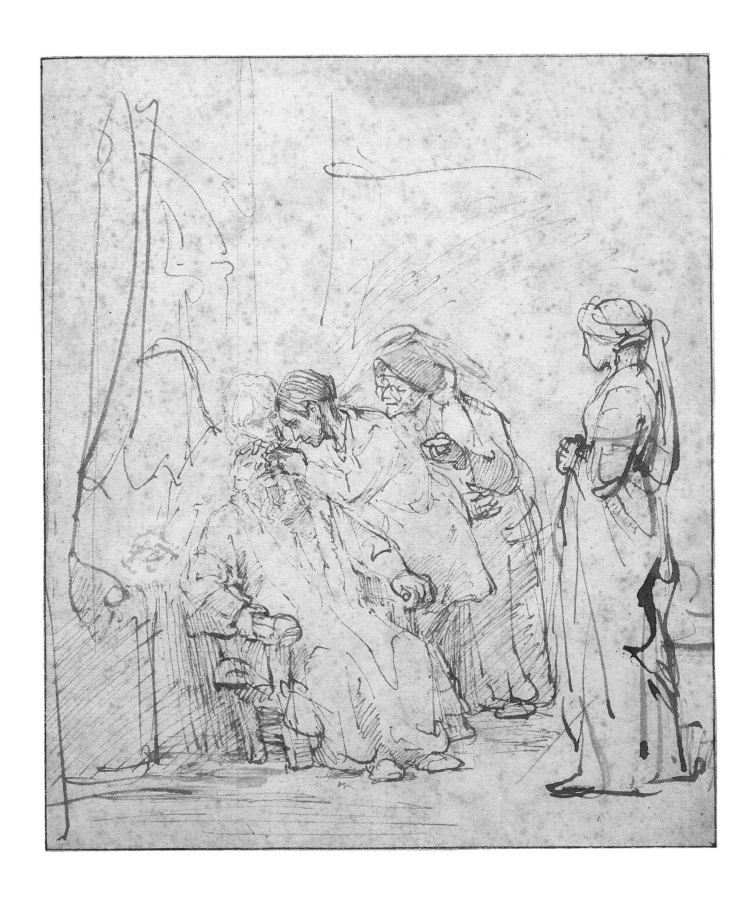

of Tobit. In the past a number of Rembrandt-esque drawings with scenes from this story have been attributed to him but most are now considered not to be by his hand. Two have recently been ascribed to Rembrandt's pupil Willem Drost (Cat. No. 46).

Rembrandt certainly owned the print by Cornelis Massys, one of a series of eight showing the story of Tobit (Fig. 18a).[2] The grouping of the figures is, in mirror-image, broadly the same, although here Anna is standing with clasped hands in the left background. There is also a man with a beard present and the bowl is held by the angel. A few other motifs have also been adopted, such as the hand of Tobias on the head of his father and Anna's hands folded together, which is Sarah's gesture in the drawing.

Rembrandt also made two etchings of scenes from the book of Tobit[3] and a painting of *The Agel leaving the house of Tobit*, dated 1637.[4] Another painting from the 1630s, *The healing of Tobit* in Stuttgart, was previously considered to be a Rembrandt but is now attributed to an unidentified pupil (Fig. 18b).[5] The group of figures seated around Tobit in the Stuttgart painting is related to the group in the drawing. It is generally dated to the first half of the 1640s, but could also have been made a little earlier.[6] The drawing could possibly have served as a source of inspiration for the painting in Stuttgart.
P.S.

1. 'Leukoma', clouding of the cornea, is translated as cataract in all translations based on the Lutheran Bible. Thus, Rembrandt has drawn the moment of the healing as if it were a cataract operation and because of this the young Tobias has a knife in his hand.
2. B. 6, Holl. 29.
3. *The Blind Tobit goes outside to meet his Son* (B. 153 of c. 1629 and B. 42 from 1651) and *The Angel departing the Family of Tobias* (B. 43 from 1641).
4. Paris, Musée du Louvre; *Corpus* III A121.
5. Stuttgart, Staatsgalerie; *Corpus* III C86. The painting only shows half of the original composition.
6. The drawing at Chatsworth, *An Actor as Bishop Gozewijn*, Benesch, No. 120, is fairly similar in style. If the actor depicted here is Willem Ruyters, drawn from life, then it must have been made before his death in 1639. Benesch dates this drawing to 1636. The drawing in Amsterdam *Joseph and his Sons* (Cat. No. 16) also displays stylistic similarity.

18a: Cornelis Massys, *The Healing of Tobit*. Amsterdam, Rijksprentenkabinet.

18b: Rembrandt pupil, *The Healing of Tobit*. Stuttgart, Staatsgalerie.

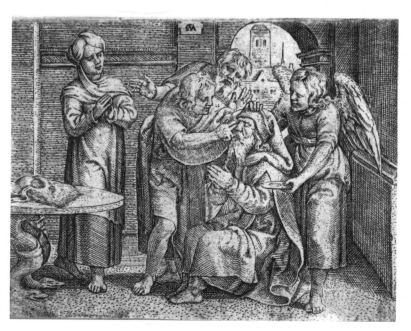

19

The Entombment, over a sketch of an executioner

Verso: *The Beheading of John the Baptist*

Pen and brown ink; a piece of paper inserted below left, 156 × 201 mm
Amsterdam, Rijksmuseum, Rijksprentenkabinet

Provenance: Dirk Vis Blokhuyzen, sale Rotterdam, 23 October 1871, No. 500; August Sträter (L. 787), Aachen, sale Stuttgart, 10–14 May 1898, No. 1176; with Colnaghi, London (after 1900); Cornelis Hofstede de Groot, The Hague, bequest 1906, in usufruct until 14 April 1930; Inv. No. RP-T-1930–28.

Literature: Henkel 1942, No. 48; Benesch 1954–57 and 1973, No. 482; Schatborn 1985, No. 19 (with other previous literature and exhibitions).

Exhibitions: Rotterdam/Amsterdam 1956, No. 82.

Four men are carrying Christ to the grave. They have laid him in a cloth which is being held by the men in the centre. To the left is a mourning woman who is only partly visible as a new piece of paper has been inserted in the lower corner at the left. In most depictions of this subject, including Rembrandt's grisaille in Glasgow (Fig. 19a)[1] and the painting from the Passion series made for Frederik Hendrik in Munich (Fig. 19b),[2] the figure of Christ is not hidden by one of the bearers. The head of Christ is usually depicted as though he were sleeping and not hanging down with loose hair. In the drawing this emphasises the lifelessness of the body. Rembrandt has thus found a more natural and realistic solution for this subject than is to be seen in his paintings. The figures have been roughly indicated in the drawing, with the exception of the most important detail of the representation, the head of Christ.

There is a clear connection with *The Entombment* in Munich in the shape of the curtain at the left hand side. Rembrandt used this curtain as the starting point for a composition which differs from the paintings in that the figure of Christ is being carried up from the left to right.[3]

If we turn the sheet through ninety degrees

we see a head and raised hands next to it at the same height as the grave. Rembrandt has drawn his *Entombment* over this sketch which can be seen again, and more clearly, on the verso. There the figure is holding a sword in his hands and is on the point of beheading a kneeling man. These two sketches are characteristic of they way in which Rembrandt would begin a drawing, in a very faint manner which could then be elaborated and corrected with darker lines. The head of the executioner on the reverse of the sheet has already been depicted in two stages.

Both sketches are related to a *Beheading of John the Baptist* in an etching from 1640 (Fig. 19c):[4] the executioner is standing in the same position as in the sketches, in mirror-image, but the figure of John has been turned a quarter to the left. The sketch of the executioner underneath the *Entombment* looks like the same figure in a drawing in the British Museum in London and here, moreover, two other stages in the narative have been depicted, the moment before the beheading and the moment thereafter with the headless body lying on the ground (Fig. 19d).[5] A drawing in the Metropolitan Museum in New York shows the same beheading scene viewed from the side and here the head is drawn three times in the foreground (Fig. 19e).[6]

Given the similarities in these two drawings it has been suggested that models had posed in a group as in a *kamerspel* ('chamber play') as Hoogstraten called it in his *Hooge Schoole der Schilder-konst* of 1678 and that pupils together with Rembrandt had drawn the group from different angles.[7] However, the sketches of the *Beheading* on the drawing in Amsterdam do not

19: verso

19a: Rembrandt, *The Entombment of Christ*. Glasgow, Hunterian Art Gallery, University of Glasgow.

19b: Rembrandt, *The Entombment of Christ*. Munich, Alte Pinakothek.

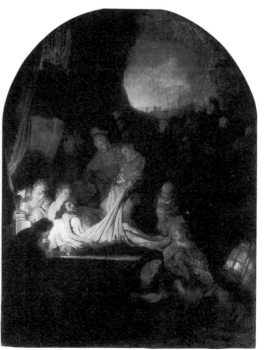

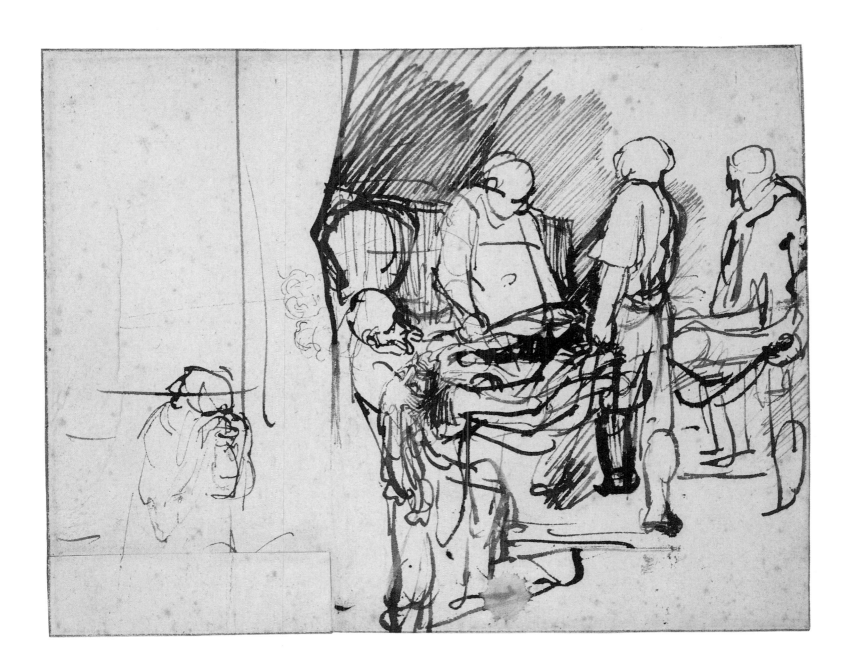

30:28

1274

1440

seem to be of the same group but they could of course have been inspired by them. The sketches were probably made by Rembrandt from imagination in preparation for the etching.

If the sketches for the *Beheading* were made in 1640 as preparation for the etching, then the *Entombment* cannot date from much later. The painted *Entombment* in Munich was already in February 1636 '*Ruym half gedaen*' (more than half done) as Rembrandt writes in a letter to Constantijn Huygens, secretary to the Prince.[8] In a letter of February 1639 he communicates that the painting is completed.[9] The drawing is therefore probably not a preliminary study for the painting, but is more likely to be a new, less conventional version of the subject.
P.S.

1. Glasgow, Hunterian Art gallery, University of Glasgow; *Corpus* III A105.
2. Munich, Alte Pinakothek; *Corpus* III A126.
3. The bearers with their heavy weight could be inspired by those in *The Entombment* by Raphael (Rome, Galeria Borghese), which Rembrandt could have known from a print by Peter Scalberg, as is noted by Keith Andrews in his review of Schatborn 1985, *The Burlington Magazine* 128 (1986), pp. 223–24.
4. B. 92.
5. London, British Museum; Benesch, No. 479.
6. New York, Metropolitan Museum, Lehman collection; Benesch, No. 478. This drawing is probably the work of a pupil.
7. Hoogstraten 1678, p. 192; Konstam 1978.
8. *Documents* 1936/1.
9. *Documents* 1639/1.

19c: Rembrandt, *The Beheading of St John the Baptist*. Amsterdam, Rijksprentenkabinet.

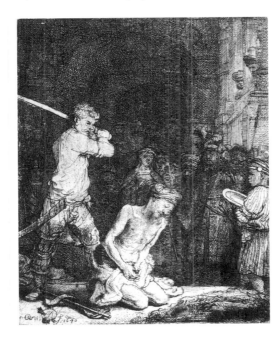

19d: Rembrandt, *Beheading of a Man*. London, British Museum.

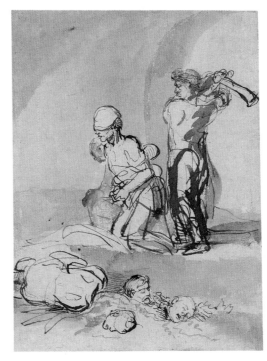

19e: Rembrandt, *Beheading of a Man*. New York, Metropolitan Museum of Art.

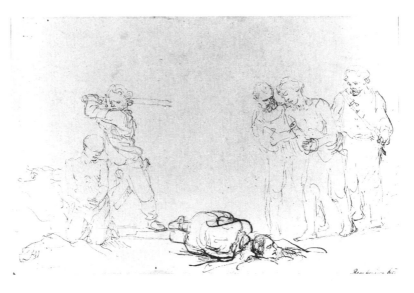

Interior with Saskia in bed

Pen and brown ink, brown and grey wash,
some traces of red and black chalk,
141 × 176 mm
Paris, Institut Néerlandais, Fondation Custodia
(coll. F. Lugt)

Provenance: William Esdaile, sale London, 24
June 1840, No. 1046; John Heywood Hawkins,
sale London, 29 April 1850, No. 1025;
A. Bellingham Smith, 1918; E. Parsons,
London; F. Lugt (L. 1028), acquired in 1919;
Inv. No. 266.

Literature: Benesch 1954–57 and 1973, No. 426;
Haverkamp-Begemann 1976, pp. 96–105;
Schatborn 1985, in No. 11.

Exhibitions: Amsterdam 1969, No. 58; New
York/Paris 1977–78, No. 88 (with other
previous literature and exhibitions).

20a: Rembrandt, *Model sheet with a woman lying in
bed*. Amsterdam, Rijksprentenkabinet.

Saskia is lying sleeping in the box bed. A chair
which Rembrandt depicted in a number of
works stands by the bed (Cat. Nos 2 and 23).
At the other end of the bed a woman is seated
in the sun between the bed and the fireplace
winding lace. She has put her feet on a cushion.
The mantelpiece, carried by two herms, has a
cloth canopy. Behind the empty chair are two
doors, rounded at the top, possibly a doorway
and a cupboard door. The light falls from the
right through a window which is not visible.

This light has been extremely carefully
depicted by Rembrandt; we see for example the
shadow of the chair in front of and against the
bed, the fall of light on the blankets and the
half-darkness of the box bed which has been
executed in a number of tones. While the
woman who is absorbed in her task is placed in
the light, the shadow in which Saskia is
shrouded in the box bed suggests that she is
asleep. What is not clear however is the cause
of the shadow to the right of the scene. The
drawing has probably been cropped somewhat
here.

The drawing is not only been made in
brown ink with the pen and the brush but also
with grey, which is not so usual. Rembrandt
probably added the grey last in order to
strengthen the areas which indicate light,
where the paper is left white.

The subject of a room with a woman in bed
is unusual in the history of art, although beds
as symbols of amorous relations are frequently
depicted in interiors in the seventeenth
century. In Rembrandt's endeavour to record
in drawings the visible world in all its shapes
and forms he encompassed the bedroom. In the
choice of such scenes Rembrandt could have
had similar subjects in mind which he could
use in paintings and etchings.

There is a certain connection with, for
example, an etching such as *Le Lit à la française*
of 1646, in which a pair of lovers are depicted
in bed.[1] Here there is also a door or niche with
a rounded top to the left of the bed. More
closely connected to the drawings is the
etching with two sketches of a woman in bed.
These were possibly made from life, with
Saskia as model and etched directly onto the
plate (Fig. 20a).[2] There are also biblical
representations which take place in a bedroom
such as *The raising of Jairus's Daughter* (Cat.
No. 36).

The drawing of the room with the sleeping
Saskia is of course also a genre sence, which
gives us a glimpse of the daily reality of
Rembrandt's life. He drew his wife in bed a
couple of times, once from close up[3] and
another time in a bedroom with a cradle (Fig.
20b).[4] This indicates that here Saskia is an

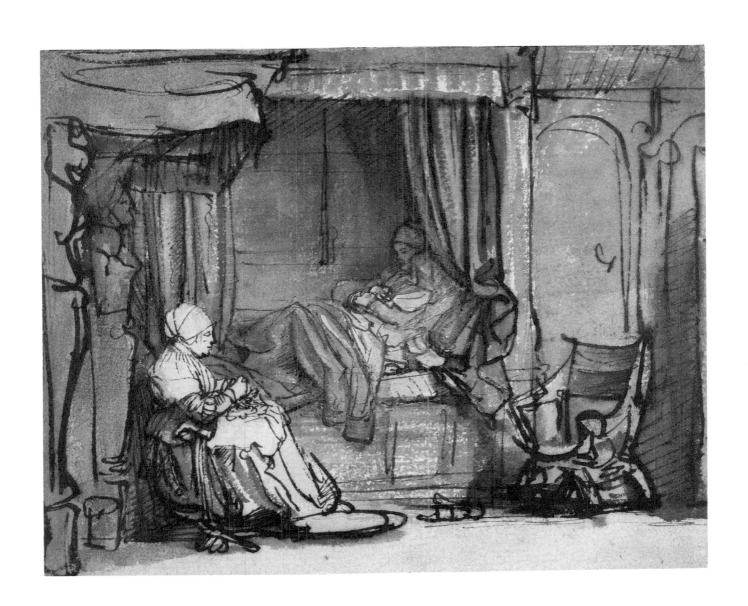

expectant mother, which could also be the case in the drawing in the Lugt collection.

The two drawings show different interiors and therefore were probably not made in the same house. We can determine in which houses these rooms were situated by a combination of the birth dates of the four children of Rembrandt and Saskia and what is known of the various addresses where they lived.[5]

Three of Rembrandt and Saskia's children died young. Only the last child, Titus, reached adulthood. Rumbartus was baptised on 15 December 1635 and was born in the house 'naest den pensijonaris Boereel, nieuwe doelstraat' (next to the Pensionary Boereel, Nieuwe Doelenstraat).[6] On the basis of style in both drawings this date would be too early for the rooms to have been in this house.[7] Cornelia was baptised on 22 July 1638 and was born in the house 'op de Binnen Amstel, 'thuijs is genaemt die Suijkerbackerrij' (on the Binnen Amstel, the house is named the Sugar-bakery).[8] The second Cornelia was baptised on 29 July 1640 and she must have been born in the house on the Breestraat, now the Rembrandthuis, which Rembrandt had bought on 5 January 1639.[9] Titus, who was baptised on 22 September 1641, must also have been born in that house.[10]

The drawing in the Lugt collection represents a later stylistic phase than the one in Amsterdam. So it is likely that this shows a room in the house on the Breestraat and that the Amsterdam drawing shows one in the house on the Binnen Amstel. The cradle was for the nursing of the first Cornelia. In the drawing in the Lugt collection—if the supposition is correct—Saskia is expecting either the second Cornelia or Titus. The Amsterdam drawing could therefore be dated to July 1638 and the drawing in the Lugt collection to before July 1640 or September 1641. Saskia died on 14 July 1642, less than a year after the birth of Titus.[11]

P.S.

1. B. 186.
2. B. 269.
3. Dresden, Kupferstich-Kabinett, Benesch, No. 255; Groningen, Museum voor Stad en Lande, Benesch, No. 282; Oxford, Ashmolean Museum, Benesch, No. 281a; London, British Museum, Benesch, No. 281; in a sketch in red chalk, Saskia is holding a child in her arms: London, Courtauld Institute Galleries, The Princes Gate Collection, Benesch, No. 280a.
4. Amsterdam, Rijksprentenkabinet; Benesch, No. 404.
5. See Schatborn 1985, No. 11.
6. This address is mentioned by Rembrandt in a letter to Huygens from February 1636; Documents 1636/1. Rumbartus had already been buried on the 15th of this month; Documents 1636/3. I.H. van Eeghen, 'De kinderen van Rembrandt en Saskia', Maandblad Amstelodamum 35 (1956), pp. 144–46.
7. Rumbartus is depicted with Saskia on a drawing in Rotterdam; Benesch, No. 228; Schatborn 1975.
8. Rembrandt gives this address on 17 December 1637 and 12 January 1639; Documents 1637/7 and 1639/2. Cornelia was buried as early as 13 August 1638; Documents 1638/9.
9. She was buried on 12 August of that year; Documents 1640/6.
10. Documents 1641/4.
11. Documents 1642/3 and 1642/4.

20b: Rembrandt, *Interior with Saskia in bed.* Amsterdam, Rijksprentenkabinet.

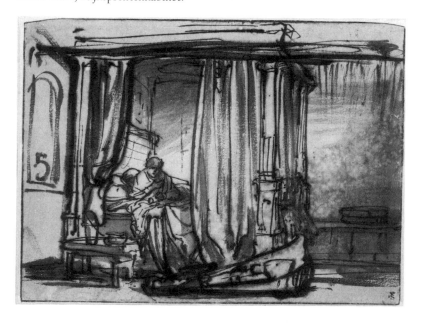

21

The Windmill on the Bulwark Het Blauwhoofd

Pen and brown ink, brown wash, mounted, 118 × 200 mm

Inscription: below left *RH 5*, in the hand of Richard Houlditch; on the reverse, on the old mount *1736*, the date of Houlditch's acquisition.
Paris, Institut Néerlandais, Fondation Custodia (coll. F. Lugt).

Provenance: Richard Houlditch, 1736 (L. 2214), sale London, 14 February 1760, No. 50 or 71; Viscountess Churchill, later Mrs Isham, sale London, 29 April 1937, No. 97, F. Lugt (L. 1028); Inv. 5174.

Literature: Benesch 1954–57 and 1973, No. 1333; Haverkamp Begemann 1976, p. 361; Giltaij 1988, in No. 20, ill. a; Washington 1990, in No. 10, Fig. 1.

Exhibitions: Brussels/Rotterdam/Paris/Bern 1968/1969, No. 116; Amsterdam 1969, No. 96; Paris 1974, No. 79; Leningrad/Moscow/Kiev 1974, No. 87; New York/Paris 1977–1978, No. 91.

To the west of Amsterdam, near the IJ, there was a bulwark called Het Blauwhoofd. On most bulwarks there were mills such as this little smockmill, of which the upper part revolves in such a way that the sails face into the wind. On a drawing of the same place by Roelant Roghman we see the sails in a different position (Fig. 21a).[1] Roghman sat on the left of the road, drawing the IJ with the palings in front of the harbour, whereas Rembrandt was seated on the right of the road. He placed the mill in the centre of the sheet. To the left he drew the cannons with their barrels sighted in the direction of the water, where a section of the palings can also be seen. To the right are trees at the bottom of the incline. The same trees are also just visible on Roghman's sheet. Next to these trees part of a wooden building can be seen behind the houses on the Zoutkeetsgracht. A rope-yard was situated here.[2]

After Rembrandt had drawn the mill, the houses, the cannons and the trees in pen, he elaborated the drawing with the brush. The brown wash has been applied in rich contrasts, creating strong shadows. The light which comes from the east, and from the right, falls low on the bulwark, as shown by the long shadow of the house on the lower section of the embankment. This indicates that Rembrandt made the drawing with its quiet mood in the early morning. Rembrandt drew the mill and houses from closer up in a drawing in Rotterdam (Fig. 21b).[3] Here we also see the other side of the IJ with the gallows-field on a peninsula, De Volewijk.[4] Boats are lying in the water behind the mill. The house standing separate from the mill and from the other two houses which we see in Roghman's drawing,

21a: Roelant Roghman, *Mill on the Bulwark Het Blauwhoofd*. Amsterdam, Gemeente Archief.

does not appear in Rembrandt's drawing. Rembrandt made another drawing of a view of Het Blauwhoofd from a bulwark situated further to the west (Fig. 21c).[5] Here the other side of the IJ can also be seen, as well as the trees at the bottom of the embankment situated to the right.

The *Windmill on Het Blauwhoofd* in the Lugt collection has been variously dated, 1645–50[6] and c. 1654.[7] The drawing of *The Montelbaen Tower* in the Rembrandthuis provides a clue for an earlier dating, to the mid 1640s.[8] Here we see how the trees have been drawn in a comparable manner with the pen and brush and that the handling of lines has the same variation of accents. On basis of topographical details this drawing can be dated to 1645–46.
P.S.

1. Amsterdam, Gemeente Archief. W. Th. Kloek, *De kasteeltekeningen van Roelant Roghman*, Alphen aan de Rijn, II, 1990, pp. 20–21. Kloek dates the drawing to the second half of the 1640s.
2. This is apparent from the depiction of the bulwark on the map of Amsterdam by Balthaar Florisz.
3. Rotterdam Museum Boymans-van Beuningen; Benesch, No. 813 (c. 1641); Giltaij 1988, No. 20 (c. 1652); Washington 1990, No. 10 (c. 1640–41).
4. Giltaij, following Bakker and Hofman, believes that it is the Nes, a peninsula lying further to the west, which is depicted, and not the Volewijck.
5. Vienna, Albertina; Benesch, No. 1280 (c. 1652); Washington 1990, No. 61 (c. 1645–49).
6. Cat. New York/Paris 1977–78, No. 91.
7. Benesch, No. 1233.
8. Amsterdam, Museum The Rembrandthuis; Benesch, No. 1309 (c. 1652–53); Washington 1990, No. 49 (c. 1648–50); Lugt 1920, p. 51 (before 1644); Schatborn 1990, p. 37 (1645–46).

21b: Rembrandt, *Mill on the Bulwark Het Blauwhoofd*. Rotterdam, Museum Boymans-van Beuningen.

21c: Rembrandt, *View over the* IJ *with the Bulwark Het Blauwhoofd*. Vienna, Albertina.

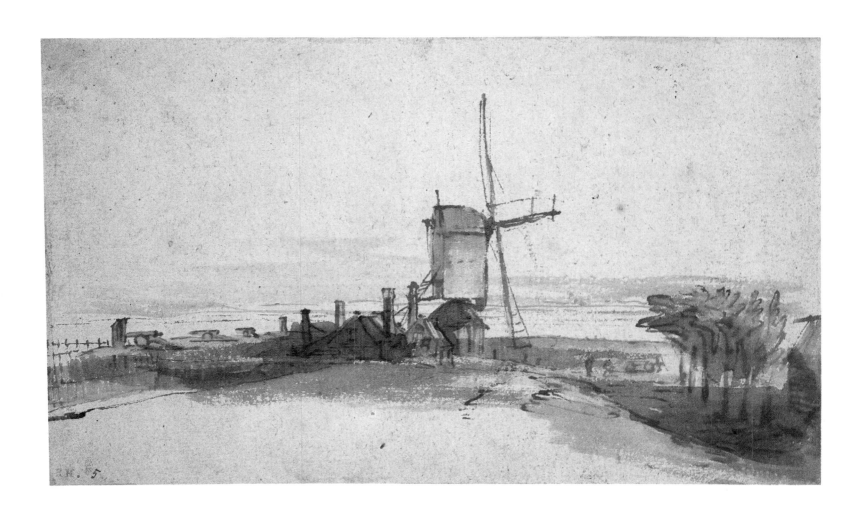

22

A ditch with overhanging bushes

Black chalk, 145 × 115 mm
Wroclaw, Library of the Ossolinski Institute of
the Polish Academy of Arts and Sciences

Provenance: Prince Hendryk Lubomirski; Lvov,
Lubomirski Museum; Inv. No. 8728.

Literature: Benesch 1954–57 and 1973, No. 817;
White 1969, pp. 204–5.

Exhibitions: Washington 1990, No. 58 (with
other previous literature).

Rembrandt usually drew his landscapes with the pen and brush, but he used black chalk for a number of cityscapes and small landscapes. These may have belonged to 'Een boeckie vol gesichten geteeckent van Rembrant' (a book with views drawn by Rembrandt), which is mentioned in Rembrandt's inventory of 1656.[1]

When Rembrandt worked out of doors, he sometimes drew in the neighbourhood of his own house, in the city centre or at the fortifications on the edge of the city (Fig. 21c). At other times he went out of town, drawing in the area surrounding Amsterdam, along the river Amstel or in the polders. His sketches, made carefully but not in detail, are a direct representation of what he saw. He often recorded recognisable places but he sometimes also drew a piece of nature or open countryside (Fig. 22a).[2]

During one of his walks Rembrandt depicted a rather unusual subject. He was standing on a small bridge which can just be seen at the bottom of the drawing. To the right of the small sheet a section of a wooden gate is visible, which gives access to a farmyard or the garden of a house. A tree to which a plank of wood has been attached is standing to the left. We look from the centre of the drawing over the ditch into the distance, where a windmill is situated. Bushes which are reflected in the water hang over the timbering of the river bank. Only the bare branches of the trees behind these bushes are visible. Above this Rembrandt has drawn a number of zig-zag lines, in order to fill this rather empty area of paper somewhat. The tree on the left has also only been finished up to a certain point and the top is indicated with a single line. The foliage of the central bush is the most elaborately worked, with sharp chalk. The bushes and trees in the further distance through which the light shimmers, have been indicated with fine chalk lines.

22a: Rembrandt, *Polder landscape*.
Vienna, Albertina.

The drawing could have been made anywhere in the environs of Amsterdam, as almost all the houses in the polder land were divided from the road by a ditch, over which there was a bridge. Richer country houses and farms, for example those along the Amstel and the Vecht, had an access gate at this bridge, which is frequently seen in other landscapes by Rembrandt. The partly visible wooden gate has a roof, which also appears in the drawing of the *View of the Amsteldijk near Trompenburg* (Fig. 22b).[3] Here there is also a low gate, a plank leaning against two palings, which, just as the plank against the tree, marks out the path to the bridge.

The subject and the composition of the landscape—the drawing has probably been cropped a little on all sides—is very unusual for a seventeenth-century representation, and not only in Rembrandt's œuvre. However, he drew more than one such view. In 1645 he made an etching of *A Boathouse under the trees*[4] and although he did not use the drawing as a preliminary study the subject is similarly unusual. (Fig. 22c). Here the branches also fade out into nothingness and here also a plank is attached to a tree, on which in this case Rembrandt has placed his signature and the date 1645. In this way motifs from real life were adopted in new compositions. There is not really a comparable predecessor for the composition of this etching, as there is for most of the landscape compositions.[5]

It seems obvious that the chalk drawing dates from 1645, the date of the etching. Rembrandt's dated etchings of landscapes were made between 1641 and 1652 and most landscape drawings are dated to approximately the second half of the 1640s, in a few cases on grounds of topographical details.[6]

P.S.

1. *Documents* 1656/12, No. 259.
2. Vienna, Albertina; Benesch, No. 812a.
3. Chatsworth, The Devonshire Collection; Benesch, No. 1219.
4. B. 231.
5. Amsterdam 1983–I, No. 64.
6. An exception is the *View of the Nieuwezijds Voorburgwal*, Benesch, No. 819; Schatborn 1985, No. 50, which must have been drawn in or after 1657.

22b: Rembrandt, *View of the Amsteldijk near the Trompenburg Estate*. Chatsworth, The Devonshire collection.

22c: Rembrandt, *A Boathouse among trees*. Amsterdam, Rijksprentenkabinet.

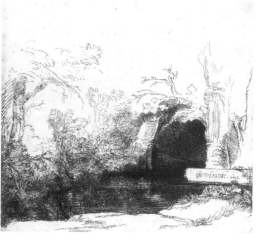

23

Portrait of Jan Six at a window

Pen and brown ink, brown and white wash, 220 × 177 mm; a piece added below. Amsterdam, Six collection

Provenance: Richard Cosway (L. 629), sale London, 14 February 1822, No. 503; Jean Gisbert Baron Verstolk van Soelen, sale Amsterdam, 22 March 1847, Livre B, No. 36.

Literature: Benesch 1954–57 and 1973, No. 767 (with other previous literature and exhibitions); Clara Bille, 'Rembrandt and burgomaster Jan Six', *Apollo* 85 (1967), pp. 260–65; J. Six, 'Jan Six aan het venster', *De Kroniek van het Rembrandthuis* 23 (1969) 2, pp. 34–52; Broos 1981, in No. 13.

Exhibitions: Rotterdam/Amsterdam, 1956, No. 27a; Amsterdam (Museum Het Rembrandthuis) 1969, A (see Six 1969).

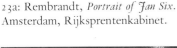

23a: Rembrandt, *Portrait of Jan Six*. Amsterdam, Rijksprentenkabinet.

23b: Rembrandt, *Portrait of Jan Six reading by the window*. Amsterdam, Six collection.

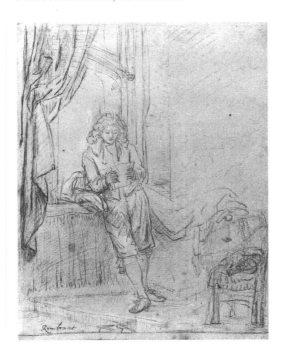

Rembrandt made two drawings in preparation for the etched portrait of Jan Six (Etchings Cat. No. 23; here Fig. 23a), firstly a pen drawing which gives the subject in broad outline and then a precise preparatory drawing in chalk. In the first drawing, which is exhibited here, Six stands leaning against the sill of an open window, his arm on a section of the cloak which is lying on the table behind him.[1] Six looks straight ahead and past the artist. He is wearing a short jacket from which a collar is peeping out at the top. A fairly large not clearly recognisable object is lying on the table.[2] A dog is jumping up at Six. A table covered with a cloth is standing in front of the window and in the left foreground stands a chair which we have seen in a number of Rembrandt's works (Cat. Nos 2 and 20). The presence of this chair might indicate that this drawing was made in Rembrandt's home. Through the window we see the contours of a building.

Rembrandt executed the drawing with the reed pen using fine and broad lines. Six's face has been indicated with only a few lines with white dots left blank for the eyes. Numerous hatchings in various directions divide the light and dark areas and shadows have also been added with the brush. Rembrandt made a few alterations during the making of the drawing, for example in the position of the feet and legs. The dog too, has achieved its shape after a lot of scratching. Various lines were painted over with white body colour and in this way areas were corrected.

This drawing of Jan Six has an exceptionally spontaneous character, in contrast to the second preparatory drawing in black chalk which is also in the Six collection (Fig. 23b). Both drawings have been corrected with white.[3] Besides having taken more care with the drawing, Rembrandt also altered it considerably. As this etching was commissioned by Six, he probably suggested the alterations himself.

Six's first rather nonchalant pose has been replaced by a more formal one. He has been made smaller in relation to the picture space and is standing reading against the windowsill with his legs in an elegant position; Six's cloak is draped behind him. The chair, now of simpler design, has been moved to the other side. The piece of clothing on it was replaced in the etching with a pile of books. A painting with a curtain in front of it now hangs on the wall. The composition has been closed off on the left in a fairly traditional manner with a curtain. All the signs are that Six, poet, collector and later burgomaster, wanted himself immortalised as an erudite man.

Before Rembrandt made this second version he had drawn the new position of Six's head and upper body in black chalk on the back of a drawing of a family of beggars (Fig. 23c).[4] This small sketch is clearly an experiment, possibly made to show Six how it would look. The hat which Six is wearing was omitted from the second sketch. In the etching, his hat is hanging next to the window.

The lines in the second draft have been indented with a sharp instrument, after Rembrandt had blackened the back of the paper. There are only a few preparatory drawings extant which show the entire composition and the two drawings are the only ones made for one and the same etching. Other indented drawings have similarly all been executed in chalk. On the other hand a few preparatory drawings for etchings which are not indented have been made in pen (Cat. No. 25).

The etching of Jan Six is dated 1647 and the drawings are therefore a good example of Rembrandt's style in that year. The small sketch of Six and the drawing of a family of beggars on the reverse are also a clue to the dating of a group of sketches in black chalk, of figures as well as landscapes (Cat. No. 22).

A few works and documents bear witness to the relationship between Jan Six and Rembrandt. Six was born in 1618 and Rembrandt had known him at least since the portrait of 1647. Rembrandt etched a frontispiece, *The Marriage of Jason and Creusa* in 1648 for Six's tragedy *Medea*.[5] In 1652, when Rembrandt made the two drawings in the Pandora album (Cat. No. 31A and B), he concluded two deals with Six on 5 October concerning the sale of paintings; one was in connection with a *Portrait of Saskia*,[6] the other a *Simon in the Temple* and a *Preaching of John the Baptist*.[7] In the following year Six lent Rembrandt a thousand guilders which he used in part as repayment on his house,[8] for which reason he probably also sold the above mentioned paintings to Six in 1652. Lastly, in 1654, Rembrandt painted the *Portrait of Jan Six* which is still in the Six collection.[9]

The Six family had made their fortune in the silk and cloth industry and after the death of his mother Anna Wijmer in 1645 Jan could live on his inheritance and devote himself entirely to literature and art. He had enjoyed a good education, had attented the Latin school in Amsterdam and the university in Leiden. As conclusion to his studies he made a trip to Italy around 1640. In 1655 he married Margaretha Tulp. He took up the public office of burgomaster of Amsterdam in 1691. By the time of his death in 1700 the collection acquired by Six included Dutch and Italian paintings, antique statues, drawings, prints and books.[10]

P.S.

1. Six suggested that his ancestor is holding a rabbit in his left hand; J. Six, 'Rembrandt's voorbereiding van de etsen van Jan Six en Abraham Francen', *Onze Kunst* (1908), p. 54.
2. Interpreted by Six as a birdcage 1969; Broos 1981.
3. Benesch, No. 768.
4. Amsterdam, Historical Museum; Benesch, No. 749; Broos 1981, No. 13.
5. B. 112.
6. *Documents* 1652/7.
7. Documented in a contract of 13 September 1658, when this and the first agreement were annulled; *Documents*, 1658/18.
8. This debt was taken over by Lodewijk van Ludick in 1657. *Documents* 1657/3.
9. Bredius/Gerson, No. 276.
10. The sale catalogue of 6 April 1702 is in the archive of the Six family.

23c: Rembrandt, *Portrait of Jan Six*. Amsterdam, Historisch Museum.

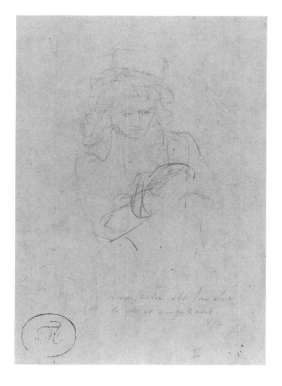

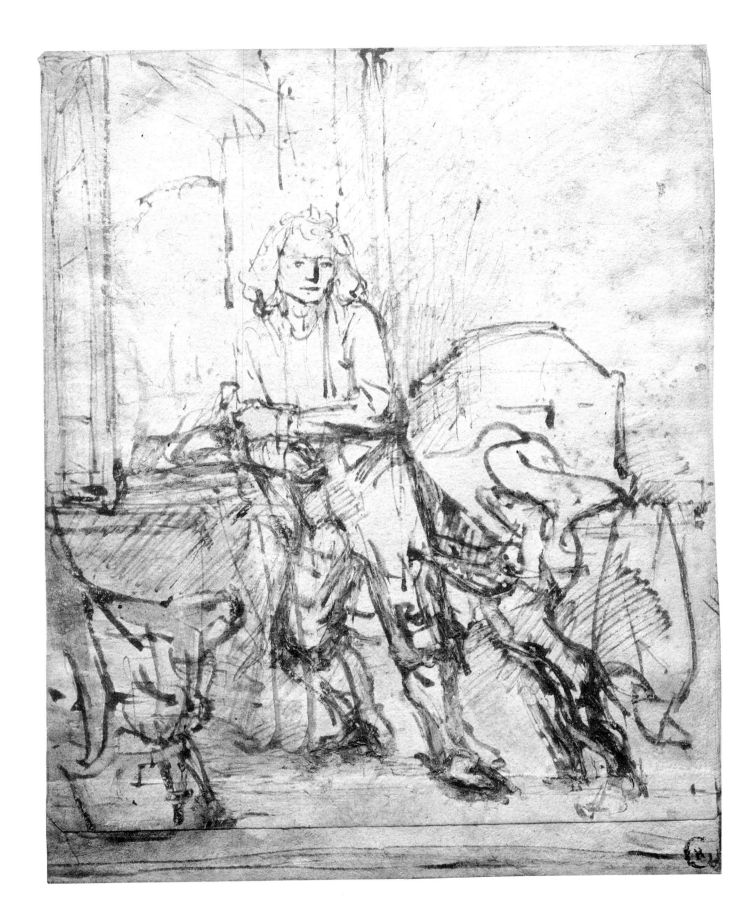

Seated female nude, as Susanna

Black chalk, white wash, 203 × 164 mm
Berlin, Staatliche Museen Preussischer
Kulturbesitz, Kupferstichkabinett

Provenance: Count Andreossy, sale Paris, 13–16
April 1864, No. 384; Jean François Gigoux
(L. 1164), sale Paris, 20 March 1882, No. 413;
KdZ. No. 5264 (1902).

Literature: Bock-Rosenberg 1930, No. 5264,
p. 224; Benesch 1954–57 and 1973, No. 590
(with other previous literature).

Exhibition: Berlin 1970, No. 37.

Life drawing formed part of the training for the apprentice artist. This exercise was useful at a later date when nude figures were depicted in biblical and mythological scenes. Rembrandt used studies of the nude in this way for the first time in two etchings dating from the beginning of the 1630s. It is uncertain whether they date from the Leiden period or were made in Amsterdam, where Rembrandt settled to work in the early 1630s.[1] A preliminary study, made in black chalk for one of these etchings, *Diana seated by the water*, is still extant, the earliest drawn nude that we know of by Rembrandt.[2]

In the later 1630s Rembrandt drew a few female nudes,[3] and in the mid-1640s boys stood as models. While the pupils drew these, Rembrandt made various etchings, which in turn served as models for pupils (Etchings Cat. No. 21).[4] A few drawings of nudes from the later period were executed in pen and these were also made with his pupils (Cat. No. 38 and 49).

The half-naked woman sits on a chair with a small back rest. She is holding her left arm up to her just visible breast and her right arm is resting on a tabletop, the edge of which is clasped by her hand. The woman has turned her head partly towards us with a startled expression. Given this pose, it is likely that the model is depicted in the role of the biblical Susanna, at the moment when she is surprised, while bathing, by the two elders. Rembrandt painted a bathing Susanna in 1636 (Fig. 24a)[5] and probably earlier in that year, he drew the copy of Pieter Lastman's painting of the same subject (Cat. No. 11). Finally, there is Rembrandt's larger painted version in Berlin dated 1647 (Fig. 24b).[6]

The question is whether a connection can be established between the exhibited drawing and either of the above mentioned paintings. In considering this we should take note of the fact that under the visible version of the 1647 painting, there is a much earlier one, which is known from a drawing by a pupil (Fig. 24c).[7] The painted Susanna of 1636 and the model in the drawing are both depicted seated, but the position of the head and hands differs considerably. In the painting, Susanna's head is placed nearer her shoulders and the body is, moreover, seen from the side.

There are also differences in Susanna's pose in the first and second versions of the Berlin painting. Judging from the drawn copy of the first version, the position of Susanna's head and shoulders was a compromise between the painting of 1636 and the second version. More of her right shoulder is seen in the final version than in the earlier one, and in addition,

24a: Rembrandt, *Susanna at the Bath*. The Hague, Mauritshuis.

24b: Rembrandt, *Susanna and the Elders* (detail). Berlin, Gemäldegalerie SMPK.

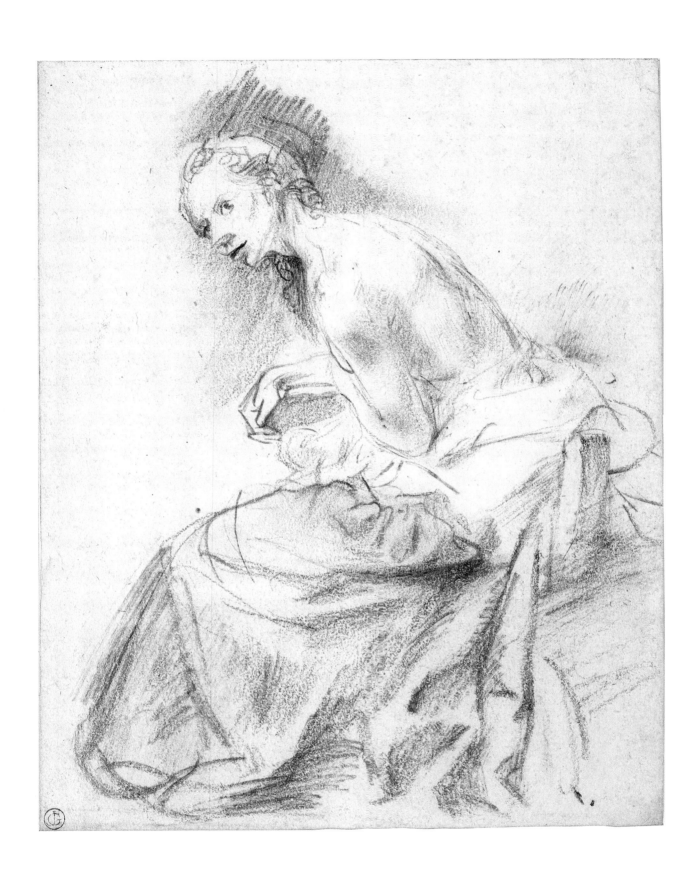

figures on the bridge, a bird in the truncated tree—and the composition was changed to the extent that Jerome's hut is substituted for the view to the right of the lopped tree. Rembrandt drew a tower with a truncated spire on the hill and a lower lying building with a chimney. The buildings were completed in a different way in the etching and the tower has no spire at all.

Rembrandt was influenced by Italian examples.[4] He had seen the print by Cornelis Cort, after Titian, of the same subject dated 1565; here a hilly landscape also forms the background.[5] The buildings are inspired by sixteenth-century Venetian prints, although there is no direct example to indicate this.[6] However, the tower and the houses in particular contain elements which are reminiscent of Dutch buildings drawn by Rembrandt.

Rembrandt drew the lion from memory, relying on the experience he had gained in drawing animals after life (Cat. No. 26). But here a model also played a part, which he also used for the drawing of *Daniel in the Lions' Den* (Fig. 26b).[7] In the latter, he adopted the lion entering the composition from the right, from a print by Willem de Leeuw after a painting by Rubens of the same subject.[8] The pose of the lion on the left hand side on the same print could have been the point of departure for Jerome's lion. The invention has therefore come about through a combination of motifs observed from nature and from examples by other masters.

The drawing and the etching are usually dated to the first half of the 1650s, but a slightly earlier dating, on grounds of similarity in style to *Daniel in the Lions' Den*, has also been suggested; the latter can be dated 1649 or before.[9] The etching of *Christ in Gethsemane* bears a date in the 1650s of which the last digit is not visible. A dating of the three drawings to about 1650 seems therefore likely, although it must be remembered that the prints were not necessarily executed at the same time. The drawing of *Daniel in the Lions' Den* could, like the two drawings in Hamburg, have been made as a preliminary sketch for an etching, although in this case the etching was never executed.

The lively, broad pen-lines, which also occur in the drawing for the etching of Jan Six (Cat. No. 23), are characteristic of the late 1640s. In the early 1650s Rembrandt's handling of line becomes tighter and less fluid. The drawings of 1652 in the Pandora album are examples of this (Cat. No. 31).

P.S.

1. P. Schatborn, 'Tekeningen van Rembrandt in verband met zijn etsen', *De Kroniek van het Rembrandthuis*, 38 (1986) 1, pp. 7–38.
2. Benesch, No. 899.
3. B. 75.
4. Clark 1966, p. 117–121.
5. J.C.L. Bierens de Haan, *L'Œuvre gravé de Cornelis Cort*, The Hague, 1948, No. 134.
6. In the literature Campagnola is particularly mentioned as a source of inspiration.
7. Amsterdam, Rijksprentenkabinet; Benesch, No. 887.
8. Schatborn 1985, No. 24, Fig. 24c.
9. See Schatborn 1985, under No. 24 and Washington 1990, No. 42, where the drawing is dated to c. 1649–1650 and the etching to c. 1650.

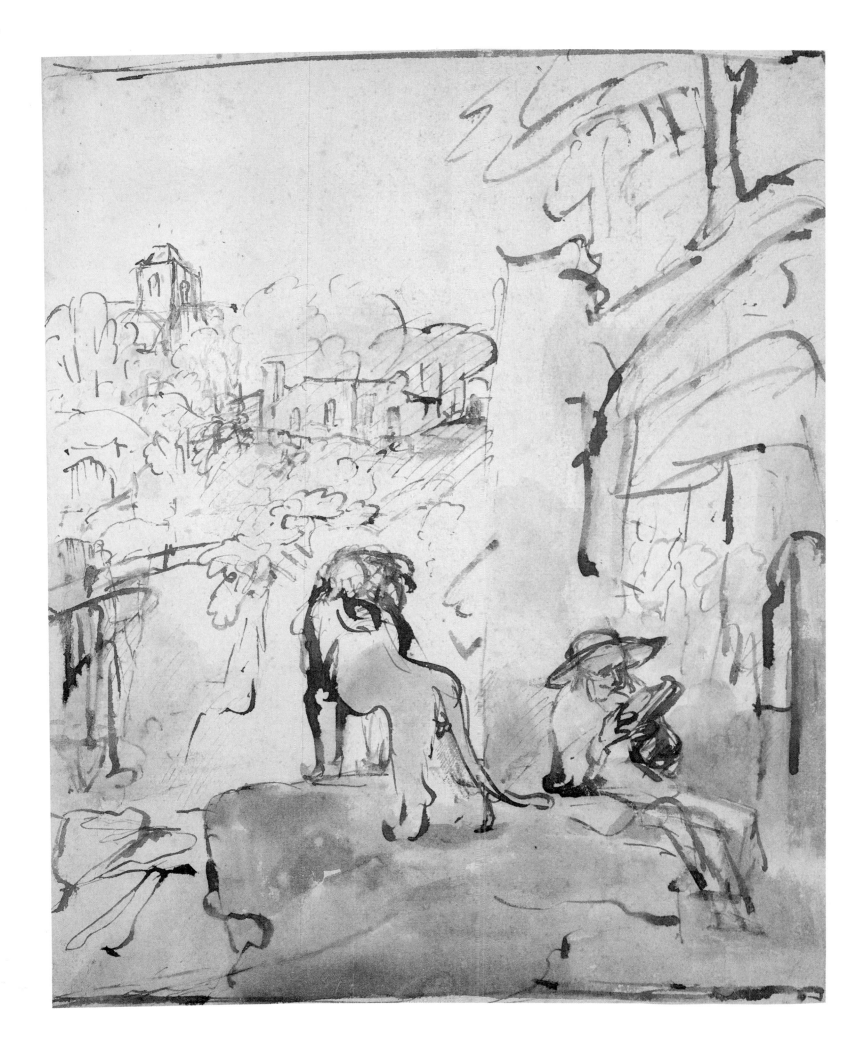

Lion lying down

Pen and brown ink, brown wash, 138 × 204 mm

Inscription: below right *Rembrandt fec.*, above left *52* (Bonnat album); verso *van rembdt na 't leven, f 10 gld.* (by Rembrandt, made from life, 10 guilders).
Paris, Musée du Louvre, Département des arts graphiques.

Provenance: H. Reveley (L. 1356), sale London, 21 April 1884, No. 157; R.P. Roupell, sale London, 12 July 1887, No. 1078; L. Bonnat (L. 1714), presented to the Louvre in 1919 (L. 1886); Inv. No. RF 4721.

Literature: Lugt 1933, No. 1119; Benesch 1954–57 and 1973, No. 1214.

Exhibitions: Paris 1988–1989, No. 43 (with other previous literature and exhibitions).

Rembrandt has depicted the distrustful looking lion exceptionally strikingly. It looks as if the drawing was quickly set down, but as usual, it was done with great care. He has, for example, left the area beneath the dark pupils white to give the animal its watchful gaze. Shadow has been indicated in the face with small strokes, whereas the mane has been made in rich contrasts of transparent wash, which gives it its rough character. Rembrandt drew the body in varying pen lines, while the supple skin was indicated with loose strokes. The forepaws have not been elaborated and the foreground is barely indicated. Finally, there are hatched lines on the left, made with a half dry pen, putting the massive head into relief.

The Berber lions which Rembrandt and his pupils drew came from North Africa and were imported by the East India Company.[1] Rembrandt's drawings of lions are not preliminary studies. He made such drawings for practice, in order to depict these animals, from memory, in biblical and other representations and as models and a source of inspiration for his pupils. Thus Rembrandt had no difficulty in depicting the lion from memory, concisely but accurately, in for example the preparatory drawing (Cat. No. 25) and the etching of *St Jerome in a Landscape* (Etchings Cat. No. 31).

The drawings of lions formed part of the art book or album, which are mentioned in Rembrandt's inventory of 1656 as *beesten nae 't leven* (animals made from life).[2] Rembrandt's lions were not only popular with his pupils but also later on. In 1729 a *Recueil de Lions* (album of lions) by Bernard Picart appeared which included 18 prints after drawings of lions (Fig. 26a).[3] Perhaps these were made after the same drawings mentioned some years before in the catalogue of the well-known art dealer Jan Pietersz. Zomer.[4] Although a fair number of drawings of lions accredited to Rembrandt appear in sale catalogues in the later eighteenth century, it is notable that only a few sheets are now considered to be by his hand.[5]

The drawing in the Louvre was made, like the others, in pen and brush towards the end of the 1640s. These studies probably predate Rembrandt's drawing of *Daniel in the Lions' Den* in Amsterdam (Fig. 26b).[6] Rembrandt's pupil, Constantijn van Renesse, similarly made a drawing of this subject which is dated 1649.[7] It is probable that Rembrandt's drawing served as a model and a source of inspiration for his pupil.

From the prices written in an old hand on the back of a number of drawings of lions, it is clear that they were already changing hands in the seventeenth or early eighteenth centuries. On the reverse of the exhibited drawing is written that it was sold for ten guilders. An inscription on the Rotterdam drawing gives the information that it costs six guilders and on one of the Amsterdam drawings is written that *5 stux leuwen* (five lions) were sold for three guilders.

P.S.

1. Schatborn 1977, p. 25.
2. *Documents* 1656/12, No. 249.
3. Schatborn 1982, p. 25–28. The Paris drawing is reproduced in the album as No. 11.
4. Schatborn 1982, pp. 21–24.
5. Two in the British Museum in London are made in black chalk; Benesch, Nos. 774 and 775. Those in Amsterdam and Rotterdam in pen and brush; Benesch Nos. 1215 and 1216; Schatborn 1985, Nos. 53 and 54; Benesch, No. 1211; Giltaij 1988, No. 23.
6. Benesch, No. 887; Schatborn 1985, No. 24.
7. Rotterdam, Museum Boymans-van Beuningen; Sumowski *Drawings*, No. 2145; Giltaij 1988, No. 130.

26a: Bernard Picart, *Recueil de Lions*, No. 11. Amsterdam, Rijksprentenkabinet.

26b: Rembrandt, *Daniel in the Lions' Den*. Amsterdam, Rijksprentenkabinet.

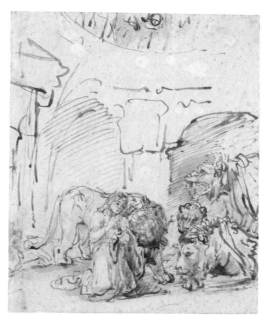

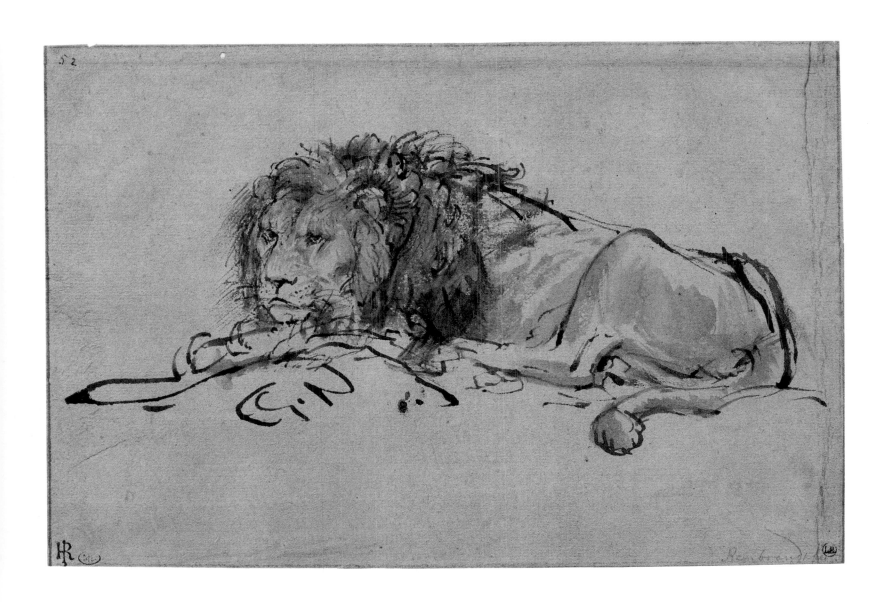

27

Farm with dovecote

Pen and brown ink, brown and white wash,
129 × 200 mm
Private collection

Provenance: Unidentified Dutch collection
(L. 2942/43); N.A. Flinck, Rotterdam (L. 959);
William Cavendish, 1st Duke of Devonshire
(1723); The Duke of Devonshire and the
Chatsworth Settlement, sale London, 6 July
1987, No. 14.

Literature: Benesch 1954–57 and 1973,
No. 1233.

Exhibitions: Amsterdam 1969, No. 87;
Washington 1990, No. 14 (with other previous
literature and exhibitions).

When Rembrandt went out to draw the
landscape, he often chose one of the many
farms in the polderland as his subject. A large,
stately farm, extended to a sort of country
house, can be seen in the exhibited drawing.
The building has two roofs and a side wing
with a large dovecote attached. A barn stands
to the right of the house and a haystack behind
the fence. Cows stand and lie in the field. The
house is divided from the road by trees which
obscure the front of the house. To the left,
grass ruffled by the wind grows on a dike
which stretches into the distance. Here, small
houses can be seen. Nearer by, a figure is
seated in the shadow of the house, leaning
against the dike, possibly a pupil drawing the
landscape further away. In the distance we see
a second small figure. Behind the houses the
sea has been indicated with a horizontal line.

Rembrandt's pen has depicted the sun-
drenched landscape in a variety of lines,
through which no linear pattern has emerged.
The areas intentionally left open represent the
sunlight in the landscape. The light brown
wash not only indicates the areas of shadow
but has also been used to depict one or two
branches which hang over the road. The
horizon of the sea has similarly been indicated
in light brown ink with the tip of the brush.
Between the trees and the horizon there was a
dot which Rembrandt covered with white.

Rembrandt probably made the drawing on
the Diemerdijk which ran eastwards along the
mouth of the IJ and the Zuiderzee.[1] It is known
that he made drawings and etchings with his
pupils there. The houses in the distance could
represent the inns situated on the bend of the
dike, where he drew the *View over the* IJ (Cat.
No. 28). We do not know of this particular
type of farm from other drawings. *The farm with
dovecote* was made in around 1650, the period in
which Rembrandt drew many landscapes.

The paper at the top of the drawing is
rounded, a form which also occurs in etchings
and paintings. At the top right we see two
marks, which were written by an unidentified
seventeenth-century Dutch collector. Similar
marks occur on drawings—particularly
landscapes—and some etchings by Rembrandt,
as well as on drawings by other artists.[2] Two
landscapes were acquired from the unidentified
collector by Nicolaes Anthonie Flinck, whose
mark is on the bottom right of the drawing.
He was the son of Rembrandt's pupil and
collaborator Govert Flinck. A large part of his
collection was acquired by the Duke of
Devonshire in 1723.[3] After having remained
together in the possession of the dukes for
centuries, a number of the drawings were
recently auctioned. Among them were twelve
landscapes by Rembrandt.[4]
P.S.

1. According to B. Bakker the farm is characteristic of
the Amstelland; Washington 1990, No. 14, p. 102.
2. Schatborn 1981–I, p. 17.
3. See also Schatborn 1982, pp. 16–21.
4. Sale London, 3 July 1984 and 6 July 1987.

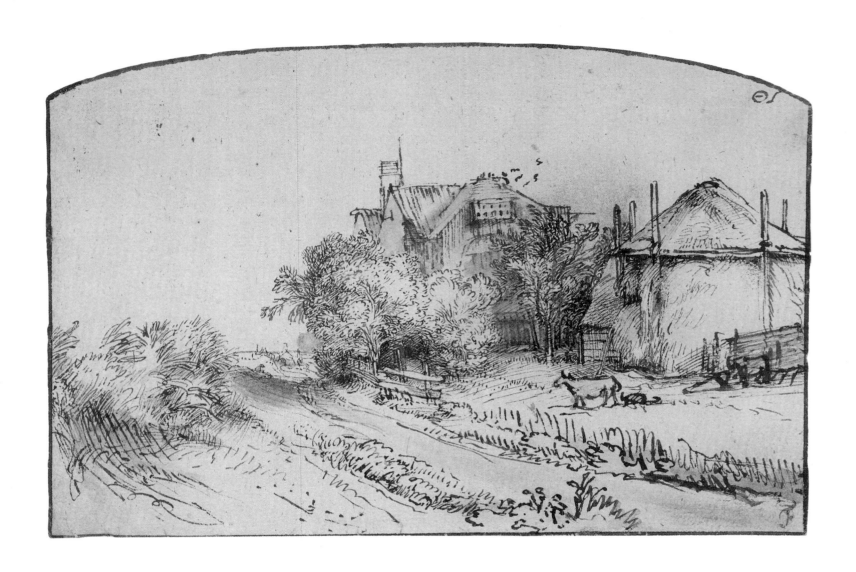

View over the IJ *near Amsterdam*

Pen and brown ink, some body colour,
cartridge paper, 76 × 244 mm
Chatsworth, The Duke of Devonshire and the
Trustees of the Chatsworth Settlement

Provenance: N.A. Flinck, Rotterdam (L. 959);
William Cavendish, 1st Duke of Devonshire
(1723); Inv. 1030

Literature: Lugt 1920, p. 143; Benesch 1954–57
and 1973, No. 1239.

Exhibitions: Amsterdam 1969, No. 84; London
1969, No. 91.

This long view over the IJ was drawn from the
Anthonisdijk or Diemerdijk, which stretched
from Amsterdam eastwards along the mouth of
the IJ and the Zuiderzee. On the other side of
the water, in the centre, lies the village of
Schellingwou, to the left in the distance is the
tower of Nieuwendam and to the right, further
inland, the tower of Ransdorp.[1]

When Rembrandt made the drawing, he was
sitting at a bend of the Diemerdijk, where a
few inns were situated. To the left he saw the
piece of land which jutted out into the IJ from
outside the dike. In the right foreground is the
oak facing which starts from here and runs
along the dike.[2] Rembrandt was therefore
drawing from where the facing began, with a
view over the land lying outside the dike.

The dike with paling facing also appears in
the foreground of a drawing in Rotterdam,
(Fig. 28a),[3] also a view of Schellingwou.[4] In
addition it shows part of a dike with two tall
beacons in the IJ. This is probably the *nieuw
ghemaakte dyck* (newly made dike), which also
appears on a print by Roelant Roghman and

where the holes can be seen which were
breached in the Diemerdijk on 5 March 1651
(Fig. 28b, detail).[5] In the centre, behind the
hole in the dike, are inns; this is the spot
where Rembrandt sat to make the drawing.
In Roghman's print we clearly see the dike
with wooden facing to the right of the inns; to
the left of the inns is the *nieuw ghemaakte dyck*,
marked with *C*.

In a drawing of an *Interior with a man drawing*
in Paris (Fig. 28c)[6] we see through the window
the same view of Schellingwou as that in the
Rotterdam drawing. Rembrandt possibly made
this together with the pupil depicted in the
Paris drawing, while they were sitting in one of
the inns with a view over the new dike to
Schellingwou. Therefore, the drawings in Paris
and Rotterdam were made shortly after the
breach of the dike in 1651. The exhibited
landscape must have been made before this.
The date of these drawings can be established
and precisely specified by means of the
topographical details.[7]

Broad compositions with a town or village

28a: Rembrandt, *View over the* IJ. Rotterdam,
Museum Boymans-van Beuningen.

28b: Roelant Roghman, *The Bursting of the Dam at
Diemen* (detail). Amsterdam, Rijksprentenkabinet.

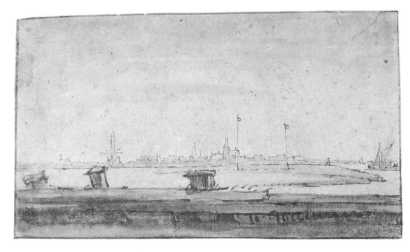

28c: Rembrandt, *Interior with a Man drawing and a
View over the* IJ. Paris, Musée du Louvre,
Département des arts graphiques.

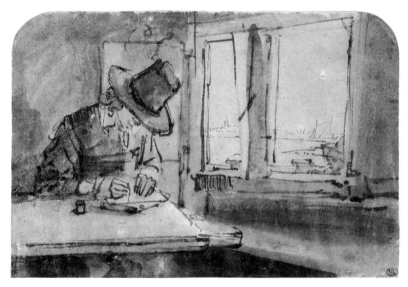

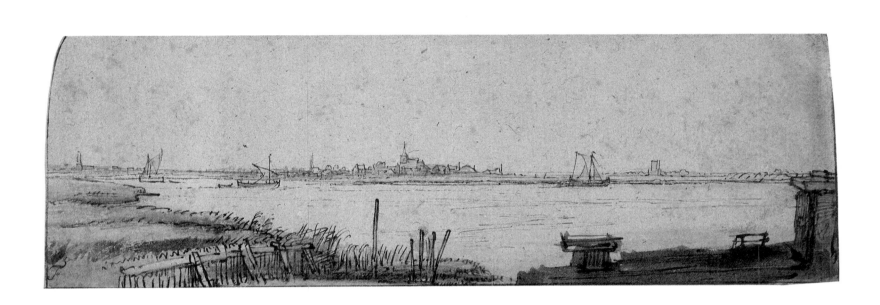

on the horizon originally appeared in atlasses and as marginal decoration on maps and plans of towns. In the seventeenth century these town profiles were also drawn as independent works, made into prints and, especially towards the end of the century, also painted. Rembrandt made an etching of the *View of Amsterdam* from a point at the start of the Diemerdijk (Fig. 28d).[8]

Rembrandt used greyish cartridge paper for the drawing. As a result the landscape has acquired a quiet atmosphere. The drawing was originally rounded at the top, but a piece has been cut off there at a later date.

P.S.

1. Identified by F. Lugt 1920, p. 143.
2. To the east behind the dike is a small lake, the Nieuwe Diep, which was created as a result of a breach in the dike in 1420.
3. Rotterdam, Museum Boymans-van Beuningen; Benesch, No. 1358 (c. 1655–1656); Giltaij 1988, No. 26 (1650–1653).
4. There is a tall roof to the left of the church tower in this drawing which is not in the Chatsworth drawing.
5. Amsterdam, Rijksprentenkabinet; FM 2017, Holl. 39. The print is made up of various representations and also shows a second breach in the Diemerdijk near Houtewael, which is nearer to the town.
6. Paris, Louvre, Département des arts graphiques; Benesch, No. 1172 (c. 1655); Lugt 1933, No. 1152 (1650–1653); Paris 1988–1989, No. 65 (1653–1656). Lugt 1933, No. 1152 (1650–1653); Paris 1988–1989, No. 65 (1653–1656). Lugt believed that Jan Six was depicted here, writing in his country house IJmond, which was situated near 'Jaaphannes', further along the wooden faced dike; Lugt 1920, p. 144. Looking in the direction of Schellingwou from this point, the new dike is not visible.
7. Benesch dates the Chatsworth drawing to 1650–1651; the catalogue of the exhibition in 1969 in Amsterdam to 1649–1650.
8. B. 210, usually dated to the beginning of the 1640s.

28d: Rembrandt, *View of Amsterdam*. Amsterdam, Rijksprentenkabinet.

29

The Rhine-gate at Rhenen

Brown ink, pen and brush, 149 × 175 mm
Chatsworth, The Duke of Devonshire and the
Trustees of the Chatsworth Settlement

Provenance: N.A. Flinck, Rotterdam (L. 959);
William Cavendish, 1st Duke of Devonshire
(1723); Inv. 1043.

Literature: Lugt 1920, p. 161–162; Benesch
1954–57 and 1973, No. 1301; Schatborn 1990,
p. 33.

Exhibitions: Chicago 1969, No. 126; London
1969, No. 95; Washington 1990, No. 52 (with
other previous literature and exhibitions).

Rembrandt and Hendrickje Stoffels probably made a trip to the east of the country in 1649. She was born in Bredevoort, not far from the German border, in 1626. From a recently discovered document it has become known that she attended a baptism there in 1649 (see Cat. No. 35).[1]

On their journey Rembrandt drew the medieval city gates of Rhenen, a town on the Rhine.[2] Like many other artists, Rembrandt had a preference for old buildings. The medieval city gates of Rhenen were probably considered to be radically different from the then 'modern' buildings of the Renaissance and Baroque. The old buildings not only symbolised transience, but were possibly also seen as relics of an indefinable past where the stories from the Bible and antiquity took place. Rembrandt's drawings of old gateways, fortifications and towers can be considered to be preparatory studies for the buildings which he depicted in the background of historical representations. These buildings, drawn from memory, are directly comparable to the old buildings drawn after life.

Rhenen was greatly loved by artists; the town appears in many drawings, etchings and paintings by various seventeenth-century artists. The drawing of the city side of the Rhine-gate focuses on the gate-house, which Rembrandt made the most highly finished part of the drawing. We see the opening in the inner gate, the massive square tower and, to the right, the two towers of the outer gate. From this, a bend in the road led to the exit from the town on the Rhine.

The medieval building has a weathered character which has been depicted with fine, lively lines. Rembrandt has indicated the darkness beneath the vault in the entrance of the gate with strong lines, while light shines in the area behind it between the inner and the outer gate. We also see one or two figures on the road here. The wall of the house to the right of the gate has been left blank to indicate the fall of light, by which Rembrandt has created a strong contrast with the dark entrance.

The style in which the buildings to the left of the gate have been depicted in turn contrasts with the detailed drawing style of the gate-house. Here, the houses are drawn sketchily in a free rhythm of loose lines with here and there hatchings and areas of shadow. Two children are sitting playing in the street in front of the houses. Rembrandt's personal style manifests itself particularly well in the alternation of precision and sketchiness, combined with the varied contrasts of light and shade.

A second view of the Rhine-gate at Rhenen,

from a slightly different viewpoint (Fig. 29a),[3] is more uniformly drawn and with less variety. The buildings to the left of the entrance to the gate are also dissimilar, but the underpass is especially different; instead of the play between light and dark in the gateway of the exhibited drawing, there is a fairly black hole in the Paris drawing, as if the entrance is closed. The light falls from different angles in the drawings; Lugt therefore noted that one drawing was made in the morning and the other in the afternoon.[4]

How to explain the differences between the two drawings? Was the Paris drawing made at another, for example later, time or was it made in the studio after the example of the exhibited drawing? Did Rembrandt work in different styles within the same period, with the Paris drawing being particularly influenced by Venetian drawings?[5] As Rembrandt often went out drawing with his pupils it is possible the work is by two hands. No doubt has ever been cast on the authorship of the Paris drawing; however, it remains to be seen whether there really is no cause for this. In the assessment it should be remembered that the grey wash was added later.

In the literature it has in the past been suggested that Rembrandt visited Rhenen twice and drew the city gate on both occasions. That could be an explanation for the differences between the drawings.[6] The drawing at Chatsworth would then have been made in 1649 and the Paris one at the beginning of the 1650s. It remains curious, though, that the buildings to the left of the gate are different in both drawings.

Related to the drawings of Rhenen are the views of *The Montelbaen Tower* and the *Tower of Swijgh Utrecht*, both are sections of the medieval walls of Amsterdam, the first from 1645–1646 (see Cat. No. 21) and the second from the beginning of the 1650s.[7]

P.S.

1. Henk Ruessink, 'Hendrikje Stoffels, jonge dochter van Bredevoort', *De Kroniek van het Rembrandthuis* 1 (1989), pp. 19–24. J.R. Voûte, 'Rembrandt's reis naar Bredevoort', *De Kroniek van het Rembrandthuis* (1990) 1–2, p. 40.
2. *The West Gate:* Haarlem, Teylers Museum, Benesch, No. 826; London, British Museum, Benesch, No. 1304; *The East Gate:* Bayonne, Musée Bonnat Benesch, No. 825; The drawing in Amsterdam, Rijksprentenkabinet, Benesch, No. 828 (Schatborn 1985, No. 111) is probably a copy and the representation is possibly a gate in Amersfoort (Fléhite [1982] 1, p. 6), where Rembrandt also made a drawing of the Singel, Paris, Louvre, Benesch, No. 824.
3. Paris, Louvre, Département des arts graphiques; Benesch, No. 1300.
4. Lugt 1920, p. 161.
5. This influence has been noticed in his work since 1650. The various possibilities are discussed by Schneider in Exh. Cat. Washington 1990, No. 52.
6. Lugt mentioned one journey which he dates to between 1650 and 1660; Lugt 1920, p. 156. Benesch believed that Rembrandt made two journeys, in c. 1648 and in 1652–53.
7. Amsterdam, Rijksprentenkabinet, Benesch, No. 1334; Schatborn 1985, No. 34.

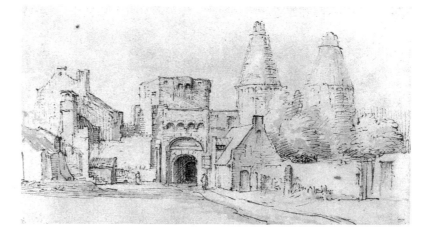

29a: Rembrandt, *The Rhine-gate at Rhenen*. Paris, Musée du Louvre, Département des arts graphiques.

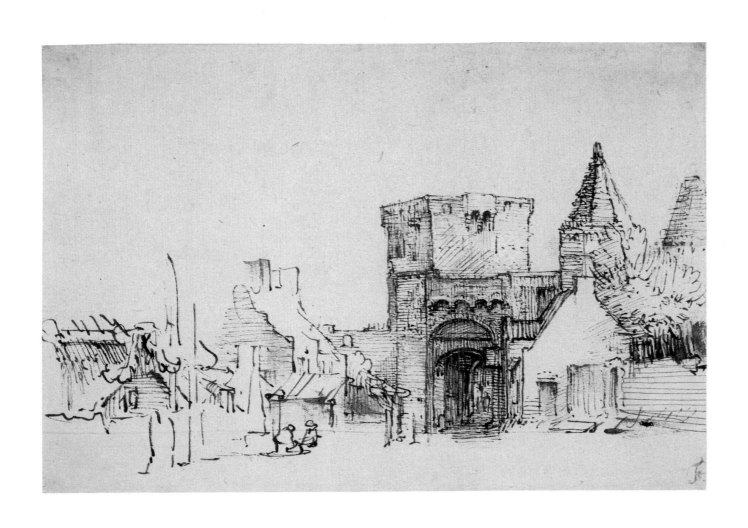

The bend in the river Amstel at Kostverloren

Pen and brown ink, brown and white wash, on cartridge paper, 136 × 247 mm, a piece of paper added to the right.
Chatsworth, The Duke of Devonshire and the Trustees of the Chatsworth Settlement

Provenance: N.A. Flinck, Rotterdam (L. 959); William Cavendish, 1st Duke of Devonshire (1723); inv. 1021.

Literature: Lugt 1920, p. 112; Benesch 1954–57 and 1973, No. 1265; I.H. van Eeghen, 'Rembrandt aan de Amstel', *Genootschap Amstelodamum*, Amsterdam 1969, Fig. IV; S. Slive, 'The manor Kostverloren: vicissitudes of a seventeenth-century Dutch Landscape Motif', *The Age of Rembrandt: Studies in Seventeenth Century Dutch Painting, Papers in Art History from the Pennsylvania State University.* Vol. III, 1988, pp. 132–68.

Exhibitions: Rotterdam/Amsterdam 1956, No. 150; Washington 1990, No. 67 (with other previous literature and exhibitions).

Rembrandt's landscapes followed in the footsteps of those artists who, at the beginning of the seventeenth century, first chose to depict the Dutch landscape.[1] Thus there are numerous similarities between Rembrandt's compsotions and those of Esaias and Jan van de Velde and Willem Buytewech.

Accurate observation of reality forms the basis of Rembrandt's depiction of landscape, although it has been suggested, probably wrongly, that he made a drawing such as this one in the studio.[2] On the left, the horizon has been depicted with one or two small dots and lines in order to indicate the distance; the trees in the right foreground have been depicted more boldly, thus creating depth in the composition.

Rembrandt created shadow with the brush: in and under the trees, in the reflection on the water, in the dark tree to the right and its shadow on the bank of the dike. In contrast the farm, the road and the path by the water along which two riders are making their way, have been placed in the light. By leaving the left foreground open—where the river bank ends, indicated by two lines—the perspective along the river from right to left has been strengthened. Rembrandt covered these lines over with white. The representation is a lyrical evocation of the Dutch landscape, in which the light and the atmosphere, also helped by the tinted paper, have been arrestingly captured.

The tower of the castle Kostverloren emerges above the trees in the centre of the landscape. This makes the location recognisable as the place by the Amstel where the café Het Kalfje is still to be found. The house has a long history and was depicted by a number of artists, including Jacob van Ruisdael and one of the Beerstratens (Fig. 30a).[3] This drawing

30a: Anthonie Beerstraten, *View of the Manor House Kostverloren and the Amstel.* Amsterdam, Rijksprentenkabinet.

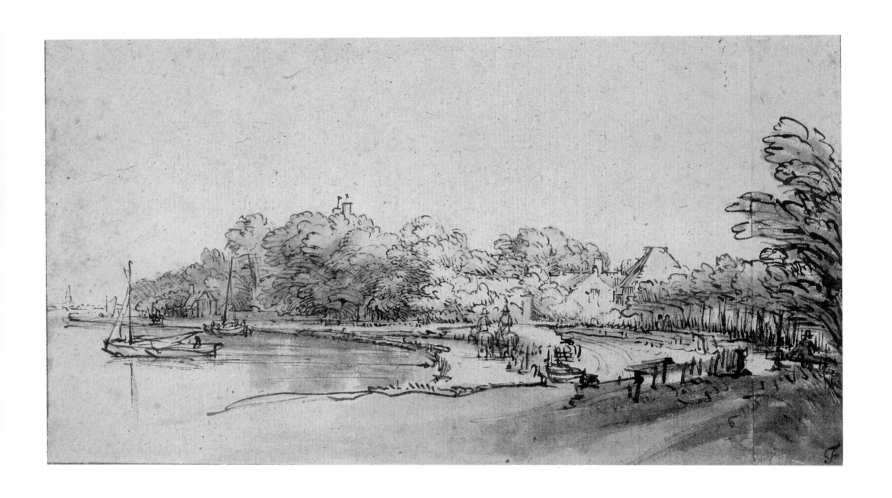

shows the house in its surroundings. To the right stands a small house which appears behind the boats in the shadow of the trees in Rembrandt's drawing.

The house appears in the background of Rembrandt's etching of 1641, *Farm with haystack*,[4] but his drawings are later.[5] The most comparable drawing is now in the British Museum (Fig. 30b).[6] It was made from a position further along the bend of the river. In the foreground here we see a large hole with fencing around it. In the distance we see the other side of the river and a house.

Tradition has it that the house burnt down in 1650 and Rembrandt drew it in this ruined condition from the south west (Fig. 30c). The drawing must date from before 1658, the year in which the house was demolished and rebuilt.[7] The other drawings probably all date from before the fire, at the end of the 1640s.
P.S.

1. See for example the catalogue of the exhibition *Landschappen van Rembrandt en zijn voorlopers* (Landscapes by Rembrandt and his predecessors), Amsterdam (Museum het Rembrandthuis) 1983.
2. Schneider (in Exh. Cat. Washington 1990, No. 67) suggests that the drawing in Chatsworth was made in the studio with a drawing in the British Museum, Benesch, No. 1269, as model, which however is probably not by Rembrandt, but perhaps by his pupil Willem Drost; see Schatborn 1990.
3. Amsterdam, Rijksprentenkabinet, Inv. No. RP-T–1988 A1558.
4. B. 225.
5. Benesch, Nos. 1266 (c. 1651–52), 1268 (c. 1651–52), 1270 (c. 1652) and a drawing in Dresden, Kupferstich-Kabinett, which has not been included by Benesch. Schneider (Washington 1990, No. 67) rightly dates the drawing to 1649–1650.
6. London, British Museum; Benesch. No. 1269.
7. Chicago, The Art Instutute; Benesch, No. 1270 (c. 1652).

30b: Rembrandt, *The Bend of the Amstel near Kostverloren*. London, British Museum.

30c: Rembrandt, *The Manor House Kostverloren*. Chicago, The Art Institute.

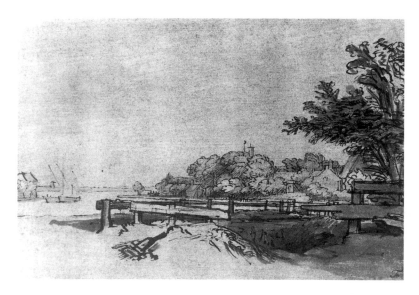

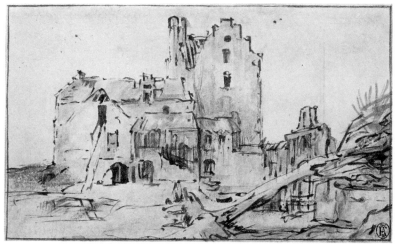

31

(A) *Homer reciting verses*

Pen and brown ink, 265 × 190 mm

Inscription: centre below *Rembrandt aen Joanus Six. 1652.*
Amsterdam, Six Collection.

(B) *Minerva in her study*

Pen and brown ink, brown and white wash, 190 × 140 mm

Inscription: centre below *Rembrandt f 1652*

Provenance: Jan Six, Amsterdam.

Literature: Benesch 1953–57 and 1973, No. 913 and 914 (with other previous literature); Dora and Erwin Panofsky, *Pandora's Box*, Bollingen series LII, New York 1956, p. 68 and 77; E. Haverkamp-Begemann, 'Rembrandt's so-called portrait of Anna Wijmer as Minerva', *Studies in Western Art, Acts of the twentieth International Congress of the History of Art*, Princeton 1963, pp. 59–65; Clark 1966, p. 166 and 184; Clara Bille, 'Rembrandt and burgomaster Jan Six', *Apollo* (1967), pp. 260–65; George Möller, *Het album Pandora van Jan Six* (1618–1700) 1983 (doctoral thesis).

Exhibitions: Rotterdam/Amsterdam 1956, No. 185a; Amsterdam 1969, No. 109, both times *Homer reciting verses.*

Among the best documented drawings, more-over in optimum condition, are two which form part of an album which has been in the possession of the descendants of Jan Six since it was made. It has a small folio format, is bound in a parchment cover and consists of 170 leaves, of which a fair number have been left blank. Jan Six must have made use of the album between 1647 and 1686. *Pandora 1651*[1] is written in black ink in decorative letters on the cover.

Pandora was created by Hephaistos and was given life by Pallas Athene (or Prometheus) and all the gods had given her gifts of distinguishing characteristics, and other presents.[2] In Six's album there are written and drawn 'gifts' to him from friends and well-known figures.

The friendship-album, *album amicorum*, was developed in the second half of the sixteenth century in the circles of usually well-to-do students who collected memories of famous

contemporaries and friends in their albums on their journeys visiting the universities of Europe. These were a sign of erudition and status, and a memory of friendship.[3]

Rembrandt contributed three times to an *album amicorum*. Apart from that for Jan Six, he drew an *Old man with clasped hands*[4] in 1634 for Burchard Grossman and in 1661 he drew a *Simon in the Temple*[5] for Jacobus Heyblocq. The drawings in the Pandora album are of classical subjects. The representation of *Homer reciting verses* is on fol. 40 and *Minerva in her study* appears two pages later. The choice of these subjects was of course determined by Six's interest in antiquity; they may even have been suggested by him. But we also find classical subjects in Rembrandt's œuvre and Rembrandt, like Six, possessed antique statues or casts made after them among them a head of Homer.[6] The drawing of Homer reciting verses bears the inscription *Rembrandt aen Joanus Six. 1652*.

The representation of Homer is inspired by Raphael's famous fresco *Parnassus* in the Vatican in Rome. Six had first-hand knowledge of it and both Rembrandt and Six probably owned Marcantonio Raimondi's print after it (Fig. 31a).[7] Rembrandt's substitution of a dignified upright pose for Raphael's elegantly posed Homer is characteristic. Various other motifs have been borrowed from Raphael's Parnassus:

the groundplan with figures placed on a lower plane in the right foreground and the men seated to the left and right of Homer, one of whom is writing down the words of the poet. The facial expressions in Rembrandt's drawing display in particular his capacity for simplifed characterisation.

The second drawing in the album, *Minerva in her study*, which has never been exhibited, is of a very different nature. The goddess is seated with her back to the window writing in a room draped with curtains. Her pen is just visible above the book lying on a book-rest. A cloth has been spread over the work table which is on a raised level. Minerva's shield with the Medusa head hangs on the wall to the right, above it her helmet and next to it a lance. In the foreground is a cast-iron stove with a bust and the end of the curtain has been draped over this.[8] We also come across a stove and bust draped with a cloth in Rembrandt's etching *An artist drawing from a model* (Fig. 31b, detail).[9]

In contrast to *Homer reciting verses* the character of this drawing is above all determined by the wash applied with the brush. Rembrandt made the white paper, as seen in the window, the strongest light-source. White paint has been used in various places, in order to lighten areas such as to the left behind the pedestal and to cover dark ink in other

areas; the wash is continually varied and transparent.

In this respect the drawing of *Rembrandt's studio with a model* of 1652 (Cat. No. 33) is most closely related. Here the window is also the source of light, which Rembrandt used to depict an equally atmospheric interior. Whereas this drawing was made after life, the *Minerva in her study* was made from imagination,[10] although some of the motifs were determined by the reality of Rembrandt's time; the table with the cloth and book-rest, the leaded window and the stove with the bust are all contemporary motifs. The shield and the lance, Minerva's attributes, come from representational tradition, while the raised curtain is a theatrical motif especially popular in portraiture and which gave the scene or the sitter a certain allure. Such a curtain was also included in the second preparatory drawing for the portrait of Jan Six. The Leiden artist Pieter Couwenhorn drew a similarly draped interior with Minerva in the *album amicorum* of Petrus Scriverius (Fig. 31c).[11]

The Roman Minerva was goddess of wisdom, science and the arts. The Medusa head, the head with the snakes, cut off by Perseus, and which turned all who regarded it to stone, adorned her shield. Rembrandt painted Minerva twice in the 1630s, once in an interior and another time depicting her larger

31a: Marcantonio Raimondi after Raphael, *The Assembly of the Gods on Mount Parnassus*. Amsterdam, Rijksprentenkabinet.

31d: Barent Fabritius, *The Sacrifice of Iphigenia*. Besançon, Musée des Beaux-Arts et d'Archéologie.

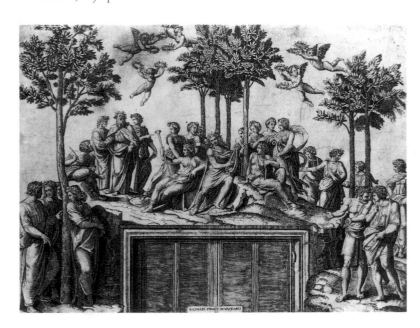

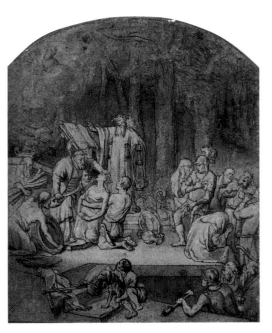

in the picture area.[12] In both paintings she is seated at a table with books, with the shield with the Medusa head hanging on the wall.

The drawings must also have been admired by Rembrandt's pupils. There is, for example, a depiction of *The Sacrifice of Iphigeneia* by Barent Fabritius, inspired by Rembrandt's *Homer* (Fig. 31d).[13]

Rembrandt's drawings in the album are the point of departure for the dating of other, undated sheets. Moreover, they enable us to see important aspects of Rembrandt's draughtsmanship at its best: his treatment of classical subjects, his concise method of characterisation with the pen and his atmospheric handling of light and dark with the brush.

P.S.

1. For earlier uses of Pandora as a title, see: Panofsky 1956, pp. 68–69.
2. She is particularly known for opening a box, from which all manner of evil was spread throughout the world.
3. K. Thomassen et al., *Alba Amicorum*, Maarssen/The Hague 1990.
4. The Hague, Royal Library; Benesch, No. 257.
5. The Hague, Royal Library; Benesch, No. 1057.
6. *Documents* 1656/12, No. 163; in addition Rembrandt possessed a bust of Aristotle and one of Socrates, together with heads of Roman emperors. He depicted the head of Homer in 1653 in his painting *Aristotle with the bust of Homer*, New York, Metropolitan Museum of Art; Bredius/Gerson 1935/1969, No. 478. Rembrandt depicted Homer as poet in a painting in The Hague, Mauritshuis; Bredius/Gerson 1935/1969, No. 483; De Vries 1978, No. XII.
7. B. 247. This probably belonged to one of the albums with prints after Raphael; *Documents* 1656/12, No. 196, 205, 206, 214.
8. The stove was identified by drs. R.J. Baarsen.
9. B. 192 (Etchings Cat. No. 15).
10. It has been incorrectly suggested that Anna Wijmer, the mother of Six, is depicted here in the guise of the goddess; see: Haverkamp-Begemann 1963.
11. The drawing is dated 1635. Thomassen 1990, No. 36 (n. 3). Victor Freijser et al., *Leven en Leren op Hofwijck*, Delft 1988, p. 49.
12. Berlin, Gemäldegalerie SMPK, *Corpus* I A38, which is dated to 1631 and Tokyo, private collection, *Corpus* III A114, dated 1635. Rembrandt painted a number of scenes with classical female figures in the beginning of the Amsterdam period: in 1633 a painting which is usually called *Bellona*, but could more appropriately be called Pallas Athene or Minerva on basis of the shield with the Medusa head (*Corpus*, II A70), in 1634 *Flora* (*Corpus*, II A93) and *Sophonisba* (*Corpus*, II A94), in 1635 another *Flora* (*Corpus*, III A112).
13. Besançon, Musée des Beaux-Arts; Sumowski *Drawings*. No. 834-x (1650–1655). Fabritius's drawing was therefore made in or after 1652.

31b: Rembrandt, *The Artist drawing a nude Model* (detail). Amsterdam, Rijksprentenkabinet.

31c: Pieter Couwenhorn, *Minerva in her Study*, *Album amicorum van Petrus Scriverius*. The Hague, Koninklijke Bibliotheek.

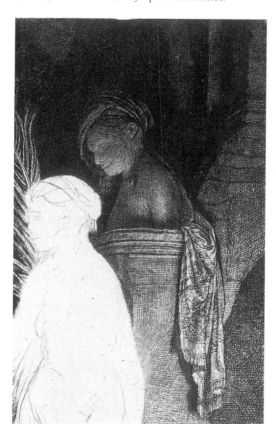

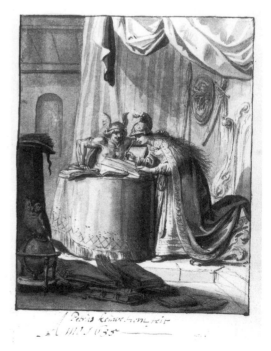

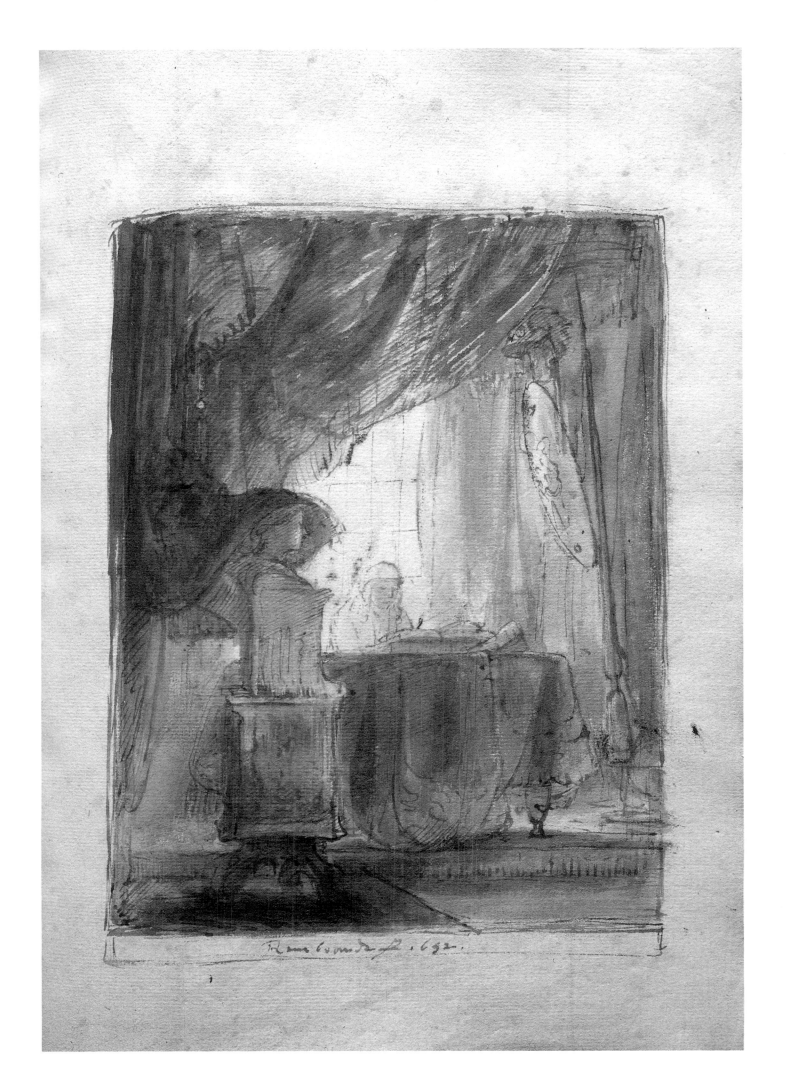

The Angel appearing to Hagar and Ishmael in the wilderness

Pen and brown ink, white wash, 182 × 252 mm

Inscription: above left *Gen:21.4.17.*
Hamburg, Kunsthalle, Kupferstichkabinett

Provenance: E.G. Harzen, Hamburg (1863);
Inv. No. 22411.

Literature: Benesch 1953–57 and 1973, No. 904;
H.v.d. Waal, Hagar in de woestijn door
Rembrandt en zijn school, *Nederlands Kunst-
historisch Jaarboek* I (1947), pp. 144–59;
Hoekstra 1983, p. 27.

When Sara, at an advanced age, gave birth to a son, Isaac, she forced Abraham to send away his second wife Hagar and her son Ishmael (Genesis 21: 9–21). Hagar and Ishmael, with bread and a water bottle, roamed the wilderness of Beersheba. When the water was finished, she laid the child under a bush and sat at some distance from him in order to spare herself the sight of his death, and cried. But an angel came, showed her a well and told her that she need not be afraid. God would make a great nation of Ishmael as well as Isaac.

In Rembrandt's drawing the angel has descended and with his right hand touches Hagar, who is sitting wringing her hands. He points with his other hand in the direction of a well.[1] Ishmael is lying sleeping peacefully in the left background. In the foreground the empty water bottle has toppled over.

The drawing has a simple and direct eloquence. The sheet is for the greater part left blank and the forms of the figures and motifs are loosely indicated with pen-lines in varying degrees. By emphasising the important elements of the representation and limiting the elaboration of the drawing, the story emerges in concentrated form.

That Ishmael is sleeping is suggested by his closed eyes and particularly by the heaviness of his head which has fallen sideways. The contact between the angel and Hagar is shown by the angel's precisely depicted index finger, which is touching her. The pointing finger of the other hand, of which the other fingers are in a relaxed position, is strongly accentuated. The angel's determination is as clearly drawn in a few lines as the despair on Hagar's face. Her rescue is indicated by the protective gesture of the angel's outstretched arms, precisely in the centre of which Hagar's head is drawn.

Rembrandt had originally given the angel a larger wing which he painted over with white, but the lines have become visible again as a result of the oxidisation of the lead white. Lines depicting Ishmael have also been painted over with white.

The story of Hagar was especially popular with Rembrandt and his pupils (see Cat. No. 41), and a number of drawings and an etching take the Old Testament story as their subject, and in particular Abraham's dismissal of Hagar and Ishmael.[2] *Hagar and Ishmael in the wilderness* was depicted by Rembrandt's teacher Pieter Lastman in a drawing from 1600[3] and in 1621 in a painting.[4] Here, Hagar is shown less despairing and the angel is higher in the air and further away from her; the angel's outstretched arms have much less expressive power in this version of the subject.

Rembrandt made the drawing at the begin-ning of the 1650s. It belongs to a group of drawings which all depict moments from the Bible in a concise and evocative manner. None of these drawings are preliminary studies or designs.
P.S.

1. It is possible that Rembrandt has drawn the well to the right of Hagar.
2. Hamann 1936. The etching B. 30 is dated 1637.
3. New Haven, Yale University Art Gallery, Inv. 1961.64.6; Sacramento 1974, No. 6.
4. Kurt Bauch, 'Entwurf und Komposition bei Pieter Lastman', *Münchner Jahrbuch der bildenden Kunst*, N.F. 6 (1955), p. 216, Fig. 5.

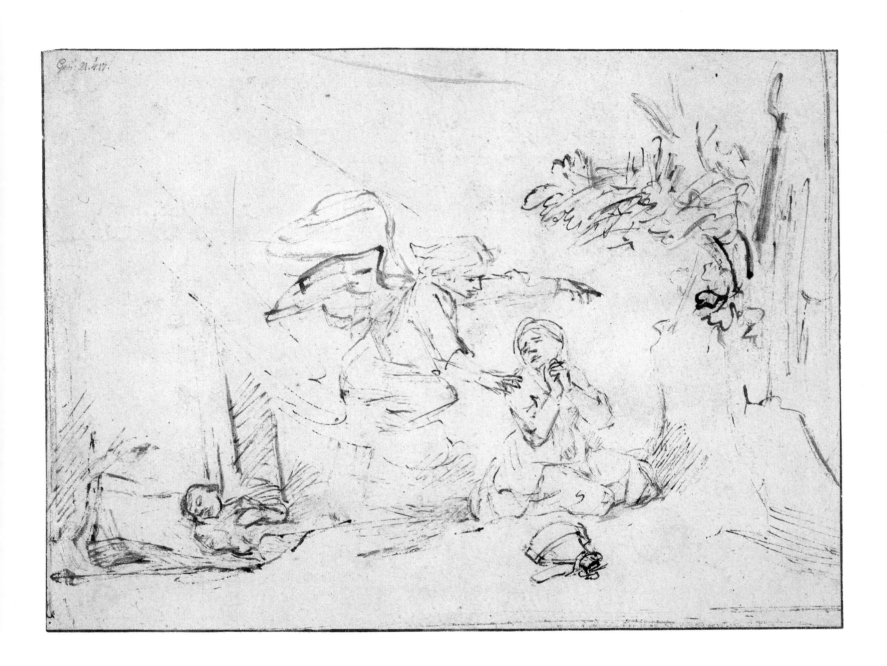

33

Rembrandt's studio with a model

Pen and brown ink, brown and white wash,
205 × 190 mm
Oxford, The Ashmolean Museum

Provenance: London, E.V. Utterson (L. 909);
London, Chambers Hall (L. 551).

Literature: K.T. Parker, *Catalogue of the collection of drawings in the Ashmolean Museum,* I, Oxford 1938, No. 192; Benesch 1954–57 and 1973, No. 1161 (with other previous literature and exhibitions); Schatborn 1981, No. 83.

Exhibitions: Amsterdam 1969, No. 119; Amsterdam 1987, No. 25.

The studio, in which a half-dressed model is seated, is lit from an upper window. The shutters of the lower windows are closed and the cloth above the window, with which the light can be tempered, has been raised. To the left we see Rembrandt's easel with a painting on it and on the stool in front of it lies what could be his painting smock. Beneath the window is a table upon which a book-rest can be seen, on which the etching plate was laid or which was used for drawing. Next to it is a cradle with a hood and a coverlet. Behind the cradle lie a few more things, a shelf is fastened to the wall and another to the wall next to it. A sculpted head is beneath the tall mantelpiece, and there is another stool under the table.

Only the window and the lit areas of the model are not in shadow, while in the rest of the scene Rembrandt has depicted the divisions of light and dark in all possible gradations of tone with the brush. In this way he created space and atmosphere. Some areas have been rubbed with the finger or a dry brush and in some places white paint has been added.

The woman in the studio had perhaps been breastfeeding her child when Rembrandt drew the interior. She is wearing a small cap and is clasping the seat of the chair with her left hand. There is a second drawing of this model, which shows her in the same pose, but seen more from the side (Fig. 33a). It could have been made by a pupil, perhaps Abraham van Dyck, who would then have been drawing to the left of Rembrandt.[1]

It is not improbable that the figure depicted is Rembrandt's wife, Hendrickje Stoffels, feeding her daughter Cornelia, who was Rembrandt's third child to be named after his mother. Cornelia was baptised in the Oude Kerk on 30 October 1654.[2] If this supposition is correct, the drawing was made in that year or slightly later, in the house which is now known as the Rembrandthuis. Hendrickje was already living there in 1649.[3] When she became pregnant out of wedlock in 1654, she was summoned by the church council no less than three times. She eventually appeared on 23 July and was 'ernstelijck bestraft, tot boetvaardicheijt vermaent en van de taffel des Heeren afgehouden' (severely reprimanded, admonished to be repentant and barred from communion).[4]

Hendrickje named Titus as her heir in the event that Cornelia should die before him.[5] Hendrickje and Saskia's son helped Rembrandt in various ways in the later years of his life. They must have had a good relationship as they set up together as art-dealers on his behalf from 1658 onwards.[6] However, Hendrickje and Titus both died before Rembrandt: she was buried in the Westerkerk on 24 July 1663[7] and Titus on 7 September 1668.[8]

Both the suggested identification and the drawing style with its fine pen-lines and graded wash indicate a date after the 1640s. The most comparable drawing is that of Minerva in the Pandora album of 1652 in the Six Collection (Cat. No. 31).
P.S.

1. London, Speelman Collection (1973); Benesch, No. 1161a. Benesch believes that the drawing has been heavily reworked but that the substance is by Rembrandt. Sumowski (1961, p. 21) does not. The attribution to Van Dyck is based especially on a comparison with a monogrammed drawing in Bremen; Sumowski *Drawings,* No. 572. If the attribution and the dating of the exhibited drawing are correct, it means that Van Dyck was still with Rembrandt in 1654. His earliest known paintings are from 1655; Sumowski 1983, Nos. 357 and 388.
2. *Documents* 1654/18.
3. *Documents* 1654/4.
4. *Documents* 1654/11, 12, 14, 15.
5. *Documents* 1661/6.
6. *Documents* 1660/20.
7. *Documents* 1663/4.
8. *Documents* 1668/8.

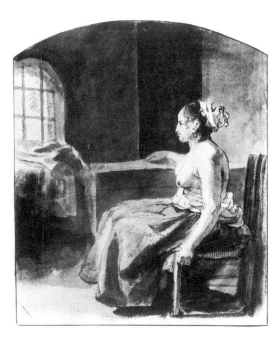

33a: Rembrandt, *A seated Woman.* London,
E. Speelman Collection (1973).

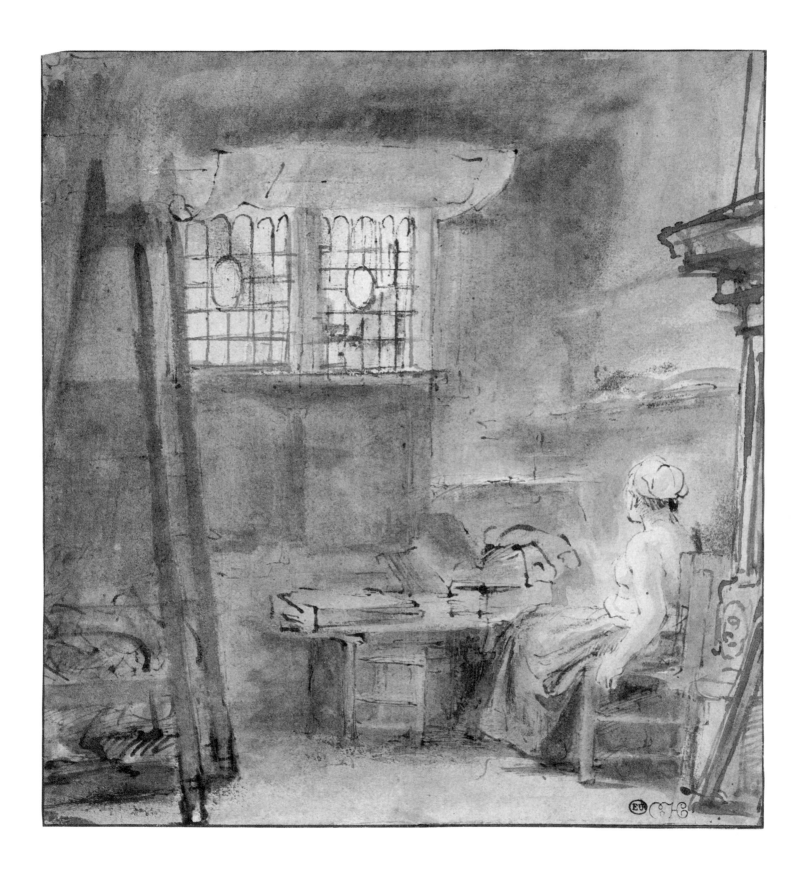

34
The Washing of the feet

Pen and brown ink, 157 × 221 mm
Amsterdam, Rijksmuseum,
Rijksprentenkabinet

Provenance: Jacob de Vos Jbzn., sale Amsterdam,
22–24 May 1883, in lot No. 424 with 14
drawings; in 1889 acquired by the Vereniging
Rembrandt (L. 2135); Inv. No. RP-T-1889
A2049.

Literature: Benesch 1954–57 and 1973, No. 931;
Schatborn 1985, No. 25 (with other previous
literature and exhibitions); Robinson 1988,
pp. 584–85.

Exhibitions: Rotterdam/Amsterdam 1956,
No. 214; Amsterdam 1964–65, No. 107;
Amsterdam 1969, No. 113; Amsterdam 1983,
No. 78.

34a: Rembrandt, *The Washing of the Feet.*
London, British Museum.

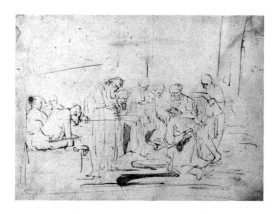

Christ crouches amid the apostles and is
washing the feet of Peter over a round bowl.
Peter initially protested against Jesus washing
his feet, but when he understood that he would
otherwise not become his associate, his feet too
were cleaned. Peter sits on the edge of his
chair, his hands supported by the ends of the
arm-rests and, with head outstretched, he looks
on attentively. His bearing reveals something
of the initial disbelief and the wonderment
with which he undergoes the washing. The
other apostles, of whom only three are
depicted, look on. Jesus does not kneel, as is
usual in this representation, but crouches: a
more natural than respectable pose. Rembrandt
has restricted himself to the depiction of the
figures, and space is only indicated by a curtain
drawn with one line.

The drawing shows the extent to which
Rembrandt employed abstraction and
idiosyncracy to express human emotions.
The drawing style is particularly evocative
and details are barely given. There are strong
contrasts between the extremely thinly drawn
lines, almost without ink, and those made with
a full pen. The lines which depict the curtain
and the legs of the figure beneath it show the
edges of the half-empty reed pen. In other
places the full pen has drawn broader lines,
by which the figure beneath the curtain in
particular has acquired a strong presence.
The faces have been reduced to their
elementary forms, but they clearly display the
attention with which the apostles witness the
event. The dark lines of the leg and the back of
Jesus were superimposed upon the initially
fainter lines of the sketch, in order to clarify
and improve upon the form.

A painting of *The washing of the feet* by
Rembrandt is mentioned twice in the
seventeenth century, once in the inventory of
Abraham Jacobz. Graeven of 1660,[1] and another
in that of Harmen Beckers of 1680; in the later
it concerns a *graeutie,* a grisaille.[2]

There is a drawing of the same subject in
the British Museum in London, which
Rembrandt made at the beginning of the 1630s
(Fig. 34a).[3] Here Jesus is kneeling, while Peter
is seen from the front, and a greater number of
apostles are depicted. When he drew the figure
of Peter in the Amsterdam drawing,
Rembrandt may have had in mind the apostle
seated to the left with outstretched head. The
composition of the London drawing broadly
reflects that of Rembrandt's most ambitious
painting from the Leiden period, *Judas repentant*
of 1629.[4] Both here and in the London drawing
the main characters of the story occupy the
whole composition, whereas in the Amsterdam
drawing the figure of Peter stands out alone

against the background. Christ's central
position has been given emphasis by the fact
that everyone else looks at him. Rembrandt
repeatedly depicted the same subject and he
has achieved a greater simplicity and intensity
in the years which separate the two drawings.

The Amsterdam drawing is generally dated
to the 1650s, especially on grounds of the
rather firm way, in broad lines, in which the
apostles on the right-hand side have been
indicated. Other areas display the lively
drawing style with richer contrasts of the
1640s, a date which has also been suggested,[5]
but preference should perhaps be given to a
later dating.

Although the drawing is now considered to
be a particularly characteristic example of the
manner in which Rembrandt depicted a
moment from the life of Jesus, it was acquired
in 1883 from the collection of Jacob de Vos
Jbzn. in a lot of 14 as 'School of Rembrandt',
and listed in the inventory as such. Shortly
afterwards, however, it was published as by
Rembrandt.[6]
P.S.

1. *Documents* 1660/3.
2. A. Bredius, 'Rembrandtiana', *Oud Holland* 28 (1910),
p. 198. In Chicago there is a painting of *The washing of
the feet* previously attributed to Rembrandt, see:
Chicago 1969, No. 81 and Sumowski 1983, No. 1921, as
School of Rembrandt.
3. London, British Museum; Benesch, No. 182. The
drawing could just be dated to the Leiden period.
4. *Corpus* I A15.
5. For the dating by various authors see: Schatborn
1985, No. 25. Robinson (1988) suggests c. 1650 as a
possible dating.
6. F. Lippmann and C. Hofstede de Groot, *Original
Drawings by Rembrandt*, I–IV, Berlin/The Hague
1888–1911; II, No. 21 (1900).

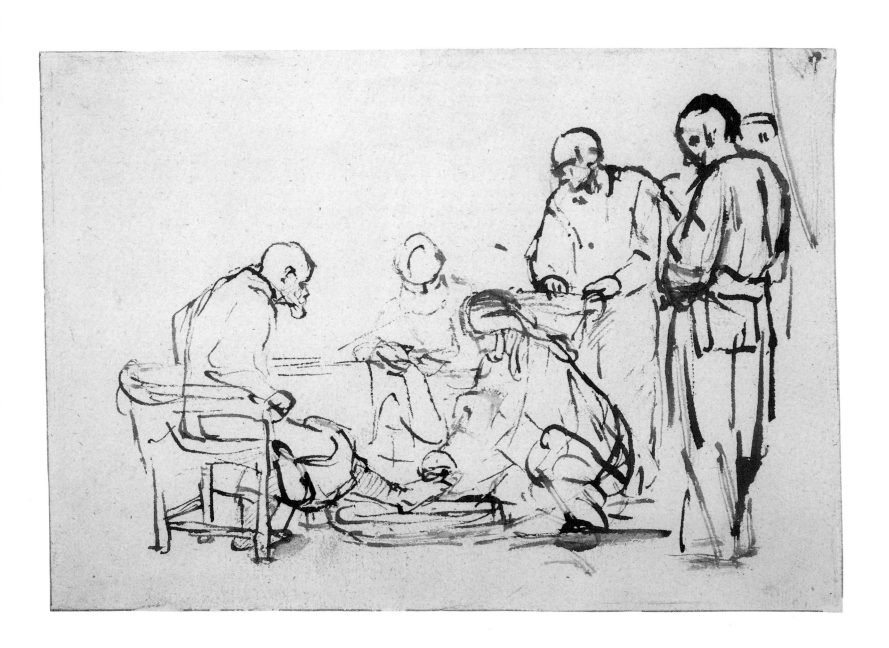

35
Hendrickje Stoffels seated in a window

Pen and brown ink, brown and white wash,
162 × 174 mm

Inscription: below right in the hand of Frederik
Sparre *1883*
Stockholm, Nationalmuseum

Provenance: Pierre Crozat, sale Paris, 10 April–13
May 1741, in lot 869 or 873; Carl Gustaf
Tessin, Paris/Stockholm; Kungliga Biblioteket,
Stockholm; Kungl. Museum, Stockholm
(L. 1638); Inv. No. 2084/1863.

Literature: Kruse 1920, IV, No. 3; Benesch
1953–57 and 1973, No. 1101.

Exhibitions: Rotterdam/Amsterdam 1956,
No. 230; New York/Boston/Chicago 1969,
No. 65 (with other previous literature and
exhibitions).

Some drawings in Rembrandt's œuvre are
executed in an exceptionally broad style and
the exhibited sheet is one of the finest examples
of this. The girl is depicted in the window
with broad strokes of the reed-pen. Her arm
rests on the window-sill, she wears a cloth over
her head and she is sitting with closed eyes in
the sun; behind her, the room is shrouded in
semi-darkness.

Despite the sketchy nature of the drawing,
it is founded on careful observation and well-
considered execution. The lines are of varying
strength and the white paper indicates the
light fall. The shadow in the background is
given with transparent brushstrokes.

Rembrandt had a predilection for depicting
figures in a window or doorway. He also drew
his first wife Saskia in an open window.
Although there is of course a considerable
difference in the drawing style, the drawing in
Rotterdam is characterised by the same
directness, precision and effective lighting
(Introduction, Fig. 8);[1] the later drawing has a
much more painterly character.

A window frame frames the figure, as it
were. Moreover, a window suggests depth and
creates distance between the outside and the
inside. Rembrandt often depicted scenes in a
doorway for the same reasons, particularly
those which include an arrival or leave-taking.
Implied movement in space and time is
expressed in such scenes, a typical aspect of
Baroque art. It is probably Rembrandt's future
wife Hendrickje Stoffels who is represented in
the exhibited drawing (see. Cat. No. 33). Her
presence in Amsterdam is first indicated on 15
June 1649.[2] In that year she appeared as a

witness when a settlement was agreed upon
with Geertje Dircks, the woman who lived in
the house with Rembrandt and who, among
other things, looked after Titus. She wanted to
conclude a favourable agreement before she left
the house.

There is a second drawing of Hendrickje in
the window in Stockholm (Fig. 35a). Both
sheets come from the collection of Pierre Crozat
and were auctioned in Paris in 1741. They were
acquired, along with more than a hundred
drawings said to be by Rembrandt, by the
Swedish ambassador in Paris, Carl Gustaf
Tessin. The catalogue of the Crozat sale is by
the dealer and collector Jean-Pierre Mariette,
who wrote the number 217 at the bottom of
the smallest of the two drawings. The other
drawing does not have such a number. The
area of paper on which the number was written
was probably cut off by a collector or dealer; it
is very apparent that both drawings have been
cropped on all sides.

A third drawing of Hendrickje, where she is
shown sleeping, is in the British Museum in
London (Introduction Fig. 1).[3] The three
drawings are dated to the mid 1650s.
Hendrickje is depicted bathing in a painting of
1655. (Fig. 35b).[4] The broad brush-strokes with
which Hendrickje's white shift is painted, are
directly comparable to the broad strokes of the
reed-pen and brush in the drawings.
P.S.

1. Rotterdam, Museum Boymans-van Beuningen;
Benesch, No. 250; Giltaij 1988, No. 8.
2. *Documents* in No. 1649/4.
3. London, British Museum; Benesch, No. 1103.
4. London, National Gallery; Bredius/Gerson, No. 437.

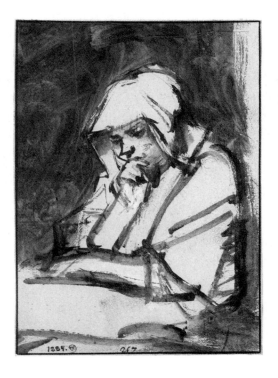

35a: Rembrandt, *Hendrickje in the window*.
Stockholm, Nationalmuseum.

35b: Rembrandt, *Hendrickje bathing*.
London, National Gallery.

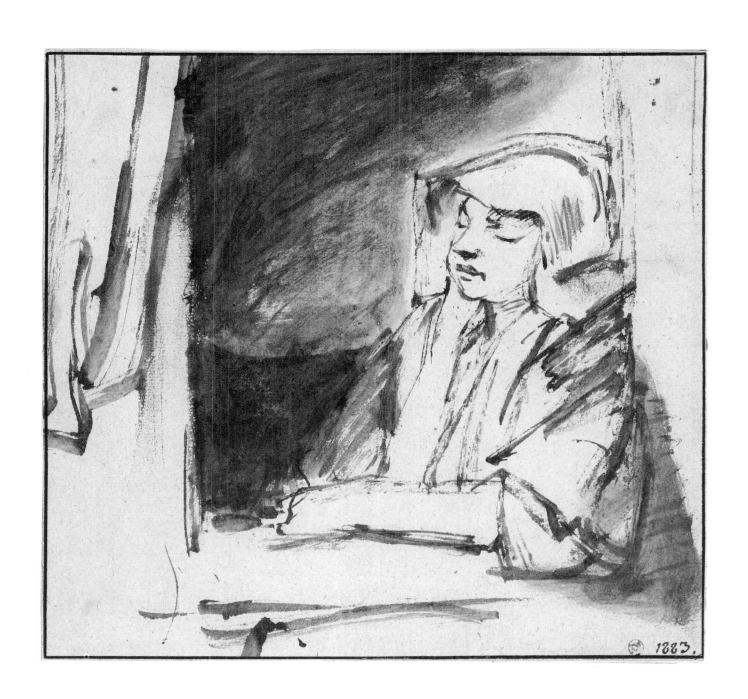

1883.

The raising of Jairus's daughter

Pen and brown ink, brown and white wash, laid down, 198 × 198 mm
Berlin, Staatliche Museen Preussischer Kulturbesitz, Kupferstichkabinett

Provenance: Sir F. Seymour Haden, London (L. 1227?), not in the sale of 15 June 1891; A. von Beckerath, Berlin; Berlin, KdZ 8508 (1902).

Literature: Bock-Rosenberg 1930, No. 8508; Lugt 1931, p. 58; Benesch 1954–57 and 1973, No. 1064 (with other previous literature and exhibitions); Hoekstra 1981, N.T.2, p. 24–25.

Exhibition: Berlin 1970, No. 75.

One of the miracles performed by Jesus is the healing of the daughter of Jairus, the ruler of the synagogue. He had fallen at Jesus's feet and begged him to cure his ailing daughter. Then came the message that she had died. Jesus entered the house of the ruler with the apostles Peter, James and his brother John, and sent the crowd away. He took the child's hand and said: get up. She immediately stood up and was cured (Mark 5: 21–43).

Jesus stands in the middle of the representation, and, rather than taking hold of the child's hand as is related in the biblical text, raises his own hand. With this, Rembrandt has made it clear that a miracle is taking place. We encounter the same gesture in an etching of 1642, *The raising of Lazarus*.[1] The mother is kneeling with hands folded at the foot of the bed. Behind her we see Peter, bald, bearded and, like the woman, with hands folded; James and his brother, the young beardless John, are also standing there. Finally, the Jairus's face is partly visible behind Jesus's raised hand and the curtain.

Jairus's twelve-year-old daughter lies on the bed resting against large pillows, her arms stretched out beside her body. Her legs, partly covered with a blanket, indicate recent movement, a first sign of her regained life. Also noticeable is a certain tension in the muscles of her neck, by which Rembrandt has indicated that, any moment now, she will be able to lift her head. The bed is placed diagonally to the picture plane. Curtains hang to the left and right of the head of the bed and a curtain also closes off the scene to the right. By this means the performance of the miracle has acquired privacy.

The drawing has been created in a specially evocative drawing style. There is great diversity in the handling of line, from the broad lines drawn with the pen pressed flat, depicting the curtain to the left and superimposed upon previously drawn areas of the picture, to the hatchings on the sleeve of Jesus's cloak made with an almost dry pen. The shadow in the background has been made by rubbing with the finger, and the dark lines have been covered over with white, particularly in the headcloth of the mother.

The emotions expresed are clear despite the imprecise description of the figures: Jesus directs his concentrated gaze on the sick child, James and Peter look on attentively and full of expectation, while the angled position of the head of the young John expresses amazement. It seems that the head of Jairus behind the curtain in the background was added at a later stage. His face appears to express astonishment and respect. This small head has been given an important place in the composition behind the raised hand of Jesus, the cause of his wonder.

Painted and etched representations with a bed as the central motif occur a few times in Rembrandt's œuvre and these compositions are always enclosed by curtains. There are drawings of this rarely depicted subject from the beginning of the Amsterdam period, but it is not certain whether they are by Rembrandt.[2] This drawing is usually dated to the second half of the 1650s.
P.S.

1. B. 72.
2. Benesch, Nos. 61 and 62, Whereabouts of both unknown. Moreover, there is a related, fairly rough pen sketch in the same style and probably also from the 1630s; Amsterdam, Rijksprentenkabinet; Schatborn 1985, No. 84.

Shah Jahan and one of his sons

Pen and brown ink, brown wash, on light-brown oriental paper, 94 × 86 mm

Inscriptions: verso, on the lining *N: 29/Bought at Hudsons sale/A:O:1779*; in the centre *autograph of Lord Selsey, at whol . . . in 1872 many years after his death his books and drawings were sold at Sotheby's in London by the representatives of the widow and her sons, Purchased by me from that sale RPR.*
Amsterdam, Rijksmuseum, Rijksprentenkabinet

Provenance: Richard Houlditch (L. 2214), London; Jonathan Richardson Sr. (L. 2184), sale London, 22 January–8 February (in fact 11 February) 1747, in lot No. 70; Thomas Hudson (L. 2432), sale London, 12–14 February 1779, No. 29; Lord Selsey, sale London, 20 June 1872, in lot No. 2635; Robert Prioleau Roupell (L. 2234), sale London, 12–14 July 1887, No. 1101; John Postle Heseltine (L. 1507), London; Henry Oppenheimer, sale London, 10–14 July 1936, No. 288; I. de Bruijn-van der Leeuw, Spiez, presented to the Rijksprentenkabinet, in usufruct until 28 November 1960; Inv. No. RP-T--83.

Literature: Benesch 1954–57 and 1973, No. 1196; B.P.J. Broos, 'Rembrandts Indische miniaturen', *Spiegel Historiael* 15 (1980), pp. 210–18; P. Lunsingh Scheurleer, 'Mogol-miniaturen door Rembrandt nagetekend', *De Kroniek van het Rembrandthuis* (1980) I, pp. 10–40; Schatborn 1985, No. 59 (with other previous literature and exhibitions).

Exhibition: Amsterdam 1969, No. 121.

Some of the most remarkable drawings in Rembrandt's œuvre are the copies he made after Indian Mughal miniatures. They are not the only copies by his hand, but they do form the largest group—23 in all.[1] In the inventory of Rembrandt's possessions of 1656 an album is mentioned with 'curieuse minijateur teeckeningen' (curious miniature drawings)[2] and these are usually considered to be the Mughal miniatures which Rembrandt used as models.[3] Almost one hundred years later 'A book of Indian drawings by Rembrandt, 25 in number' is mentioned in the sale catalogue of Jonathan Richardson Sr., and most of the drawings now known carry his collector's mark. The exhibited drawing was previously in the collection of Richard Houlditch (died 1736), whose mark is below that of Richardson.

Almost all these drawings are portraits of Shah Jahangir (ruler from 1605 to 1628) and Shah Jahan (ruler from 1628 to 1658) and courtiers from the years 1635–1650. In most drawings we see one or two figures depicted full-length, but there are also some with a rider,[4] one of a group of seated scribes[5] and one of emperor Timur, considered to be the progenitor of the dynasty, surrounded by his followers and courtiers.[5] In addition there are one or two small half-length portraits, two of an Indian woman[7] and two of Shah Jahan, the latter two in the Rijksprentenkabinet in Amsterdam.[8] In general such portraits have no background representations. In Rembrandt's drawings the backgrounds usually consist of shadow only.

In the exhibited drawing we see the Shah behind a balustrade, with a rug hanging over it. Standing close next to him we see his son.[9] The Shah is depicted in profile, with jewels on his turban, around his neck, in his ear and around his arm. He is also holding a ring or bracelet in his left hand. The boy, seen diagonally from the front, also wears a turban and has laid his small hand on the balustrade. It is uncertain which of the sons is depicted.

It is not known precisely which miniatures Rembrandt made use of, although there are a number of related miniatures in the so-called *Millionenzimmer* in the Schönbrunn palace outside Vienna.[10] We cannot point to any direct model for the Amsterdam drawing. There are various types of miniatures in which the Shah is depicted with one or more of his sons; in addition more of this type of portrait exist, showing the shah behind a balustrade with a rug.

Many Mughal miniatures are brightly coloured with the brush; others are well-nigh monochrome. Rembrandt remained relatively faithful to his own drawing style and used pen and brush, in contrast to the Indian miniaturist. He added some colour—red and yellow—to some of the drawings. He used a particularly fine pen and in his characteristic way applied wash with the brush in many gradations. What is exceptional about these drawings is that they are not literal imitations, neither in technique, nor in style. With Rembrandt's experience in drawing from life, he was able to give them a more natural appearance, as if they were drawn from real life.[11]

There is an etching by Rembrandt, *Abraham entertaining the angels*,[12] dated 1656, which, in the figures and composition, clearly show the influence of comparable Mughal miniatures. Rembrandt's compositions after Indian miniatures are usually dated to that year, the year in which the inventory was also compiled. These drawings are not individually mentioned in it and nor are the other copies which he made after Lastman (Cat. No. 11) and Leonardo, among others.

Rembrandt was still using the same fine pen in the 1660s.[13] The style of the miniatures perhaps also determined the drawing style of Aert de Gelder, Rembrandt's pupil at that time. This influence is clearly expressed in his drawing of *A group of Orientals* (Cat. No. 47).
P.S.

1. Benesch has included 21, Nos. 1187–1194, 1194A, 1195–1206. One drawing not mentioned by Benesch was in a French private collection (mentioned in New York 1979–1980, at No. 75) and another is in the collection of Mrs Christian Aall in New York (Robinson 1988, Fig. 4a), the drawing of a *Young Woman standing with a flower* in Stockholm (Benesch, No. 450) could also belong to this group (Lunsingh Scheurleer 1980, pp. 17–18). Finally, two drawings were previously in Weimar, on which Rembrandt had written *oostindisch poppetje* (East Indian figure) (HdG 1906, Nos. 541–42).
2. *Documents* 1956/12, No. 203.
3. Lunsingh Scheurleer (1980, p. 15) does not really consider this probable, as such miniatures in the seventeenth century were usually called 'Mogolse', 'Suratse' or 'Oost-Idiaanse' miniatures.
4. Paris, Musée du Louvre, Département des arts graphiques; Benesch, Nos. 1197, Paris 1988/1989, No. 67 and London, British Museum; Benesch, No. 1205.
5. London, British Museum; Benesch, No. 1187.
6. Paris, Musée du Louvre, Départment des arts graphiques; Benesch, No. 1188; Paris 1988/1989, No. 68.
7. Rotterdam, Museum Boymans-van Beuningen; Benesch, No. 1206, Giltaij 1988, No. 31 and New York, collection Mrs Christian Aall, not in Benesch (see note 1).
8. Amsterdam, Rijksprentenkabinet; Benesch, Nos. 1195 and 1196; Schatborn 1985, Nos. 58 and 59.
9. Broos (1980) believed that the child was added to the Mughal portrait of the Shah by Rembrandt.
10. Established by H. Glück; J. Strzychowski and H. Glück, *Asiatische Miniaturenmalerei*, Klagenfurt 1933.
11. New York/Cambridge 1960, at No. 63; Broos 1980, p. 212.
12. B. 29.
13. Examples of this are *Isaac and Rebecca being spied on by Abimelech*, New York, private collection, Benesch, No. 988; *Elsje Christaens hanging on the gallows*, New York, The Metropolitan Museum of Art, The H.O. Havemeyer Bequest, Benesch, No. 1105 and The Lehman Collection, Benesch, No. 1106.

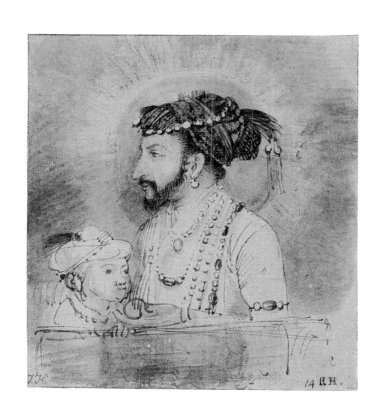

38

Seated female nude

Pen and brown ink, brown and white wash,
211 × 174 mm
Chicago, The Art Institute, The Clarence
Buckingham Collection

Provenance: L. Corot, Nîmes (L. 1718);
A. Strölin, Paris/Lausanne; Inv. No. 1953. 38.

Literature: Benesch 1953–57 and 1973,
No. 1122; Schatborn 1981, No. 84 and p. 56;
Schatborn 1987, pp. 307–20; Giltaij 1988,
at No. 185.

Exhibitions: Rotterdam and Amsterdam 1956,
No. 237; New York and Cambridge 1960,
No. 74; Chicago, Minneapolis and Detroit 1969,
No. 137; Washington, Denver and Fort Worth
1977, No. 40; Amsterdam and Washington
1981–82, No. 84.

38a: Aert de Gelder, *Seated female Nude*
(Cat.No. 49).
Rotterdam, Museum Boymans-van Beuningen.

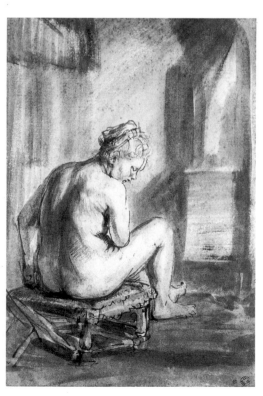

Rembrandt drew nudes from life at various times (see Cat. No. 24). Most of the late studies of models were originally attributed to Rembrandt himself, but from a comparison with drawings by pupils from that time, in particular Aert de Gelder (Cat. No. 49) and Johannes Raven (Cat. No. 51), it seems likely that they made drawings alongside Rembrandt and in his style.

Rembrandt drew the *Seated female nude* while Aert de Gelder depicted the model in the same pose from a different angle (Cat. No. 49; Fig. 38a). A comparison of the two drawings gives a clear insight into the way in which the pupil assimilated Rembrandt's drawing style, without equalling his master.

The drawings are extremely similar at first sight: almost analogous positioning in the picture plane, the use of the same ink, an imprecise descriptive pen-line and the continuous transparent wash with the brush. One of the most important differences is the rendering of light. Here, it is also one of Rembrandt's most noticeable distinguishing characteristics. It is only a consistent depiction of light and dark which gives the figure plasticity, suggests texture and creates space.

In the drawing in Chicago the light comes from a high window to the left, falling onto the model and the ground next to her, where Rembrandt has left the paper white. The parts of the figure nearest the light have been left open but in the areas further back and in those where shadow falls Rembrandt has applied wash with the brush, on the whole in subtle gradations and sometimes with strong accents. The precision with which he did this—and it is greater than appears at first sight—has given the figure three-dimensional form.

The pen-lines give the impression of being sketchy. The contours are here and there interrupted and apart from the lines which describe the form, there are other lines which have a corrective function. For example, within the outline of the buttock there are a few lines which do not describe anything and only serve the purpose of making the area appear smaller. The long diagonal through the calf of the left leg similarly creates no form, but improves the impression which the leg makes as a whole. The contour of the right shoulder is primarily defined with the brush; the outline of the other shoulder is made up of various lines, which together give the impression of the correct form. All these peculiarities of draughtsmanship are characteristic of Rembrandt's aim to present a convincing representation of the figure as a whole.

The brush-strokes in the background have various directions and tones, so that space and atmosphere are created by an abstract pattern, without any clear form. The woman is probably sitting near a wall, onto which her shadow falls, indicated by short vertical strokes. In the drawing by Aert de Gelder (Cat. No. 49) we see that the model sits by a stove, which also appears in one of Rembrandt's etchings.[1] From a written source it appears that artists, from approximately the middle of the century, had the opportunity to draw collectively from a model and Rembrandt's pupil Samuel van Hoogstraten, in his *Academy* of 1678, also mentions 'Teyckenschoolen of Academien' (Drawing schools or academies) where nude models sat 'in de warme stooven' (by the warm stoves).[2] Perhaps Rembrandt and Aert de Gelder drew the same model at such a session, and Rembrandt's drawing must have simultaneously served as a model for Aert de Gelder.

It is uncertain precisely when this took place. De Gelder, who was born in 1645 in Dordrecht, was first a pupil of Samuel Hoogstraten in that town, probably towards the end of the 1650s, and thereafter followed in the footsteps of his first master and studied under Rembrandt. The nudes were probably made around 1660 or shortly after. Rembrandt similarly made a life-drawing with another pupil from a later time, Johannes Raven. Drawings showing the same model in the same pose by these two artists are also extant (see Cat. Nos. 50 & 51).
P.S.

1. B. 197.
2. Hoogstraten 1678, p. 294.

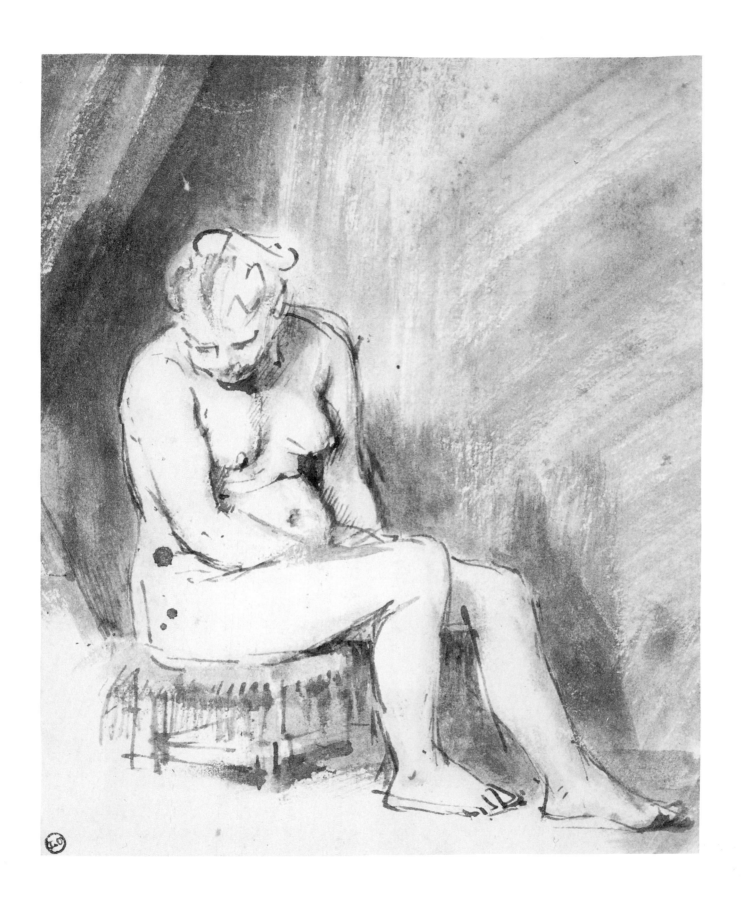

39

The conspiracy of the Batavians under Claudius Civilis

Pen and brown ink, brown and white wash,
196 × 180 mm

Inscription: below left *5070* (old Inv. No.);
verso: partial text of a funeral ticket of Rebecca
de Vos, 25 October 1661
Munich, Staatliche Graphische Sammlung

Provenance: Elector Carl Theodor of the
Palatinate (L. 620), Mannheim (1758).

Literature: Benesch 1954–57 and 1973,
No. 1061; C. Müller Hofstede, HdG 409.
'Eine Nachlese zu den Münchener Civilis-
Zeichnungen', *Konsthistorisk Tidskrift* 25 (1956),
pp. 42–55; B. Haak, 'De nachtelijke
samenzwering van Claudius Civilis in het
Schakerbos op de Rembrandttentoonstelling te
Amsterdam', *Antiek* 4 (1969), 3, pp. 136–48;
C. Müller Hofstede, 'Zur Genesis des Claudius
Civilis-Bildes', *Neue Beiträge zur Rembrandt-
Forschung*, Berlin 1973, pp. 12–30 (Discussion
pp. 41–43); W. Wegner, *Die Niederländischen
Handzeichnungen des 15.–18. Jahrhunderts.
Kataloge der Staatlichen Graphischen Sammlung
München*, I, Berlin 1973, No. 1097 (with other
previous literature). J. van Tatenhoven and
P. Schatborn, Review of Wegner 1973, *Oud
Holland*, 92 (1978), p. 134; Carl Nordenfalk,
*The Batavian's Oath of Allegiance, Rembrandt's only
Monumental Painting*, Stockholm 1982.

Exhibitions: Stockholm 1956, No. 56;
Rotterdam/Amsterdam 1956, No. 249;
Amsterdam 1969, No. 135; *Zeichnungen aus der
Sammlung des Kurfürsten Carl Theodor*, Munich
(Staatliche Graphische Sammlung) 1983–84,
No. 75.

The composition sketch shows *The conspiracy of
the Batavians under Claudius Civilis*, which
Rembrandt painted for one of the arched spaces
of the gallery which ran on all sides of the
interior of the new town-hall on the Dam in
Amsterdam. The extant central section of the
painting, which was about 5.5 meters high and
broad in its original state, is now in the
Nationalmuseum in Stockholm (Fig. 39a).

The subject is derived from Tacitus who
describes how, under the leadership of Claudius
Civilis, the Batavians revolted against the
Roman oppressors in A.D. 69.[1] This subject
was chosen as decoration for the town-hall
because of its parallel with the revolt of the
Dutch against Spanish rule, which ended in
1648.

The drawing shows Civilis and his
supporters congregated in a place—Tacitus
mentions a grotto—in the Schakerbos, under
the pretence of sharing a meal.[2] When the
lateness of the hour and the alcohol had
warmed their spirits, Civilis began to speak of
the honour and glory of his people and the
injustice that was being done to them; after
this they swore a confederacy against the
Romans and 'barbaarse rituelen' (barbarous
rituals) followed.

The commission for eight paintings with
subjects from the revolt of the Batavians and
four scenes from Jewish and Roman history,
went to Rembrandt's pupil Govert Flinck in
1659, but he died shortly afterwards on 2
February 1660. On 13 January 1661 Jan Lievens
and Jacob Jordaens were commissioned to do
one painting each, but none of the sources
mention the commission given to Rembrandt.[3]

Rembrandt made his drawing on the back of
a still partially legible funeral ticket, on the

39a: Rembrandt, *The Batavians' Oath of Allegiance*.
Stockholm, Nationalmuseum.

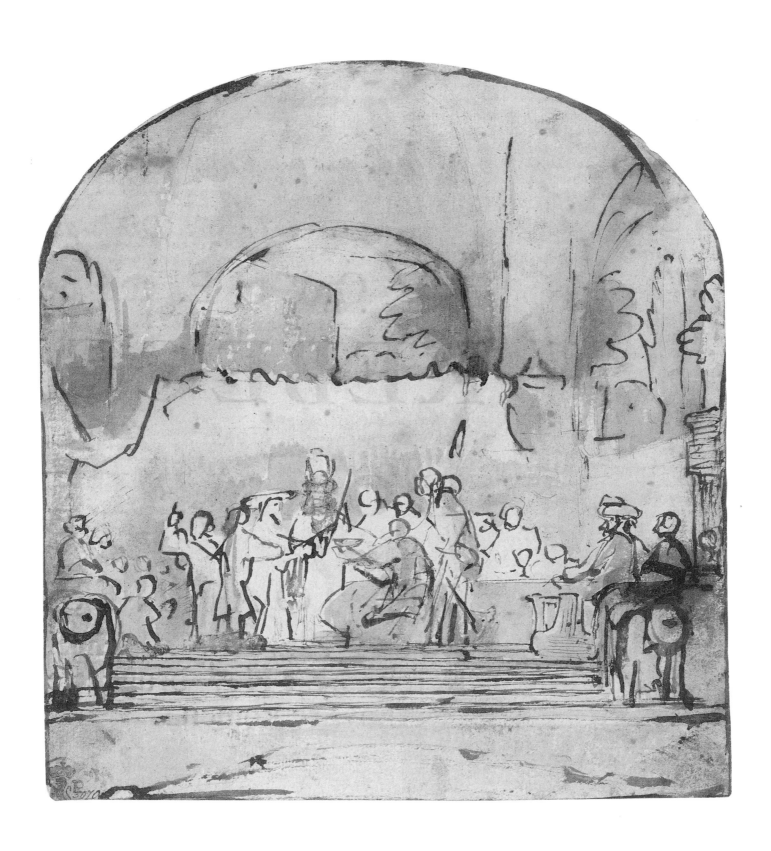

Rembrandt has depicted the figures in the third drawing, in Berlin, in the left-hand section of the painting (Fig. 40c).[3] Part of a hat can be seen on the right-hand side of this sheet, where the drawing has been cut, and the drawing probably showed the composition in its entirety.

It is not absolutely clear what role the drawings played in the creation of the painting. Rembrandt did not usually make direct preliminary studies for paintings. Drawings which are nevertheless related to them, were usually made when he was planning to make an alteration in the composition. When Rembrandt made the drawings of the individual figures, the composition as a whole had already been made. This is apparent from the fact that, in the Rotterdam drawing, the space in the lower left corner is left open for Jacob van Loon's chair. Volkert Jansz. is standing upright in the drawing and it is clear from the x-ray that this was also the case in the first painted version of this figure. Rembrandt has made him lean forward slightly in the final version, as if here were preparing to stand up or sit down. By depicting one figure in movement, an original motif rarely occurring in a group portrait, Rembrandt has eliminated the static character.[4] It is clear that the drawings of the group of Staalmeesters and that of Volkert Jansz. were made before the latter's pose was altered.

Van Loon is wearing a stiff collar in the painting, and is seated on a chair which appears on other occasions in Rembrandt's work (Cat. No. 2, 20, 23). He is wearing a simpler collar in the drawing and is sitting on a straight-backed chair with straight legs. In the drawing a section of the projecting wall can be seen behind Volkert Jansz. This area has been moved to the right in the painting, and in the Berlin drawing the background has yet again been rearranged.

The figure of the messenger, Frans Hendriksz. Bel, was initially not included in the Berlin drawing, that is, if he did not occupy the area that has been cut off. A very rough sketch of his head was added to the drawing, in the position he was to take in the final version of the painting.[5]

The drawings of Van Loon and Jansz. were made on accounting paper, which, in the exhibited drawing, is only evident from the reverse. Rembrandt also used this paper for one of his nudes, which is, moreover, drawn in the same colour ink.[6]

The Rotterdam and Berlin drawings are made with broad, rough lines of the reed-pen; the one in Amsterdam with fine lines for the face and hands. Wash has been applied in the background in a painterly manner. The white highlights were originally clearer, but they are still fairly bright in the overall scene.

From the most sketchy depiction of the figures in the Berlin drawing it appears that Rembrandt was mainly concerned with discovering the best composition. The paper was even damaged while he was working on it and maybe this accounts for the section cut off at the right. By working in a chiefly functional manner, Rembrandt developed a style which is now considered to be expressive. The broad pen-lines and brush-strokes in the drawings of *The Staalmeesters* have their parallel in the evocative handling of brush of the late paintings.

P.S.

1. *Corpus* III A146.
2. Rotterdam, Museum Boymans-van Beuningen; Benesch, No. 1180; Giltaij, No. 36; Luijten and Meij 1990, No. 36.
3. Berlin, Kupferstichkabinett SMPK; Bock-Rosenberg, No. 5270; Benesch, No. 1178.
4. A. van Schendel, 'De schimmen van de Staalmeesters', *Oud Holland* 71 (1956), pp. 1–23.
5. Van Schendel 1956, p. 14 (n. 4), sees this as a sculpted head, a part of the fireplace.
6. Amsterdam, Rijksprentenkabinet; Benesch, No. 1142; Schatborn 1985, No. 55.

40b: Rembrandt, *One of the Staalmeesters, Volkert Jansz.* Rotterdam, Boymans-van Beuningen.

40c: Rembrandt, *Three Staalmeesters.* Berlin, Kupferstichkabinett SMPK.

41

FERDINAND BOL

*Hagar at the well
on the way to Shur*

Pen and brown ink, brown wash,
182 × 232 mm

Inscription: below right *R ft*
Amsterdam: Rijksmuseum,
Rijksprentenkabinet

Provenance: Jan Pieter Graaf van Suchtelen
(L. 2332), St Petersburg, not in the Paris sale,
4 June 1862; Remy van Haanen, Vienna;
H. Lang Larisch, Munich (1900); Cornelis
Hofstede de Groot, The Hague, gift of 1906,
in usufruct until 14 April 1930; Inv. No.
RP-T-1930-27.

Literature: Henkel 1942, No. 1; Sumowski
Drawings 1979, No. 89 (with other previous
literature and exhibitions); Albert Blankert,
Ferdinand Bol, Doornspijk 1982, in Cat. 1; B.P.J.
Broos, Review of Sumowski Drawings 1–4, *Oud
Holland* 98 (1984), p. 180 and N. 114; Giltaij
1988, in No. 43; Sumowski 1983, in No. 89.

41a: Ferdinand Bol, *Hagar in the Desert*.
Gdánsk, Muzeum Pomorskie.

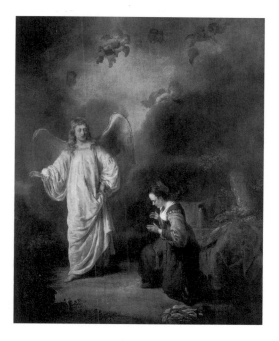

As Sara could give him no children, Abraham
took the servant Hagar to serve him as wife.
When she became pregnant, the jealous Sara
forced her to leave the house. On the way to
Shur, near a spring of water, an angel appeared
who encouraged Hagar to return, and to serve
Sara again. The angel told her that she would
bear a child whose name would be Ishmael
(Genesis 16: 1–16).

The angel has appeared from out of a cloud
and, gesticulating, addresses the kneeling
Hagar. Her amazement is expressed by her
arms and by her hands which are somewhat
outstretched. A water bottle and Hagar's cloak
lie next to her.

Bol has drawn the figures in fairly even lines
and applied only one or two strong accents.
The hatching on the wing and on the inside of
the angel's robe have also been finely drawn;
however, broader lines have been placed in the
right background. The figures are lightly
shaded with the brush, as are the trees.
The foreground and Hagar's cloak are depicted
with darker brushstrokes.

The drawing has been ascribed to
Rembrandt in the past. The inscription *R ft*
was added by a later owner in order to make
this attribution plausible.[1] The sheet was
recognised as by the hand of Bol in 1924.[2]

There is a clear relationship with a painting
of upright format in Gdánsk (Fig. 41a),[3] where
the composition is almost the same. Here,
Hagar is shown more in profile and the angel
holds up a section of his robe; in addition,
angels are hovering in the sky. Bol often
borrowed motifs from the work of Rembrandt;
the angels were probably inspired by
Rembrandt's etching of *The Annunciation* from
1634.[4]

The style of the drawing is based on the one
by Rembrandt from the mid 1630s. But Bol
draws the forms a little more precisely and less
evocatively. The painting is dated to
approximately 1650[5] and the drawing to the
end of the 1630s.[6] The drawing is therefore not
a direct preliminary study. Ferdinand Bol was
born in Dordrecht in 1616. After an apprentice-
ship with an Utrecht master, he went to study
with Rembrandt in Amsterdam. Notes made
by Rembrandt on the reverse of a drawing after
a painting by Lastman, *Susanna and the Elders*
(Cat. No. 11, Fig. 11b), indicate that he sold
work by Bol. If the dating of this drawing to
1636 is correct, then it was made in the year
that he came to Rembrandt; he is mentioned
as still being in Dordrecht in 1635.

The relationship between Rembrandt and
Bol is not wholly clear. We do not know of
works by Bol dating from the second half of the
1630s. Bol was probably one of those pupils

who, after a traditional apprenticeship, took
further training from Rembrandt and
simultaneously had a share in the work
produced by the studio.[7] The earliest dated
and signed work by Bol is from as late as
1641;[8] a few other paintings are attributed to
him and dated to approximately 1640.[9]
Although a number of drawings can be con)-
sidered to be preliminary studies for paintings
(and etchings), the precise relationship
between Bol's drawings and paintings is
not clear. Bol could have made use of an earlier
drawing around 1650 for the exhibited drawing.

All in all, there is reason enough to consider
the exhibited drawing as characteristic of Bol's
work. On the basis of the style of Rembrandt's
drawings, which it reflects, a dating to the
second half of the 1630s is the most probable.
P.S.

1. Broos reads here part of the name of Bol; Broos 1984,
p. 180.
2. L. Münz, 'Federzeichnungen von Rembrandt und
F. Bol', *Belvedere* 5 (1924), 27, pp. 106–12.
3. Blankert 1982, Cat. 1; Sumowski 1983, No. 89.
4. B. 44 (Etchings Cat. No. 9).
5. By Blankert 1982.
6. T. Gerszi, 'Etudes sur les dessins des élèves de
Rembrandt', *Bulletin du Musée Hongrois des Beaux-Arts*
(1971), 36, p. 105 and n. 46; W.R. Valentiner, 'Notes on
old and modern drawings. Drawings by Bol', *The Art
Quarterly*, 20 (1957) 1, pp. 54. 56.
7. Thus J. Bruyn in his review of Sumowski 1983,
I *Oud Holland* 98 (1984), pp. 151–52.
8. *The Sacrifice of Gideon*, Utrecht, Rijksmuseum Het
Catharijneconvent; Blankert 1982, No. 11; Sumowski
1983, No. 79.
9. Sumowski considers *The liberation of Peter* in the Baaij
collection at Schoten and the corresponding drawing as
early works of c. 1640 (Sumowski 1983, No. 78;
Sumowski Drawings, No. 87). Blankert doubts this
attribution (Blankert 1982, No. D4). Two other
drawings are also dated by Sumowski to the same
period (Sumowski 1983, Nos. 132 and 159); Bruyn
1984 (n. 7), pp. 151–52.

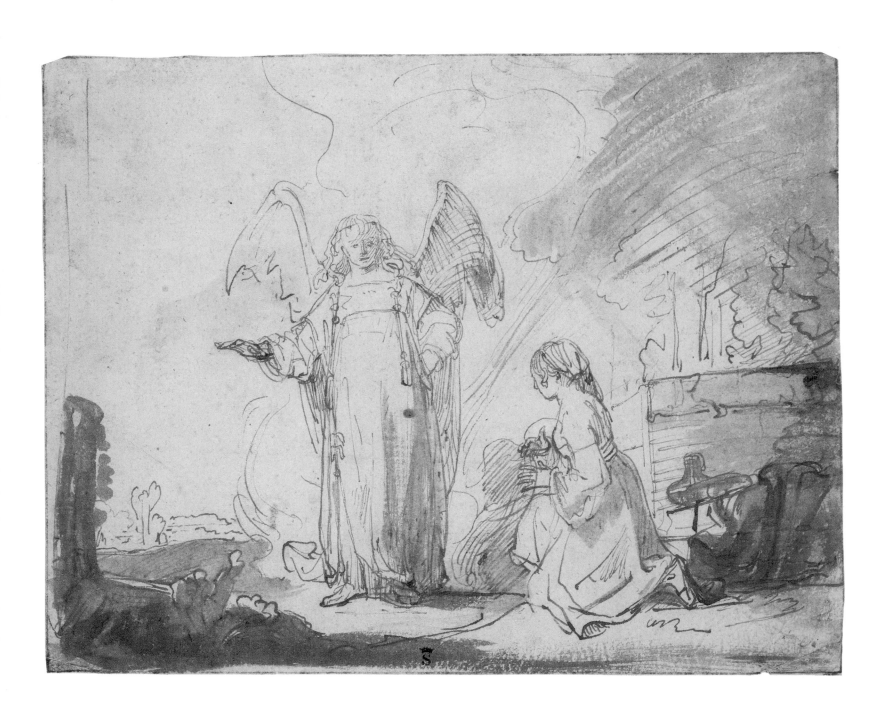

42

FERDINAND BOL

Vertumnus and Pomona

Pen and brown ink, grey and white wash,
170 × 152 mm; with upper corners rounded
Rotterdam, Museum Boymans-van Beuningen

Provenance: Earl of Dalhousie (L. 717a); Franz
Koenigs (L. 1023a), Haarlem (1923); presented
by D.G. van Beuningen to the Stichting
Museum Boymans (1940); Inv. No. R. 44.

Literature: Benesch 1954–57 and 1973, No. 165;
Giltaij 1988, No. 43 (with other previous
literature and exhibitions).

Exhibition: Amsterdam 1969, No. 59.

42a: Ferdinand Bol, *Vertumnus and Pomona*.
Cincinnati, Cincinnati Art Museum.

In Benesch's catalogue and in the previous
literature, this drawing had always been
considered to be by Rembrandt. Benesch dated
it to approximately 1638, Valentiner to approx-
imately 1645.[1] In the exhibition in Amsterdam
in 1969 it hung among characteristic drawings
by Rembrandt and it was then that doubt was
cast on its authenticity.[2] It was first attributed
to Bol in the 1988 catalogue of the Rotterdam
drawings by Jeroen Giltaij, an attribution based
on a comparison with the drawing of *Hagar at
the well on the way to Shur* (Cat. No. 41.)

Bol depicted mythological scenes more often
than Rembrandt and three paintings have
Vertumnus and Pomona as their subject (Fig.
42a).[3] However, the drawing is not a
preliminary study for one of these paintings,
just as the Amsterdam drawing is not a prelim-
inary study, although it was used as a model
for a painting (Cat. No. 41).

It is related in Ovid's *Metamorphoses* how
the nymph Pomona kept all admirers at bay by
means of a fence around her garden. But
the god Vertumnus managed to approach her
in the guise of an old woman and to
recommend himself as a candidate. When he
revealed himself in his true shape, Pomona
declared herself won over.

We see Vertumnus holding forth while
Pomona, with a garland around her head and
hands folded in her lap, listens attentively.
Vertumnus's stick is lying across his knee.
According to Van Mander in his *Uitlegginge en
singhevende verclaringe* of the *Metamorphoses* from
1604, this motif is 'het steunstocsken der
traecheijt' (the crutch of sluggishness) which
he must relinguish 'met alle vrouwlijck wesen'
(with all female characteristics) in order to
achieve virtue, by which is meant Pomona.[4]
The garden in which they are sitting is not
indicated, unlike in the three paintings by Bol.

There are important similarities with the
Amsterdam drawing by Bol (Cat. No. 41).
There are not many contrasts within the
figures, who are drawn with equally even, light
pen-lines. Here and there are one or two
accents, for example in the hands of the angel
and those of Vertumnus. The relationship
between the lines and the areas left blank is
also fairly consistent. The wash differs in colour
but is applied in a similar manner: some light
shadows are to be seen on the figures, while the
background is more broadly and transparently
shaded. The stronger wash in the foreground of
the Amsterdam drawing is comparable to the
shadow to the right of Vertumnus. The figures
have been placed in between the darker and
lighter wash in both drawings. So, in their
execution, the Amsterdam and the Rotterdam
drawings display all sorts of similarities.

This also applies to the faces of the angel and
Pomona, both depicted by half ovals and both
having similar facial expressions, including a
straight mouth and areas left blank for the
eyes.

Just as with the Amsterdam drawing, a
dating to the second half of the 1630s is the
most probable.

P.S.

1. Valentiner II, 1934, No. 614.
2. Haverkamp-Begemann 1971, p. 88.
3. Blankert 1982, Cat. 36, 37 and 38; Sumowski 1983,
No. 84.
4. Amsterdam 1969.

43

NICOLAES MAES

Absalom hanging from an oak

Pen and brown ink, brown wash,
209 × 323 mm
Amsterdam, Rijksmuseum,
Rijksprentenkabinet

Provence: From an album of drawings, mainly
by Matthijs Balen; Inv. No. RP-T-1957–161.

Literature: Sumowski *Drawings*, pp. 4259–60
and No. 1923–x (with previous literature).

Nicolaes Maes was born in Dordrecht in 1634.
Around 1650 he was a pupil of Rembrandt in
Amsterdam. His first independent work is a
signed painting from 1653.[1] In addition to some
early works with biblical subjects, he chiefly
painted interior genre scenes in the 1650s.
From then on and until his death in 1693, he
worked as a portrait painter in Amsterdam,
where he went to live in 1673.

Maes made innumerable drawings as
preliminary studies for paintings.[2]

However, one group of sheets with biblical
representations had a different function and was
made as practice in forming compositions, in
the depiction of events and the resulting
expressions.[3] In this, Maes was following in the
footsteps of his teacher. The drawings from this
group are dated to the mid 1650s;[4] some are
variations on scenes by Rembrandt.

The exhibited drawing, and a second one
showing a different moment from the story of
Absalom (Fig. 43a),[5] originate from an album
acquired by the Rijksprentenkabinet in 1957.
It mainly consists of drawings by Maes's later
fellow-townsman, Matthijs Balen (1684–1766).[6]
The thirteen drawings by Maes at the back of
the album, were probably acquired by Balen
from the artist or his heirs *en bloc.* Having
remained in the album until 1957, the drawings
are in excellent condition.

The moment depicted is that when David's
son Absalom, during the battle with his father,
is caught by his long hair in the branches of a
tree and kept hanging there (I Samuel 18: 9).
The army is in the left background and closer
by, a man stands behind a tree. He will relate
the incident to Joab, David's general, who was
subsequently to kill Absolaom with three
arrows. This moment is depicted in the other
drawing from the album (Fig. 43a).

The attribution to Maes rests, among other
things, on the similarity between this sheet and

other historical scenes from the same group,
including a drawing of a *Rumblepotplayer at the
entrance of a house.*[7] There is a painting of this
scene by Maes in Dordrecht.[8]

Absalom hanging from an oak is fluently drawn
with a lively pen. The composition was first
roughly indicated in fine lines (as can still be
seen in the left background) and then elabora-
ted with looser pen-lines, here and there with
a half dry pen. Thereafter Maes strengthened
contours with the brush and added shadow.

We come across this loose drawing style, in
which a few details have been more precisely
given, in drawings by Rembrandt from the
time that Maes was his pupil. An example is
the compositional design of *Jerome reading in
a landscape* (Cat. No. 25), which is dated to
approximately 1650.[9]

P.S.

1. *The Dismissal of Hagar*, New York, Metropolitan
Museum; Sumowski 1983, No. 1315.
2. William W. Robinson, 'Nicolaes Maes as a
Draughtsman', *Master Drawings* 27 (1989) 2,
pp. 146–62.
3. William W. Robinson, 'Rembrandt's sketches of
historical subjects', *Drawings Defined*, New York 1987,
pp. 241–57.
4. Sumowski *Drawings*, p. 4260.
5. Amsterdam, Rijksprentenkabinet; Sumowski
Drawings, No. 1924–x.
6. Inv. Nos. RP-T-1957–9 up to and including 152.
7. Sumowski *Drawings*, No. 1768.
8. Sumowski 1983, No. 1360.
9. Other examples are *Christ in the Garden of Gethsemane*
and *Daniel in the Lions' Den* (Fig. 25a and 26b); Benesch,
Nos. 899 and 887.

43a: Nicolaes Maes, *Joab killing Absalom.*
Amsterdam, Rijksprentenkabinet.

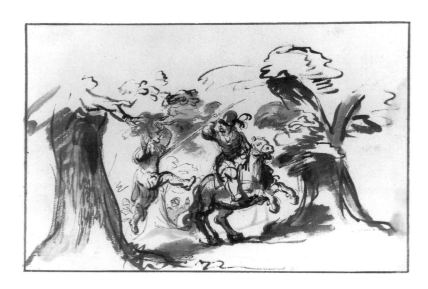

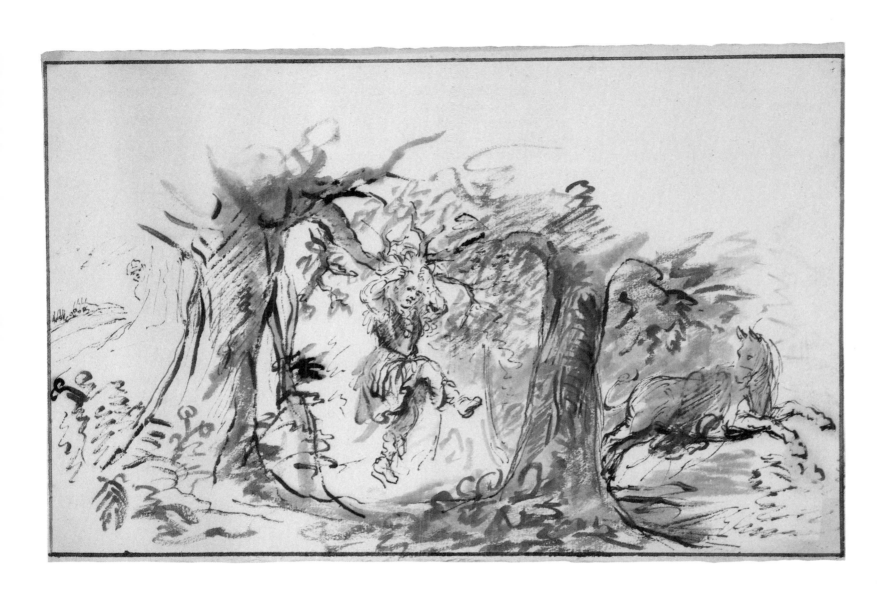

44

NICOLAES MAES

Panoramic view from a hill

Pen and brown ink, brown, grey and orange-brown wash, 145 × 196 mm
Amsterdam, Rijksmuseum,
Rijksprentenkabinet

Provenance: W.N. Lantseer, sale Amsterdam, 22 April 1884, No. 392; W. Pitcairn Knowles (L. 2643), sale Amsterdam, 25 June 1895, No. 527; Inv. No. RP-T 1899 A4334a.

Literature: Henkel 1942, No. 76, as Rembrandt; Benesch 1954–57 and 1973, No. 829, as Rembrandt; Sumowski *Drawings*, No. 1956a–x, as Maes (with other previous literature and exhibitions).

As early as 1900, Woldemar von Seidlitz doubted the attribution of the drawing to Rembrandt.[1] Even so, various authors still considered it to be by his hand, although mention was made that its somewhat unusual character was caused by later additions.[2] Formerly, attributions had been made to a number of other artists, among them, Jan Ruisscher, Aert Gelder and Roelant Roghman,[3] but Benesch considered the landscape to be by Rembrandt. Finally, Sumowski proposed that the work be included in the œuvre of Maes and then in the group to which *Absalom hanging from an oak* also belongs (Cat. No. 43).

Between the verge of the road which bends off to the right and a higher part of the hill on the left of the drawing, we see a panoramic view. The plane and the foreground are lit, whereas the high verge and the edge of the hill are in shadow; a part of the foreground, at the lower edge of the drawing, is also in shadow.

In the initial design the plane is depicted in fine horizontal pen-lines, comparable to the background of *Absalom hanging from an oak*. The road and the verge were also drawn with the pen in the first draft, afterwards elborated with the brush. The relationship between the pen and the brush is the same in both drawings. The brush renders form—such as the plants in the foreground—as well as shadow. Shadow has been lightly indicated with the brush on the tree to the right of Absalom, the surface of the bark depicted in darker strokes later. Maes did something

similar in the shadowing of the verge, where the growth was suggested with darker brushstrokes over a lighter wash, which Maes had first allowed to dry. Numerous light brushstrokes depict the foliage above Absalom, and the sunlit verge on the right of the landscape was rendered in the same way. The forms of the leaves and the branches are similarly comparable: the branch to the left of Absalom has, in its design and in the relationship of pen and brush, the same character as the high bush to the right of the landscape. Also characteristic are the zig-zag and looped lines with which the contours of the foliage are indicated. In both drawings contours have been strengthened here and there with the brush.

The colour of the ink is the same in both drawings. To the left of the landscape grey and lighter brown wash has also been added. The use of the brush with grey ink in a drawing made with the pen and brush in brown occurs also, and to a much stronger degree, in a drawing similary attributed by Sumowski to Maes of a *View of Ravenstein* (Fig. 44a).[4] Maes also drew one or two views of his birthplace, Dordrecht, where he worked until 1673.[5] On the basis of these topographical drawings it can be assumed that the *Panorama from a hill* was also made directly from nature. Previously, when Rembrandt's name was attached to the drawing, it was proposed that it must have depicted an area in Gelderland, near Rhenen.[6] We know that Maes did travel in that direction from a drawing of a *View of the Belvedere in Nijmegen*.[7]

The attribution of landscapes to Maes is based on a drawing of a *Landscape with trees along a road*[8] on the reverse of a characteristic sketch of figures from a representation of *Christ blesses the children* in Lille.[9]

P.S.

1. Woldemar von Seidlitz, review of Lippmann and Hofstede de Groot, I–II, 'Zeichnungen von Rembrandt Harmensz van Rijn', *Repertorium für Kunstwissenschaft* 23 (1900), p. 489.
2. According to Benesch, the zig-zag line in the left foreground and the blue-grey and brown of the small hill above it are later additions.
3. For these attributions, see: Sumowski *Drawings*, No. 1956a–x.
4. Amsterdam, Rijksprentenkabinet; Sumowski *Drawings*, No. 1902–x. This combination of materials also appears in another landscape by Maes, *A village street*, in Cambridge; Sumowski *Drawings*, No. 1903–x.
5. *View of Dordrecht*, Amsterdam, Stichting P. & N. de Boer; Sumowski *Drawings*, No. 1900–x and Cambridge, Fogg Art Museum; William W. Robinson, 'Nicolaes Maes as a draughtsman', *Master Drawings* (1989), p. 159, ill. 36.
6. Lugt 1920, p. 162.
7. *View of the Belvedere in Nijmegen*, Berlin, Kupferstich-kabinett SMPK; Sumowski *Drawings*, No. 1899a–x.
8. Lille, Musée des Beaux-Arts; Sumowski *Drawings*, No. 1763.
9. Lille, Musée des Beaux-Arts; Sumowski *Drawings*, No. 1761.

44a: Nicolaes Maes, *View of Ravenstein*. Amsterdam, Rijksprentenkabinet.

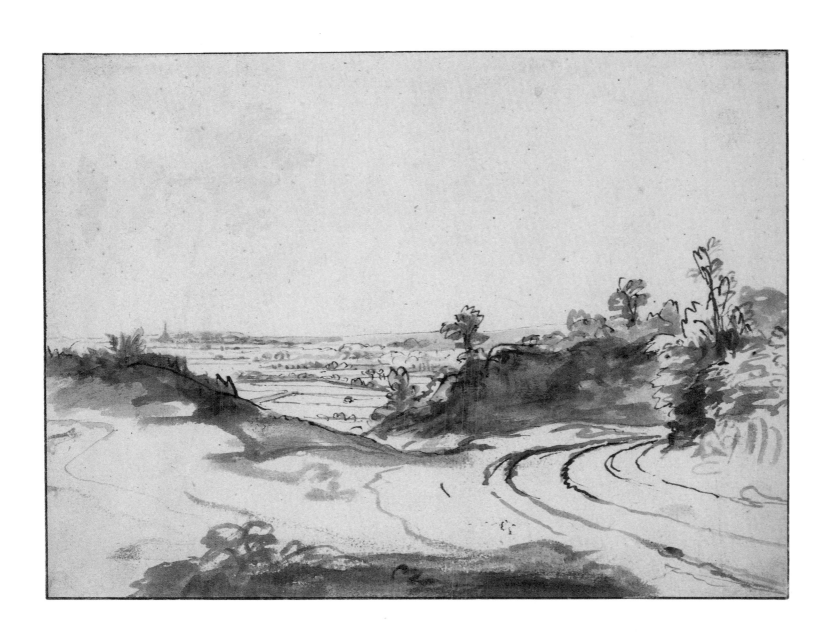

45

WILLEM DROST

Ruth and Naomi

Pen and brown ink, brown and white wash,
187 × 235 mm
Bremen, Kunsthalle

Provenance: L. Franklyn, London;
Inv. No. 54/437.

Literature: Benesch 1954–57 and 1973, No.
C100; D. Pont, 'De composites Ruth en Naomi
te Bremen en Oxford. Toeschrijving aan
Willem Drost', *Oud Holland* 75 (1960), pp. 205–
21; Sumowski *Drawings*, No. 546 (with other
previous literature and exhibitions); Sumowski
1983, in No. 311.

Exhibitions: Leiden 1956, No. 112, as Eeckhout;
Bremen 1964, No. 50, as Drost.

Willem Drost was studying with Rembrandt in around 1650. His earliest work is a *Self-portrait* etching of 1652 (Fig. 45a).[1] He travelled to Italy in the second half of the 1650s and he was certainly back in 1663.[2] Drost's painted and drawn œuvre has increased considerably over the years and this growth will probably continue.[3]

The exhibited drawing was wrongly considered by Benesch to be a copy. Pont attributed it to Willem Drost in 1958[4] and also related it to the painting of the same subject in Oxford (Fig. 45b). Both attributions are generally accepted.

The draughtsman has depicted a moment from the book of Ruth. After Naomi and her two daughters-in-law from Moab were widowed, Naomi wanted to return to her country of birth, Judea. One of her daughters-in-law, Ruth, went with her to Bethlehem. In the drawing we see Ruth and Naomi, accompanied by a dog, in a hilly landscape with a high bridge and a town in the background.

The fairly even lines are characteristic of Drost's drawing style. Also extremely typical are the many and various hatchings, placed close together and further apart in several directions all over the scene. In Naomi's skirt they have merged to form shadows, a handling of line which occurs more often in other drawings by Drost. The hatchings which are intended to create shadow do not always produce depth and plasticity, but give the drawing a rather linear character. The figures do not stand out strongly against the background, although it is evident that the light falls from the left. Naomi's features are succinctly depicted, the eyebrows with one continuous curved line and the open mouth with two short lines.

The overall impression of the sheet is mainly determined by the even pattern of lines. As a result the atmosphere is not especially perceptible. This is not so in the painting. There, the figures are strongly lit against a dark background, creating a theatrical effect. In contrast to the drawing, the painting is upright in format and the figures are standing in the centre of the composition.[5] Their dress is also given in more detail. Only a bridge is to be seen in the dark background.

A good comparison of the drawing style can be found in Drost's etched self-portrait of 1652. The style of drawing, with many hatchings, appears to be derived up to a certain point from etchings by Rembrandt of that time. The painting and the drawing are dated to the beginning of the 1650s.[6]

On the basis of the convincing attribution of the drawing and the painting to Drost, the former has become the point of departure for the attribution of another drawing to this pupil, which was, until recently, still considered to be a Rembrandt (Cat. No. 46).
P.S.

1. Holl. 1.
2. There is a painting dated 1663 of a portrait of Hillegonda van Beuningen in a Dutch private collection; Sumowski 1983, No. 342.
3. Of the drawings in the Rijksprentenkabinet, sixteen were attributed to Drost; Schatborn 1985–I, pp. 100–3.
4. D. Pont, *Barent Fabritius*, 1624–1673, Utrecht 1958 (diss.), p. 129, in No. 4.
5. Bruyn concludes, on the basis of the format of the drawing, that the painting has been cut down (Bruyn 1984, p. 154). However Drost may deliberately have chosen a composition with figures placed large in the picture plane.
6. Pont dates both works to 1652–1653, Sumowski approximately 1651.

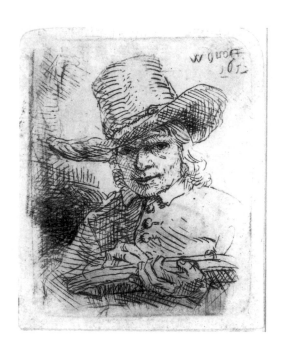

45a: Willem Drost, *Self-portrait of the Artist drawing*. Amsterdam, Rijksprentenkabinet.

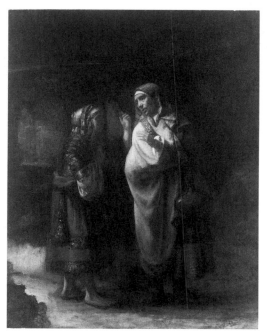

45b: Willem Drost, *Ruth and Naomi*. Oxford, Ashmolean Museum.

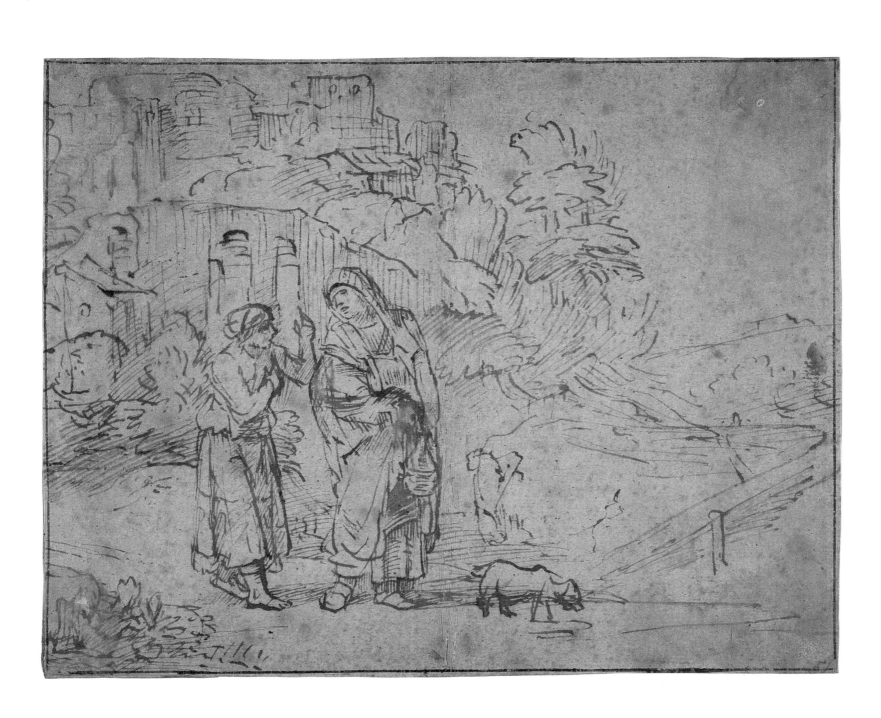

46

WILLEM DROST

The Angel departing from the family of Tobit

Pen and brown ink, 193 × 245 mm

Inscription: verso:
Purchased in 1783 at Mr. Forster's Sale
New York, The Pierpont Morgan Library

Provenance: J. Richardson Sr. (L. 2184), sale
London, 22 Jan.–8 Feb. 1747 (old calendar
1746), possible No. 68 or in No. 43, 64 or 66
(?); Ingham Foster; H. Reveley, sale London,
21 April 1884, no. 154; Sir J.C. Robinson;
C. Fairfax Murray; J. Pierpont Morgan,
New York (1910); Inv. No. IF. 197.

Literature: C. Fairfax Murray, Vol. I, 1905,
No. 197; Benesch 1954–57 and 1973, No. 893,
as Rembrandt.

Exhibition: New York/Cambridge 1960, No. 70
(with other previous literature and
exhibitions).

The scene depicted is the departure of the
angel from the house of the family of Tobit,
after Tobit's blindness had been healed by his
son Tobias (see Cat. No. 18). Until recently,
the drawing was always considered to be a
work by Rembrandt.[1]

The drawing style looks very much like that
of Willem Drost, expressed in *Ruth and Naomi*
(Cat. No. 45), and other drawings. Here too
the numerous hatchings are the most
characteristic feature. In the doorway and on
the wall to the left the lines have merged, as
occurs to a lesser degree on the skirt of Naomi,
and more often in other drawings by Drost.
The draughtsman has also rubbed areas with
his finger, which Rembrandt also used to do.
The figures lack a degree of plasticity and this
is partly due to the predominant linear pattern.
The fall of light has also been fairly flatly
interpreted.

The composition is roughly similar to
Rembrandt's etching of 1641 of the same
subject (Fig. 46a). In his own characteristic
style, the pupil has made a variation on
Rembrandt's composition. In Rembrandt's
etching, which is of course more elaborate than
the drawing, the light is particularly effectively
rendered and the figures are much less flat, a
result of the contrast between the light areas
and those which are strongly shaded. In the

etching, only half of the angel who is flying
away can be seen and the pupil has not
adopted this original motif.

Drost's drawing can be compared to
drawings by Rembrandt from the beginning of
the 1650s. Although a number of Rembrandt's
drawings have similar stylistic characteristics,
there is in his work a different relationship
between the various elements which constitute
the drawing, for example, the hatching is not
so prominent. There are also numerous
hatchings in a drawing in the Louvre of *Christ
among the Doctors* (Fig. 46b),[2] but these are
more varied and in some places they clearly
contribute to the creation of depth. While a
secondary figure, such as the man standing
above Jesus, is very lightly drawn, other
figures—the man in the left foreground and
the central figures—are strongly accentuated.
This also creates variation and strengthens the
suggestion of depth. It is also notable for
example, that the small figure of Jesus is not
covered with hatchings but is left white,
standing out from the hatchings around him.
The pupil uses the master's method but applies
it in a less refined and less effective manner.

Although some variation in the lines and
hatchings in the drawing of *The Departure of the
Angel* is perceptible, the individual figures are
not very clearly demarcated. There is a

46a: Rembrandt, *The Angel departing from the
Family of Tobit*. Amsterdam, Rijksprentenkabinet.

46b: Rembrandt, *Christ among the Doctors*.
Paris, Musée du Louvre, Département des arts graphiques.

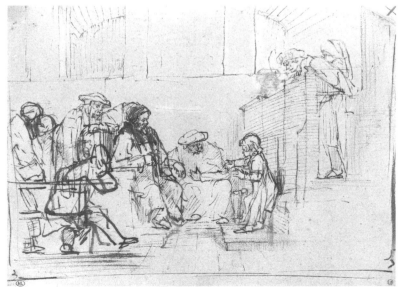

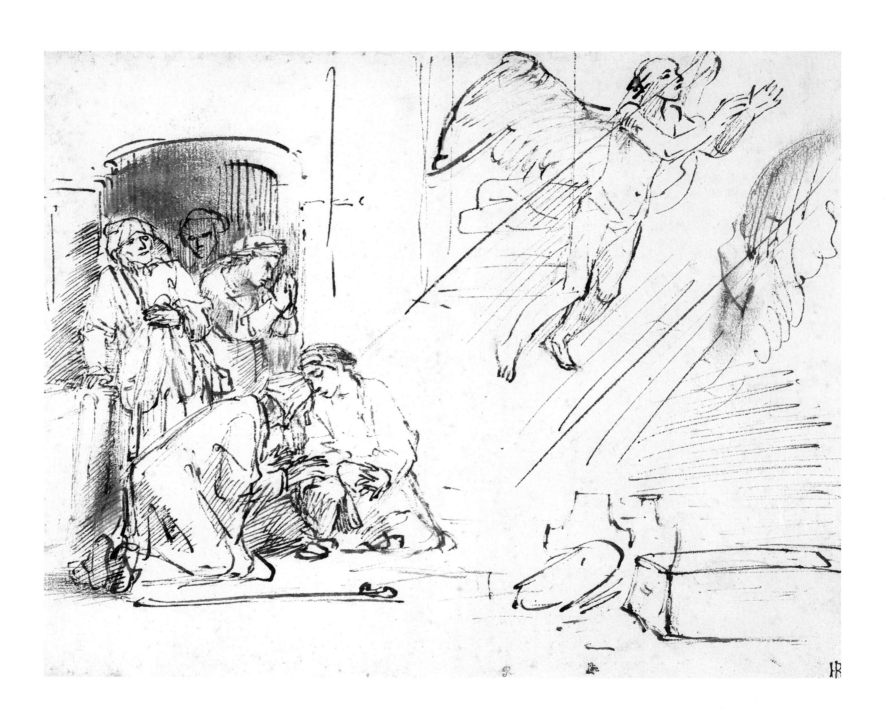

similarity with *Ruth and Naomi* in the way the faces are depicted. The mouth, in which some white is visible between the lips, and a profile with a dark eye occur on both drawings. The sketchily depicted hands are also fairly comparable.

An attribution of the New York drawing to Drost seems plausible and this can be confirmed by a comparison with other drawings attributed to Drost by Sumowski and others.

There is a drawing by another pupil, Constantijn van Renesse, which is closely related to Rembrandt's etching and especially to Drost's composition (Fig. 46c).[3] Renesse was not a regular pupil, but probably had occasional lessons from Rembrandt. On these occasions Rembrandt corrected drawings made by Renesse, including the sheet with *The departure of the angel*.[4] He must also have had Drost's drawing at his disposal in Rembrandt's studio at the beginning of the 1650s.[5] It is possible that Drost was not only a pupil but also a co-worker for some time, at least in the time before his earliest dated etching of 1652. So, Renesse not only used Rembrandt as his model, but in this case, Drost too.

P.S.

1. William W. Robinson kincly informed me that he believed the drawing to be by the hand of Drost.
2. Paris, Musée du Louvre, Département des arts graphiques; Benesch, No. 885; Paris 1988–1989, No. 50.
3. Vienna, Albertina; Benesch. No. 1373; Sumowski *Drawings*, No. 2189–xx.
4. Benesch assumed that the drawing by Renesse, corrected by Rembrandt, was the point of departure for his drawing in New York. Sumowski dates both sheets to the beginning of the 1650s.
5. According to an inscription on a drawing in Rotterdam, Renesse visited Rembrandt for the second time on 1 October 1649; Sumowski *Drawings*, No. 2145. He must have made another visit to Rembrandt at the beginning of the 1650s; Sumowski *Drawings*, p. 4911.

46c: Constantijn van Renesse, *The Angel departing from the Family of Tobit*. Vienna, Albertina.

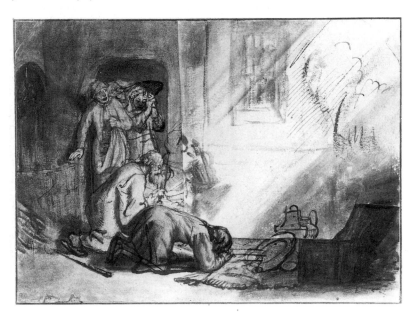

47

AERT DE GELDER
A group of Orientals

Pen and brown ink, white wash, 151 × 195 mm
London, private collection

Provenance: London, Parsons & Sons Gallery
(inventory list 1923, No. 190, as Rembrandt);
Basle, C. de Burlet; Munich, Herbert List; sale
Berlin, 11 May 1964, No. 252, as Rembrandt
School.

Literature: Sumowski *Drawings*, No. 1052
(with other previous literature and
exhibitions); Sumowski 1983, at No. 724.

Exhibitions: Chicago, Minneapolis & Detroit
1969–1970, No. 181.

In 1934 this sketch, showing a discussion
between a group of Orientals, was related to a
painting by Aert de Gelder now in the
Mauritshuis in The Hague (Fig. 47a).[1] In the
painting a scene showing Peter and John
healing a cripple at the Temple-gate is depicted
in the right background; in the left foreground
is a group of Orientals, similar in arrangement
and stance to the drawing (Fig. 47b). The man
in the centre background and the head drawn
between the three figures talking together are
omitted in the painting; other Orientals were
added to the scene. More variation in the
clothing was introduced in the execution of the
painting. In particular the fairly similar turbans
were replaced by all manner of richly decorated
head gear.

The style of the drawing is in some respects
comparable to the painting. The dark accents
in the painted figures also occur in the draw-
ing, although not in the same places. Similar,
too, is the manner in which the eyes are
depicted with dark dots.

It is therefore probable that the drawing
played a part in the making of the painting
dated 1679. Such a relationship is rare in the
œuvre of Aert de Gelder. There is moreover
the problem of whether the drawing and the
painting date from the same period. The style
of the drawing, made with a fine pen, reflects
that of a number of late drawings by Rem-
brandt.[2] De Gelder's sheet could therefore
presumably be dated to the time of his
apprenticeship with Rembrandt or after it, in
the early 1660s.

Aert de Gelder was born in Dordrecht in
1645. There, he was first a pupil of Samuel van
Hoogstraten, who had worked with Rembrandt
in the 1640s. So de Gelder had already become

47a: Aert de Gelder, *The Temple Entrance.*
The Hague, Mauritshuis.

47b: Detail from 47a.

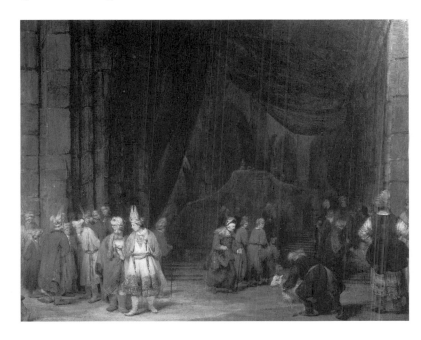

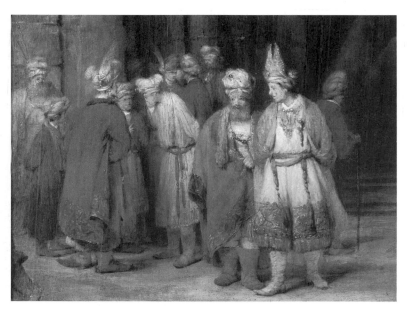

acquainted with Rembrandt's drawing style during his apprenticeship with Hoogstraten.[3]

Striking characteristics of the exhibited drawing are the loose, occasionally short, jaunty lines and the darker covering strokes of the pen, which somewhat randomly accentuate the forms. Improvements were also made with these dark lines in the face of the man standing in the left foreground, for example. Characteristic, too, are the groups of hatchings suggesting shadow. These hatchings consist of lines drawn closely together which end in a loop; on the back of the man in the left foreground a group of such lines ends in a short zig-zag line. Such hatchings also occur in de Gelder's paintings and are achieved by scratching with the end of the brush in the still-wet paint. He has probably also rubbed the hatchings with his finger, a technique which de Gelder had learnt from Rembrandt. In this way shadow could be finely rendered. The contours are emphatically indicated with single lines and not as 'een omtrek, die als een swarten draet daer om loopt' (as an outline, which surrounds it like a black thread), as de Gelder's first teacher, Samuel van Hoogstraten describes it in his *Hooge Schoole der Schilder-konst* of 1678.[4] Most of the hands are not visible, whereas the eyes are drawn with rather differing uneven black marks and a single line, or one or two uneven lines indicates the mouths. The right hand of the second Oriental is depicted without any indication of the fingers, as if the man is wearing a glove; a thumb and two fingers of the other hand are visible.

A couple of drawings by de Gelder have the same loose style, including the *Self-portrait while drawing* (Fig. 47c).[5] A drawing which has been attributed to de Gelder for some time, *Jacob being shown Joseph's blood-stained coat* (Fig. 47d),[6] has a tighter handling of line, but the same relation between the lines, hatchings and shadows.

The drawing of the group of Orientals and the sheets directly related to it are the point of departure for the attribution to de Gelder of other drawings (Cat. No. 48 and 49).
P.S.

1. Valentiner II 1934, p. XXXIV; Sumowski 1983, No. 724.
2. The copies after Indian miniatures, dated to the second half of the 1650s, are an example of this (Cat. No. 37). This also applies to the sketch of *Isaac and Rebecca spied on by Abimelech*, which was used for *The Jewish Bride*, dated 16 . . ., Benesch, No. 988, and to the two drawings of *Elsje Christiaens hanging from the gallows* from 1664, Benesch No. 1105 and 1106.
3. Schatborn 1985, pp. 105–6.
4. Hoogstraten 1678, p. 28.
5. Amsterdam, Rijksprentenkabinet, Inv. No. RP-T-1975–56.
6. Chicago, The Art Institute; Benesch, No. A83. The attribution is by W. Valentiner, (II 1934, p. XXXIV).

47c: Aert de Gelder, *Self-portrait of the Artist drawing*. Amsterdam, Rijksprentenkabinet.

47d: Aert de Gelder, *Jacob being shown Joseph's blood-stained Coat*. Chicago, The Art Institute.

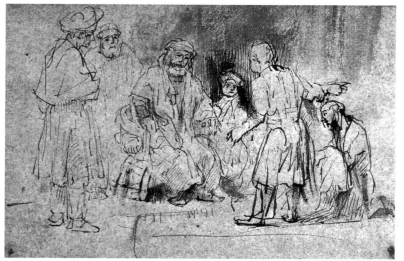

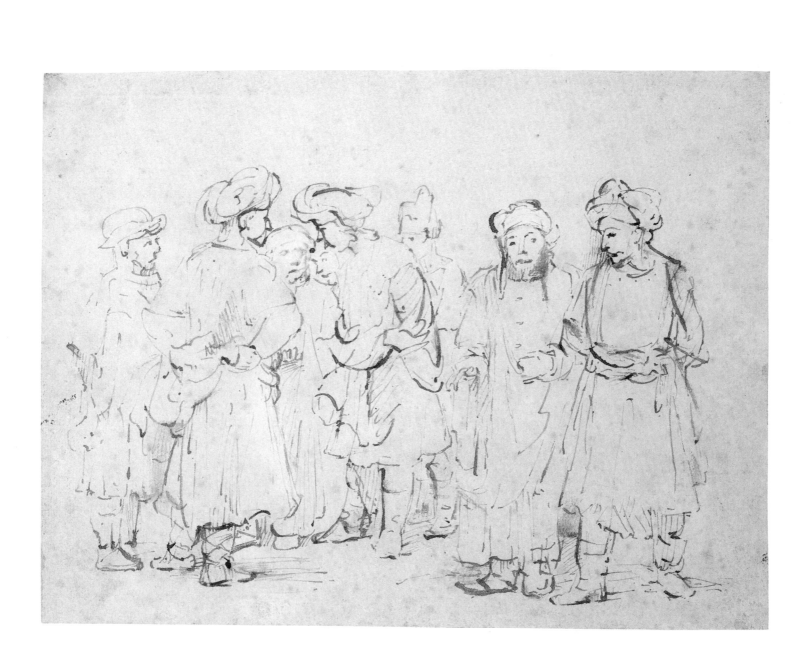

48

AERT DE GELDER

Seated female nude on a bed

Pen and brown ink, brown and white wash, on brownish paper, 142 × 176 mm

Inscription: verso: latin text
Dresden, Kupferstich-Kabinett der Staatlichen Kunstsammlungen

Provenance: Dresden, The Electors of Saxony (L. 1647), acquired before 1756; Inv. No. C1344.

Literature: Benesch 1954–57 and 1973, No. 1109, as Rembrandt; Schatborn 1987, as Aert de Gelder.

A young girl is seated on a bed, leaning with her left elbow on a pillow, her right arm resting on the cloth covering her legs. She is looking to the right. At the lower right a section of the bed on which she is sitting is indicated.

This study from a model had always been considered to be by Rembrandt until an attribution to Rembrandt's pupil Aert de Gelder was suggested.[1] The attribution is based on a comparison with *A group of Orientals*, and one or two other related drawings considered to belong to the same group (Cat. 47, Fig. 47c & 47d). All these drawings were executed with a fine pen. The figure of the seated girl has been built up with shorter and longer lines of varying thickness. The less important lines, such as those indicating the folds of the cloth, were made with very fine strokes, sometimes with an almost dry pen. The three-dimensional effect of the figure is in the main the result of the fine hatching on the underarm and the right hand, the wash applied with the brush between the back and the pillow and the hatching in the background. We encounter comparable vertical hatching in the background of *Jacob being shown Joseph's blood-stained coat* (Fig. 47d). There, wash was added with the brush, in the same way as it was added to the left of the body on the bed, and on the pillow, in the study of the model. The hair of the model is transparent, depicted in part with half-dry strokes, or rubbed with the finger. Although the *Self-portrait* and *A group of Orientals* are made with numerous loose, wavy lines, there are far fewer of these in the drawing of the nude model. Here, the lines are tighter, as is the case in *Jacob being shown Joseph's blood-stained coat*.

The plasticity of the seated nude is not particularly well suggested, and this also applies to the figures in the other drawings. The lines create a fairly fine pattern, the liveliest in *A group of Orientals*. Yet one can see the same relationship between the individual lines. Loose, fine lines are alternated with stronger lines and accents. The darker lines do not appear to have a clear relation to the fall of light in the drawings, thus causing the lack of plasticity. Just as in the drawing of the nude, depth has been created in particular by the hatching, placed here and there between and on the figures.

The nude study and the self-portrait were made from a model, with the artist drawing what he saw. The two sketches were made from imagination. The nude is one of a number of late model studies considered by Benesch in his catalogue of the œuvre to be by Rembrandt. Benesch divided them into one or two groups which he dated to the mid 1650s and the beginning of the 1660s. A number of the approximately thirty drawings are in the Graphische Sammlung in Munich. Most of these are considered by critics of Benesch to be imitations or the work of a follower. Of the remainder, a few had already been questioned and one group was attributed to Johannes Raven (Cat. No. 51).

It is possible that it was Aert de Gelder who was responsible for some of these late nudes in Rembrandt's style. This pupil lived until 1727 and he may have continued until late in life to draw from the model more or less in the style of his teacher, although there are no clues to such an attribution in his painted œuvre.
P.S.

1. Schatborn 1987.

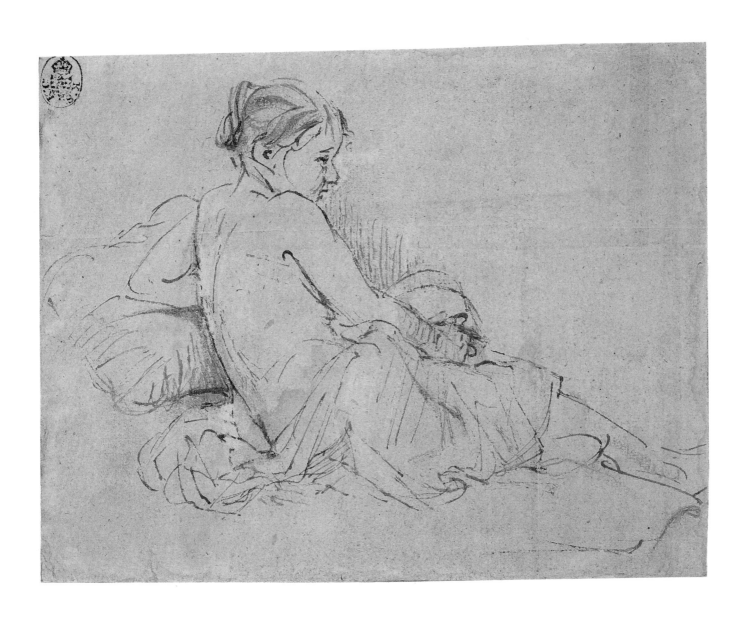

49

AERT DE GELDER

*Seated female nude
in front of a stove*

*Verso: Head and shoulders
of a seated female nude*

Pen and brown ink, brown wash,
292 × 195 mm

Inscription: verso: *12 Rembrandt, 41.*
Rotterdam, Museum Boymans-van Beuningen

Provenance: Baron R. Portalis (L. 2232), sale
Paris, 2 February 1911, in No. 174 (as School
of Rembrandt); E. Rodrigues, Paris (L. 897);
F. Koenigs (L. 1023a). presented to the
Stichting Museum Boymans by D.G. van
Beuningen (1940); Inv. No. R1.

Literature: Benesch 1954–57 and 1973,
No. 1121, as Rembrandt; Schatborn 1987,
as Aert de Gelder; Giltaij 1988, No. 185, as
Anonymous.

Exhibition: Rotterdam 1988, No. 185 (Giltaij
1988).

49: verso

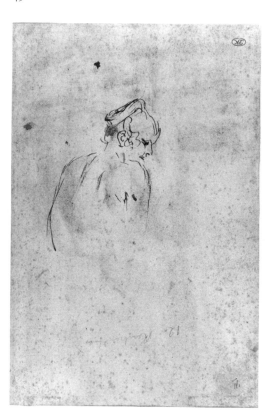

The nude model is seated on a low stool with her back to the draughtsman. In the background a stove provides the required heat for the nude model. We know of this type of stove from an etching by Rembrandt, *Seated nude by a stove*,[1] and from a written source we know that artists and pupils drew from the life 'bij de warme stooven' (by the warm stoves) (see Cat. No. 38).

The drawing, together with the *Seated female nude* (Cat. No. 48), belongs to a fairly large group of nudes, which until recently were considered to be the work of Rembrandt. While the exhibited drawing is ascribed to an unknown pupil of Rembrandt in the catalogue of the drawings in Rotterdam, an attribution to Rembrandt's pupil Aert de Gelder is also suggested.

This attribution is in the first instance based on a comparison with a drawing by Rembrandt of the same model (Cat. No. 38). He made this study simultaneously with the pupil, but from a different angle. Although the drawings display similar characteristics, there are considerable differences, although these are not immediately evident. In any event, the study by the pupil is strongly influenced by Rembrandt.

It is more likely that two artists were simultaneously working from the same model, than that one artist drew the same model twice in the same pose, although this is of course not to be ruled out. There is, moreover, a comparable example of the master working with another pupil, Johannes Raven (Cat. No. 51).

Rembrandt and his pupil used the same materials. The most important difference can be seen in the depiction of light. Whereas Rembrandt leaves the foreground open, his pupil fills it with brushstrokes, which create the impression of an uneven floor. The pupil has rendered the shadow underneath the stool rather disproportionately, although he was presumably trying to depict it accurately with, among other things, brushstrokes along the spindles; he also tried to draw the stool itself with the same accuracy in pen, but in his attempt to work fluently he has produced a rather rickety looking piece of furniture. The stool drawn by Rembrandt seems to be of simpler construction; this is because he has depicted no details and abstracted the forms to a certain degree. As a result—and with far fewer pen-lines—a much sturdier piece of furniture has been created, which is also spatially more convincing. Rembrandt has achieved this by depicting light in half of the area under the stool, by strongly accentuating the left leg and allowing the right to dissolve

in shadow. The pupil lacks such refinement.

The fall of light on the body also reveals such differences. Although the pupil is not completely unsuccessful, the brushstrokes are less evocative. In some places they have a fairly descriptive character: they follow the contours of the shoulder, thigh and calf, and the outline of the stomach and shoulderblade. Furthermore the backbone is indicated with one uninterrupted brushstroke between the other areas of wash. The pupil also depicted the background with brushstrokes which are as transparent as Rembrandt's, but contribute less to the suggestion of space around the figure than his abstract pattern of lines. The background appears to be divided into various sections, while the repetition of brushstrokes on the left actually creates a rather flat impression. The darkest shadow made by the pupil on the model's back has become just too much of an independent shape, as the edges of the shadow do not suggest the dispersal of light with enough precision.

The most notable difference in the use of the pen can be seen in the depiction of the head-dress. Rembrandt only needed a few lines and a little wash to evoke the plasticity of the form. The pupil has depicted the cap in a rather messy way with various lines in pen and brush. The crumpled-looking headdress moreover does not form such a natural entity with the head as it does in the Rembrandt drawing.

The pupil has drawn a zig-zag hatching in pen on the lower back, a somewhat isolated element and a stylistic characteristic of Aert de Gelder, appearing repeatedly in a number of drawings attributed to him (Cat. No. 47 and 48). Just as in the Rembrandt, the face of the woman is indicated with the pen and touches of the brush. But here too, the method has created rather isolated forms.

The pupil started the drawing on the reverse of the sheet. Here, we see the head and part of the back, drawn in pen only. The lines create a fragmented impression, which cannot only be explained by the omission of the wash. The pupil apparently did not think this drawing successful, which is why he turned the paper over and started again on the other side. The ear of the woman is depicted in a rather idiosyncratic manner on the recto of the sheet, by means of a few lines forming a circle in which a dark dot has been placed. We come across a similarly typical characteristic in the *Seated female nude* (Cat. No. 48). This drawing was attributed to Aert de Gelder because of the similarity in style with *A group of Orientals* (Cat. No. 47) and directly related sheets.

The Rotterdam drawing is closer to Rembrandt than the other, particularly the

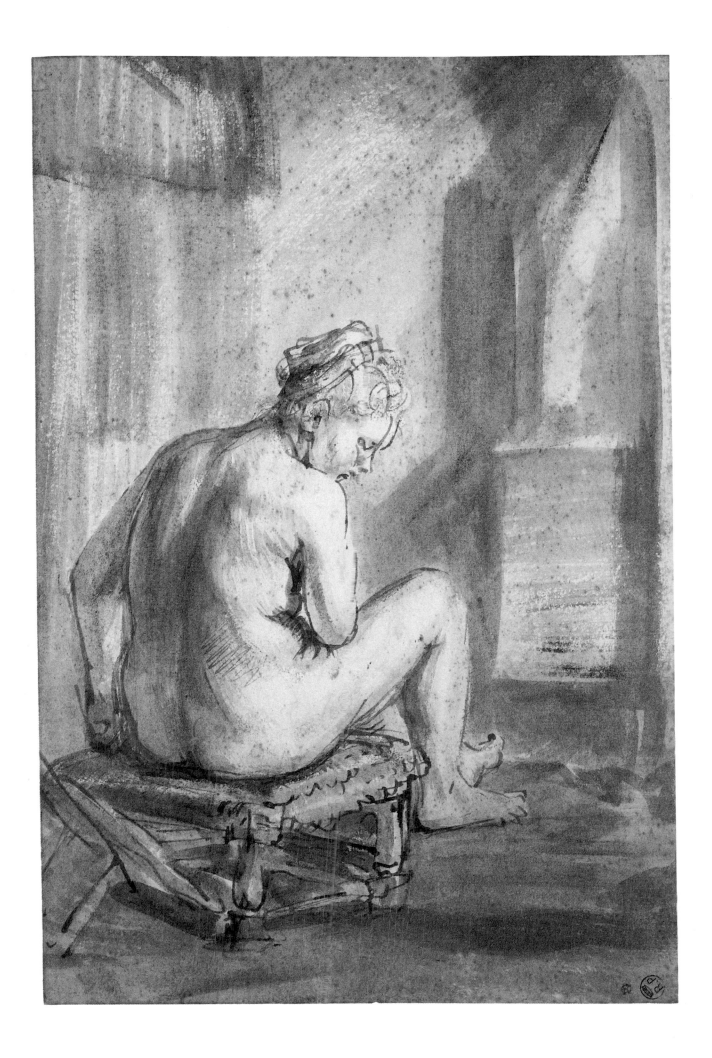

depiction of the profile on both sides of the drawing is similar to that of the *Seated female nude*. The composition of the face, the dark dot which indicates the eye and the method of shading with transparent strokes or marks, as in the neck of the woman on the back of the Rotterdam drawing, are comparable. The relation between the loose pen-lines depicting the hair and the wash through it is particularly close. The fingers of the hands of the nude seated on the bed and the visible finger of the nude by the stove are depicted with fairly similar, looped lines. The short hatchings on the stomach of the woman by the stove appear in larger scale on other drawings. Only the germ of the characteristics of de Gelder's style is to be found in the Rotterdam drawing. However, after establishing that the drawing is not by Rembrandt, it provides sufficient evidence to support the attribution to Aert de Gelder.

P.S.

1. B. 197.

50

JOHANNES RAVEN

Seated half-nude boy with clasped hands

Pen and brown ink, brown and white wash, 198 × 160 mm

Inscription: below right old Inv. No. 4912; verso: *Johannes de Jonge Raven* Munich, Staatliche Graphische Sammlung

Provenance: Mannheim, Elector Carl Theodor of the Palatinate; Inv. No. 1567.

Literature: Wegner 1973, No. 851; Sumowski *Drawings*, No. 2141 (with other previous literature); Schatborn 1985, under No. 69; Schatborn 1987, p. 313.

Exhibitions: Wolfgang Wegner, *Rembrandt und sein Kreis*, Munich 1966–1967, No. 117.

We know of Johannes Raven as a draughtsman by his signature on the reverse of the exhibited drawing (Fig. 50a).[1] He is mentioned in 1659 as a twenty-five year old painter in Amsterdam and he died in 1662.

Raven was probably a pupil of Rembrandt for a while and, together with him, made life-drawings (see Cat. No. 51). His drawing style betrays influence from Rembrandt's late drawings of the female nude. Two of Rembrandt's nudes are in Chicago (Cat. No. 38) and Amsterdam (Fig. 51b) respectively.

Raven drew the boy seated with clasped hands in scratchy, fairly carelessly placed pen-lines, with double and sometimes overlapping contours, closely placed together accents of short lines and here and there darker and broader accents. Some shadows are indicated by zig-zag hatchings. With the brush, Raven also added light shadows on the body and darker shadows in broad strokes along or very near to the outline of the figure and the cloak. The drawing was then probably completed in pen, with which Raven added new accents over the brushwork. The shadow in the background is, just as in the figure and the cloak, built up of layers of varying thickness. Especially in the hands and face we can see how Raven's fairly scratchy pen has unevenly and with occasional sharp accents, drawn the forms. The strokes of the brush along or next to the contours are also characteristic of Raven's drawing style.

A drawing of a *Seated boy holding a rope* was also attributed to Raven by Sumowski.[2] A group of nudes, which was considered by Benesch to be the work of Rembrandt, is now similarly attributed to Raven (Cat. No. 51).

P.S.

1. The drawing bearing Raven's name was published by Wolfgang Wegner in *Oud Holland* 69 (1954), pp. 236–38.
2. Basle, Kunstmuseum, Kupferstichkabinett; Sumowski *Drawings*, No. 2142–x. Henkel 1942, p. 100, under No. 1; this author attributed the drawing to Renesse. The drawing style could also be compared to that of Abraham van Dyck.

50a: verso of Cat. No. 50.

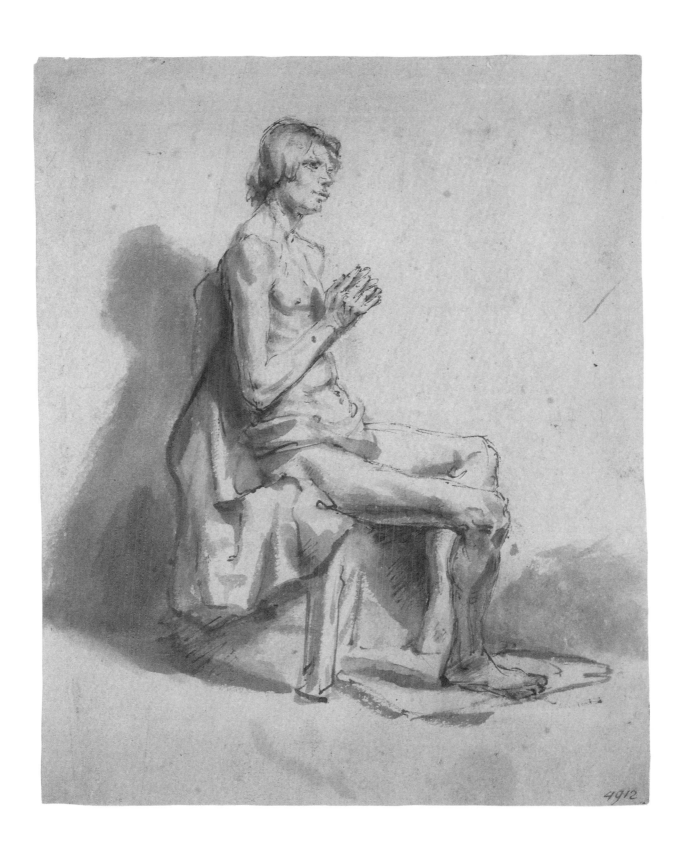

4912

51

JOHANNES RAVEN
Seated female nude

Pen and black ink, brown and grey wash, 291 × 155 mm

Inscriptions: verso: . . . *im Lanore valle Las Cases* (?); below left *No 1025, Sammlung Gsell, 230, Rembrandt*; below right *A No 610* Amsterdam, Rijksmuseum, Rijksprentenkabinet

Provenance: Joseph Daniel Böhm, sale Vienna, 4 December 1865, No. 1388; F.J. Gsell, sale Vienna, 14 March 1872, No. 610; Max Freiherr von Heyl zu Herrnsheim, Darmstadt, sale Stuttgart, 25 May 1903, No. 251; Cornelis Hofstede de Groot, The Hague, gift of 1906, in usufruct until 14 April 1930; Inv. No. RP-T-1930–57.

Literature: Benesch 1954–57 and 1973, No. 1146, as Rembrandt; Schatborn 1985, No. 69, attributed to Johannes Raven (with other previous literature and exhibitions); Schatborn 1987, p. 313, as Johannes Raven.

The group of late drawings of female nudes, to which the exhibited drawing belongs, is notable for the use of sharp pen-lines, loose hatching and extensive use of wash.[1] Always considered to be by Rembrandt, it was suggested in 1969 that only the dark wash was later added by another hand, but that otherwise the drawing was by Rembrandt.[2] In 1985 an attribution to Johannes Raven the younger was suggested for this group, a pupil by whom one documented drawing is extant (Cat. No. 50).

The seated female nude's arms are raised and she holds a cord in both hands. She is sitting on a chair covered with a cloth. The drawing is executed with various materials: initially drawn in almost black ink with the pen and then extensively elaborated with the brush in brown and grey. The contours are partly drawn with loose, sloping lines and partly with short lines; the features are depicted in the same manner. Loose and fine hatching has been applied on and around the figure. The brush has retraced the contours, and shadows have also been added to the face with the brush. The folds of the cloth have been indicated in various widths of brushstroke and the area behind the figure has been fairly evenly shadowed. Lighter shadows in grey were added to the figure and a section of the paper to the left of the figure was also covered with grey.

A drawing belonging to the same group, in London (Fig. 51a),[3] was made when Rembrandt simultaneously drew the same model from a different viewpoint (Fig. 51b).[4] The pen-lines of the London drawing are clearly derived from those of Rembrandt, but the wash displays great similarity to the exhibited sheet. Here the pupil has borrowed the loose hatching over the body from Rembrandt's drawing. But he did not adopt Rembrandt's characteristic use of transparent wash.

The most notable similarity between the exhibited drawing and the nude study by Raven (Cat. No. 50) is the way in which the wash has been applied with the brush. This is most apparent in the depiction of the clothing, where the brushstrokes follow the contours. In both cases loose hatchings have been added with the pen next to or through them. The structure of the pen lines also shows affinity, to be seen in the outlines as well as in the accents placed here and there. The feet were depicted in a similar manner, while the same scratchy lines appear in the faces.

There are also, of course, differences. In the Amsterdam drawing the pupil has allowed himself greater liberties than with the study of the male nude. The latter has a slightly more reserved character and is executed with greater precision. The drawing of the seated woman

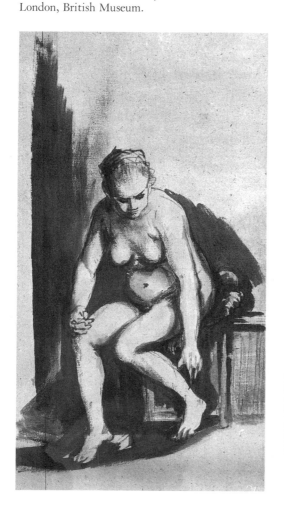

51a: Johannes Raven, *Seated female Nude*. London, British Museum.

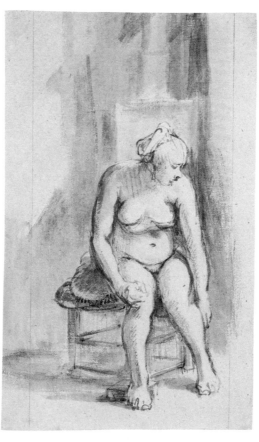

51b: Rembrandt, *Seated female Nude*. Amsterdam, Rijksprentenkabinet.

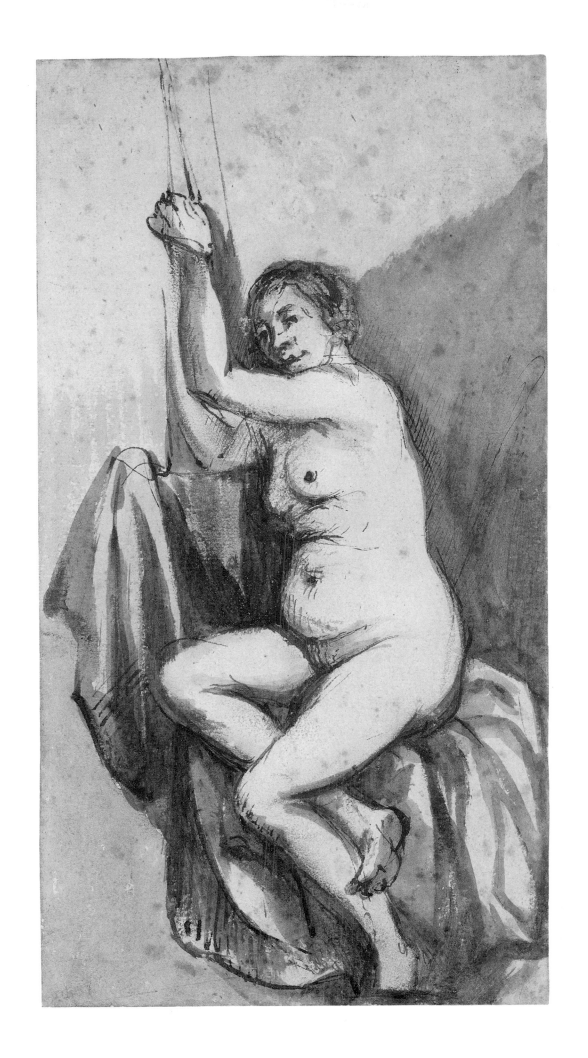

was made when Raven was still in contact with Rembrandt and the *Seated boy with clasped hands* was presumably made when he was an independent artist, in 1659 or later.

The drawing style of pupils often betrays a certain ambivalence: the pupil wants to depict the forms as well as possible, but is at the same time stimulated by Rembrandt's example to take a certain amount of liberty and to work freely; as this fluency is not developed from personal experience, the pupil sometimes aspires too high.

There is a drawing in the British Museum from the group of five female nudes,[5] possibly made when Rembrandt etched his *Woman with the arrow*, although the right arm is depicted in differing positions in the etching and the drawing.[6]

It is unlikely that the pen-drawing is by Rembrandt himself and that the wash was added later by another hand, as has been suggested. The pen-drawing itself is too far removed from Rembrandt's characteristic style, as we know it from both the drawing in Chicago (Cat. No. 38) and that in Amsterdam (Fig. 51b). Raven's pen is more careless and the forms have less plasticity. The precision with which Rembrandt drew the head with the cap and the face of the woman in the above mentioned drawings is utterly lacking with Raven; this is also the case with Aert de Gelder (Cat. No. 49).

However, it should not be ruled out that Raven himself later elaborated his drawings with the brush, but it is difficult to draw a dividing line between this later application of wash and the original drawing.
P.S.

1. London, British Museum, Benesch, Nos. 1143, 1145 and 1147; Rotterdam, Museum Boymans-van Beuningen, Benesch, No. 1144, Giltaij 1988, No. 186, as by an unknown pupil.
2. Haverkamp-Begemann in White 1969, p. 187, No. 19.
3. London, British Museum; Benesch, No. 1143.
4. Amsterdam, Rijksprentenkabinet; Benesch, No. 1142; Schatborn 1985, No. 55.
5. London, British Museum; Benesch, No. 1147.
6. B. 202.

Etchings

The exhibition of Rembrandt's Etchings was originally planned and selected by Hans Mielke and Peter Schatborn in 1988/89. The authors have been responsible for its development since 1990.

In Berlin and Amsterdam the exhibited etchings are from the respective collections (the Kupferstichkabinett SMPK and the Rijksprentenkabinet). In London the exhibited etchings are from the collection of the British Museum. In the catalogue inventory numbers are given in brackets and * indicates the example which is illustrated.

The authors are particularly grateful to Jan Kelch, Hans Mielke, Martin Royalton-Kisch and Peter Schatborn for their stimulating suggestions.

Holm Bevers and Barbara Welzel

Rembrandt as an Etcher
Holm Bevers

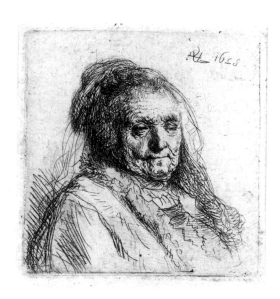

1: Rembrandt, *Portrait of his mother.* Amsterdam, Rijksprentenkabinet.

'I have seen a number of his printed works which have appeared in these parts; they are very beautiful, engraved in good taste and in a good manner . . . I frankly consider him to be a great virtuoso.'[1] So wrote in 1660 the Italian baroque painter Guercino to the Sicilian aristocrat and connoisseur Don Antonio Ruffo, whose collection contained a number of works by Rembrandt. The fame of the Dutch artist was not just confined to his native land, but was already well established in large parts of Europe, principally because of his prints.[2] In his book on the history of prints published in 1662, the English author John Evelyn praised the 'incomparable Reinbrand, whose Etchings and gravings are of a particular spirit.'[3] Rembrandt's etchings had already become collectable during his own lifetime. Michel de Marolles, whose large and important graphic collection formed the nucleus of the Bibliothèque Nationale in Paris, lists 224 entries under Rembrandt's name in his catalogue of 1666.[4] Even today, the fascination of collecting etchings by Rembrandt, especially rare impressions and states, has lost none of its mystique. Equally, his style awoke the interest of contemporary artists, and was copied by Giovanni Benedetto Castiglione (1609–1665) among others. Entire generations of artists in the eighteenth and nineteenth centuries worked in Rembrandt's manner. Even prints by Pablo Picasso contain numerous references to his etchings.

Rembrandt produced prints from about 1628 to 1661, that is from his juvenile beginnings in Leiden to his late years in Amsterdam. For unknown reasons he appears to have abandoned etching after 1661, as the only known work after this date is a portrait (B. 264) from 1665.

The earliest *catalogue raisonné* was compiled by Edmé Gersaint in 1751, and followed by Adam Bartsch's in 1797. These two authors constructed an œuvre of 341 and 375 works respectively, using his signed and dated prints as the comparative basis against which unmarked works could be stylistically evaluated. The classification system devised by Bartsch, which groups and numbers prints thematically, has successfully withstood the test of time. The number of etchings presently accepted as being by Rembrandt has shrunk to around 290, with many of those attributed to him by Gersaint and Bartsch now given to pupils or followers.

A cursory study of the prints shows that they cover a wide variety of subjects. In his paintings, Rembrandt confined himself principally to the two areas most highly regarded at that time: portraiture and illustrative themes taken from the Bible, mythology and history. For his etchings, however, he expanded his repertoire to include subjects which in seventeenth-century Dutch art were usually executed by specialists. In addition to the above-mentioned, Rembrandt turned his attention to genre, landscape, nudes, miscellaneous sketches and studies as well as allegories and still-life. The combination of his thematic diversity and his mastery of the various techniques enabled him to achieve an unrivalled intensity of artistic expression.

Known since about 1430, the medium of engraving was chiefly used in the seventeenth century for reproductive prints, that is the reproduction of paintings by professional engravers. Etching is a younger invention; some of the earliest examples were made by Dürer during the second decade of the sixteenth century. In the course of the next century, the status of etching rose to a par with that of engraving, with etchings being highly prized by collectors and artists alike. It was first and foremost the medium of the painter-etcher, that is of those artists who actually etched their own inventions. In his 1645 treatise on printmaking, the French engraver and author Abraham de Bosse recommended that etched lines be made to look like engraved ones, as these have a precise, sharp-edged appearance and produce a clearly definable structure. Rembrandt took the opposite approach: he used the needle as if it were a paintbrush, and in doing so became the first artist to maximise the aesthetic possibilities of the medium.

The soft layer of wax covering the copper plate allows the artist to draw flowing lines of diverse strength to mould his forms. Rembrandt obtained the nuances of tone used to create light by multiple biting of the plate or using acids of varying intensity. He only occasionally used the burin—the engraver's principal tool—to optimise the effectivness of hatching. Of far greater importance was drypoint, a technique which involved scratching the line directly in the metal surface with a special needle—almost like using pen on paper. The action pushes the displaced metal to the side and creates the so-called 'burr', which is coated when the plate is inked, and produces an impression with black velvety lines. The first artist to employ this technique was the Master of the Housebook, who was active in the region of the middle Rhine during the late fifteenth century. But it was Rembrandt who became the greatest exponent of drypoint by fully integrating its specific characteristics into his pictorial concept, either on its own, or in conjunction with etching. With the

exception of the landscape etchings of Hercules Seghers, no other artist experimented with printing techniques to the extent Rembrandt did. He created a very fine, powdery tone, probably by using sulphur to bite the metal, which produced an effect similar to that obtained by aquatint—a technique first tried by Jan van de Velde IV in Amsterdam during the 1650s.[5] Impressions from a plate with a porous ground are characterised by fine gradations of tone and appear as if washed. Two of the finest examples of Rembrandt's application of this technique, which he in fact rarely used, are his portrait of *Jan Cornelius Sylvius* (Cat. No. 22) and *The landscape with the three trees* (Cat. No. 19).[6]

Rembrandt was not a trained engraver but a painter, and so it is hardly surprising to find that he favoured techniques which matched his artistic inclination. For him, etching and dry-point were not subordinate mediums suitable only for reproductive exercises, rather they represented a means of achieving new heights of personal expression. While his prints were, for the most part, stylistically, iconographically and compositionally independent of his painting, they were, nevertheless, accorded equal status.

Little is known about Rembrandt's beginnings as an etcher. The two earliest dated prints are from 1628 and show Rembrandt's elderly mother (B. 352, 354). But the twenty-two year-old artist was already an accomplished and talented etcher. All the specific characteristics of his manner are evident. The lines of *The Artist's Mother* (Fig. 1) are airy and sketch-like, light and shadow are indicated not only by hatching of varying thickness, but also by lines which have been bitten to different depths. Rembrandt's attention to physiognomic detail may have been inspired by the miniature portraits engraved and drawn by Dutch Mannerists such as Jacques de Gheyn or Hendrick Goltzius. However, no prints are known which could have been of immediate importance for the development of Rembrandt's etching technique. Neither of his teachers, Jacob Isaacz. van Swanenburgh in Leiden nor Pieter Lastman in Amsterdam, can have taught Rembrandt the art of etching; indeed. Lastman did not etch at all. The question of Rembrandt's beginnings is related to the evaluation of two etchings which are usually categorised in the literature as representing the first works of the young artist, from the years 1625/26. *The Circumcision of Christ* (S. 398; Fig. 2) and *The Rest on the Flight into Egypt* (B. 59; Fig. 3) are both executed in a somewhat schematic and uncertain manner, and although the former bears the signature *Rembrant fecit*, its

authenticity is by no means certain.[7] *The Rest on the Flight into Egypt* is related, but not stylistically identical. Its quick, sketchy lines and the frequent use of zig-zag are features of a group of early etchings by Jan Lievens, who was also active in Leiden between 1625 and 1631.[8] His etching of *St John the Evangelist* (Fig. 4) bears the name of Jan Pietersz. Berendrecht, a publisher in Haarlem, whose address also appears on *The Circumcision* attributed to Rembrandt. While the conceptual approach of both artists shows the influence of their teacher Lastman, their graphic style does not.[9] Moreover, their manner of etching cannot be connected directly to the generation of important Dutch etchers, such as Esaias and Jan van der Velde and Willem Buytewech, who were active during the first three decades of the seventeenth century. A possible source of inspiration may have been the etchings of Moses van Uyttenbroeck and Jan Pynas;[10] equally Gerrit Pietersz. Sweelinck, the first important Dutch painter-etcher and Lastman's teacher, may have played a role.[11] Related to *The Rest on the Flight into Egypt* is a small group of etchings (B. 9 & 54) which are considered to be by Rembrandt from c. 1626/27. However, Rembrandt as an etcher is only really tangible with the appearance in 1628 of his first dated prints.

Towards the end of his stay in Leiden and for a period after he moved to Amsterdam in 1631, Rembrandt produced a number of small self-portraits (Cat. Nos. 1 & 2), portraits of old men, possibly including his own father, as well as some of his aged mother (Cat. No. 4). All of these served as studies of the 'affetti' and physiognomy of the elderly. Around 1629/30 he captured beggars and other street dwellers in small genre illustrations (Cat. No. 3), for which he was thematically and technically motivated by the etchings of beggars by the French artist Jacques Callot. A group of etchings showing heads and beggars executed around 1631 in a coarse and schematic style was previously accepted, by Bartsch among others, as original; they can, however, now be attributed to pupils, including Jan Joris van Vliet.[12] In addition to portraits and genre scenes, Rembrandt now turned his attention to an object which was to fascinate him for the rest of his life: the bible. Instead of following the tradition of producing a complete cycle to illustrate his chosen subject, he usually confined himself to a single print. The majority of those produced around 1630 are small many-figured scenes, conceived in a painterly fashion (B. 48, 51, 66); indeed, images such as *The Circumcision of Christ* (B. 48; Fig. 5) are more or less translations of his earlier history paintings into miniature-scale

etchings.[13] Rembrandt constructed his figures and the other elements of his composition by means of a complex system of lines of varying density and bitten depth.

As well as his role as a painter-etcher in the early 1630s Rembrandt turned to reproductive prints. His model was undoubtedly Rubens, who sought to publicise his compositions by having them reproduced in Antwerp by engravers who remained under his constant supervision. In 1631 Jan Joris van Vliet, then active in Leiden, etched four designs which name Rembrandt as the *inventor*; one of the paintings which served as a model is still in existence.[14] After Rembrandt moved to Amsterdam in 1631 Van Vliet continued to work for him; he reproduced some studies of heads in addition to his more famous etchings of Rembrandt's two large baroque compositions, *The Descent from the Cross* (B. 81; Fig. 6) of 1633 after the panel from the cycle of the Passion painted for Frederik Hendrik (Munich, Alte Pinakothek), and the *Ecce Homo* (B. 77; cf. Cat. No. 38) of 1635–1636 after a grisaille specially painted for this purpose (London, The National Gallery).[15] Both etchings were at one time believed to be by Rembrandt, but he probably made only the final corrections to the plates before the prints—with his name and privilege—were placed on the market. Other grisaille paintings from the 1630s may have been intended to serve as models for prints which were never made.[16] As it was, Rembrandt made little use of the possibilities of reproductive prints, and by 1636 had abandoned them altogether—in contrast to Rubens for whom they constituted a successful and profitable section of his business. Apparently Rembrandt's standing as a painter-etcher was such that he felt he could devote himself exclusively to this activity, especially as he knew public opinion judged etching to be artistically equal to reproductive prints.[17] Furthermore, there may also have been the problem of finding suitable engravers and publishers—essential for anyone wishing to compete with the outstanding quality of the prints leaving Rubens's studio.[18]

The majority of Rembrandt's own etchings from the early 1630s illustrate genre and biblical themes. In his principal religious etching of this period, *The Annunciation to the Shepherds* of 1634 (Cat. No. 9), Rembrandt's dramatic rendering of light and dark paves the way for his future achievements. Despite the acclaim he received as a portraitist during his first years in Amsterdam, Rembrandt etched only a few portraits (B. 266, 269). A distinctive group of prints from the middle of the 1630s are his etched sheets of sketches (Cat. No. 5 & 12), and Rembrandt

2: Rembrandt, *The Circumcision*.
Amsterdam, Rijksprentenkabinet.

3: Rembrandt, *The Rest on the Flight into Egypt*.
Amsterdam, Rijksprentenkabinet.

4: Jan Lievens, *St John the Evangelist*.
Amsterdam, Rijksprentenkabinet.

appears to have been the first to render as a print an artistic process which belongs to the medium of drawing.

Towards the end of the 1630s, possibly from 1637, Rembrandt developed a more spontaneous and freer approach, and on occasions simply delineates his figures. From 1639 he used the medium of drypoint with increasing frequency, particularly to accentuate contours, and indeed entire sections, by means of dark velvety lines. Rembrandt must have realised that he could not achieve a sufficiently dramatic and painterly effect when rendering light and dark by relying solely on bitten lines of varying depth. The first two etchings to be reworked using drypoint were his wonderful rendering of *The Death of the Virgin* (Cat. No. 14) of 1639 and *The Presentation in the Temple* (B. 49), probably from the same year.

The Death of the Virgin reflects Rembrandt's preoccupation with Dürer's woodcut cycle devoted to the Life of Mary. Rembrandt's study of the works of other artists must be seen as a continuous and varied dialogue. His own enormous collection of paintings, sculpture, medallions and numerous albums containing drawings and prints by predecessors and contemporaries provided a constant source of inspiration.[19] *Imitatio* was not considered a sign of an artist's inability to invent, rather it demonstrated the breadth of his erudition and education. Artists should attempt not only to compete with famous models but also to surpass them.[20] Rembrandt had detailed knowledge of his artistic heritage, especially the history of graphic art. The fact that he filed his own prints among the works of those artists he most admired testifies to his awareness of his own role within the historical development. His collection was undoubtedly a status symbol intended to document his affiliation to the social class of 'gentlemen *virtuosi*'.[21]

The contents of the *kunst boecken* show Rembrandt to be a collector with encyclopaedic taste and the eye of a connoisseur; he was as interested in quality as in variety and completeness. Thanks to the inventory of 1656 we are well-informed about the contents and arrangement of his collection.[22] He possessed folders of prints of the great Italian renaissance and baroque artists: engravings and etchings by Andrea Mantegna, the Carracci, Guido Reni and Jusepe de Ribera; woodcuts after designs by Titian and three *kostelijcke boecken* devoted entirely to prints after Raphael. In addition, Rembrandt owned albums containing works by the most important earlier and contemporary Netherlandish and German artists: engravings and woodcuts by Martin

Schongauer, Lucas Cranach, Albrecht Dürer and Lucas van Leyden; prints after Pieter Bruegel and Marten van Heemskerck; engravings by his famous Dutch predecessor Hendrick Goltzius; reproductive prints after Rubens, Jacob Jordaens and Anthony van Dyck; not to mention works by his own contemporaries and pupils, such as Jan Lievens and Ferdinand Bol.

The works he used as models served very different purposes. Beyond providing inspiration for compositions (Cat. No. 8, 10, 24, 40), they offered Rembrandt the opportunity of engaging in artistic *paragone*: his *Ecce Homo*, for example, is related to the famous engraving by Lucas van Leyden, which Rembrandt had acquired for a large sum of money (Cat. No. 38). It was not unusual for him to integrate into his compositions individual elements or figures 'borrowed' or adapted from other artists, as in the case of a putto from Raphael's *Triumph of Galatea* whom Rembrandt changed into an ordinary boy (Cat. No. 10). Rembrandt studied the printing technique of Andrea Mantegna, especially his manner of hatching (Cat. No. 36 & 37). The initial idea for his famous *Self-portrait leaning on a stone sill*, in which he portrayed himself as a true *gentiluomo* (Cat. No. 13), came from Raphael's portrait of *Baldassare Castiglione*, which Rembrandt copied in 1639, and Titian's so-called *Ariosto*.

It is difficult to characterise the stylistic tendencies of the 1640s. Simple, quiet forms abound. More emphasis is placed on the contours of the figures, while at the same time a reduction in their vitality and movement can be observed. Moreover, frequent changes in style occur. For example, *Abraham and Isaac* (B. 34) and *The Rest on the Flight into Egypt* (B. 57) are both from 1645 (Figs. 7–8), yet the former could be described as 'painterly' in style, while the latter is more 'linear'. To a certain degree, the subject matter influenced Rembrandt's choice of etching technique. His portraits (Cat. No. 16) are more in line with the systematic parallel- and cross-hatching of engravings, while the sketchy manner of his landscapes is not unlike that of his landscape drawings (Cat. No. 20). In other words, the artist approached these two particular themes in a very different manner.

Around 1646–47 Rembrandt made a number of portraits, most of which were probably commissioned, of friends and public figures in Amsterdam. In the most important of these, the portrait of 'Jan Six' from 1647 (Cat. No. 23), Rembrandt favoured a dense, dark structure, broken only by a few bright areas to highlight and define the sitter's features. In no other etched

5: Rembrandt, *The Circumcision*. Amsterdam, Rijksprentenkabinet.

6: Rembrandt, *The Descent from the Cross*, Amsterdam, Rijksprentenkabinet.

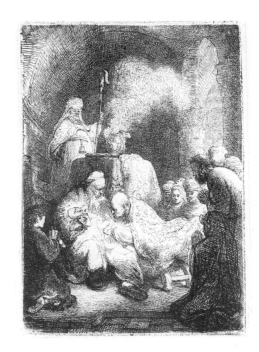

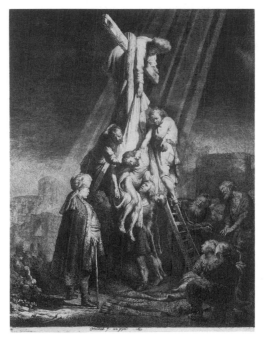

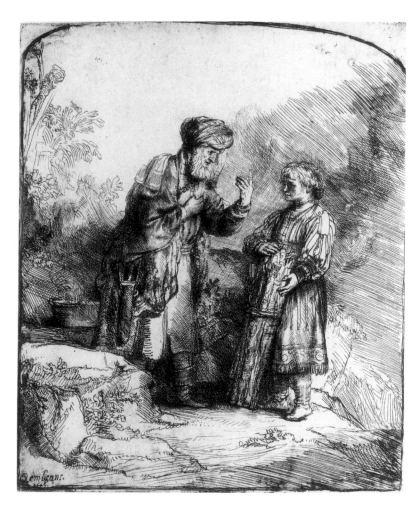

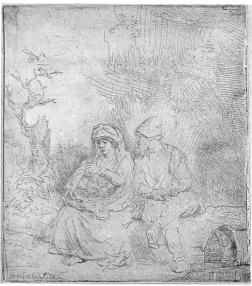

portrait did he come as close to giving his print the appearance of a mezzotint. This can hardly have been a coincidence, but rather the result of Rembrandt constantly exploiting all the means at his disposal to achieve optimum tonality. The technique of mezzotint was discovered during the 1640s; it involves first roughening the entire plate and then scraping down the 'burr' created by this process in proportion to the lightness of tone required.[23] The 'painted' appearance of the superb *Hundred Guilder Print* (Cat. No. 27) of 1647 is the result of the combined use of different techniques and lines; here Rembrandt employed his entire stylistic repertoire in one work.

Although Rembrandt painted comparatively few landscapes, they play an important role in his etched œuvre. In his paintings of the late 1630s and early 1640s he made ample use of heroic compositions with mountains and dramatic lighting, but for his prints—and drawings—he turned to the low, flat countryside of his native soil. It was also during these years that he produced a number of prints of male nudes, which, among other things, may have served as models for his pupils to improve their drawing skills (Cat. No. 21).

Around 1650 a radical change occurred in Rembrandt's graphic work. The individual, block-like elements of his compositions are organised into a clearly definable arrangement of receding parallel layers. His attitude to the actual line also changed considerably: in place of finely moulded forms, he now favours regular oblique lines of parallel hatching which cut across the different elements. Rembrandt may have adapted this hatching system from the engravings of such artists as Andrea Mantegna. These lines are especially prevalent in his biblical themes which, around the middle of the 1650s, were frequently conceived as cycles (Cat. No. 36 & 37). In Rembrandt's landscape etchings of 1650–1652 drypoint plays an increasingly important role (Cat. No. 28), as is evident from the velvet tonality of early impressions of the first state of the *Landscape with three cottages* (Cat. No. 32). The same applies to his portraits from the middle of the 1650s (B. 274, 275), with the exception of the 'sketchy' *Portrait of Clement de Jonghe* (Cat. No. 30). Rembrandt's triumphant masterpieces of the 1650s are the two large religious illustrations, *The Three Crosses* of 1653 (Cat. No. 35) and the *Ecce Homo* of 1655 (Cat. No. 38). Both are done in drypoint—although other techniques are evident in the former—and apparently without using bitten lines to provide a rough guide. The soft, velvety tonality of the drypoint burr is

particularly effective in the *Ecce Homo*, especially in the early impressions of the first state printed on Japanese paper (Fig. 9).

The 1650s can be termed Rembrandt's 'experimental phase', with the actual process of printing assuming an even greater importance. Either by leaving the ink on the plate, or by wiping it so that only a film of ink remains, Rembrandt achieved a surface tone somewhat like a wash. This not only affected the actual appearance of the impression, but had the further advantage of making each impression unique. The effect created by surface tone is comparable with that produced by monotype, or single print. This technique, invented by Giovanni Benedetto Castiglione in the 1640s, requires the artist to draw his design directly in the inked plate before running it through the press. Understandably, scratched or bitten lines play no part in this process. The most extreme example of Rembrandt employing surface tone can be seen in *The Three Crosses* (Cat. No. 35): in the first, second and fourth states the crucified figure of Christ is bathed in light, otherwise he is submerged with his fellow suffers in a uformly dark surface tone.[24] Moreover, Rembrandt consciously used the condition of the plate to create surface texture by retaining the scratches and stains which occur when the plate is wiped or incorrectly bitten. The sky of many of his landscapes, including *The Goldweigher's Field*, *St Jerome* and the *Landscape with the three cottages* (Cats. Nos 28, 31 & 32 respectively), is marked by such irregularities.

The type of paper used played an ever increasing role for the overall appearance of the impression. In addition to the common white hand-made paper of Europe, Rembrandt used paper from the Far East which was imported through the port of Amsterdam. Paper from Japan and China was luxurious and expensive, thin and absorbent, and its ivory-yellow or light grey tone produced a warm, soft effect. Such paper was particularly well-suited as it softened the otherwise hard contrast between bitten and scratched lines, as the impressions of *The Landscape with the Goldweigher's Field* (Cat. No. 28) exemplify. The majority of the first and second state impressions of the *Hundred Guilder Print* (Cat. No. 27) owe at least part of their atmospheric effect to having been printed on Japanese or Chinese paper. Far Eastern paper was also used for quite a large number of impressions of the *Ecce Homo* (Cat. No. 38). Not quite so common are prints on thick, grey oatmeal (cartridge) paper, which also produces an interesting surface texture. Rembrandt sometimes used vellum (Cat. No. 35), but this was expensive and not very suitable as it

9: Rembrandt, *Ecce Homo* (detail). Berlin, Kupferstichkabinett SMPK.

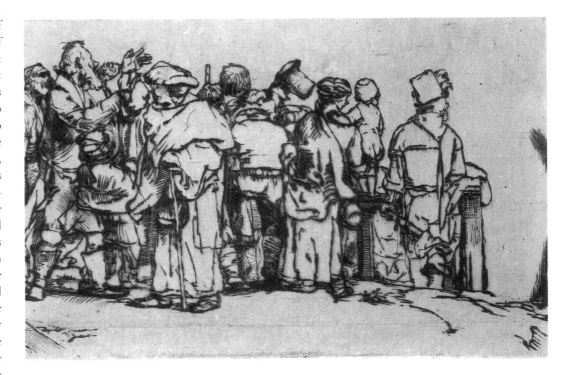

soaked up a lot of colour, made lines appear fuzzy and, because it tended to run, produced almost completely black areas.

An important aspect of Rembrandt's graphic art is his reworking of his plates. In the beginning, such changes were frequently just corrections to unimportant details, as in *The Artist's Mother* (Cat. No. 4) and *The Fall of Man* (Cat. No. 11). It is unfortunately not always possible to establish—and the existing catalogues are not very precise—the role of the different states of a plate in the evolution of a design. To take the example of first-state impressions: is one dealing with a finished design even when alterations follow, or with a trial proof; that is, an impression taken by the artist from the unfinished plate so that he can establish whether further work is required? Obvious mistakes and the number of extant impressions could in a number of cases help clarify the problem.[25] Only two impressions of the first state of *The Annunciation to the Shepherds* (Cat. No. 9) exist, and both of these are trial proofs. The first state of the *Self-portrait drawing at a window* (Cat. No. 25) could be a trial proof, even though a relatively large number of impressions exist. The case of *The Pancake Woman* (Cat. No. 10) is more complex: the two known impressions of the first state show the principal figure unfinished, yet both are signed and dated—a fact which could understandably be interpreted as confirmation that Rembrandt had completed his work on the plate. This may indeed have been the situation, and only after a number of impressions had been made did he reconsider the result and return to the plate—an approach which is also evident in other prints.

From 1647/50, or the start of Rembrandt's 'experimental phase', a more radical reworking of his plates involving changes to the original design can be observed (Cat. No. 35, 38). The most drastic alteration in the history of prints was made by Rembrandt to his two large illustrations of the Passion from the middle of the 1650s. The fourth state of *The Three Crosses* (Cat. No. 35) differs from the preceeding ones to such an extent that one can speak of a new pictorial variation which condenses and dramatises the original composition. Less far reaching are the alterations to the plate of the *Ecce Homo* (Cat. No. 38).[26]

No other artist in the history of print-making reworked his plates as frequently as Rembrandt. Rare states were highly prized by collectors from the start. Rembrandt himself possessed a number of 'proefdrukken' or trial proofs of engravings after Rubens and Jacob Jordaens.[27] The famous collection amassed from about 1670 by Jan

Pietersz. Zomer (1641–1724) contained, according to the catalogue published in 1720, all of Rembrandt's etchings in different states.[28] At that time, connoisseurs collected prints according to the quality of the impressions and the paper, as well as for their rarity. Arnold Houbraken, discussing Rembrandt in his *Groote Schouburgh* (1718), wrote:'This manner [of producing different states] brought him great fame and not a small profit; especially his art of making slight changes and unimportant additions to his prints so that they be sold anew. Indeed, the tendency at this time was such that no one could call himself a connoisseur who did not possess Juno with and without a crown, Joseph with a light and dark face, and others of the same kind'.[29] Basically, he sees in the frequent reworking of the plates a good business sense. It is, however, wrong to imagine that pure market-strategy lay behind Rembrandt's working methods and artistic intentions.[30] Houbraken's story is not unlike those recorded by other writers on art, such as Gersaint's tale of Rembrandt fabricating the auction of his estate for financial gain: they all belong to the myth that Rembrandt was avaricious.[31] But Houbraken's text does contain a grain of truth, for at the same time as connoisseurs awoke to the desirability of such prints as visual documentation of the intellectual creative process it became interesting for artists to produce so many different states; Rembrandt, it could be said, both created and satisfied the demand.

The fact that alterations to the plates could play an important role in the evolution of a design indicates that Rembrandt may have frequently drawn his composition directly in the thin layer of ground covering the plate without first making preparatory studies; in exceptional cases he may have even scratched the design directly into the plate itself.[32] This may also account for the presence in some etchings of parts of older and abandoned designs which Rembrandt did not bother to burnish out—possibly because bizarre 'capricci' appealed to him. Such prints include the *Landscape with three trees* (Cat. No. 19) and *The Virgin and Child in the clouds* (B. 61). The latter shows an upside-down head at Mary's feet which may possibly have been the Virgin's face in an earlier version.[33] Rembrandt also employed a method commonly used by engravers, including Hendrick Goltzius, which involved using a 'sketch' on the plate as the basis for the composition. The few extant trial proofs, such as those for *The Annunciation to the Shepherds* (Cat. No. 9) and the *Portrait of a bald-headed man* from

1630 (B. 292), give valuable insights into this process. The first state (Fig. 10) of the latter shows the finished head of the old man, but with the bust only lightly sketched; the second (Fig. 11) shows the bust completely etched-in.

When changes were to be made to an existing plate, Rembrandt frequently tested his ideas on an earlier impression rather than make an extra preparatory sketch. However, he did not always use these corrections. He added his body in black chalk on the second and fourth states of his early *Self-Portrait* of 1631 (B. 7; in London and Paris respectively; Fig. 12), but only in the fifth state did he actually etch it. Rembrandt made corrections on six different impressions of the first state of his *Self-portrait leaning on a stone sill* before finally deciding which was the most suitable for the second state (Cat. No. 13). Comparable alterations can also be seen in the complex evolution of the *Raising of Lazarus* (Cat. No. 7), while corrections on the counterproofs of the portraits of *Jan Cornelisz. Sylvius* (B. 266; London) and *Jan Lutma* (B. 276; Amsterdam) indicate that they may also have served the same purpose.

Although preparatory drawings by Rembrandt for etchings are rare, the extant examples are sufficient in number to permit us to establish their function within the creative process: they served as preparatory sketches for individual features as well as for entire compositions, as studies for single figures and groups, as complete designs and, finally, as an actual model—the latter two naturally in reverse to the etching itself.[34] In many cases Rembrandt probably first sketched a rough outline of the composition, although few such drawings have survived. A sketch in red chalk for the small etching of 1638 showing *Joseph telling his Dreams* (B. 37; Drawings Cat. No. 2) is known.[35] Individual studies of figures were made before or during work on the copperplate. On a sheet of drawings in Leiden, Rembrandt experimented with the pose of Adam and Eve for the etching of *The Fall of Man* (Cat. No. 11), and studies of figures and groups for the *Hundred Guilder Print* have also survived. One can assume that such studies also existed for equally complicated, many-figured compositions such as the *Ecce Homo* (Cat. No. 38) and *The Three Crosses* (Cat. No. 35).

More frequent are pen and wash studies. The principal features of the compositions for *Jan Cornelisz. Sylvius* (Cat. No. 22) and *St Jerome* (Cat. No. 31) were established in such studies, although the finished etchings show minor changes. Only four drawings have survived which were used to transfer the design directly onto the copper-plate. They are drawn in black or red chalk, and include one for each of the portraits of *The Preacher Cornelis Claesz. Anslo* (Cat. No. 16) and *Jan Six* (Cat. No. 23). The numerous studies for the latter show the care taken by Rembrandt in the preparation of this portrait, but this is an exception.

We know almost nothing about the distribution of Rembrandt's etchings. For a short period during the 1620s he may have been employed, together with Jan Lievens, by the Haarlem publisher Johannes Pietersz. Berendrecht (cf. p. 160). During the early 1630s Rembrandt appears to have attempted to establish a commercial publishing company for reproductive prints modelled on the system devised by Rubens in Antwerp (p. 163). Hendrick Uylenburch, an influential art dealer in Amsterdam and a relative of Rembrandt's wife, Saskia, was involved in the enterprise as he is named as publisher on the third state of *The Descent from the Cross* (B. 81).[36] However, they soon disbanded their association. As all other etchings omit any mention of a publisher,[37] it seems possible that Rembrandt printed them in his own studio; he may even have been responsible for their distribution. Such an assumption is supported by the high standard of the impressions and the frequent reworking of the plates. It seems probable that the majority of Rembrandt's plates were still in his studio during his last years, even though they are not listed in the inventory of 1656.[38] Nevertheless, one cannot exclude the possibility that outside publishers were recruited. Documents relating to a legal battle show that in 1637 Rembrandt sold the plate of *Abraham casting out Hagar and Ishmael* (B. 30) to the Portuguese painter Samuel d'Orta, then a resident of Amsterdam. This transaction probably gave d'Orta the right to make further impressions.[39] If d'Orta was also active as a publisher—as the sale of the plate to him indicates[40]—then the inference is that Rembrandt may have frequently sold plates after he had made a number of impressions for his own use. This is supported by the legal dispute which reveals that Rembrandt was accused of making too many impressions for himself, contrary to his agreement with d'Orta. In individual cases the plates may have passed to the person who commissioned the etching, particularly if it involved a portrait (Cat. No. 23).

Only much later does a publisher again enter the scene. It is unclear whether Rembrandt actually worked for Clement de Jonghe (Cat. No. 30). It was probably only after Rembrandt was declared insolvent in 1656 that De Jonghe acquired seventy-four of his plates. Although he did not add his own name, de Jonghe, who died in 1677, continued to have impressions made from them, even after Rembrandt's death in 1669. These plates, which included *The Fall of Man* (Cat. No. 11), *The Pancake Woman* (Cat. No. 12), *The Hurdy-Gurdy Player and his Family receiving Alms* (Cat. No. 26) and *Faust* (Cat. No. 33), are listed in the 1679 inventory of de Jonghe's estate.[41] They span the different phases of Rembrandt's career, and show that impressions from older works could always be produced if there was a demand. In the eighteenth century, and indeed up to 1906, impressions were made from a number of the extant plates. many of which had been reworked since Rembrandt's day to enliven worn-out areas.[42]

The original number of impressions published in an edition is a matter for conjecture. An estimate can be gauged from the extant impressions, even after taking into account that a number have been lost over the centuries and that not all surviving examples from a plate are known. An etched plate can only produce a certain number of high-quality impressions because the process of printing wears down the etched lines, making them more indistinct with every impression. Approximately one hundred excellent impressions could have been obtained from one of Rembrandt's plates. However, this number sank drastically if drypoint was used because the burr is much more fragile. From such plates Rembrandt may have acquired fifteen to twenty really excellent impressions; a number which is consistant with existing examples. The velvet tonality so characteristic of the technique diminishes with every impression made over and above this number. Unfortunately, it is difficult to tell, especially when the plates have not been reworked by a later hand, whether it was Rembrandt or later owners who produced impressions of poor quality. Light could be shed on this problem by examining the watermarks, as well as by placing greater importance on the actual quality of extant impressions. Moreover, research in the archives in Amsterdam into publishers who might have worked together with Rembrandt could also prove to be rewarding.

When Rembrandt died in 1669 his etchings were to be found in all the famous print collections. The importance of his graphic work was never questioned, even by those late seventeenth- and eighteenth-century classicists who criticised his apparent disregard for the 'rules' of art. In his book on graphic art published in Florence in 1686 Baldinucci praised Rembrandt's 'highly bizarre technique, which he invented for etching and

which was his alone, being neither used by others nor seen elsewhere. This he achieved by using lines of varying lengths and irregular strokes, and without outlines, to create a strong *chiaroscuro* of painterly appearance'.[43] Baldinucci emphasised the free and easy manner of Rembrandt's etchings, and it is this which separates them from the systematised appearance of reproductive prints and ensured they maintained an exemplary position until well into the nineteenth century. Of course Rembrandt was not the only artist in the seventeenth century to work in this manner, but he was the only one to apply it so significantly and in such extremes.

The important exhibitions on Rembrandt in Rotterdam and in Amsterdam in 1956 and again in Amsterdam in 1969 completely ignored his etchings. Unfortunately this has not been rectified in recent years, although Rembrandt's paintings and drawings continue to be the subject of much discussion. Such neglect may be the result of an increased interest in the more easily definable reproductive prints which distract attention from Rembrandt's very different 'bizarre' style. Our view of Rembrandt as a painter and draughtsman has been changed both by the work of the Rembrandt Research Project and the publication of numerous catalogues devoted to his drawings.[44] Moreover, because considerable attention has been paid to paintings and drawings by Rembrandt's pupils and followers,[45] it has been possible to make a clearer distinction between these and autograph works by the master. This in turn has furthered our knowledge of studio practice and the method of working favoured by Rembrandt. Unfortunately, his prints have not yet been subjected to a comparable study. The aim of such a study should be twofold: on the one hand, technical aspects relating to questions on states and trial-proofs, the number of impressions which made up an edition as well as the watermarks must be examined, and on the other, a more detailed analysis of the themes and function of Rembrandt's etchings must be undertaken.

1. '. . . perche io ho veduto diverse sue Opere in stampa comparse in queste nostre parti, le quali sono riuscite molto belle, intagliato di buon gusto e fatte di buona maniera . . . et io ingenuamente lo stimo per un gran virtuoso.' Cf. W. Strauss and M. van der Meulen, with the assistance of S. Dudok van Heel and P.J.M de Baar. *The Rembrandt Documents*, (hereafter cited as *Documents*), 1979, p. 457, No. 1660/7.

2. Slive 1953, pp. 27 ff.

3. Cf. *Documents* 1979, p. 519, No. 1662/16.

4. *Documents* 1979, p. 565, No. 1666/7.

5. Cf. e.g. Holl. 1 (*Portrait of Christina of Sweden*) and Holl. 2 (*Portrait of Oliver Cromwell*).

6. Boston 1980–81, p. XXIII and pp. 150 ff., Cat. No. 97.

7. *The Circumcision*, which Gersaint (1751, G. 48) first recognised as entirely autograph, is generally considered to be Rembrandt's earliest etching. However, Hind (1912, No. +388) rejected the sheet. Under no circumstance should the inscription *Rembrant fecit* be taken as absolute proof as this was only added in the second state.

8. B. and Holl. 4, 10; cf. Amsterdam 1988–89, pp. 22 ff.

9. Only a small pen drawing by Lastman from 1613 (Paris, Fondation Custodia) shows comparable lines; cf. Amsterdam 1988–89, pp. 5 ff.; Schatborn 1990, pp. 120 ff., Fig. 5.

10. Bauch 1960, pp. 103 ff.

11. Slatkes 1974, p. 252. On Gerrit Pietersz., see Boston 1980–81, pp. 18 ff.; Holl. 1–6.

12. Among others: B. 6, 175, 298, 314, 337; cf. Hind 1912, pp. 24 ff.

13. This can be seen, for example, from a comparison between the paintings of *Judas returning the Thirty Pieces of Silver* (Corpus A15) and *The Presentation in the Temple* (Corpus A34).

14. It is the *Old Woman reading* (B. 18) after the painting in the Rijksmuseum, Amsterdam (Corpus A37); cf. Cat. No. 4, Fig. 4a. The etching is reversed. The other etchings are B. 1, 12 and 13; cf. Bruyn 1982, pp. 35 ff.

15. Corpus A65 & A89; Hind 1912, pp. 28 ff; Royalton-Kisch 1984.

16. *Joseph telling his Dreams*, Rijksmuseum, Amsterdam (Corpus A66); *John the Baptist preaching*, Gemäldegalerie SMPK, Berlin (Corpus A106); cf. Paintings Cat. No. 20.

17. Robinson 1980–81, p. XLIV.

18. The extent to which other etchings, which are generally accepted as by Rembrandt, could in fact be reproductive works by pupils has not as yet been explained satisfactorily, and cannot be dealt with here; some scholars consider the following to fall into that category: *The Good Samaritan* from 1633 (B. 90) and *Jan Uytenbogaert weighing Gold* from 1639 (B. 281). The hatching in the upper part of the etching of *The Artist drawing from a model* (Cat. No. 15) could be by a pupil. See for example, Haden 1877, pp. 34 ff.; Hind 1912, pp. 28 ff.; Royalton-Kisch 1984.

19. Scheller 1969.

20. Cf. Amsterdam 1985–86, pp. 4 ff.

21. Scheller 1969, pp. 128 ff.

22. *Urkunden*, pp. 200 ff., No. 169; *Documents* 1979, pp. 367 ff. No. 1656/12.

23. Cf. Boston 1980–81, pp. XXXIII ff.

24. See the detailed description in London 1969, pp. 18 ff., No. X; Boston/New York 1969–70, pp. 86 ff., No. XIII; Amsterdam 1981, pp. 41 ff.

25. Pure trial-proofs are B. 8 I, 44 I, 77 I (van Vliet), 222 I, 281 I, 292 I, 340 I and II, 354 I.

26. On this cf. Boston/New York 1969–70, pp. 101 ff.. No. XIV.

27. *Urkunden*, p. 203, no. 169; *Documents*, p. 375, No. 1656/12; Robinson 1980–81, p. XLIII.

28. Robinson 1980–81, p. XL.

29. 'Dit doen bragt hem grooter roem en niet min voordeel by: inzonderheid ook het kunsje van lichte verandering, of kleine en geringe byvoegzelen, die hy aan zyne printjes maakte, waar door dezelve andermaal op nieuw verkogt werden. Ja de drist was in dien tyd zoo groot dat zulke luiden, die het Junootje met en zonder 't kroontje, 't Josephje met het wit en bruine troonitje en diergelyke meer, niet hadden.' Houbraken 1718, p. 271. Significantly, Houbraken follows this with a discussion of Rembrandt's pupils and the income they generated.

30. Alpers 1989, pp. 242 ff.

31. Gersaint 1751, pp. XXVIII–XXIX; Kris/Kurz 1980, p. 145.

32. See B. 107, 192 and 222 for sketches in drypoint. On B. 192, cf. Cat. No. 15.

33. Cf. Campbell 1980, pp. 10 ff.

34. Cf. Schatborn 1986, pp. 1 ff.

35. See Giltaij 1990.

36. In the fourth state the address was changed to that of Justus Danckers, who worked in Amsterdam during the 1680s.

37. An exception is the fifth state of *The Three Crosses* (Cat. No. 35): it bears the address of Frans Carelse.

38. Strauss 1983, pp. 261 ff.

39. *Documents*, p. 145, 1637/7; Amsterdam 1987–88, pp. 78 ff., nos. 55–56.

40. Plates sometimes found their way into the hands of other artists. A case in point is that of a plate by Hercules Seghers which was in Rembrandt's possession and which he transformed from a rendering of *Tobias and the Angel* into *The Flight into Egypt* (B. 55); cf. White 1969, pp. 218 ff.

41. De Hoop Scheffer/Boon 1971, pp. 2 ff.

42. A number of De Jonghe's plates were acquired by the Amsterdam collector Pieter de Haan (1723–1766), and later by the French amateur-engraver Claude-Henri Watelet. He owned 81 plates obtained from different sources. These plates were then bought by the French dealer Pierre François Basan, who had new impressions made for his *Recueil*, which was published between 1789 and 1797. The plates, which were in use until 1906, are now in the Museum of Raleigh, North Carolina. Cf. Hind 1912, pp. 16 f., note 2; White 1969, Vol. 1, pp. 11, 19; De Hoop Scheffer/Boon 1971, pp. 2 ff.

43. '. . . fu una bizzarrissima maniera, ch'egli s'inventò, d'intagliare in rame all'aqua forte, ancor questa tutta Sua propria; ne più usato da altri, ne più Veduta, cioè, con certi freghi, e freghetti, e tratti irregolari, e senza dintorno, facendo però risultare dal tutto un chiaro scuro profonda, e di gran forza, ed un gusto pittoresco . . .'; *Urkunden*, pp. 419 ff, No. 360, § 13.

44. Of particular importance are the catalogues of Rembrandt's drawings in Amsterdam and Rotterdam; cf. Schatborn 1985 and Giltaij 1988 respectively. The catalogue of the collection in London by Martin Royalton-Kisch will be published to coincide with the opening of the exhibition in the British Museum. Hans Mielke is preparing the catalogue of the drawings in Berlin.

45. Cf. Sumowski, *Drawings*.

I

Self-portrait in a cap, open mouthed

Etching and burin, 51 × 46 mm; one state
Signed: *RHL 1630.*
B./Holl. 320; H. 32; White pp. 108–9

Berlin: I (36–16)*
Amsterdam: I (O.B. 697)
London: I (1973 U. 769)

Rembrandt, lips parted and eyes open wide, fixes the viewer with his stare. A harsh light from the upper left plays across his face, casting the underside of his cap, forehead and left cheek into deep shadow. The left shoulder across which Rembrandt looks towards the viewer is only cursorily indicated, and the turn of his head increased the impression of spontaneity. The image suggests a 'snapshot' of a face captured in a moment of alarm. In the very small scale of the etching the figure is pushed close to the picture plane thus enhancing its presence.

This print belongs to a group of physiognomic studies. Their varying sizes suggest, however, that the group was not conceived as a series. Rembrandt used his own face as the model from which to observe and record various emotions (Fig. 1a; Cat. No. 2). Even though no preparatory drawing for this etching has survived, other prints in this group were based on drawings.[1] The intention nonetheless, is to give an impression of uninhibited spontaneity, as if the etching had been produced while the artist was looking at his own reflection in a mirror. It is primarily through the nature of the strokes used that this effect is achieved: passages of shadow are not established by even hatching but rather with seemingly arbitrary, unsystematic lines.

Karel van Mander, in his didactic verse treatise of 1604, expressly recommended that painters should study the representation of the passions:

'Gheen Mensch soo standvastich / die mach verwinnen
Soo gantschlijck zijn ghemoedt en swack gheneghen /
Of d'Affecten en passien van binnen
En beroeren hem wel zijn hert' en sinnen /
Dat d'uytwendighe leden mede pleghen /

En laten door een merckelijk beweghen /
Soo in ghestalten / ghedaenten / oft wercken /
Bewijselijcke litteyckenen mercken.
[. . .]
Dees affecten / zijn niet soor gaer en lichte
T'exprimeren / als sy wel zijn te loven /
Eerst met de leden van den aenghesichte /
Thien oft wat meer van diverschen ghesichte /
Als / een voorhooft twee ooghen en daer boven
Twee wijnbrouwen / en daer onder verschoven
Twee wanghen / oock tusschen neus ende kinne
Een twee-lipte mondt / met datter is inne'.[2]

(No man is so steadfast as to be able to master his emotions and weaknesses completely, or to reach a point where the stirrings of passion do not touch his heart and his mind. The visible parts of the body work in concert so that either through a clear movement of the whole figure, or in the face or through the gestures, one can make out clear signs of that which is felt within [. . .] These passions are not at all so easy to represent as they are claimed to be, and this is above all the case with the various parts of the face; for here we find ten or more different aspects, such as the forehead, two eyes and above them two eyebrows, and squeezed in beneath them two cheeks, and between the nose and the chin a mouth with two lips and all that is inside them.)

Rembrandt studied such emotions in his own face. His intention was evidently to achieve an authentic representation of his own facial expressions. Samuel van Hoogstraten, a pupil of Rembrandt, wrote in 1678: 'Dezelve baet zalmen ook in't uitbeelden van diens hartstochten, die gy voorhebt, bevinden, voornaemlijk vor een spiegel om tegelijk vertooner en aenschouwer te zijn'.[3] (The same benefit can also be derived from the depiction of your own passions, at best in front of a mirror, where you are simultaneously both, the representer and the represented.)

The purpose of this exercise seems to have been not only to record the artist's own face and its expressions, but also to assemble a repertoire of emotions for use in the composition of history paintings. Even the earliest among Rembrandt's painted self-portraits seem intended as models for various facial expressions and effects of *chiaroscuro*.[4] Rembrandt's face occurs, for example, among the figures in *The stoning of Saint Stephen* in Lyon[5] and in the unidentified historical scene in Leiden.[6] Even the protagonist in *Samson threathing his Father-in-law* (Berlin),[7] a painting from the Amsterdam period, has a physiognomy similar to that of the artist, where it conveys rage through its frowning brow,

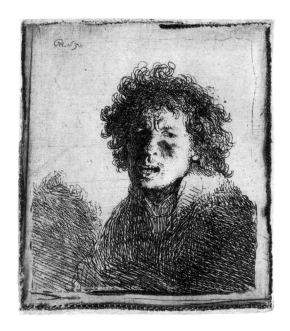

1a: Rembrandt, *Self-portrait*.
Berlin, Kupferstichkabinett SMPK.

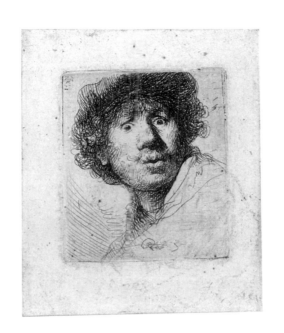

squinting eyes and open, cursing mouth. As this work is clearly not intended to allude to events in Rembrandt's own life, it is a persuasive example of the artist's attempt for an authentic and not merely formulaic rendering of emotion. Rembrandt's early etchings, clearly intended for sale, are the first record of his study of passions from the live model.

The etching exists in one state only. The earliest impressions, for example in London, reveal uneven plate edges, which were later smoothed down.[8] Although the plate was almost entirely bitten, in some areas further work was added in burin.[9] Rembrandt seems, for example, to have strengthened and made more precise the shadows on the left cheek and on the neck through the subsequent addition of several lines.[10]

B.W.

1. Amsterdam, Benesch 54; Schatborn 1985, No. 1 is possibly a preparatory drawing for B. 338; see also the drawing Benesch 53 in London.
2. Karel van Mander (1916), pp. 134–37.
3. Hoogstraten 1678, p. 110.
4. Amsterdam (*Corpus* A14); The Hague (*Corpus* A21); Munich (*Corpus* A19). See Bruyn 1983, pp. 57–58 and Raupp 1984, pp. 250–55.
5. *Corpus* A1.
6. *Corpus* A6.
7. *Corpus* A109.
8. Münz (11) refers to two states.
9. Not described in Hollstein.
10. The Berlin proof shows slight additions in black chalk, probably by a later hand, that extend the torso beyond the plate mark and add background shadow at the right.

2

Self-portrait, frowning

Etching, I: 75 × 75 mm; from II: 72 × 60 mm; 4 states (3 according to Hollstein)
Signed and dated: (in I only): *RHL. 1630*
B./Holl. 10; H. 30; White p. 108

Berlin: IIa (6–16)*
Amsterdam: I (O.B. 20)
London: I (1925-6-15-23); II (1843-6-7-5); III (1973 U. 765)

'Op 't voorhooft (welck de Heidensche
 geslachten
Genius toewijdden) segg' ick / behoeven
Wy te letten / nadien 't eenighe achten
De Siel-wroeger / en 't aenschijn der
 gedachten /
Iae 't Boeck des herten / om lesen en proeven
Des menschen gemoet: want kreucken en
 groeven
Daer bewijsen / dat in ons is verborgen
Eenen bedroefden geest / benout / vol sorgen.
Ia 't voorhooft gelijckt wel de lucht en 't
 weder /
Daer somtijts veel droeve wolcken in waeyen /
Als 't hert is belast met swaerheyt t'onvreder'.[1]

(It is my view that we should pay attention to the forehead which, according to the Ancients, was the seat of genius and which some held to be able to reveal the secrets of the soul, and to be the visage of thought and even the book of the heart, in which human passions could be detected and tested: for its folds and dimples show that within us is hidden a distressed and troubled spirit. Indeed, at times when the heart is burdened with melancholy and discord, the forehead resembles the turbulent air crowded with dark clouds.)[1]

This etched self-portrait with an angry expression also dates from 1630 (see Cat. No. 1). Presenting himself half-length, Rembrandt again uses the turned head looking across the left shoulder to establish both spatial depth and spontaneity. The tousled hair and heavily shaded torso add force to the figure's scowling expression, while the frontally-viewed head provides a certain monumentality. Characteristic here is the harsh and steeply slanted light that contrasts brightest illumination with deepest shadow. The shading makes the face appear asymmetric and so reiterates, with the nervous and wilful use of line, an impression of grim defensiveness. The zig-zag outlines of the fur coat are typical of work from Rembrandt's Leiden period.

No preparatory drawings have survived, as is the case with Cat. No. 1. The etching, however, is known in several states which document the work-process. In addition to those cited in the literature, there is a state (IIa) in Berlin not previously described. After Rembrandt had reduced the size of the plate to print state II, he added a second shoulder outline and a broader collar, as an experiment, in state IIa. In state III, both of these correction have been removed. While in state I, apparently by mistake, several white patches remain,[2] in state II these are filled in and state IIa was produced after this correction.

B.W.

1. Karel van Mander (1916), p. 147.
2. Not described in Hollstein.

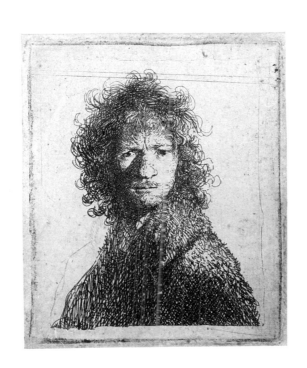

3

Beggar with a wooden leg (The Peg-leg)

Etching, I: 114 × 66 mm; II: 112 × 66 mm;
2 states. c. 1630
B./Holl. 179; H. 12

Berlin: I (266–16)
Amsterdam: I (O. B. 419)*
London: II (1973 U. 743)

3a: Rembrandt, *Seated Beggar*.
Berlin, Kupferstichkabinett SMPK.

3b: Jacques Callot, *The Beggar with the wooden leg*.
Berlin, Kupferstichkabinett SMPK.

During his Leiden period, between about 1628 and 1631, Rembrandt was especially preoccupied with the subject of the beggar. His numerous beggar etchings are usually small in scale and show the subjects as isolated figures with no precise indication of setting.[1] These etchings seem to be intended as individual sheets, not as part of a series of the kind that was usual in the traditional depiction of beggars.

The Peg-leg shows an old man, dressed in rags, with a wooden leg and a pair of crutches; his left arm is in a sling. His bristly face lies in shadow and its details are difficult to distinguish: his eyes appear to lie in deep hollows, his mouth is open as if shouting. To judge by its style and etching technique, the print dates from about 1630, from the same time as the *Seated Beggar* dated 1630 (Fig. 3a), which it also matches in size and use of line and which was perhaps conceived as a pendant to *The Peg-leg*.[2] In both the style and the subject of this work, the young Rembrandt was inspired by Jacques Callot's famous beggar series *Les Gueux* (1621–22; Fig. 3b).[3] The influence of Callot, recognised by Gersaint in 1751,[4] is clear in the treatment of light and the contrast between bright and heavily-shaded areas, and also in the use of line—in particular the use of long, vertical strokes to model the figure. The same stylistic characteristics are to be found in Rembrandt's chalk studies of standing male figures from about 1629–30 (see Drawings Cat. No. 1).

Images of beggars may be traced back to medieval examples; in late fifteenth- and sixteenth-century German and Netherlandish prints the subject is frequently treated in a complete series of images. The prevailing attitude of scorn and condemnation of the poverty that beggars brought upon themselves persisted into the seventeenth century. Thus, the ragged figures in the etched beggar series of Jan Joris van Vliet (1632)— who was a member of Rembrandt's Leiden circle—were presented as caricatures, open to ridicule and disparagement.[5] Like Rembrandt, Van Vliet included in his series a beggar with crutches and a wooden leg (Fig. 3c). Scholars have responded in various ways to the question of how far Rembrandt's early etchings are to be understood in this sense, i.e. with a moralising and derisive attitude towards beggars.[6]

Rembrandt's *Peg-leg* shows a bogus cripple. He has tied on a wooden leg to arouse pity: his own leg has not been amputated but only bent back. This motif is to be found in Sebastian Brant's *Narrenschiff* (Ship of Fools) (1494).[7] A satirical inscription on a print after Pieter Breughel (about 1560), showing a whole group of beggars, censures bogus cripples that only go begging out of laziness.[8] In his *Zede-printen* (descriptions of Customs) (1623–24) Rembrandt's friend Constantijn Huygens casts scorn on beggars who, among other lazy tricks, try to arouse pity by displaying their peg-legs and crutches: 'Then he points to his peg-leg, then he beats on the ground with his crutches and, out of pity, you reach for your purse.'[9]

It is probable that Rembrandt's contemporaries would have received his own beggar images such as *The Peg-leg* in essentially the same spirit. It appears, however, that Rembrandt's interest in beggars and vagabonds was determined by the fascination that these figures had exerted on him at the start of his career. They offered him a chance to study emotions in a way comparable to his etched self-portraits of the same period (Cat. No. 1 & 2). Etchings such as the *Peg-leg* and the *Seated Beggar* employ the same method of using gestures and facial expression to record the sort of states of mood that Constantin Huygens had so greatly admired in the figure of Judas in Rembrandt's painting *Judas returning the Pieces of Silver* (1629).[10] Both Rembrandt's beggar images seem to embody the feeling of despair and anger, conveyed in the open-mouthed shriek. The moralistically devaluing tendency of contemporary beggar series is subordinate in Rembrandt's images to a sober depiction of revealed emotion. His attitude towards beggars seems to be imbued with the Lutheran idea that 'We are beggars on earth (as Christ

Himself was)'.[11] It is surely significant that Rembrandt twice etched the scene of *Peter and John healing the Cripple at the Doors of the Temple*, in about 1629 and in 1659.[12] Here the concern with beggars is united with another subject often treated by the artist: the Prodigal Son. Both of these stress the inherently sinful nature of man, insisting that man is destined to sin and then to be forgiven.[13]

The two states of *The Peg-leg* differ only in their size; in state II the plate has been slightly reduced.

H.B.

1. B. 138, 150, 160, 162–167, 171, 173–175, 179, 183; on this, see also Bauch 1960, pp. 152 ff. In the case of the etchings and the drawings it is not always clear whether real beggars or, rather, merely simple people from the poorest class are shown; see Schatborn 1985, p. 10, Cat. Nos 2–4.
2. B. 174. The *Seated Beggar* has mostly been interpreted as a self-portrait, but it is by no means certain that this is correct; see, most recently, Held 1984, pp. 32–33.
3. Lieure 1924, Nos. 479–503.
4. Gersaint 1751, p. 143, No. 172.
5. B. 73–82, especially B.74.
6. Stratton, for example, stresses the satirical, moralising intention of the early beggar images (Stratton 1986). Held and Baldwin, on the other hand, conclude that Rembrandt had a positive view of beggars: Held believes that the sympathetic presentation of beggars is above all to be understood as a motif adopted for personal and psychological reasons (Held 1984), while Baldwin interprets the sympathetic treatment of the subject in Rembrandt's work in a religious light as a parable of man who, following Christ, is a beggar on earth (Baldwin 1985).
7. See Braunschweig 1978, p. 134.
8. Holl. 34.
9. Huygens 1623–24, p. 212. 'Dan maent hij met een stomp, dan slaet hij met twee krucken, En doet medoogentheit den neck ter borse bucken'.
10. Tümpel 1977, p. 33; Baldwin 1985, p. 122.
11. Baldwin 1985.
12. B. 95, 94.
13. On this point, see Held 1984.

3c: Jan Joris van Vliet, *The Beggar with the wooden leg*. Berlin, Kupferstichkabinett SMPK.

Etching, 149 × 131 mm; 3 states
Signed: *RHL. f*; c. 1631
B./Holl. 343; H. 52; White, p. 112

Berlin: II (426–16)
Amsterdam: II (62–116)*
London: II (1973 U. 786)

There is no documentary evidence that this
print really shows Rembrandt's mother.
In Clement de Jonghe's inventory the print
is cited with this title,[1] and the fact that the
same old woman appears in several etchings
(e.g. Introduction, Fig. 1) and paintings seems
to prove this identification.[2] Just as
Rembrandt's early etched self-portraits were a
means of capturing the expression of mood (see
Cat. 1 & 2), Rembrandt's mother was a model
from which the young artist might study the
physiognomy and form of old women.
This seems to be the only explanation for the
reproduction of a 'role portrait' in the form of
a print. Gerard Dou, who from 1628 to 1631
worked in Rembrandt's studio, also used his
teacher's mother as a model, and in 1631 Jan
Joris van Vliet published a print after
Rembrandt's *Reading Prophetess* which has his
mother's facial features (Fig. 4a).[3]
 Neeltgen Willemsdochter van Zuytbroeck, a
baker's daughter, had nine children, the eighth

4a: Jan Joris van Vliet, *Reading Prophetess*.
Berlin, Kupferstichkabinett SMPK.

5

Sheet of sketches with a self-portrait

Etching, I: 101 × 114 mm; II: 100 × 105 mm;
2 states; c. 1631
B./Holl. 363; H. 90

Berlin: II (485–16)
Amsterdam: I (O.B. 764)*
London: I (1848–9–4–187)

Etched sheets of sketches with individual
figures and heads are a special case among
Rembrandt's prints.[1] One of the earliest
examples of this type shows studies of the
figures and heads of old men and beggars as
well as a portrait of the artist. The figures are
distributed across the sheet as if there were no
connection between them, facing various
directions; Rembrandt's portrait, viewed in a
mirror and thus shown frontally, is towards the
top right corner. The passages left blank which
cut into the dark hair and the shaded eye area
show that the head was originally intended to
be covered by a broad-brimmed hat.[2] The
similarity between this print and another
etched self-portrait of 1631 suggests that the
sheet of studies was made in the same year
(Introduction, Fig. 12).[3]

The impression of a freely executed sheet
with sketches from life comes not only from
the fragmentary and dissimilar figures, but also
from the extensive scratching and experimental
strokes and—in state I—the large acid spots,
which seem to be traces of unskillful, speedy
work on the plate. Studies after whole figures
and parts of the body were a traditional
method of practice for the draughtsman.
They served not only for the preparation of a
particular scene, but could also be used as
occasion demanded, in the tradition of pattern
books for a variety of compositions. A fine,
albeit rare, example of this type from among
Rembrandt's drawings is the *Sheet with nine
studies of heads and figures* in Birmingham (see
Drawings Cat. No. 8).[4]

Engraved or etched scenes with detailed
studies of this type were to be found in draw-
ing instruction manuals from the baroque
period; budding artists carried out their first
exercises in drawing by following these exam-
ples.[5] However, in contrast to Rembrandt's
etching, which brings together disparate motifs

as if by chance, engraved model sheets in
instruction manuals usually show similar
figures or motifs in various arrangements—
the same head, for example, seen from various
angles. It is possible that Rembrandt had
intended a number of etchings made in the
1630s and 1640s—*The Walking Frame* (see
Cat. No. 21), *The Artist drawing from the Model*
(see Cat. No. 15), as well as study sheets with
heads (see Cat. No. 12)—for a drawing
instruction manual.[6] It seems improbable,
however, that the young artist had already
conceived this plan at the beginning of the
1630s.

Rembrandt's etched sheets of studies should,
rather, be seen in terms of the tradition of
drawn study sheets, in which an apparently
chance collection of disparate figures and motifs
was intentional. Jacques de Gheyn, with whose
work Rembrandt was familiar, produced
drawings of this kind which have survived:
these seek to emulate the appeal of sheets of
studies or sketches made from life, and this
itself becomes the real 'subject' of such works.[7]
Rembrandt's etched study sheets were not
intended as pattern book models for pupils or
workshop assistants; they reproduce, rather,
a type of drawing that was highly valued by
both art critics and collectors in the seven-
teenth century as *crabbelinge* or *griffonnement*.[8]
That this was the aim here is indicated not
only by the carefully contrived grouping of the
subjects, but also by the introduction of the
irregular, black-printed plate edges as a type of
frame for the whole. Nor do the impurities in
the plate, such as the experimental strokes,
appear to have come about by chance. In a
similar way, in a sheet of studies in Rotterdam
(Museum Boymans-van Beunigen), Jacques de
Gheyn introduced experimental pen lines into
his composition, that are apparently not
roughly scribbled but deliberately placed (Fig.
5a).[9] Rembrandt's collection of bizarre ideas—
which, like the beggars, preoccupied him at the
start of the 1630s—must have been carried out
as independent works of art for collectors of
such *capricci*.

In state II the plate was somewhat reduced
in size, and the spots of acid, for example above
the artist's head, were erased.
H.B.

1. B. 363, 365–370.
2. This is also revealed in a small drawing dated 1630,
in the Louvre, Paris, showing the artist's portrait in a
mirror image of the self-portrait in B. 363; see Lugt
1933, p. 18, No. 1149, Plate xxxiii; Bauch 1960, Plate
261, note 132. Bauch classified the drawing as a
reversed model for the head on the sheet of studies.
Today the attribution to Rembrandt is no longer
accepted; and the sheet was not included in the Paris
1988–89 catalogue.
3. B. 7.
4. Benesch 340.
5. Bolten 1985; Dickel 1987.
6. Emmens 1968, pp. 157 ff.; Bruyn 1983, pp. 57 ff.
7. Van Regteren Altena 1935, pp. 46 ff.; Bruyn 1983,
p. 55.
8. Held 1963, p. 89. Both terms signify a rough sketch,
scrawl or scribble.
9. Van Regteren Altena 1983, Vol. II, No. 772, Vol. III,
Plate 359.

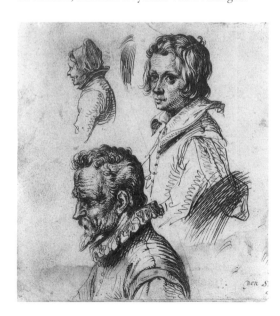

5a: Jacques de Gheyn, *Sheet of studies*. Drawing.
Rotterdam, Museum Boymans-van Beuningen.

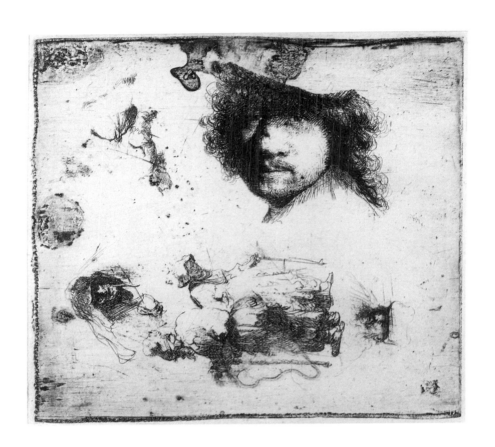

6

Seated female Nude

Etching, 177 × 160 mm; 2 states
Signed: *RHL.* c. 1631
B./Holl. 198; H. 43; White pp. 172–73

Berlin: II (288–16)*
Amsterdam: I (61: 1108)
London: II (1843–6–7–126)

6a: Wenzel Hollar, *Seated female nude.*
Berlin, Kupferstichkabinett SMPK.

'He chose no Greek Venus as his model, but rather a washerwoman or a treader of peat from the barn, and called this whim "imitation of nature". Everything else to him was idle ornament. Flabby breast, ill-shaped hands, nay, the traces of lacings of the corsets on the stomach, of the garters on the legs must be visible if nature was to get her due. This is *his* nature which would stand no rules. No principle of proportion in the human body.'[1] This unambiguous condemnation, drawing on the classicist aesthetic norms of the late seventeenth and early eighteenth centuries, is in marked contrast to the appreciation for this etching registered at the time of its creation, as shown by the copy of it made as early as 1635 by Wenzel Hollar (Fig. 6a).[2]

The *Seated female Nude*, together with two other prints which also may date from 1631,[3] record Rembrandt's earliest preoccupation with the nude in his etched œuvre. Rembrandt shows the woman sitting sideways on a mound but with her torso turned towards the viewer. The shapes formed by the female body are recorded with great realism, as in the case of the folds of skin caused by the twist of the torso. The figure is lit from the right, and the gradations of light and shaded flesh give the etching its sensual allure. The woman looks intently at the viewer, but her eyes remain in shadow. The subtle tension established between the lighting and this direct stare, also a quality of Rembrandt's early self-portraits, gives the image its distinctive stamp.

While the early etching *Jupiter and Antiope* (Fig. 40a) depicts a mythological subject and thus belongs to the realm of *historia*, the other two show single figures. The subject of one of these has been identified: *Diana at the bath* (Fig. 6b). Our print, however, has until now only been given titles such as *Naked Woman seated on a mound* or, even more simply, *Seated female Nude*. In this way, albeit not explicitly, it has come to be understood as having no subject. It is possible that this impression may have been encouraged by the loosely-structured composition of the print, in which Rembrandt makes a draughtsman's use of the blank sheet. The brightly lit area of the drapery is conveyed with only a few cursory strokes. The work is distinct in this respect from the more pictorial construction and carefully considered background of the Diana etching. The current title is only a slight modification of that adopted by Gersaint in his catalogue raisonné of 1751— '*femme nue*'.[4] Gersaint, admittedly, also treated other, now thematically identified etchings, such as the *Diana*, as '*femmes nues*', including these under the heading '*Sujets libres, Figures nues, & Figures académiques.*'

Rembrandt's female nude sits on raised ground which it is not possible to define more precisely,[5] though several sprigs of leaves indicate an outdoor setting. In this respect the work is fundamentally distinct from Rembrandt's drawings and etchings of the 1640s in which male nudes are clearly presented as studio models.[6] This etching is linked with *Diana at the bath* not only through the almost identical dimensions—a plate size that Rembrandt appears to have used only for these two etchings. Furthermore, the two female figures are seated on their drapery with complementary turns of the torso, each rests one arm on a higher level of the bank, and each gazes directly at the viewer. Diana, however, protectively turns her body away from the viewer—for mortals were forbidden to gaze on her.[7] In the case of the present etching one would, then, be less likely to think perhaps of an Old Testament subject such as that of Susanna or Bathsheba—a model of chastity or a moral exemplar—than of a figure from classical mythology, even perhaps the figure of a nymph from among Diana's maidens. It is unlikely that we will be able to determine how far the two etchings were intended to be seen as a pair. Wenzel Hollar, in any case, made a copy of only one of them. The omission of unambiguous thematic references—in the case of the Diana too these are also more clearly defined in the preparatory drawing than in the completed etching—might have been understood by Rembrandt's contemporaries as having been removed from its traditional iconographic context.[8] If not the specific subject itself, then certainly its thematic associations, would have been immediately obvious to Rembrandt's contemporaries, though not to Gersaint more than a century later. Thus, neither did Wenzel Hollar feel the need to add attributes to the figure in his own copy.

In contrast to the *Diana*, which was preceded by a detailed preparatory drawing[9] and, after tracing, executed in a relatively schematic manner, the etching in question impresses by its freer use of line. A clear contour, for example, is only found where light and shade meet each other directly, as on the woman's stomach. In other areas several outlines are set alongside each other and then rendered less distinct through the use of hatching running across them. In the region of the eyes, for example, planes which are not defined by an outline are filled in with hatching, which is used to create shadow, and is drawn right across the shapes. Within areas of shadow the forms are made less distinct at the edges. A systematic use of cross-hatching is eschewed,

in contrast to the procedure in the *Diana* etching.[10]

In view of this approach it is not surprising that preparatory drawings have survived.[11] The differences to be detected between the two states of the etching are not in the composition, but entirely in the lighting. In state II new areas of shading are introduced. Certain individual passages of shadow in state I, for example on the woman's right foot, are burnished out, in order more effectively to contrast light and shade. Both the detailed *modello* and the pictorial composition of the *Diana* etching could well indicate a commissioned work. One is tempted to assume that Rembrandt later produced a second composition of a nude, mythological subject which was freer in every respect. As indicated by the copy made only a few years later by Wenzel Hollar, Rembrandt's contemporaries fully appreciated this version.

B.W.

1. A. Pels, *Gebruik en misbruik des toneels*, Amsterdam, 1681, pp. 35–36.
2. B. 603.
3. B. 201, B. 204.
4. G. 190.
5. The literature follows Gersaint in speaking exclusively of a mound, even though the etching itself fails to define the setting fully.
6. See Cat. No. 21.
7. On the myth and its presentation as a painted *historia* in Rembrandt's œuvre, see Paintings Cat. No. 16.
8. The concept of '*Herauslösung*' was introduced by Tümpel (1969) in his enquiry into the iconography of Rembrandt's biblical narratives.
9. Benesch 21; London, British Museum.
10. It is possible that in the case of the *Diana* one should once more consider the collaboration of studio assistants in the production of the etching. On this point, though not with regard to this etching, see Royalton-Kisch, 1984.
11. On questions in this area, see the discussion in Cat. No. 39, and also the ones regarding other etchings.

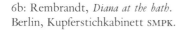

6b: Rembrandt, *Diana at the bath*. Berlin, Kupferstichkabinett SMPK.

7

The Raising of Lazarus

Etching and burin, 366 × 258 mm; 10 states
Signed: *RHL van Ryn* (I–IV), *RHL van Ryn f.*
(V–X). c. 1632
B./Holl. 73; H. 96; White pp. 29–33

Berlin: V (314–1893) and VIII (132–16)*
Amsterdam: III (O.B. 595) and VIII (O.B. 597)
London: IX (1973 U. 823)

7a: Jan Lievens, *The Raising of Lazarus.*
Brighton City Art Gallery.

7b: Rembrandt, *The Raising of Lazarus.*
Los Angeles, County Museum of Art.

With a impressive gesture, Christ summons the dead Lazarus back to life. In the first stirrings of his resurrection, Lazarus struggles to sit up in his grave. The onlookers react with surprise and alarm.[1] The etching, which dates from about 1632, is the largest made by Rembrandt up till that date; and it surpasses his earlier etched works in both emotion and baroque theatricality. It is the first of a series of prints in which Rembrandt—probably in daring competition with the work of Rubens—lays claim, through the use of a large scale, to the status of a painted representation of the subject. This aim is also suggested by the introduction of a black frame. While other prints by Rembrandt, such as the *Ecce Homo* (Fig. 38b) and *The Good Samaritan*, are not universally seen as the work of his own hand,[2] *The Raising of Lazarus* has been accepted as an authentic work. The work-process may be described as complex in several respects.[3] Not only is the etching known in a large number of states, ten in all, but it is also obvious that its original motivation was to surpass a painted composition by Jan Lievens (Fig. 7a), which Rembrandt may even have owned.[4] Like Lievens, Rembrandt seems to have started on a painting of the *Raising of Lazarus* (Fig. 7b).[5] During work on this painting he turned to treating the subject in the print medium.[6] While Rembrandt took the principal arrangement of the composition in his painting from that adopted by Lievens (though with decisive modifications in the use of gesture and thus in the character of the narrative), in his etching he altered the composition as a whole. Christ is no longer viewed from the front but, rather, from behind and in lost profile. Light streams out from the central area of the

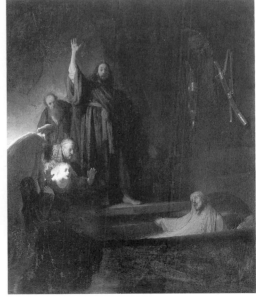

composition, so that the figures of Christ, of the man shrinking away on the left, and of the woman in the right foreground—Martha, the sister of Lazarus—are perceived by the viewer largely as silhouettes. This dramatic illumination reveals Rembrandt's attention to the work of the Utrecht Caravaggists, above all Ter Brugghen.

Research into Rembrandt's painting technique suggests that the picture and the etching are intimately linked in their development. Rembrandt did not produce a reproductive print after his own painting; he evolved, rather, a distinct solution to suit each medium. Although most of Rembrandt's etchings survive in several states, we know of only a few genuine trial proofs printed before the completion of the full composition. Often the various states differ only in the correction of details. In the case of *The Raising of Lazarus*, however, working proofs have survived (they show unsmoothed plate edges, occasional interrupted contours, and spots of etching fluid) dating from a stage before the full composition, in its third state, was satisfactorily established on the plate. Although, from this point, Rembrandt maintained the basic arrangement of the scene, he nonetheless altered the figures of the onlookers in terms of both pose and gesture. The first alteration is drawn in on a impression of state III in London (Fig. 7c).[7] After an intermediate state, IV, in which the frame is completely registered with cross-hatching, the changes to the figure are incorporated in state v. Here Rembrandt alters the pose of Martha. No longer shown bending back behind the grave in a pose corresponding to that of the man with his shrinking gesture, Martha is a sharp silhouette moving towards the resurrected Lazarus. The next re-working concerns the figure of the man with outstretched arms to whom Rembrandt gives a cap, the emphasis provided by its shaded part marking off the group of figures against the still brightly lit background. At the same time, a more distinct character is given to Lazarus's second sister, Mary Magdalen. In a third stage of alteration, the three men behind the above-mentioned figures, were re-worked in order to give the group a greater relief-like compactness. The subsequent two states may be understood as final corrections.

It has frequently been observed that, as well as Lievens's composition, Rembrandt drew on other works, above all compositions by Raphael: Marcantonio Raimondi's engraving after Raphael's *Saint Peter preaching* being cited in this connection.[8] It is doubtful, however, that really specific borrowings are to be detected here; one might, rather, ask if it

would not be more reasonable to speak of general similarities to the figurative style of Raphael—particularly in the case of Rembrandt's figure of Christ, both in its statuesque quality and in the firm, imposing character of its gesture. It is known that Rembrandt constantly added to his own collection of works of art, above all his collection of prints. It is thus possible that Muller's engraving after *The Raising of Lazarus* by Abraham Bloemaert may have provided Rembrandt with an artistic challenge.[9] Rembrandt would certainly also have been familiar with the compositional solutions devised by his teacher, Pieter Lastman.[10] The number of specific models that Rembrandt may have used in evolving his own compositional solution (which, as the various states show, was only reached through the working process) is itself a reflection of his aim to present a new and exciting record of the Biblical episode. B.W.

1. John 11: 1–44.
2. B. 81, B. 77; B. 90. On the *Ecce Homo* and the *The Decent from the Cross*, see Royalton-Kisch, 1984.
3. Münz, 192 did not deny the possibility that Van Vliet may also have worked on the etching. Hind (No. 96) regards the composition, but not the later states, as authentic.
4. Now in the collection of the City Art Gallery, Brighton; Sumowski 1983, No. 1193. The 1656 inventory of Rembrandt's estate lists a painting of *The Raising of Lazarus* by Jan Lievens (*Urkunden* 169, No. 42. Lievens himself made a reproductive print of his painting—and according to the most recent considerations of Royalton-Kisch, it remains to be established whether this was made directly after the completion of the painting or at a later stage. In an as yet unpublished article, Royalton-Kisch also proposes a date different from that accepted in previous research for the drawing Benesch 17, suggesting that is was made in the mid-1630s, and thus after the production of the etching. Consideration of the drawing is therefore omitted from the present discussion.
5. Los Angeles, private collection, *Corpus* A30.
6. See *Corpus* A30, with bibliography.
7. Benesch 83 a, London, British Museum.
8. B. 44; Münz 192; discussed most recently in *Corpus* A30.
9. B. 18; see Berlin 1970, No. 73.
10. Mauritshuis, The Hague; also Sale: Dobiaschowsky, Berne, May 1990.

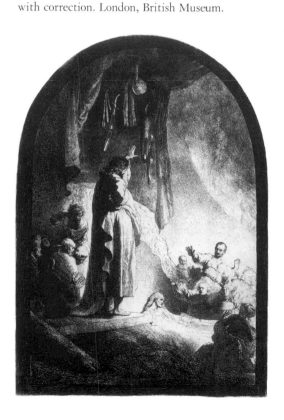

7c: Rembrandt, *The Raising of Lazarus*, State III, with correction. London, British Museum.

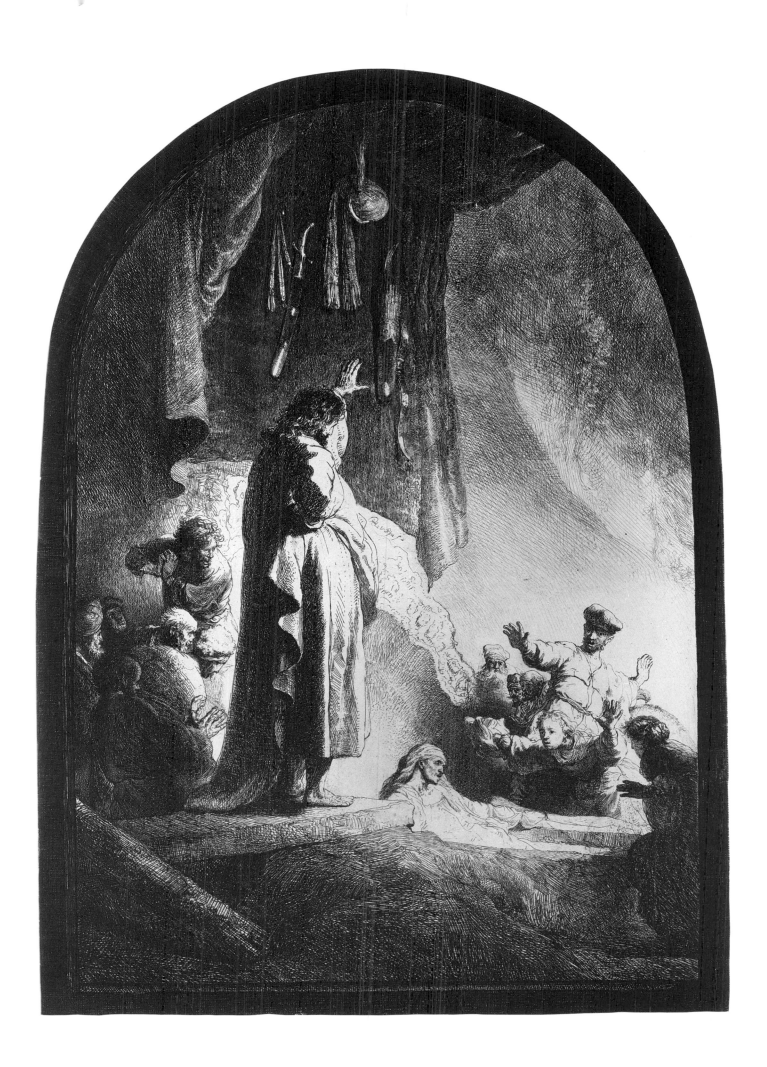

8

Joseph and Potiphar's Wife

Etching, 90 × 115 mm; 2 states
Signed and dated: *Rembrandt f. 1634*
B./Holl. 39; H. 118; White p. 36

Berlin: II (59–16)*
Amsterdam: I (O.B. 78)
London: I (1933–9–9–11); II (F4–64)

8a: Antonio Tempesta, *Joseph and Potiphar's Wife*.
London, British Museum.

Unambiguously bared, a woman lying on a bed attempts to pull back towards her a man who, defending himself, turns to flee. The print shows a scene from the story of Joseph who, after being sold to the Egyptians by his brothers, was employed in the house of Potiphar, treasurer to the Pharaoh. 'And it came to pass after these things, that his master's wife cast her eyes upon Joseph; and she said, Lie with me. But he refused, and said unto his master's wife, Behold, my master wotteth not what is with me in the house, and he hath committed all that he hath to my hand; There is none greater in this house than I; neither hath he kept back any thing from me but thee, because thou art his wife: how then can I do this great wickedness, and sin against God? And it came to pass, as she spake to Joseph day by day, that he hearkened not unto her, to lie by her, or to be with her. And it came to pass about this time, that Joseph went into the house to do his business; and there was none of the men of the house there within. And she caught him by his garment, saying, Lie with me: and he left his garment in her hand, and fled, and got him out.'[1]

In the *Aniquitates Judaicae* by Flavius Josephus, the episode was further embellished in order emphasise Joseph's self-control and his success in protecting his chastity against the women's urgent entreaty. It was possible to see the same interpretation of the subject in Antonio Tempesta's engraving (Fig. 8a)[2] that inspired Rembrandt.[3] Rembrandt, however, reduces the indication of spatial depth and background detail to leave only the bed; the door is sketchily indicated, and there is no view through it to a landscape beyond. He has, indeed, 'increased the blunt realism according to the subject'.[4] While the woman's recumbent posture, above all her bared pudenda, emphasises her lascivious intent, Joseph, by contrast, is vehemently abrupt in his movement as he turns away, overcome with disgust. While Joseph does not even touch the woman and shrinks back to rebuff her importunate demand, her own impulse is, quite literally, grasping. The use of *chiaroscuro* in the composition is especially determined by the moral exemplar the scene conveys: while the figure of Joseph is set against a light background, Potiphar's wife is shown against the darkly shaded area of the bed.

So frank a treatment of the episode was later found disturbing. In a impression of the etching from the Mariette collection, for example, the impact is corrected by the addition of a cloth drawn in to cover the woman.[5]

In this work from 1634 Rembrandt uses two distinct styles of etching: the linear treatment used for the left background and the figure of Joseph with very restrained shading, and an approach based on modelling through the accumulation of planes defined largely by light and shade, as seen in the body of the woman and in the treatment of the right background. Both methods were to retain a determining role in Rembrandt's work as an etcher.
B.W.

1. Genesis 39: 71–12.
2. B. 71.
3. Berlin 1970, No. 18.
4. Berlin 1970, No. 18.
5. Fitzwilliam Museum, Cambridge; see White 1969, p. 36.

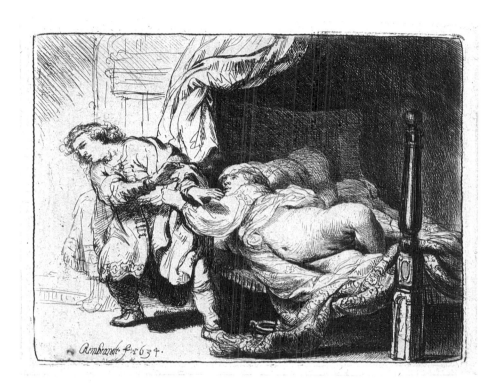

9

The Angel appearing to the Shepherds

Etching, dry-point, burin and sulphur tint
262 × 218 mm; 3 states
Dated: (from II) *1634*
B./Holl. 44, H. 120, White pp. 36–39

Berlin: III (471–1901)*
Amsterdam: III (62: 19)
London: I (1973 U. 850); III (1868–8–22–662)

The darkness of the night is suddenly shot through with light. Men and animals scatter in terror. The brightly illuminated and imposing figure of the angel announces the message of Christmas; but only a few figures—such as the kneeling shepherd, who raises his arms in fright—even notice this. 'And there were in the same country shepherds abiding in the field, keeping watch over their flock by night. And, lo, the angel of the Lord came upon them, and the glory of the Lord shone round about them: and they were sore afraid. And the angel said unto them, fear not: . . . And suddenly there was with the angel a multitude of the heavenly host . . .'[1]

Rembrandt succeeds here in capturing the full impact of the event. The deep black of the night sets off the glittering light of the divine apparition. The angel, a large-scale figure poised on a cloud-bank, calmly dominates the scene. This is in dramatic contrast to the alarm and tumult below. The reactions of those picked out by the light range from sheer terror to panic-stricken flight. Still in darkness, however, are the two shepherds clambering out of a hollow on the right—probably coming to see what is happening. The animals too are shown to react in various ways. Those caught in the stream of light scatter, while others remain quite unaffected. The dove of the Holy Ghost is depicted in the bright centre of the sky, which opens up into a funnel of light. *Putti* circle around the light. Rembrandt offers here a bravura exercise in *scorci* (foreshortening) and in variations of movement. In the valley below, lit up as if in a fairy-tale, one can make out a river, spanned by an imposing bridge. Figures standing in front of a fire reflected in the water are just detectable.

The evolution of the print is not recorded in surviving drawings, but two working proofs

from the unfinished plate exist (Fig. 9a).[2] Rembrandt first established the entire composition on the plate with sketch strokes. As the same time he established the principal division of light and shade. The deepest blacks and all of the background were virtually completed at this stage. This approach is also found in other Rembrandt etchings, for example in *The Artist drawing from the Model* (Cat. No. 15). It is, however, important to note that such a procedure parallels that found in painters' working methods. Through establishing gradations of grey tones in his etching of *The Angel appearing to the Shepherds*, Rembrandt creates a scene that is not only painterly, but also composed in pictorial terms. With his impressive range of velvety-black tones Rembrandt here reaches the virtual limits of the technical possibilities of etching. First Rembrandt established the dark areas of the print through a fine network of hatching, and bit these lines deeply, then went over the plate-surface with the burin once again. By doing this he avoided sharp contours outlining dark areas. Rather, the forms are marked through areas made up of hatching of varying degrees of fineness. By this procedure, the atmosphere of the night is captured in a most suggestive manner.

The signed second state shows the composition at its most complete. In state III, finally, Rembrandt has shaded through additional hatching a number of details such as the lower branch of the large tree and the angel's wings. It has not, however, been previously remarked that Rembrandt is less specifically concerned here with aesthetic effect, than with the correction of technical aspects. Almost all the passages worked with additional hatching in state III, were apparently bitten with sulphur tint in state II.[4] Rembrandt made a few trial proofs of this state[5] and, not satisfied with the result, re-worked the areas concerned.

Night scenes had been popular in art since the sixteenth century. The paintings of Elsheimer exerted a considerable influence that had spread even more widely through their reproduction in prints by Goudt as well as through the engravings of Jan van der Velde that drew on these. In *The Angel appearing to the Shepherds*, as in many of his works, Rembrandt re-worked suggestions borrowed from earlier sources. Rembrandt's fleeing shepherds, for example, are to be found in a print by Sadeler after M. de Vos; and Rembrandt may also have known Saenredam's reproductive prints after Abraham Bloemart.[6] Rembrandt himself developed his composition further in the painting of the *Ascension* (1636) commissioned

by Prince Frederik Hendrik.[7] Even in drawings from a later period, Rembrandt revised this idea.[8] The adoption of the compotition by other seventeenth-century painters[9] testifies to the popularity of Rembrandt's print.

Although nocturnal scenes are found in some of Rembrandt's early paintings, *The Angel appearing to the Shepherds* is his first etched example. Rembrandt conceived of nocturnal scenes as an artistic challenge, which became important again in his late work.[10]
B.W.

1. Luke 2: 8–10 and 13.
2. London; Dresden.
3. On this manner of working, see Van de Wetering: 'Painting materials and working methods', in *Corpus*, pp. 111–33, especially 29.
4. On this technical procedure, see Cat. No. 22.
5. Only three proofs of II are known: these are now in Amsterdam, London and Vienna.
6. Berlin 1970, 41; Münz 199.
7. Munich, Alte Pinakothek, *Corpus* A118; Paintings Cat. No. 13.
8. Benesch 501; Benesch 502; Benesch 999, Schatborn 1985, No. 38; Benesch 1023, Schatborn 1985, No. 44.
9. Flinck, Louvre; Berchem, Louvre; Bout, Braunschweig.
10. See Cat. No. 37.

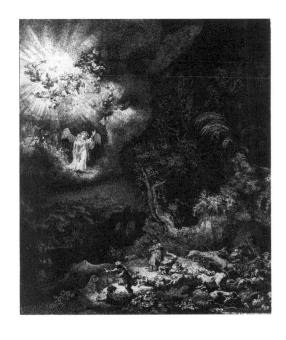

9a: Rembrandt, *The Angel appearing to the Shepherds*, State I. London, British Museum.

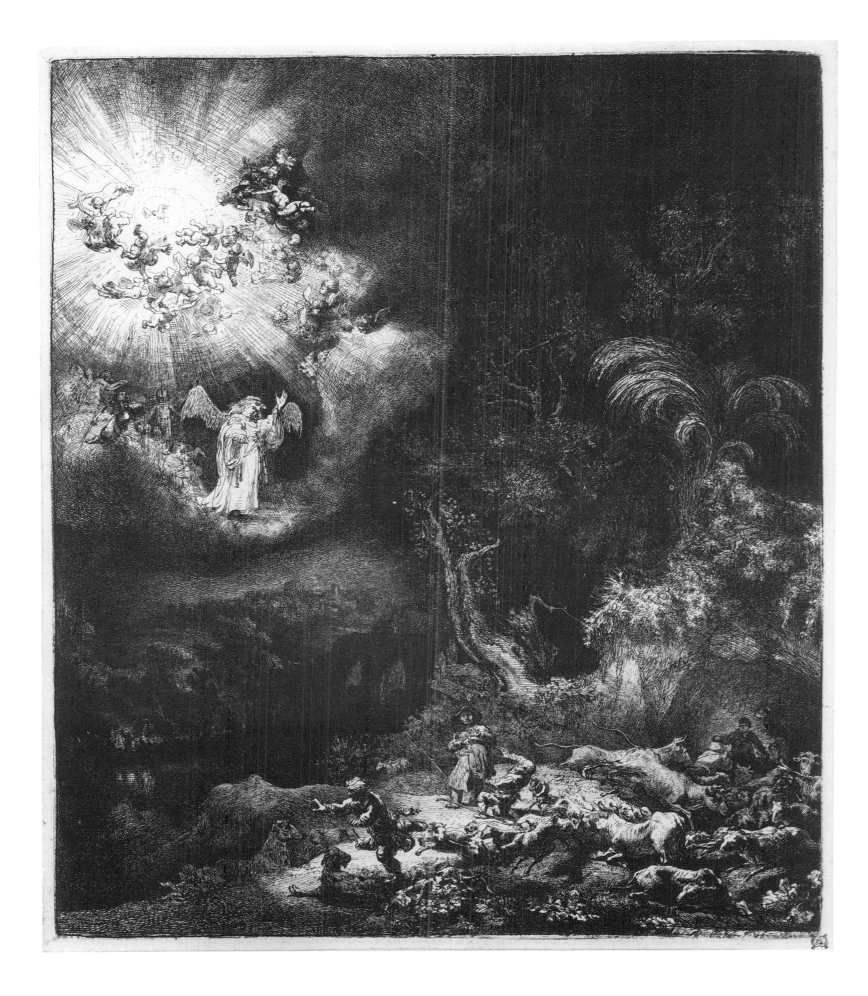

10

The Pancake Woman

Etching and drypoint, 109 × 77 mm; 3 states
Signed and dated: *Rembrandt. f 1635*
B./Holl. 124; H. 141; White, pp. 156–58

Berlin: II (473–1901)
Amsterdam: II (61–1056)*
London: II (1973 U. 880)

10: State I

This small etching shows a popular subject of
seventeenth-century Dutch genre. In the centre
an old woman sits making pancakes in a large
pan. This attracts the attention of a group of
children: two boys, in the background, look at
a coin which they will probably use to buy a
pancake, while three children of various ages—
one in a broad-brimmed hat already devouring
a pancake with relish—look on as the old
woman prepares the next batch. An inquisitive
toddler is held back by his mother, and a boy
in the foreground, watched by a black cat, tries
to save his pancake from an over-eager dog.

The iconography of this subject may be
traced back to the mid-sixteenth century.
In scenes of the 'Fools' Kitchen' and the 'Feud
between Carnival and Lent' from the circle of
Pieter Bruegel the Elder one can find similar
pancake women.[1] In the seventeenth century
the motif became a subject in its own right in
Dutch genre painting, for example in the work
of Willem Buytewech, Jan van de Velde and
Adriaen Brouwer.[2] Rembrandt's etching is
close in its composition to an engraving by Van
de Velde (of about 1626) (Fig. 10a) and also to
a painting by Brouwer (of about 1620–30) in
Philadelphia that may have been owned by
Rembrandt.[3] The subject of the pancake
woman was often treated moralistically.
In Jan van der Veen's emblem book (1642),
for example, the preparation of undercooked
pancakes is used as a symbol for stupid jollity,
and the idle chatter that corrupts good
manners.[4]

A pen drawing of about 1635 by Rembrandt,
now in the Rijksprentenkabinet in Amsterdam

10a: Jan van de Velde, *The Pancake Woman*.
Berlin, Kupferstichkabinett SMPK.

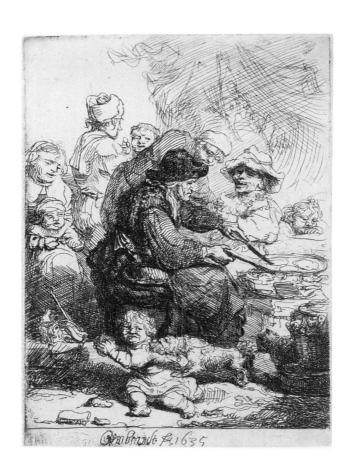

(Fig. 10b), treats the same subject yet differs considerably from the etched scene in its composition. In the drawing, the pancake woman is seen almost from the front and she is placed right at the edge of the scene. In the etching—following the iconographic tradition for the subject—she is shown in pure profile at the centre of the sheet. Rembrandt appears to have taken account here of the fact that a more ordered arrangement was required in a print intended for sale.[5] A pen drawing from about 1635, formerly in the Kunsthalle in Bremen, might have been made in connection with the etching (Fig. 10c).[6] It shows a woman with five children in various poses. The mother, who holds a baby in her arms, has a certain similarity with the corresponding figure in the group in *The Pancake Woman*. There is also an almost identical a child, who turns its head and reaches away with bent, thrusting legs, on the left in the drawing and in the foreground of the etching.

The motif of the sprawling boy appears to have been popular in seventeenth-century Dutch art.[7] It has not previously been remarked that Rembrandt is here citing a celebrated model: the *putto* skimming the waves in Raphael's *Triumph of Galatea*, a composition widely known through reproductive engravings by, among others, Marcantonio Raimondi and Hendrick Goltzius (Fig. 10d).[8] Rembrandt did not transfer the figure mechanically, but rather keyed the splayed pose to a context in employing it to show the boy's effort to save his pancake from the eager dog. This motif—with other examples—shows to what extent Rembrandt drew on foreign models as well as

on sources found in works in his own collection; studies from life often played a minor role or served only as starting points for freely devised versions of a figure. In his scenes with children, in particular, which at first glance seem so closely observed from life, the stereotypical, formulaic record of certain figures and motifs stands out: these may be traced back to Rembrandt's reference to ancient sculpture, among other sources.[9]

Within the network of lines in the background, one can make out the mouth, potato-shaped nose and eye of a grimacing face. It remains open to question whether Rembrandt has here allowed a bizarre idea, appearing perhaps by chance in the etching process, to remain.[10]

In state I, which is rare, the pancake woman's dress and hat are principally indicated only in outline; in state II they are heavily hatched, in part with emphatic drypoint lines, so that the old woman now stands out more boldly from the band of children than in state I.
H.B.

1. See, for example, the *Fools' Kitchen* of about 1560, a drawing from the Bruegel circle, in the Albertina in Vienna (Benesch 1928, p. 12, No. 75) and the engraving after it by Pieter van der Heyden (Holl. IX, p. 28, No. 48). In Bruegel's painting of 1560, *The Feud between Carnival and Lent*, (Vienna, Kunsthistorisches Museum), there is a pancake woman (Grossmann 1955, plates 6 and 8). On this subject see Trautscholdt 1961 and Lawrence, Kansas; New Heaven and Austin 1983/84, pp. 110 ff., Nos. 25–26.
2. On Buytewech see Haverkamp-Begemann 1959, pp. 107–8, Nos. 38–38a, Figs. 60 and 56; on Van de Velde, Holl. 148.
3. In the 1656 inventory of Rembrandt's estate there is mention of a painting by Brouwer with this subject; it remains, however, a matter of speculation as to whether this is to be identified with the picture in Philadelphia; see *Urkunden*, p. 190, No. 169; 'Een Stuckie van Ad. Brouwer, sijnde een koekebakker (A work by Ad. Brouwer, being a [pan]cake maker). On Brouwer's panel see Berlin 1984, p. 122, No. 20.
4. Amsterdam 1976, p. 87, No. 16, with illustration.
5. Benesch 409; Schatborn 1985, pp. 16–17, No. 6. See also Bruyn 1983, p. 57, who regards the Amsterdam drawing as a free variant on Brouwer's composition.
6. Benesch 402.
7. Schatborn 1975, p. 11. A drawing in the Louvre, Paris, Benesch 112, which shows a young boy and a dog in a similar way, albeit reversed, has on occasion been seen as a preparatory study for this group. This must, rather, be a copy drawn by another hand, after the etching; see Schatborn 1985, p. 16, No. 6, note 3.
8. Marcantonio Raimondi: B. 350; Hendrick Goltzius: B. 270.
9. Bruyn 1983, especially p. 53. Meder points to the tradition, especially for scenes with children, of using models taken from ancient or contemporary works of art; Meder 1923, p. 402.
10. It has also been suggested that this face symbolises the childrens' fears, or images that could trigger those fears; Robinson 1980, p. 166.

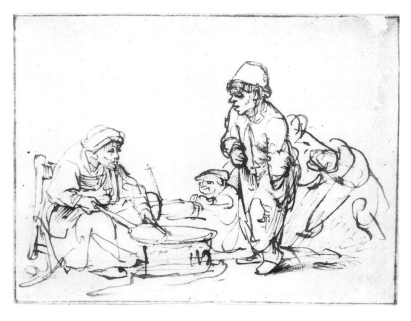

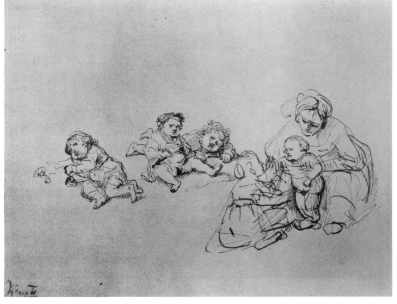

Etching, 162 × 116 mm; 2 states
Signed: *Rembrandt. f. 1638*
B./Holl. 28; H. 159; White, pp. 41 ff.

Berlin: II (48–16)
Amsterdam: II (61:992)
London: II (1843–6–17–16)*

Rembrandt's etching of 1638 may well be claimed as one of the most psychologically penetrating images of the subject of the Fall of Man in the history of art. In the Bible we read: 'Now the serpent was more subtle than any beast of the field which the Lord God had made. And he said unto the woman, Yea, hath God said, Ye shall not eat of every tree of the garden? And the woman said unto the serpent, We may eat of the fruit of the trees of the garden: But of the fruit of the tree which is in the midst of the garden, God hath said, Ye shall not eat of it, neither shall ye touch it, lest ye die. And the serpent said unto the woman, Ye shall not surely die: For God doth know that in the day ye eat thereof, then your eyes shall be opened, and ye shall be as gods, knowing good and evil. And when the woman saw that the tree was good for food, and that it was pleasant to the eyes, and a tree to be desired to make one wise, she took of the fruit thereof, and did eat, and gave also unto her husband with her; and he did eat.' (Genesis 3: 1–6).

Adam and Eve are shown completely naked, in the state of paradisaic innocence, of which they only become aware after the Fall. Following iconographic tradition, Rembrandt shows the moment when Eve is about to give the apple to Adam; she seems to have persuaded him with her seductive voice. In reaching for the apple, Adam pauses, raising his right hand as if to remind Eve that God had forbidden them to eat from the tree of knowledge. His body, bent as if in pain, seems to be an expression of his awareness of guilt and his fear of punishment. Rembrandt shows Eve's tempter lurking in the tree, in the form of a dragon, not a snake. The bible says that it was only after the Fall that God the Father condemned the beast to crawl on the ground, which implies that it must have had another

10b: Rembrandt, *The Pancake Woman*. Drawing. Amsterdam, Rijksprentenkabinet.

10c: Rembrandt, *Sheet of studies with a mother and five children*. Drawing. Destroyed.

10d: Marcantonio Raimondi, after Raphael. *The Triumph of Galatea*. Berlin, Kupferstichkabinett SMPK.

appearance until that moment. The use of a dragon in place of a snake was not unusual in the iconography of the subject.[1] Rembrandt was inspired by Dürer's scene of *Christ in Limbo* from the *Engraved Passion* (1512) (Fig. 11a).[2] In adopting this motif, Rembrandt also adopted the further meaning it conveyed: it is possible that there is here an allusion to Christ's victory over Satan, who had seduced Adam and Eve, and thus to the Redemption of Humanity after the Fall.[3]

As Adam and Eve are lit from behind, their bodies—with surfaces modelled by the play of light and shade—stand out clearly against the background. Possibly in order to emphasise Eve's role as seductress, Rembrandt places her at the centre of the scene—an exception in the iconographic tradition—and draws attention both to the apple and to her pudenda through their strong contrasts of light and shade.

From the time of Van Eyck's Ghent Altarpiece scenes of Adam and Eve had been associated with anatomically correct studies of the nude. The nude was often idealised, and Adam and Eve were shown as a young and handsome couple. Rembrandt has shown them quite differently. In the tradition of classicist art criticism, Gersaint and Bartsch censured the exaggerated naturalism and ugliness of Adam and Eve in Rembrandt's scene.[4] They accused him of incompetence in drawing the nude, failing to see that Rembrandt had deliberately employed these stylistic means to convey the full impact of the psychological conflict.

Rembrandt had previously treated the subject of the Fall in two drawings.[5] The sheet in the Prentenkabinet of the Rijksuniversiteit in Leiden is a study for the etching (Fig. 11b). In it, Rembrandt experiments with two different means of conveying the tense relationship between Adam and Eve. In the left-hand sketch, executed in detail, Eve holds out the apple to Adam with one hand only, while he uses both hands in a gesture of self-defence. The smaller sketch resolves the composition into the arrangement found in the etching: here Eve holds the apple to her breast with both hands, while Adam reaches one hand out towards it, while pointing upwards in warning with the other.[6] The elephant seen trotting along in the sunny landscape of Paradise is based on the chalk drawings of elephants, made in about 1637 (see Drawings Cat. No. 13).[7]

The states of the etching differ only slightly from each other. In state I the upper edge of the over-grown stoney bank to the left of Adam is not yet marked in with an unbroken line. In the example of state I in London, Rembrandt has drawn in a tree stump to the left of Adam with black chalk.

H.B.

1. See, for example, *The Fall of Man* by Hugo van der Goes, of about 1470, in the Kunsthistorisches Museum in Vienna; Panofsky 1953, Plate 298.
2. B. 16.
3. Tümpel 1970, No. 1.
4. Gersaint 1751, pp. 18–19, No. 29. 'Comme Rembrandt n'entendoit point du tout à travailler le nud, ce Morceau est assez incorrect, & les têtes sont tout-à-fait désagréables' (As Rembrandt did not understand at all how to draw the nude, this scene is rather incorrectly treated, and the heads are altogether ugly). B. 28.
5. Benesch 163–64.
6. Benesch 164; Schatborn 1986, pp. 30–31. The red chalk study of about 1637 of a *Nude Woman with a Snake (as Cleopatra)* in the Getty Museum in Malibu, shows a striking similarity with Rembrandt's Eve in its distribution of light and shade across the naked figure, and it might have served as a preparatory study for this; see Benesch 137; White 1969, p. 42; Goldner/Hendrix/Williams 1988, p. 256, No. 114.
7. Benesch 457–460.

11b: Rembrandt, *Sheet of studies with Adam and Eve*, Drawing. Leiden, Prentenkabinet der Rijksuniversiteit.

11a: Albrecht Dürer, *Christ in limbo*. Berlin, Kupferstichkabinett SMPK.

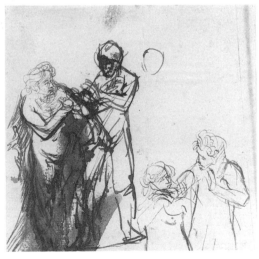

Rembrandt f. 1638

*Sheet of sketches
with a portrait of Saskia*

Etching and drypoint, 127 × 103 mm;
3 states
Signed: (only in II) *Rembrandt*; c. 1637
B./Holl. 367; H. 153; White, pp. 119–20

Berlin: I (493–16) II (494–16)
Amsterdam: I (O. B. 769), II (62:120)*
London: I (1848-9-11–189), III (1973 U. 892)

12: State I

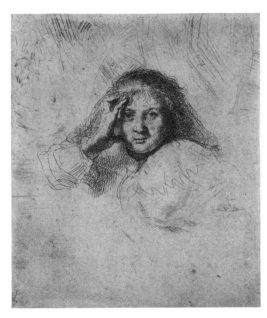

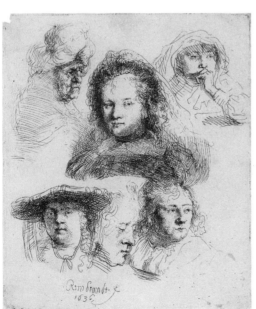

Rembrandt had been married since 1634 to
Saskia van Uylenburgh and he often used his
young wife as a model in allegorical, symbolic
portraits as well as for free sketches. Several
drawings and etchings show her in her sickbed;
in 1642, after a long illness and at the age of
only 30, Saskia died.[1]

In the period 1636–37 Rembrandt made
three etchings with head studies of Saskia
(Fig. 12a).[2] In the first state of B. 367 she is
shown *en face*, looking out at the viewer and
supporting her head with her right hand. Both
head and hand are carefully modelled with fine
hatching, but the arm and shoulder areas are
only sketchily indicated. The apparent
spontaneity of the execution and the alert
presence of Saskia lead one to assume that
Rembrandt worked directly on the plate in
front of his model. The same directness of
expression is conveyed in the 1633 silverpoint
Portrait of Saskia in the Kupferstichkabinett in
Berlin (Drawings Cat. No. 3).[3] Here Saskia,
four years younger than in the etching and
newly betrothed to Rembrandt, is shown with
a much brighter expression and her hand rests
only lightly against her face (Fig. 12b).
In the etching, on the contrary, she looks out
broodingly and seems to lean her head heavily
on her hand.

In state II, there are two heads as well as the
barely legible signature; the carefully hatched

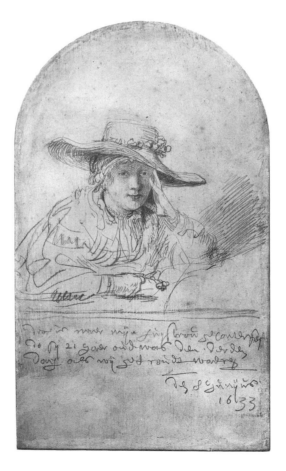

head at the lower right shows Saskia again, and
the unfinished sketch immediately next to it,
would also appear to be a record of her. This
head, indicated with only a few strokes,
provides an insight into Rembrandt's working
method: first he made his sketch in the wax
covering of the plate, then he carried it out in
detail (see Introduction p. 160). In state III, the
scratches on the upper part of the plate, and
also the signature, have been smoothed away.
A drawing, also dating from 1636–37, with four
studies of Saskia, in the Museum Boymans-van
Beuningen in Rotterdam, reveals a similar
appearance.[4] Rembrandt transferred the free
character of the drawn sheet of sketches to the
etching; the fact that he did not produce the
etching in one process but, rather, prepared
three states, questions the assumed 'random'
quality of the head studies. Rembrandt must
also have consciously etched the drypoint lines
of the first two states—at least, he consciously
allowed them to remain—in order to simulate
the directness of a sketch (see Cat. No. 5).
Even if Saskia's features are here recorded as in
a portrait, the real purpose of the etching is
different. The print-dealer Clement de Jonghe
(see Cat. No. 30) had among his stock of
printing plates several by Rembrandt, showing
sheets of sketches, among them some of Saskia.
This shows that works of this kind were
desirable collectors' items, intended for the
market.

H.B.

1. Among others Benesch 405, 425, 426; etching B. 369.
2. B. 365, 367, 368.
3. Benesch 427.
4. Benesch 360; Giltay 1988; p. 55, No. 109.
5. De Hoop Scheffer/Boon 1971, pp. 6 ff., No. 16
(probably the *Sheet of sketches with Saskia*, B. 365);
No. 39 (probably the *Sheet of sketches with Saskia*, B. 367
or B. 368); No. 42 (probably the *Sheet of sketches with
Rembrandt's Self-portrait*, B. 363).

12a: Rembrandt, *Sheet of sketches of Saskia*.
Amsterdam, Rijksprentenkabinet.

12b.: Rembrandt, *Portrait of Saskia*.
Silverpoint drawing.
Berlin, Kupferstichkabinett SMPK.

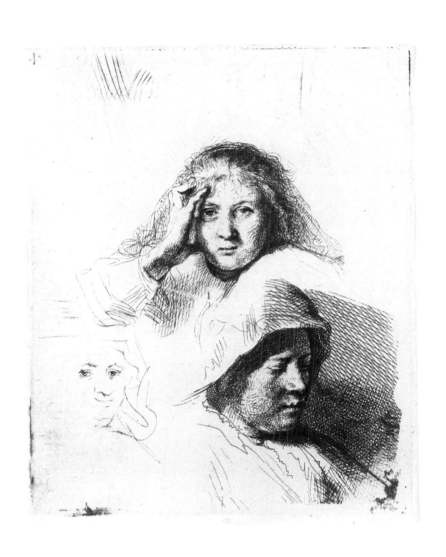

13

Self-portrait leaning on a stone sill

Etching and drypoint, 205 × 164 mm; 2 states
Signed and dated: *Rembrandt f. 1639*
B./Holl. 21; H. 168; White pp. 120–22

Berlin: II (1–16)
Amsterdam: I with corrections (O.B. 37)*;
II (O.B. 38)
London: I with corrections (1868–8–8–3177);
II (1868–8–22–656)

13a: Renier van Persyn, after Titian, '*Ariosto*'.
Amsterdam, Rijksprentenkabinet.

13b: Rembrandt, drawing after Raphael,
Baldassare Castiglione.
Vienna, Graphische Sammlung Albertina.

In 1631, at the age of 24, Rembrandt etched his important self-portrait in daring competition with Rubens's self-portrait which had become widely known through a reproductive engraving.[1] However, in 1639, Rembrandt made what is perhaps his most ambitious etched self-portrait. The next year he enhanced its significance by producing a painted version of the work.[2] Again, Rembrandt referred to an important model from the past, probably indeed to two. Yet neither of these is an artist's self-portrait. Doubtless Rembrandt was intending to compete with, and to surpass, Titian's so-called *Ariosto*.[3] At the end of the 1630s this painting is known to have been in Amsterdam, and, as demonstrated by drawings and reproductive prints (Fig. 13a), it was seen by artists there.[4] In contrast to the current view, the sitter was then identified as the Renaissance poet Ariosto, whose influence may be traced in seventeenth-century Amsterdam.[5] In contemporary texts, such as those by Karel van Mander, Titian himself was presented as a an ideal artist. Raphael too was especially praised, and his work recommended as suitable for imitation. Raphael's portrait of *Baldassare Castiglione*[6] was in Amsterdam at the same time as Titian's *Ariosto*. Castiglione was the author of the *Libro del Cortegiano*, in which the ideal of the cultivated courtier had found its most striking formulation.

Rembrandt made a drawing after Raphael's portrait in April 1639 (Fig. 13b) during a sale of works from the collection of Alfonso López.[7] In contrast to the other records of this work, however, such as the painted version of about 1620 by Rubens,[8] or the comparable Dutch

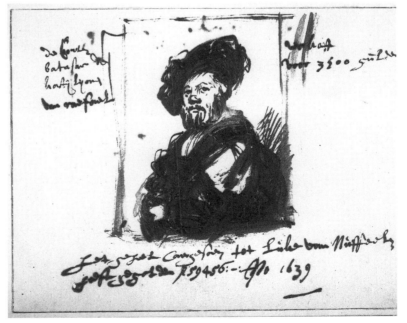

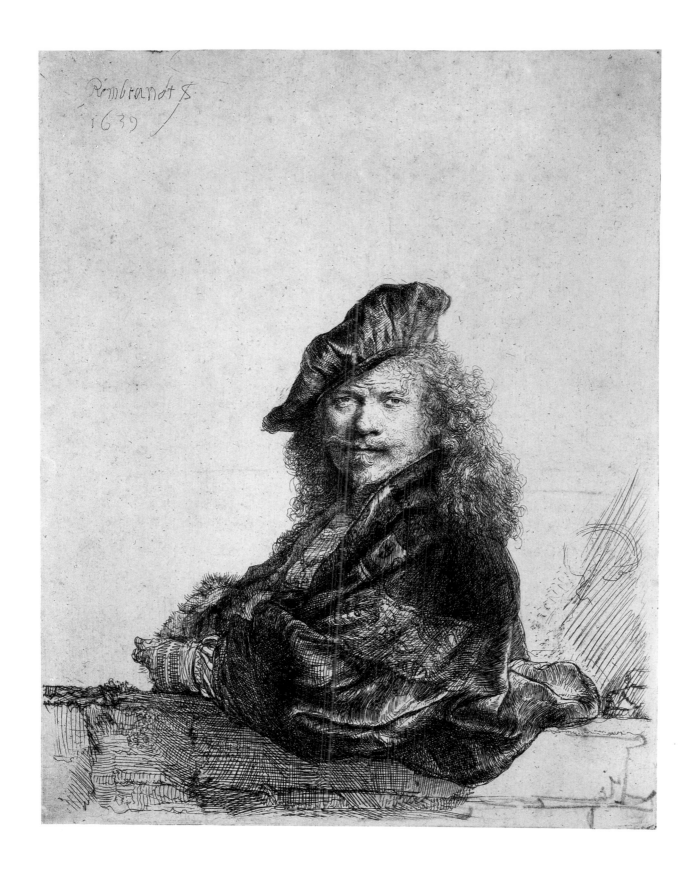

drawn copies and reproductive engravings,[9] Rembrandt's drawing is by no means an exact copy. On the contrary, it is closer to the Venetian portrait type. No longer viewed frontally, the sitter looks over his shoulder at the onlooker. The angle and proportions of the head covering have also been altered. The question of whether Rembrandt made the drawing before or after his portrait etching has caused controversy.[10] It is probable that Rembrandt's Titianesque portrait type was influenced by his record of Raphael's painting. At first glance, it seems as if Rembrandt has transferred this model into his own formal language. The drawing would then belong to the evolutionary process that led to the *Self-portrait* of 1639.

Resting his left arm on a ledge and turning his head, Rembrandt looks directly at the viewer over his shoulder. He wears a beret, its diagonal slant repeated in his upturned collar, an arrangement that both frames the face and at the same time gives structure to the composition. His hair falls in the shadow of his body on the right, but curls luxuriantly down over his left shoulder. While artists were commonly shown wearing such berets, the luxurious, fur-trimmed costume, so voluminous that it drapes over the paparet, seems to be more than a simple indication of social rank.[11] It must, rather, have been intended as a Renaissance costume, defining the portrait as *all'antica*. The size of the background is striking, its extent being emphasised through the placing of signature and date in the top left corner. Hatched strokes behind the shoulder indicate a dark area like a shadow. Nonetheless the figure is lit from the right.

The face turning towards the front, the cap, the turned-up collar, and the more marked integration of the hands taken from Raphael's work are combined by Rembrandt with Titian's picture structure characterised above all by the arm leaning on the ledge and the glance over the shoulder. Rembrandt evolved his self-portrait from a synthesis of the portraits by Titian and Raphael. The reference to tradition—to Raphael and Titian—must have been intended as a foil to the contemporary viewer's perception of this work. Rembrandt's solution should be understood in the sense of *aemulatio*.[12] In theoretical discussions, this term is used to describe competition between artists. The artist selected as a model was seen to present a challenge and, at the same time, to be surpassed through a personal artistic interpretation. Rembrandt thus presents himself in his 1639 self-portrait in artistic competition with Titian and with Raphael—representatives of two distinct

schools of Italian Renaissance painting. The self-portrait functions here not only as a representation of a personalised expression, but also as a programmatic formulation of the artist's identity and profession.

Although not documented through drawings, the etching provides evidence of Rembrandt's extrordinarily careful elaboration of this work. The etching is altered in its second state only in an apparently minor detail: The cap band continues right around the head. State I, with the more spontaneous effect of its nuances, was evidently corrected in the interest of greater formal unity. Six proofs of the first state are known, to all of which Rembrandt has added corrections.[13] These make it clear that Rembrandt was trying out further possible means of introducing greater firmness into the composition. Thus, in one proof, in London (Fig. 13c), Rembrandt strengthened the pilaster that had merely been suggested, while in another proof, in Amsterdam, he added further detail to the wall at the lower right. Only the corrections to the cap, however, were incorporated in the next state. Rembrandt had been interested, even before the first surviving state, in the exact shape of the cap. Traces of fine lines clearly used by Rembrandt to sketch outlines before he elaborated the image, reveal that a more drooping shape had at first been envisaged. The final correction may thus be seen as a result of careful experiment.

The next year (1640), Rembrandt made a painted version of the portrait after the print which he had probably intended for sale.[14] The similarities with Titian's painting are clearer in the painted image, which reverses that of the etching. Among Rembrandt's pupils, this iconographic solution is repeatedly adopted for artists' self-portraits.[15] Rembrandt's innovation, developed in a spirit of competition, was evidently judged to be a model in its own right.

B.W.

1. B. 7; Fig. 12 in the introduction.
2. National Gallery, London, *Corpus* A139; Paintings Cat. No. 32.
3. National Gallery, London.
4. Copy by Theodor Matham in the Herzog Anton Ulrich-Museum, Braunschweig; copy by Joachim Sandrart in the Fondation Custodia (F. Lugt collection), Instuitut Néerlandais, Paris; reproductive engraving by Reinier van Persyn, Holl., XVII, No. 15. See New York 1988, No. 25.
5. See De Jongh 1969.
6. Now in the Louvre, Paris.
7. Albertina, Vienna, Benesch 451; *Urkunden* 71.
8. Courtauld Institute Galleries, London.
9. Copy by Sandrart (Louvre, Paris), engraved by Reinier van Persyn (Holl. XVII, No. 41).
10. While De Jongh 1969, in particular, has argued that the drawing was made after the etching, Chapman 1990 has recently argued that the etching followed the drawing.
11. Chapman 1990, pp. 71 ff.
12. De Jongh 1969; Raupp 1984, pp. 168–81; Chapman 1990, pp. 69–78.
13. Amsterdam (2), London, Madrid (2), Melbourne.
14. Paintings Cat. No. 32.
15. Ferdinand Bol, Govert Flinck, Frans Mieris; see *Corpus* A139.

13c: Rembrandt, *Self portrait leaning on a stone sill*. State I, with corrections. London, British Museum.

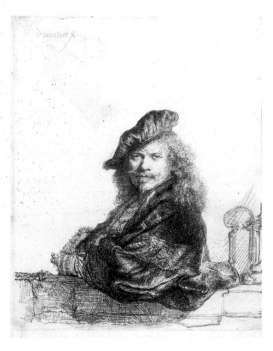

14

The Death of the Virgin

Etching and drypoint, 409 × 315 mm;
3 states
Signed and dated: *Rembrandt f. 1639*
B./Holl. 99; H. 161; White pp. 43–46

Berlin: III (316–1893)*
Amsterdam: I (62:2)
London: I (1973 U. 898)

In a stately bed a woman lies dying. Around
her is a large assembly of mourners. The
heavens open; an angel, surrounded by *putti*,
steps down from the clouds. While not
recounted in the Bible, the story of the death
of the Virgin had already been widely known
since the early Middle Ages, primarily from the
account in the *Golden Legend*. The death of the
Virgin is an important theme in catholic
iconography. For Calvinists, however, worship
of the Virgin was forbidden. As in the case of
the etching Rembrandt made two years later,
The Virgin and Child in the Clouds,[1] and *The
Virgin and Child with the Snake* (Cat. No. 36),
it would seem that this work was intended for
the Catholic connoisseurs in Amsterdam.

The point of departure for Rembrandt's
print was the corresponding episode in Dürer's
etched *Life of the Virgin*, produced between
1502 and 1510 (Fig. 14a).[2] A year earlier, in
1638, Rembrandt had bought a set of Dürer's
series at auction.[3] Rembrandt sought to surpass
Dürer even in the dimensions of his etching, for
Dürer's woodcut measures 295 × 210 mm.
While Dürer shows the death of the Virgin as a
liturgical ceremony in the presence of only the
twelve Apostles, Rembrandt depicts a large
group of mourners, including both men and
women, an arrangement found in the earlier
engraving by Philip Galle after Pieter
Breughel.[4] It would appear that Dürer's
composition was already known to Rembrandt
indirectly, through a work by Dirk Crabeth.[5]
Specific aspects of Rembrandt's composition,
such as the altered spatial arrangement, would
seem to have been prompted by what
Rembrandt found here.

The effect of his wife's illness[6] on
Rembrandt is shown both in a poignant sheet
of etched sketches (Fig. 14b)[7] and in the
artist's rendering of the Virgin. While none

of the sketches should be understood as a preparatory drawing for the etching, it is probable that observations made from the model left their mark on Rembrandt's treatment of the scene, giving the figure of the Virgin as authentic an appearance as possible. Departing from iconographic tradition, Rembrandt introduces the figure of a doctor, who takes the Virgin's pulse, a motif familiar from other death-bed scenes.[8]

Rembrandt varies the crowd of mourners thronging around the bed through their different expressions of sorrow. Individual figures stand out from the group because of their imposing appearance. Especially striking is the figure of the priest who, accompanied by a server, approaches at the left of the death bed. Both figures, indeed, find a loose parallel in Dürer's print where in the foreground one of the apostles kneels and holds a crucifix, and Peter, identified by his mitre as the first bishop of Rome, stands in the left background. In Rembrandt's print, however, the figure of the priest does not participate in the religious ceremony. The dress of the figures is something of an orientalising fantasy costume, intended to place the event in the ancient Jewish Middle East. Among several figures who indicate the time-honoured sanctity of the event is the man sitting in the left foreground in front of the boldly illuminated bible. Lastly, prominent because of their size, the lamenting woman in front of the bed and the brightly-lit figure whose outstretched arms lead the eye on to the high curtain, set the tone of strongly expressive sorrow. The enormous curtain, which would seem out of place as the furnishing of an interior as Dürer shows it, is employed by Rembrandt as a symbol of majesty. It is also possible that it symbolises a boundary between the earthly and heavenly kingdoms.[9] In addition to establishing distinct groups among the figures—those who mourn and those whose presence alludes to the sanctity of the event—Rembrandt adds a third group of figures: the angels and *putti* belonging to the heavenly realm. Three types of space seem to be adopted: the 'normal' space of the interior, an intermediate, 'sanctified' space, and the space of the heavenly sphere.

Rembrandt's range of techniques is exciting to behold, for it embraces both a painstaking record of details and a bold sketchy style. Only the lighting is minimally altered in the three states of the etching: the chair in state II, for example, is heavily shaded with dry-point while the foreground bedpost in state III is more strongly shaded. In any case, it is possible that Rembrandt rejected his first design for *The Death of the Virgin*, and then executed the design of the print as we now know it on a new plate. Impressions of the *Landscape with the three trees* (Cat. No. 19) show traces of a re-working of the plate which appears to be a compositional outline for *The Death of the Virgin*.[10] If this is indeed the case, this would constitute clear evidence that Rembrandt based some of his compositions not on detailed preparatory drawings, but rather on hasty sketches drawn directly on to the plate.
B.W.

14a: Albrecht Dürer, *Death of the Virgin*. Berlin, Kupferstichkabinett SMPK.

14b: Rembrandt, *Sheet of studies*. Amsterdam, Rijksprentenkabinet.

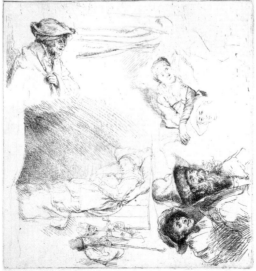

1. B. 61.
2. B. 93.
3. *Urkunden* No. 56. See Cat. No. 11; on Rembrandt's adoption of elements from the work of Renaissance masters such as Dürer and Lucas van Leyden, see also the commentary on the *Ecce Homo* (Cat. No. 38).
4. See Campbell 1980.
5. Glass painting in the Oude Kerk in Amsterdam; see White 1969, p. 45.
6. For example, Benesch 379, Schatborn 1985, No. 12, Amsterdam.
7. B. 369.
8. Tümpel 1969, p. 194.
9. Campbell 1980, p. 4.
10. Campbell, 1980.

15

The Artist drawing from the Model (Allegory of the Glorification of Drawing)

Drypoint, etching and burin, 232 × 184 mm;
2 states; c. 1639
B./Holl. 192; H. 231; White, pp. 160 ff.

Berlin: II (279–16)
Amsterdam: II (1962:66)
London: II (1973 U. 995)*

15a: Pieter Feddes van Harlingen, *Pygmalion*.

15b: Jacopo de' Barbari, *Allegory of Fame and Victory*. London, British Museum.

The sheet produced in about 1639 is only partially executed: the background, where one can see just the upper section of an easel, a bust on a high pedestal and suggestions of an arch, is carefully worked out in various kinds of hatching, while the remainder of the scene is only shown in a few sketchy drypoint strokes. An artist, whose facial features recall those of Rembrandt is engaged in drawing a nude female model who stands on a low footstool with her back to the viewer. The position of the model's supporting leg and her leg at rest, her pose and the turn of her head suggest the inspiration of a statue of Venus from Antiquity. The model has a cloth draped over her left arm, and she holds a long palm spray in her right. In both the left and right corners of the scene, there are suggestions of a chair. The canvas on the easel and the props on the wall—a shield, a sword and a feathered hat, objects owned by Rembrandt which appear in his works—show that the setting is an artist's studio.

With regard to the composition and the figure of the model, there are certain parallels with an etching made earlier by Pieter Feddes van Harlingen (Fig. 15a).[1] This shows Pygmalion, the sculptor from Antiquity who, falling in love with a female statue he had himself made, begged Venus to breathe life into the figure.[2] In the eighteenth century Rembrandt's sheet too was given the title *Pygmalion*.[3] Rembrandt's artist, however, is not shown as if overcome

with love for his own creation, but looks at the model in order to record her on the paper.

Scenes of artists at work in their studios were a common motif in the seventeenth century. The most famous examples are *Las Meninas* of Velázquez and Vermeer's *Art of Painting*. The central element of this motif, the relation of artist to model, was usually treated allegorically; thus, for example, the artist shown by Vermeer is painting Clio, the Muse of History, and his scene may thus be understood as an allegory on the Glory of History Painting. Rembrandt's model holds a palm spray, the symbol of fame. Rembrandt's immediate source—as also that of Feddes van Harlingen—must have been the corresponding figure in an engraving by Jacopo de' Barbari of about 1498–1500, showing the *Allegories of Fame and Victory* (Fig. 15 b).[4] The palm spray in the hands of an undraped female figure could, however, also indicate that Rembrandt here intended to show the Allegory of Veritas (Truth). The embodiment of Fame or Truth is also, in an extended sense, the artist's model here: as the Muse that inspires him. The real subject of this sheet is, therefore, the Glorification or the Truth of Drawing.[5] From the Renaissance, *disegno*—meaning both a drawing and an idea—was regarded as the basis of all the arts, because it was the most direct embodiment of the artist's conception. Rembrandt illustrates this theoretical connection by showing the draughtsman sitting in front of the canvas on his easel. For it is only after making the preparatory sketch that the painter—and here Rembrandt is probably alluding to himself—reaches for brush and palette, in order to transfer to the canvas, with the help of colours, the theme he has observed.[6] In this conceptual context, the bust in the background might perhaps be understood as a symbol of *Sculptura*.

The old title of the etching probably had its source in the classicist art criticism of the late seventeenth and the eighteenth centuries, which censured self-love in artists (Rembrandt too was seen to be guilty of this) through the image of Pygmalion.[7]

But why was the plate left unfinished? By this time Rembrandt enjoyed widespread fame in Europe as an etcher. He might have deliberately published the unfinished plate in order to reveal to the public his own print-making technique.[8] It is possible that Rembrandt intended to incorporate in the unfinished sheet a challenge to his pupils to enter into artistic competition with their master by nobly completing the studio scene on which he had embarked.[9] It is also probable that the plate was not further worked up on

VOLGHT·NIET·Pygmalion·
DEYGHEN·LIEFD·HEM·VERWON·
DOER·EEN·BEELD·VAN·SIN·WERKEN

VEEL·DOLEN·NOCH·DEES·TYDT
IN·EYGHEN·ZIN·SO·WYDT
EN·KOENENT·ZELF·NIET·MERK

account of deficiencies in the drawing and inconsistencies in the composition. It is not absolutely clear, for one thing, how the draughtsman is sitting; he seems to sit near the chair rather than on it, as the four chair legs are scratched on to the plate to his left. Curious uncertainties are revealed in the allegorical figure's two pairs of legs. One pair is too long in proportion to the rest of the body, but the feet are correctly placed on the footstool, while the other pair of legs is in proportion to the body, but floats unsupported in the air. The elongated legs supported by the footstool are more weakly sketched-in.

In state I, the uncertain record of the model's feet is even more obtrusive; here the footstool is only lightly marked in (Fig. 15c). In the related drawing in London, which shows the composition in reverse and on about the same scale, the model's pose is fully resolved (Fig. 15d). The confused tangle of lines at the right of the etching is also lacking here, being replaced by the base of a pillar. This indicates that the drawing was only made during the preparation of the etching and, indeed, after this had reached state II, presumably with reference to a counter-proof bearing the reversed imprint of the etched composition.[10] It is evident that Rembrandt sketched the scene directly on to the plate without any preparatory study, and only later, and with the help of the London drawing, attempted to correct his rather botched composition.

The fact that the etching was published as a fragment is witness to collectors' appreciation of such unfinished sheets. They would have seen them as works in which the artist's first thoughts were revealed. Unfinished engravings had already been published by Hendrick Goltzius and Jacob Matham; in these it almost appears as if the scenes depicted were deliberately left in a fragmentary state.[11]

In the rare state I, in which the drypoint passages are still very strong, the upper part of the easel and the drapery on the model's arm are not yet hatched; between the draughtsman and his model, and in front of the blank canvas on the easel, there is a small printing press. The London example of this state reveals black pencil corrections in Rembrandt's hand on the turban-like head covering of the bust as well as on the chimney or pillar to the right; in state II hatching is added in these areas.

Hind gave a late dating to the unsigned etching, around or after 1648, but it must have been made earlier, in about 1639.

H.B.

1. Holl. 21; Saxl 1910, pp. 42 ff.
2. Ovid, *Metamorphoses*, X, 243 ff.
3. Yver 1756, p. 61, No. 184.
4. B. 18, Hind 26; Saxl 1910, p. 43; Amsterdam 1985–86, pp. 66 ff., Nos. 53–55.
5. Emmens 1968, p. 160.
6. It is not possible to deal exhaustively here with the complex content of the scene. See Held 1961, pp. 73 ff., Figs. 1–2 on a painting by Guercino with a related subject, in which the Father of Drawing shows his daughter, the Allegory of Painting, a sketch from which she then executes the scene shown in the picture.
7. Emmens 1968, pp. 159 ff.
8. In this connection, Emmens argued that the uncovered bust in the background alluded to this function; Emmens 1968, pp. 160 ff.
9. Emmens 1968, pp. 160 ff. It is perhaps worth considering, once again, whether the rather weak finished part of the etching, already ascribed by Francis Seymour Haden to Ferdinand Bol, really was executed by Rembrandt himself and not, rather, by one of his pupils; Haden 1877, pp. 41–42.
10. On the drawing, see Benesch 423; Schatborn 1986, pp. 18–19. The correct identification has been established by Martin Royalton-Kisch, who will publish it in the catalogue of the London Rembrandt drawings now in preparation. Münz attributed the etching, as also the related drawing, to Gerbrand van den Eeckhout; Münz 1952, Vol. II, pp. 182–83, No. 339. Two counter-proofs of the etching survive, one in Cambridge and one in Vienna.
11. Three engravings of this kind by Goltzius are known: *The Adoration of the Shepherds*, Holl. 15; *The Massacre of the Innocents*, Holl. 17; and a *Standing Female Allegory*, Holl. 54.

15c: Rembrandt, *The Draughtsman drawing the Model*. State I. London, British Museum.

15d: Rembrandt, *The Draughtsman drawing the Model*. Drawing. London, British Museum.

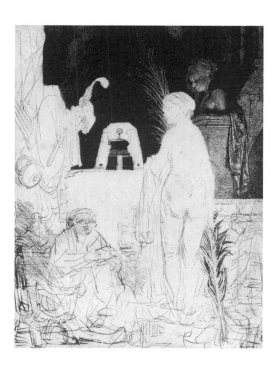

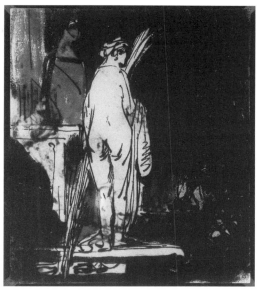

16

Portrait of the Preacher
Cornelis Claesz. Anslo

Etching and drypoint, 188 × 158 mm; 2 states
Signed and dated: *Rembrandt f. 1641*
B./Holl. 271; H. 187; White pp. 124–25

Berlin: I (78–1887)*
Amsterdam: II (O.B. 524)
London: II (1973 U. 945)

Cornelis Claesz. Anslo (1592–1646), a cloth
merchant successful in both domestic and
overseas trade, was a member of the 'Water-
landse Gemeende' (Waterland congregation) in
Amsterdam. This was a liberal group in
comparison with the rather stricter
Mennonites, who had taken their name from
the Frisian Anabaptist, Menno Simonsz.
However, the Waterland congregation also held
that the spoken word had absolute priority
over the visual image in the transmission of
Christian faith. The group had no ordained
preachers and preferred, rather, to select from
among its number those gifted in expounding
the Scriptures. In Amsterdam, Anslo presided
as spiritual adviser and preacher at the Grote
Spijker, the congregation's chapel on the River
Singel. Cornelis Anslo was distinguished,
apparently, by his talent as a speaker, but
equally by his deep religious faith and, at a
time of often dogmatic religious opinion in
Amsterdam, by his tolerant attitude towards
Baptists of differing persuasions. A double
portrait of 1642 shows Anslo with his wife,
Aeltje Scholten Gerritsdr. (Paintings Cat.
No. 33).[1]

The portrait etching of 1641 shows Anslo
expounding the word of God to an imaginary
listener, with his eyes not looking directly at
the observer. His right hand, holding a pen,
rests on an upturned book, while with his left
hand he points to a large open volume of the
Scriptures. His dress—fur collar, ruff and
hat—demonstrates that he belongs to the
wealthy bourgeoisie. Behind him, a picture is
turned to face the wall, apparently having been
removed from the illusionistically painted nail
above. As Busch has shown, Rembrandt is
alluding here to the dispute over the relative
importance of word and image in the imparting
of the message of Salvation, a question
unambiguously resolved in this case in favour

of the written and spoken word.[2] One might however ask if it is mere chance that the etching is signed on the reversed painting.

The preparatory drawing (Fig. 16a) matches the etching in both its dimensions and (though reversed) in its composition, and it reveals signs of tracing.[3] Because it has been so carefully executed, one may assume that it served not only as preparatory material for the artist, but also as a *modello* to be submitted to the patron.[4] Very few of Rembrandt's drawings which were intended for direct transfer to the etching plate survive.[5] In the case of other portrait etchings, for example the *Posthumous portrait of the preacher Sylvius* (Cat. No. 22), where preparatory drawings have survived, no *modelli* are known.

While the figure of Anslo is transferred in almost every detail from the drawing, the backgrounds show alterations in several respects. Most important is Rembrandt's addition of the picture taken down from the wall. The arrangement of light and shadow in the etching eschews specific emphasis in favour of very evenly distributed illumination; and the execution is more schematic than in the case of other portrait etchings.

The first state shows a minimally altered picture area, which in state II is enlarged both below and, to a small degree, at the left, thus the image as a whole is expanded to fit the size of the plate. A few shadows are marked in more precisely with drypoint.

This portrait of Anslo bears no text, nor does it reveal any space for the insertion of a handwritten panegyric. However, on both the mounting of the preparatory drawing and on a proof of state II in London, there is an epigram by Joost van den Vondel, arguably the most important Dutch poet of the baroque era, in a seventeenth-century hand:

'Ay Rembrandt, mael Kornelis stem.
Het zichtbre deel is 't minst van hem;
't Onzichtbre kent men slechts door d'ooren.
Wie Anslo zien wil, moet hem hooren'.[6]

(Ah Rembrandt, paint Cornelis's voice
the visible is the least important part of him
One can experience the invisible only through the ears
Whoever wants to see Anslo, must hear him.)

Scholars have been much concerned with the relationship between Rembrandt's print and this poem. Emmens proposed that the text be understood as a reference to the etching, and that it was the import of this text that had spurred Rembrandt to lay more stress on the word in his painting.[7] This theory has been disputed on several grounds.[8] It is especially striking that, even in the etching, Anslo turns towards an invisible listener with his mouth slightly open, that is to say, speaking, thus clearly stressing the word and the voice. In addition, it is necessary to consider the purpose of poems of this sort. They conform to a literary tradition of their own, rather than making direct reference to contemporary artistic practice. 'Regarding Vondel's lines it has to be suggested that Rembrandt was well aware of the poet's ill-will towards him, but had on the other hand—and according to his commission—shown in his picture the priority of the word over the image, at least the divine word, and in this respect being fully in accordance with Vondel.'[9]

B.W.

1. Berlin, *Corpus* A143.
2. Busch 1971.
3. Benesch 758; London, British Museum.
4. A comparable *modello* for the figure of Anslo in the Berlin double portrait also survives, Paris, Benesch 759.
5. An early example is the etching of *Saint Paul*, B. 149, and the related drawing Benesch 15; see also the *Diana* etching B. 201 and the drawing Benesch 21, as well as the portrait etching of *Jan Six* (Cat. No. 23).
6. *Urkunden* No. 100.
7. Emmens 1956.
8. Busch 1971; *Corpus* A143.
9. Busch 1971, p. 199.

16a: Rembrandt, *Cornelisz Claesz. Anslo*. Drawing. London, British Museum.

17

The Flute-Player

Etching and drypoint, 116 × 143 mm;
4 states
Signed (from II): *Rembrandt. f 1642*
B./Holl. 188; H. 200; White, pp. 164 ff.

Berlin: II (182–1878)
Amsterdam: II (61:1096)*
London: III (1973 U. 958)

In 1642, the year Rembrandt finished painting *The Nightwatch*, he etched a small-scale genre scene that was known, until the eighteenth century, by the misleading title *Till Eulenspiegel (L'Espiègle)*.[1] A young man is seen lying on the bank of a stream, his crook shows him to be a shepherd. An owl is perched on his shoulder, and in his hands he holds a flute. He seems to have only just broken off playing and is now eyeing the legs of his young companion. She wears a broad-brimmed straw hat and is seen plaiting flowers into a garland. In the background, sheep and goats crowd towards the water. At first glance this seems to be a pastoral love scene. Influenced by pastoral poetry such as P.C. Hooft's *Granida* (1605), scenes with shepherds, or pastorals, were very popular in Holland from the 1620s. Central to such scenes was the joyful gathering of shepherds to sing and make love.[2] Rembrandt only rarely treated this subject: apart from half-length portraits of *Saskia as Flora in the Costume of a Shepherdess*, only a few drawings and etchings with a bucolic theme are known.[3]

The Flute Player, nonetheless, breaks with the tradition of pastoral scenes in containing motifs that disturb the normally peaceful, idyllic character. The young man's face, in contrast, to the tradition for such figures, is ugly, almost vulgar; Rembrandt may have been inspired here by the figure with a flute in a woodcut after Titian.[4] The vulgar character of the shepherd is supported by the way in which he surreptitiously and voyeuristically peers up the girl's skirt. The owl on his shoulder, which appears to be wearing a collar with fool's bells, is an old symbol of folly and sinfulness. The

young man is seen to point his flute towards the revealed crotch of the shepherdess, and not by chance: the flute was often described in contemporary commentaries as a phallic symbol. In a pastoral scene by Abraham Bloemaert (1627), in the Niedersächsische Landesgalerie in Hannover (Fig. 17a), a shepherd pushes his flute, in an equally unambiguous manner, under the skirts of his female companion.[5] The floral garland may be understood in direct relation to the motif of the flute. Since the Middle Ages, the making of floral garlands had served as a metaphor for entering into an amorous relationship. The garland itself, however, was also a symbol of the female genitalia, or of the virginity that a girl declares she is ready to sacrifice by offering a garland to her lover. The purse of the shepherdess too may be understood, in this context, as a sexual symbol. The lascivious allusions in this scene are finally stressed through the presence of the sheep and the goats, as these animals were widely associated with sexual excess. Rembrandt repudiates the traditional pastoral scene in exaggerating the erotic aspects of the subject through bold sexual symbols and allusions. Iconographically, the *Flute Player* may be traced back to the moralising love scenes in German and Netherlandish prints of the fifteenth and sixteenth centuries, although it is impossible to point to a specific model. It seems that Rembrandt wished to comment satirically on the pastoral genre.[6]

The head emerging from the bushes towards the upper right corner remains a mystery: is it a faun or a wood spirit peeping out? But why,

17a: Abraham Bloemaert, *Shepherd scene*. Hannover, Landesgalerie.

then, is its gaze turned away from the main scene? Or is this all that remains of a figure from an earlier scene, worked in part on the plate and then abandoned?[7] As the face appears in a corner, one might assume that an originally larger plate had been cut down. It seems that Rembrandt valued the charm of bizarre motifs of this sort, looking as if they had come about by chance. In the *Virgin in Glory* (B. 61), for example, he allowed an etched head of the Virgin to remain in the proofs (visible upside down in the Virgin's dress).[8]

In the four states of the *Flute Player* it is above all the relation of light and shade that is varied. In state I, shadows lie across the hat of the shepherdess; in the signed and dated state II these are thoroughly lightened and reworked as delicate foliage. In state III, the area above the hat is once again substantially darkened with drypoint lines. In state IV, changes in the foreground can be detected, and the face in the bushes has been removed. In all four states certain areas, for example in the bushes behind the shepherd, show a fair amount of surface tone.

In the Berlin example of state I, and long unnoted, there are pen additions in grey ink—in one place also in brown wash—on the shepherd's costume, on his face, on the right corner of the girl's skirt as well as on the ground visible at the right between the shepherd's shoulders and the goats (Fig. 17b). The London impression of state I shows almost the same corrections. Thicker shading is tried out with the brush additions; these must be in Rembrandt's hand as, in state II they are followed in the additional drypoint hatching lines on the plate.

H.B.

1. Gersaint 1751, pp. 148–49, No. 180.
2. On this, see McNeil Kettering 1977.
3. *Corpus* A93, A112; Benesch 424, 748; B. 189, 220.
4. McNeil Kettering 1977, p. 35, Fig. 19, p. 39.
5. Braunschweig 1978, pp. 48 ff., No. 3.
6. It is difficult to be precise about the meaning of Rembrandt's scene. Emmens interprets it as the artist's commentary on the pastoral inspiration of poetry. He claims however, that, in the vulgar character of the scene, Rembrandt was not referring to the high lyrical form of poetic inspiration, but rather to the lower, erotic form of inspiration which served the *poeta vulgaris* (Emmens 1968, pp. 147 ff.). White assumes that Rembrandt is illustrating a particular pastoral poem (White 1968, p. 164).
7. McNeil Kettering 1977, p. 21, note 7.
8. On this matter in general see Robinson 1980.

17b: Detail of Cat. No. 17, State I. Berlin, Kupferstichkabinett SMPK

18

The Hog

Etching and drypoint, 145 × 184 mm;
2 states
Signed and dated: *Rembrandt f. 1643*
B./Holl. 157; H. 204; White, pp. 165 ff.

Berlin: I (240–16)
Amsterdam: I (61:1081)*
London: I (1910–2–12–364)

One of the oddest records of everyday life
among Rembrandt's prints is this scene of a
tethered pig lying on the ground with its
trotters tied. A boy walks past, laughing, with
a pig's bladder in his hands, while an old man
is seen making ready to slaughter the animal.
In his right hand he holds a basket and what
appears to be a cleaver, in his left a bent
wooden stick which will be used to hang the
slaughtered pig up on a bar. A wooden trough
hangs on the wall. A small boy, supported by
his mother, looks at the animal with slightly
anxious surprise.[1] Another laughing boy,
wearing a hat, is indicated in the background.

Scenes of pig slaughtering, for example in
late medieval book illumination, were originally
incorporated into series of the months of the
year, mostly representing the month of
December. November was illustrated by pig
fattening.[2] Late autumn was the traditional
time for slaughtering, as the animals had been
fattened during the summer and early autumn.
In Dutch, November was also known as
slachtmaand (the slaughtering month), and
during November the *varkensfest* (pig festival)
or *varkenskermis* (pig fair) was celebrated.[3]
The calendrical tradition endured into the
seventeenth century. In a series of months of
the year by Cornelis Dusart (about 1690) pig
slaughtering represents November.[4] By this
time, however, the subject had taken on a
certain independence as a genre scene. An
etching by Adriaen van Ostade (Fig. 18a), from
about the same time as Rembrandt's print,
shows the event without integrating it into a
series of months.[5] Children, looking on with
amusement or scepticism, were a traditional
element in scenes of pig slaughtering.
Rembrandt's scene, however, departs from
iconographic tradition in one significant
respect. It does not show the slaughter itself,

18a: Adriaen van Ostade, *The Pig Killers*.
Berlin, Kupferstichkabinett SMPK.

but rather the moment preceding it. Interest is focused on the pig, which seems to have resigned itself to its tragic fate; almost smiling, and without a trace of agitation, it lies there peacefully.

The laughing boy holds an inflated pig's bladder as if it were a toy. This motif was exceptionally popular in Dutch painting, mostly in slaughter scenes.[6] Like the soap bubble, the animal bladder is found in contemporary emblem books as a symbol of earthly transience: *Homo Bulla*—man is like a bladder, puffed up with wind only to burst.[7] The pig's bladder in Rembrandt's etching could be pointing to the animal's inescapable fate, but perhaps also in a wider sense to that of man. In contemporary literature and art, pig slaughtering was treated as an allusion to earthly transience in the widest sense: 'You that see fit to slaughter your oxen, pigs and calves, think of God's verdict on the Day of Judgment'.[8]

A sheet of studies from life in the Louvre in Paris (Fig. 18b) shows two pigs, of which the recumbent one is similar in many respects to the one in the etching, though one could not speak here of a preparatory drawing in the strict sense.[9]

Rembrandt has almost exclusively etched the plate. While the background figures are marked in sketchily, the pig is precisely drawn, even down to the details of its hide. Here, Rembrandt has strengthened the contours with a few drypoint lines. In state II, of which only one example—in London—is known, a few strokes were added to the toddler's ear, to the face of the boy with the pig's bladder, and in particular to the pig.

H.B.

1. This group of mother and child was often used by Rembrandt (see Cat. No. 10); Schatborn 1975, p. 10.
2. For example, in the *Breviarum Grimani*, c. 1510–20.
3. Lawrence, Kansas; New Haven and Austin 1983/84, p. 176, No. 48.
4. B. 30, Holl. 30.
5. B. 41, Holl. 41; Lawrence, Kansas; New Haven and Austin 1983/84, pp. 176 ff., No. 48.
6. Amsterdam 1976, p. 116, No. 24.
7. Amsterdam 1976, pp. 44 ff., No. 4.
8. Amsterdam 1976, pp. 116 ff., No. 24, (from a source from 1667). 'Ghy die naer u welbehagen Os en Swijn en Kalf doet slaen; Denckt hoe ghy ten Jongsten Dage Voor Godts Oordeel sult bestaen'.
9. Benesch 777. Schatborn 1977, pp. 10–11. Paris 1988/89, p. 36, No. 25.

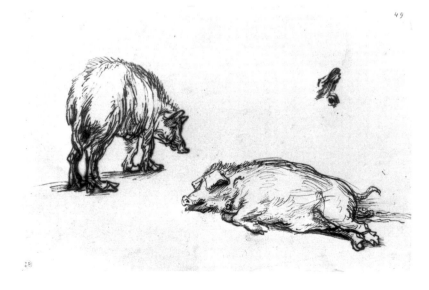

18b: Rembrandt, *Sheet of studies with two pigs*. Drawing. Paris, Musée du Louvre, Département des arts graphiques.

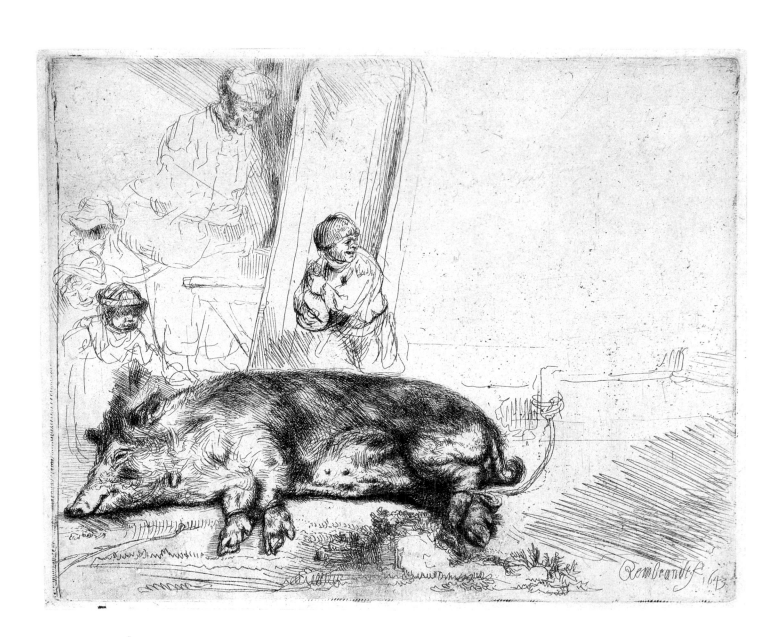

19

Landscape with three trees

Etching, worked over with engraving and
drypoint; in places, sulphur tint etching
213 × 279 mm; 1 state
Signed and dated: (barely visible) *Rembrandt f.
1643*
B./Holl. 212; H. 205; White, pp. 198 ff.

Berlin: (303–1898)
Amsterdam: (O. B. 444)*
London: (1868–8–22–678)

19a: Rembrandt, *The Shepherd and his family.*
Amsterdam, Rijksprentenkabinet.

19b Detail of Cat. No. 19.

The *Landscape with three trees* is Rembrandt's
largest and, on account of its painterly
execution, perhaps most celebrated landscape
etching. The view, from about eye level,
is of the gentle slope of a hillock with three
large trees, and of a broad low plain with a
silhouetted city in the distance.
The foreground is in dark shadow, while the
landscape in the distance is brightly lit.
The trees are shown against the light and
form a powerful contrast to the sky, which has
lightened in this region. Thick parallel hatching
strokes run across the upper left corner.
Whether, as has mostly been assumed, these
are intended to represent a shower, remains to
be established, as comparable etching clusters
in the *Three Crosses* (see Cat. No. 35) are used to
embody rays of light. It is equally uncertain
whether a turbulent, stormy sky is really
shown here, as has usually been claimed by
commentators. In that case it would be difficult
to explain why the figures, for example the
farmers and cowherds in the plain, do not react
to the storm. In spite of the turbulent sky, the
landscape exudes complete calm. The treetops
sway only slightly in the wind; and sun and
cloud, bringing light and shadow, seem to pass
swiftly, in turn, over the earth. To this extent
Rembrandt has, indeed, recorded the effects of
weather—perhaps the atmosphere of morning
or evening, with a rising or setting sun—but
not a storm in the real sense.[1]

In the left foreground we can see a fisherman
with a woman sitting beside him; to the right,
hardly detectable in the thick bushes on the

slope of the hillock, there are two lovers. Along
the ridge of higher ground, a horse and cart are
moving slowly along, carrying several
passengers; and nearby there is a seated man
who is drawing. The motif of the draughtsman
in the landscape was often used in the sixteenth
century in the circle of the Netherlandish
Mannerists, for example in the work of Lukas
van Valckenborch or Paulus van Vianen.
Rembrandt made this his central subject in an
etching of 1642–43.[2] The draughtsman seen in
the *Landscape with three trees,* however, differs
from the traditional treatment of this motif in
one key respect: he is not looking at the
landscape that is shown in the scene that the
viewer of the etching beholds, instead he looks
to the right where the landscape, hidden from
the viewer, is apparently sunnier. Rembrandt
is perhaps alluding here to the notion that the
landscape artist is inspired more by his inner
imagination than by the direct observation of
nature.[3] Lying behind the trees, brightly lit by
the sun, is a farmhouse.

It is probable that Rembrandt has here
reworked his own impressions of the region
around Sint-Anthoniesdijk (Diemerdijk) or
around Haarlemmerdijk, not far from
Amsterdam, which itself seems to be visible,
silhouetted in the distance.[4] The *Three Trees,*
however, is not intended to be a reliable,
topographical view but, rather, a freely
composed one. In a far greater measure than
in Rembrandt's other landscape etchings with
motifs from the environs of Amsterdam or
Haarlem (see Cat. No. 20, 28 & 32), the
present etching shows an idealised landscape
and, indeed—because of the trees pushed into
such an exposed position in the scene and the
dramatically presented sky—even a 'heroic'
landscape. Rembrandt's success in capturing
the atmosphere, and the different appearance of
illuminated and shadowed regions, recalls the
ideal landscapes of the French painter active in
Rome, Claude Lorraine, whose work may have
inspired Rembrandt's treatment of the
Landscape with three trees.[5] Also evident are
connections to pastoral landscapes with rural,
idyllic scenes of shepherds, that had been very
popular in Holland since the 1620s.[6] The man
and woman by the water—as in Rembrandt's
small etching, *The Shepherd's Family* (Fig. 19a)[7]
—are shown as a shepherd and shepherdess,
the broad-brimmed straw hat of the seated
woman and the basket by her side (Fig. 19b)
being the traditional attributes of a shepherdess
(see Cat. No. 17). A clear erotic component is
added through the introduction of the pair of
lovers in the bushes on the slope—hidden in
the manner of the couple in Rembrandt's *Omval*
of 1645.[8] The barely-visible goat near to them,

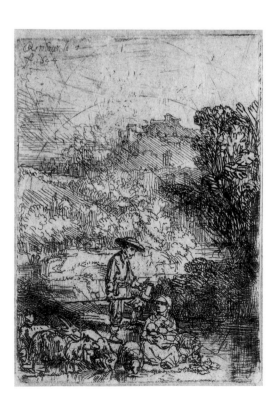

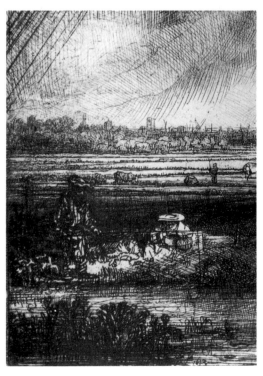

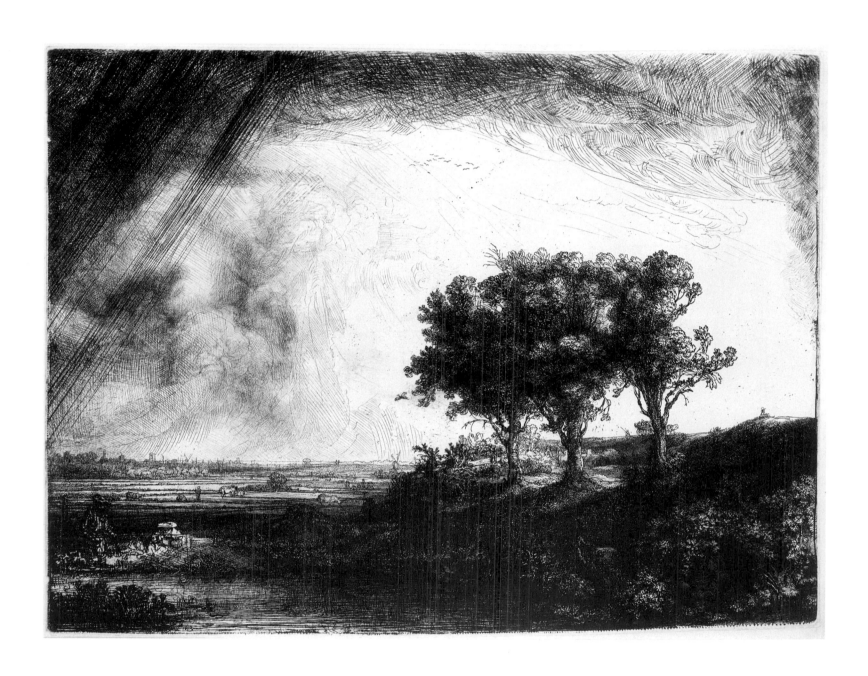

a symbol of unbridled sexuality, stresses the erotic strain of this scene (see Cat. No. 17).[9]

The Three Trees is close to Rembrandt's landscape paintings of the late 1630s and early 1640s, for example the *Hilly Landscape* in the Herzog Anton Ulrich-Museum in Braunschweig (Fig. 19c).[10] Rembrandt very deftly transfers the contrast of light and shade found in the coloured painting to the black and white print. Most of the sheet is etched, although parts of the foreground and of the sky are worked over with engraving and with drypoint. This is the earliest of Rembrandt's landscape etchings to be so extensively worked with drypoint.[11] The view of lowland, so reminiscent of the work of Hercules Seghers, has a grainy, painterly surface tone, obtained through the use of sulphur tint; and this enables Rembrandt to bring out the most delicate nuances of light and shade.

The treatment of the cloud-covered parts of the sky developed from an earlier scene, on the same plate, with a Death of the Virgin. If one turns the sheet on its side, traces of an angelic aureola can be detected, resembling that in the *Death of the Virgin* of 1639 (see Cat. No. 14). Quite cleary, Rembrandt had tried out a first version of this subject and then rejected it. He polished most of the plate smooth, in order to start work on it anew while retaining, in part, his rendering of the clouds. This procedure is also revealed in the occasional small strokes and spots from the earlier scene that remain around the trees.[12] Similarly, the cumulus cloud appearing in the background emerged as a chance product of the previously etched lines.[13]
H.B.

1. The description of this sheet as a stormy landscape could have arisen because of the way the etching was interpreted by artists: in a reproductive engraving by William Baillie from the end of the eighteenth century, the landscape is supplemented with, among other additions, a flash of lightning, and it appears much more dramatic than it is in the original; see Campbell 1980, pp. 19 ff., Fig. 21.
2. B. 219; Washington 1990, pp. 85 ff., No. 7.
3. Washington 1990, p. 241, No. 75.
4. Lugt 1920, p. 146; Filedt Kok 1972, p. 126; Campbell 1980, pp. 14 ff.
5. Rembrandt must have known Claude Lorraine's etchings, which were published since about 1630. Their compositions are often arranged in a similar manner to that found in Rembrandt's etching, with a group of trees on higher ground and a distant view over lower country; pastoral elements are also to be found in the work of Claude Lorraine. See Mannocci 1988, Nos. 8, 14, 18.
6. McNeil Kettering 1977.
7. B. 220.
8. B. 209.
9. McNeil Kettering 1977, p. 38. The goat is clearly visible on the counterproof in Boston; Washington 1990, p. 242, note 17.
10. *Corpus* A137; Schneider 1990, p. 175, No. 3.
11. White 1969, p. 200.
12. Campbell 1980, pp. 10 ff.
13. A comprehensive essay on the *Three Trees* has recently appeared, in which the landscape is interpreted, after examination of its geometrical structure and of the figures with symbolic significance, as an expression of the '*Verstandeskultur des 17. Jh.*' (seventeenth-century cult of the intellect), a '*jardin d'intelligence*' (nursery of intelligence); see Werbke 1989.

19c: Rembrandt, *Mountain Landscape*.
Braunschweig, Herzog Anton Ulrich-Museum.

Six's Bridge

Etching, 129 × 224 mm; 3 states
Signed and dated: *Rembrandt f 1645*
B./Holl. 208; H. 209; White, p. 202.

Berlin: III (301–16)
Amsterdam: III (O. B. 268)
London: III (1868–8–22–674)*

The sketchy quality of this etching conveys
the impression of a drawing made directly from
nature on a warm, sunny summer's day.
A river crowded with boats flows in a broad
curve from the right into the background.
A bridge at the point where the river bend
appears to continue over a side canal. On the
bridge there are two men who seem to be deep
in discussion; and beyond one can see the roofs
of village houses and the spire of a church. The
old title *Six's Bridge* stems from the inventory
drawn up by Valerius Röver in 1731 and from
an eighteenth-century inscription—'*den Heer
Six en Brugh*'—on the example in the
Rembrandthuis in Amsterdam.[1] Gersaint uses
this title in his 1751 catalogue raisonné of
Rembrandt's etchings. The traditional
identification is not correct, however. The
estate of Jan Six was near Hillegom; but the
tower in the left background of the etching
appears to be that of Ouderkerk on the Amstel,
not far from Amsterdam; the view must
have been obtained from near to the estate
Klein-Kostverloren on the Amstel which,
at the time of the etching, belonged to Albert
Coenraadsz. Burgh, one of the Burgomasters of
Amsterdam.[2]

Gersaint also relates an anecdote, in which
Rembrandt, on a visit to the estate of his
friend Jan Six, bet Six that he could draw on a
plate the view from the house of his friend, in
the time that a servant would take to collect
from a neighbouring village the mustard that
had been lacking from the table. Rembrandt,
who always carried wax-covered plates with
him, won the bet.[3] Gersaint's apochryphal
story is witness to the aesthetic judgment of
the eighteenth century, in which the sketchy
quality of Rembrandt's etched landscapes,
recalling the spontaniety of a drawing, was
admired in its own right. Since the
Renaissance, the ability to make a sketch in

a few well-placed lines met with the highest admiration from writers on art and from collectors; indeed such a sketch was often judged to be of more value than a carefully prepared, finished drawing, as the former revealed the artist's first thoughts. The appreciation of swift execution is implied in the story.[4] Gersaint was thus adopting a traditional *topos* of artistic theory; in relating his apochryphal tale of the origin of the print, he must have had an older artistic anecdote in mind.[5] It is also difficult to believe in Gersaint's claim that Rembrandt always carried with him a sketch block of prepared copper plates, allowing him to draw on the plate while he was in front of his subject. *Six's Bridge* with several other etchings, was often counted as an example of a landscape etching *naer het leven*, that is to say drawn directly from nature, because of this supposition.[6] The low viewpoint, the exclusion of any middle ground, and the fragmentary record of the sailing boat that is cropped at the right edge certainly do prompt one to think of a direct record of nature. Nonetheless, it is clear that a conscious artistic purpose is at work here, for the composition is devised in a very well-thought-out manner: through the complementary positioning of the trees and the boat, as well as of the balustrade of the bridge on the left and the figures on the right, the two halves of the sheet have a pleasing balance.

We only know of one drawing made by Rembrandt directly from nature (Fig. 20a)

which serves, with slight changes and additions, as the model for an etching (Fig. 20b) (drawing in the Rijksprentenkabinet, Amsterdam).[7] However, there are further landscape drawings which are directly connected with printed sheets, that is to say drawings that record views that have then been etched in a modified form (see Cat. No. 28 & 34).[8] From this evidence one can conclude that Rembrandt always carried out his landscape etchings in the studio, but referred, in doing so, to landscape studies drawn *naer het leven*. Both etching and drypoint require, from the very beginning of the process (whether marking lines in the wax or scratching the plate), so high a measure of control that, purely from the technical viewpoint, it would be most improbable for work on the plate to be carried out *en plein air*.[9] It is possible that Rembrandt consciously selected this 'spontaneous' character recalling a landscape sketch for *Six's Bridge*, because he was aware how highly such sketches were appreciated by collectors.[10]

In state II, only the hat of the man in the foreground is lightly hatched; in state III, also that of the man talking to him.

H.B.

1. Van Gelder/Van Gelder-Schrijver 1938; Filedt Kok 1972; p. 124.
2. Lugt 1920, pp. 114 ff.
3. The key passage reads: '. . . & comme Rembrandt avoit toujours des planches toutes prêtes au vernis, il en prit aussi-tôt une, & grava dessus le Paysage qui se voyoit du dedans de la salle où ils étoient: en effet, cette planche fut gravée avant le retour du Valet'. Gersaint 1751, pp. 162–63, No. 200 and p. XXVIII.
4. Held 1963, pp. 88–89.
5. Carlo Malvasia (1678) records a similar anecdote: the painter Elisabetta Sirani was said to have been so inspired by the account of a scene of the Baptism of Christ that she reached at once for paper and so swiftly recorded her own *Baptism of Christ* that this was finished before the end of the conversation; Held 1963, p. 88.
6. Amsterdam 1983, p. 7. Washington 1990, p. 26. Schneider cites as examples for etchings probably made directly from nature: *Six's Bridge*, B. 208; *View of Amsterdam*, B. 210; *Farmhouse with the Draughtsman*, B. 219; *The Fence in the Wood*, B. 222; *The Goldweigher's Field*, B. 234. On B. 234, see also Cat. No. 28.
7. Benesch C41; Schatborn 1985, pp. 68–69, No. 30.
8. Washington 1990, pp. 207 ff., Nos. 58–59; pp. 253 ff., Nos. 81–84.
9. Emmens 1968, pp. 155 Slatkes 1973, p. 260.
10. Held 1963, pp. 86–87.

20a: Rembrandt, *Cottage with paling*. Drawing. Amsterdam, Rijksprentenkabinet.

20b: Rembrandt, *Cottage with paling*. Amsterdam, Rijksprentenkabinet.

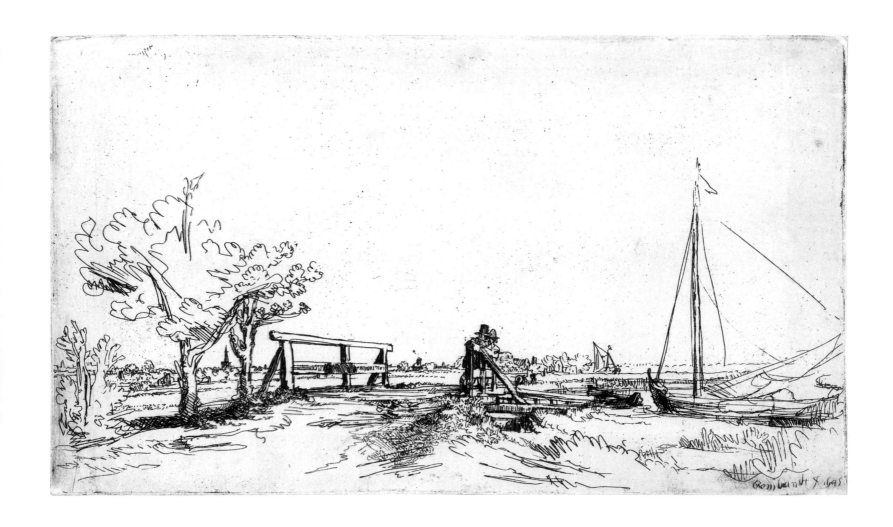

Two male Nudes and a Mother and Child ('Het Rolwagentje')

Etching, 194 × 128 mm; 3 states
c. 1646
B./Holl. 194; H. 222; White, pp. 178 ff.

Berlin: I (171–1898)
Amsterdam: II (O. B. 251)*
London: I (1973 U. 983)

21a: Rembrandt pupil (?), *Standing male nude model.* Vienna, Graphische Sammlung Albertina.

In 1646 Rembrandt made three etchings with male nudes, which were studies from the same model (Fig. 21b).[1] The etchings are identical in style and technique, yet one differs from the others in including a background scene. In the foreground we find two male nudes, one seated, the other standing. Behind, Rembrandt has sketchily indicated the figure of a mother teaching her child to walk with a walking frame.

During his long career, Rembrandt often employed various pupils and assistants, and traditionally, drawing from the model counted as part of the young artist's training. Four drawings by Rembrandt's pupils record the same model as seen in the etchings.[2] Three of these drawings show the same standing boy as in the etching with the walking frame. As he is recorded from a slightly different viewpoint in each case, one may conclude that three pupils—or even more—as well as the teacher drew from the model at the same time. The drawing in Vienna is closest to the etched figure (Fig. 21a).[3] The reversal occasioned by printing shows that Rembrandt himself drew directly on the prepared copper plate during the studio sitting.[4]

Rembrandt's etchings with male nudes were probably planned as models for the instruction of his pupils. The French art critic, d'Argenville, reported in 1745 that Rembrandt had produced a small teaching manual: 'Son livre à dessiner est de dix à douze feuilles' (His drawing (instruction) book has ten to twelve pages).[5] Not a single example of this has survived, but it is certainly possible that Rembrandt assembled a drawing instruction booklet of this sort from etched illustrations. Among these would have been sheets with nude models and perhaps also studies of heads (see Cat. No. 5).[6] The similarity of Rembrandt's models to both the nude figures in surviving drawings by pupils, and to models in contemporary drawing instruction manuals, supports the assumption that these works served as models in Rembrandt's studio. In *'t Light der teken en schilder konst* (Guide to Drawing and Painting) (1643) by Crispijn de Passe II, we find, for example, a seated male nude (Fig. 21c) in the same pose as that of the seated model in the etching B. 196 (Fig. 21b).[7]

What, though, in this context, is the meaning of the background scene? Is this a sheet of studies in which thematically unconnected scenes are brought together because of their aesthetic appeal? In 1751, Gersaint had already declared that he could find no thematic connection between the motifs: '. . . y ayant plusieurs choses gravées, qui, quoique finies, n'ont aucun rapport entre

elles' (showing several engraved motifs which, though finished, have no connection with each other).[8] On occasion, the child and woman have been interpreted as Rembrandt's son Titus and the child's nurse Geertje Dircks.[9] The background scene, however, is not in itself without significance: in an extended sense, it points to the role that the nude model plays in the teaching of drawing.[10] The child in its walking frame was used in seventeenth-century literature and emblem books as a symbol of man growing to maturity only through learning and exercise. Franciscus Junius and Joost van den Vondel compared the constant exercise of training artists with a small child's laborious attempts to walk. The sketched scene in the background thus alludes to the role of the model sheets: the young pupil is presented with nude models, who he is to draw, and at the same time he is advised that art is to be mastered only through constant exercise: *Nulla dies sine linea*—no day should pass without drawing—so went the saying. Rembrandt's etching *The Artist drawing from the Model* also takes as its subject the significance of study from life and of the art of drawing (see Cat. No. 15). Despite their didactic intent, Rembrandt's works were also desired collectors' pieces.[11]

The differences between the states are not significant; in state I several white spots of etching fluid, especially on the figure of the seated model, can be seen; in state II they have been covered over with fine, short hatching lines. State III underwent further small reworkings. A maculature and a counterproof, in both cases of state I, have also survived.
H.B.

1. B. 193, 194, 196.
2. Benesch A 48, A 709, A 55, 710; Amsterdam 1984–85, pp. 4 ff. and pp. 30 ff., Nos. 18 ff.
3. Benesch IV, 709; Amsterdam 1984–85, p. 33, No. 21.
4. The same goes for the two other etchings with male nudes. The fourth pupil's drawing in this group shows a seated boy similar to the corresponding model in the etching B. 193, here also reversed; Benesch A 48; Amsterdam 1984–85, pp. 30–31, Nos. 18–19.
5. Emmens 1968, p. 157.
6. Emmens 1968, p. 158; Bruyn 1983, S. 57.
7. Emmens 1968, Figs. 36–37; Bolten 1985, pp. 27 ff.
8. Gersaint 1751, p. 152, No. 186.
9. For example in Münz 1952, Vol. II, p. 80, No. 136.
10. On this, see Emmens 1968, pp. 154 ff.
11. Amsterdam 1984–85, pp. 6–7.

21b: Rembrandt, *Seated male nude model*. Berlin, Kupferstichkabinett SMPK.

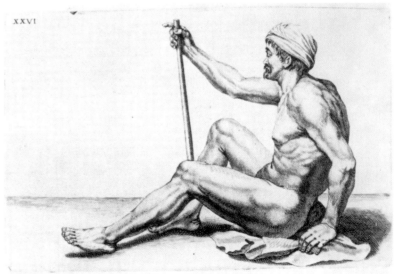

21c: Crispijn de Passe II, *Seated male nude model*, from *'t Light der teken en schilder konst*, Plate XXVI.

Portrait of the Preacher
Jan Cornelisz. Sylvius

Etching, drypoint, burin and sulphur tint
278 × 188 mm; 2 states
Signed and dated: *Rembrandt 1646*
B./Holl. 280; H. 225; White pp. 127–28

Berlin: II (372–16)
Amsterdam: II (62:107)*
London: I (1973 U. 984)

Translations of the Latin inscriptions read:
'My hope is Christ. Johannes Cornelisz.
Sylvius, Amsterdamer, filled the function of
preaching the holy word for forty-five years
and six months. In Friesland, in Tjummarun
and Firdgum, four years; in Balk and Haring
one year; in Minnertsga four years; in Sloten,
Holland, six years, in Amsterdam twenty-eight
years and six months. There he died, on 19
November 1638, 74 years of age.'

'Thus is how Sylvius looked—he whose
 eloquence taught men to honour Christ /
And showed them the true path to heaven. /
We all heard him when with these lips /
He preached to the burghers of Amsterdam. /
Those lips also gave guidance to the Frisians. /
Piety and religious service were in good hands /
As long as their strict guardian looked over
 them. /
An edifying era, worthy of respect on account /
Of Sylvius's virtues; he tutored full-grown
 men /
In catechism until he himself was old and
 tired. /
He loved sincere simplicity and despised false
 appearance. /
He did not attempt to ingratiate himself /
To society with outer display. /
He put it this way: Jesus can better be taught /
By living a better life /
Than by raising your voice. /
Amsterdam, do not let his memory fade; he
 edified you /
Through his righteousness and represents you
 illustriously to God.'
C. Barlaeus

'This man's gift I cannot paint any better. /
I attempt to emulate him, but in verse I fail.'
P. S. [Petrus Scriverius][1]

Jan Cornelis Sylvius (1564–1638), who 'preached the holy word for forty-five years and six months' as a member of the reformed congregation, embarked on his church career with a long series of country posts in Friesland. In Amsterdam from 1610, Sylvius was pastor at the city hospital from 1619 to 1622, before becoming minister at the Oude Kerk. During the course of his 16 years in office, there were many passionate disputes about church policy and administration, in which the remonstrants finally prevailed. The fact that Sylvius was able to retain his place on the church council until his death, despite the quarrels between the Reformed Church and the Remonstrants, may have owed much both to his tolerance and to his liberal attitude in political and religious matters.

In 1595 Sylvius married Saskia's elder cousin, Aaltje van Uylenburgh. In 1634 Sylvius acted as proxy for Saskia, who was then still living in Friesland, at her official betrothal to Rembrandt in Amsterdam. It may have been on the occasion of his engagement to Saskia in 1633 that Rembrandt produced his first portrait of the cleric (Fig. 22a).[2] This shows Sylvius in his study, in concentrated mood and with his hands laid, one over the other, on the open Bible. Two years later Sylvius and Aaltje were godparents to Rembrandt and Saskia's first child, and in 1638 Sylvius performed the baptism of their second child.

In 1646 Rembrandt etched a second, posthumous portrait, which shows Sylvius within an oval frame surrounded by an inscription and with an obituary added below. Significantly, the inscription does not come from the hand of a scholar who belonged to the Reformed Church. Caspar Barlaeus, whose 14-line Latin poem honours equally the piety, virtue, simplicity and eloquence of the cleric, was a Remonstrant, as was the author of the succinct commemorative poem, Petrus Scriverius.[3]

Only two of Rembrandt's portraits have added inscriptions, the other being the portrait of Johannes Uytenbogaert of 1635,[4] which is presumed to be the first 'official' portrait by Rembrandt who had previously produced etchings of members of his own family. As the early portrait of Sylvius also shows the sitter without an inscription, it would seem that Rembrandt portrayed him there as a relative. It was, however, usual in the seventeenth century for portraits to bear inscriptions; and it would thus seem that the later portrait of Sylvius uses an official formula.[5] It is possible that, in producing the posthumous etching of 1646, Rembrandt was trying to strengthen his relations with Saskia's family.[6] These had

swiftly deteriorated after Saskia's death in 1642, although Rembrandt remained dependent on the Uylenburghs. Although it is also possible that the portrait was commissioned,[7] there is no record of such a commission. An attempt to follow the evolution of the posthumous portrait of Jan C. Sylvius is, not least, dependent on the dating of the two preliminary sketches; for it is only from this moment that one can establish Rembrandt's preoccupation with the portrait.[8]

The first of the two preparatory drawings marks out the basic elements of the composition (Fig. 22b).[9] In the London drawing the figure does not lean out of the frame, but the drawing shows the forward-leaning pose which engages with the viewer, though still lacking the crucial distribution of light and shadow and the dramatic use of the frame-cutting figure (Fig. 22c).[10] In contrast, for example, to the drawing for the portrait etching of Anslo (Cat. No. 16), the London drawing is not finished in the manner of a *modello*, but is rather sparing in its indication of the intended appearance of the portrait.

The ensuing etching strengthened the theatrical effect. Sylvius leans forwards in an illusionistic movement out of the frame, so that a bold shadow is cast by his hand gesturing as if to accompany his words, by his profile and by the book in which he is careful to keep his place. In Dutch painting there are a number of earlier examples of such an illusionistic use of an oval frame;[11] however and in the case of Rembrandt's etching it can be shown that there is a specific model—the engraving made by Jan van der Velde after the portrait of Petrus Scriverius painted by Frans Hals (Fig.

22a: Rembrandt, *Portrait of the Preacher Jan Cornelis Sylvius*. Berlin, Kupferstichkabinett SMPK.

Spes mea Christus. Iohannes Cornelÿ Sylvius. Amstelodamobat, functus S.S. Minÿst:aõs 45. et 6. menſes.In Frisia.in Iremarum et Phrisdatum aõs 4.InDale et Harch unicum.Minuatum 19. Novembr. natus aõs 74.

obÿt aõ 1638. ibidemÿ menſes 28. et 6.

Hollandia Slotis aõs 6. Amstelodami

In Frisia, in Iremarum et Phrisdatum aõs 4

Cuius adorandum docuit Facundia Christum.
 Et populis veram pandit ad astra viam.
Talis erat Sylvÿ facies. audivimus illum
 Amstelÿs isto civibus ore loqui.
Hoc Frisÿs præcepta dedit; pietasÿ. severo
 Relligioÿ diu vindice tuta stetit.
Præluxit, veneranda suis virtutibus, ætas.
 Eruditÿ. ipsos sossa senecta viros.

Simplicitatis amans fucum contemsit honesti,
 Nec sola voluit fronte placere bonis.
Sic statuit:Iesum vita meliore doceri
 Rectius, et vocum fulmina posse minus.
Ambola, sis memor extincti.qui condidit urbem
 Moribus, hanc ipso fulsÿt illo Deo.
 C. Barlæus.
Haud amplius deprædico illius dotes,
 Quas. æmulor, frustraqué perseguor versu.
 P.S.

22b: Rembrandt,
Study for the Portrait of Jan Cornelis Sylvius.
Drawing. Stockholm, Nationalmuseum.

22c: Rembrandt,
Study for the Portrait of Jan Cornelis Sylvius.
Drawing. London, British Museum.

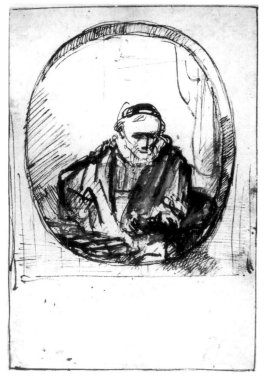

22d).[12] As Petrus Scriverius was one of the two authors of the inscriptions in Rembrandt's etching, it would seem that he might have drawn Rembrandt's attention to this portrait. This may explain the most significant of the differences between the London preparatory drawing and the final etching—the use of the figure gesturing out of the frame. At the same time the innovations made by Rembrandt become more evident through comparison with the earlier work by Frans Hals, dated 1626. Rembrandt has transformed the calm gesture recorded by Hals into a most lively one. Sylvius directly addresses the viewer.

Rembrandt has achieved a subtle gradation of grey tones by creating a network of fine lines. The technique employed for the rendering of the face and the texture of the frame is particularly striking. Here Rembrandt uses a special method of etching—sulphur tint. Grains of sulphur, suspended in an oily liquid, are applied to the plate.[13] Rembrandt used this technique on several occasions in the 1640s,[14] and it is possible that he may also have done so even earlier.[15] The richly rendered grey tones, achieving the effect of a soft wash, were greatly praised in the early eighteenth century as a precursor of the mezzotint process which was then just coming in to fashion. Houbraken, for example, drew particular attention to the

delicate and brilliant softness of the shading achieved through this technique.[16]

B.W.

1. English translation cited from the English edition of Schwartz (1985), p. 185.
2. B. 266.
3. On the two scholars, see Schwartz 1987 and also Kauffmann 1920.
4. B. 279.
5. Amsterdam 1986/87, pp. 15 ff.
6. Amsterdam, 1986/87, p. 23.
7. Schwartz 1987, p. 135, for example, supports this view, arguing that the etching was possibly made on the occasion of the marriage of Wendela de Graeff and Willem Schrijvers (Scriverius).
8. The evolution of the first sketch (Benesch 762a) has repeatedly been fixed in the period 1639–40 (Welcker 1954, Boon 1956; see White 1969, p. 127). If this dating is correct, art-historical research would no longer have to explain the late and very markedly posthumous award of the commission of the Sylvius etching but, rather, the fact that Rembrandt allowed more than five years to elapse between the sketch and the completion of the etching.
9. Benesch 762a; Stockholm, Nationalmuseum.
10. Benesch 763; London, British Museum.
11. For example, the portrait of the musician Jan Pietersz. Sweelinck, ascribed to Gerrit Pietersz. Sweelinck (1566–1616) now in the Gemeente Museum in The Hague; see Slatkes 1973.
12. The painting by Frans Hals is now in The Metropolitan Museum, New York; see also Washington 1989, No. 20.
13. For discussion on this technique, see White, and Boston 1980/81, No. 97. I regard as correct the unequivocal assessment of the technique of this last item as an etching procedure, a conclusion also supported by examination with a microscope.
14. See the *Landscape with the three trees* (Cat. No. 19).
15. For example, *The Angel appearing to the Shepherds* (Cat. No. 9).
16. Houbraken 1718, p. 271.

22d: Jan van der Velde, after Frans Hals, *Petrus Scriverius.* Amsterdam, Rijksprentenkabinet.

23

Jan Six

Etching, drypoint and burin. 244 × 191 mm; 4 states
Signed and dated: (from II) *Rembrandt f. 1647*
B./Holl. 285; H. 228; White pp. 130–32

Berlin: III (369-16)
Amsterdam: I on Japanese Paper (O.B. 578)*
London: III (1973 U. 986)

A notary's certificate of 1655 remarks of an apparently unexecuted portrait etching to be made for Otto van Kattenburch that it was to equal in quality the portrait etching of Jan Six. The proud sum of 400 gilders is cited as the estimated price: '. . . en conterfeytsel van Otto van Kattenburch, twelck de voorsz. van Rijn sal naer 't leven etsen, van deucht als het conterfeytsel van d'Heer Jan Six, ter somme van f 400, o'.[1]

It seems that the portrait etching of *Jan Six* was commissioned by the sitter. Jan Six (1618–1700) came from a noble Huguenot family which had fled at the end of the sixteenth century from Saint Omer in France to Amsterdam, being active there in both the textile trade and silk dying. Until about 1652 Jan Six had carried on the family business, in 1656 he became a lawyer specialising in marital disputes. In 1691 he was made a burgomaster of Amsterdam.

Six devoted a considerable part of his time to the arts, in particular poetry. He was a member of the so-called 'Muiden Circle' that gathered around the successful man of letters, Pieter Cornelisz. Hooft (1581–1647), and which had, at times, also invited the poet Joost van den Vondel to its meetings.[2] Like Rembrandt, Jan Six was a passionate collector of works of art (Dutch and Italian Masters, antique sculpture, engraved gems etc.). In about 1640 Six, like Hooft, had travelled to Italy. Although his taste tended rather towards the classical artistic ideal, Six is known to have purchased paintings by Rembrandt, for example *John the Baptist preaching* (Paintings Cat. No. 20).[3]

A series of drawings and etchings in particular allow one to assume that Rembrandt and Jan Six enjoyed a friendly relationship that, at times, went beyond a mere business connection. Documentation such as letters has not survived. A year after the 1647 portrait etching of Jan Six, Rembrandt created the title page for Six's tragedy *Medea*.[4] Two drawings for Six's *Pandora*, an *album amicorum* of the sort then in use in Humanist circles, and dated 1652. A variety of *symbola amicitiae*, dedications, poems, emblems and, in particular, portraits of celebrated authors and artists, served to embody the idealised presence of friends as well as the memory and the strengthening of friendship. For Six, the devotee of Italian art, Rembrandt produced two drawings with classical themes: *Homer reciting verses*, which bears the dedication 'Rembrandt aen Joanus Six' (From Rembrandt to Johannes Six),[5] and *Minerva in her Study* (Drawings Cat. No. 31 A & B).[6] In 1654, Six married Margaretha Tulp, daughter of the anatomist and burgomaster Nicolaes Tulp, one of Rembrandt's first patrons in Amsterdam. It was probably in the same year that Rembrandt painted the portrait of Jan Six that is still in the collection of the Six family.[7]

The work process of the portrait etching dated 1647 is documented in three drawings. The earliest of these (see Drawings Cat. No. 23, here Fig. 23a)[8] shows the sitter looking relaxed and suave. Leaning on the window ledge, he looks at the viewer, a dog jumping up to his knee. It appears, however, that this arrangement failed in the end to meet with the sitter's approval. In a small, sketchy study, the pose of the figure is altered,[9] and it is then elaborated in a thoroughly composed preparatory drawing (Fig. 23b).[10] This last drawing has been traced on to the copper-plate, indicating that it served as an direct *modello*.

In his portrait etching, Rembrandt managed not only to acknowledge the social status of Jan Six, but also to present him as a cultivated man of letters and an art collector. This becomes especially clear in comparison with earlier portraits, for example the engraving of Scriverius after the portrait by Frans Hals (Fig. 22d). There the pose of the sitter reveals none of the virtues praised in the inscription: 'This is the portrait of a man who shunned office, / protected the Muses with his own money / and who loved the seclusion of his house . . .'.[11] Pose and text complement each other. In Rembrandt's portrait of Jan Six, on the other hand, praise of the scholar and a record of his social position are incorporated into the visual presentation. This etching does not require an added explanatory inscription.

At the window, framed by a heavy curtain—a traditional motif associated with worthiness in formal portraits—and thus standing in the light, Jan Six leans, reading a book. The unmarked paper surface used for the

window is skilfully integrated into the composition and leads the viewer's attention to the face of the sitter. It is possible that the elegance of the pose points to the ideal of the educated courtier that had found its literary formulation in the *Libro del Cortegiano* of Baldassare Castiglione.[12] Books and manuscripts on the chair in the foreground as well as the painting on the wall—provided with a curtain as was usual in the seventeenth century—acknowledge the sitter's erudition and connoisseurship. The sophisticated iconography allows one to assume an intensive dialogue between the artist and his patron.

Although the first state of the etching (only known in two examples in Amsterdam and Paris) is not signed and is apparently a trial proof, it shows the completed composition, apart from later corrections of detail. The work is striking for the richness of its technical execution. With the use of a fine network of hatching, worked up with the burin and, in certain places, with drypoint, Rembrandt achieves subtle gradations of the velvety black and grey tones. This artful execution stresses the high standard to which Rembrandt was working—as if in competition with a painted portrait—apparently as requested by Jan Six. Thus, as Röver wrote in 1731, he possessed impressions of burgomaster 'den ouden burgemeester Jan Six, een van de allerraarste van alle de printen van Rembrandt, omdat de familie deze plaat en affdrukken altijt onder zig heeft gehouden en de printen overal a tout prix opgekogt'[13] (the old Jan Six, [which was] one of the rarest of Rembrandt's prints because the family [of Six] still owned the plate and sold

the prints everywhere at the full price) (Fig. 23c).
B.W.

1. *Urkunden* 163. The appreciation of this etching is already documented within Rembrandt's lifetime in the form of a panegyric by Lascaille (*Urkunden* 223).
2. See R. P. Meijer 1971, pp. 104 ff.
3. *Corpus* A106.
4. B. 112.
5. Benesch 913.
6. Benesch 914.
7. Bredius 276.
8. Benesch 767, Amsterdam, Six collection.
9. Benesch 749 verso, Amsterdam Historisch Museum.
10. Benesch 768, Amsterdam, Six collection.
11. English translation cited from English edition of Schwartz (1985), p. 25.
12. On this, see Smith 1988.
13. Van Gelder/Van Gelder Schrijver 1938, p. 4. The plate is still in the possession of the Six family (Six 1969, p. 69).

23a: Rembrandt, *Jan Six*. Drawing. Amsterdam, Six Collection.

23b: Rembrandt, *Jan Six*. Drawing. Amsterdam, Six Collection.

23c: The etching plate for the Portrait of Jan Six. Amsterdam, Six Collection.

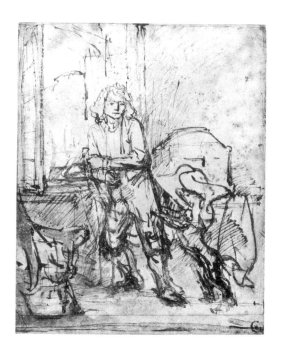

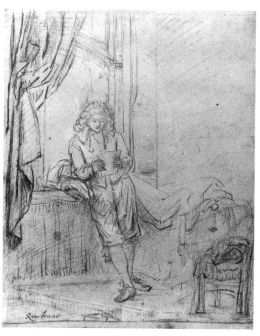

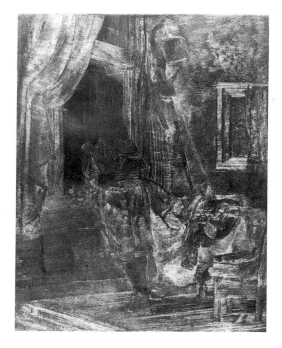

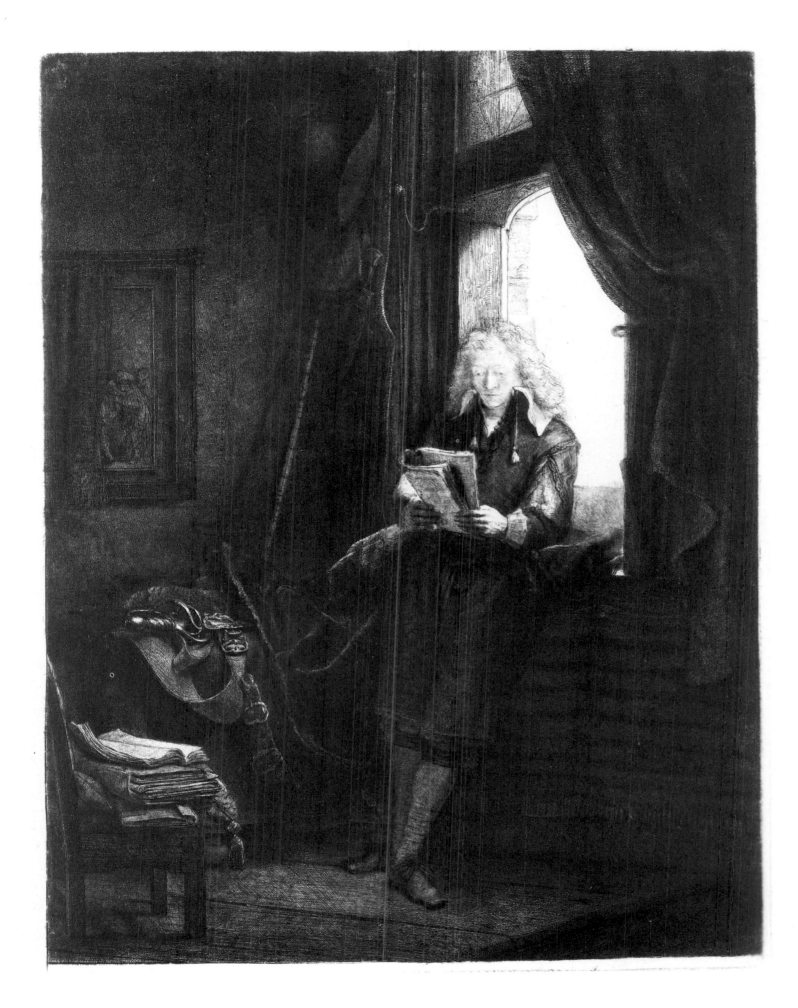

24

Saint Jerome
beside a pollard willow

Etching and drypoint, 180 × 133 mm;
2 states
Signed and dated: (only in II) *Rembrandt. f.*
1648.
B./Holl. 103; H. 232; White, pp. 206 ff.

Berlin: I (155–16)
Amsterdam: I (O. B. 168)*
London: I (1973 U. 996)

24a: Rembrandt (?), *The pollard willow.*
Drawing. Turin, Biblioteca Reale.

Rembrandt, who was a Protestant, treated a great many biblical subjects; yet scenes with saints worshipped by the Catholic church are rarely found in his work. Only the figure of Saint Jerome, who appears in a number of Rembrandt's etchings, preoccupied the artist over many years (see Cat. No. 31).[1] Rembrandt would have been fascinated by the combination of the ascetic and the scholarly in the life of this saint and Church Father. On account of his self-denying way of life—for several years he retreated to the wilderness to live as a hermit—and his translations and expositions of the Bible, he had become an honoured model for scholars and Humanists both north and south of the Alps during the Renaissance. As one of his attributes, Jerome is accompanied in pictorial representations by a lion, out of whose paw, according to legend, he had pulled a thorn.

Rembrandt shows the saint cut off from the world in a peaceful, sunny landscape. Jerome sits, absorbed in his writing, next to the gnarled stump of a willow at the water's edge, more a philosopher and learned author than a hermit doing penance. In front of him lie a skull and a crucifix—alluding to the expectation of Salvation in the life to come and to the saint's piety—and next to him lies his cardinal's hat. The lion looks out from behind the tree trunk. In the background, indicated with only a few strokes, a hilly landscape rises up with a waterfall cascading down it.

The plate was worked in two clearly separate stages. The central motif, the willow stump and a few sprays of grass and reeds, were etched first; and the remaining elements of the picture—the saint with his desk, the lion and the large, lower branch of the willow—were added with drypoint in the second working. In addition, drypoint reworkings are to be found on the base of the trunk and on the reed in the foreground. It thus seems as if the study of a dormant willow was the starting point for the scene, and one might speculate that the figure of the saint was only added as an afterthought, perhaps because Rembrandt regarded the subject of a single tree as too trivial for an etching intended for sale. This thesis is supported by the fact that a drawing in the Biblioteca Reale in Turin records a very similar willow stump, significantly in reverse (Fig. 24a).[2] The attribution of the drawing, however (which scholars have usually regarded as a study for the tree in the etching) is no longer secure; and the fact that comparable willow stumps are also to be found in the *Omval* (1645) and *Saint Francis* (1657) etchings[3] indicates that the tree found in the *Saint Jerome* is not necessarily to be seen as a study from nature.

There is also iconographic evidence that the scene was conceived from the start as a unified whole. The ancient tree stump with new shoots of greenery, accompanied by a crucifix, was a traditional motif in scenes with Saint Jerome, where it symbolised the renewal of life.[4] Rembrandt apparently first intended to show the crucifix attached to the tree trunk, but then decided to show it lying on the desk behind the skull; for somewhat below the short branch that could have served to show the bar of the cross, traces of a re-working of the plate can be seen. Rembrandt's *Jerome* is, however, closer to iconographic tradition than is often assumed.

As in the later Jerome scene of 1654 (see Cat. No. 31), here too Rembrandt was re-working Venetian models. An engraving by Marcantonio Raimondi after Titian, or a reversed reproductive engraving by Agostino Veneziano after that, may have served as his inspiration. In these the saint is shown seated in a similar manner at a desk fastened to a tree trunk.[5]

State I has the strongest drypoint passages, especially in the foliage of the projecting branch and in the reeds in the foreground. In state II, printed with less drypoint burr, the foreground is somewhat altered, and the signature and date are added; as well as this, both the lion's head and several reed stems are modelled with delicate short strokes.

H.B.

1. B. 100–6.
2. Benesch 852 a; White 1969, Vol. I, p. 206; Vol. II, Fig. 313; Washington 1990, pp. 164 ff., No. 41, note 1.
3. B. 209, 107.
4. Kuretsky 1974; Wiebel 1988, p. 112.
5. Marcantonio Raimondi: B. 102; Agostino Veneziano: B. 103. See also Washington 1973, pp. 396–97, Fig. 19–6. Dürer's dry-point print B. 59 is often cited, though in my view without any real justification, as a model for Rembrandt's *Jerome*; see, for example, Washington 1990, pp. 164 ff., No. 41.

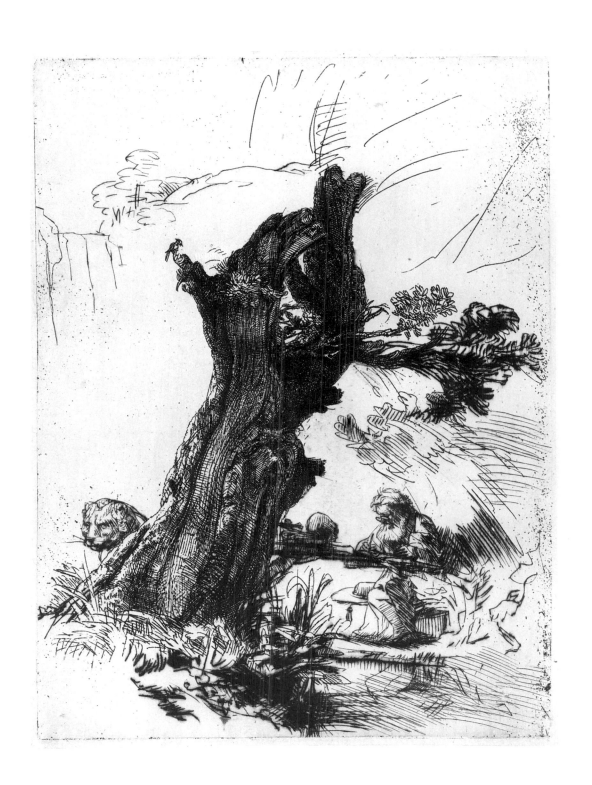

25

Self-portrait drawing at a Window

Etching, drypoint and burin, 160 × 130 mm; 5 states, the last 2 probably not by Rembrandt
Signed and dated: (from II) *Rembrandt. f 1648*
B./Holl. 22; H. 229; White pp. 132–34

Berlin: I (305–1898)*; II (2–16)*
Amsterdam: I on Chinese paper (O.B. 39);
II (62:9)
London: I (1855–4–14–260);
II (1910–2–12–357)

After his ambitious self-portrait of 1639 (Cat. No. 13), it was not until 1648 that Rembrandt made another etched self-portrait. Particularly in comparison with the earlier work, this representation of the self seems to have an unpretentious air. Nonetheless the half-length portrait with the view through a window to one side reflects a traditional portrait type that, in varying forms had been used increasingly by artists since the fifteenth century.

Rembrandt looks at the viewer with unswerving directness. He shows himself working. The copper plate—or, possibly, as a reference to the superiority of *disegno* in art theory—the drawing sheet on which Rembrandt is at this moment working, rests on a thick book.[1] While, in his self-portrait of 1636 (Fig. 25a)[2] the artist is indeed similarly depicted engaged in drawing—though there, he is shown in a double-portrait with his wife Saskia—in the present etching he is not dressed to emphasise his social rank. On the contrary, he wears a simple hat and a plain smock. This outfit is also seen in a drawing from a few years later (about 1655/60), one of Rembrandt's few full-length self-portraits (Fig. 25b).[3] A Dutch inscription, probably not from before the eighteenth century, is added to this sheet: 'Getekent door Rembrandt van Rijn naar sijn selves, sooals hij in sijn schilderkamer gekleet was' (Rembrandt van Rijn, drawn by himself, as he was usually dressed when in his studio).[4]

In the etched self-portrait, it is not only

25a: Rembrandt, *Self-portrait with Saskia*. Berlin, Kupferstichkabinett SMPK.

25b: Rembrandt, *Self-portrait*. Drawing. Amsterdam, Museum het Rembrandthuis.

25 State I

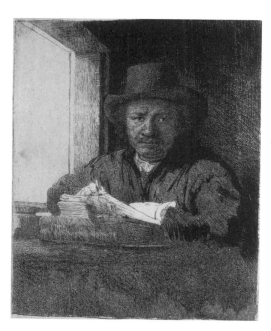

236

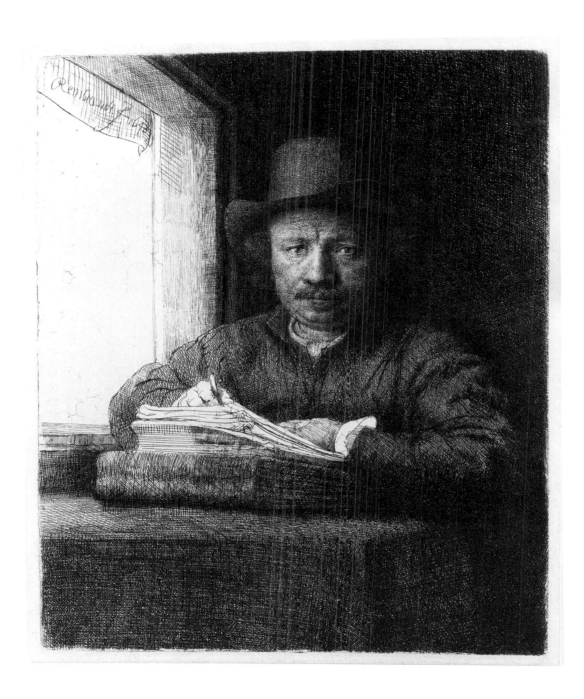

composition and lighting that focus attention on Rembrandt's face. The detailed and sensitive record of physiognomy provokes greater interest in contrast to the more summary treatment of both the torso and the setting. The light, entering from the left through the window, is closely studied in its effects. Trial proofs of the unfinished plate (state I) give an insight into Rembrandt's working method. To begin with, the composition as a whole is bitten, with the distribution of light and shadow. The evidence of some burnishing-out of the worked plate, for example below the artist's right hand, indicates that corrections have been made. While the face is already modelled in detail at this stage, the other forms are at first recorded only as simple shapes. Rembrandt has included the deepest blacks with heavy drypoint strokes. Not until the second state does Rembrandt fully establish the gradual changes within the passages of shadow, using further bitten cross-hatching and lines applied with the burin and with drypoint. Rembrandt signed this version and only made some final, minor corrections in state III. Only three states of the etching come from Rembrandt's hand; and the decorative provision of the landscape in the view from the window in the two other known states is probably a later addition.

Keen attempts have been made to find traces of biographical information in Rembrandt's facial expression in this portrait. It has been claimed that after his luxurious and self-conscious way of life in the 1630s, Rembrandt was deeply marked by Saskia's death but gradually found a new inner calm. Such interpretations will always depend on personal associations. We should also probably see in this portrait a comment on the artist's own position. Rembrandt has here defined his self-representation in direct reference to his activity as a draughtsman. This form of artist's self-portrait is taken up once again in an etching dated 1658 and now generally accepted by Rembrandt's hand (Fig. 25c).[5] Obviously, even in Rembrandt's late work, with its quite distinct style, the self-presentation of the artist as a draughtsman, as invented in the 1648 etching, was still found to be appropriate.
B.W.

25c: Rembrandt, *Self-portrait*. Drawing. Vienna, Graphische Sammlung Albertina.

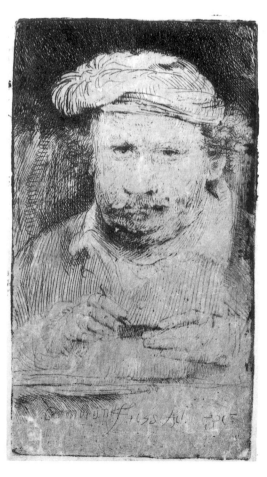

26a: Jan Steen, *The Burger of Delft and his daughter*. Penrhyn Castle, Lady Janet Douglas-Pennant.

1. On the discussion of this matter, see most recently Chapman 1990, p. 82, with bibliography.
2. B. 19.
3. Rembrandthuis, Amsterdam, Benesch 1171.
4. A French inscription on the mounting makes the same claim; Filedt Kok 1972, No. 1.
5. Holl. S 279. Only two impressions of this etching are known (Vienna, Albertina and Paris, Dutuit collection).

The Hurdy-Gurdy Player and his Family receiving Alms

Etching, slightly worked over the burin and drypoint, 165 × 128 mm; 3 states
Signed and dated: *Rembrandt. f. 1648.*
B./Holl. 176; H. 233; White, pp. 167 ff.

Berlin: I (13–1892)*
Amsterdam: I (62:65)
London: I (1868–8–22–673)

In both drawings and prints from the 1640s, Rembrandt took up again the beggar subjects that had so fascinated him as a young artist in about 1630, during his Leiden period (see Cat. No. 3).[1] The etching of 1648 shows a young woman with a walking stick and a basket, carrying a baby in a sling on her back. She reaches out her hand to take alms from an elderly man who appears at the open door of a house. Next to the woman, and viewed from the back, is a boy in a broad-brimmed hat, and beyond the woman stands an old man. While the domestic realm of the alms-giver, even the gutter in front of his house, is shown in detail, the area associated with the pedlar family is left vague.

The etching has been given the rather inaccurate title *Beggars at the Door of a House* since Gersaint's reference to it (1751).[2] From the point of view of iconography, the scene belongs to another tradition, that of the wandering hurdy-gurdy player.[3] The shoulder and hat of the boy mask a hurdy-gurdy. This, and the bagpipes, were the musical instruments traditionally associated with pedlars. The hurdy-gurdy was played above all by the blind; and in the etching the curiously blank stare of the old man must be intended to show him to be blind. The subject of the blind hurdy-gurdy player whose wife collects alms goes back to the sixteenth century and was probably popularised at the start of the seventeenth century by David Vinckboons in Amsterdam.[4] Rembrandt himself had treated this subject before, in two etchings of about 1634–35 and of 1645.[5]

Rembrandt's scene of 1648 is distinct from his beggar scenes of about 1630 (see Cat. No. 3) not only stylistically but also in terms of content.[6] Constantin Huygens, in his *Zede-printen* (Descriptions of Customs) made fun of

lazy beggars who used the raucous din of the bagpipes and the hurdy-gurdy as a way of forcing people to give them money.[7] The title page of Jan Joris van Vliet's beggar series of 1632 takes as its subject the giving out of alms, and in its title at least—*By 't geeve bestaet ons leeve* (Our life depends on [your] gift)—seems to suggest criticism of charity for lazy beggars.[8] In Rembrandt's etching, however, the young woman and the old man are not presented as caricatures; indeed, they almost appear respectable. They certainly wear poor people's clothes, but not the rags and tatters of beggars, such as one finds in the earlier scenes. Clearly, these are not inveterate wandering pedlars, but rather the needy who have fallen into poverty through no fault of their own. Rembrandt treats them objectively, and without any satirical implications: he presents the act of charity as it is advocated in the Bible (Matthew 25: 31–46).

In the *Zedekunst* (Art of Customs), published several times during the sixteenth century, the Haarlem Humanist and writer Dirck Volkertsz. Coornhert had emphasised the difference between poverty encountered through a man's own guilt and with the aim of cheating others, and poverty honestly come by.[9] Charity played an important part in public life in Holland. But only needy town dwellers profited from it, and not the rootless pedlars scattered throughout the countryside.[10] Rembrandt appears to show a rich citizen's private act of charity towards a poor fellow citizen. Through this sociable act, the giver and the receiver of alms are linked in the context of social convention, although they remain clearly separated by the doorstep of the house.

The subject of street vendors and musicians, shown standing in the street at the edge of the domestic sphere of the citizen, is often seen in Dutch painting in the mid-seventeenth century. Rembrandt's etching itself had some influence on the treatment of this subject. Jan Steen's painting of 1655, for example, shows a rich man with his daughter on the outer step of a house, in front of which a poor woman is asking for alms; the woman's pose and gestures are taken from Rembrandt's scene (Fig. 26a).[11]

From the point of view of both style and content, a chalk drawing of about 1647–48 in the Amsterdam Historisch Museum (Fodor collection), also showing a needy family, is closely connected to Rembrandt's etching (Fig. 26b). The people here, however, are differently arranged to those in the etching; the blind man, who stands on the left, carries a hurdy-gurdy. The family turns the right, seemingly towards someone giving alms, who would be needed to complete the scene. This might be an initial preparatory study for the etching.[12]

The differences between the states are only slight; they principally concern the shading on the door arch above the head of the alms giver. H.B.

1. See, among others, Benesch 721 and 750–51.
2. Gersaint 1751, p. 141, No. 170.
3. On this, see the study by Hellerstedt 1981.
4. Hellerstedt 1981, pp. 17 ff. Various versions of the subject by Vinckboons show the old hurdy-gurdy player surrounded by village children, while his wife begs for alms at the door of a house.
5. B. 119, 128.
6. Stratton 1986; Lawrence, Kansas; New Haven and Austin 1983/84, pp. 81 ff., No. 16.
7. Huygens 1623–24, p. 212.
8. B. 73.
9. Stratton 1986, p. 79; Braunschweig 1978, pp. 133 ff., Nos. 28–29.
10. Schama 1987, pp. 570 ff.
11. Schama 1987, pp. 573 ff., Smith 1988, pp. 54 ff., Fig. 57.
12. Benesch 749 r; Broos 1981, p. 55 ff., No. 13. On the verso of the sheet there is a sketch showing Jan Six reading (see Cat. No. 23).

26b: Rembrandt, *The Hurdy-Gurdy Player and his Family*. Drawing.
Amsterdam, Historisch Museum.

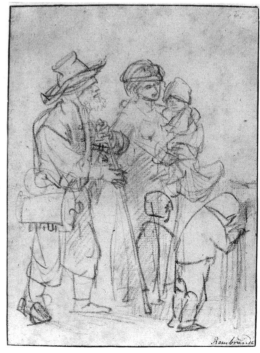

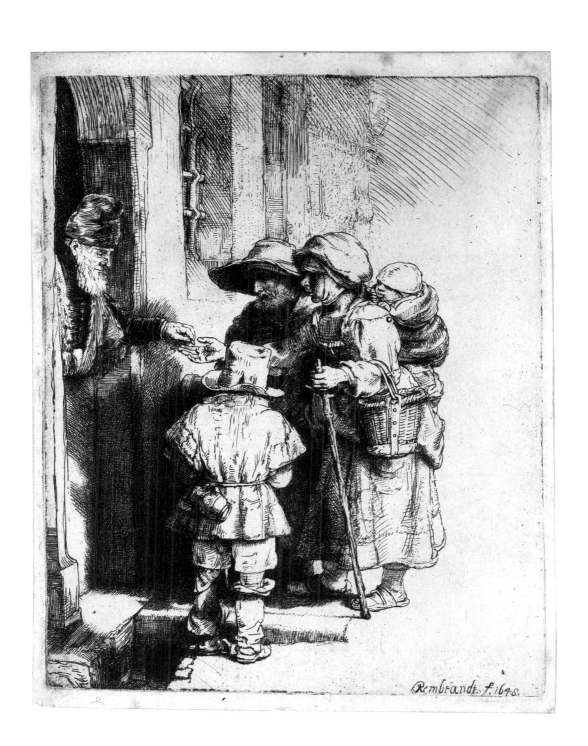

Rembrandt f. 1648.

'The Hundred Guilder Print'

Etching, drypoint and burin, 278 × 388 mm; 2 states
Unsigned and undated; c. 1647/49
B./Holl. 74; H. 236; White pp. 55–65

Berlin: II on Japanese paper (302–1898)
Amsterdam: I on Japanese paper (O.B. 601)*
London: I on Japanese paper (1973 U. 1022)

Inscriptions on the reverse of the example in Amsterdam:
(in brown ink)
'Vereering van mijn speciale vriend Rembrandt tegens de Pest van m. Anthony'[1]

(also in brown ink but in another hand)
'ici-dessous est decrit en pierre noire
vereering van mijn speciaele
vriend Rembrand, tegens de
pest van M. Antony.

Rembrand amoureux d'une
estampe de M. A. savoir la
peste, que son ami J. Pᶻ.
Zoomer, avoirt de fort belle
impression, & ne pouvant
l'engager a lui vendre,
lui fit present, pour l'avoir,
de cette estampe-ci, plus-
rare & plus curieux encore
que l'estampe que l'on . . . oine
de Hondert Guldens Print, par
les addition dans clair obscur
qu'il y a dans celle-ci, dont
il n'y a eu, suivant le raport
qui m'en a ete fait, que
tres peu d'impressions, dont
aucune n'a jamais été vendue
dutemps de Rembrand, mais
distribuées entre ses amis.'

Gersaint, the author of the first printed catalogue raisonné of Rembrant's etchings (1751), praised the *Hundred Guilder Print* as the best etching from the master's hand. He drew particular attention to the variety in Rembrandt's record of human expression, which was shown 'avec tout l'esprit imaginable'.[2] Houbraken too celebrated the work as supreme, but as a result of his own artistic ideals and of his view of Rembrandt, he regarded it as unfinished. 'This is particularly clear in the so-called Hundred Guilder Print, at the treatment of which we can only wonder, because we cannot understand how he [Rembrandt] could have worked this up from what was originally nothing but a rough sketch . . .'[3]

The title *Hundred Guilder Print* is not given by Rembrandt himself.[4] Already used in the eighteenth century, it provoked a number of fanciful explanations. Gersaint, for example, reports—probably following the inscription on the Amsterdam example—that the artist had been able to give this etching to a Roman art dealer in exchange for several engravings by Marcantonio Raimondi which, together, were valued at a hundred guilders.[5]

The original significance of the work was obscured by the title *Hundred Guilder Print* until the end of the nineteenth century when its meaning was reconstructed.[6] The subject is not a single episode ('suffer the children come unto me' or 'the healing of the sick'), but rather the whole of the nineteenth chapter of the Saint Matthew's Gospel.[7] This interpretation was supported by the later discovery of a poem by H. F. Waterloos (a contemporary of Rembrandt), inscribed on an impression in Paris:

'Aldus maalt Rembrants naaldt den zoone
 Godts na 't leeven;
en stelt hem midden in een drom van zieke
 liên:
Op dat de Werelt zouw na zestien Eeuwen
 zien,
De wond'ren die hij an haar allen heeft
 bedreeven.
Hier hellept Jezus handt den zieken. En de
 kind'ren
(Dat's Godtheyt!) zaalicht hij: En strafftze die'r
 verhind'ren
Maar (ach!) den Jong'ling treurt. De
 schriftgeleerden smaalen
't Geloff der heiligen, en Christi godtheits
 straalen.'

(And so Rembrandt drew from life, with his
 etching tool,

The Son of God in a world of sorrow,
Showing how, sixteen centuries ago,
He gave the sign of His miracles.
Here Jesus' hand helps the sick. And to the
 children
(Mark of Divinity!) He gives His blessing, and
 punishes those that hinder them.
Yet (oh!) the young man wails. And the scribes
 sneer
At the faith in Holiness that crowns Christ's
 Divinity).

Rembrandt stresses the varied nature of the miracles performed by Christ, in amalgamating different episodes from the account in the Bible. The viewer is introduced to the crowded scene through the diagonal arrangement of the composition and, above all, through the use of lighting. The darkness that appears to deepen behind the figure of Christ evokes the suggestion of a monumental, arched structure. Christ's nobility, however, is enacted as the Redeemer shines forth against the depths of this darkness.

The *Hundred Guilder Print* is striking for the variety of printing techniques Rembrandt uses. Its large scale is apparently matched by its ambition to compete with painting; and the graphic range of etching is united with its painterly scope in an unusually broad spectrum. In this respect, the work cannot be compared directly with any single work from Rembrandt's printed œuvre. Related examples among the etchings of the period around 1640 may be found for the figures on the left treated in cursory outlines.[9] The participants on the right, however, are characteristic of work from no earlier than the second half of the 1640s in their shading, which is elaborately modelled with short, delicate lines.[10] For this reason, there is unanimity regarding a date of 1647/49 for the completion of the print. There has, however, been disagreement as to when Rembrandt started work on the plate. Was the *Hundred Guilder Print* produced in its totality in about 1647/49, incorporating earlier stylistic means, or should one, rather, posit an interruption in the work, and date Rembrandt's first version to the late 1630s?[11]

Those arguing for an early dating have eagerly pointed to Rembrandt's dated oil sketch of 1634 for *John the Baptist preaching*.[12] At first glance, the similarity of the compositional arrangement seems convincing— the view is led diagonally into the picture and the protagonists are arranged diagonally to the picture plane. However, the compositional principle of the London painting of 1644, *Christ and the Woman taken in Adultery*,[13] is on the whole nearer to that of the *Hundred Guilder*

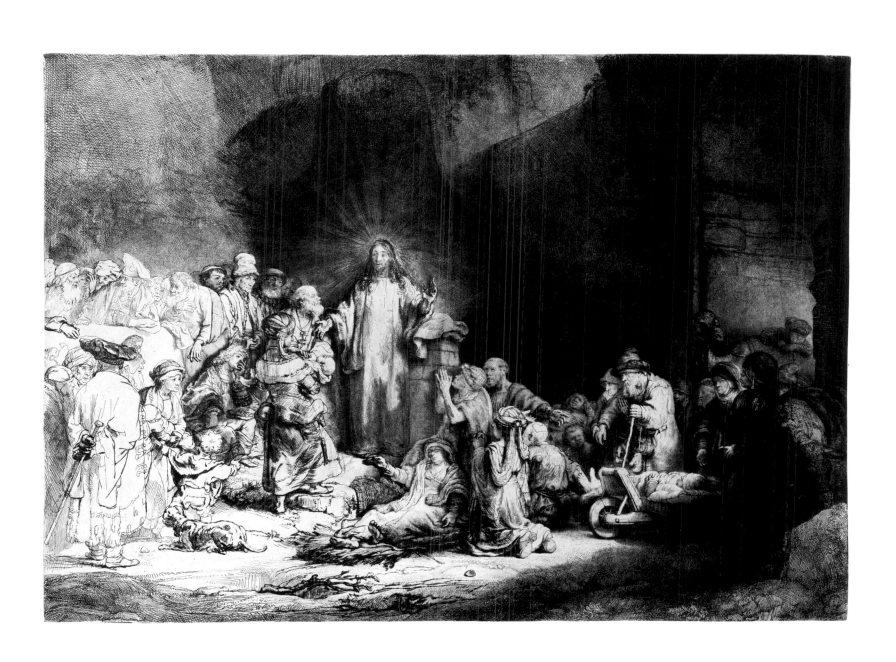

Print. Here one finds the arrangement of figures as if in 'relief', and the careful control of both the view and the lighting across the figures seen from the back to the meeting of Christ and the woman kneeling in front of him.

The surviving states of the etching give no insight into the process of its development. The alterations in state II are concerned only with minor details. The less resolved passages are more insistently enclosed through finer incised hatching strokes (the back of the donkey's neck, the area of the right background behind Christ's head). Nevertheless, the various traces of alterations, clearly reveal Rembrandt's intensive work on the plate.[14] Christ's face and the position of his arms are re-worked; and even his right foot was originally placed somewhat higher. The woman with a child in her arms was initially posed stepping forward more vigorously. None of these visible traces of the working process points to an alteration of the composition as a whole or to a full re-arrangement of any individual figure.

Various preparatory drawings were made for the figures that are crucial in the arrangement of the composition and in guiding the viewer's attention. The sick woman on the bier[15] held particular interest for Rembrandt (Fig. 27a), and he worked out this whole group in a sheet now in Berlin (Fig. 27b).[16] In further surviving studies one can see the blind man,[17] the man with an outstretched arm,[18] and the woman with a child in her arms who stands in front of Christ.[19] These drawings and the etching must be assessed in relation to each other. The drawings have, accordingly, been dated from the late 1630s to, more recently, about 1647.[20]

The basic compositional arrangement of the etching is not affected by any of these figure-studies.

The repeatedly stated assumption that one of Rembrandt's painted study heads for Christ is a preparatory work for the face of Christ in the *Hundred Guilder Print* can now be dismissed.[21] It would be most unusual for Rembrandt to make an oil sketch in preparation for a single figure in a multi-figure etching. The surviving heads of Christ are, moreover, now all given a later date (about 1655/56), and to a large extent no longer ascribed to Rembrandt.[22] In the *Hundred Guilder Print*, on the contrary, Rembrandt used the type of Christ that is characteristic of his work in the 1640s[23]— the type described by contemporaries, such as Waterloos in his poem, as 'een Christus tronie nae 't leven' (a face of Christ from life)'.[24]

In summary, we can say that neither the visible traces of alterations made on the plate nor the surviving drawings lead to the conclusion that Rembrandt fully re-worked in about 1647/49 a version of the *Hundred Guilder Print* he had made in the 1630s. Nonetheless, neither are the variations within the finished work satisfactorily explained by the theory that Rembrandt used a new style to complete the unfinished parts of a plate he had long abandoned.

One of the strands of tradition to which research has as yet paid too little attention constantly describes the *Hundred Guilder Print* as extraordinarily rare. In the inventory drawn up by de Burgy, for example, it is called 'extraordinairement rare'; Gersaint too calls it 'very rare'; and, finally, the Amsterdam

27a: Rembrandt, *Studies of a sick woman*. Drawing. Amsterdam, Rijksprentenkabinet.

27b: Rembrandt, *A group of figures*. Drawing. Berlin, Kupferstichkabinett SMPK.

impression is similarly celebrated: 'deze is een alder eerste en dus raarste druk van deze plaat . . .'[25] (this is one of the first, and very rare, impressions of this plate). When Captain Baillie re-published the print in 1775 heavily re-worked, he added the inscription: 'The Hundred Guilder-Print. Engraved by Rembrandt about the year 1640 after a few Impressions were printed was laid by and thought to be lost.'

The second inscription on the reverse of the impression in Amsterdam perhaps offers an explanation for this: here it says that Rembrandt had not made this work for the art market, but rather presented it as a gift of friendship. Even the unusual portrait of Aert de Gelder, now in Leningrad,[26] in which the sitter appears with an impression of the *Hundred Guilder Print* in his right hand, could play a part in this tradition. In this connection, one might also consider again the fact that Rembrandt, surprisingly, did not sign the *Hundred Guilder Print*. Thus one might imagine that Rembrandt is making a pragmatic demonstration of the totality of his abilities as an etcher. The printing styles used here range from the sketchiness that Houbraken mistook for unfinished work, to the tonal gradations of painterly *chiaroscuro* values that are possibly to be understood as experimental competition with the new mezzotint technique.[27] The variety of methods in print-making should not, in this case, be understood to indicate that Rembrandt evaluated the work over several years, but rather as a record of Rembrandt's reference to his own œuvre—a deliberate display of virtuosity.

B.W.

1. See *Urkunden* 266, there claimed to be the handwriting of the Amsterdam art collector Jan Pietersz. Zoomer. This identification has been opposed by Dudok van Heel 1977, p. 98.
2. Gersaint 1751, No. 75, pp. 6 ff.
3. '. . .als inzonderheid aan de zoo genaamde honderd guldens prent en andere te zien is, waar omtrent wy over de wyze van behandelinge moeten verbaast staan; om dat wy niet konnen begrypen hoe hy het dus heeft weten uit te voeren op een eerst gemaakte ruwe schets . . .' Houbraken 1718, p. 259.
4. See also Cat. No. 33.
5. Gersaint p. 60; see Dudok van Heel 1977, p. 98.
6. Jordan 1893.
7. On the significance and the iconographic tradition see, most recently, Tümpel 1986, pp. 255–61.
8. *Urkunden* 266. Haak 1969, 214.
9. *The Presentation in the Temple*, B. 49; *The Triumph of Mordechai*, B. 40; see also Cat. No. 14.
10. See Cat. No. 26.
11. This argument is put forward at length by White 1969, pp. 55–65.
12. Gemäldegalerie, Berlin; Paintings Cat. No. 70. See White 1969, p. 57.
13. Bredius 566.

14. See White 1969, pp. 62 ff.
15. Amsterdam, Benesch 183, Schatborn 1985, No. 21; Benesch 388, Sale: Sotheby, London, 1970.
16. Kupferstichkabinett, Berlin, Benesch 188.
17. Louvre, Paris, Benesch 185.
18. Courtauld Institute, London, Benesch 184.
19. Pushkin Museum, Moscow, Benesch 1071. It is possible that in this figure Rembrandt made use of the insights obtained from his very varied studies of mother and child from the late 1620s. A drawing in Rotterdam (Benesch 288) shows—albeit not in reversed form—striking similarities with the figure in the etching. An impression in the British Museum has black chalk corrections in the figure of the standing woman with the child.
20. Schatborn 1985, No. 21.
21. See White 1969, p. 61.
22. The *Hundred Guilder Print* has been discussed in connection with, among others, the painting in the Fogg Art Museum, Cambridge/Mass. (Bredius 624A; Tümpel 1986, Cat. 79). Only the work in Berlin (Bredius 622, Tümpel 1986, Cat. 78, Paintings Cat. No. 20) is still assumed to be by Rembrandt. See also Bredius 626 / Tümpel A20; Bredius 621 / Tümpel A17; Bredius 624 / Tümpel A19.
23. This type can be seen, for example, in the 1648 painting of *Christ at Emmaus*. Louvre, Paris, Bredius 578.
24. See also the sale inventory of 1656. *Urkunden* 159.
25. *Urkunden* 266.
26. See, most recently, Chapman 1990, Fig. 170.
27. See the considerations of Holm Bevers in the introduction to this catalogue.

28

Landscape with the Goldweigher's Field

Etching and drypoint, 120 × 319 mm; 1 state
Signed and dated: *Rembrandt. 1651.*
B./Holl. 234; H. 249; White, pp. 213 ff.

Berlin: on Japanese paper (97–1887)
Amsterdam: (1962:91)
London: (1973 U. 1037)*
Berlin: II (242–16)

The most panoramic of Rembrandt's landscapes is the *Landscape with the Goldweigher's Field*. The long, narrow sheet shows the view, looking down from higher ground, over the area around Haarlem. In the left background the city of Haarlem can be seen in silhouette, dominated by the medieval Grote Kerk. The centre of the middle ground is taken up by the Saxenburg estate of Christoffel Thijsz., and to the right of this is the church of Bloemendaal.[1] In the fields in front of this there are people bleaching linen.

Somewhat later in about 1670, the view from the dunes not far from Haarlem of the bleaching fields and the city with the Groote Kerk in the background was a favourite subject of Jacob van Ruysdael. In the early seventeenth century, Hendrick Goltzius had already made several panoramic landscapes of the area around Haarlem, drawn from observation—a milestone in the development of the naturalistic Dutch landscape.[2] Rembrandt must have been inspired by comparable panoramas by Hercules Seghers. The etching by Seghers, *View of Amersfoort* (of about 1630) has a long, narrow shape similar to that of Rembrandt's etching (Fig. 28a); moreover, the view is taken from higher ground, and the horizon line is high, above the vertical mid-point of the sheet.[3]

The old title of Rembrandt's etching derives from the inventory made by Valerius Röver (1731); it is also the title used by Gersaint.[4] It alludes to the tax-collector Johan Uytenbogaert, whom Rembrandt had portrayed as a gold-weigher in the etching B. 281. It appears, however, that the landscape etching shows the estate of Christoffel Thijsz. Rembrandt had bought his house in the Sint-Antonisbreestraat from him in 1639. As he still owed a great deal of money to Thijsz in 1651, the etching of the view of his estate might have been made to appease him.[5]

The fields, the groups of trees, and the houses in *The Goldweigher's Field* are almost reduced to abstract forms. As far as the eye can see, the landscape is ordered through a series of intersecting diagonal lines. A sense of depth is sparked by the emphatic inky, black drypoint passages distributed across the sheet. The whole foreground forms a long, curved line, creating an optical impression that the landscape is slowly turning around an imaginary point in the distance. A drawing by Rembrandt in the Museum Boymans-van Beuningen shows a similar view of Haarlem from a slightly altered and higher viewpoint.[6] This study from nature was not used as direct preparatory material for the etching; but Rembrandt may have referred to it, without slavishly transferring the details. The foreground, which is left blank in the drawing, stands out in the engraving through the use of powerful drypoint strokes; this was also perhaps a device to increase the impression of depth in the landscape to counteract the breadth of the view.[7] The drawing, in which the church of Bloemendaal is placed on the left and the city of Haarlem in the right background, corresponds to topographical reality; and it is surprising that, in producing the plate, Rembrandt did not take the reversal of left and right into account. The fact that there are six surviving counterproofs (Fig. 28b)—showing the landscape in mirror image, and thus topographically correct—might indicate that Rembrandt later became aware of this.[8]

The Landscape with the Goldweigher's Field exists in only one state, though the proofs of this state vary a great deal according to the degree of burr still found along the drypoint lines and the amount of surface tone; the proofs on Japanese paper are also striking for their varying appearance.

H.B.

1. Lugt 1920, p. 157, note 1. Van Regteren Altena 1954. The identification of the individual groups of buildings has been disputed. Van Regteren Altena thinks that the large building with a tower on the right is the manor house of Thijsz., while other commentators interpret this building as the church of Bloemendaal.
2. Reznicek 1961, Vol I, pp. 131–32, pp. 427 ff., Nos. 400, 404–5; Vol. II, Figs. 380–81, 351.
3. Haverkamp-Begemann 1973; Holl. 30.
4. Gersaint 1751, pp. 182–83, No. 226.
5. Van Regteren Altena 1954, p. 9; Washington 1990, p. 260. No. 84.
6. Benesch 1259; Giltaij 1988, p. 78, No. 21; Washington 1990, pp. 258–59, No. 83.
7. The marked panoramic elongation of the view, the curvature of the foreground, and the striking effect of distortion of the image in the corners of the sheet through the velvety tone of the dry-point burr, all prompt one to think of the view through a wide-angle lens. It would be tempting, though risky, to speculate as to whether Rembrandt had perhaps conceived the *Landscape with the Goldweigher's Field* with the help of such lenses. The use of lenses to help with picture construction played an important part in the work of pupils of Rembrandt such as Carel Fabritius and Samuel Hoogstraten; and Constantin Huygens was interested in optical instruments. There is no evidence, however, that Rembrandt himself used lenses; see Wheelock 1977, especially pp. 206 ff.
8. Schneider does not exclude the possibility that the etching was itself made from observation; Washington 1990, pp. 26, 31 (note 40) and 261, No. 84. On this, see Cat. No. 20.

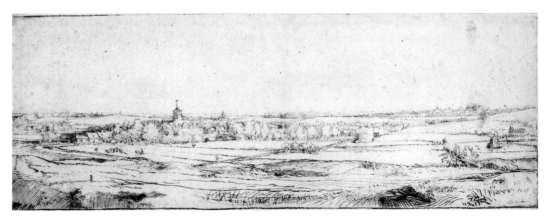

28a: Hercules Seghers, *View of Amersfoort*. Amsterdam, Rijksprentenkabinet.

28b: Rembrandt, *The landscape with the Goldweigher's field*. Counterproof. London, British Museum.

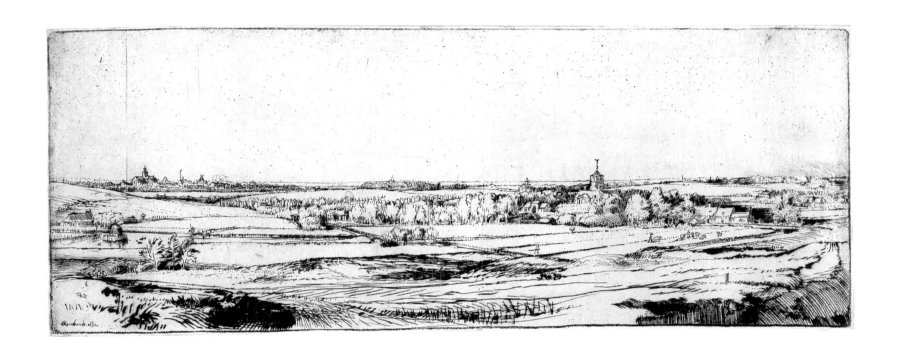

29

The Shell
(Conus marmoreus)

Etching, re-worked in drypoint and burin
97 × 132 mm; 3 states
Signed and dated: *Rembrandt. f. 1650.*
B./Holl. 159; H. 248; White, p. 169

Berlin: II (242–16)
Amsterdam: I (O. B. 241), II (O. B. 242)*
London: I (1973 U. 1035), II (1973 U. 1036)

The only still-life among Rembrandt's prints—and one of few examples of still-life in his work as a whole—is the small etching of a conical shell.

Rare mussel and mollusc shells, brought back to Holland from exotic lands by the great trading companies, were popular collectors' items in the seventeenth century. The collecting of mussel shells had almost become an obsession.[1] On account of their beauty and value, these objects were seen to embody the transition from Nature (*Natura*) to Art (*Ars*), or their union. Conchylia (the shells of molluscs) and other natural objects were to be found alongside man-made works of art in the collections amassed by princes and displayed in a *Kunst-* or *Wunderkammer*. A *Kunstkammer* of this time is described as follows: 'In our *Kunstkammer* we now delight to look at the empty shells and houses of the most beautiful and rarest conchylia in their many wonderous shapes and beauties; these are the work of nature and yet, at the same time, they seem like the product of art; we are both diverted by the sight and prompted by it to praise the Creator of these

works.' The writer adds that the greatest artist could not compete with the richness of colour to be found in these natural images.[2]
The *Kunstkammer* was also a feature of life in the cities of Holland. The objects from Rembrandt's own encyclopaedic *Kunstkammer* are well documented in the inventory of 1656, and among them were the shells of mussels and molluscs.[3]

Conchylia are to be found in records of such collections, for example in the case of the *Kunst-* and *Wunderkammer* of Frans Francken the Younger.[4] Almost as if disengaged from such scenes, there are the rare pure still-lifes with shells painted by Balthasar van Ast (Fig. 29a), in which many prized conchylia from distant lands are displayed.[5] Shells are found also in flower paintings and *vanitas* still-lifes where, as symbols of natural beauty that are also very fragile, they point to the transience of all that is earthly.[6]

Rembrandt shows a conical shell (*conus marmoreus*), which comes from the East Indies. He appears to have been moved above all by the play of light and shade on the rounded

29 State I

29a: Balthasar van Ast, *Still life with shells.*
Rotterdam, Museum Boymans-van Beuningen.

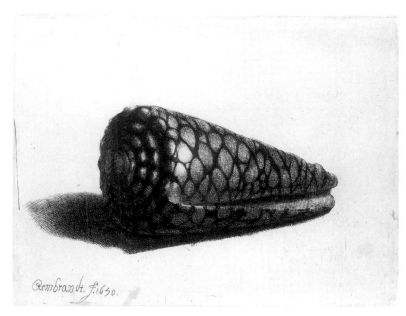

Rembrandt. f. 1650.

Rembrandt. f.1650.

surface of this lovely creation; and it almost seems as if he wished to show that art could still use its own means to rival nature. It is in any case clear that Rembrandt's etching is not a scientific illustration in the manner of the shells depicted by Wenzel Hollar that are often invoked as direct models for Rembrandt's sheet. Hollar's series might have served as inspiration only for the idea of taking a single shell as the subject of an engraving (Fig. 29b).[7]

State I—executed in drypoint over an etched outline—shows the shell isolated in front of a background that is left white. The shell casts a shadow, without occupying a real space; and this contradiction may have prompted Rembrandt to shade in the background in state II and to suggest a cabinet or shelf, so that the shell now seems to lie on a board. Reworking with the burin on the surface of the shell reduces the highlights of state I. In state III (only surviving proof in Amsterdam) Rembrandt has extended and more sharply defined the central spiral form that in state II appears rather flat.

Just like a real mollusc shell, Rembrandt's *conus marmoreus* would have been acquired by collectors as an item fit for a *Kunstkammer*.
H.B.

1. On this see, in particular. Schneller 1969, pp. 119 ff. The fashion for collecting shells was censured in Roemer Vischer's *Sinne-poppen*. The picture of shells, bears this emblem: 'Tis misselijck waer een geck zijn gelt aen leijt' (it is disgusting [to see] what a fool will pay good money for); see Bergström 1956, pp. 156–57; Boston 1980/81, pp. 91 ff., No. 54.
2. Scheller 1969, p. 120.
3. *Urkunden*, p. 199, No. 190, item 179.
4. Scheller 1969, Figs. 5–8.
5. Bergström 1956, pp. 70 ff., Fig. 60.
6. Bergström 1956, pp. 154 ff.
7. A *conus imperialis* from Hollar's series has been seen as a model for Rembrandt: see Pennington 1982, p. 337, Nos. 2187–224, in this case No. 2195. Van Regteren Altena 1959, pp. 81 ff.

29b: Wenzel Hollar, *Conus Imperialis*. Berlin, Kupferstichkabinett SMPK.

30

The Print-Dealer
Clement de Jonghe

Etching, re-worked with burin and drypoint
207 × 161 mm; 6 states
Signed and dated: *Rembrandt f 1651.*
B./Holl. 272; H. 251; White, pp. 135 ff.

Berlin: II (359-16)*
Amsterdam: III (O. B. 527)
London: II (1843-6-7-158)

The etching was first cited as a portrait of
Clement de Jonghe in the inventory drawn up
by Valerius Röver in 1731, and it has generally
been accepted as such. Rembrandt must have
known Clement de Jonghe well. Born in
Schleswig-Hollstein in 1624 or '25, he came to
Amsterdam in about 1650 according to some
sources, and in about 1656 according to others.
He was active there as a publisher of, and
dealer in, engravings, maps and books.[1] His
first shop was at the weighhouse on the
Nieuwmarkt, and in 1658 he moved to a new
address, Kalverstraat 10, near the Dam, the
centre of the Amsterdam art trade. Among
other things, De Jonghe published engravings
and etchings by Roelant Roghman and Jan
Lievens, and he must have had access to a large
stock of printing plates. Nevertheless, it seems
that his business did not really flourish. After
De Jonghe's death in 1677, his son took over
the business; in 1679 he drew up an inventory
of his father's estate. Here, among other things,
74 etched plates by Rembrandt are cited by
their titles.[2] Surprisingly, in view of what one
might have expected, the plate with De
Jonghe's own portrait was not in the print-
dealer's estate. This, as has often been
observed, could argue against the identification
of the sitter as De Jonghe.[3]

The print dealer is dressed in a cloak and a
broad-brimmed hat that lightly shadows his
face: he is sitting in a chair in front of a white,
undefined background. No reference at all is
made to a profession or activity (see the very
different case of Cat. No. 16). De Jonghe faces
the viewer and looks at him, but he is pushed
slightly away from the centre of the sheet,
towards the left, where he leans his elbow on
the arm of his chair. On his left hand, which
hangs almost nonchalantly, De Jonghe wears a
glove, the traditional sign of a nobleman.[4]

Rembrandt, who made portraits throughout his life, only rarely used the three-quarter length form.[5] This type had its roots in Venetian art, for example in the work of Titian, Tintoretto, Veronese and Lorenzo Lotto, where it was first developed in 'official' portraits for persons of high rank, but became more widely used.[6] Rembrandt had himself seen Venetian paintings; but in the case of this etching, he might, nonetheless, have been inspired by a Flemish model, perhaps the *Portrait of Martin Ryckaert* by Anthony van Dyck, that appeared in engraved form in 1646 in the *Iconografie* (Fig. 30a).[7] For, even in Venetian painting, there are hardly any models for the sitter being both seated and boldy placed facing the viewer in a comparable manner. It is this that gives extraordinary presence to Clement de Jonghe in the etching. Yet, at the same time, the severe frontality of the figure—ultimately deriving from the hieratic image of Christ—establishes a distance between the sitter and the viewer. The subject—whether or not he is indeed the print-dealer Clement de Jonghe—must have commissioned the plate from Rembrandt, and himself chosen the tense pose that expresses both his retiring nature and his official and social rank.

The plate exists in six states, all of which were considerably altered in the region of the eyes and mouth, with corresponding changes in De Jonghe's facial expression: in one case he seems to be smiling, then again somewhat sullen, elsewhere almost peering out drowsily. In state I the facial expression is extraordinarily clear and transparent (Fig. 30b), and yet it seems almost like that of an old man, which must have led to the transformation into the features of a youngish man in state II. States I and II show the sitter in front of a white background; in state III a simple, rounded arch was introduced; and in state IV this was emphasised with hatching (Fig. 30c).

H.B.

1. The biographical details regarding De Jonghe vary. It has been claimed that the print-dealer was born in Braunschweig and was active in Amsterdam from about 1650 (De Hoop Scheffer/Boon 1971, p. 4); elsewhere, Schleswig-Hollstein is cited as the region of his birth, while the start of his activity in Amsterdam is given as c. 1656 (Amsterdam 1986–87, pp. 58–59, No. 42.
2. De Hoop Scheffer/Boon 1971.
3. Van Eeghen 1985 and Voûte 1987 take issue with the traditional attribution. On account of a certain similarity in physiognomy and dress between the sitter in the etching and those of Jan Six in the celebrated painting of 1654 in the Six collection, Amsterdam (Bredins/Gerson 276), Voûte puts forward the argument that this etching also shows Jan Six. Whatever the truth of the matter, the identity of the sitter in the etching does now have to be reconsidered.
4. Smith 1988, p. 46.
5. On this point in general, see Chapman 1990.
6. Chapman 1990, pp. 93 ff.
7. Chapman 1990, pp. 93–94, Fig. 137.

30a: Anthony van Dyck, *Portrait of Martin Ryckaert*. Berlin, Kupferstichkabinett SMPK.

30b Rembrandt, *Clement de Jonghe*. State I. Amsterdam, Rijksprentenkabinet.

30c: Rembrandt, *Clement de Jonghe*. State IV. Amsterdam, Rijksprentenkabinet.

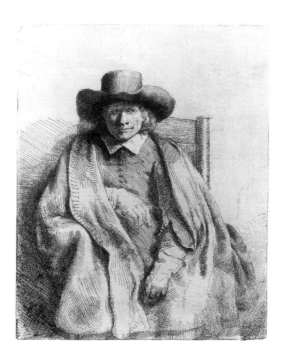

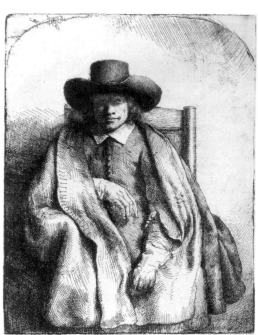

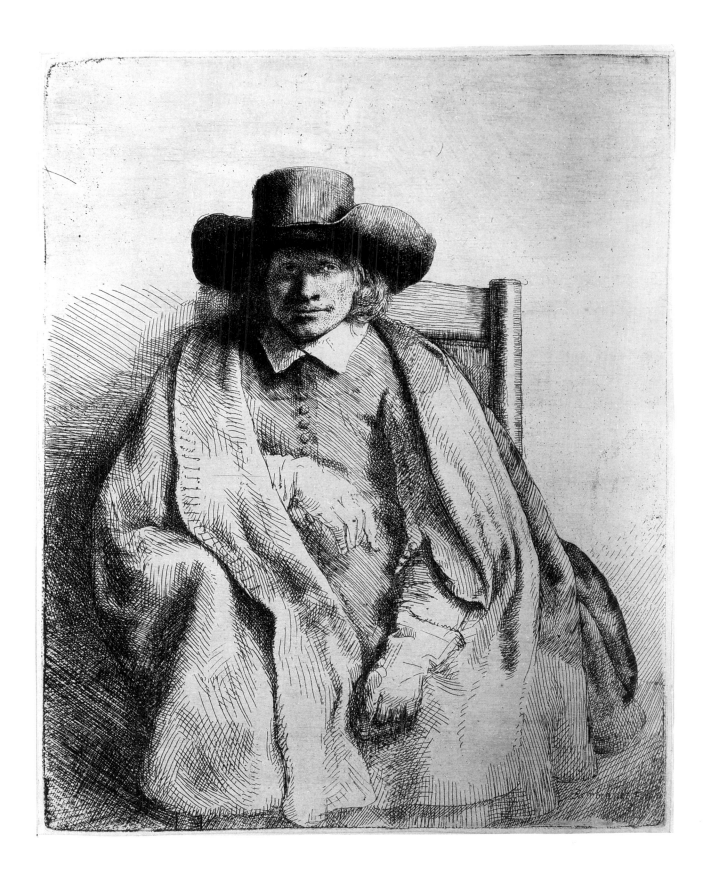

31

Saint Jerome in an Italian Landscape

Etching and drypoint, with some sulphur tint,
259 × 210 mm; 2 states
c. 1653–54
B./Holl. 104; H. 267; White, pp. 220 ff.

Berlin: I on Japanese paper (444–1908)*
Amsterdam: I on Japanese paper (O. B. 184)
London: I on Japanese paper (1973 U. 1151)

31a: Cornelis Cort, *St Jerome*.
Amsterdam, Rijksprentenkabinet.

31b: Rembrandt, *St Jerome reading in a landscape*.
Drawing. Hamburg, Kunsthalle.

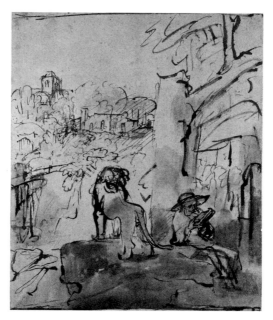

One of the finest examples of Rembrandt's endeavours to capture light and atmosphere in the 1650s is the etching from 1653–54 showing *Saint Jerome in an Italian Landscape*. The saint sits, turned towards the viewer, on a large rock, and appears absorbed in his reading; next him stands a lion, looking towards the background which shows a hilly landscape with a group of buildings. Without the presence of the lion, it would not be obvious that this is a scene of Saint Jerome, for the other traditional attributes—crucifix and skull—are missing and, instead of the usual cardinal's hat, the saint wears a sort of sunhat as protection against the dazzling light, while he reads. The sandals which he has removed might at first be taken for a genre motif; but they may be found in the iconography of this subject and symbolise the saint's readiness to meet God.[1]

The scene is enlivened by the play of light and dark on the sheet. Parts of the hilly land in the background are caught in bright, almost harsh light, others lie in deep shadow. Gersaint and Bartsch thought the sheet unfinished, not recognising that Rembrandt, in leaving the foreground substantially free, and indeed only sketchily treated, wished to indicate a bright summery light.[2]

The subject of Saint Jerome shown in meditative mood in a charming landscape, more as a philosopher than as a penitent, may be traced back to sixteenth-century northern Italian and Venetian painting.[3] Rembrandt could have taken his cue from a composition by Titian known through an engraving by Cornelis Cort (1565) (Fig. 31a).[4] In both cases, the foreground scenery establishes a powerful diagonal thrust into the picture-space, and beyond this the view opens on to a hilly landscape with human settlements. The immediate source for Rembrandt's figure of the saint could have been an engraving by Giulio Campagnola which shows *Saint Jerome reading* (1503–4).[5] Rembrandt's background landscape too, with its apparently northern European buildings, was inspired by corresponding landscapes in engravings and woodcuts by Giulio and Domenico Campagnola.[6] Considered as a whole, the present sheet, with its light-flooded, atmospheric landscape, owes much to Rembrandt's intensive study, during the 1650s, of Venetian painting. A sheet of about equal size with a reversed study for the etching is in the Kunsthalle in Hamburg (Fig. 31b).[7] It reveals that Rembrandt had originally planned to show the rocky ledge and the saint in shadow, but discarded this plan in favour of a brightly lit foreground (see Drawings Cat. No. 26).

The early proofs of state I, mostly printed on japanese paper, show extremely powerful drypoint passages, above all in the area of the bushes in the middle ground as well as on the lion's mane, with the effect of further intensifying the opposition of warm light and deep shadows. In state II, the bridge piers at the right edge are worked over with drypoint strokes. Several examples of this state are printed on a rough paper of a grey-brown colour, similar to packing paper—in English known as 'oatmeal paper' or 'cartridge paper'.
H.B .

1. Wiebel 1988, p. 96.
2. Gersaint 1751, pp. 90–91, No. 104.
3. See Wiebel 1988, pp. 123 ff.
4. Bierens de Haan 1948, p. 141, No. 134; Wiebel 1988, p. 123, Fig. 57.
5. Hind 7; Washington 1973, pp. 396–97, Fig. 19–7.
6. See, for example, the group of buildings, inspired by Dürer, in the above cited engraving by Giulio Campagnola, Hind 7. Further examples in Washington 1973, pp. 390 ff., Chapters XIX–XX. Rembrandt's familiarity with northern Italian models from the circles of Titian and Campagnola is shown by the fact that he copied a landscape drawing by Titian, and also worked over a landscape drawing in his own possession that has often been attributed to Domenico Campagnola (Benesch 1369). See Washington 1990, pp. 156 ff., Nos. 38–39.
7. Benesch 886; Schatborn 1986, pp. 22–23.

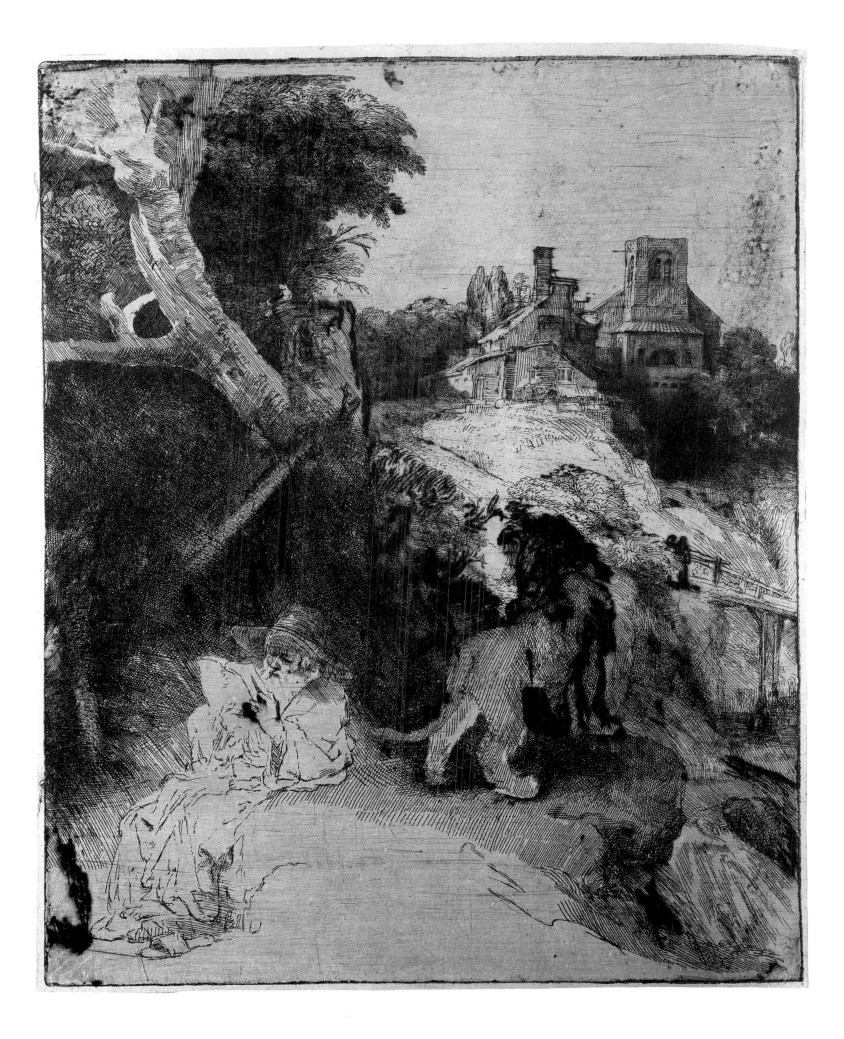

32

Landscape with three gabled cottages

Etching and drypoint, 161 × 202 mm; 3 states
Signed and dated: *Rembrandt f. 1650*
B./Holl. 217; H. 246

Berlin: I (317–1893)*
Amsterdam: III (O.B. 275)
London: I (1847–11–20–6)

Even the shape of this scene, with its rounded corners such as were used for ambitious history paintings, emphasises the monumental character of the composition. The structure is based on two powerful diagonals: a steep plunge into the depth of the depicted space in the form of a road leading from the immediate foreground to the horizon, and the imaginary line that divides the trees and houses from the sky. The sky itself is very effectively integrated into the scene as a surface left white. On the right, an enormous tree occupies the full height of the sheet, dominating the three handsome cottages along the road. A few people have gathered in front of the middle one. The depiction of the scene becomes less precise at a greater distance towards the low horizon, although further trees and houses can be made out. The strong sense of spatial recession is emphasised by the marked difference of scale between the tree and the cottages with the people standing in front. The tree is given heroic prominence, as if it were the protagonist of the composition.

Excellent impressions of this landscape etching show traces of Rembrandt's process of working. Rembrandt obviously fundamentally re-worked the appearance of the tree. Its left half, at first recorded in etching with feathery foliage, was altogether smoothed away at a later stage of work. Traces of a whole mass of foliage can be made out on the left, below the dead branch that is now visible. The thick branches and the summarily noted foliage are drawn in with powerful drypoint strokes that give the scene its imposing quality. Further details are altered accordingly: in the first version the roof of the nearest house was delineated in a very meticulous fashion. Similarly, the bushes behind this house first sketched have been summarised with drypoint hatching.

The small alterations between the three extant states consist merely in varied distribution of light and shade; thus patches in front of the nearest house, left white in the first state, are filled in with hatching in state II, giving this region more visual unity. On the contrary, the compositional changes in the treatment of the tree took place before any of the recorded phases of the work. The sheet thus appears to have been already completed in the exclusively etched version, before Rembrandt subjected it to a fundamental alteration. We do not know, however, how much time passed between the work on these two versions.

The visible alterations have, on occasion, led scholars to the assumption that Rembrandt started work on the etching *en plein air*, and then completed it in the studio.[1] The first sketch of the tree was then judged to be a freely formulated image made from nature. There seems, however, to be no evidence that seventeenth-century artists carried etching plates around with them to be used like a sketch book.[2] We must, on the contrary, regard both versions of the etching as made in the studio and assume that, during the second stage of the working process, Rembrandt abandoned the original composition in favour of one of greater formal value.

At least two drawings record the same property on the Sloterweg near Amsterdam.[3] Only one drawing (Benesch 835), however, is generally dated to the year of the etching; the second drawing was apparently not made before 1652/53.[4] Rembrandt seems to have made the earlier drawing (Fig. 32a) *en plein air*; and this drawing may have served as general inspiration for the composition of the etching.[5] However, Rembrandt altered the architectural setting by adding a third building. The heroic picture structure contradicts the concern for an exact topographical record.[6] There are several sources for Rembrandt's compositional

arrangement in Netherlandish art of the seventeenth century, for example an engraving by Hieronymus Cock also shows a road with houses along it, leading diagonally into the picture space.[7]

Rembrandt, however, increased the dramatic treatment of the landscape through the structure of the composition. The altered treatment of the motif is also the decisive difference between the etching and the Berlin drawing. The drawing is centred on one of the houses, in front of which a tree sways in the wind. Further trees bend in the same direction, allowing one to sense the atmosphere of the landscape. In the etching, interest in mood gives way to concern for a tightly organised picture structure, as if the artist had wanted to avoid the impression of a scene glimpsed by chance. Instead, the tree, with the emphatic incorporation of branches that are already dead as well as leafy tree tops, becomes a symbol of growth and decay, of the transience of all life.
B.W.

1. For example C. P. Schneider, (Washington 1990, No. 20), reports a discussion with J. P. Filedt-Kok.
2. See Cat. No. 22.
3. Benesch 835, Berlin and Benesch 1293, Berlin. See Bakker 1990, who identified the location.
4. See, most recently, Bakker 1990.
5. Benesch 835; the connection between the drawing and the etching was first recognised by Haverkamp-Begemann 1961, 57.
6. See the *Landscape with a Tower* (Cat. No. 37).
7. V. Bastelaer 1908, No. 22; see Amsterdam 1983, No. 17.

32a: Rembrandt, *Landscape with cottages*. Drawing. Berlin, Kupferstichkabinett SMPK.

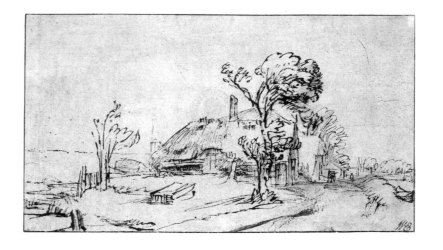

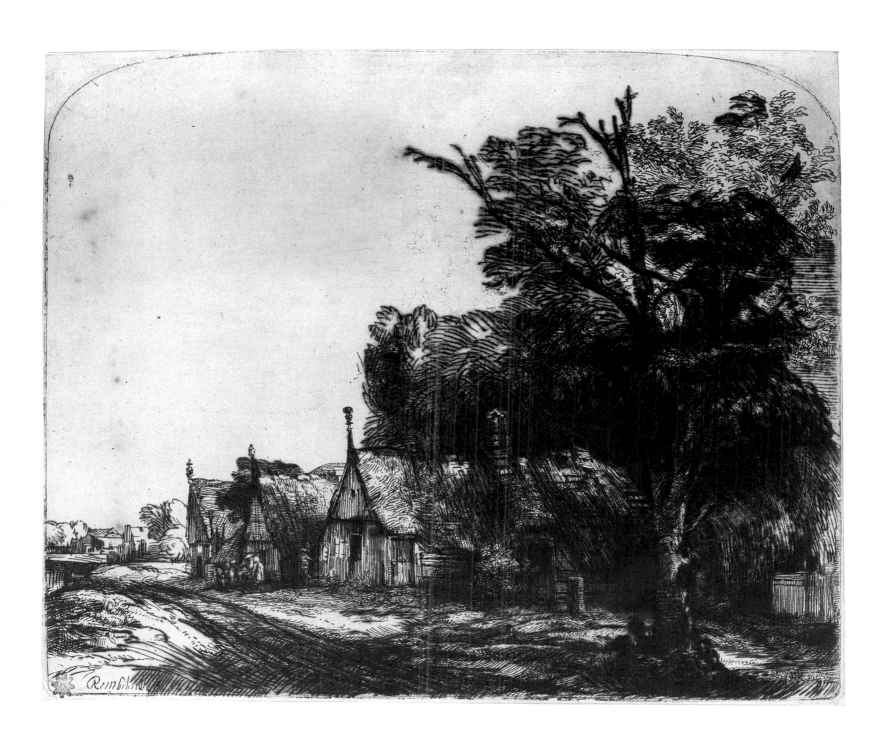

Rembrandt

33

'Faust'

Etching, drypoint and engraving,
210 × 160 mm; 3 states
Unsigned and undated; c. 1652
B./Holl. 270; H. 260

Berlin: II (355–16)*
Amsterdam: I on Japanese paper (62:122)
London: I (1982 U. 2752)

Anagram inscribed in concentric circles from
centre outwards:
INRI
+ ADAM + TЄ + DAGERAM
+ AMRTET + ALGAR + ALGASTNA + +

33a: Rembrandt, *Old man in meditation.*
Amsterdam, Rijksprentenkabinet.

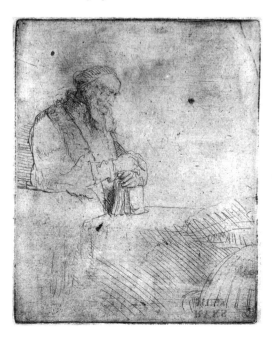

Rembrandt made his so-called *Faust* etching in about 1652. It shows an elderly man who concentrates on an apparition forcing its way through the closed window. The head of this apparition is made up of a circle of light with an anagram inscribed within it; and its hand points to a mirror-like object. The man's surroundings, including an astrolabe, a skull and books, indicate his learning.

The elaborate composition of the etching, almost like that of a painting, is especially notable. This prompts one to wonder if Rembrandt had devised the etching in response to a formal commission—although the existence of such a commission is pure speculation. The etching could just as well have been made for the market. The meticulous elaboration of the scene shows the work to have been an ambitious venture. Both the use of several kinds of paper and the variation in the impressions through the differences in the inking of the plates, further reveal Rembrandt's concern for this work.

It is exceptionally difficult to interpret the subject of this print.[2] The difficulties appear the more severe in that it has not proved possible to identify precisely the meaning of the anagram. The same sequence of letters has been found on amulets.[3] It is perhaps intended merely to suggest a magic formula, rather than a precise message that requires decoding.[4]

There are no surviving drawings in which Rembrandt resolved the composition of the etching. Therefore the etching seems to have been executed without any significant interruptions.[5] The three states differ only in details. For example, in state II, Rembrandt more strongly shaded the book placed on the right with further hatching, probably to soften the brightness that, in state I, had competed with that of the apparition. The development of the etching would seem to give no explanation as to the meaning of the work.

In the earlier eighteenth century (1731), Valerius Röver listed in the inventory of his art collection, an etching by Rembrandt with the title *Dr. Faustus.*[6] Research has, probably correctly, taken this entry to refer to our sheet. Since Gersaint, the work has been universally listed with the title *Faust* in catalogues raisonnés. A decisive factor in the subsequent history of the reception of the work was the fact that in 1790 Goethe commissioned a copy of the sheet to serve as the engraved title page for his early *Faust* fragment. In the early twentieth century there were efforts to find an older version of the Faust legend that Rembrandt might have been illustrating in his etching. A Dutch version of Christopher Marlowe's play, *Doctor Faustus*, known to have

been performed in Amsterdam in Rembrandt's lifetime, was cited.[7] There was even an attempt to determine precisely which moment in the play Rembrandt was illustrating.[8] Such views are no longer accepted for a number of reasons, for example the known illustrations of the Faust legend usually showed the devil.[9] Finally, Van de Waal (1964) argued that the man shown in the etching was a disguised portrait of Faustus Socinus, founder of the sect of the Socians, who had died in 1604.[10] This interpretation had the advantage of explaining how the title *Faust* referred to the figure shown. According to this theory, Rembrandt did not so much intend to show Socinus himself, as the entity of his ideas.

This explanation fails, however, to do full justice to Rembrandt's etching.[11] In no other of his portraits does Rembrandt show his sitter in lost profile. For this reason, the sitter can hardly have been intended to be identified. The subject of the etching is, rather, the event that Rembrandt illustrates. By precise control of perception of the scene, Rembrandt leads the viewer's attention, like that of the man himself, towards the apparition. A third area of emphasis is established by the astrolabe at the lower right edge, which stands out both through its brightness and for its size. Thus both composition and the pictorial narrative make clear that we are here observing a scholar concerned with astrology and confronted by an apparition.

As early as 1679, Clement de Jonghe mentioned an etching with the '*Practisierende Alchemist*' (Alchemist at Work).[12] Without exception, research has found this entry to refer to our etching. De Jonghe's entries and those of Röver have been seen as equally reliable. While De Jonghe must have known Rembrandt personally,[13] Röver's designation comes from a period when other works were also given new titles apparently because their original significance was no longer known or possibly because they had lost their former interest—one may recall the case of the *Hundred Guilder Print*[14] or that of the *Nightwatch*.[15] The title *Alchemist at work* might, indeed, have become accepted had it not been recognised that the seventeenth-century iconographic tradition for the presentation of alchemists was quite different from this. Thus, for example, paintings by Teniers always show a fire as the most important attribute of the alchemist.[16]

Rembrandt, on the contrary, takes up a motif from earlier scenes with scholars:[17] he shows a man of learning, looking up from his books and, indeed, holding a writing instrument in his right hand. In his own etching of a scholar, made in 1645 (Fig. 33a),[18]

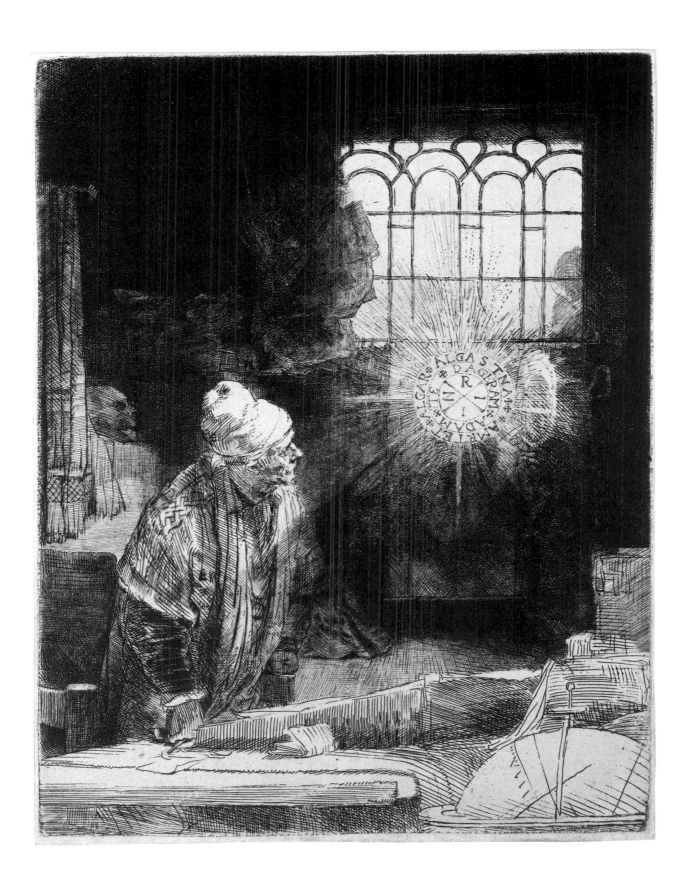

the figure is placed next to a table. In this earlier sheet the figure leans on a book, with a pen in his hand, and looks up thoughtfully. The two etchings show an altogether comparable arrangement of planes: in the earlier work, the figure of the scholar is set off against the brightly lit plane on the right, and in the *Faust* etching this area is occupied by the window and the apparition. In both sheets, the lower right corner is emphasised through the cropped image of an astrolabe. The 1645 scene with the scholar may have served as inspiration for Rembrandt's *Faust* etching. Starting from the iconography of the earlier sheet, Rembrandt presents a new interpretation of scholarship. The room, only sketchily indicated in 1645, is as detailed as a painting in the later sheet and becomes a setting that is used to define the protagonist.

Recently, Carstensen and Henningsen have drawn attention to a tradition of scenes of cabbalistic conjuration, apparently well-known in Amsterdam at the start of the seventeenth century.[19] Literary scholarship and magical rites were unified in this form of astrological belief, in which a Magus sought to invoke the ethereal spirits of the stars. Rembrandt might have learned these ideas from Menasseh-ben-Israel, who could have passed on to him various ideas from cabbalistic tradition.[20]

It seems that Rembrandt has here established for the first time a visual representation for a form of alchemy that had previously only been recorded in literary tradition. This novel iconographic formula—unlike earlier scenes with alchemists—shows the union of literary scholarship and magic. It introduces a personality that was to receive its classic literary formulation in Goethe's *Faust*. This may be seen to explain the persistent appeal of the essentially ahistorical title.
B.W.

1. As claimed, for example, by Carstensen/Henningsen 1988, p. 300.
2. A survey of the history of research on this matter is provided by Van de Waal 1964, pp. 45–46, *Documents* p. 14, and, most recently, Carstensen and Henningsen 1988.
3. See Van de Waal 1964, pp. 9–11; Rotermund 1957.
4. Carstensen/Henningsen 1988, p. 302.
5. On the question of the relation between drawings and etchings, see, for example the, *Hundred Guilder Print* and the drawings accompanying its own evolution (Cat. No. 27).
6. *Urkunden* 346.
7. Leendertz 1921.
8. Leendertz 1921, p. 136.
9. Van de Waal 1964, Figs. 1–3.
10. Van de Waal 1964.
11. See, most recently, Carstensen/Henningsen 1988.
12. Van Gelder/Van Gelder-Schrijver 1938, p. 1.
13. See Cat. No. 30.
14. Cat. No. 27.
15. *Corpus* A146.
16. For example, Prado, Madrid; Musées Royaux des Beaux-Arts, Brussels.
17. See the examples given by Van de Waal, as well as B. 105, B. 147 and B. 148.
18. B. 147.
19. Carstensen/Hennigsen 1988, who, following Panofsky, elaborate on the context of Rembrandt's *Faust* etching in terms of intellectual history.
20. See the Menetekel inscription in the London *Belshazzar's Feast* painting Paintings Cat. No. 22.

Landscape with a Tower

Etching and drypoint, 213 × 319 mm; 4 states
Unsigned, c. 1651
B./Holl, 223; H. 244; White pp. 212–13

Berlin: I (94–1887)*; III on Japanese paper
(120–1894)*
Amsterdam: I on Japanese paper (O.B. 456);
IV (O.B. 457)
London: II (1973 U. 1028); III (1973 U. 1029)

The principal motif in this print of about 1651
with its strip-like format is a compact entity
surrounded by trees, between which a path
leads. A flock of birds sweeps over the
buildings. On the left the view stretches,
uninterrupted, to the horizon. Darkness has
already crept up on the first group of trees—
in one half of the sky the hatching lines close
up—and those nearby appear to bend in the
wind. The broad, lit foreground emphasises the
falling darkness of the evening sky.

The location depicted here has been
identified as '*Het Huys met Toorentje*' (The
House with a Turret) on the Amstelveen road
very near to Amsterdam.[1] A drawing by
Rembrandt formerly in the Hirsch collection
(Fig. 34a)[2] cannot have served as direct
preparatory material because of its completely
different treatment of the main motif.
However, in it Rembrandt has drawn the same
group of houses, recognisable through the
tower, but from a greater distance and, rather,
as the silhouette of a village not dominated by
any individual motif. For his etching
Rembrandt selects a closer view, in which the
main motif, surrounded by trees, becomes the
focus of attention. In the drawing the
unworked paper surface is already incorporated
into the formal structure of the composition.
In the printed version even more is made of
this device. The dramatic use of light is crucial
for the effectiveness of the etching.

In many of his landscape etchings
Rembrandt seems to conceive the images in
pictorial terms.[3] These works stand out for
their formal compactness and, above all, their
fully elaborated foregrounds. 'First, it seems
that our foreground is detailed and emphasised,
in order to let the rest [of the composition]
retreat behind it, and so that we are persuaded

34a: Rembrandt, *Landscape with a tower*. Drawing.
Malibu, J. Paul Getty Museum.

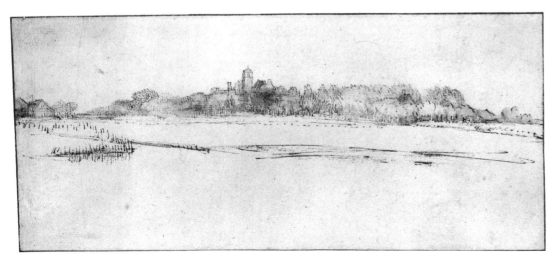

that something important is to be introduced into the foreground [. . .]'[4] In this etching, however, Rembrandt selects a compositional arrangement that is deliberately not taken from the sphere of traditional landscape painting. Obviously he is seeking to give the impression of a spontaneous study of light effects. The etching owes its particular allure to the contrast between the open foreground and the tightly organised composition in the central area.

The house is sheltered by the trees which sway in the wind. The swelling foliage is captured in short, light strokes. In state I Rembrandt uses line to contrast the solidly constructed wall and the feathery lightness of the thatched roof. In the later states Rembrandt denies the material aspects of the subject through his use of even, unifying cross-hatching. At the same time his interest in the topography wanes: in state III the cupola of the tower is burnished out, so that it no longer dominates the scene. The compact quality of the group of house and trees is now emphasised. A realistic record of the village is eschewed in favour of a composition based on formally determined passages, and where the principal concern is the effect of light and shadow.

The further, small corrections, ultimately insignificant for the composition as a whole, add to the intended effect of the image. Spots of etching fluid, visible in state I as black patches in the dark passages of the sky, are burnished out, though the triangular patch on the left near to the house persists through all the states. The lengths to which Rembrandt has gone in establishing the final version of this landscape etching are documented in the four states, each of them surviving also in the form of counterproofs. In some impressions Rembrandt experimented with different sorts of paper as well as with several inks and various degrees of wiping of the plate before printing. The manner in which the *Landscape with a Tower* evolved—a process during which composition, lighting, and printing technique were all re-worked—reflects Rembrandt's obsessive concern with the possibilities of the landscape etching.

B.W.

1. Van Regteren Altena 1954, 12–17; Washington 1990, No. 81.
2. Getty Museum, Malibu; Benesch 1267; see Washington 1990, No. 82.
3. A particularly clear example is *Landscape with the three trees* (Cat. No. 19).
4. 'Alvooren onsen voor-gront sal betamen Altijts hart te zijn / om d'ander doen vlieden / En oock voor aen yet groots te brenghen ramen'. Karel van Mander (1916), p. 204.

34
State I
State III

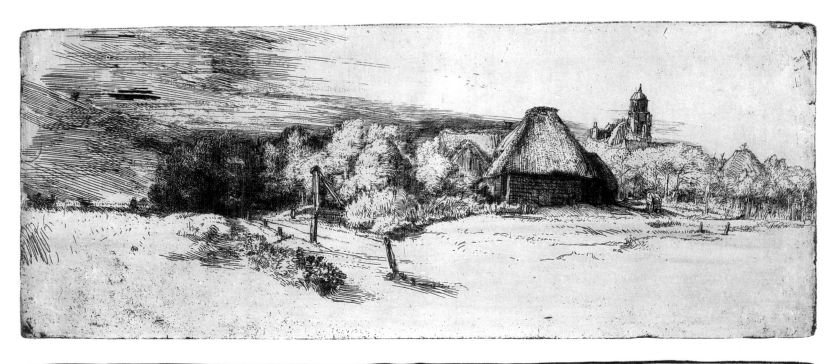

35

The Three Crosses

Dry point and burin, 385 × 450 mm; 5 states
Signed and dated: (in III, also still detectable in
IV) *Rembrandt. f. 1653.*
B./Holl. 78; H. 270; White, pp. 75 ff., 99 ff.

First version (I–III)
Berlin: III (646–16)*
Amsterdam: III (62:39)
London: III (1973 U. 941)

Second version (IV–V)
Berlin: IV (643–16)*
Amsterdam: IV (62: 40)
London: IV (1973 U. 942)

35a: Detail of Cat. No. 35, State III.

35b: Detail of Cat. No. 35, State I, on parchment.

35c: Master B with the Die, *The Crucifixion with
the Conversion of the Centurion.*
Vienna, Graphische Sammlung Albertina.

In 1653, or shortly before, Rembrandt made
one of the masterpieces of his printed œuvre:
The Three Crosses. The scene has the scale of a
painting; and it was radically reworked in a
later state, and in a way that is unique in the
history of printmaking.

The first three states—the first version of
the subject—show a crowded Calvary. This
type of scene had its roots in fifteenth- and
sixteenth-century Netherlandish art, but it was
something of an exception in Dutch painting of
the seventeenth century. Rembrandt's
depiction of the Crucifixion is based, to a large
degree, on the text in the Gospel according to
Saint Luke: 'And it was about the sixth hour,
and there was a darkness over all the earth
until the ninth hour. And the sun was
darkened, and the veil of the temple was rent
in the midst. And when Jesus had cried with a
loud voice, he said, Father, into thy hands I
commend my spirit: and having said thus, he
gave up the ghost. Now when the centurion
saw what was done, he glorified God, saying,
Certainly this was a righteous man. And all the
people that came together to that sight,
beholding the things which were done, smote
their breasts, and returned. And all his
acquaintance, and the women that followed
him from Galilee, stood afar off, beholding
these things.'[1]

The cross itself forms the centre of the
scene; and, following tradition, Rembrandt
included the two thieves who were crucified
with Christ. On the left are the Roman
soldiers; and the Centurion who was converted
at the death of Christ has already dismounted

and kneels at the foot of the cross with
outstretched arms. On the opposite side are the
mourning Disciples. Mary has fainted in the
arms of a companion; John presses his hands to
his head as if to tear at his hair (Fig. 35a).
Mary Magdalen, consumed with sorrow,
embraces the cross. Rembrandt omits some
elements in the narrative of the Passion that
are frequently found in Calvary scenes, such as
the motif of the soldiers casting lots for
Christ's clothing. He enhances the scene,
however, by including the figures of the
onlookers, described in Luke's account as
turning away so as not to witness the horror of
the event. Two men in the foreground,
apparently Jewish scribes, run in panic towards
a cave, and further to the left a man, possibly
Simon of Cyrene, who is clearly deeply
shocked, is led away by his companions. One
man covers his face with his hand, another
shields his eyes, and fleeing people are thrown
to the ground in their haste. It is not always
clear whether these are intended as followers or
opponents of the crucified Christ; but they
all appear to be in a state of great shock.
Rembrandt's psychologically penetrating study
of terrified humanity has no equal in the
iconography of Calvary.

We are shown the climax of the Passion:
the moment of Christ's death. The natural
phenomena—the quaking earth, the darkness
—are illustrated with a powerful use of
chiaroscuro. Vast beams of bright light pierce the
turbulent black sky, falling in a cone to
illuminate Christ on the cross and the
converted thief on his left who persists in his

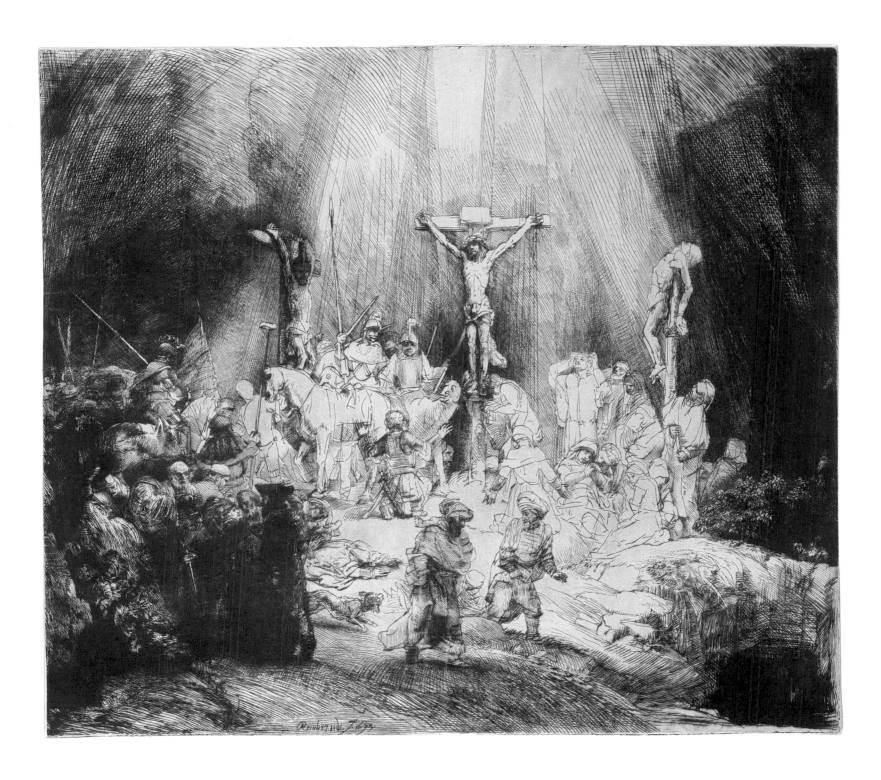

refusal to believe in the Lord.[2] The violent contrasts in illumination create an impression of chaos. Christ triumphs over this earthly tumult; he shows no trace of sorrow, and exudes a solemn air of peace. Rembrandt must have consciously adopted the form of the crucified Christ found in medieval art, with the feet placed next to each other and each nailed separately to the cross, a presentation that emphasises the idea of Christ's composure and his essential 'distance' from the surrounding confusion.

The angular style of the figures, often only shown in outline, corresponds to the style of Rembrandt's pen drawings of the same period. Apart from a disputed sheet of studies in Weimar, perhaps made in preparation for the group with the man led away by his companions, no preparatory drawings have survived.[3] One can, however, assume that there may have been further preparatory studies for the individual figures and for the composition as a whole. Rembrandt apparently transferred the scene directly on to the copper plate in drypoint, and in a few places also with the burin. Only in the case of small landscapes, are there earlier examples of works by Rembrandt executed exclusively in drypoint.[4] The transfer of a technique allowing a high degree of control to a large-scale work is witness to the artist's technical virtuosity. In his presentation of darkness, Rembrandt exploited in a unique way the effect peculiar to the drypoint stroke—it appears velvety and 'painterly' when printed because of the burr thrown up at the edges of the lines.

The Calvary scene may have been conceived as a pendant to Rembrandt's Ecce Homo of 1655 (see Cat. 38).[5] Both sheets were, perhaps, planned as parts of a Passion cycle which was, however, left unfinished. This possibility is supported by two observations: the Ecce Homo, in its first state before the plate was cut down, has almost the same scale as the Three Crosses, and both works are executed in the same technique. In addition, there are other groups of biblical cycles of the 1650s, for example the Passion of 1654 (see Cat. No. 37).[6]

Rembrandt's Ecce Homo, in its basic conception, follows Lucas van Leyden's engraving of the same subject from 1510 (see Cat. No. 38).[7] The Three Crosses would also seem to have evolved in conscious relation to the large Calvary scene by Lucas van Leyden of 1517,[8] yet not in the sense of a direct formal reference to the earlier work, but rather as a reinterpretation of the subject. It appears that Rembrandt wished to demonstrate that he was able to surpass his great Dutch predecessor, whose two most important works Rembrandt

had acquired for large sums. Rembrandt reworked other models directly. The figure of the converted Centurion is derived from an engraving by the Master B with the Die (1532), an Italian engraver from the circle of Raphael (Fig. 35c).[9] It is perhaps in this source that the image of the group of Disciples found its inspiration. For the group leading away the old man, a corresponding group from the Conversion of Saint Paul by Lucas van Leyden could have been the source.[10] The Horse Tamers of Antiquity, from the Palazzo del Quirinale in Rome, served as a model for another group in the left half of the scene in the first version (this is even more evident in the second version): the Centurion's horse and the servant holding its reins.[11] In spite of these formal borrowings, however, Rembrandt's Golgotha scene is totally original in its composition and iconography.

States I and II differ only minimally; Rembrandt experimented incessantly at these stages, in order to try out various pictorial effects. He used different kinds of paper; many proofs of state I are printed on thick vellum (Fig. 35b), which is very unabsorbent, so that the drypoint lines appear blurred, producing deep black passages in places. In addition, the plate was inked in varying degrees, or wiped with uneven pressure, so that, in one and the same proof, certain areas of the picture may emerge brighter or darker. Each proof is unique. In state III, signed and dated 1653, individual strokes are added to the groups of figures, especially on the left and in the foreground, and also in the areas of sky at the sides, which are now shown as heavier and darker. Only with this state were the proofs printed, without exception, on white paper with slight and even surface tone. The fact that this state is also signed shows that Rembrandt viewed state III as finished and intended it for sale.

The fourth state of The Three Crosses shows a thoroughly altered composition. Opinion has been divided as to whether Rembrandt reworked the plate in 1653, or shortly thereafter (that is to say, in direct connection with the third state), or did so only several years later, in about 1661. Important evidence in support of the second of these possibilities is to be found in the striking similarity of the newly introduced figures, above all that of the soldier right next to the cross, to the figures of Rembrandt's painting in Stockholm, The Conspiracy of Claudius Civilis, finished in 1661.[12] Acceptance of the later date has generally prevailed.[13] One can only speculate on the reasons for the alteration; the most obvious

explanation would be that the old plate, with its numerous drypoint passages, no longer allowed a satisfactory print to be made, and that Rembrandt took this opportunity to make a new scene.

The plate was substantially and smoothly polished and then reworked with drypoint and burin; in certain passages the lines from the first version are still clearly recognisable under the new strokes. Powerful hatching lines now steep the whole scene in a deep darkness. Only the Crosses with Christ and the thief on his right, and also one of the fleeing men in the foreground, are retained in their original form, though even here there is slight reworking. Even the group of mourners differs from that in the first version, for the characterful figure of John now stands out from those of the other young men, isolated through the beseeching gesture of his raised arms. The figure of the converted Centurion appears almost erased, and it is now superceded by that of a man on horseback. There are, nonetheless, some alterations in the treatment of the figure of the Centurion. Christ has been finely modelled: the facial features are more human, and more sorrowful; the eyes and the mouth are slightly open. It seems as if Rembrandt here shows us the dying Christ, rather than Christ who has just died as in the first version. This could also explain the suppression of the figure of the kneeling Centurion, who was converted to the message of the Gospels only in the very moment of Christ's death.

The role of the main figure on the left, derived from the equestrian figure of Gian Francesco Gonzaga on a medal by Pisanello (of about 1444), remains a mystery (Fig. 35d).[14] Possibly he is intended to be the personification of those in power, and thus a symbol of earthly injustice and unbelief; or he might be Longinus with his spear, or Pontius Pilate. The identification of this equestrian figure as Pontius Pilate is substantiated by iconographic tradition; for even in crucifixions of the fifteenth and sixteenth centuries the equestrian figure of Pilate is, on occasion, depicted in his capacity as a military commander. This is also suggested in the long stick carried by the figure on horseback here; this would seem to be the same stick as Rembrandt gave to the figure of Pilate in the Ecce Homo (Cat. 38), as a sign of his power as a judge.[15] The greater emphasis on the figure of the Apostle John in state IV in relation to the earlier version, also indicates that the figure on horseback is Pilate. John, in his Gospel, speaks throughout of the presence of the Roman Governor at Calvary; it was Pilate that had prevailed in his disputes with the Jews and, for this reason, had insisted that

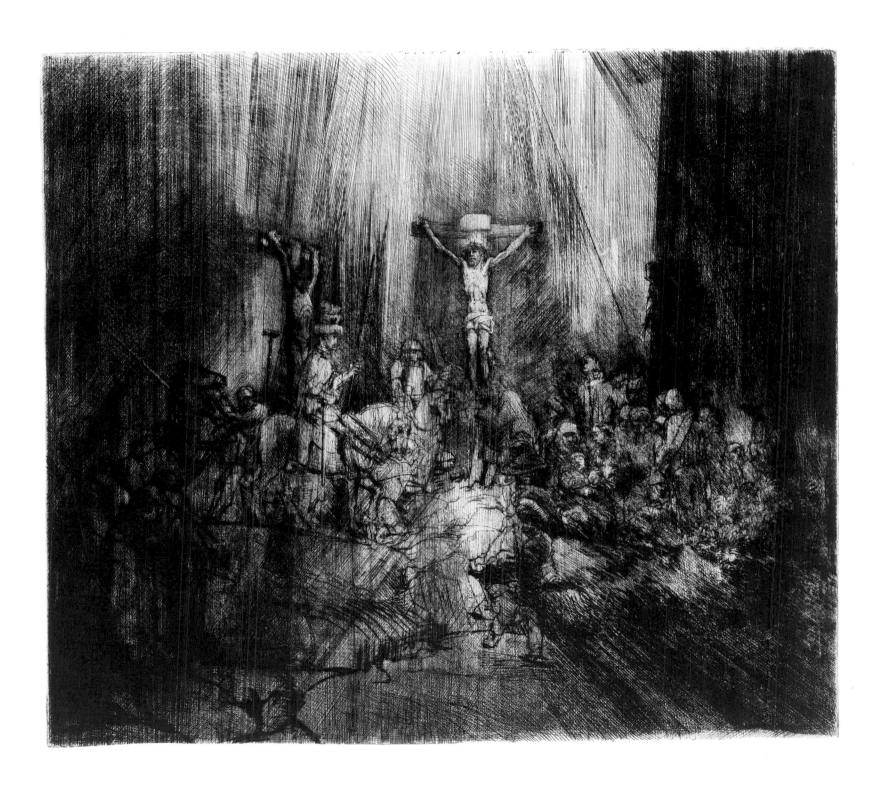

Jesus should be given the title 'King of the Jews' which was to appear on a plaque attached to the cross. It would seem that, in the later version of the *Three Crosses*, Rembrandt had wanted to show the crucifixion as a documented historical event, for John was an eye-witness to the Passion: 'And he that saw it bare record, and his record is true: and he knoweth that he saith true, that ye might believe.'[16]

Both versions of *The Three Crosses* are informed by one of the themes underlying Rembrandt's treatment of religious subjects: the tragic entanglement of sinful man in his own guilt. Rembrandt often characterised the sinner who had come to see the error of his ways—for example, the Prodigal Son—not as a damned being but as an individual fated to be sinful.[17] This explains his emphasis on the Roman Centurion in the early version of *The Three Crosses* and on the figure of Pontius Pilate in the later one. Both men were responsible for the death of Christ: the Centurion recognised his own guilt and repented, and the Governor, convinced of Christ's innocence, made himself guilty in a tragic manner, because he was too weak to resist the High Priest, who had demanded Christ's death. But even the sinner who fails to see the error of his ways merits understanding. It is perhaps for this reason that the unconverted thief on Christ's left in the first version appears in a bright light: he will eventually attain understanding and inspiration. The thief on Christ's right, meanwhile, is already converted, and is now repentant.

The proofs of state IV also vary considerably, depending on the burr remaining in the dry-point passages, the kind of paper used, and the manner of inking the plate. There are proofs with so much surface tone that the scene is almost entirely drowned in the blacks. Rembrandt made counterproofs (of which three survive) (Fig. 35e)—that is to say, images printed off freshly made proofs and so recording the composition unreversed as it appears on the plate. In addition there is a maculature, a second proof taken from the plate before re-inking, in which the individual parts of the composition are more clearly legible than in the proof itself. Both images allow one better to study the intended alterations to be made on the plate.

It seems that Rembrandt wanted to alter the scene once more, perhaps in order to achieve a yet more penetrating account of the Crucifixion, this turning point in world history. In the end he settled for the sombre picture of human catastrophe he had achieved in the two versions of *The Three Crosses*.
H.B .

1. Luke 23: 44–49.
2. As the thief on Christ's left is caught in the bright rays of light, he has usually been seen as the converted thief, even though, in iconographic tradition, he belongs on Christ's right. He does, however, hang painfully bent upon his cross, that is to say in a pose usually characterising the bad thief, who is seen to writhe in agonising death throes. It is also significant that his eyes are bound, suggesting that he refuses to recognise the truth. The body of the man crucified on the right of Christ does not hang in such a contorted fashion on his cross, and may thus be supposed to be in

35d: Antonio Pisano, called Pisanello, Medal of Gian Francesco Gonzaga.
Berlin, Staatliche Museen, Münzkabinett.

35e: Rembrandt, *The Three Crosses*. Counterproof.
Berlin, Kupferstichkabinett SMPK.

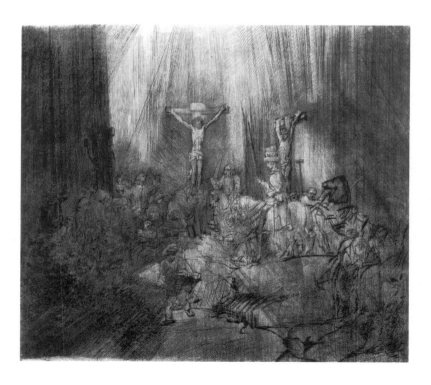

less agony; he must be the thief who believes in the innocence of Jesus. It would also be fair to assume that Rembrandt was familiar with iconographic tradition and that he was well aware that he was reversing the two sides. Wolfgang Stechow, proceeding from the conventional interpretation, suspected that Rembrandt had altered the plate in state IV, in order to make his own iconographic error less evident; but why then would he have fully altered the plate simply on this account?

3. Benesch 1000. Haverkamp-Begemann accepted the sheet in Weimar as a study for this group; Haverkamp-Begemann 1961, p. 86, on Benesch 1000. The sketch for a man leaning forwards in the Staatliche Graphische Sammlung in Munich has been connected with the figure of the Magdalen embracing the cross; Benesch 925; Wegner 1973, No. 1124.

4. B. 221–22; Washington 1990, p. 126, No. 25, p. 132, No. 27.

5. B. 76.

6. B. 50, 83, 86, 87.

7. B./Holl. 71.

8. B./Holl. 74.

9. B. 3. Less convincing is the comparison with a Calvary scene by J. B. Fontana (B. 14), which Rembrandt is said to have used as a source; Münz 1952, Vol. II, p. 104, No. 223.

10. B./Holl. 107.

11. It was known, among other examples. through an Italian engraving dated 1584; Münz 1952. Vol. I, Fig. 70, Vol. II, p. 104, No. 223.

12. See Stechow 1950, p. 254. On this matter, see also Paris 1986, p. 230, No. 115.

12. Bredius/Gerson 482; White 1969, p. 99.

13. It has, in any case, been overlooked that the signature and the date 1653 were not fully polished away and can still be clearly recognised under the new application of hatching. However, Rembrandt may not have regarded this as important.

14. This is the reverse of the medal for the Duke of Mantua, that must have been in Rembrandt's possession; see Münz 1952, Vol. I, Fig. 69; Vol. II, p. 104, No. 223.

15. B. 76.

16. John 19: 35.

17. Białostocki 1973.

36

The Virgin and Child with the Snake

Etching, 95 × 145 mm; 2 states
Signed and dated: *Rembrandt. f. 1654.*
B./Holl. 63; H. 275; White, pp. 80 ff.

Berlin: I (118–16)
Amsterdam: I (62:33)*
London: I (1910–2–12–380)

There are only a few print cycles in Rembrandt's œuvre. However, in 1954, he made two etched series of biblical scenes: a Passion (see Cat. No. 37), and a series of five or six sheets with scenes from the Childhood of Jesus.[1] There is only a loose connection between individual scenes within each of the series, and each print can stand as a work in its own right. The cycle with scenes from the Childhood of Jesus includes *The Virgin and Child with the Snake*.

The Virgin sits in a room, warmly cuddling the child. Joseph looks in from outside, with almost sad eyes. A cat is playing with the hem of the Virgin's dress. She places her foot on a snake: the motif, common in Catholic iconography indicates that she is to be seen as the new Eve, who will overcome original sin. The armchair and the curtain opening above it suggest a throne with a canopy, a traditional symbol of honour used to present the Mother of the Lord as the Queen of Heaven. The Virgin has not, however, taken her place in the armchair; instead she sits on the floor. Rembrandt is here adopting the motif of the *Madonna dell'umiltà* originating in Italian art of the fourteenth century, and in the North in the fifteenth century.[2] The Virgin confronts the viewer not in a distanced manner, in majesty, but as if humanised; and this impression is increased through the familiar, domestic surroundings—the fire in the hearth, the playful kitten and the open laundry basket. The holy scene takes place in a simple room. Joseph is excluded in that he stands outside; but he can take part in this moment indirectly, as Rembrandt shows him, looking in through the window. The visible traces of a reworking of the plate on the right at the chimney could indicate that Joseph was first placed here, inside the room.[3] The circular central pane of the leaded glass seems to form a halo around

the heads of the Virgin and child.

A comparably intimate atmosphere is to be found in Rembrandt's painting *The Holy Family* of 1646, in Kassel (Fig. 36a).[4]

As in fifteenth century Netherlandish painting, there is a deeper meaning hidden within Rembrandt's apparently secularised scene. The closed, doorless room, into which Joseph has no right to enter, points to Mary's virginity, just as the dividing window-pane is a symbol of her purity. It is not only the snake that alludes to original sin; the cat too must be intended as an embodiment of evil, and of Satan, who dwelt, according to popular superstition, in the chimney.[5] As early as 1641 Rembrandt had shown, in the etching *The Virgin on the clouds*, an explicitly Catholic motif: the worship of the Mother of God.[6] These works must have been intended principally for members of the Catholic merchant classes, who were also to be found in Protestant Holland.[7]

Iconographically and compositionally, the scene is based on models in earlier Netherlandish art. Various pictures of the Virgin from the circle of the Master of Flémalle, for example, show the Virgin and child in an interior, sitting on the floor in front of a bench near the hearth. The motif of the Virgin's halo represented symbolically by an everyday object is also derived from the Master of Flémalle.[8]

An engraving by Andrea Mantegna, meanwhile, provided a direct model for the Virgin and Child (Fig. 36b).[9] Rembrandt was especially interested in the motif of the tender, intimate embrace, and he adopted this almost literally. Mantegna shows the group slightly *di sotto in su*, like a stone sculpture in a niche; however, Rembrandt softened monumentality by placing it at eye level and rejecting the sharply folded and creased drapery in favour

of more supple cloth. The preoccupation with Mantegna is evident not only in the adoption of motifs and in the clear organisation of the picture planes, but also in the use of relatively restrained line and regular parallel hatching strokes.

In state I white spots are visible on the upper right edge; in state II these have been filled in with hatching. There is further reworking in the upper left corner.

H.B .

1. *The Passion*: B. 50, 83, 86, 87; *The Childhood of Jesus*: B. 47, 55, 60, 63, 64 and probably also B. 45, *The Adoration of the Shepherds*, although the sheet differs a little in size from the other scenes.
2. See Meiss 1936, pp. 434–64. Haverkamp-Begemann 1980, p. 168.
3. Filedt Kok 1972, p. 60.
4. Bredius/Gerson 572.
5. Slatkes 1973, pp. 257–58.
6. B. 61.
7. Tümpel 1977, pp. 29–30.
8. See, for example, the *Virgin at the hearth* in London, and the middle panel of the *Mérode Altar*; Panofsky 1953, Vol. I, pp. 163 ff., Vol. II, plates 90–91.
9. B. 8, Hind 1. Haverkamp-Begemann 1980, p. 168.

36a: Rembrandt, *The Holy Family with the curtain.* Kassel, Staatliche Kunstsammlungen, Gemäldegalerie Alte Meister.

36b: Andrea Mantegna, *The Virgin and Child.* Berlin, Kupferstichkabinett SMPK.

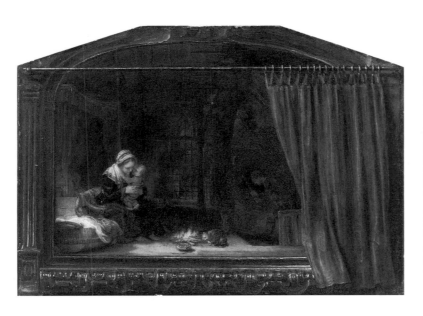

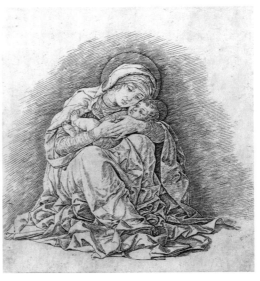

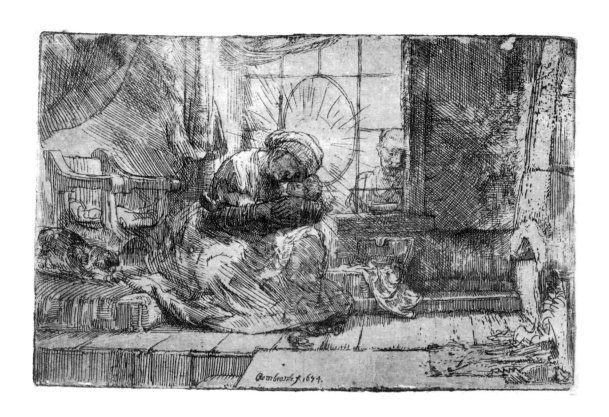

37

The Descent from the Cross by torchlight

Etching, worked over with drypoint, 210 × 161 mm; 1 state
Signed and dated: *Rembrandt.f.1654.*
B./Holl. 83; H. 280; White, p. 81

Berlin: (143–16)
Amsterdam: (O. B. 147)
London: (1973 U. 1084)*

In the early 1650s Rembrandt focused his attention on a subject that had concerned him throughout his career: the Life and Passion of Christ. In his capacity as a printmaker, he produced various biblical scenes that were probably intended as groups or cycles, even if the relationship of the sheets seems relatively loose and the series incomplete. Rembrandt's interest in the iconographic tradition in sixteenth-century printmaking of treating subjects in a series would have given a decisive impetus to his own cyclical arrangement of biblical material.[1]

As well as a small-scale series of scenes from the *Childhood of Jesus* of 1654 (see Cat. No. 36), Rembrandt produced a large-scale *Passion of Christ*.[2] *The Presentation in the Temple, The Descent from the Cross, The Entombment* (Fig. 37a) and *Christ at Emmaus* belong to this series.[3] The sheets are alike in size, technique and use of line; two of them are dated 1654, including *The Descent from the Cross*.[4] Characteristic of this group is the block-like construction of compositions dependent on strong horizontal and vertical lines.

The deposition takes place in darkness; a torch at the left is the only source of light. The dead body of Christ has just been taken down with the help of a large white cloth, and lies in the arms of a helper. Another helper, standing below the earthen bank, stretches out his arms, in order to take hold of the corpse. In the foreground, Joseph of Arimathea spreads a shroud out on the bier that is to serve as Christ's last resting place.

In the Gospels the event is only briefly described: a rich councillor, Joseph of Arimathea, asked Pilate for the dead body of Christ; he took it down from the cross, wrapped it in a cloth, and laid it in a rock tomb. From the Middle Ages the scene was

shown with increasingly more attendants, above all Mary and a group of mourners. The group around Mary, in particular, often took on an important place in the depiction; in Rembrandt's etching, however, this group is pressed into the background and can hardly be detected in the darkness.

Rembrandt's scene differs decisively from iconographic tradition in another way: the cross is not at the centre of the scene, but is visible only as a fragment at the left edge. The group of helpers around the cross with the body of Christ is isolated by the horizontal line of the earthen bank and the vertical lines of both the cross on the left and the building in the right background, and thus constitutes an independent subject within the scene as a whole. The bright lighting of the group also adds to this effect. One almost has the impression that the figures are carrying out their tasks in the narrow space of a reliquary, and this prompts a contemplative viewing of the scene.

Another skilfully devised motif, on the other hand, takes up the whole of the foreground: the preparation for the Entombment. Here we see the bier with the shroud laid across it; it is as brightly lit as the cloth and the body of Christ being taken down from the cross, and in terms of the composition it constitutes a clear parallel to the corpse. Rembrandt does not show the moment at which Christ is wrapped in the cloth, but rather the individual phases of action that lead up to this moment. The gestures of the friends seem to be made in calm understanding: while one helper, notable for the heavy load he bears, supports the body in his arms—for the remaining nail has yet to be removed from Christ's foot—another companion already stretches out his hands in order to take the body, and Joseph of Arimathea, meanwhile, is seen spreading out the shroud. The composition culminates in the motif of the hand, picked out by the light from the torch and so set off against the darkness, towards which Christ's head sinks.

In combining the Deposition with the preparation for the Entombment, Rembrandt's etching constitutes an iconographic exception. Rembrandt had often treated the subject of the Deposition.[5] The painting of 1633 from the Passion cycle for Frederik Hendrik emerged from a close concern with Rubens's Antwerp *Deposition*.[6] The 1633 etching closely follows the pictorial arrangement of the painted version albeit in reverse, (see Introduction, Fig. 6) but it adds the motif of the shroud that was to retain its central place and importance in the later, 1654, version.[7]

Like the other three sheets of the Passion,

the *Deposition* is almost entirely etched; additions with drypoint are only to be found in isolated places. The application of line with long, diagonally drawn parallel hatching strokes was a result of Rembrandt's interest in the copper engravings of Andrea Mantegna (see Cat. 36).

H.B.

1. Tümpel 1977, p. 103.
2. The following belong to the first series: B. 45, 47, 55, 60, 63 and 64.
3. B. 50, 83, 86, 87.
4. The view that the four sheets were intended as a cycle is not undisputed; Münz Vol. II, p. 110, Nos. 240–241 denies the connection between them and give the two undated sheets B. 50 and B. 86 as later, to the late fifties.
5. On this, see Stechow 1929.
6. *Corpus* A65.
7. B. 81. The *Deposition* in Leningrad, dated 1634 and signed by Rembrandt, where the motif of the shroud in the foreground is even more strongly stressed, is no longer accepted by the Rembrandt Research Project as authentic; *Corpus* C49.

37a: Rembrandt, *The Entombment*. Amsterdam, Rijksprentenkabinet.

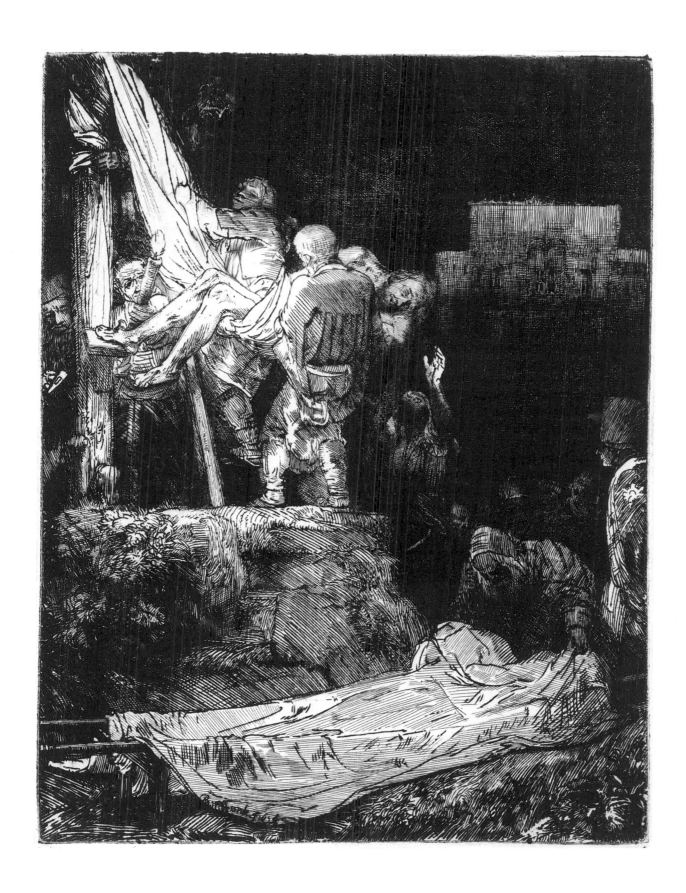

38

Ecce Homo

Drypoint, 383 × 455 mm;
from IV 358 × 455 mm; 8 states
Signed and dated: (from VII) *Rembrandt f. 1655*
B./Holl. 76; H. 271; White pp. 87–92

First version (I–V)
Berlin: I on Japanese paper (93–1892)*
Amsterdam: III on Japanese paper (75:1; cited
in Holl. as English private collection)
London: IV (1868-8-22-665)

Second version (VI–VIII)
Berlin: VIII (635:16; with later additions at the
upper edge)
Amsterdam: VIII (62:121)
London: VIII on Japanese paper (1973 U. 931)*

38
State I
State VIII

38a: Lucas van Leyden, *Ecce Homo.*
Berlin, Kupferstichkabinett SMPK.

It was not only in the seventeenth century that competition with the inventions of masters of previous generations was a part of artistic practice. Theorists celebrated competition between artists, and art collectors valued this programmatic demonstration of virtuosity. The work of Lucas van Leyden, above all his engravings, constituted a special model for emulation in seventeenth-century Holland. In 1614 the Humanist Scriverius (Fig. 22d) said of Rembrandt's home town, Leiden: 'This city has been praised as much through Lucas's fame / As for the wools and linens that also bear its name'.[1] The deceased Leiden artist Willem van Swanenburg, the brother of Rembrandt's teacher Jacob Isaacsz. van Swanenburg, was praised by Scriverius as a 'new Lucas van Leyden'.[2] The appreciation for Lucas van Leyden as a virtually unsurpassable engraver was a provocation to artists to enter into competition with him. Thus Goltzius engraved a Passion series in the manner of Lucas van Leyden, yet with his own distinct style in the movement of figures and other aspects of the work, which should not be underrated.[3] Thus for seventeenth-century connoisseurs it was obvious that Rembrandt's late *Ecce Homo* was based on a critical examination of Lucas van Leyden's version of the scene (Fig. 38a). Rembrandt had acquired works by this predecessor for a vast sum, as early as 1637, among them the *Ecce Homo*.[4] It was only in the period around 1655, however, that Rembrandt made his own *Ecce Homo*, to compete with Lucas van Leyden. Possibly conceived as a pendant to the *Three Crosses* (Cat. No. 35), the *Ecce Homo* is similarly executed throughout in drypoint, and it marks a further highpoint in Rembrandt's late work as an etcher. As in the *Three Crosses*, Rembrandt embarked on a full re-working of the plate after the first version had gone through several states.

Rembrandt had turned to the subject of the *Ecce Homo* as early as the 1630s. A grisaille sketch[5] was made in preparation for the earlier etching, which was then largely executed by Van Vliet (Fig. 38b).[6] In this work from Rembrandt's first Amsterdam period, the dialogue between Pilate and the High Priest, who have taken upon themselves the power of judgment, is recorded with theatrical gestures.[7] The thrusting mob must be appeased. The confusion of figures and contrary movements in the narrow space establish a mood of dramatic disturbance. Christ is removed from this aggressive bustle, through the patience conveyed in the expressive power of both his pose and his face.

Our etching, on the other hand, clearly shows the altered narrative style of Rembrandt's work of the 1650s. A strongly centred figural narrative has taken the place of the earlier lively, diagonally arranged composition. We are presented with figures who act with rather restrained gestures, placed as if in a relief, in front of the architectural façade. The spacious setting evoked on the sheet is taken up with imposing buildings. Stone figures of Justice and Fortitude identify this as the place of judgment and constitute a frame for the main scene. The principal figures rise up in front of the black hollows of the entrance to the palace. Christ, with his hands bound and his head bare, is shown to the people. Pilate, wearing a turban and carrying the justicial rod, points to him. Behind them stands Barabbas, the real criminal. It is unusual for Barabbas to be included in scenes of the *Ecce Homo*; and only a few examples are to be found in iconographic tradition.[8]

Rembrandt here defines his own pictorial narrative through deliberate reference to the biblical text. The variety of his motifs accurately reflects the complexity of the biblical account.[9] Thus he illustrates the full breadth of the narrative. For example, a figure standing next to the left stone pedestal, already holds a water jug and a bowl, in which Pilate will innocently wash his hands. The Governor's wife leans at a window on the left; and, in the shadowy interior of the palace, only detectable as a silhouette, is the messenger who has just taken his leave of her in order to report her warning dream to her husband.

In the *Ecce Homo* etching Rembrandt does not use a uniform scale for his figures. With a form of hierarchical perspective, the figures on the platform are shown larger than those among the crowd in the foreground, thus negating their greater distance from the viewer. Particularly striking is the figure seated by the left parapet who seems to be recording the

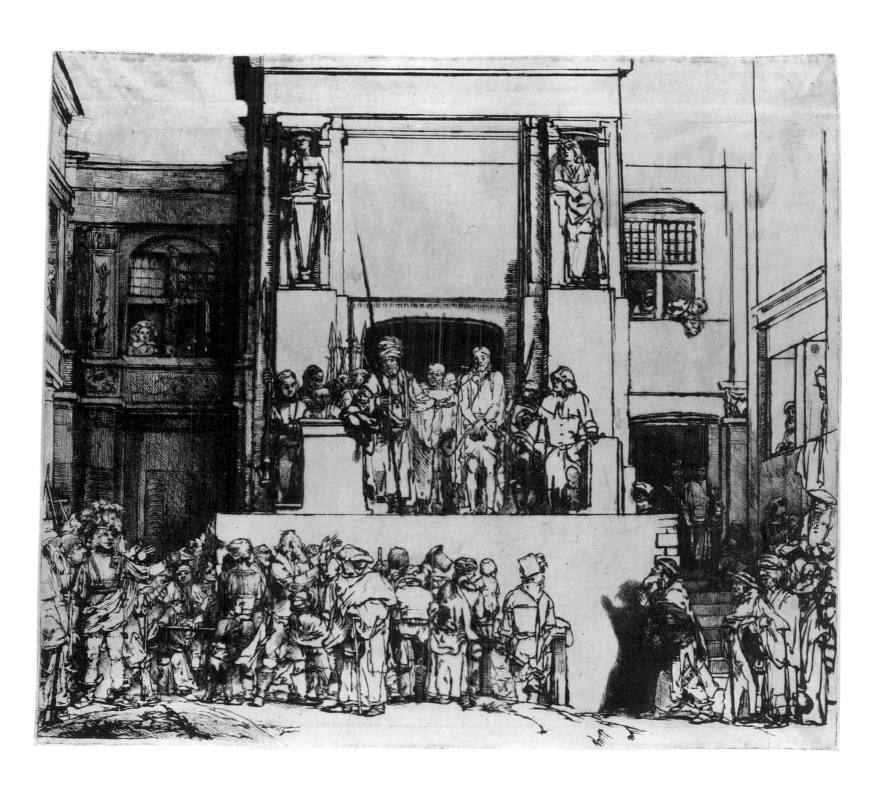

event in writing or, more probably, in a drawing. Rembrandt integrates an 'artist-chronicler' of this sort into other scenes, for example the oil sketch for *John the Baptist preaching*,[10] and some of the landscape etchings.[11] However, it remains uncertain whether Rembrandt intended this figure as a commentary on the role of the artist.

Rembrandt obviously selected the Renaissance model (Fig. 38a) as the starting point for the composition of his own *Ecce Homo* etching.[12] The marked spaciousness of Lucas van Leyden's print, where the view is drawn to the far distance in an almost calculated manner, is replaced in Rembrandt's scene with an imposing building that runs across the whole picture plane with hardly any recession in depth. One has the impression, nonetheless, that Rembrandt had been looking at Lucas van Leyden's engraving while he was at work on the first version of his own drypoint etching. If one considers the way an etched image comes about, with the drawing as marked on the plate reversed in the printed form of the image, a large number of borrowed motifs are apparent. Thus, for example, the architectural façade on the left, with figures leaning out of the windows, and the staircase placed nearby, are conceived in analogy with Lucas van Leyden's sheet. The group of figures in the earlier work standing in front of this staircase, and so linking the figures at the side with the main event, has been concentrated, in Rembrandt's scene, into a single male figure, dramatised both through its pose and through the lighting which repeats its gesture in the form of a sharp cast shadow. The figure with a stick and a purse standing out from the crowd in the foreground is also derived from a model in the earlier work, although without in the least being a copy. While the bare-headed man between Christ and Pilate is only one of Pilate's henchmen in the Lucas van Leyden scene, Rembrandt makes him Barabbas.

Around 1600, appreciation for Lucas van Leyden had focused, above all, on his engraving manner. Thus, Karel van Mander writes of Goltzius: 'In as far as he could realise that which constituted the particular character of the style of any master whose works he had previously come to know, he could, with his own hand alone, bring to expression the peculiarities of several hands in compositions that were of his own invention.'[13] It was above all in the imitation of earlier manners of engraving that Goltzius and other artists of his generation saw a challenge.

Competition with Lucas van Leyden's manner did not correspond to Rembrandt's artistic ideal. The *Ecce Homo* etching is, indeed, executed in Rembrandt's own, unmistakeable 'handwriting'. The figures are established with a few, broken lines. Continuous contours are avoided. This use of line clearly stems from his experience as a draughtsman. In contrast to this, the shaded regions are darkened through the use of concentrated hatching. By these means, Rembrandt clearly establishes a different form of competition with his source than that undertaken by artists of the previous generation.

It is striking that in the *Ecce Homo* and *The Three Crosses*, possibly conceived as pendants and with linked subjects and a similar size, the difference of narrative style is crucial: in *The Three Crosses* the powerful drama of the event dominates the composition. One could ask, however, if in these two etchings Rembrandt has substituted variations of narrative style for the variations in engraving style so praised by Karel van Mander in the work of Goltzius.

The first version (states I to V) of the *Ecce Homo* is not signed. However, a large number of impressions have survived; some of them—for example, the sheet in London—on Japanese paper. For this reason, one is tempted to describe this as a final composition intended for sale and not as a rejected working stage.

For the fourth state of the etching, Rembrandt reduced the size of the plate, presumably to make it compatible with standard paper sizes. The impressions of the earlier states are printed on paper with a narrow strip attached to the upper edge. After five states the artist introduced a fundamental change into the composition, comparable to the full re-working of *The Three Crosses*. After making the trial proof state VI, Rembrandt signed and dated (1655) this second variant of the *Ecce Homo* in state VII, thus acknowledging it as finished. The eighth and last state simply corrects a few shadings. Rembrandt had re-polished the plate in the foreground and removed the crowd grouped below the tribune. The most striking of a large number of changes is the introduction of the two dark cellar arches and, between them, the sculpted, half-length figure of a bearded old man, who supports his head with his right hand. Through an emphatic distribution of light and shade, the figure of Fortitude acquires a greater liveliness and, above all, a fierce facial expression. Lastly, Rembrandt re-works the physiognomies of the main group.

Lucas van Leyden's exemplary status plays no part in Rembrandt's second version of the *Ecce Homo*, as is immediately apparent. Rembrandt now finds his starting point exclusively in his own composition. There has been much controversy over Rembrandt's motivation in subjecting the already finished plate to this fundamental re-working. Was it principally aesthetic considerations that caused dissatisfaction with the first version? Or was Rembrandt striving to articulate distinct aspects of content? Probably, it would not be constructive to pursue these possibilities in strict opposition to each other. The meaning of the second version must, in any case, count as yet unexplained in many respects. Above all, the stone figure remains a mystery. It has been identified as Neptune,[14] but also as Adam. The Father of Mankind had committed the original sin, but he is redeemed by Christ in his role as the 'new Adam'.[15] It is, however, to be observed that Rembrandt challenges the viewer to a new form of dialogue with the event. The removal of the foreground arena with the gesticulating crowd reduces the sense of depth. By means of this device, the side figures draw closer towards the main group, while still retaining their framing role. The imposing block of the tribune is strongly balanced through axial symmetry, and this increases the impression of restrained action. The scene is concentrated on the two protagonists. The pictorial narrative reaches its climax in Pilate's decision of conscience, a decision in which the viewer participates.

The *Ecce Homo*, with its elaborate process of development and radical alteration into a second independent version, is yet another witness to Rembrandt's constant concern with his own narrative style.

B.W.

1. English translation cited from English edition of Schwartz (1985), p. 24.
2. See Schwartz (1985), p. 24.
3. Karel van Mander (1906), p. 247.
4. B. 71; *Urkunden* 51.
5. National Gallery, London; Paintings Cat. No. 15.
6. B. 77; Royalton-Kisch 1984.
7. Berlin 1970, No. 96.
8. See Winternitz 1969.
9. Matthew 27: 15–26.
10. Gemäldegalerie, Berlin; Paintings Cat. No. 20.
11. See *The Three Trees*, Cat. No. 19.
12. Münz 235 has referred to further possible sources of inspiration for individual elements of the composition.
13. 'Want bedenckende wat hij [Goltzius] over al voor handelinghen hadde ghesien, heeft hy met een eenighe hant verscheyden handelinghen van zijn inventie getoondt'. Karel van Mander 1906, p. 243.
14. White 1969, p. 90.
15. Winternitz 1969.

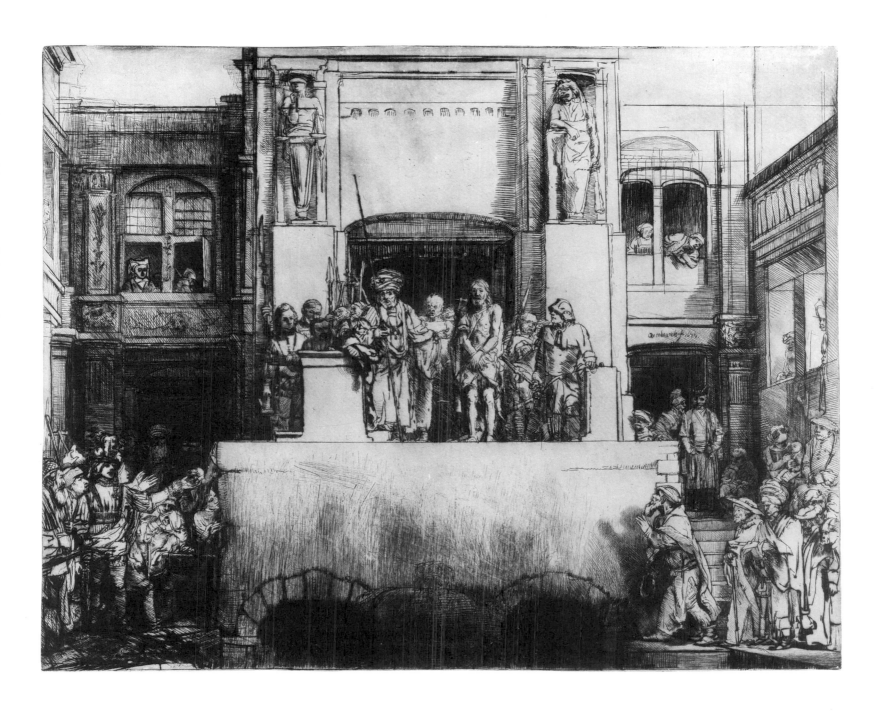

39
Abraham's Sacrifice

Etching and drypoint, 156 × 131 mm; 1 state
Signed and dated: *Rembrandt f 1655* ('d' and '6'
reversed)
B./Holl. 35; H. 283; White pp. 92–93

Berlin: I on Japanese paper (53–16);
I (54–16)
Amsterdam: I (62–14)*
London: I on Japanese paper (1973 U. 1091)

39a: Rembrandt, *Abraham and Isaac*.
Leningrad, Hermitage.

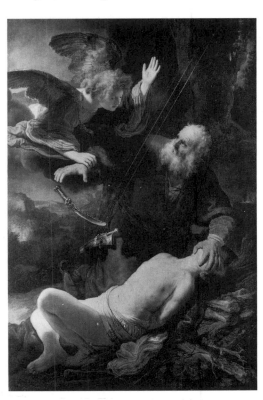

In 1655, the year of the dated state of the *Ecce Homo* (Cat. No. 38), Rembrandt etched *Abraham and Isaac*. Abraham is about to sacrifice Isaac at God's bidding. At the last moment, however, he is restrained by an angel. Rembrandt had already treated this subject in 1635, at the high-point his first Amsterdam period. The large-scale painting (Fig. 39a) depicts the event in terms of powerful physical action.[1] Abraham roughly pushes down the head of the bound Isaac while the angel suddenly grasps Abraham's arm, so that the knife falls from his hand. In 1645 Rembrandt etched another scene from this biblical story— the dialogue between Abraham and Isaac before the sacrifice.[2] In 1655 Rembrandt turned once again to the sacrifice itself. Here the mood of the event is thoroughly altered. Rembrandt 'interprets the Biblical text with greater independence of descriptive details and with deeper human insight. Isaac is no longer stretched out like any sacrificial victim. He kneels with an innocent submissiveness beside his father, who presses the son's head to his own body. It is a gesture infinitely more human than the one in the earlier version. The angel appears from behind Abraham, grasping both his arms with an embrace that is powerful and highly symbolic.'[3] Rembrandt has succeeded in making abundantly clear both Abraham's obedience and his inner torment.

The change of narrative style, in which dramatic, theatrical action and exaggerated gesture give way to an increasingly psychological record of the event, is a typical measure of Rembrandt's artistic development. The change in approach to this subject may also have been prompted by the treatment of the event in the *Antiquitates Judaicae* of Flavius Josephus. Occasionally, Rembrandt drew on this work, treating it as a supplement to iconographic tradition and the biblical text.[4] After describing the walk to the place of sacrifice, the dialogue between father and son, and Abraham's declaration of his intention to sacrifice Isaac, Josephus goes on: 'Isaac, however, noble-minded as the son of such a father, responded obediently to what had been said and, in turn, declared that it would not have been worth his being born if he did not obey what God and his father had decided for him, as it would be wrong enough to be disobedient even if it had been his father alone who had issued the order. And thereupon he approached the altar in order to be slaughtered. And certainly he would have been, had God had not prevented it. For he called Abraham by his name and told him to refrain from the killing of his son. He, the Lord, was not thirsty for human blood, nor had he demanded the

Child Care
& Development

5th Edition

Pamela Minett

HODDER
EDUCATION
PART OF HACHETTE LIVRE UK

Orders: please contact Bookpoint Ltd, 130 Milton Park. Abingdon, Oxon OX14 4SB. Telephone: +44 (0)1235 827720. Fax: +44 (0)1235 400454. Lines are open from 9.00–5.00, Monday to Saturday, with a 24-hour message-answering service. You can also order through our website www.hoddereducation.co.uk.

British Library Cataloguing in Publication Data
A catalogue record for this title is available from the British Library

ISBN 978 0 340 88915 2

First published 1985 by John Murray (Publishers) Ltd
Fifth edition 2005
Impression number 10 9 8 7 6 5 4
Year 2008

Typeset by Fakenham Photosetting Limited, Norfolk.
Printed in Italy for Hodder Education, part of Hachette Livre UK, 338 Euston Road, London NW1 3BH.

PREFACE TO THE FIFTH EDITION

The four previous editions of **Child Care & Development** have been gratifyingly well received and have proved very popular in schools and colleges, and also with private students. Since the publication of previous editions there has been a considerable number of changes in the child-care field. These have taken place in legislation, medicine and approaches to the subject, and subsequently to the syllabuses. Producing a new edition has provided the opportunity to carry out a thorough review of the text and illustrations, and to update the book to reflect changing conditions and terminology. Publication is in full colour, enhancing student appeal. This textbook is now accompanied by *Child Care & Development: Revision Exercises,* which covers the core material of the subject.

Each of the 76 topics ends with a bank of questions to reinforce knowledge, and further activities to broaden the subject. These include guidelines for Child Study (an important element in almost any course of child care and development), investigations and discussions. A logo identifies those activities relating to the Key Skills of Communication, Application of Number and Information Technology at Level 2.

The book continues to be intended primarily as a textbook for students of subjects involving child care and development. In particular, it covers syllabus requirements of the GCSE Examining Groups and the 'knowledge and understanding' required for courses leading to National Vocational Qualifications (NVQs). It will also be useful for lower level Council for Awards in Children's Care and Education (CACHE) courses as well as those parts of Social Studies and Community Studies which are concerned with children and with aspects of Health and Social Care GNVQ.

Courses in child care and development are not always followed by an examination. The subject covers an area of study which has a strong appeal to many young people and can, therefore, provide an excellent vehicle for the encouragement of a wide range of related educational activities. In addition, it provides useful guidelines for the parents of the future, helping young people to understand what is involved in bringing up children. Awareness of the effects of the care of children on their development can lead to a greater understanding of a person's own behaviour – and, it is hoped, to a greater tolerance of the behaviour of others.

Students of this subject in schools and colleges are mainly young people who are not yet parents, nor even contemplating parenthood. The book has therefore been written at this level and with this approach. A broad outline of the subject has been presented in a simple, straightforward manner. Technical terms have been explained or an everyday alternative given. Where controversy exists, I have attempted to give a balanced view. Although written primarily for students, it is hoped that the book will be of interest to the many parents and others who are concerned with the care of children.

ACKNOWLEDGEMENTS

I have received much help and advice in preparing the fifth edition and would like to thank all those who have contributed in any way, not least those teachers who have taken the trouble to write to me or discuss various aspects of the book. Help from those who have experience of using the book in the classroom has been invaluable.

I particularly wish to acknowledge the contributions made to this edition by Dr. Rosalyn Proops (Consultant Community Physician, Norfolk), Elizabeth Ramsden (Senior Sister, Guy's Hospital), Jill Purkis (Practice Nurse, Lewisham), Anna Shorto (Legal consultant), Madelaine Borg (Manager of Medical Illustration, James Paget Hospital, Great Yarmouth) and Tam Fry (Child Growth Foundation).

I continue to be indebted to all who helped me in any way with previous editions. I remain particularly grateful to the late Professor Robert Illingworth, an internationally recognised authority in paediatrics, for his considerable guidance during the preparation of the first edition.

P.M.

Examination questions have been reproduced in the *Exercises* section by permission of the following examination boards:

NICCEA	Northern Ireland Council for the Curriculum, Examinations and Assessment
AQA	Assessment and Qualifications Alliance
WJEC	Welsh Joint Education Committee

Illustrations are by Kathy Baxendale, Dawn Brend, Chris Forsey, Jenny Mumford, Pat Tourret and Philip Wilson.

PHOTO CREDITS

■ **SECTION 1**

p.1 James Davis Worldwide; **p.3 and p.4** Anthea Sieveking/Collections; **p.8** Mary Evans Picture Library; **p.9** Sally & Richard Greenhill; **p.12** Pamela Minett; **p.13** *top* David Cumming/Eye Ubiquitous, *middle* Geoff Howard/Collections, *bottom* Lesley Howling/Collections; **p.14** Anthea Sieveking; **p.17** BDI Images.

■ **SECTION 2**

p.27 and p.37 James Paget NHS Trust, Great Yarmouth; **p.38** Petit Format/Nestle/Science Photo Library; **p.49, p.50, p.51, p.59, p.60 and p.63** James Paget NHS Trust, Great Yarmouth.

■ **SECTION 3**

p.67 Pamela Minett; **p.68** James Paget NHS Trust, Great Yarmouth; **p.70** Pamela Minett; **p.74** BDI Images; **p.76** *top* BDI Images, *bottom* Angela Hampton/Bubbles; **p.77** BDI Images; **p.80** *top* Anthea Sieveking/Collections, *bottom* Mothercare; **p.81** Damien Lovegrove/Science Photo Library; **p.85 and p.89** James Paget NHS Trust, Great Yarmouth; **p.91** Mothercare; **p.96** Wellcome Trust Photo Library; **p.98 and p.99** BDI Images; **p.100** James Paget NHS Trust, Great Yarmouth; **p.101** BDI Images; **p.104** Mothercare; **p.105** BDI Images; **p.108, p.111 and p.112** Mothercare.

■ **SECTION 4**

p.115 Paul Seheult/Eye Ubiquitous; **p.116** Sally & Richard Greenhill; **p.122** Anthea Sieveking/ Collections; **p.123** Camera Press London; **p.125** Tony Langham; **p.126** Child Growth Foundation; **p.132** James Paget NHS Trust, Great Yarmouth; **p.135** Sally & Richard Greenhill; **p.136** Anthea Sieveking/Collections; **p.137** James Paget NHS Trust, Great Yarmouth; **p.138** Jennie Woodcock/Bubbles; **p.140 and p.143** James Paget NHS Trust, Great Yarmouth; **p.145** Ian West/Bubbles; **p.148 and p.150** Anthea Sieveking/Collections; **p.158** Sally & Richard Greenhill; **p.160 and p.174** Anthea Sieveking/Collections; **p.175** Dr Jeremy Burgess/Science Photo Library.

■ **SECTION 5**

p.181 Anthea Sieveking/Collections; **p.186** Mothercare; **p.187** Pamela Minett; **p.188** Mothercare; **p.192** Anthea Sieveking/Collections; **p.195** *top* Anthea Sieveking/Collections, *bottom* BDI Images; **p.197** Sally & Richard Greenhill; **p.202** Anthea Sieveking/Collections; **p.203** Sally & Richard Greenhill; **p.215** Loisjoy Thurston/Bubbles; **p.217** Anthea Sieveking/Collections; **p.218 and p.221** Sally & Richard Greenhill; **p.225** Pamela Minett; **p.227** Startrite.

■ SECTION 6

p.231 James Davis Worldwide; **p.241, p.244 and p.245** BDI Images; **p.248** Loisjoy Thurston/Bubbles; **p.249** BDI Images; **p.251** Anthea Sieveking/Collections; **p.254** Ian West/Bubbles; **p.261** Steve Shott/Mother & Baby Picture Library; **p.263** Sally & Richard Greenhill; **p.264** James Paget NHS Trust, Great Yarmouth.

■ SECTION 7

p.265 Sally & Richard Greenhill; **p.273** National Medical Slide Bank/Wellcome Trust Photo Library; **p.277** James Paget NHS Trust, Great Yarmouth; **p.278** Dr P Marazzi/Science Photo Library; **p.279** BDI Images; **p.281 and p.293** James Paget NHS Trust, Great Yarmouth; **p.294** *top* Mark Clarke/Science Photo Library, *bottom* Jacqui Farrow/Bubbles; **p.301** Mothercare; **p.304** Dave Fobister/Eye Ubiquitous; **p.305** Sally & Richard Greenhill; **p.309** BDI Images.

■ SECTION 8

p.313 James Paget NHS Trust, Great Yarmouth; **p.315** Sally & Richard Greenhill; **p.320** BDI Images; **p.324** Gary Parker/Science Photo Library; **p.325** *top* Alexander Isiaras, *middle* Pete Jones/Courtesy of Muscular Dystrophy Campaign, *bottom* Karen Robinson/Format; **p.326** Hattie Young/Science Photo Library; **p.336** Andrew Lambert; **p.337** *top* David Cumming/Eye Ubiquitous, *bottom* Maggie Murray/Format.

CONTENTS

CONTENTS

CONTENTS

The book deals with different aspects of child care and development in self-contained topics. This allows for flexibility both in the selection of topics to be included in a particular course, and in their order of study.

■ Arrangements of topics

The 76 topics have been grouped into eight sections as shown in the contents list, pp. ix–xi. The first two sections of the book deal with the family, the home and parenthood. These are followed by sections on the care of young babies, their development, and early childhood.
The later sections deal with food, health and safety, and the relationship between the family and the community.

■ Within each topic

Information – with clear headings and presented in a succinct manner to emphasise the important aspects of the topic.
Questions – which can be used to check knowledge and understanding of the topic and as a basis for notes.
Activities – which include suggestions for:

- **Extension** – containing suggestions to extend the subject for the more interested or advanced students.
- **Discussion** – subjects for group or class discussions are suggested.
- **Investigation** – suggestions for carrying out various types of investigation are given on pp. 355–358.
- **Design** – guidelines for design are to be found on p. 358.
- **Child study** – discussed in detail on p. 354.

This logo appears next to activities relating to the **Key Skills** of:

- **Communication** (C2.1a–b, C2.2, C2.3)
- **Application of Number** (N2.1, N2.2a–d, N2.3)
- **Information Technology** (IT2.1, IT2.2, IT2.3).

■ Exercises

Pages 344–352 contain a selection of questions, many from examination papers, which relate to each of the eight sections.

■ Child Care & Development: Revision Exercises

Revision Exercise 27

The 76 exercises in the *Revision Exercises* book (ISBN 0 340 88916 0) cover the core material of the subject and form a revision course. Each exercise consists of a page of questions and a page of answers, with explanations where appropriate. This enables students to mark their own work, identify areas of weakness, revise and re-test themselves. The number in the logo at the end of each topic refers to the relevant exercise for that topic.

SECTION 1

FAMILY AND HOME

THE FAMILY

The family is the basic unit of society. It is a group of people of various ages who are usually related by birth, marriage or adoption.

FUNCTIONS OF THE FAMILY

One of the most important functions of a family is to provide for a child's needs, because children are unable to care for themselves. These needs include:

- food and drink
- shelter
- warmth and clothing
- love and companionship
- protection and support
- care and training
- a secure environment in which they can develop into young adults
- boundaries for behaviour
- encouragement with their education.

Family ties

The members of a family usually feel that they have a special relationship with each other based on some or all of the following:

- blood – knowing that they have the same ancestors
- affection
- duty – due to a traditional sense of obligation
- shared experiences
- common interests.

VARIETY OF FAMILY STRUCTURE

There are different types of family.

Extended family

The extended family is a large family group which includes grandparents, parents, brothers, sisters, aunts, uncles and cousins.

Such a family is the basis for the traditional pattern of family life in many countries. When the members of an extended family are closely connected by affection, duty, common interest, or daily acquaintance, they may help and support each other in a number of ways such as:

- providing comfort at times of distress
- helping the parents to bring up their children
- looking after the children in an emergency or when the parents are working
- giving advice on problems
- helping financially.

In recent years, changes to the traditional pattern of family life have been taking place in some countries, particularly the countries of western Europe and the USA:

- Effective methods of contraception have led to families with fewer children.

An extended family at home

- Moving away from the family base is common in a changing industrial and technological society.
- Many grandparents are living longer and are more independent.
- Many mothers go out to work.
- Parents may choose not to marry.

These changes have led to weakening of links between members of the extended family, and to the **nuclear family** becoming the most common family unit.

Nuclear family

A nuclear family consists of parents and their children. They form a self-contained family unit living in a separate household. Life in a nuclear family differs from that in an extended family:

- Nuclear families can be separated by long distances from other members of the extended family.
- Parents may bring up their children with little or no help and support from grandparents and other relations.
- Grandparents and grandchildren may be deprived of each other's company.
- Contact with other relatives is a matter of choice.
- Often, both parents have jobs and the children may be cared for by adults who are not part of the family.

A nuclear family becomes an **extended family** when, for example:

- grandparents come to live with the family
- a teenager in the family becomes pregnant and both the new parent(s) and baby continue to live in the family home.

A nuclear family at home

One parent families (lone parent families; single parent families)
In this type of family the children are brought up by only one parent. Usually the parent is the mother, but sometimes it is the father.

The one parent has to do everything that is usually shared by two parents – provide food, shelter, clothes, a sense of security, daily care and training. This is very hard work for one parent and, as in any other family, this work continues for many years until the children have grown up.

One parent families can vary as widely as two parent families in terms of health, wealth, happiness and security. The family situation can also change, with a one parent family becoming a two parent family or the other way round.

Reasons for families being 'one parent' include:

- divorce or separation of the parents
- death of one parent
- births to single women
- one of the parents being away from home for a long time through work, illness or imprisonment.

Step-families
A step-family is one in which there is a child (or children) who is the natural child of one partner in a marriage (or partnership) but not both.

Such a family is usually the result of divorce, or the death of a parent, followed by re-marriage. Since the step-child will not have grown up with the step-parent from birth, it may often (but not always) take some time for them to adjust to living together, and resentments can arise. This may be further complicated when there are other children from the step-parent's previous marriage to get used to.

One parent families

Example of a step-family

Shared-care families
These are families where the parents live in separate homes and the children spend part of the week living with one parent and the rest of the week with the other. Both parents are equally responsible for looking after their children's needs. The main reasons for shared arrangements are either divorce or separation of the parents.

Foster families
These are families who care for children who are not related to them. Sometimes there are a number of children from different families living in the same foster home.

Residential children's home

Children without families, or whose families are unable or unwilling to look after them may live (reside) in a residential home. Usually, the adults who care for the children try to make life in the home as much like normal family life as possible.

QUESTIONS

1 a What is a family?
 b List nine needs of a child which are provided for by the family.
 c The members of a family usually feel that they have a special relationship.
 Give reasons for this.

2 a Describe briefly the difference between an extended family and a nuclear family.
 b Give five ways in which members of an extended family can help and support each other.
 c Give five changes to the traditional pattern of family life which have taken place in some countries.
 d List five differences between life in extended families and nuclear families.

3 a (i) What is a one parent family?
 (ii) Name some of the tasks that the one parent has to do which are normally shared by two parents.
 b Give four reasons for one parent families.

4 a What is a step-family?
 b What problems may possibly occur when a step-family is formed?

5 Describe **(i)** a shared-care family, **(ii)** a foster family.

Revision Exercise 1

FURTHER ACTIVITIES

DISCUSSION

C2.1a Discuss possible factors which may complicate life in a step-family, and the ways in which such situations might be eased.

CHILD STUDY

(See p. 354 for general instructions for carrying out this study.)

Begin a long-term study of one child, or a group of children, or of a particular aspect of development by:

- obtaining the parents' permission
- recording general information
 — first name (if the study is to be confidential, the name should be fictitious)
 — age
- describing physical appearance
 — height (in cm)
 — weight (in kg)
 — colouring
 — special features, e.g. glasses
- describing personality, e.g. lively, shy with strangers

Use a word processor to present your work.

Suggestions for Child Study activities are given at the end of many of the topics throughout this book.

2 FAMILY LIFESTYLES

FACTORS WHICH HAVE BROUGHT CHANGES TO FAMILY LIFE

The general pattern of family life in the UK has changed since the 1890s due to many factors:

- Laws have been introduced which give women much more independence – votes, property rights, equal opportunities.
- Education and career choices are similar for boys and girls.
- Women can opt out of marriage because they do not need to rely on a husband for financial support.
- Labour-saving devices in the home have made domestic work less exhausting and have given women more free time for outings with the children. a job outside the home, more social life, hobbies etc.
- State benefits have eased financial problems to some extent.
- Reliable methods of contraception allow couples to choose not to become parents or to have fewer children.
- There are more single parent families and step-families.
- Divorce is easier and has become more socially acceptable.

ROLES WITHIN THE FAMILY

Traditional roles At the beginning of the 20th century in the UK, the roles of husband and wife within the family were distinct. The traditional role of the husband was to be the 'breadwinner' and to make the important decisions, whilst that of the wife was to care for her home, husband and children.

During the course of the century these roles have become blurred in many families. Many women have paid jobs and many of the household jobs are shared by both sexes. The two World Wars have been major causes of this change.

This change in society has been reflected in legislation. Employers must offer equal terms of employment to men and women doing the same or similar jobs (*Equal Pay Act 1970*). Also it is illegal to discriminate against a person on grounds of sex or marital status (*Sex Discrimination Act 1975*). Both these acts have been amended by the *Sex Discrimination Act 1986*, but the basic principles still apply.

Shared roles In some families, mother and father do not have distinct roles. Each parent may have a job (perhaps part-time) and each contributes to the family finances, and shares the household jobs and child care. The advantages claimed are:

- Fathers have a closer relationship with their children.
- Mothers have more time to enjoy their children and to follow other interests.
- Children benefit from greater variety.
- The quality of the marriage improves.

Role reversal When 'role reversal' takes place, the father cares for the home and children while the mother earns the money.

Trends in family life in Britain

At the beginning of the 20th century . . .

Women had no legal or voting rights

Men were the chief providers for the family

The day-to-day upbringing of the children was usually left to the mother

Holidays were rare for most people, with often only an occasional day out for the fortunate

Poor housing was widespread, with overcrowding and communal toilets

Children were expected to be 'seen and not heard' and to 'respect their elders and betters'

For many people, the working day was long and hard in order to obtain necessities of life

Poor families were commonplace, with few possessions, clothes, or toys for the children

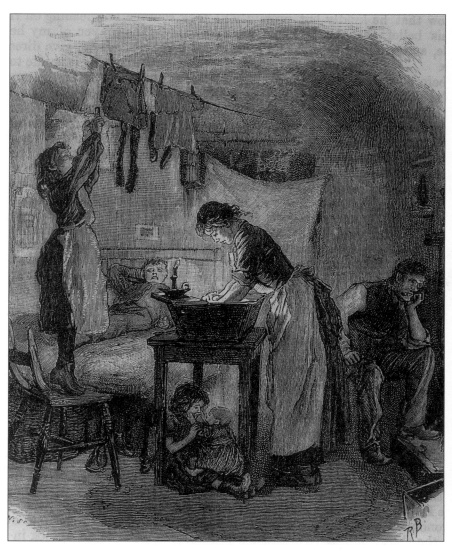

Divorce was a social disgrace, and divorced women had no rights to property or to financial support

Families with large numbers of children were common

Married women stayed at home, caring for the house and children

At the beginning of the 21st century . . .

Children are given more freedom and less discipline

Divorce is easier, with legal rights for women

The general standard of living is greatly improved

It is common these days for both men and women to contribute to the family income

Small families are usual

Many women who have dependent children also have a job outside the home

Women are entitled to vote and own property, and they have the same education, training and career prospects as men

Each family expects to have its own home with a piped water supply, flush toilet, electricity and television, and many own cars and computers

Fathers are more involved in the day-to-day upbringing of the children

Longer holidays and travel abroad are commonplace

Working hours are shorter, pay and conditions are better, and state benefits help ease hardship

Sexual roles Boys are physically programmed by their **genes** (p. 120) and **hormones** to develop into men, and girls into women. Their sex hormones control the development of body shape and the activities of the sex organs. Differences in behaviour are often noticeable from the age of three months.

Boys tend to be more: active and energetic, aggressive, competitive, keen to explore.

Girls tend to: walk and talk earlier, control the bladder earlier, be better with words, be more interested in people.

The extent to which children develop male and female roles as they grow into adults is due to two main reasons:

1. **Physical factors**, which make them more suited to certain activities; for example, men usually have larger muscles and greater strength, and women bear children.
2. **The encouragement or discouragement of distinct male and female roles in childhood** by:
 - **the expectations of adults** – boys are usually expected to be brave, and girls expected to cry
 - **toys** – girls and boys are often given different types of toys
 - **clothes** – girls and boys are usually dressed differently
 - **the child's own observations** of how men and women behave inside and outside the home, and how they are portrayed in books, newspapers, television etc.

QUESTIONS

1 Study the pictures on pp. 8 and 9. Place the labels in appropriate pairs in a table like the one below (there are 11 pairs).

Typical of family life at the beginning of 20th century	Typical of family life today

2 Name eight factors which have brought changes to family life.

3 a Compare the traditional roles of husband and wife at the beginning of the 20th century.
b What has happened to these roles since then?
c What is the difference between shared roles and role reversal?
d List four advantages claimed by those who practise shared roles.

4 a Give examples of differences in behaviour between boys and girls that are often noticeable at an early age.
b Name four factors which can affect the development of distinct male and female roles.

FURTHER ACTIVITIES

INVESTIGATION

C2.1b Interview one or more people aged 70 or over and try to list 20 ways in which they think that family life has changed since they were children. Use the information to give a short talk to your class about what you discovered from your interviews.

DISCUSSION

C2.1a Do mothers and fathers play differently with their children?

EXTENSION

a From your experience, list five jobs in the family which are *usually* part of (i) a father's role, (ii) a mother's role.
b (i) For each item in your lists state why you think it is usually part of the father's or the mother's role – is it habit, tradition, preference, physical strength, or what? (ii) What effect do you think it would have on the family if all the jobs were shared between them.

CHILD STUDY
Give a brief history of the child up to the date of starting the study.

Revision Exercise 2

10

3 VARIATION BETWEEN FAMILIES

There is no such thing as a typical family. Families differ from each other as much as individuals differ from each other, and they change with time.

Some of the ways in which families vary

Size from two people .. to many people

Age range of the
members from very young .. to very old

Location of the
family home from urban (town, city) to rural (country)

Health from generally healthy to generally unhealthy

Wealth from rich ... to poor

Feelings

The feelings of members of a family towards one another can vary from:

- care ⟶ to indifference
- respect ⟶ to contempt
- love ⟶ to hate
- trust ⟶ to fear

Attitudes of parents to their children

- The children may be:
 wanted ⟶ tolerated ⟶ unwanted
- Parents may: over-indulge their children ⟶ act responsibly ⟶ neglect them
- Parents may enforce:
 strict discipline ⟶ moderate discipline ⟶ no discipline

CULTURE

Culture means the way of life of a group of people, for example a family or people living in the same country, and is passed on from adults to children. Aspects of culture include:

- language
- religion
- traditions
- education
- hygiene
- food, diet and eating habits
- music, songs, drama, literature and art
- leisure activities
- style of dress.

Influence of religion on culture

The cultural life of any family will be influenced by the religious background of the country in which the family lives, as well as by any religious group to which the family belongs. Religion may:

- provide a set of rules for behaviour
- set special times for worship and festivals
- affect style of dress, diet, leisure activities etc.

Multicultural societies

Britain is a multicultural society. This means it contains people of many different **ethnic groups** – people of differing races or countries of origin. Each ethnic group will have its own particular culture, for example, customs and language. This makes for much greater variety of lifestyles, and also brings about social changes:

- The ethnic groups have to adapt to life in a country which has a different culture.
- The native population has to accept people of various cultures as equal members of the community.

There is a cultural mix when people of different ethnic origins marry, also when children of one culture attend a school where most pupils are of another culture. Children often adapt to a new culture more quickly than their parents, and this may result in children living in two cultural styles – one at school and another at home.

The *Race Relations Act 1976* makes racial discrimination unlawful in employment, training, housing, education, and the provision of goods, facilities and services. The *Commission for Racial Equality* has the power to enforce this Act, which gives everyone an equal chance to learn, work and live free from discrimination and prejudice, and from the fear of racial discrimination and violence.

QUESTIONS

1 a How do families differ in **(i)** size, **(ii)** age range, **(iii)** location, **(iv)** health, **(v)** wealth?

 b Give examples of ways in which feelings towards other members of the family can vary.

 c Give examples of variation in attitudes of parents to children.

2 a What is meant by culture?

 b **(i)** Give nine examples of aspects of culture. **(ii)** Suggest aspects of culture shown by each of the four photographs on pp. 12–13. Give reasons for your suggestions.

 c Give ways in which religion may influence culture.

3 a What is meant by ethnic groups?

 b Give two ways in which people living in multicultural society need to change.

 c Give two examples of a cultural mix.

4 Give the function of the Race Relations Act.

FURTHER ACTIVITIES

INVESTIGATION

People of different ethnic groups and ways of life celebrate different festivals – special days of celebration. Using at least two different sources (e.g. library, Internet, CD-Rom) find the names and dates of two traditional festivals celebrated by each of five groups, e.g. Christians, Jews, Hindus, Sikhs, Muslims.

IT2.1 Write a short article for a local newspaper comparing two different festivals.

CHILD STUDY

Describe the child's family. Make a family tree. If this is not possible, make a family tree of your own family.

Revision Exercise 3

4 THE HOME

The home provides a base in which babies develop into young adults. Different aspects of a child's development are encouraged when the home provides the facilities and opportunities shown below and on page 16.

A

the child is encouraged to improve skills

Praise and encouragement

B

lighting adequate for playing and reading

space to display pictures and posters

shelves and cupboards for toys, books and clothes

A place which the child can call his or her own and where possessions can be kept

C

vocabulary increases

bonds between parent and child develop

listening and understanding are encouraged

Opportunities for parent and child to play or read together

D

easy-to-clean floor and furniture

furniture can be moved easily

Space for play

EFFECTS OF THE HOME ENVIRONMENT ON DEVELOPMENT

The **home environment** – the conditions in the home – affects all aspects of a child's development:

- **physical** – development of the body (p. 132)
- **speech** – learning to talk (p. 145)
- **social** – learning to interact with people (p. 150)
- **emotional** – learning to control feelings (p. 153)
- **intellectual** – development of the mind (p. 174)
- **cultural** – acquiring knowledge of the society in which the child is growing up.

E

questions can be answered

interests can be shared

plans can be made

Opportunities for conversation

F

the child feels useful and wanted

Opportunities to help

G

self-confidence develops

Opportunities to meet other adults

H

co-operation and sharing are learnt

Opportunities to play with other children

Television in the home

Nearly all homes have one or more televisions and many have video recorders or DVD players, computers and games consoles, and they are very much part of most children's lives. Even babies are fascinated by movement on a television screen and they will stare at it for quite a long while – but they will not understand what they see. Gradually children become able to understand, particularly those programmes made especially for them. When they watch with adults and talk about what is seen they will more quickly increase their understanding of the world in which they live.

Television is beneficial for children when it:
- stimulates curiosity
- increases knowledge
- enlarges vocabulary
- encourages family discussions and conversation
- entertains.

Television is harmful for children when:
- it is on continuously – because it makes conversation difficult
- too much time is spent watching – because this reduces opportunities for talking, playing, reading and drawing
- children watch unsuitable programmes or videos which may frighten them or encourage them to behave in an antisocial way
- it prevents them having sufficient fresh air and exercise
- they are tired in the morning from late-night viewing.

FURTHER ACTIVITIES

EXTENSION
For each of pictures A–H, state which aspect(s) of development (p. 16) are being encouraged.

INVESTIGATION
Analyse the television programmes on BBC1 and ITV1 for one day. Write a report saying which programmes are (i) suitable for pre-school children; (ii) suitable for 7-year-olds; (iii) unsuitable for children under the age of 7. Give brief reasons in each case.

DESIGN
IT2.3 Use a graphics program to design a layout for a 5-year-old's bedroom. (i) Draw a floor plan. (ii) Design wall-to-wall storage units 3 m long, 2 m high and 40 cm deep, to hold a child's clothes, toys, books etc.

CHILD STUDY
1 Describe the child's home.
2 How much time does the child spend watching television or videos, or using a computer or games console? What type of programmes or videos are watched? What reactions have you observed?

QUESTIONS

1 List six aspects of a child's development, briefly explaining what each means.

2 Under the heading 'Development is encouraged when the home provides', list the facilities and opportunities shown in pictures A–H in this topic.

3 a Give five benefits of television for children.
 b Give five harmful effects of television on children.

Revision Exercise 4

5 PARENTHOOD

Couples who hope to start a family should be reasonably happy together and fairly self-confident, because child-rearing is a long and demanding job. This is why it is often considered undesirable for young people still in their teens to become parents. They themselves have not finished growing up, and they may not be sufficiently mature to cope with the demands of parenthood and the changes it will bring to their lives.

HOW PARENTS' LIVES CHANGE

Having children changes the lives of the parents in many ways:

- **Children are hard work**. When young, they are by nature neither clean nor tidy. Also, they have to be cared for seven days a week and at nights as well.
- **They are a long-lasting responsibility**. Children require years of care as they grow from 'dear little babies' into adolescents who can be much more difficult to manage.
- **They require sacrifices from the parents** of both time and money.
- **They restrict the parents' freedom**, but at the same time, provide a new and continuing interest.
- **They bring the parents much pleasure and satisfaction** if the parents are prepared to give time and energy to bringing them up.

PREPARATION FOR PARENTHOOD

Preparation for parenthood begins in childhood. As children and teenagers, the parents-to-be will have been influenced by:

- the way in which they themselves were brought up
- experience gained through helping with younger brothers, sisters or cousins, or neighbours' children
- baby-sitting or experience of working with young children
- the study at school or college of subjects such as Child Care and Development or Nursery Nursing.

Children are hard work . . .

. . . but they bring much pleasure

NEW PARENTS

In these days of smaller families, it is quite possible that new parents will have very little knowledge of how to bring up children. If they live far away from their own families, then the grandparents will not be at hand to give help and advice.

Sources from which the parents of today can get information, advice and support include:

- other members of their families and friends
- preparation classes at the antenatal clinic
- the health visitor, at the Child Health Clinic (baby clinic) or on home visits
- the National Childbirth Trust – see p. 341
- television programmes and videos produced for parents
- pamphlets issued by the local Health Promotion Service and many other organisations – a list of some of them is given on pp. 340–343
- books – there are many to choose from which have been written by parents or doctors.

Suggestions for parents

1. **Love your baby** ⎫ to give your baby the security of feeling wanted.
2. **Cuddle your baby** ⎭

3. **Speak to your baby** – so that your baby can learn how to talk.

4. **Listen to your baby** as well as talking to your baby and you will learn how to communicate with each other.

5. **Play with your baby** – your baby will enjoy it, and it will enable a far closer relationship to develop between you.

6. **Keep your baby clean** and comfortable, but do not be over-fussy.

7. **Be firm with your child** when your baby is old enough to understand what is wanted. Boundaries for behaviour help a child to be socially acceptable to other children and adults.

8. **Praise is more effective than punishment** in the training of children.

9. **Do not over-protect** – children must gradually learn to be responsible for their own lives.

10. **Do not spend all your time and energy on your child**. If you do not leave time for yourselves and your own interests, you will become very dull people. When the child has grown up and left home there will be the danger that you will be lonely and bored.

Children are more important than the housework

HAPPY FAMILY LIFE

When parents set up home and have a family, they naturally hope to create a happy environment in which the children can grow up. Some of the factors which can help to make a home happy are given below.

- **Parents who love and respect each other and their children**. This helps to give all the members of the family a sense of security.
- **Parents who consider that children are more important than the housework**. Worrying too much about tidiness or the state or appearance of the house can make for a great deal of nagging and unpleasantness. Children would rather have happy, contented parents who have time to do things with them than a spotlessly clean and tidy home.
- **Parents who realise they themselves are not perfect**. No parents are perfect. There are days when they are cross and irritable, particularly when they are tired, unwell or worried. It happens in all families.
- **Parents who realise that no child is perfect**. All children go through phases of good and bad behaviour.
- **Parents who do not expect too much of their children**. Children enjoy life more when they are praised and loved for what they can do, rather than criticised for what they are unable to do.

QUESTIONS

1 Name five ways in which having children changes the lives of their parents.

2 a Name four ways in which preparation for parenthood can begin in childhood.
 b Name seven ways in which new parents can obtain information, advice and support.

3 List ten suggestions which may be of help to new parents.

4 Name five factors which can help to make home a happy place.

Revision Exercise 5

FURTHER ACTIVITIES

EXTENSION

C2.3 List your daily routine on a typical school day, or day at college (from midnight to midnight). Compare this routine with that of a parent who has a home and a young baby to care for. Remember that a baby needs to be cuddled and played with, kept clean, fed about five times a day, and the nappy changed about eight times a day. Write a pamphlet for new parents explaining how their lives might change. Include illustrations.

INVESTIGATION

C2.2 Compare two books written for parents which deal with the care and development of young children.
Points to be compared could include topics covered (contents list), the illustrations, and the usefulness of the index. Write a report on your findings.

6 FAMILY PLANNING AND SEXUAL HEALTH

Family planning (birth control) means taking action so that only wanted babies are born. When sexually active women or their partners do not use some form of contraception, 80–90% of the women will become pregnant within a year. This shows that for most women, pregnancy is very likely to occur unless action is taken to prevent it.

UNPLANNED PREGNANCIES

It is estimated that at least one in three pregnancies is unplanned. Although many babies which result from unplanned pregnancies become wanted babies, some are unwanted, and may be terminated. **Termination of pregnancy** (abortion) means the removal of the fetus (developing baby) from the womb before it has grown enough to survive on its own.

Unplanned pregnancies can happen to girls and young women because either they have been given wrong advice, or they have ignored sound advice. A girl who does not wish to become pregnant should remember the following facts:

- pregnancy can follow first intercourse
- pregnancy can occur even if the penis does not enter the vagina (sperm can swim)
- pregnancy sometimes occurs when intercourse takes place during a period
- pregnancy can occur even when the woman does not 'come' (have an orgasm)
- intercourse in any position can result in pregnancy
- withdrawal ('being careful') can result in pregnancy
- douching (washing out the vagina) will never prevent pregnancy, however soon after intercourse
- breast-feeding does not prevent pregnancy, although it may make it less likely.

CONTRACEPTION

Contraception (*contra* = against, *ception* = conceiving) is the deliberate prevention of pregnancy.

It is natural for men and women in relationships to have intercourse. But if they do not want a baby, they need to know about the various methods of contraception. Using this knowledge, they are able to plan their family and start a baby only when they want one.

The following table lists the different methods of contraception and explains briefly how they work, and how effective they are at preventing pregnancy.

21

Different methods of contraception, how they work and how effective they are

Method	How it works	How effective it is in preventing pregnancy
Abstention – saying 'No' (not having intercourse)	Because intercourse does not take place there is no danger of an unwanted baby.	100%.
Withdrawal ('being careful'; coitus interruptus)	The penis is withdrawn from the vagina before the semen is ejaculated.	Very unreliable because a little semen can escape from the erect penis before the main amount is released.
Male sterilisation* (vasectomy)	A simple operation in which the sperm ducts (vas deferens) are cut or blocked to prevent semen from containing sperm.	More than 99.5%.
Female sterilisation*	An operation in which the Fallopian tubes from the ovaries are blocked so that the egg and sperm cannot meet.	99.5%.
Combined pill*	This type of pill contains two hormones – oestrogen and progestogen – which stop ovulation (stop the ovaries from producing eggs). **Progestogen** is similar to progesterone made by the ovaries.	More than 99% if taken at the same time each day. Not reliable if taken over 12 hours late, or after vomiting or severe diarrhoea, or during antibiotic treatment.
Contraceptive patch* (an alternative to the combined pill)	A small thin, beige plastic patch that releases oestrogen and progestogen is placed on the skin of the buttocks, abdomen, back or upper arm once a week for 3 out of 4 weeks. No patch is used in the 4th week.	99% if used according to instructions. Not affected by vomiting, diarrhoea or antibiotics.
Vaginal ring* (an alternative to the combined pill)	A flexible transparent ring about 2 inches in diameter is inserted in the vagina. Low doses of oestrogen and progestogen are slowly released. After 3 weeks, the ring is removed for a 1 week break.	99% if used according to insturctions. Not affected by vomiting, diarrhoea or antibiotics.
Progestogen-only pill*(mini-pill)	This type of pill contains one hormone – progestogen – which causes changes to the lining of the womb. This makes it very difficult for sperm to enter the uterus or for an egg to settle there.	99% effective if taken at the same time each day. Not reliable if taken over 12 hours late, or after vomiting or severe diarrhoea.
Contraceptive injections*	An injection of progestogen is given every two or three months. The hormone is slowly absorbed into the body and works in a similar way to the progestogen-only pill.	More than 99%.
Contraceptive implant*	A small flexible tube 40 mm × 2 mm containing progestogen is inserted just under the skin on the inside of the upper arm. The hormone is slowly released into the blood stream, and works by preventing the egg and sperm from meeting. The implant is effective for up to 3 years. If a pregnancy is desired, the implant can be removed, and fertility returns immediately.	More than 99%.

Method	How it works	How effective it is in preventing pregnancy
IUD*(intra-uterine device; coil; loop)	A small plastic and copper device is put into the womb. It stops sperm meeting an egg or may stop a fertilised egg from settling in the womb. Depending on the type, it can stay in place for 3–10 years, but can be taken out at any time.	98–99%.
Intra-uterine system (IUS)* (Mirena)	A small T-shaped plastic device is placed in the womb. It contains progestogen, which is slowly released. This stops sperm from meeting an egg. The IUS can be left in place for 5 years, but can be taken out at any time.	More than 99%.
Diaphragm or cap with spermicide*	A diaphragm is a flexible rubber dome which covers the cervix (the entrance to the womb). A cap is smaller and fits neatly over the cervix. Used with spermicide, these devices form a barrier which helps to prevent the sperm from meeting an egg and must stay in place for at least 6 hours after intercourse. Spermicide (jelly or cream) makes sperm inactive.	92–96% if used carefully and according to instructions.
Male condom	Made of very thin rubber, it is put over the erect penis before intercourse takes place. It prevents sperm from entering the woman's vagina. Using a condom also helps to protect against sexually transmitted diseases, including AIDS.	98% if used carefully and according to instructions.
Female condom	A soft polyurethane sheath lines the vagina and the area just outside. It is placed in position before intercourse takes place and prevents the sperm from entering the vagina. Using a condom also helps to protect against sexually transmitted diseases, including AIDS.	95% if used carefully and according to instructions.
Natural methods (sympto-thermal method; temperature method; cervical mucus method; calendar method; urine analysis)	These methods allow a woman to recognise the days when she is fertile and can become pregnant. This is done by noting and recording the different natural signs such as changes in temperature and cervical mucus that happen during the menstrual cycle. Sperm can live inside a woman for 3–7 days, so intercourse a week before an egg is released may result in pregnancy. To avoid pregnancy, intercourse should not take place during the fertile days unless another method of contraception is used.	98% for sympto-thermal methods if used according to instructions. Very unreliable when periods are irregular, during illness, when travelling, and unless very careful records are kept. Instruction from a teacher who has been specially trained in natural methods of family planning is recommended.

*These methods require medical advice or treatment from a doctor or at a Reproductive and Sexual Health Clinic (Family Planning Clinic).

WHICH METHOD OF CONTRACEPTION TO USE

Deciding which of the methods of contraception to use depends on a number of factors, including:

- individual preference
- religious beliefs
- age
- whether a short- or long-term method is wanted.

The **reliability** of any of the methods of birth control depends on using that method correctly. Many of the failures which result in pregnancy are due to incorrect use. The advantage of attending a Family Planning Clinic or Health Centre is that advice is given in choosing a suitable method, and instructions are given to help make that method as safe as possible.

EMERGENCY CONTRACEPTION

When intercourse has taken place without using contraception or when any precautions which were taken might have failed, there are two emergency methods of contraception which can be used. It is important to contact a doctor or Family Planning Clinic as soon as possible because pregnancy can usually be prevented by:

- emergency contraceptive pills (previously known as 'morning after' pills) containing hormones which are taken within 72 hours
- an IUD (coil) fitted within five days of intercourse.

TERMINATION OF PREGNANCY (ABORTION)

If a baby is found to be developing abnormally, or the mother has emotional or other problems which the birth of a baby will (according to at least two doctors) worsen to a harmful degree, a pregnancy can be terminated (aborted) before the end of the 24th week.

OBTAINING ADVICE

Advice on contraception and sexually transmitted diseases is provided free by the National Health Service (NHS). It can be obtained by people of all ages, married or single, male or female, from the following sources:

- **Reproductive and Sexual Health Clinics**, which advise on family planning, contraception and sexually transmitted infections.
- **Leaflets**, which can often be obtained from Health Centres, where doctors (GPs) and nurses can advise.
- Special confidential **telephone helplines** are available.
- **Websites** are another helpful source of information.

SEXUALLY TRANSMITTED INFECTIONS (STIs)

These diseases are so-called because the usual way in which they spread from one person to another is by sexual intercourse. Examples are:

Chlamydia This very common sexually transmitted disease is one of the most serious. Because infection often does not produce any symptoms, the infected person may not seek medical help. The number of cases almost tripled between 1995 and 2003, leading to the introduction of a National Screening Programme for under-25s. If left untreated, it can cause infertility in both males and females.

Gonorrhoea Again, symptoms may or may not be present, but if left untreated in women, the infection can lead to pelvic inflammatory disease and infertility.

Genital warts Whitish lumps appear on the genitals and cause intense itching.

Genital herpes Sores on or around the genitals may be accompanied by itching, small blisters, pain when passing urine or a flu-like illness.

Syphilis Painless sores are followed by flu-like symptoms. If left untreated, it can lead to heart disease or brain damage.

Hepatitis type B This liver disease is usually caught from infected blood, but it can be transmitted sexually.

AIDS (Acquired Immune Deficiency Syndrome)

This is caused by a virus called HIV (human immunodeficiency virus). People infected with the virus may or may not develop the disease called AIDS, but they will develop HIV antibodies. A blood test for HIV antibodies will show whether a person is infected with HIV. When AIDS develops, the patient easily becomes infected with many kinds of germ (because the virus reduces immunity) and also tends to develop a particular kind of cancer.

HIV may pass from an infected person to another:
- during unprotected sexual intercourse – the virus is present in men's semen and in women's vaginal fluid (including menstrual blood)
- by contact with infected blood, for example when using the same needle for drug injections
- during pregnancy, from an infected mother to her unborn baby.

HIV is *not* caught:
- by shaking hands, touching and cuddling someone who is infected with the virus
- from lavatory seats – the virus is very delicate and dies quickly outside the body
- from swimming pools.

QUESTIONS

1 What is **(i)** contraception, **(ii)** the chance of a woman becoming pregnant if no form of contraception is used?

2 Match each of these methods of birth control with one of the statements a-i: vasectomy; cap; abstention; male condom; withdrawal; combined pill; natural methods; IUS; female sterilisation

 a stops the ovaries from producing eggs

 b stops sperm entering the vagina

 c covers the entrance to the womb

 d blocks the Fallopian tubes

 e prevents semen from containing sperm

 f intercourse avoided on fertile days

 g intercourse does not take place

 h does not deposit semen in the vagina

 i stops sperm from meeting an egg

3 a List the different methods of birth control in order of their effectiveness in preventing pregnancy.

 b **(i)** Name one method which requires the use of a spermicide. **(ii)** What does the spermicide do?

 c Why is withdrawal an unreliable method of contraception?

 d **(i)** What do natural methods depend on? **(ii)** When are natural methods unreliable?

4 a Name twelve methods of contraception which depend particularly on the woman.

 b Name two effective methods of contraception available to men.

 c Which methods of contraception require medical advice or treatment?

 d **(i)** When deciding which method of contraception to use, give four factors which may be taken into account. **(ii)** What does the reliability of any method depend on? **(iii)** Give two advantages of attending a Reproduction and Sexual Health Clinic.

5 Give the meaning of: **(i)** IUS, **(ii)** IUD, **(iii)** AIDS.

6 a To prevent an unwanted pregnancy, list eight facts which it might be useful to know.

 b Describe two methods of emergency contraception.

 c What is meant by termination of pregnancy?

7 a What is an STI?

 b Which two STIs can cause infertility?

 c Which two STIs cause itching on or around the genitals?

 d In what ways can HIV pass from an infected person to another person?

 e Give four types of contact in which HIV is not caught.

FURTHER ACTIVITIES

EXTENSION

N2.1 For each of the methods of contraception in the chart on pp. 22–23, find the number of women who are likely to become pregnant, e.g. 99% = one in a hundred. Assuming that the methods were used correctly, place them in order of effectiveness in preventing pregnancy, starting with the most effective.

WEBSITE ANALYSIS

The NHS website www.playingsafely.co.uk is a guide to sexually transmitted infections aimed especially at young people. Write a summary of the website saying whether you consider that it is user-friendly for teenagers, and whether it presents the information in a way that can be easily understood. What is the main message that this website gives?

EXERCISES

Exercises relevant to Section 1 can be found on p. 344.

Revision
Exercise
6

BECOMING A PARENT

A baby starts life with two parents – a mother and a father. When the couple make love and have sexual intercourse ('have sex'), a baby begins to develop if a sperm from the father **fertilises** (joins with) the mother's egg (ovum). 'A baby has been conceived' or 'conception has taken place' means that an egg has been fertilised and a baby is developing – the mother is pregnant. How does this happen?

Puberty is the stage during which the sex organs mature and start to produce sperm or eggs and also to secrete sex hormones. The male sex hormone **testosterone** causes the penis to enlarge, shoulders to broaden, the voice to deepen, and body hair to grow. The female sex hormones **oestrogen** and **progesterone** cause periods to start, breasts to enlarge, and body hair to grow.

MALE REPRODUCTIVE SYSTEM

A man has two testes (each is a testis) where sperm are made, and a penis which is used to deposit the sperm inside the woman's body.

The foreskin of the penis will be absent in males who have been circumcised. **Circumcision** is the removal of the foreskin by surgery. It is rarely necessary for medical reasons although it is widely carried out amongst some religious groups.

A Side view

urethra (7) - a tube for both semen and urine (during intercourse the exit from the bladder is closed)

penis (3) - ejaculates the sperm into the vagina of the female

foreskin (5) - covers and protects the tip of the penis

bladder (9)

seminal vesicle (1)

prostate gland (2)

sperm tube (8) (vas deferens)

glands which secrete fluid to mix with the sperm to make **semen**

epididymis - where the sperm are stored

testis (6) - where sperm are made and testosterone is produced

testicle

scrotum (4) - a bag which hangs below the abdomen and contains the testes. In this way, the sperm are able to be stored at a cooler and more suitable temperature than if they were inside the body

← arrows show the path of the sperm during intercourse

B Front view

Diagrams of the male reproductive organs
(The numbers in the side view refer to numbers 1–9 in the front view)

28

FEMALE REPRODUCTIVE SYSTEM

The female reproductive system is more complicated than that of the male because it has more things to do. It has to produce eggs (ova), receive sperm, protect and feed the unborn child, and then give birth.

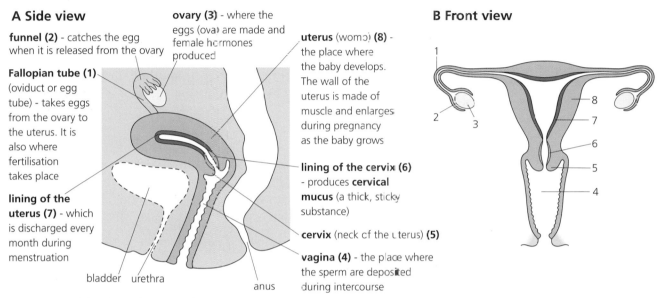

A Side view

funnel (2) - catches the egg when it is released from the ovary

Fallopian tube (1) (oviduct or egg tube) - takes eggs from the ovary to the uterus. It is also where fertilisation takes place

lining of the uterus (7) - which is discharged every month during menstruation

ovary (3) - where the eggs (ova) are made and female hormones produced

uterus (womb) **(8)** - the place where the baby develops. The wall of the uterus is made of muscle and enlarges during pregnancy as the baby grows

lining of the cervix (6) - produces **cervical mucus** (a thick, sticky substance)

cervix (neck of the uterus) **(5)**

vagina (4) - the place where the sperm are deposited during intercourse

bladder urethra

anus

B Front view

Diagrams of the female reproductive organs
(The numbers in the side view refer to numbers 1–8 in the front view)

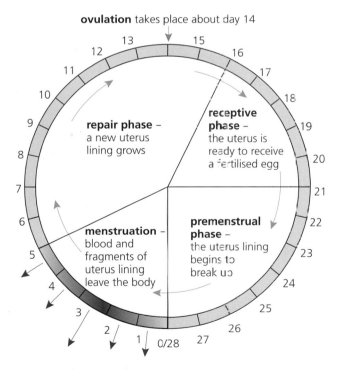

ovulation takes place about day 14

repair phase – a new uterus lining grows

receptive phase – the uterus is ready to receive a fertilised egg

menstruation – blood and fragments of uterus lining leave the body

premenstrual phase – the uterus lining begins to break up

Diagram of a typical menstrual cycle

MENSTRUATION

Some time between the ages of 10 and 17, girls begin to menstruate – have periods. This shows that the reproductive organs are getting into working order. It is usual for the periods to be irregular and scanty at first. It is not uncommon for a year or more to elapse between the first and second period, and for months to elapse between periods in the second year. The periods gradually become regular, although they may stop for a while during illness, poor diet or emotional upsets.

MENSTRUAL CYCLE

The menstrual cycle is sometimes called the monthly cycle as it takes about 28 days to complete. The purpose of the cycle is to produce an egg and prepare the uterus to receive the egg if it becomes fertilised.

During the first part of the cycle, the lining of the uterus is built up into the right state to receive the egg. If the egg is not fertilised, then the lining

breaks down, and is removed from the body in a flow of blood called a **period** or **menstruation**.

Some time between the ages of about 45 and 55, the menstrual cycle and periods cease. This stage is called the **menopause**, and the woman can then no longer conceive a baby.

Although the cycle, on average, takes about 28 days to complete, it is normal for it to vary between 21 and 35 days. The cycle continues over and over again until such time as an egg is fertilised. It then stops during pregnancy and does not start again until several months afterwards.

1

egg containing genes from the mother

sperm containing genes from the father

OVULATION

Generally, an egg is released every month from one or other of the ovaries. This usually happens about half-way through the menstrual cycle, that is, about the 14th or 15th day. After being released from the ovary, the egg is moved slowly along the Fallopian tube (oviduct).

2

3

CONCEPTION

Conception is the start of pregnancy.

egg and sperm fuse (join together)

4

Fertilisation

Sexual intercourse (coitus)

Before intercourse, the man's penis enlarges and becomes hard and erect. It is now able to penetrate the vagina of the woman and **semen** is ejaculated there. Semen is a thick, milky-white substance containing millions of sperm. Once inside the vagina, the sperm use their tails to swim in all directions. Some may find their way into the uterus and along the Fallopian tubes.

Fertilisation

If intercourse takes place at about the time that an egg has been released from the ovary, then the egg has a chance of meeting sperm in the Fallopian tube. If this happens, the egg will be fertilised by one of the sperm.

Conception occurs when an egg in the Fallopian tube is fertilised by a sperm, and the fertilised egg then becomes implanted in the uterus

After fertilisation, the egg continues to be moved along the Fallopian tube towards the uterus. By the time it gets there, the uterus lining will be ready to receive it.

Implantation

This means the embedding of the fertilised egg in the uterus wall. The fertilised egg becomes attached to the uterus wall about six days after conception. The mother is now able to supply it with food and oxygen so that it can grow and develop into a baby.

HORMONES

Hormones play a very important part in controlling the menstrual cycle, pregnancy, birth and breast-feeding. They are substances which act as chemical messengers. They are produced in glands called **endocrine glands** and then circulate in the bloodstream, carrying messages to various parts of the body. There are many different hormones and they help control the way the body works. Examples are:

- oestrogen (female sex hormone) – responsible for the development and functioning of the female sex organs
- progesterone (pregnancy hormone) – helps to prepare the uterus to receive the fertilised egg and maintain a state of pregnancy; it also interacts with oestrogen and other hormones to control the menstrual cycle
- oxytocin – stimulates the uterus to contract during childbirth
- prolactin – controls milk production.

INFERTILITY

Sometimes couples plan to have a family and find, to their disappointment, that they are unable to produce children. Being unable to conceive is known as **infertility**.

There are many reasons for infertility and couples can obtain advice from their doctor or Family Planning Clinic. With some couples the right advice soon solves the problem. Other cases may require treatment from a doctor who specialises in the problems of infertility.

Causes of infertility:
- **too few sperm being produced** – at least 20 million sperm need to be ejaculated at any one time to ensure that one fertilises the egg
- **failure to ovulate** – the ovaries are not producing eggs
- **blocked Fallopian tubes** – the eggs cannot be fertilised
- **the cervical mucus in the neck of the uterus (womb) is too thick** – so sperm are unable to enter
- **hysterectomy** – an operation to remove the uterus.
- **sexually transmitted infections** – chlamydia and gonorrhoea

TREATMENTS FOR INFERTILITY

With advances in technology there are now a number of different fertility treatments which can be offered to couples who would otherwise remain childless.

Fertility drugs

Women who have difficulty in ovulating may be given hormones (fertility drugs) to encourage the ovaries to produce eggs. It can be difficult to adjust the dose to suit an individual person. This sometimes causes several eggs to be produced at the same time, resulting in multiple births – twins, triplets, or more.

Blocked Fallopian tubes

These can sometimes be successfully operated on.

IVF (In vitro fertilisation)

Fertilisation takes place outside the body using eggs removed from the woman and sperm obtained from the man. A few days later, two or three embryos are placed in the woman's uterus in the hope that one will become embedded there.

DI (Donor insemination; artificial insemination)

Sperm obtained from an anonymous donor is used for IVF.

GIFT (Gamete Intra-Fallopian Transfer)

This treatment uses a couple's own eggs and sperm, or that of donors, which are mixed together and then placed into the woman's Fallopian tubes for fertilisation to take place there.

ICSI (Intra-Cytoplasmic Sperm Injection)

Fertilisation is achieved outside the body by injecting a single sperm into an egg. After a few days, the embryo is transferred to the woman's uterus.

Surrogacy

Eggs are obtained from one woman and fertilised using IVF with sperm from the woman's partner. An embryo is then transferred to the uterus of another woman – the **surrogate mother** – who will eventually give birth to a baby. In UK law, the birth mother is the legal parent and the couple who donated the eggs and sperm need to adopt their own genetic child. Surrogacy may be used for a woman who has no uterus or is unable to carry a child.

QUESTIONS

1 a What is puberty?
 b What are the effects of testosterone?
 c Name the female sex hormones and give their effects.

2 a What is conception?
 b Where does fertilisation take place?
 c Copy the diagrams showing fertilisation (p. 30).

3 a Where are sperm made?
 b What is the scrotum?
 c Where are the sperm stored?
 d What is the technical name for the sperm tube?
 e Name the central tube to which both sperm tubes join.

4 a Where are eggs made?
 b How often are eggs usually released?

5 a What is the function of the penis in reproduction?
 b **(i)** Name the substance which is deposited by the penis in the vagina.
 (ii) About how many sperm does it contain?
 c If an egg is in a Fallopian tube, how can the sperm reach it?
 d After fertilisation, where does the egg move to?

6 a What is the purpose of the menstrual cycle?
 b What happens to the uterus lining during menstruation?
 c What happens to the uterus lining after menstruation?
 d Give four reasons why menstruation may stop for a while.

7 a **(i)** What are hormones? **(ii)** In which glands are they produced? **(iii)** How do they reach the various parts of the body?
 b **(i)** Name four hormones important in controlling the menstrual cycle, pregnancy, birth and breast-feeding, and give a function of each. **(ii)** Which two hormones help to control the menstrual cycle?

8 a **(i)** What is infertility? **(ii)** Give six causes of infertility.
 b **(i)** When may fertility drugs be used?
 (ii) Why may multiple births result?
 c **(i)** What is IVF? **(ii)** Describe another treatment for infertility which involves IVF.
 d What is the meaning of **(i)** GIFT, **(ii)** ICSI?
 e Explain how a couple can have a baby with the help of a surrogate mother.

FURTHER ACTIVITIES

1 a Copy diagram B on p. 28 showing the front view of the male reproductive system. Use the information in diagram A to add the correct labels for 1–9 on your diagram.
 b Add arrows to your diagram to show the path of the sperm during intercourse.

2 a Copy diagram B on p. 29 of the female reproductive system, front view.
 b Complete your diagram by adding the correct labels 1–8.
 c Add arrows to show the path of an egg from ovary to uterus.
 d Colour in red the part called 'uterus lining'. (This is the part which is shed every month during menstruation.)

3 Copy and complete the chart below using information from the diagram of the menstrual cycle.

Days	Phase	What happens
0–	menstruation	
–		
–		
–28		

Alternatively, use a graphics program to copy the diagram at the bottom of p. 29.

Revision Exercise 7A	Revision Exercise 7B	Revision Exercise 7C

8 GROWTH AND DEVELOPMENT BEFORE BIRTH

<center>**Embryo at week 6
(enlarged)**</center>

'gills'

position
of eye

umbilical
cord

'tail'

developing
limbs

A human egg is just large enough to be seen – about the size of a full stop. After being fertilised, the egg soon starts to divide, first into two cells, then into four, then eight and so on until it is a mass of cells. By this time it has become attached to the wall of the uterus. The number of cells continues to increase and gradually a tiny **embryo** forms.

Besides producing the embryo, the fertilised egg also gives rise to the placenta, umbilical cord and amnion. These structures are developed for the support of the baby, and they are expelled from the uterus at birth.

The timing of pregnancy

Pregnancy is timed from the first day of the last menstrual cycle, not from conception. So what is called 'week 6' or 'six weeks pregnant' is actually about four weeks after conception. Pregnancy normally lasts for 37–42 weeks from the first day of the last menstrual cycle, the average being 40 weeks.

GROWTH AND DEVELOPMENT OF THE BABY

Week 6

At this stage a human embryo looks rather like the embryo of a fish or frog (tadpole). It is possible to see a tail, and parts which look as though they might develop into gills. The actual size of the embryo at this stage is shown in diagram **A**.

Week 9

The embryo has grown to look more human-like and it is now called a **fetus** (or foetus): see diagram **B**. The main organs of the body are developing and the heart can be seen beating on an ultrasound scan.

Week 14

During weeks 10–14 the nerves and muscles develop rapidly and by the end of this time, the fetus can swallow, frown, clench the fist, and move by turning the head and kicking. The mother does not feel the movements at this stage. The fetus is now about the size of a mouse and weighs about 55 g, diagram **C**.

A

<center>Week 6 (actual size)</center>

B

<center>Week 9 (actual size)</center>

C

<center>Week 14 (actual size)</center>

Week 20

About this time the mother is able to feel the movements inside the uterus as the baby practises using its muscles. The heartbeat can be heard, and very fine hair (lanugo) covers the skin. The fetus weighs about 350 g.

Week 28

Development is almost complete. The baby will spend the remaining time in the uterus growing larger and stronger. It will become more plump as a layer of fat is stored under the skin. The length will be doubled and the weight increased three times. By about week 32 the baby is usually lying head downwards and ready for birth. The **fetal position** is shown in diagram **B** below – the back is curved, head forwards, knees bent, and arms crossed over the chest.

A Embryo in the uterus

B Fetus just before birth

INSIDE THE UTERUS

In the uterus, the baby develops in a 'bag of water' (amniotic fluid) which remains at a constant temperature of about 37°C. The drawings above show two stages of development inside the uterus and the following parts are labelled:

- **uterus wall** – this is made of muscle. During pregnancy the muscle tissue expands as the embryo grows. It becomes greatly enlarged – for example, a uterus weighing 30 g at the start of pregnancy may weigh about 1 kg at the end.
- **cervix** – a ring of muscle which surrounds the outlet of the uterus. It is able to expand widely during childbirth.
- **amnion** – the bag which contains the amniotic fluid.
- **amniotic fluid** – the water in which the baby floats before birth. It acts as a cushion against shocks and so helps to protect the baby from being damaged.
- **umbilical cord** – this cord links the baby with the placenta. It grows to be about 50 cm long and 2 cm in width. The cord contains blood vessels.

- **placenta** – a large, thick, disc-like structure firmly attached to the wall of the uterus. It is fully formed at about 12 weeks and then grows steadily to keep pace with the baby. When fully grown it is about 15 cm across and weighs about 500 g. When twins are developing, non-identical twins each have their own placenta. Identical twins share the same placenta (see p. 345).
- **cervical mucus** – the mucus forms a plug which seals the uterus during pregnancy.

FUNCTION OF THE PLACENTA

The placenta is the organ through which the baby feeds and breathes and excretes waste matter while in the uterus. Blood from the baby flows continuously to and from the placenta through the umbilical cord. In the placenta, the baby's blood comes very close to the mother's blood, but they do not mix. However, they are close enough for food and oxygen to pass from mother to baby, and for carbon dioxide and other waste products to pass in the other direction.

Viruses, alcohol, antibodies, and chemicals from smoke and medicines can cross the placenta from the blood of the mother to the blood of the baby. Some of these substances may damage the developing baby, especially in the early months of pregnancy.

Non-idential twins each
have their own
placenta

The baby feeds, breathes and excretes
waste matter through the placenta

SURVIVING ALONE

If the fetus is born before 24 weeks it will have little chance of surviving. The lungs have not yet finished developing and the baby will not be able to breathe properly.

More than half the babies born at 28 weeks survive with expert medical care. If born after 32 weeks, they stand a very good chance, although intensive care will be needed for a while. A baby born before 37 weeks is said to arrive **pre-term**. The usual time (**full-term**) is about 40 weeks.

A pre-term baby in an incubator

PRE-TERM BABIES

A pre-term (premature) baby is one which is born before 37 weeks. Most pre-term babies weigh less than 2500 g (2.5 kg) and, being very small and weak, need special care. Frequently they have difficulties with breathing, sucking and keeping warm, and need to be kept in an **incubator** for the first few days or weeks. The incubator acts as a half-way house between the uterus and the outside world. The baby is kept isolated, protected and in a controlled environment. The temperature is kept constant, so is the humidity. The baby can be fed through a tube or dropper until it has the strength to suck. If necessary, extra oxygen can be supplied to help with breathing.

MISCARRIAGE

Miscarriage (spontaneous termination) is the loss of pregnancy before 24 weeks. The baby comes out of the uterus accidentally and too early to survive on its own. The first sign of a miscarriage is bleeding, sometimes with pain. Miscarriages are quite common – it is estimated that about one in eight pregnancies end in miscarriage. The majority of miscarriages occur in the first three months of pregnancy, sometimes very early on, when the woman is not aware that she is pregnant. The usual reason is that there is something wrong with the baby's development.

ECTOPIC PREGNANCY

An **ectopic** pregnancy occurs when a fertilised egg does not become implanted in the uterus wall but in a Fallopian tube or elsewhere in the abdomen. An operation is needed to remove the embryo and repair the damage. In rare cases of ectopic pregnancy, infants have survived long enough to be born alive by Caesarian section (p. 61).

QUESTIONS

1 a Describe the appearance of the embryo at 6 weeks.
 b (i) By what age after conception does the embryo look human-like?
 (ii) What is it now called?
 c (i) What parts develop rapidly during weeks 10–14?
 (ii) Give five examples of the movements the fetus is able to make at 14 weeks. **(iii)** When should the mother be able to feel those movements?
 d By how many weeks is **(i)** the heart beating, **(ii)** the skin covered with hair, **(iii)** development almost complete?

2 a Draw a diagram to show the fetus in the uterus just before birth.
 b Label and describe the following parts – uterus wall; amnion; amniotic fluid; umbilical cord; placenta.
 c Describe the fetal position.

3 a Name the organ through which a baby feeds, breathes and excretes while in the uterus.
 b In the placenta, does the mother's blood mix with the baby's blood?
 c Name one waste product which passes from baby to mother.
 d Name six substances which may pass from mother to baby.

4 Explain the meaning of **(i)** pre-term baby, **(ii)** miscarriage, **(iii)** ectopic pregnancy.

Revision Exercise
8

FURTHER ACTIVITIES

EXTENSION

1 Why can an incubator be thought of as a half-way house? Name ways in which the incubator resembles
 a the uterus
 b the outside world.
2 Study the photograph below of a fetus at 7 weeks of pregnancy. What parts of the body can you identify?

INVESTIGATION

C2.1b Carry out a survey (see pp. 355–356) of the resources available to help parents explain human reproduction to their young children. Use the information to prepare and give a short talk to your class on different ways of explaining human reproduction to children at Key Stage 2.

PREGNANCY

Pregnancy is the process that occurs between conception and birth.

PRE-CONCEPTION CARE

The first three months after conception are the most important time for the developing baby. Before pregnancy begins, the mother-to-be should:

- be in good health
- be free from infection
- not be overweight
- give up smoking and drinking alcohol
- not take any drugs or medicines which could be harmful
- have a good nutritious diet, in particular plenty of foods rich in folic acid.

Folic acid
(one of the B vitamins) is particularly important in the baby's early development and helps to prevent defects such as spina bifida (p. 325). Women who are hoping to become pregnant are advised to take a daily dose of folic acid (in the form of tablets), and to continue to do so until three months into pregnancy.

Foods containing folic acid

SIGNS OF PREGNANCY

For a woman whose periods are regular, and who has had intercourse recently, the first sign that a baby is on the way is usually a missed period. (Adolescent girls may miss periods for other reasons, see p. 29.)

By the time a second period has been missed, other signs of pregnancy may be noticeable. For example, enlarged breasts, darkening of the skin around the nipples, more frequent passing of urine, constipation, and possibly feelings of nausea (sickness).

When the mother is four months pregnant, it will begin to show as her waistline enlarges. At this stage, the baby is still very tiny, and the increase in size is due to the uterus becoming much bigger.

Pregnancy tests

HCG (human chorionic gonadotrophin) is present in the urine of pregnant women, and reaches its highest level at the 8th week of pregnancy. It can usually be detected from 10 days to 16 weeks after conception, but this varies in different women and with different brands of pregnancy test.

INFECTIOUS DISEASES

Most minor infections such as colds do no harm to the unborn baby, but a few infectious diseases can cause problems and action should be taken to avoid them during pregnancy.

The earlier in pregnancy that infection occurs, the more serious the possible effects on the fetus.

Rubella (German measles)

This disease is dangerous in the first four months of pregnancy. The mother will not be very ill, but the baby may be harmed. If it survives, it may be born deaf, blind, have heart disease or a learning disability.

Most women are immune (protected against the disease) when they become pregnant because they had rubella as a child or have been vaccinated against it. A blood test early in pregnancy checks to see if the mother is immune. If she is not, she will be advised to avoid children with rashes and to keep well away from any known cases of rubella. The mother cannot be vaccinated against the disease until after her baby is born.

Chicken pox

I've got shingles

Most women are immune to this disease. If it is caught during pregnancy, the mother may become quite ill and the unborn baby could be affected with brain damage as well as severe skin problems. Pregnant women are therefore advised to avoid children with rashes or who are known to have chicken pox. They should also avoid adults with **shingles** as this is caused by the same virus.

Animal-borne diseases

A rare disease called **toxoplasmosis** can be caught from cat faeces and soil contaminated by faeces. The disease is usually harmless in a pregnant woman with perhaps a mild flu-like illness, but if it passes to her unborn baby it can damage the nervous system, particularly the eyes. To prevent toxoplasmosis, pregnant women are advised to wash their hands thoroughly after handling cats and kittens and to wear gloves when cleaning out the litter tray and when gardening. This disease can also be caught from handling raw meat.

Pregnant women are also advised not to help with lambing or come into close contact with newborn lambs or with sheep that have recently given birth. If they do so, they may be at risk from **chlamydiosis** (a lambing disease) which could cause them to miscarry.

A

B

C

D

E

Milk-borne infections

Drinking unpasteurised milk should be avoided during pregnancy because it may contain bacteria or other organisms which can cause illness. Only milk which has been heat-treated, i.e. pasteurised, sterilised, or UHT (ultra-heat-treated) is recommended. This advice also applies to milk from goats and sheep.

Listeriosis

This is a rare disease which, in its mild form, resembles influenza. It is caused by a species of bacteria (*Listeria monocytogenes*) which is able to grow in certain foods at normal refrigerator temperatures. It is important to avoid this disease during pregnancy because even a mild attack in the mother can result in miscarriage, stillbirth, or severe illness in the newborn baby. Pregnant women should therefore avoid:

F

- soft cheeses, e.g. Brie, Camembert, and blue-veined cheese
- pâté
- 'cook-chill' meals, unless they have been heated until piping hot throughout
- meat which is not cooked thoroughly, particularly chicken.

HIV and AIDS

Current evidence suggests that an HIV positive mother in good health and without symptoms of the disease is unlikely to be adversely affected by pregnancy. However, one in six children born to HIV positive mothers is likely to be infected. HIV positive mothers may also pass on the virus through breast milk (see also p. 49).

MEDICINES, DRUGS AND ALCOHOL

In a strictly technical sense, medicines are drugs – a drug being any substance which has an effect on the working of the body. However, in general conversation the words tend to be used rather differently – medicines are used for the treatment of disease and drugs are taken for their effect on the mind, and we shall use the words in this sense.

Medicines

When medicines are taken by a pregnant woman, they are likely to cross the placenta and reach the baby. There is a chance that the medicine will interfere with the baby's normal pattern of development. If this happens the baby will develop abnormally. There is a greater chance of this occurring during the first three months after conception than later.

Medicines known to be harmful to the baby include travel-sickness pills and some antibiotics. To be on the safe side, no medicines should be taken during pregnancy, except on the advice of a doctor.

Drugs

When the word 'drug' is used, it usually refers to a habit-forming (addictive) substance which affects the mind. Examples are cannabis, LSD, ecstasy, crack, cocaine, heroin and the fumes from some solvents and glues. If taken by a pregnant woman these drugs almost always cross the placenta and may cause the baby to be deformed, or to be born addicted to the drug. The baby will then suffer dreadful withdrawal symptoms shortly after birth, in the same way that an adult addict suffers, and may suffer severe long-term damage.

Alcohol

This may be thought of as a tonic or a pleasure, but it is also a drug. Like the substances mentioned above, it can be both habit-forming and affect the mind.

When a pregnant mother has an alcoholic drink, the alcohol crosses the placenta and the baby takes in alcohol as well. It is unlikely that an occasional drink will harm the developing baby, but regular drinking of even moderate amounts of alcohol could interfere with the growth and development of the unborn baby. A pregnant mother who is an alcoholic can give birth to a baby who is also addicted to alcohol and who may suffer severe long-term damage (fetal alcohol syndrome).

SMOKING

When a pregnant woman smokes, some of the chemical substances in the smoke pass from her lungs into the bloodstream, and soon reach the uterus. At the placenta, the chemicals cross from the mother's blood into the baby's bloodstream. They are then carried to all parts of the baby's body.

Two of the harmful chemicals in smoke that reach the baby's bloodstream are:

- nicotine – makes the baby's heart beat too fast
- carbon monoxide (the same poison as in car fumes) – takes the place of oxygen in blood. The baby receives less oxygen and does not grow as well as expected.

Effects of smoking

Pregnant women who smoke have an increased risk of having:

- a miscarriage
- a stillborn baby
- a pre-term baby
- a low-birthweight baby.

Pre-term and low-birthweight babies are more prone to illness and infections.

Passive smoking

After babies are born:

- Those exposed to tobacco smoke are more at risk of cot death (see p. 74).
- Children who regularly inhale smoke are more likely to suffer from asthma, bronchitis, pneumonia or other chest infections, ear infections and glue ear. About 17,000 children under five years old in England and Wales are admitted to hospital each year due to illnesses caused by their parents smoking.

Children who live in a home where there is a smoker are more likely than average to become smokers themselves when older.

To protect the baby

The best way to protect the baby is for a pregnant mother to give up smoking. If she cannot break the smoking habit, she can reduce the harmful effects by:

- cutting down the number of cigarettes she smokes to as few as possible
- smoking less of each cigarette
- not inhaling
- taking fewer puffs.

My mother stopped when I started

Lucky you!

QUESTIONS

1 a Before a woman becomes pregnant, she is advised to include foods containing folic acid in her diet. Why?

b Name five foods containing folic acid.

c Name another source of folic acid which women who hope to become pregnant are advised to take.

d For how long into pregnancy should these be taken?

2 a How does a woman know she is pregnant? Name six signs which may be present.

b At what stage can pregnancy be detected by a pregnancy test?

c What can be expected to happen to the mother's figure when four months pregnant?

3 a **(i)** When is rubella a dangerous disease to catch? **(ii)** What damage may it do? **(iii)** Why are most women immune? **(iv)** If a pregnant woman is not immune, what advice will she be given?

b Explain why a pregnant woman should avoid each of the situations shown in the drawings A–F on pp. 40–41.

c **(i)** What causes listeriosis? **(ii)** Why is it dangerous during pregnancy? **(iii)** Which foods should pregnant women avoid?

4 a **(i)** Why are pregnant women advised not to take medicines? **(ii)** Name two types of medicine known to be harmful to the baby.

b **(i)** Name seven substances which are used as drugs. **(ii)** Name two effects which drugs of this type can have on the baby in the uterus.

c Name two characteristics which drugs and alcohol have in common.

d Name two effects which alcohol can have on the baby in the uterus.

5 a Name two harmful chemicals in smoke and say why each is harmful.

b Use these words to complete the sentences below: body chemicals uterus lungs placenta bloodstream

When a pregnant woman has a cigarette, – – - from the smoke in her – – – pass into the bloodstream. They soon reach the – – -, cross the – – -, enter the baby's – – – and are then carried to all parts of the baby's – – -.

c Give four increased risks to the baby when the mother smokes during pregnancy.

d What is the cause for concern when babies are smaller than they ought to be?

e Name four ways of reducing the effects of smoking.

FURTHER ACTIVITIES

EXTENSION

If the unborn child in the drawing on page 43 could understand the effects that his mother's smoking might be having on him, why would he say 'lucky you'? How does smoking affect birth-weight, brain development and health? When the child gets older, what may encourage him to become a smoker? Make a list of your suggestions.

INVESTIGATION

IT2.3 Carry out a survey (see pp. 355–356) of the following facilities in your district:

- antenatal clinics
- maternity hospitals
- dentists
- Child Health Clinics
- parent and toddler groups
- playgroups
- Health Centres
- parks
- playgrounds.

Use a word processor and graphics program to produce an information leaflet for new parents. Include a map of the district showing the positions of the various facilities. Comment on the ease of access to these places (are they near bus routes, car parks etc.?)

Revision Exercise 9

Pregnancy is a normal and natural process, and necessary for the survival of the human race. It is not an illness, and the expectant mother does not need to be treated like an invalid. Nevertheless, she does need to keep healthy for the sake of her unborn baby and herself. Also, she has to adjust to the various changes that take place in her body as the pregnancy proceeds.

Changes will take place in the mother's:
- **size**, **shape** and **weight**
- **hormones** (substances which help to regulate the way the body works)
- **emotions** (she will feel different)
- **way of life** (at least in the latter part of pregnancy).

SICKNESS

Hormone changes are responsible for the **nausea** (feeling sick) and **vomiting** (being sick) from which many women suffer during the early stages of pregnancy. The symptoms may occur throughout the day, or just in the mornings or in the evenings or during the night. They may be experienced on only a few occasions or at the same time every day, but they rarely last beyond the 15th week of pregnancy.

DIET

When a woman is pregnant, she does not need to eat much more than usual, and certainly not enough for two – she would get far too fat. The developing baby will take what food it requires, and the mother will suffer if she eats too much or too little.

It is *what* the mother eats that is important. Her diet needs to contain extra protein, vitamins (particularly folic acid – see p. 39) and minerals for the baby, also extra fibre because expectant mothers are prone to constipation. She does not need extra carbohydrate and fat. Fried foods and spicy foods should be avoided if they lead to indigestion. Also, foods which could cause listeriosis should be avoided (see p. 41).

Odd tastes and cravings
It is quite common during pregnancy for a mother's tastes in food to change. She may have the urge to eat the oddest foods at the most unusual times, especially in the early months. Often she dislikes things she used to enjoy such as tea, coffee, alcohol and cigarettes.

Heartburn
This is not indigestion, but a strong burning sensation in the chest due to stomach acid passing up into the oesophagus (gullet). It is common in later pregnancy due to relaxation of the valve at the entrance to the stomach. Large meals, particularly late in the evening, should be avoided. Heartburn may be eased at night by lying propped up or even sitting up.

EXERCISE

Regular exercise is good for everyone, including expectant mothers. It keeps the muscles in a healthy condition, and helps to bring restful sleep at night. The right type of exercise during pregnancy is the sort the mother *wants* to do: maybe walking, swimming, cycling, dancing. But, like everything else at this time, it should be done in moderation.

Pelvic floor exercises

The pelvic floor (the floor of the abdomen) is composed of muscles which surround the vagina and the openings from the bowel and bladder. These muscles come under great strain in pregnancy and childbirth, and special exercises can help to strengthen them. Slack pelvic muscles are one of the main reasons for the leaky bladder which some women suffer from after pregnancy.

Good posture before pregnancy

POSTURE

The increase in weight in the abdominal ('tummy') region alters the normal balance of the body. When walking there will be a tendency to hollow the back and to waddle and plod along. To avoid this, the spine needs to be kept upright and the head erect. It is particularly important at this time to bend the knees and not the back when lifting a heavy weight.

REST

During the latter part of pregnancy, the increase in weight puts more strain on the legs, feet and back. A rest in the middle of the day helps to prevent problems like backache, varicose veins and over-tiredness.

Bad posture in pregnancy, which may cause backache

Varicose veins

These are veins which have become stretched and swollen. This may sometimes happen to veins in the legs during pregnancy. The legs may then ache. This condition is made worse by standing still for long periods of time.

Resting now and again with the feet up takes the pressure off the veins, reduces the swelling, and makes the legs feel better. If the veins are uncomfortable or painful then it may be helpful to wear elastic tights (support tights) or support stockings. Support stockings need to be specially measured to suit the individual. They will not cure varicose veins but they may relieve the discomfort.

The condition of the veins almost always improves after the baby is born, although it may not completely disappear.

Good posture in pregnancy

VISITING THE DENTIST

Contrary to popular belief, teeth do not lose calcium during pregnancy, even when the mother's diet is short of calcium. However, they are more prone to decay and the gums may become a little swollen and spongy and may bleed more easily than usual. A visit to the dentist for a check-up at an early stage is advisable, and again after the baby is born. Dental treatment is free during pregnancy and for one year after the birth.

MATERNITY CLOTHES

During pregnancy, the breasts enlarge and the abdomen expands greatly. The mother will therefore need clothes which are expandable or loose around the waist, and a larger, properly fitted bra with good support, and a cup that does not squeeze the nipple. The bra should have wide straps and adjustable fastenings.

Feet may ache or swell slightly in pregnancy, so it helps to wear shoes which are comfortable. They should also be designed to give support to the foot, and have low or medium heels. Shoes of this type help the mother to keep her balance as well as helping to prevent backache.

A good support bra, loose clothing and flat shoes are comfortable during pregnancy

QUESTIONS

1 a Nausea is common in the early weeks of pregnancy. What is the cause?
 b Does it always occur in the morning?
 c Is it likely to occur throughout pregnancy?
 d Explain what is meant by heartburn.

2 a Does an expectant mother need to eat for two?
 b What substances should she make sure she eats enough of?
 c What substances should be avoided?
 d Do some mothers have cravings for odd foods at this time?

3 a Give two reasons why regular exercise is good for expectant mothers.
 b Give examples of the types of exercise that an expectant mother can do if she wants to.
 c Explain why pelvic floor exercises are recommended for pregnant women.

4 a Which parts of the body are particularly affected by the increasing weight?
 b What problems does a daily rest help to prevent?

5 a What are varicose veins?
 b What can make varicose veins worse?
 c What is the advantage of resting with the feet up?
 d What may also help to relieve the discomfort?

6 a Why should an expectant mother have a dental check-up?
 b When should she visit the dentist?
 c For how long is dental treatment free?

7 Describe types of clothing suitable during pregnancy.

FURTHER ACTIVITIES

IT2.2 **EXTENSION**

1 Study the posture drawings on p. 46. Describe the difference between 'good' and 'bad' posture. How does posture affect walking?
2 Use a word processor and a desk-top publishing program (if available) to prepare an information sheet for expectant mothers about some aspects of good practice during pregnancy. This could be done as a group exercise or by students individually.
3 Use a spreadsheet to analyse the cost of a maternity bra, trousers, shirt, and dress by comparing prices from four different sources.

DESIGN

Collect some pictures of clothes and shoes suitable for wearing during pregnancy. Design (see p. 358) some styles yourself and comment on their suitability.

Revision Exercise

10

Antenatal (*ante* = before, *natal* = birth) care is given throughout pregnancy, either at an antenatal clinic, or with the mother's own doctor (GP) or community midwife. This is to make sure that the baby is developing properly and to prevent things going wrong during pregnancy or the birth. The mother also has the opportunity to ask questions and talk about any worries.

The first antenatal visit takes place between the 8th and 12th week of pregnancy. Further check-ups usually take place once a month until about the 30th week. Then more frequent check-ups are needed. Employers are required by law to allow women to receive paid time off from work for antenatal care.

WHAT HAPPENS AT THE CLINIC

On the first visit to the antenatal clinic, a medical history is taken to discover any relevant information which may affect the health of the mother or her baby. The mother will have a general physical examination including a check on her heart and lungs.

Weight check

Apart from the first few months, a pregnant woman gains, on average, about 450 g in weight per week. In total she puts on about 12 kg. The increased weight is due to the baby plus the greatly enlarged uterus, the placenta, umbilical cord, and amniotic fluid. In addition, extra fat may be stored in the layer under the skin. This fat will be used in milk production after the baby is born.

The mother's weight may be checked on every visit to the clinic. If she puts on too much weight, she will be advised to adjust her diet.

Blood tests

It is routine for a small sample of blood to be taken from the mother to check for the following:

1. **Anaemia** – This condition is common in pregnancy and makes the mother feel tired and weak. The usual treatment is to take iron and folic acid (iron-folate) tablets.
2. **Blood group** – This is essential information if a blood transfusion should be needed in an emergency.
3. **Rhesus factor** – Most people have this factor in the blood, and the blood is termed Rhesus positive. Those who do not have it are Rhesus negative.

 The Rhesus (Rh) factor is inherited and problems can arise in families when the father is Rh positive and the mother is Rh negative. If the children are Rh negative like their mother there is no problem. The first Rh positive baby will usually be all right. But a second Rh positive baby may have anaemia and jaundice, may be mentally handicapped, or may even die. Further Rh positive babies would also be affected. The problem can nowadays be avoided. Rh negative mothers can be given an injection when 28 weeks pregnant, and again after birth, to prevent the build-up of harmful substances in her blood which could damage her babies.

4. **Immunity to rubella (German measles)** – If the blood test shows that there are no antibodies against rubella, it means the mother is not immune to the disease. After the baby is born, she will be offered a rubella vaccination for long-term protection.
5. **Hepatitis B** – This liver disease can infect the baby unless special care is taken.
6. **HIV** – Pregnant mothers are recommended to have this test as it is the only way to tell if they may be infected with this virus. It is important to know if the mother is infected because:
 - she can then receive treatment for HIV
 - the birth can be managed in a particular way in order to reduce the risk of the baby being infected.

Without treatment one baby in six born to HIV infected mothers is likely to be infected. With treatment this can be reduced to one in a hundred.

Blood pressure check

Blood pressure check

The mother's blood pressure is checked at every visit to the clinic. If it rises too high then she must rest, possibly in hospital.

High blood pressure (hypertension) may be a sign of **pre-eclampsia** (toxaemia of pregnancy). This condition occurs only during pregnancy, and disappears as soon as pregnancy is over. As well as high blood pressure, symptoms include swollen ankles and the gaining of too much weight. One of the benefits of regular attendance at the antenatal clinic is that pre-eclampsia will be diagnosed in the early stages. Steps can then be taken to prevent it from becoming worse. Should the condition be allowed to continue, the mother may develop a kind of epilepsy (eclampsia) at the end of the pregnancy. This can be fatal to the baby and also to the mother. Fortunately it rarely occurs nowadays.

Urine test

At every antenatal visit a sample of urine is tested for:
- sugar (glucose) – if present it may indicate diabetes
- protein (albumin) – if present it may indicate infection of the kidneys or bladder, or be an early sign of pre-eclampsia.

It is not very likely that either of these substances will be present. If they are, further tests will be made so that early treatment can be given if needed.

Vaginal examination

On the first visit to the antenatal clinic, the mother's vagina may be examined:

■ **to check that there is no infection**, for example, thrush
■ **to obtain a cervical smear**, in order to detect early warning signs of cancer of the cervix (rare in pregnant women, but more common in later life).

Towards the end of pregnancy, a vaginal examination may be performed to check that the pelvic outlet will be big enough for the baby's head to pass through.

Examination of the uterus

By gently feeling the outside of the abdomen, it is possible for the doctor to get some idea of the baby's size and position in the uterus. Towards the end of pregnancy, it is important to know if the baby is in the best position to be born, that is, with the head downwards so that it comes out first. Should the baby be in the 'breech' position (p. 60), the doctor may try to turn it so that the head points downwards.

Baby's heartbeat

In the second half of pregnancy, the baby's heartbeat can be heard through a stethoscope, pinard or doppler machine placed on the mother's abdomen. It will be beating between 120 and 160 times per minute, which is much faster than the mother's heart.

Doppler – a hand-held ultrasound machine

Pinard – a type of ear trumpet that magnifies sounds made by the baby's heart.

Ultrasound scan

Ultrasound – sound at a higher frequency (pitch) than can be heard by the human ear – is used to produce pictures of the baby in the uterus. Information can be obtained about the baby's size, age, and position; also about the position of the placenta and whether twins are present. A scan can be carried out at any stage of pregnancy, usually between 16 and 20 weeks.

A **nuchal translucency scan** may be carried out at 11–14 weeks of pregnancy to measure the amount of fluid at the back of the baby's neck (**nucha** – the nape of the neck). If the amount of fluid is higher than normal there is a risk that the fetus has Down's syndrome, and further tests will be carried out.

Ultasound scan

At 12 weeks
Note the
- placenta
- head
- body
- lower limb
- amniotic fluid
- uterus wall

At 19 weeks
Note the
- face
- heart
- spine

At 28 weeks
Note the
- ear
- neck
- upper limb
- lower limb

Ultrasound scans

Chorionic villus sampling (CVS)

With this test, a small piece of the placenta is removed and the cells examined. It is carried out from 11 weeks of pregnancy on women whose babies are at high risk of having Down's syndrome or certain inherited diseases, e.g. sickle cell anaemia or thalassaemia. Results from CVS take three to five days.

Triple test

This blood test is sometimes carried out at about 16 weeks of pregnancy to help in the detection of babies with Down's syndrome and spina bifida. The levels of three substances in the mother's blood are measured. Two of the substances are hormones (HCG and oestriol) and the third is a protein (**AFP** – alpha-fetoprotein). This protein is made by the baby and passes into the mother's blood. The levels of these three substances are used in combination with the woman's age to estimate the risk of her baby having Down's syndrome. A high level of AFP indicates an increased risk of spina bifida. The triple test does not make a diagnosis of these disorders but indicates if further tests such as amniocentesis are needed.

Amniocentesis

This test may be carried out when the triple test or the ultrasound scan indicate that there could be a problem with the baby's development. A hollow needle is inserted through the mother's abdominal wall and into the uterus to obtain a sample of amniotic fluid (the water surrounding the baby). By examining this fluid and the cells from the baby which it contains, it is possible to detect spina bifida and chromosome disorders such as Down's syndrome. Amniocentesis is usually carried out at 16 to 18 weeks of pregnancy, and the results take three weeks.

Cordocentesis

This test involves removing a small sample of blood from the umbilical cord. It is only carried out after 20 weeks of pregnancy if a scan taken at this time shows a possible problem with the baby's development, which could be due to a chromosome disorder (see p. 122).

PREPARATION CLASSES

Many hospitals and clinics hold preparation classes. They are especially useful for mothers who are expecting their first baby. At these classes they find out about:

- diet and health in pregnancy
- how the baby develops
- how it will be born, and how to prepare for labour
- different types of pain relief available during labour
- breast-feeding
- how to look after the new baby.

The mothers may also be taught special exercises to help with breathing and relaxation, for use when in labour. Controlling the breathing during a contraction and being able to relax between the contractions helps to make the birth easier.

Fathers are welcome at many of these classes. The father is often the person who can give the greatest help and encouragement to the expectant mother. Understanding the progress of pregnancy will enable him to be even more interested and helpful. If he plans to be present at the birth, he needs to be prepared for what is going to happen and know how he can be of support.

Preparation for breast-feeding

Mothers should be encouraged to breast-feed because breast milk is the natural food for babies. They should certainly do so for the first two weeks (the baby will receive colostrum, see p. 82), and ideally for several months. There are very few mothers who do not produce enough milk to breast-feed, but some may need advice and encouragement, especially if they come from families where breast-feeding is not popular.

QUESTIONS

1 a What is the meaning of the word 'antenatal'?
 b (i) What is the purpose of antenatal care? **(ii)** How often should check-ups take place?

2 a (i) What is the average total weight gain in pregnancy? **(ii)** What is the average weekly gain?
 b Name six factors which contribute to this increase in weight.

3 a Name six tests which are routinely carried out on the mother's blood, and give a reason for each.
 b Why is it important for a pregnant mother to have an HIV test?
 c (i) Name three symptoms of toxaemia of pregnancy. **(ii)** Why is this condition dangerous?
 d Name two tests which are carried out on the mother's urine, and give reasons.
 e Give two reasons for a vaginal examination.

4 a (i) How can the doctor tell the difference between the baby's and mother's heartbeats? **(ii)** Compare the doppler machine with the pinard and describe how each is used.
 b What information can be obtained from an ultrasound scan?
 c (i) What is the purpose of the 'triple test'? **(ii)** What may a high level of AFP in the mother's blood indicate?
 d (i) Briefly explain the difference between amniocentesis, cordocentesis and chorionic villus sampling. **(ii)** Why may these tests be carried out?

5 a How may preparation classes be useful to the mother of a first baby?
 b Why may breathing and relaxation exercises be taught at these classes?
 c Why are fathers welcomed at these classes?
 d Give reasons why mothers are encouraged to breast-feed.

FURTHER ACTIVITIES

INVESTIGATION

1 Find out more about:
 a Antenatal clinics in your area.
 b Preparation classes.
 c Rhesus problems in pregnancy and what can be done to prevent them.
 d The ultrasound scan and its uses.

2 Attendance at antenatal clinics
Prepare a questionnaire (see p. 356) and use it to find out from mothers of young children in your area: **(i)** Whether they attended an antenatal clinic (Yes or No).
If they attended the clinic: **(ii)** The month of pregnancy in which they first attended (2nd–9th). **(iii)** How convenient it was to attend (a scale of 1–5). **(iv)** How worthwhile the visits were (a scale of 1–5).
If they did not attend the clinic: **(v)** The reason for not attending. **(vi)** Did they receive any other type of antenatal care or advice?
Enter your survey answers into a database file and use it to analyse the results.

N2.2c

Revision
Exercise
11

12 ARRANGEMENTS FOR THE BIRTH

Opinions vary about whether home or hospital is the best place for a mother to give birth. Most doctors and midwives consider that hospital is the best place for the delivery because it is the safest place to be if problems should arise. On the other hand, some people take the view that a home delivery is likely to be a happier event, and therefore better for the mother and for the future wellbeing of the child.

Sometimes the mother has no choice. She may have to go into hospital for the birth because of medical or other reasons, or because the local doctors will deliver babies only in hospital. However, should a mother wish to have her baby at home, midwives are required by law to care for her there. If any help is needed, the midwife will summon a doctor or send for an ambulance to transfer the mother to hospital.

HOSPITAL DELIVERY

Delivery in hospital is definitely advised for higher-risk mothers who:
- are having their first babies
- are under 17 or over 35
- are expecting a multiple birth, e.g. twins, triplets
- have had three or more children previously
- have already had a Caesarian section
- have Rhesus negative blood
- have medical problems such as diabetes or high blood pressure
- have inadequate home conditions
- begin labour prematurely.

HOME OR HOSPITAL?

Mothers who have the choice of home or hospital should take the following points into consideration when deciding which they prefer.

Advantages of a hospital delivery
1. Trained staff are present all the time.
2. Special monitoring equipment is there to check the baby's health and safety throughout labour.
3. Other equipment is immediately available in the event of an emergency.
4. The mother has the opportunity to rest and relax after the birth while the nurses share responsibility for the baby.
5. The mother is free from domestic responsibilities and worries.
6. The mother is protected from too many visitors.
7. There are other mothers to talk to and share experiences with.

Advantages of a home delivery
1. The mother is in familiar surroundings, amongst family and friends.
2. She will be attended by the doctor and midwife she knows.
3. Any other children in the family can be involved in the exciting event.
4. She will have more privacy than in a ward with other women.
5. She will be able to choose the conditions in which she gives birth.

6. She will not have to keep to the hospital routine of meals etc.
7. She will be able to look after her baby in her own way.

Hospital and home

A common scheme which combines the best of both is for the birth to be in hospital and for the mother to return home a day or two afterwards. She then comes under the care of the community midwife. This can work well provided that the mother does not have all the domestic responsibilities immediately she comes out of hospital. She should have someone in the home with her, 24 hours a day, for the first seven days after delivery.

The domiciliary scheme (**domino scheme**) also combines home and hospital. The mother is visited at home by one of a small group of midwives who goes to hospital with her and delivers the baby. If both mother and baby are well, they go home after a few hours with the midwife, who continues to care for them until the health visitor takes over.

HAVING A BABY AT HOME

The room in which the birth will take place should have:
- a bed for the mother
- a plastic or polythene cover over the mattress
- a cot for the baby
- a table for the equipment of the midwife and doctor
- adequate light and heating
- a cover over the carpet for protection
- a wash basin or bowl and jugs of hot and cold water
- disinfectant
- a bucket for used dressings.

The midwife will bring her own delivery pack containing items such as sterilised instruments, towels and cotton wool.

PREPARING A BIRTH PLAN

Some hospitals or midwives ask mothers to complete a questionnaire, detailing their preferences for pain relief, any special conditions they desire, whether they would prefer not to have artificial help such as induction etc.

MEDICAL STAFF

Midwife

This is a nurse who is specially trained in the care of pregnancy and childbirth. About three-quarters of all babies born in Britain are delivered by midwives. Besides being present during labour, they undertake the antenatal care of a normal pregnancy, and also the postnatal care for up to 28 days after delivery. They either work in the maternity department of a hospital or in the community looking after mothers and babies in their own homes.

Obstetrician

This is a doctor who specialises in pregnancy and childbirth. Obstetricians attend antenatal clinics to check the health of expectant mothers. They also attend the births of babies born in hospital when there are likely to be any complications such as a breech birth or Caesarian section.

Gynaecologist

This is a doctor who specialises in the functions and diseases of the female reproductive system. Gynaecologists are usually also obstetricians.

Paediatrician

This is a doctor who specialises in the care of children from the time they are born. The medical check-up given to babies born in hospital will be carried out by a paediatrician.

QUESTIONS

1 a Give seven advantages of a hospital delivery.
 b Give seven advantages of a home delivery.
 c Describe two schemes which aim to combine the advantages of **a** and **b**.
 d Name nine groups of women for whom a hospital delivery is definitely advised.

2 How should a room be prepared for a home delivery?

3 a What is the job of a midwife?
 b What is the difference between an obstetrician and a gynaecologist?
 c What is a paediatrician?
 d Which type of hospital doctor would you expect to find **(i)** in an antenatal clinic, **(ii)** carrying out a check-up on a newborn baby?

Revision Exercise

12

FURTHER ACTIVITIES

INVESTIGATION
What are the aims of the National Childbirth Trust? There are branches in different parts of the country. Where is your nearest branch? Find out about the branch and the activities it organises (see p. 341).

EXTENSION
Use the figures in the table below to construct a bar chart comparing home and hospital births in the 40 years between 1959 and 1999.

Percentage of births by place of delivery in England and Wales					
	1959	1969	1979	1989	1999
Hospital	64	84	98	99	98
Home	36	16	2	1	2

What changes do you think took place during these years to allow nearly all births to take place in a hospital? Give at least three suggestions.

13 BIRTH

The baby in the drawing is ready to be born. It is lying in the correct position with head downwards. During the last few weeks, the mother may have felt her uterus contracting from time to time as it prepared for birth.

As the mother goes through the process of giving birth she is said to be in **labour**. It is probably called 'labour' because the mother's muscles have to work hard to open the cervix and push the baby through the birth canal. Every birth follows its own particular pattern and timetable, usually taking between four and twelve hours.

A midwife will be present to help the mother and assist in the birth. A doctor may also be present.

A placenta (afterbirth)
B uterus (womb)
C backbone
D amniotic fluid
E cervix (neck of uterus)
F vagina
G pelvis (hip bone)
H plug of mucus

Ready to be born

HOW TO ESTIMATE THE DATE OF DELIVERY

Delivery is another name for childbirth. Pregnancy lasts on average 38 weeks from the date of conception. The actual date of conception is often unknown, but is likely to have been about two weeks after the first day of the last period. The estimated date of delivery (**EDD**) can be worked out in two ways:

1. By adding 40 weeks to the first day of the mother's last period. Or:
2. By adding nine calendar months and one week to the first day of the mother's last period.

However, the baby usually arrives a little earlier or later than the estimated date.

THE THREE STAGES OF LABOUR

Stage 1: The neck of the uterus opens
When the mother notices one or more of the following signs she will know that labour has started:
- **A show** – This is a small discharge of mucus mixed with blood. It has come away from the cervix where it formed a plug.
- **Rupture of the membranes (breaking of the waters)** – The amniotic fluid (bag of water) in which the baby has been developing breaks, and the fluid is released.

■ **Regular and strong contractions occur** – These contractions of the uterus start very slowly, perhaps every 20–30 minutes. They then become stronger, regular and more frequent.

During the first stage of labour, contractions of the muscles in the wall of the uterus gradually open the cervix. The membranes rupture at some time during this stage, either at the very beginning of labour, or later on. The first stage is the longest stage of labour and it comes to an end when the cervix has opened wide enough for the baby's head to pass through.

The first stage of labour

Different women will find different positions the most comfortable for labour. Some lie on their back, sometimes propped up by pillows, some lie on their side, some prefer to crouch or kneel for at least part of labour.

Stage 2: The baby passes through the birth canal

The uterus, cervix and vagina have by now become one continuous birth canal. The contractions are very strong and they push the baby head-first through the birth canal. The mother must help to push. When the baby's head emerges from the vagina it is called **crowning**.

Crowning

When the baby's head has emerged, the midwife may clear mucus from the nose and mouth. The baby may then start to breathe, and even to cry, before the rest of the body comes out.

The midwife or doctor now eases the shoulders through the birth canal and the baby slides out into the world.

Sometimes the opening to the vagina will not stretch enough for the head to pass through. A small cut is then made to widen the opening and prevent the skin from tearing. This minor operation is called an episiotomy.

Stage 3: The baby becomes a separate person

Once the baby is breathing, the umbilical cord is clamped in two places and a cut is made between them. This separates the baby from the mother. Clamping the cord prevents bleeding. Cutting the cord does not hurt either the mother or the baby.

When the baby first appears, the skin is a bluish colour. As soon as breathing starts, the skin quickly turns pink (this shows that oxygen is being obtained from the air).

The contractions continue until the placenta (afterbirth) becomes separated from the wall of the uterus and has been pushed out through the vagina. The mother may be given an injection of **syntometrine** to speed up the process and to prevent excessive loss of blood. Labour is now completed.

End of stage 2

The baby is separated from the mother

The placenta is pushed out

This woman in labour has been linked to a monitor which keeps a continuous check of the baby's heartbeat, and the time and strength of the contractions. This information is valuable in helping to make labour as safe as possible for the baby

PAIN RELIEF

Labour is usually painful. There are a number of ways in which the pain can be relieved:

■ **Relaxation and breathing exercises** (taught in antenatal classes) help to make labour easier for many women, especially during the first stage.

■ **Aromatherapy** may be of help in the first stage of labour. A few drops of certain oils such as lavender or camomile can help to relieve anxiety, fear and pain.

■ **Gas-and-air** (Entanox®) is often offered to the mother towards the end of the first stage of labour, when the contractions are very strong. A gas such as nitrous oxide ('laughing' gas) is mixed with oxygen. The mother inhales the mixture through a mouthpiece attached to the gas supply.

■ **Pethidine** – an injection of this pain-killer may be given if the contractions become very uncomfortable.

■ **Epidural anaesthetic** – this is injected into the lower part of the spine. It stops the pain by blocking the nerves that carry painful sensations from the abdomen to the brain (all pain is felt in the brain).

■ **TENS** (Transcutaneous Electrical Nerve Stimulation) is a method of relieving pain in labour. It works by reducing the intensity of the pain messages which the body sends from the uterus, cervix and vagina to the brain. At the same time, it increases the amount of a hormone (called endorphin) which the body produces as its own natural response for dealing with pain. Four pads are strapped to the mother's back at the start of labour. These are connected to a hand-held device which the mother operates as necessary during contractions.

AFTER THE BIRTH

The baby

The newly born baby is handed to the mother so that she can hold the baby closely to her. If she wants, she can put the baby to her breast. It is comforting for the baby to be cuddled and loved, and it gives the mother her first opportunity to begin to get to know her new baby. At one minute and five minutes after birth, the APGAR test is carried out (see the table below). The baby is also given a dose of vitamin K to prevent a rare bleeding disorder (see pp. 64 and 235). After being weighed, measured and cleaned, the baby will spend much of the first day sleeping.

The **APGAR Score** is used to assess the health of a new-born baby by evaluating 5 vital signs. A high score indicates a healthy baby. A low score warns that urgent attention is needed.

APGAR test

Signs	In a healthy baby
Heartbeat	over 100 per minute
Breathing	good (not noisy)
Activity	active movements
Colour	pink (not blue)
Refex response to touch on foot or nostril	responds to touch by crying, sneezing, coughing

The mother

Giving birth is hard work. After it is all over, the mother will want to rest and sleep for a while to recover. The uterus shrinks back to size in the days following the birth, and this is speeded up by breast-feeding. Eventually the uterus will be almost the same size as it was before the baby was conceived. Bleeding from the place in the uterus to which the placenta was attached continues until the wound has healed. It may take up to 6 weeks to heal completely.

OTHER WAYS OF BEING BORN

Breech birth Babies are usually born head first. Occasionally they are born bottom first, and this is called a breech birth. Delivery is more difficult and may need to be assisted by forceps or a vacuum extractor.

Forceps delivery Special forceps (like large tongs) fit over the baby's head and are used to ease the baby through the birth canal. A forceps delivery may be necessary when the contractions are not strong enough to push the baby out, or when the baby is lying in an awkward position, or there are other difficulties. The baby's head may look a little bruised afterwards but it soon returns to normal.

Vacuum extraction (ventouse delivery) A rubber suction cup is attached to the head of the baby and gently pulled. This may be used instead of forceps.

Most hospitals are happy to have the father present at the birth. When this happens, the mother, father and baby are all together as a family from the very first moment

Caesarian section This is an operation to remove the baby from the uterus. It is carried out when the birth canal is too narrow, the umbilical cord is around the baby's neck, the baby is very late, or the health of the baby or mother makes immediate delivery necessary. An incision is made through the abdominal wall and into the uterus so that the baby can be removed. The umbilical cord is cut, the placenta is then removed and the uterus and abdominal wall are sewn up. The operation takes about 20 minutes.

Epidural anaesthetic is commonly given for this operation. The mother remains conscious and the father can be present at the birth to support her. When the mother is given a general anaesthetic she will be unconscious while the baby is being delivered.

Induction Induction means that the process of labour is started artificially. It may be possible to do this by breaking the waters. A 'drip' may also be given to the mother through a vein in her arm. The drip contains the hormone **oxytocin** which stimulates the uterus to start contracting. The birth may be induced when the baby is very late, or when the health of the mother or baby is at risk.

QUESTIONS

1 a Give another word which means childbirth.
 b What is meant by EDD?
 c If the first day of the mother's last period was 9th December, work out the EDD using both ways mentioned in this topic.
 d What is the process of giving birth called?
 e What three signs indicate that labour has started?

2 a List briefly the three stages of labour.
 b **(i)** Which is the longest stage? **(ii)** When does it come to an end?
 c Name the three parts that together make the birth canal?
 d What is crowning?
 e At what stage may the baby start to breathe?
 f How is the baby separated from the mother?
 g When is labour complete?

3 Describe ways in which the pain of childbirth can be relieved.

4 What is meant by **(i)** breech birth, **(ii)** forceps delivery, **(iii)** venthouse extraction, **(iv)** induction, **(v)** Caesarian section?

5 a What is the purpose of the APGAR score?
 b Give five signs shown by a healthy baby.

FURTHER ACTIVITIES

EXTENSION
 a Copy the diagram of the birth position on p. 57. Add the correct labels for A–H.
 b Study the diagrams on pp. 58 and 59. Describe what is happening in each of the diagrams.

INVESTIGATION
A drug-free childbirth is ideal from the baby's point of view. On the other hand, drugs ease the pain for the mother. Find out more about the advantages and disadvantages of the use in childbirth of:
 a pethidine
 b epidural anaesthetic
 c TENS.

Revision
Exercise
13

14 POSTNATAL CARE

The word **postnatal** refers to the first days and weeks after the baby is born (*post* = after, *natal* = birth).

MIDWIFE

The mother will have help from a midwife for the first ten days after the birth. If she is in hospital, she will be looked after by the midwives there. If she is at home, a midwife will call daily.

HEALTH VISITOR

The health visitor will call to see the mother and baby at home about ten days after the birth. She will call from time to time after that. The purpose of her visits is to:

- advise the mother on how to keep herself and her baby healthy
- check that the baby is making normal progress
- advise on feeding
- advise the mother to attend a baby clinic
- discuss a timetable for immunisation
- give help and guidance on any emotional problems
- put the mother in touch with other mothers locally and with postnatal groups.

She will also tell the mother how she can be reached when the parents want advice, for example because the baby will not feed, or will not stop crying, or is vomiting, or has a sore bottom, or spots, or if there is any other matter which is worrying the parents. Health visitors are trained nurses with some experience in midwifery and extra training in family health and child development.

FORMALITIES AFTER THE BIRTH

Notification of the birth The local Health Authority must be notified of every birth within 36 hours. This is usually done by the doctor or midwife present at the birth.

Registration A baby has to be registered by the parents within six weeks of birth (or three weeks in Scotland). The name under which the child is to be brought up must be given to the Registrar of Births. A **birth certificate** will then be issued. If the parents are married to each other, either of them can register the child. If they are not married to each other:

- Both parents can together register the child, and details of both parents will be entered on the birth certificate.
- The mother or father can register the child on her or his own. Details of the other parent can be entered on the birth certificate provided the correct documents (declarations, court orders etc.) are given to the Registrar.
- The mother can register the birth on her own, but not give any details of the father. It is possible for the child to be re-registered at a later date and the father's details entered on the birth certificate.

Some hospitals arrange for the local Registrar of Births to visit the hospital so that the baby can be registered before going home. Otherwise, the parents must visit the office of the Registrar of Births.

Parental Responsibility (PR) All mothers automatically have parental responsibility, which gives them full legal responsibility for their child. If the father is married to the mother, he will also automatically have parental responsibility. If the parents are not married, the father will not have parental responsibility and will not legally be allowed to make important decisions about the child. To change this situation he must specifically request parental responsibility from the Registrar.

Medical card When a baby is registered, the parents are given a card to take to their family doctor. This enables the baby to be registered with the doctor and to receive an NHS medical card.

PKU test

THE BABY

Examination of the baby Every newborn baby is given a routine examination, usually the day after birth and in the presence of the mother. A doctor examines the baby's eyes, listens to the heart, checks the mouth for cleft palate, and looks to see if an extra finger or toe is present. Other checks include testing the movement of the hip joints for **congenital dislocation of the hip**. If a dislocated hip is discovered, the baby will require hospital treatment to correct the hip joint to prevent the development of a permanent limp. The genitalia of a male baby are also checked.

PKU test (Guthrie test) When babies are 7 to 9 days old, they are tested for a rare disorder called PKU (phenyl ketonuria). The test involves pricking the baby's heel and collecting a few drops of blood on a test card. If PKU is discovered, the baby is put on a special diet and will then be able to develop normally. When PKU is left untreated, the brain becomes damaged and the child will have learning difficulties. (PKU is a metabolic disorder – the baby is unable to metabolise a chemical called phenylalanine which is present in milk and other foods.)

Thyroid function test This test is carried out at the same time and in the same way as the PKU test. The object is to check that the thyroid gland is producing the hormone thyroxine. This hormone is needed for normal growth and development. A child who lacks thyroxine will be undersized and have learning difficulties. This condition can be prevented by giving the child regular doses of the hormone from an early age. The photographs on the left show a baby aged 3 months just before thyroxine treatment began, and aged 6 months, now normal and healthy.

Before and after thyroxine treatment

Hearing test It is now possible to test new babies (neonates) for deafness. The **neonatal audiological screen test** is used for babies at high risk of deafness, for example if the parents are deaf or the baby was very premature.

Vitamin K It is recommended that breast-fed babies are given a second dose of vitamin K at 10 days and a further dose at 6 weeks. This is unnecessary for bottle-fed babies as vitamin K is added to baby milk.

Umbilical cord During the week to ten days following the birth, the stump of the umbilical cord attached to the baby dries and shrivels. It then drops off to leave the navel (belly button).

THE MOTHER

Besides looking after the baby, the mother also needs to care for herself. The baby needs a healthy, happy mother who:

- has a suitable diet
- does not get over-tired
- does not worry too much about domestic chores
- is able to relax for a while each day
- has the energy to play with and talk to her baby and to take him or her out for outings.

Postnatal exercises Pregnancy greatly stretches the muscles of the abdomen and afterwards they are very loose and floppy. The muscles of the pelvic floor (those in the groin) are also loosened and stretched during delivery. All these muscles will gradually improve and tighten. Special postnatal exercises will help them to regain their shape more quickly.

Postnatal examination This takes place when the baby is about 6 weeks old and is carried out either at the hospital or by the family doctor. The baby is examined to make sure he or she is healthy and making normal progress. The mother is examined to make sure she is healthy and that the uterus has returned to its normal state.

Re-starting the menstrual cycle The time at which periods start again varies considerably, and may be six months or longer after the birth if the mother is breast-feeding. It is possible to become pregnant before the periods return. It is also possible to become pregnant while still breast-feeding, although conception is less likely.

Baby blues and postnatal depression During the week following the birth, commonly between the third and fifth day, it is quite usual for the mother to feel miserable and depressed without knowing why. This period of mild depression is often called the 'baby blues'. Reasons for it include:

1. **Hormones** which controlled pregnancy and childbirth have not yet settled back into their normal pattern of activity and they are making the mother feel 'out of sorts'.
2. Tiredness due to disturbed nights and busy days.

3. Reaction to the excitement of the birth – now it is all over, life seems to be a constant round of feeding, changing nappies and washing.

It helps the mother:
- if she can talk to someone about how she feels
- to ask for advice
- to know that these feelings are quite common in new mothers
- if she can get plenty of rest.

An attack of the 'baby blues' should pass in a few days. If it develops into long-term depression (**postnatal depression**) then this is something rather different and needs the help of a doctor.

THE FATHER

The father can play an important role in supporting the mother in the days immediately following the birth. He may wish to take **paternity leave** (time off from work for fathers of newborn babies). He will then be able to spend more time in helping with the care of the mother and baby, and general household tasks.

CHILD HEALTH CLINICS

These are usually referred to as **baby clinics**. They are run by the local Health Authority or general practitioners (GPs – family doctors) and are held at regular times every week. Parents can please themselves whether they go or not, but clinics do have the following advantages:

- A doctor and health visitor will be present to examine the baby and check that normal progress is being made.
- A record will be kept of the baby's progress and weight.
- Advice can be obtained about any problems such as feeding, weaning and skin rashes (but the family doctor is still the person to consult when the baby is ill).
- Advice is given about immunisation.
- Developmental checks are usually given at about 6 weeks, 8 months, 18 months and 3½ years.
- It is a good place for parents to meet and get to know other parents with children of the same age.
- It may be possible to buy baby foods at a lower price, also second-hand clothes and equipment.

Parent-held records New parents are given a **Personal Child Health Record (PCHR)** in which they can keep a record of their child's health, growth and development. The parents fill in details about the child (address, name of family doctor, progress etc.). Doctors and other health staff fill in medical details (about immunisation, height and weight records, hearing tests, health problems etc.). The book also contains information and advice which parents could find useful (when to call a doctor, feeding a baby, teeth care etc.).

1 a Why does a health visitor come to see the mother and baby?
 b The health visitor is likely to suggest that the baby is taken to the baby clinic. What are the advantages of going to the clinic?

2 When a doctor examines a newborn baby: **(i)** Who else is also present? **(ii)** Name four checks the doctor will make. **(iii)** If a dislocated hip is discovered, why is treatment necessary?

3 a **(i)** Describe a PKU test. **(ii)** How can PKU be treated?
 b Why is it important that PKU should be treated?
 c Two photographs of the same baby are shown on p. 63. Explain the baby's condition at **(i)** 3 months, **(ii)** 6 months.
 d What is the purpose of the neonatal audiological screen test?
 e Why is a dose of vitamin K recommended for breast-fed babies at ten days old but not for those who are bottle-fed?

4 a Name four ways a mother can help care for herself.
 b In what way will the baby benefit from having a healthy, happy mother?
 c Which two sets of muscles regain their shape with the help of exercises?
 d Give three reasons why a mother may suffer from 'baby blues'.

5 a When does the postnatal check-up take place?
 b When will the mother's periods return?
 c Is it possible to become pregnant before the periods return?
 d Is it possible to become pregnant while still breast-feeding?

6 a By what age does a baby's birth have to be registered?
 b What name has to be given to the Registrar of Births?
 c Who has parental responsibility for the child?
 d What two items will be issued for the baby?

7 a **(i)** What do the initials PCHR stand for? **(ii)** Who holds this record?
 b Give six examples of the type of details the record will include.

8 **(i)** Who is entitled to parental leave? **(ii)** How long is it? **(iii)** When can it be taken?

INVESTIGATION

Arrange a visit to a Child Health Clinic. Make a list of all the activities that take place there.

DISCUSSION

C2.1A In your opinion, what are the points for and against **(i)** an expectant mother working up to the seventh month of pregnancy; **(ii)** a mother returning to employment about two months after the birth? Contribute to a class discussion on this topic.

DESIGN

Draw a plan of a room which is to be used as a nursery for a young baby. Mark in the position of the cot and heater. What other equipment and furniture would you have in the room? Give reasons for your decisions.

EXERCISES

Exercises relevant to Section 2 can be found on p. 345.

Revision Exercise 14

CARING FOR BABIES

THE NEW BABY

Until two hours ago, the baby on the previous page had spent all his life inside his mother. She had provided him with food, breathed for him, removed (excreted) his waste products, kept him warm and protected him from damage and disease. Suddenly, at the moment of birth, the baby is on his own. He is now a separate person who can move freely and has to breathe, feed and excrete for himself.

SIZE OF A NEW BABY

People who are not used to looking at newborn babies are always surprised at their smallness. Three measurements are taken immediately after birth – weight, length and head circumference. They are used as the starting points for measuring the child's growth.

1. **Weight** – The birth-weight of **full-term** babies (those born at the full term of about 40 weeks) varies considerably around the average of about 3.5 kg for boys and a little less for girls. Full-term babies may weigh as little as 2.25 kg, or as much as 6.5 kg. (Birth-weight is discussed further on pp. 70–71.) Babies usually lose weight in the first few days of life and do not regain their birth-weight until the second week.
2. **Length (height)** – The length of a new baby is difficult to measure accurately. The average length of a full-term baby is about 50 cm.
3. **Head circumference** – The average head circumference of a full-term baby is about 35 cm.

Reasons for the variations in size of full-term babies include the following:

- small parents tend to have smaller babies and large parents tend to have larger babies
- first babies tend to weigh less than brothers and sisters born later
- boys are usually larger than girls.

SHAPE

This drawing shows the shape of the new baby. The head is very big compared to other parts of the body. The legs are very short. The abdomen (tummy) is large. A layer of fat under the skin of full-term babies gives the legs, arms and body a plump appearance.

The stump of the umbilical cord can be seen. As it dries out, it will shrink and drop off within a week to ten days after birth.

When resting on his back, a newborn baby lies with his head to one side. Often, the arm and leg on the face side are out-stretched and the opposite arm and leg are bent. The soles of the feet are turned inwards.

HEAD

Hair The amount and colour of the hair on the head at birth varies from baby to baby. Some babies have a lot of hair – much more than the baby in the photograph on p. 67. Often the hair which the baby is born with falls out in a few weeks or months. The new hair which grows to replace it may be a different colour.

Eyes Many babies have blue-grey eyes at birth, although babies with brown skins may have brown eyes. The baby will be several weeks old before the parents know for certain what colour the eyes are going to be.

Soft spot There is a soft spot, **fontanelle**, on the top of the head where the four pieces of bone which make up that part of the skull have not yet joined together. Parents may notice that the soft spot pulsates (moves up and down) with the beat of the heart. This is normal and is caused by the blood being pumped through the artery underneath. There is no need to worry about touching the soft spot when washing the baby's head. It is covered by a very tough membrane which protects the brain underneath.

SKIN

Vernix At birth. the baby's body is covered with a greasy, whitish substance called the vernix, which protects the skin while the baby is in the uterus. It is also thought to give some protection against infection after birth. For this reason, in some hospitals babies are not bathed until they are several days old.

Lanugo If the baby arrives early, the skin may be covered by a fine layer of hair called lanugo, which is normally shed during the last two weeks in the uterus. It will come off by itself soon after birth

The stork bite on this baby's forehead can be seen in the photograph on p. 67.

Milia

Many newborn babies develop small, whitish-yellow spots on the face, particularly the nose. They are known as milia or milk spots and are the blocked openings of the oil glands in the skin. These spots will disappear quite quickly of their own accord.

Jaundice

At least half of all newborn babies develop jaundice on the second or third day after birth. The skin and eyes become tinged with yellow and remain yellow for three to four days. It is normal and harmless and usually no treatment is necessary.

Birth marks

There are different kinds of birth mark. Most are harmless, need no treatment, and disappear with time. **Red blotches** on the skin of the upper eyelid, on the middle of the forehead, and on the back of the neck, will disappear within a few years. They are often called **stork bites**. (The old wives' tale is that this is the place where the stork's beak gripped the baby when it was being delivered to the mother.) **Strawberry marks** are another type of birth mark. They appear a few days after birth as bright red raised areas, and may get bigger for up to six months. They gradually fade and will be gone by 5 to 10 years of age.

BIRTH-WEIGHT

Babies born at	Average birth-weight
28 weeks	1.5 kg
32 weeks	2.0 kg
36 weeks	2.6 kg
40 weeks	3.5 kg

Low birth-weight babies are those who weigh 2.5 kg (2500 g) or less at birth. The reason is likely to be one or more of the following:
- **the baby inherits a small size**, probably because one or both of the parents are small – these babies are perfectly normal
- **the baby is born prematurely** and therefore has not had time in the uterus to grow to full size
- **shortage of food while in the uterus**, which prevents the baby from growing at the normal rate.

Low birth-weight babies in the last two groups need special care. They will be weaker and less able to cope with the stress of being born, and then of living an independent existence outside the uterus. These babies may therefore need to be kept for a while in an incubator.

A baby who grows more slowly in the uterus than is normal is said to be **'small for dates'** or **'light for dates'**. This may be due to:
- the mother being underfed during pregnancy
- the mother smoking during pregnancy (see pp. 42–43)

- pre-eclampsia (see p. 49)
- the mother regularly drinking alcohol in large quantities
- drug addiction
- a problem with the baby's development in the uterus, e.g. rubella infection or a malfunctioning placenta.

AGE STAGES

When the following terms are used, they usually relate to children of the age range indicated:

- **perinatal** – from about the 28th week of pregnancy to 1 month after birth
- **neonatal** – from birth to 4 weeks
- **infant** – from 4 weeks to 1 year
- **young baby** – the first 6 months
- **older baby** – from 6 months to 1 year
- **toddler** – from 1 year to 2½ years
- **pre-school** – from 2½ to 5 years.

QUESTIONS

1 a What does 'full-term' mean?

 b For what period of a child's life does the term neonatal apply?

 c Describe what is meant by the following: **(i)** fontanelle, **(ii)** vernix, **(iii)** lanugo, **(iv)** milia.

2 a What measurements are taken at birth?

 b What are the average measurements of full-term babies?

 c What factors may account for the variations in size of full-term babies?

3 Need parents be alarmed if their new baby:

 a is covered with a fine layer of hair

 b is not bathed immediately after birth

 c has red blotches on the skin of the eyelids, forehead or back of the neck

 d develops jaundice a day or two after birth

 e develops milk spots

 f develops a strawberry mark?

Explain why in each case.

4 a What is a 'low birth-weight' baby?

 b Give three main reasons for low birth-weight.

 c Give six possible reasons why a baby is 'small for dates'.

FURTHER ACTIVITIES

EXTENSION

1 Draw a diagram of a newborn baby and describe its shape.

2 Find pictures of newborn babies to accompany your notes. Study them and make a note of any differences between the babies.

3 Use the conversion data below to convert the five metric measurements on p. 68 and the average birth weights on p. 70 into imperial measurements.

N2.2a

 1 kilogram (kg) = 2.2046 lb
 1 centimetre (cm) = 0.3937 in

INVESTIGATION

N2.2c Carry out a survey (see pp. 355–356) of the birth-weights of at least 20 children to find out how closely your results agree with the average birth-weights given on p. 70.

CHILD STUDY

If possible, ask the parents what the child was like when born and record the information.

Revision Exercise 15

Although basically helpless, newborn babies are able to do many things besides cry. There are times when they sleep and times when they are awake. They can move their arms, legs and head. They can stretch, yawn, hiccup, sneeze and make many other movements. They are also able to receive a certain amount of information from the world around them through their senses – sight, hearing, taste, smell and touch.

MOVEMENTS

Babies display a number of movements called **reflexes** or **reflex actions**. Movements of this kind are inborn and made automatically without thinking. The diagrams illustrate six reflexes shown by newborn babies.

A **Swallowing and sucking reflexes** – When anything is put in the mouth, the baby immediately sucks and swallows. Some babies even make their fingers sore by sucking them while still in the uterus.

B **Rooting reflex** – When gently touched on the cheek, the baby's head turns as if in search of the nipple.

C **Grasp reflex** – When an object is put in the baby's hand, it is automatically grasped.

D **Walking reflex** – When held upright with the feet touching a firm surface, the baby will make walking movements.

E **Startle reflex** – When the baby is startled by a sudden loud noise or bright light, the hands are clenched, the elbows are bent to bring the forearms in, and she may cry.

F **Falling reflex ('Moro' reflex)** – Any sudden movement which affects the neck gives the baby the feeling that she may be dropped. It makes the baby fling back her arms and open her hands, then bring the arms together as if to catch hold of something.

Some of these reflexes are necessary for a baby to survive, for example, sucking and swallowing. Others might have been more useful at an earlier stage of human evolution. For example, it is thought that the grasp reflex dates back millions of years to the time when our ancestors lived in trees. Grasping would have enabled the young animal to cling to its mother's fur or to a branch of a tree.

These reflexes mainly disappear by the age of 3 months and are replaced by actions which the baby has to learn. For example, the walking reflex disappears long before the baby learns to walk.

THE SENSES

Sight Newborn babies can see. Their eyes focus at a distance of about 20 cm, so they are short-sighted. They see most clearly those things which are near to them, for example, the mother's face when she is holding or feeding her baby. They also notice brightness, e.g. they will look towards a brightly lit window, or shut their eyes when a bright light is suddenly turned on. Sight is discussed in Topic 30.

Hearing Newborn babies can hear. They respond to sounds by blinking, jerking their limbs, or drawing in breath. They may stop feeding at the sound of a sudden noise. If crying, a baby may become quiet and appear to listen when someone speaks to her, and soon learns to recognise her mother's voice. Hearing is discussed further in Topic 31.

Smell and taste Babies are sensitive to smell and taste. An unpleasant smell makes a baby turn her head away. The baby will also indicate if she finds a taste pleasant or unpleasant. When near her mother's breast, she smells the milk and may try to get her mouth to it.

Touch New babies can feel. They are sensitive to touch and pain and change of position. They will cry if the bath water is too hot or too cold. They will be comforted by contact with another human being, as happens when they are held close and cuddled.

SLEEP

Many newborn babies spend most of their time asleep, waking at intervals to be fed. The amount of sleep varies from baby to baby, and often from day to day. Some sleep 20 out of 24 hours, whilst others spend much more time awake. It is impossible to say how long a baby should sleep at any one time. It could be for five hours, or perhaps only for an hour.

Very young babies cannot help falling off to sleep, and it can be difficult or impossible to wake them. But by 9 months old, sleep has become more of a voluntary process, and they have some control over whether they stay awake or not.

Pattern of sleep At first, newborn babies do not have a regular pattern of sleep. Gradually, as they become aware of daylight and the sounds of movement around them, sleep starts to fall into a pattern. They begin to sleep less during the day and more at night, although some babies decide that night-time begins at 10 p.m. or later. Many babies are sleeping through the night by the age of 3 months. They will still have one or more naps during the day, and may continue to need sleep in the daytime for several years.

Sleeping position It is recommended that young babies are placed on their backs for sleeping, with the head turned to one side. This allows any milk brought up to trickle out of the mouth. The sleeping position is only important until babies are able to turn over and move around in the cot. They can then take whichever position they prefer.

Cot death This is a sudden and unexpected death of a baby who has shown little or no sign of illness. Cot death is rare, usually affects babies between 1 and 5 months old, and can occur anywhere and not just when babies are in their cots. In some cases a postmortem reveals the cause. Cases that have no explanation are registered as **Sudden Infant Death Syndrome (SIDS)**. To reduce the risk:

- **Lay babies on their backs**. Babies put to sleep face downwards are more at risk of cot death.
- **Keep babies away from tobacco smoke**. Babies whose parents smoke before and after birth are three times more at risk of cot death.
- **Do not let babies become overhot** with too high a room temperature (see p. 76) or too much bedding or clothing, especially if the baby is feverish.
- **Breast-feed** if possible, because breast milk contains antibodies which help to protect the baby against infections.
- **Seek medical advice** quickly if the baby seems unwell.

QUESTIONS

1 a What is the name given to movements which are inborn and automatic?
 b Name six such movements shown by newborn babies.

2 a Name the five senses.
 b For each of these senses, give an example which indicates that it is already functioning in a newborn baby.

3 a How much time does a newborn baby spend asleep?
 b Does a newborn baby have a regular pattern of sleeping?
 c By what age is a baby likely to **(i)** be sleeping through the night, **(ii)** have some control over whether she sleeps or stays awake?

4 a **(i)** Which is the recommended sleeping position for young babies? **(ii)** Why should babies not be placed on their fronts for sleeping?
 b What other advice is given to help reduce the risk of cot death?
 c What does the acronym SIDS stand for?

Revision Exercise

16

FURTHER ACTIVITIES

EXTENSION

1 What is a newborn baby able to do? Make a list of as many things as you can think of. Add drawings or photographs to show some of these.

2 A reflex action can be defined as an automatic response to a stimulus. Continue the table below, describing the reflexes mentioned in this topic.

Reflex action	Stimulus (cause of movement)	Response (movement which follows)
Grasp reflex	Something is placed in the hand	It is automatically grasped

INVESTIGATION

N2.1 Record the sleep patterns of one or more babies and/or young children over several weeks. Present the information as a diagram and compare it to information in another source such as a textbook.

CHILD STUDY

Find an opportunity to look at a very young baby. Describe the appearance and movements of the baby. If possible, compare this baby with other babies of about the same age.

17 THE NEEDS OF A BABY

Every baby has certain needs. Some of these are essential for the baby to survive and to grow and develop physically. Others provide favourable conditions in which the child can thrive emotionally, socially and intellectually. Table 1 lists the needs of a baby and the main topics of this book in which they are discussed.

Table 1

The needs of a baby	Topic number
Warmth	17
Food	19–21, 52, 55
Shelter	4
Clothing	24
Protection from illness and injury	60, 67–70
Fresh air and sunlight	17
Exercise and rest	16
Love and comfort	34
Continuity of care	17
Security to make the baby feel safe	35
Training in habits and skills	33, 37
Stimulation from play to help in learning	40, 41
Praise and opportunities to develop self-confidence	4

As the child gets older, the needs increase. The additional needs of an older child are given in Table 2.

Table 2

Additional needs of an older child	Topic number
Discipline which is firm but kind	36
Companions to play with	33
The opportunity to gain self-esteem	34
The opportunity to become independent	–
The opportunity to be useful to others	–
The opportunity to be successful in some way	–
The opportunity to take responsibility	–

WARMTH

Normal body temperature of both adults and children can be anywhere from 36 to 37.5°C (97 to 99°F). It varies slightly throughout the day, generally being higher in the evening than in the morning. It is also affected by the temperature of the surroundings and by exercise. Crying, too, makes a baby hot and raises the body temperature slightly. The stomach or back are a more reliable guide to the baby's temperature than the hands or feet.

A nursery thermometer enables a quick check of the temperature of the baby's room

While in the uterus, the mother keeps the baby at the right temperature. After birth, the baby is dependent on the parents and carers for protection against becoming too hot or too cold. For the first month of life, babies should be kept in a room temperature of 16–20°C, day and night. 16–20°C is a comfortable temperature for a lightly clothed adult. As babies grow larger and stronger, they gradually become more able to keep themselves warm when in a cold place, but the room in which a baby sleeps should continue to be kept about 16–20°C until the baby is several months old.

Effects of cold

Full-term babies have some protection against losing warmth from the body, as they are born with a layer of fat under the skin. This fat helps to keep the warmth in, and can also be used as fuel to supply extra heat when necessary. However, if babies are kept in a cold place for too long, they lose more heat than they can generate, and will suffer from **hypothermia** (low body heat). This condition may cause a baby to suffer from **cold injury** and can even cause death. The smaller the baby, the more quickly heat will be lost from the body.

Effects of heat

If young babies get too hot, they are not able to move away from the heat or kick off the covers. In a very warm room, or in hot weather, a young baby who is covered by too many clothes or blankets will become very uncomfortable and irritable and may develop a **heat rash** (see p. 277).

In hot weather, water is lost from the body by sweating. Excessive water loss leads to drying out – **dehydration** – of the body. This dangerous condition is prevented by ensuring that children, particularly babies, take in sufficient water in food and drinks. A very important sign of dehydration is when the soft spot (fontanelle) on the baby's head becomes sunken.

FRESH AIR AND SUNLIGHT

Babies benefit from being out of doors for a while each day, as long as they do not become too hot or too cold. Being in the fresh air helps to make them lively, improves the appetite, puts a healthy colour into the cheeks, and helps them to sleep soundly at night.

Sunlight contains ultraviolet rays which kill bacteria and also make the skin produce vitamin D. As these rays cannot pass through glass, children need to be out of doors to benefit in this way.

Tim at the seaside

Too much hot sun can easily burn a baby's delicate skin, and cause overheating. It is therefore best to keep young babies in the shade. When in direct sunlight, a sun-hat will protect the baby's head, and sun-protection cream should be used on all exposed skin.

Air pollution

Smoke from factories and fumes from vehicles pollute the air and may cause or worsen breathing problems such as asthma. The use of catalytic converters in cars has helped reduce this problem as their purpose is to change harmful exhaust gases into less harmful ones.

Lead in car exhaust fumes has also been a cause for concern. Since the year 2000, strict controls limiting the sale of leaded petrol have been in force, reducing the amount of lead particles in the air being breathed in. This has been of particular benefit to young children as they are most at risk from brain damage caused by lead poisoning.

CONTINUITY OF CARE

It is better for a baby to be cared for by a small number of people who are familiar, rather than by strangers. These carers provide a constant centre to the baby's life, giving a sense of **security** – making the baby feel safe. A baby cannot cope with meeting many new people at the same time but needs to get to know them one by one.

The mother is usually the main person who looks after the baby, but the more the father is involved the happier life can be for all. He can help the mother with the continuous and tiring day-and-night care of their new baby. At the same time, he can share the fun and interest of watching the baby develop.

Baby Tina in a city street

ROUTINE

Most young babies soon fall into a pattern of times for sleeping, being awake, and wanting to be fed. The pattern varies from baby to baby and may change quite often as the baby gets older.

The new mother may sometimes be told that it is important to have a routine – that is, set times for feeding and changing the baby and for bath time, bedtime and so on. This is sound advice if the mother fits the routine around the baby's natural pattern of behaviour. When a mother tries to make her baby feed and sleep at set times, the result can be an irritable and uncooperative baby and an exhausted mother.

When a baby becomes old enough to understand what is wanted, which will probably not be until at least the age of 1 year, then a suitable routine can be very helpful to family life and give the child a sense of security.

QUESTIONS

1 a What are the needs of a baby?
 b What additional needs does an older child have?

2 Compare the photographs on pp. 76 and 77
 a Name five possible advantages to Tim of being in the fresh air and sunshine.
 b **(i)** Name two substances more likely to be in the air being breathed by Tina than by Tim. **(ii)** In what way can lead damage children?
 c If the body temperatures of Tim and Tina were both normal, within what range would you expect them to be?
 d The body temperature of these two babies will vary throughout the day. Name four causes of such variations.
 e How may Tim behave if he gets too hot?
 f What may happen to Tina if she remains outside in the cold for too long?

3 a From the section on p.77 'Continuity of care', describe a situation which helps to give a baby a sense of security.
 b When does a routine give a baby a sense of security?

FURTHER ACTIVITIES

EXTENSION
Table 1 on p. 75 lists the needs of a baby. Taking each item in turn, give a reason why it is necessary. Do the same with the list of the additional needs of an older child, Table 2.

CHILD STUDY
How many people help to look after the child? How does the child react to them? How does he or she react to strangers?

Revision Exercise
17

18 CRYING

All babies cry – it is the only way they have of telling other people that they are hungry, lonely, bored, uncomfortable or in pain. A short cry does not harm a baby, but crying for a longer time is distressing to the baby and may worry the parents.

Babies vary in the amount they cry. Placid ones are often content to wait for quite a long time before crying for attention, whereas others scream the moment they wake up. During the first three months, some babies have a regular time of the day at which they cry, often in the evenings.

It is impossible to teach young babies to be patient by letting them cry for a long while before attending to them. At this stage they are too young to learn, and only become more distressed. During the first few months, parents need not worry about 'spoiling' their baby by picking her up when she cries. An older baby can be 'spoilt' by always getting what she wants the moment she cries for it. The baby will then begin to cry just to get her own way.

Tears are not usually shed until the baby is 3–4 weeks old. Sometimes older babies cry without producing tears and when this happens the baby is really shouting for attention.

WHY BABIES CRY

Although it is not always possible to tell why a baby is crying, parents soon learn that there are a number of reasons:

- **Hunger** – Babies vary considerably in the amount of food they need and how often they get hungry. It is usual to feed a baby 'on demand', that is at any time from about two to five hours after the last feed, whenever the baby cries and seems hungry.
- **Thirst** – Bottle-fed babies are likely to get more thirsty than those who are breast-fed. In hot weather or a centrally heated house, they may need a drink of water (boiled and then cooled) or diluted fruit juice between feeds.
- **Discomfort** – Babies cry when they are uncomfortable, perhaps because of a wet or soiled nappy, or if they are too hot or too cold, or when a bright light is shining in their eyes, or when they have wind (p. 92) or are teething (p. 261).
- **Pain** – A baby in pain will cry, maybe loudly or just a continuous whimper. When a baby cries for no apparent reason *and* behaves in an unusual way, a doctor should be consulted.
- **Tiredness** – A tired baby becomes cross and irritable (like an adult) and, in addition, shows her feelings by crying. It may be possible to soothe the baby and rock her to sleep. If left alone to cry, the baby will continue to do so until she falls asleep through exhaustion.
- **Dislike of the dark** – Some babies cry when they are put in a room to sleep and the light is turned out. It may help to leave a dim light on, but this should be discontinued when it becomes unnecessary.

A cot light may comfort the baby at night

This baby is comforted by closeness to her mother

A bouncing cradle enables the baby to see what is going on

■ **Loneliness** – A common cause of crying in babies is loneliness. They want to be picked up and cuddled and to feel close to another person. In many cultures, babies are carried in a sling on the back of their mother or elder sister. These babies cry much less than babies who spend a long time on their own in a cot or pram. Baby carriers or slings are becoming increasingly popular (see p. 110).

■ **Colic** – an abdominal pain which comes and goes is a common cause of crying in the first three months. It occurs mainly in the evenings. The baby appears to be in pain and screams for up to 20 minutes with her legs drawn up. She then stops and is just about to go off to sleep when another attack occurs. Fortunately, the colic does not seem to do the baby much harm.

These crying sessions have usually stopped by the time the baby is 3 months old – to the great relief of the parents.

■ **Boredom** – A baby will cry with boredom if she is put in her pram or cot to sleep when she would much rather be watching what is going on in the family, or playing with a toy. The extent to which a baby is liable to suffer from boredom depends on her personality. An alert and interested baby will want to be propped up in the pram, put in a bouncing cradle or carried round more than a placid and contented baby.

■ **Noise** – A sudden noise may make a baby cry.

SOOTHING A BABY

Parents can try to stop their baby from crying by rocking her up and down and making soothing noises in a low tone of voice. Low noises have a more soothing effect than high-pitched sounds. A rhythm of sounds similar to that of the adult heartbeat (about 60 times per minute) has a particularly soothing effect. The repetitive sounds and movements will help to send the baby to sleep. Audio tapes of soft music or 'whooshing' noises (similar to repetitive sounds the baby heard in the uterus) help to soothe some babies.

Baby massage

Baby massage is another way of soothing fretful or distressed babies, for example those in pain from colic or when teething. Babies are very aware of being touched, and can be calmed by the gentle, stroking hand movements of parents or carers. Guidance and advice can be obtained from health visitors, and there may also be a baby massage group in your area.

VIRTUAL PARENTING

Virtual babies (infant simulators) are computerised baby dolls programmed to cry at random intervals. The crying stops when a care key is inserted and held in place for the length of time it takes to simulate feeding, nappy-changing, bathing and comforting. The baby dolls also cry when handled roughly or abused. Their purpose is to help young adults understand that:

■ babies' demands are unpredictable and must be met promptly
■ babies require a great deal of attention
■ they change a parent's lifestyle.

QUESTIONS

Alice

1 a Look at the photograph above of baby Alice crying. Why is she crying? Make a list of at least ten suggestions.

b (i) Will leaving her to cry teach her to be patient? **(ii)** Why?

c (i) Will it spoil Alice to pick her up every time she cries? **(ii)** Might it spoil her when she gets older?

d What is meant by 'feeding on demand'?

2 a Can you see any tears in the photograph?

b Was Alice able to produce tears at birth?

c When she gets older and cries without producing tears, what will this tell her parents?

3 Perhaps Alice is crying because she has colic.

a What is colic?

b Describe how babies with colic behave.

c By what age is it usual for 'evening colic' to stop being a problem?

4 a Suggest what Alice's mother or father can do to try to soothe her and stop the crying.

b What helps to send a baby off to sleep?

c Why can massage help to soothe a baby?

5 a What is a virtual baby?

b What is its purpose?

FURTHER ACTIVITIES

INVESTIGATION

Spend a weekend in the home of a real baby, or caring for a 'virtual baby'. Record:
- the number of times the baby cries
- the amount of time spent on each of the activities of feeding, nappy-changing, bathing or comforting
- the total amount of time per day (24 hours) that the baby required attention.

DISCUSSION

How does caring for a baby affect the lifestyle of teenage parents?

MEDIA SEARCH

C2.2 Carry out a media search to find out what advice is given to parents whose babies cry a great deal. Summarise the information given, saying from which source it was obtained.

CHILD STUDY

How often does the child cry? What are the reasons for crying? What will stop the crying?

Revision
Exercise
18

Sucking comes naturally to babies. If put to the breast immediately after birth, they will usually start to suck.

At this stage there will be no milk but a yellowish liquid called **colostrum**. Besides containing water, colostrum is rich in protein. It also contains **antibodies** to protect the baby against disease. Colostrum continues to be produced in small quantities until, two or three days after the birth, it is replaced by milk. This is the right time for the baby as the appetite develops slowly. Very little food is needed in the first few days and this is supplied by colostrum.

A baby who is to be bottle-fed is usually given a bottle of infant milk soon after birth.

A mother breast-feeding her baby provides comfort as well as food

A baby held while being bottle-fed also receives comfort

MILK

Milk contains all the necessary food ingredients that a new baby needs. It is about 90% water and 10% food substances – sugar, fat, protein, vitamins and minerals (including salt). The sugar in milk is a type called **lactose** (milk sugar). Lactose is much less sweet than the ordinary type of sugar (**sucrose** – from sugar cane or sugar beet).

BREAST MILK

Breast milk is the natural milk for babies.

- **It contains the right amounts of all the necessary food substances.** As the baby grows, the amounts of the various ingredients alter to meet the changing needs of the baby. This helps the baby to grow at the right pace.
- **It contains antibodies** to help protect the baby against infections.
- **The milk is at the right temperature** – not too hot to burn the baby's mouth, nor too cold to make the baby cold.
- **It is easy for the baby to digest and absorb.**
- **It is clean and safe.** Fully breast-fed babies almost never get gastro-enteritis (sickness and diarrhoea).

COW'S MILK

Cow's milk is the natural milk for calves but is not suitable for human babies unless specially treated. It differs from human milk in having:

- different types of fat and protein
- more protein
- more salt and other minerals
- less sugar
- antibodies which help to protect a calf against disease but are no use to babies.

Cow's milk is difficult for young babies to digest. Besides having more protein, it also has a much higher amount of a particular protein called **casein**.

Casein forms curds in the baby's stomach and is difficult to digest. Little white lumps (curds) of undigested protein may be seen in the baby's stools (faeces).

Fat is present in milk in the form of droplets. Although the fat content of cow's milk and breast milk is about the same, the fat droplets in cow's milk are larger and more difficult to digest.

Cow's milk has a higher salt content The amount of salt in the body needs to be kept at a more or less constant level and this is normally done by the kidneys. However, the kidneys of a young baby are unable to remove excess salt, so if the baby takes in too much salt he or she will become very ill. This can happen if the baby is fed on undiluted cow's milk or given strong feeds, see p. 91. Salt (sodium chloride) is a compound of two elements – sodium and chlorine. It is the **sodium** which is so dangerous for young babies in large amounts.

BABY MILK (INFANT FORMULA MILK)

Baby milk is made from cow's milk and altered (modified) to make it more like human milk. Additional vitamins and iron are added. Two types of baby milk are 'first milk' and 'follow-on milk'.

First milk This is a substitute for breast milk and intended as a complete source of nourishment for the first six months of life. First milk suits nearly all babies. If they appear to dislike it, or suffer from constipation, this is most likely to be due to how the bottle of milk was prepared (e.g. with too much milk powder). Changing the baby's milk to a soya-based product should only be done after consulting a doctor, as it can be harmful to some babies.

Follow-on milk This type of milk is recommended for use from 6 months onwards. When weaning starts, milk is still an important item in the diet, even though the baby will be having a variety of other foods. Bottle-fed babies should be given follow-on milk to drink until 12 months of age to prevent any risk of anaemia.

QUESTIONS PARENTS ASK

Is the baby getting enough food? If the baby is gaining weight satisfactorily, then he is getting enough food.

Are extra vitamins required? The doctor or health visitor may recommend that babies over 1 month old be given vitamins in the form of vitamin drops or fruit juices.

- **Vitamin drops** contain vitamins A, C and D. They may be recommended for breast-fed babies. Bottle-fed babies normally obtain enough of these vitamins in baby milk.
- **Fruit juice** contains vitamin C. Unsweetened well-diluted orange juice, apple juice, blackcurrant juice and rose-hip syrup are suitable for babies.

Are extra minerals required? Milk contains all the minerals a baby needs for the first few months of life. Although milk is low in iron, a baby is born with several months' supply stored in the liver.

When can cow's milk be introduced? Cow's milk should not replace baby milk or breast milk until the age of 12 months, but it can be introduced in small quantities (e.g. on breakfast cereals, in sauces and custards) from 6 months. Milk used should be pasteurised whole (not skimmed) milk.

Is extra water needed? Breast milk contains all the water a baby needs. Unless the weather is extremely hot, and provided the baby is allowed to feed as often as he wants, there should be no need to give extra water between the feeds. Giving water between feeds may cause the baby to suck less well on the breast and therefore to receive less food. In the case of bottle-fed babies, the baby can be given water between feeds. All water given to young babies should first be boiled.

QUESTIONS

1 a Name the main substance in milk.
 b Name five other substances in milk.

2 Comparison of breast milk and cow's milk (grams per 100 ml):

	Sugar	Fat	Protein	Minerals	Water
Breast milk	7	4	1.2	0.4	90
Cow's milk	4.7	4	3.3	0.75	88

 a **(i)** Which type of milk is sweeter? **(ii)** How does milk sugar differ in taste from ordinary sugar?
 b **(i)** Is the fat content the same for both milks? **(ii)** Why is the fat in cow's milk less easy for a young baby to digest?
 c **(i)** Which type of milk has the most protein? **(ii)** Why is the protein in cow's milk less suitable for young babies?
 d **(i)** Which type of milk has a higher mineral content? **(ii)** Which particular mineral can be dangerous for young babies in large amounts?
 e **(i)** What is baby milk? **(ii)** Give the two main types of baby milk and say for what age group each is intended.

3 Give five reasons why breast milk is the natural milk for babies.

4 When a baby is held close while being fed, what else is being provided besides food?

5 a How does a mother know if her baby is getting enough food?
 b Should babies be given water between feeds if they are **(i)** breast-fed **(ii)** bottle-fed?
 c Milk has a low iron content; does a baby need to be given iron or other minerals?
 d Which vitamins are contained in vitamin drops?
 e At what age can cow's milk replace baby milk or breast milk?

Revision
Exercise
19

FURTHER ACTIVITIES

DISCUSSION
What extra problems are involved in feeding twins? How may these problems be overcome? Is it possible for a mother to breast-feed both babies?

INVESTIGATION
Note the contents of two or more different brands of baby milk. Compare them, and also compare them with breast milk and cow's milk (see question 2).

20 BREAST-FEEDING

Breast-feeding is the natural way to feed a baby. Early on in pregnancy, the breasts enlarge and start to prepare for the job of supplying the baby with milk. In the last 12 weeks or so of pregnancy they may secrete colostrum. When colostrum is first secreted it is clear and colourless; later on it becomes a yellow colour.

The baby's birth is the signal for the breasts to begin producing milk and two or three days later it starts to flow. Breast milk tends to look watery and bluish at the beginning of a feed and creamy towards the end.

HOW MANY FEEDS A DAY?

Babies should be put to the breast regularly in the first few days. They will not need or get much food, but they will enjoy sucking.

Between the third and the sixth day, babies become much more hungry and may want to be fed ten or twelve times a day (a day being 24 hours). This may be inconvenient for the mother, but it helps to establish a good supply of milk – because the more the baby sucks, the more the breasts are stimulated to produce milk.

Frequent 'demand-feeding' may continue for several weeks. After that, babies settle down to a pattern, which varies from baby to baby, but most will want to be fed about six times a day with the intervals varying from three to five hours. Gradually the interval between feeds in the night gets longer until the night feed is given up altogether. This may have happened by the time the baby is 3 months old but some babies take longer.

STRUCTURE OF THE BREASTS

Each breast contains about 20 sections (lobes) in which milk is produced from milk glands. Each section has a duct which opens on the surface of the nipple; the milk therefore comes from about 20 tiny openings. The dark area around the nipple is called the **areola**.

The size of the breasts before pregnancy depends on the amount of fat tissue and not the number of milk-producing glands. So women with naturally small breasts will be able to breast-feed just as well as those with larger breasts.

skin

milk gland

fat

reservoir for storing milk

nipple

opening of duct

areola

ADVANTAGES OF BREAST-FEEDING

1. It is **safe**.
2. It is **easy** for most mothers – there are no bottles to sterilise, or feeds to mix and get to the right temperature.
3. Breast milk **never causes indigestion** (unless the mother has been eating unwisely, e.g. eating an excessive amount of fruit, or taking certain laxatives).
4. Breast milk **contains antibodies**. In the first few months of life, and especially when newborn, babies do not have very much resistance to infections such as coughs, colds and diarrhoea. They are likely to become more ill at this age than when older, and complications are more likely to follow. Compared with bottle-fed babies, breast-fed babies get fewer infections, are less prone to severe infections, and almost never get gastro-enteritis.
5. The baby is **less likely to become overweight**.
6. The baby is **less likely to be constipated**.
7. The baby is **less likely to develop nappy rash**.
8. The baby is **less likely to develop allergies such as asthma and eczema**.
9. It is **cheaper**.
10. Breast-feeding gives time for a **bond of attachment** to develop between mother and baby. A mother who breast-feeds spends a long time each day in very close contact with her baby. This gives the opportunity for a close and loving relationship to develop between them which is very important for the future wellbeing of the child.

Benefits for the mother

Besides giving the child a good start in life, breast-feeding also benefits the mother. Her uterus will shrink back to size more quickly. Her periods will take longer to return, so she may be more relaxed and contented for not being bothered by the irritable feelings often linked with menstruation. A mother who enjoys breast-feeding feels especially close to her baby.

HOW LONG SHOULD BREAST-FEEDING CONTINUE?

Many doctors advise mothers to try to breast-feed at least for the first two weeks, and ideally for six months. In the latter case, the babies are then at the right age to be weaned gradually from breast milk to a mixture of other foods. As the amount of nourishment from other foods increases, the need for breast milk decreases. Breast-feeds become fewer and smaller until either the supply of milk fails or the baby refuses to feed from the breast any more. Some mothers continue to breast-feed for a year or longer, perhaps for only one feed a day with older babies.

A baby who is fed entirely on milk beyond the age of about 6 months may find it difficult to take to new foods. If weaning (p. 247) has not started before 9 to 10 months, there is a danger of anaemia due to the shortage of iron in breast milk. The baby is born with a store of iron in the liver, which is gradually used up as the baby grows.

REASONS FOR NOT BREAST-FEEDING

A few mothers do not have enough milk to breast-feed and a few more are unable to breast-feed for medical reasons. But although nearly all mothers are able to breast-feed their babies, many choose to bottle-feed. Those who could breast-feed, but decide not to do so, give reasons which include:

'Breast-feeding will spoil my figure' – The mothers fear that their breasts will enlarge and they will not regain their former size.
- Breast-feeding does not alter the shape of the breasts permanently and they should return to normal size by about six months after breast-feeding has ceased. It also helps the mother to regain her figure because fat stored in the body during pregnancy can be used to produce breast milk.

'My baby may not get enough milk'
- Regular weighing of the baby will show whether the baby is getting enough milk.

'I feel embarrassed about feeding my baby on the breast'
- It may help to overcome embarrassment to realise that breast-feeding is nature's way to feed a baby.

'It is impossible to breast-feed if it is necessary to leave the baby for long intervals in order to go out to work'
- A compromise would be for the mother to breast-feed for the first few weeks, then change to bottle-feeding when she needs more freedom. Some mothers overcome the problem by using a breast pump to express their milk into bottles. A baby-minder can then give the breast milk to the baby while the mother is at work.

Hand-operated breast-pump

QUESTIONS

1 It is usual for a mother to start breast-feeding her baby within a few hours of birth. At this stage there is no milk but a yellowish liquid.
 a Name this liquid.
 b Name three substances which the liquid contains (see previous topic).
 c When do the breasts begin to produce milk?
 d What helps to establish a good supply of milk?
 e Between 3 and 6 days old, how often may a baby want to be fed?
 f About how many times a day will the baby want to be fed when he settles down into a pattern?

2 a Draw a diagram to show the structure of the breast.
 b Whereabouts in the breast is the milk produced?
 c Does milk leave the breast from one opening or many?
 d Before pregnancy, what does the size of the breasts depend on?

3 Give ten advantages of breast-feeding.

4 a Name three ways in which a mother can benefit from breast-feeding.
 b What is considered to be an ideal length of time for a baby to be breast-fed?
 c Name two possible effects of breast-feeding for a longer time.

FURTHER ACTIVITIES

EXTENSION
What reasons do mothers give for deciding not to breast-feed? Suggest a solution in each case.

INVESTIGATION
Carry out a survey (pp. 355–356) to find out what proportion of children were breast-fed and for how long. Present your findings in either pie charts or bar charts.

CHILD STUDY

N2.2c Find out if the child is/was breast-fed or bottle-fed. If the mother had any problems with feeding, how did she overcome them?

Revision
Exercise
20

21 BOTTLE-FEEDING

Not all mothers wish to breast-feed their babies and in a few cases they are unable to do so no matter how hard they try. The babies will then be bottle-fed. Babies will also need to be bottle-fed if a mother returns to work and the baby is being looked after by a carer. If properly bottle-fed, there is no reason why the babies should not thrive, grow and develop in the same way as breast-fed babies.

ESSENTIAL RULES OF BOTTLE-FEEDING

1. Use the right type of milk for a young baby.
2. Keep every piece of equipment scrupulously clean.
3. Follow the instructions on the container for making up the feed.
4. Give the baby similar cuddling and attention to that which he would receive in breast-feeding.

ADVANTAGES OF BOTTLE-FEEDING

Bottle-feeding has some advantages over breast-feeding:

- The mother knows how much milk the baby is taking.
- The baby can be fed anywhere. This is an advantage to mothers who would be embarrassed to breast-feed in public.
- Other people are able to feed the baby besides the mother. When the father takes a turn in giving the feed, it provides him with an opportunity to cuddle and get to know his baby.
- When the mother does not have to be present at feeding times, it means that she can return to work before the baby has been weaned.

EQUIPMENT FOR BOTTLE-FEEDING

Feeding bottle
A suitable feeding bottle is one which has the features shown in the diagram.

a wide neck for easy cleaning

made of clear material — to check that it is clean inside

graduated measurements on the side — in millilitres or fluid ounces

a cap to keep the teat clean

designed so that the teat can be placed upside down in the bottle for storage or travelling

sealing disc placed in the bottle to prevent spillage of milk

Teat

The most important thing about the teat is the size of the hole. A hole of the right size allows the milk to drip out rapidly without having to shake or squeeze the bottle. The hole readily becomes blocked by dried milk and should be tested before every feed.

When the hole is too large, it may cause the baby to choke as he tries to swallow the milk. When the hole is too small, the baby will suck so hard and for so long that a great deal of air will be swallowed. The baby will then have trouble with wind.

CLEANING AND STERILISING

Equipment used for bottle-feeding must be sterile to prevent germs getting into the milk and mouth. It can be sterilised in various ways, but first it must be cleaned.

1. Wash your hands thoroughly.
2. Clean the bottle, the teat and the cap using hot water, detergent and a bottle brush. Special care should be taken to ensure that the teat is cleaned well. A 'teat cleaner' can be used. Rinse off the detergent. Bottles and teats are easier to clean if they have been rinsed out with cold water immediately after use.
3. Sterilise the equipment in one of the following ways:

 a **chemical sterilisation** – place in a sterilising solution and leave for at least 30 minutes. Make sure that everything is completely covered by the solution and that there are no air bubbles. Metal spoons or other metal objects should not be put in the sterilising solution because they will dissolve. Fresh solution needs to be made up every day.

 b **steam sterilising** using a steamer specially designed for bottle-feeding equipment.

 c in a microwave oven by creating steam in a **microwave steriliser**.

 d by **boiling** for at least 10 minutes. This is not recommended as regular treatment for plastic bottles. They soon become rough and cloudy and may crack.

4. Wash your hands again. Remove the bottle and teat from the sterilising solution. Rinse with boiled water. Make up milk in the bottle, put the teat on, and protect with the cap.

bottle brush

keeps feeding equipment submerged in the sterilising solution

tray for holding teats, etc.

sterilising tablets

Using sterilisng solution Using a steam steriliser Using a microwave steriliser

PREPARING FEEDS

Follow the instructions on the container. Tins of baby milk carry detailed instructions on how to mix the feeds – and they should be followed precisely. The amount of milk powder and water has been carefully worked out to make the feed just right for the baby. Even if the milk seems tasteless to you, do not add extra sugar and **never** add salt.

The water used for making the feeds must be boiled and then cooled to the temperature recommended in the instructions. Too much water will make a poor feed. Too little water will make the feed too strong. It is important to measure the necessary amount of boiled water into the bottle before adding the milk powder, not to put the powder in first.

The scoop provided with the milk powder is an accurate measure when used correctly. To obtain the exact quantity, fill the scoop, then gently level off the powder with the back of a plastic knife. Do not pack the powder down, or heap it up.

Harmful effects of making the feed too strong

When using milk powder there may be a tendency to think that it is 'good for the baby' to add more powder than the instructions say. This results in a strong feed which contains too much protein and salt. A baby who is given a strong feed is likely to become thirsty and cry. The baby may then be given another feed instead of boiled water because the mother thinks that he is still hungry. If this happens often, the baby may become too fat. A worse danger is that the extra salt in strong feeds may make the baby very ill, possibly causing convulsions, coma and permanent brain damage.

GIVING A BOTTLE

When giving a bottle feed:

1. Make sure that the milk is at a suitable temperature for the baby. If the milk has come out of the fridge, it will need to be warmed up before being given to the baby. This can be done by placing the bottle in a jug of water or in an electric bottle warmer. To check that the milk is not too hot, sprinkle a few drops onto your wrist.
2. Check that the hole in the teat is not blocked.
3. Hold the baby in a comfortable position. Tilt the bottle so that the teat is kept full of milk, otherwise the baby will suck in air as well as milk.
4. From time to time, remove the teat from the baby's mouth to let air get into the bottle, otherwise a vacuum is created. When this happens the teat goes flat and no milk can pass through. If the baby continues to suck on a flattened teat he will take in air – and this will result in wind.
5. After a feed, help the baby to bring up any wind.

Electric bottle warmer

Helping the baby to bring up wind

An alternative way of helping to bring up wind

WIND

'**Wind**' is air which has been swallowed. All babies suck in air when feeding. An air bubble which forms in the stomach may cause the baby to cry with discomfort until it has been brought up.

When a baby takes too long on a feed, air will be swallowed instead of milk. If being bottle-fed, the baby may take in air because the hole in the teat is too small, or if breast-fed, because there is too little milk present.

Bringing up wind (burping the baby)

When breast- or bottle-feeding, it is usual to give the baby the chance to bring up wind. Whether this is done once or twice during the feed, or at the end, depends on what seems to suit the baby. There is no good reason for interrupting the feed while the baby continues to suck happily. Babies do not need to 'burp' with every feed – it depends on how much air they swallow.

The wind can escape more easily when the baby is held against the shoulder (a cloth on the shoulder helps to catch any milk which comes up with the wind). Gently patting the baby's back may help. Some mothers prefer to use one hand to hold the baby in a sitting position and leaning slightly forwards, the other hand gently rubs the baby's back.

Normally wind is brought up without much trouble. If the baby cries a great deal after a meal, it is likely to be due to reasons other than discomfort from wind, for example for any of the reasons mentioned on pp. 79–80.

GIVING THE BABY PLENTY OF CUDDLING AND ATTENTION

When a mother holds her baby close to her and talks and smiles at him as she feeds him from the bottle, she can feel just as loving towards her baby as a mother who breast-feeds.

Care needs to be taken to give bottle-fed babies the same amount of time to develop a bond of attachment with the mother as when breast-feeding. This will not happen if a variety of people hold the baby when he is being fed, or if the bottle is propped up so that the baby feeds himself.

The mother will feel more comfortable if she chooses a chair which supports her back and arms. If she also takes the opportunity to relax as she feeds, she will enjoy the contact with her baby as much as the baby enjoys being held close and fed.

If the baby is left to feed himself:

- there is a danger the baby might choke
- the baby is deprived of the comfort of being held close and of feeling loved and wanted
- there is no one to notice that the baby is taking in air by sucking on a flattened teat or an empty bottle
- there will be no one to help the baby bring up wind.

GASTRO-ENTERITIS

Gastro-enteritis is inflammation of the stomach and intestines. Illness of this type is rare in breast-fed babies but far too common in those who are bottle-fed. Many cases of this illness could be prevented with better hygiene, particularly when preparing bottles or dealing with nappies.

Germs which cause gastro-enteritis live in the bowel and also thrive in warm, moist food. These germs can be given accidentally to the baby when:

- the equipment used for bottle-feeding is not sterilised properly
- the water used to mix with the milk powder is unboiled
- the feed is stored in a warm place before being given to the baby
- dirty hands contaminate the teat or milk.

The symptoms of gastro-enteritis are vomiting, diarrhoea and abdominal pain, and their effect is that the baby loses too much water from the body too quickly. The body cannot function properly when it is **dehydrated** (short of water). Babies who show indications of possible dehydration – the soft spot on the baby's head is sunken, the eyes look glazed and sunken and the mouth is dry – need urgent medical attention.

QUESTIONS

1 a Suggest four advantages of bottle-feeding over breast-feeding.
 b Give four essential rules to follow when bottle-feeding.

2 a What features would you expect a suitable feeding bottle to have?
 b Why does the hole in the teat need to be the right size?
 c What test can be done to find out if the hole in the teat is the right size?
 d Describe how to sterilise feeding bottles.

3 a How should the scoop be used to obtain the correct amount of milk powder?
 b Name two substances which should not be added to a milk feed.
 c Why is a strong feed likely to make a baby thirsty?
 d What should a thirsty baby be given?
 e What is the danger of giving a baby too much salt?

4 a Describe how to give a bottle-feed.
 b Describe, in words or pictures, two ways to 'wind' a baby.

5 a Name four disadvantages of leaving a baby to feed himself from a bottle.
 b Give one reason why a baby might swallow air instead of milk while **(i)** breast-feeding, **(ii)** bottle-feeding.

6 a What are the symptoms of gastro-enteritis?
 b Why is this a dangerous illness in babies?
 c Are babies who suffer from gastro-enteritis likely to be breast- or bottle-fed?
 d Name four ways in which gastro-enteritis germs can be given to a baby.

FURTHER ACTIVITIES

DISCUSSION
Should a mother who does not breast-feed her baby feel guilty?

Revision Exercise **21A**

Revision Exercise **21B**

22 KEEPING A BABY CLEAN

It is almost impossible to keep a baby spotlessly clean all the time, nor indeed is it necessary. After a feed, babies often bring up a little milk (a posset). They frequently wet and soil their nappies. When they start to feed themselves they make a great deal of mess. This is all part of babyhood, and parents would be far too busy if they changed the baby's clothes every time they were a little soiled. There is evidence that keeping a baby too clean can prevent the baby from coming into contact with enough germs to build up immunity against disease.

The aim of parents and carers should be to keep the baby's skin, feeding bottles, clothes, bedding and other equipment sufficiently clean so as not to become a breeding ground for germs. Some of the germs which can harm a baby live in the bowel and are present in the stools. Other types of germs grow and multiply in urine. They can also thrive in milk and other foods.

PROTECTION BY CLEANLINESS

The parents and carers can protect the baby against germs by:
- keeping their own hands and nails clean – hands should be washed after visiting the toilet, changing a nappy, and before giving a feed
- careful disposal of disposable nappies
- washing terry nappies thoroughly
- regularly washing clothes and bedding
- regularly cleaning nursery equipment and toys
- not giving the baby stale food, or food which has been kept in a warm place for several hours.

CHANGING THE NAPPY

The nappy will need to be changed several times a day. Points to note are:
- The job can be done more quickly when the equipment needed is collected together first.
- The job is easier when the baby is placed on a flat surface rather than the lap – both hands are then free for nappy changing. The safest place to change the nappy is on the floor.
- Placing the baby on a changing mat or plastic sheet helps to prevent dirtying objects underneath.
- There is no need to wash the baby's bottom every time a wet nappy is removed, although wiping with wet cotton wool or a 'baby wipe' will help to prevent nappy rash. 'Baby wipes' are ready-moistened with a special solution which neutralises the ammonia from urine.

When the nappy has been soiled, any solid matter on the baby's skin should be gently removed with cotton wool or tissues. (When the baby gets older, a corner of the nappy can be used.) The skin can then be cleaned with cotton wool and warm water, or with baby wipes.

This type of changing mat with a PVC coating is an ideal surface to clean and change a baby

Make sure the skin is dry. A little 'nappy cream' may then be smoothed over the skin before the clean nappy is put on. The cream may be zinc and castor oil cream, or another type of cream, lotion or oil made for the purpose. It helps to prevent nappy rash by forming a protective layer over the surface of the skin. Cream does not need to be used at every nappy change.

DISPOSAL OF DISPOSABLE NAPPIES

Cotton wool, wipes or tissues which have been used to clean the baby's skin can be placed inside the used nappy. This is then rolled up and taped into a 'parcel' and disposed of. Special deodorising 'nappy sacks' can be bought to wrap the dirty nappy in; these are particularly useful if away from home.

CARE OF RE-USABLE NAPPIES

Re-usable nappies need to be kept clean and free from germs. After being removed from the baby, it is usual for them to be stored in a bucket with a lid while waiting to be washed. This keeps in smells and keeps out flies.

1. **Remove any solid matter** from nappies before placing in the bucket. One way of doing this is to hold the nappy under the flushing water in the lavatory. This may be unnecessary if a nappy liner has been used; remove the nappy liner and flush it away.
2. **Wash nappies** in hot water with soap or mild detergent. The water should be at least 60°C. Boiling helps to whiten nappies, but it is not necessary every time they are washed. 'Biological' detergents should be avoided as they may irritate the baby's skin.
3. **Rinse thoroughly**. All traces of soap or detergent should be removed by rinsing in several changes of clean water. Nappy softener can be added to the last rinsing water, but this is unnecessary unless the nappies have become hard, as it may cause irritation to the baby's skin.
4. **Dry**. Drying outside in the open air helps to keep nappies soft. Sunlight whitens them and also helps to destroy germs. Drying nappies on radiators or hot pipes makes them stiff.

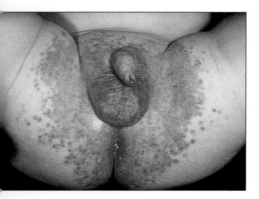

NAPPY RASH (AMMONIA DERMATITIS)

All babies will get nappy rash from time to time. The first sign is when the skin becomes red and sore in the nappy area. If the rash is not promptly treated, the skin becomes rough and septic spots may appear.

Nappy rash is caused by ammonia, and a strong smell of ammonia may be noticed when the nappy is changed. The ammonia is produced from urine when the urine comes into contact with bacteria in the stools (faeces). The same type of germs may also be present in a nappy which has not been properly washed. The longer the baby lies in a wet, dirty nappy the more time there will be for the germs to produce ammonia. The ammonia irritates the skin and a rash appears.

Breast-fed babies are less likely to suffer from nappy rash because their stools are more acidic. The acid discourages the activity of the germs which produce ammonia.

Prevention of nappy rash Nappy rash cannot always be avoided, but much can be done to prevent it. The rules to observe are:
- do not let a wet, dirty nappy remain on the baby for longer than is necessary
- apply a protective layer of a suitable cream or lotion to the baby's bottom
- leave off the nappy whenever possible
- wash cotton nappies thoroughly after they are removed from the baby
- use 'one-way' liners
- do not use tightly fitting plastic pants more than is necessary – they keep warmth and moisture in and encourage nappy rash.

Treatment of nappy rash When a baby develops nappy rash, the bottom needs to be kept as clean and dry as possible to allow the skin to recover. It is best to leave the nappy off altogether, but this is not always practical. Alternatively:
- leave the nappy off as often as possible
- use only sterilised nappies
- change the nappy as soon as it becomes wet or soiled during the daytime
- change the nappy at least once during the night
- use nappy liners
- do not use plastic pants
- apply cream every time the nappy is changed
- seek medical advice if the rash becomes wet and oozing.

OTHER CAUSES OF SORENESS

A baby's skin is very delicate and it is quite common for the bottom to become sore, however well the baby is cared for. There are a number of causes besides nappy rash. For example, a rash similar to nappy rash can develop if the soap, detergent or sterilising solution is not removed from the nappies by thorough rinsing. Nappy softener and other fabric conditioners have also been known to be the cause of such a rash.

Soreness around the anus is caused by the skin being in contact with the wet stools. It is common in very young babies and at times of diarrhoea when

older. The chances of it happening are increased by not changing the nappy frequently. For treatment follow the guidelines for nappy rash.

THE NOSE

It is necessary to wipe a baby's nose to prevent soreness or blockage of the nostrils. By the age of 2 years, children should be able to do this for themselves. It is often very difficult to get them to blow the nose, but it is a useful skill for them to learn before starting school.

THE FEET

To keep the feet healthy:

- dry thoroughly between the toes after washing
- use baby powder if there is much sweating
- put on clean socks every day
- cut toenails regularly – cut them straight across, but not too short nor down into the corners
- when shoes are necessary, it is essential that they should fit well (see p. 227).

QUESTIONS

1 a Name six ways in which cleanliness by parents helps to protect their baby.
 b Explain why there may be a danger in keeping a baby too clean.

2 Give one reason for doing each of the following when changing a baby's nappy:
 a collecting the equipment needed first
 b placing the baby on a flat surface
 c using a changing mat
 d using cream.

3 Describe how to: **(i)** dispose of disposable nappies **(ii)** wash nappies.

4 a What is ammonia dermatitis?
 b Where does the ammonia come from?
 c Name two places where germs which cause nappy rash may be found.
 d Describe what nappy rash looks like.
 e Give six rules that help to prevent nappy rash.
 f Give eight suggestions for the treatment of nappy rash.

5 Name other causes of a sore bottom apart from nappy rash. What treatment would you recommend in each case?

6 a Give two reasons for wiping a baby's nose.
 b By what age should children be able to wipe their own noses?
 c How can feet be kept healthy?

FURTHER ACTIVITIES

INVESTIGATION

1 Compare (see p. 357) the information which accompanies two brands of nappy steriliser. List the similarities and the differences.

2 a Devise experiments (see pp. 356–357) to find out **(i)** which of at least three brands of disposable nappy is able to absorb most liquid, **(ii)** whether a terry nappy or a disposable nappy can absorb the most liquid, **(iii)** the effect of a nappy liner.
 b Carry out the experiments and use the numerical data collected to support your findings.

N2.2a

Revision
Exercise

22

23 BATHTIME

When babies get used to the idea, they enjoy being bathed and this makes bathtime fun. Some parents prefer to give an evening bath as they find the activities of bathtime help the baby to sleep more soundly. Others find it more convenient to bath the baby in the morning. It does not matter which.

PREPARATIONS FOR BATHTIME

A warm room Young babies lose body heat very quickly and easily become chilled. Therefore it is important that the room in which the baby is to be bathed is draught-free and warm – at least 20°C.

Warm water

The bath water should be warm but not hot – about body temperature, i.e. about 37°C. A bath thermometer is useful for taking the temperature of the water. If this is not available, the water can be tested by using your elbow. Another thing to remember is always to put the cold water in the bath before the hot water, because if hot water goes in first, the bottom of the bath may be too hot for the baby.

Equipment

Before putting the baby in the bath collect everything needed for washing, drying and dressing the baby.

BATHTIME ROUTINE

The following routine, or one very similar, is often recommended for bathing young babies.

1. After washing your hands, undress the baby apart from the nappy and wrap her in a warm towel (**A**).
2. Test the temperature of the bath water with a bath thermometer or your elbow to check that it is right for the baby (**B**).
3. Gently wash the baby's face with wet cotton wool. Soap should not be used. The eyes should only be cleaned if infected or sticky. Wipe each eye from the inside corner outwards, using a clean piece of damp cotton wool for each eye.
4. Wash the scalp with water (**C**). Soap or shampoo only needs to be used once or twice a week. The hair must then be well rinsed, using a jug of clean, warm water for the final rinse.
5. Take off the nappy and clean the bottom with wet cotton wool (**D**). Do not try to force back (retract) the foreskin of a little boy's penis. This action is likely to tear the foreskin and make it bleed. The foreskin will gradually become able to retract, usually completely so by the age of 3 years.
6. Add some baby bath lotion (liquid soap) to the water before placing the baby in the bath. The baby needs to be held securely (**E**): note how one of the mother's hands holds the baby's shoulder, while the baby's head rests on her arm.
7. Lift the baby out onto a towel. Dry by patting gently (**F**) not by rubbing. Pay particular attention to the creases of the neck, armpits, groin, back of the knees and back of the ears. If the creases are not dried, they easily become sore. When turning the baby over to dry the back, the safest way is to turn the baby towards rather than away from you.
8. Apply nappy cream to the bottom and into creases in the skin to prevent soreness.

Cleaning the ears
Wax can be cleaned away from the end of the ear canal (ear hole), but the inside of the canal should never be cleaned. The wax is there for protection. Cotton wool buds can be useful for cleaning outside and behind the ears, but should never be poked inside. Anything which is poked into the ear canal may damage the ear drum.

Cradle cap
This is the name given to the greasy scales or crusts which form on the scalp of many young babies. It first appears around 4 weeks of age and usually clears up by itself after about 6 months. It is harmless. If it is considered to be unsightly, it can be removed by the use of a special cream made for the purpose.

Cutting the nails
The fingernails of very young babies grow quickly and need to be cut every few days. This is best done while the baby is asleep. If the nails are left to grow too long, the baby will scratch herself. With an older baby, the nails can be cut immediately after a bath.

Rounded ends for safety

Toys such as boats and plastic cups will make bathtime fun for an older baby

'TOPPING AND TAILING'

It is not necessary to bath the baby every day as long as the face, hands and bottom are kept clean by 'topping and tailing':

1. Clean the baby's face and hands with warm water and cotton wool, and then dry.
2. Clean the bottom using warm water with a little 'baby bath', baby lotion or soap and more cotton wool. Dry and then apply a nappy cream.

OLDER BABIES

When a baby is bathed in the family bath it is desirable to put a non-slip mat on the bottom of the bath. **Never leave the baby unattended** for a moment, even if she can sit steadily. Babies can drown in a few centimetres of water.

QUESTIONS

1 a **(i)** What is a suitable room temperature for bathing a baby? **(ii)** Why does the room need to be at this temperature?
 b **(i)** What is a suitable temperature for the bath water? **(ii)** Give two ways of testing the temperature.
 c Why should cold water be put into the bath before hot water?

2 List the items in the drawing on p. 98 which have been collected together in preparation for bathtime.

3 When bathing a young baby:
 a **(i)** Do the eyes need to be cleaned? **(ii)** If so, how?
 b Should soap be put on the face?
 c How often does shampoo need to be used on the scalp?
 d Why should a boy's foreskin not be forced back?
 e When a baby being held on the knees is turned over, in which direction is it safest to turn her?
 f How should a baby be held when in the bath?
 g Why should the creases in the skin be thoroughly dried?

4 a Why is it dangerous to poke anything into the ear canal?
 b What is cradle cap and how can it be removed?
 c Is it necessary to bath a baby every day?
 d Describe how to 'top and tail' a baby.

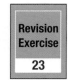

Revision
Exercise
23

FURTHER ACTIVITIES

EXTENSION
1 Describe the bathtime routine using illustrations and/or words.
2 Use a life-size doll to practise bathing a baby.

CHILD STUDY
Help to bath the child. Describe the bathtime routine and the child's behaviour when being bathed.

24 BABY'S FIRST CLOTHES

The baby's first set of clothes may be referred to as the **layette**. A new baby does not need many clothes, just enough to keep warm, but they will need to be washed frequently. In addition to nappies, the items shown in the photograph should be sufficient.

Expectant mothers often enjoy collecting items for the new baby. They may be tempted by pretty or attractive clothing. This may give the mothers pleasure, but it is not of importance to their babies. The requirements of the babies are rather different.

Requirements for baby clothes Baby clothes should be:

- loose and comfortable
- easy to put on and take off
- easy to wash and dry
- lightweight, soft and warm
- non-irritant (will not scratch or otherwise irritate the skin)
- porous (so that moisture can escape)
- flame-resistant (will not easily catch fire).

Points to remember
1. Clothing should not be tight, especially round the neck and feet. When young feet are cramped for a long while they can become deformed.
2. Avoid drawstrings and ribbons near the baby's neck – they could pull too tight and strangle the baby.
3. Avoid loosely knitted or open-weave garments – a strand of wool or nylon caught round a baby's finger or toe can cut off the blood supply.
4. Babies grow quickly and sleepsuits will not stretch indefinitely.

5. Several layers of lightweight clothing are warmer than one thick, bulky layer.
6. The amount of clothing a baby needs to wear depends on the temperature. There are cold days in summer and it is very warm in an over-heated house in winter. In hot conditions, the minimum of clothes is required, and when very hot, a nappy is all that is necessary.
7. All clothes for babies up to 3 months old *must* carry a permanent label showing whether or not the garment passes the low flammability test for slow burning (see p. 298).
8. Most new parents have a limited amount of money to spend. Therefore it is sensible to buy only the essential items required for the baby. The money can be saved until later when the baby needs more clothes:

 - in larger and more expensive sizes
 - for daytime and night-time
 - because they will get dirty more easily and more often.

MATERIALS USED FOR BABY CLOTHES

Both natural and synthetic materials are used for baby clothes.

Natural materials Two natural materials used for baby clothes are:
- **wool** – warm to wear and therefore more suitable for cold weather. Wool garments should not be placed next to a baby's skin as they are likely to cause irritation.
- **cotton** (e.g. terry towelling, muslin) – absorbent and therefore more comfortable to wear next to the skin when the body is hot, as it can absorb sweat.

Synthetic materials These are easier to wash and dry than natural materials. In general, they are cold to wear in winter because they do not retain body heat, and hot and clammy in summer because they do not absorb sweat. There are exceptions: acrylic gives warmth and viscose is absorbent. Synthetic materials include:
- **acrylic** (e.g. Acrilan®) – a bulky fabric which is soft and warm to the touch, lightweight, crease-resistant and non-irritating to the skin; used as an alternative to wool
- **polyester** (e.g. Terylene®) – crease-resistant and does not catch fire easily; used as an alternative to cotton
- **viscose** (rayon) – absorbent, retains whiteness, pleasant to handle but lacks strength
- **nylon** – very strong and does not shrink.

Many baby clothes are made of mixtures of different types of material. In this way, the advantages of different materials can be combined.

WASHING BABY CLOTHES

Most ready-made garments are machine washable. A label on each garment gives instructions about washing or dry-cleaning, bleaching, ironing and other necessary information.

Fabric care symbols

Washing

60	Maximum temperature of the water
	Bar indicates reduced machine action for synthetics
	Broken bar indicates much reduced machine action for wool
	Handwash only
	Do not wash

Bleaching

CL	Bleach may be used
	Do not bleach

Drying

	May be tumble-dried
	Do not tumble dry
	Drip-drying recommended
	Dry flat

Ironing

One dot – cool temperature

Two dots – warm temperature

Three dots – hot temperature

Do not iron

Dry cleaning

ⓅCan be dry cleaned (the letter indicates the solvent to be used)

Unsuitable for dry cleaning

Woollen garments Wool is a very useful fabric for children's clothes when warmth is required, but it needs careful washing, preferably by hand. If the water is too hot, the garments shrink. They can easily be pulled out of shape when being dried.

Cotton garments Cotton can be washed in hot water, although the colour may fade. The advantage of white cotton is that it has no colour to lose and it can be boiled or bleached when necessary to remove stains and to whiten it. See p. 95 for washing of nappies.

Synthetic materials and mixtures Follow the instructions that accompany the garments. The charts on these pages show the meanings of some of the symbols used on garment labels.

Fabric conditioners These may irritate the baby's skin.

NAPPIES

Disposable nappies These are commonly used because:

- changing the baby's nappy is quick and easy
- nappies are available in various sizes to suit the baby's increasing weight
- there are nappies for daytime and for night-time use
- stretch waistbands and sides ensure a comfortable fit
- the fastening tapes are easy to use
- the nappies are designed to keep moisture away from the baby's skin to help prevent a sore bottom
- a waterproof outer covering prevents moisture escaping from the nappy
- being disposable, the nappies are thrown away after use.

One disadvantage of disposable nappies is the cost. They work out more expensive than terry nappies, even when allowing for the cost of nappy liners and of washing and drying the terry nappies. There is also the environmental problem for Local Authorities of disposing of the vast numbers of nappies that are put into rubbish bins.

Re-usable nappies There are three main types and they need to be washed after use (see page 93):

- **Traditional terry nappies**. Each is a square of terry towelling that is folded into shape and then fastened with a curved safety pin (A). They come in one size and are worn with waterproof pants.
- **Shaped terry nappies**. These are shaped to fit neatly around the baby's bottom with easy fastening tabs (B) They come in different sizes and are worn with waterproof pants.
- **All-in-one nappies**. These are padded pants with absorbent cotton inside and an outer waterproof cover. They are sold in a variety of styles and sizes.

Nappy pin

Waterproof pants

Bodysuit

Sleepsuit

Muslin squares Because they are not as bulky as terry towelling, muslin squares may be used as nappies for very small babies. They may also be used to line terry nappies for babies with sensitive skins.

Nappy liners A nappy liner placed inside a terry nappy helps to prevent soreness by acting as a barrier between the baby's skin and a wet nappy. Liners are made of material which allows moisture to pass through but does not absorb it. So, when a liner is placed inside a terry nappy, the urine passes through to be absorbed by the nappy while the lining itself keeps dry.

Nappy pins These are large, curved and have a safety catch which is removed in order to open the pin. When putting the pin in a nappy, one hand should be kept under the nappy to prevent the baby from being pricked accidentally.

Waterproof pants These are worn over terry nappies to keep the clothes and bedding dry, and by doing so, reduce the amount of washing. But because the urine remains inside the pants, the baby's skin is kept damp and this encourages nappy rash (p. 96).

Trainer pants These are useful for older toddlers who are being potty-trained. They are made to look like real pants, are easy to pull down, and yet are absorbent like nappies. They have a waterproof covering and are ideal for use at night-time, at playgroup, and when travelling. Trainer pants can be re-usable or disposable.

Swim nappies These are waterproof nappies for babies to wear in the swimming pool or for playing in the sea.

BABY CLOTHES

Bodysuits A bodysuit is an all-in-one vest and pants which is worn over the nappy. Being worn next to the skin, it needs to be made of material which is soft and non-irritating, for example cotton. Many bodysuits have wide 'envelope-type' stretch necklines which are easy to pull on and off over the baby's head. 'Poppers' at the crotch hold the garment in position to allow for nappies to be changed easily.

Sleepsuits These cover the baby well, are easy to wash, and need no ironing. As the feet are covered, there is no need for bootees except in cold conditions. They must be loose-fitting to allow plenty of room for the baby to move. Sleepsuits are designed with poppers down the front and in the crotch. This makes them easy to put on and take off, and convenient for quick nappy changing.

Cardigan A cardigan is worn when an extra layer is required for warmth.

Bootees These are useful in cold weather. They can be worn outside a sleepsuit, or inside if there is plenty of room.

Mittens Warm mittens are essential when the baby is outside in cold weather. **'Scratch' mittens** are thin mittens which are sometimes put on to prevent the baby from scratching himself.

Hat or bonnet This is necessary in cool or cold weather. If the baby is out in hot sun then a cotton sun hat is necessary with a flap to protect the neck.

Shawl A shawl needs to be lightweight and warm. A cellular blanket makes a good shawl. The holes in a blanket of this type make it lightweight, and air trapped in the holes will hold the baby's body heat.

Pramsuits or snowsuits These are fleecy or padded, all-in-one jacket and trousers for outdoors on cold days. They usually have a hood and bootees attached.

Bibs Paper tissues or paper towels may be used as bibs and thrown away afterwards. Bibs made of terry towelling are absorbent but need frequent washing if they are to remain hygienic. Bibs made of soft plastic or plastic backed material must be securely tied around the waist as well as the neck or held in place by velcro fastenings. This will prevent the plastic from flapping over the face and causing suffocation. For the same reason, any bib should always be removed before the baby is put in his cot or pram. Bibs made of stiff plastic with a 'catch-all' pocket are for older babies (p. 253).

Snowsuit

Bib

QUESTIONS

1 List the items for a baby's first set of clothes shown in the photograph on p. 101.

2 a What are the requirements for baby clothes?
 b What points are useful to remember when choosing clothes for a new baby?

3 a Name two natural materials used for baby clothes.
 b Name four synthetic materials used for baby clothes.
 c Name two types of material suitable for wearing in cold weather.
 d Name two absorbent materials suitable for wearing in hot weather.
 e Why are baby clothes often made of a mixture of different materials?
 f Draw and describe the symbols used for washing instructions.

4 a Describe three different types of nappy. Give one advantage of each.
 b How is a nappy liner able to act as a barrier between the baby's skin and a wet nappy?
 c Describe **(i)** a nappy pin and how to use it, **(ii)** training pants, **(iii)** swim nappies.
 d Why does the use of waterproof pants encourage nappy rash?

5 a Why are bodysuits and sleepsuits useful garments for babies?
 b What are scratch mittens?
 c When is a pramsuit useful?
 d Give an advantage and a disadvantage of using a towelling bib.
 e **(i)** How should a soft plastic bib be secured on a baby? **(ii)** Why is this necessary?
 f When should a bib always be removed?

Revision Exercise 24

FURTHER ACTIVITIES

EXTENSION

1 Make a list of the items (apart from nappies and waterproof pants) you consider to be essential for a new baby. Find the cost of these items, and calculate their total cost.

2 Collect different labels from clothes, showing fabric care instructions. Describe how you would wash, dry and iron each garment.

INVESTIGATION

1 Compare (see p. 357) at least three different brands of disposable nappy. (They could be the same brands which were used in the absorbency experiment on p. 97).

 IT2.3

Use a spreadsheet to record your findings.
Set up the spreadsheet like this:

	A	B	C	D	E	F
00	Brand	Shape	Faste-ning	Pack cost	No. in pack	Unit cost
01						(D01

2 Estimate and compare (see p. 357) the costs of using towelling and disposable nappies for one year, with six nappy changes per day. Use middle-priced disposable and towelling nappies, liners, plastic pants, steriliser, washing powders etc. for your comparison. Assume that two dozen towelling nappies are used, and that they will last for two years.

EXPERIMENT

1 Devise and, if possible, carry out an experiment (see pp. 356–357) on the washability of

N2.2a
N2.3

different types of materials used for baby clothes, in relation to one or more of the following: **(i)** temperature of water, **(ii)** stain removal, **(iii)** washing powders, **(iv)** fabric conditioner. Use at least one synthetic material and one natural material.

Besides needing clothing, a baby also needs somewhere to sleep, to be bathed, to sit and to play. It is also essential to have some equipment for keeping the baby safe when necessary, and for taking the baby out to the shops or park. Some of the equipment designed for these purposes is discussed in this topic.

FOR SLEEPING

Cot

Cot

A cot of the type shown in the drawing is suitable for all babies, even when newborn. The space and safety of a cot of this type is essential after the age of about 6 months. Another advantage is that the slatted sides allow the baby to see out. The safety features to check for in a cot are:

- The bars should be between 45–65 mm apart, to prevent the baby's head being caught between them.
- The mattress should fit so that there is just enough room for the bedclothes to be tucked in. There should be no gap more than 4 cm anywhere round the mattress in which the baby's head, arms or legs can become trapped.
- Cots usually have one side which drops down, with catches to hold the drop-side in the upper position. The catch needs to be too difficult to be undone by the baby or a young brother or sister. When the baby can climb out of the cot it is time for a bed.

Cot bumper

This is a foam-padded screen which fits around the sides of the cot. It protects the baby from draughts, and from knocking his head on the sides. Alternatively, a blanket can be pinned firmly round one or more sides.

Cot bumpers are not recommended for children who can sit unaided in case they become entangled in the ribbons holding the bumper in position.

Carry-cot

Carry-cot

A carry-cot makes a suitable first bed. It is useful for the first 6 months or so, until the baby becomes too big and active to be left in it safely. The sides and hood keep out draughts, and it can be carried from room to room. If made of weatherproof material and fitted with hood, apron and wheels, a carry-cot has the added advantage of being a pram as well as a bed.

If there are cats around, a **cat net** over the carry-cot or pram will prevent one from snuggling against the baby's face for warmth and comfort.

Travel cot

This is a folding cot with fabric sides, meant for temporary use when travelling or on holiday. Some are large enough for use by toddlers, and some double as a play-pen when the mattress is removed.

Moses basket

'Moses basket'

This can be used as a bed for a young baby.

Place the baby near the foot of the cot for sleeping. This prevents the baby from wriggling down under the covers and becoming too hot or suffocating

Mattresses

These are needed for the cot, carry-cot or cradle, and pram. The baby will spend much time lying on a mattress, so it should be comfortable. A firm mattress is safer than a soft one because the baby cannot bury his head in it and suffocate. A waterproof covering on the mattress allows it to be sponged clean.

Ventilated mattresses are available which have a part with ventilation holes through which air can flow and so help to prevent any risk of suffocation. When a baby is put in the cot, the head should be placed on the part of the mattress which has the ventilation holes.

Blankets and sheets

It is better for these to be made of materials which are easy to wash and dry. Babies often dribble milk on them, or are sick, and they can also become very damp and smelly with urine after a night's sleep.

Sheets are needed to cover the mattress of both cot and pram. A minimum supply of three is required, although more will be useful as they need to be washed regularly. The material which is usually recommended when warmth is required is flannelette (brushed cotton).

Acrylic blankets, particularly the cellular ones, are lightweight, reasonably warm, and easily washable. Woollen blankets are warmer, but they do not wash so well and take much longer to dry.

Duvets and cot quilts are not recommended for use for babies under 12 months because of the risk of suffocation.

Pillow

A baby does not need a pillow for sleeping. It is safer without one because of the danger of suffocation. When a pillow is used to prop up the baby in a chair or pram, it should be firm and not soft.

If a baby needs to sleep with the head raised higher than the feet, for example if the baby has breathing difficulties due to a cold, a pillow can be placed under the mattress.

Baby monitors

These are devices which enable a baby to be monitored by the parents or carers when they are not in the same room. The device is in two parts, the **transmitter** which transmits information from the baby's room and the **receiver** which receives the information. Some monitors can be plugged into the electricity system in the home. Others are battery operated and can transmit baby noises by radio to a receiver up to 100 metres away, and so can be used both in the home or out in the garden. Monitors are also available which keep a check on the temperature of the baby's room and the baby's breathing rhythms. TV monitors enable carers to look in and listen to the baby from another room.

Baby monitor

A

Pram

B

Carry-cot and wheel base

C

Baby car seat and wheel base

D

Pushchair

FOR GOING OUT

Prams and pushchairs

Whatever type of pram or pushchair is used, or whether it is new or second-hand, it should:

- have efficient brakes
- be stable – should not tip over easily
- be easy to steer
- have anchor points for a safety harness – which needs to be used as soon as the baby can sit up
- have a basket which fits underneath where heavy shopping will not cause the pram to overbalance
- be the right height for the parent to be able to push easily without stooping and yet still be able to see where she or he is going.

Until a baby can sit up unaided for a reasonably long time a pram or pushchair which allows the baby to lie flat or almost flat will be needed, preferably one in which the baby can be placed facing the mother. This can be a traditional pram (**A**), a carry-cot which fits onto a wheel base to form a pram (**B**), or a baby car seat which clips onto a wheel base (**C**). The pushchair shown in **D** is suitable for older babies and toddlers. Which is most suitable depends on the age of the child, parents' way of life and their budget.

Points to consider when deciding which pram or pushchair to choose include:

- weight – will it need to be carried very far, upstairs, or very often?
- size – will it be used in busy streets, narrow passages or lifts?
- comfort – will the child be spending much time in it?
- where it is to be stored – does it need to fold up?
- outings – will they be on foot, by car, or by public transport?
- is a combined pram and pushchair required?
- is it needed for one baby or two?
- is good suspension important – for a more comfortable ride?
- swivel front wheels – for easier pushing in difficult conditions or crowded spaces
- should the seat be detachable – for use as a car seat or baby seat?
- the family budget – new or second-hand?

The pushchair can be fitted with additional items, such as hood and apron to protect the child against bad weather, and a canopy or parasol to protect against strong sunlight.

Safety harness

A baby or child in a pushchair needs to be secured by a safety harness with shoulder, waist and crotch straps.

Baby nest
This looks like a tiny sleeping bag, with or without handles. It is designed to keep a young baby warm while being carried. The baby will only be safe when lying on his back, otherwise the face may become buried in the soft surface and the baby may suffocate. A baby should never be left alone when in a baby nest, nor should the nest be used for sleeping. Some babies have died while sleeping in a baby nest, either by suffocation or because they have become overhot.

Baby carriers
These enable parents to carry their babies about with them, leaving their hands free for other tasks. At the same time, the babies have the comfort and security of being close to a parent.

A carrier for a young baby needs to have a head support

An older baby in a back-carrier can see all around

Walking rein
A walking rein attached to a harness gives a toddler freedom of movement while remaining in the control of an adult. This can be replaced by a wrist strap when the child has outgrown the rein (see p. 309).

uncing cradle

gh chair

FOR SITTING

Bouncing cradle or rocker

From the age of a month or two the baby can be put in a 'bouncing cradle' (see p. 80) or 'rocker'. This makes a change for the baby from lying on his back in the cot or pram, and the baby will enjoy the bouncing or rocking movement and being able to look around. When a bouncing cradle or rocker is used, it must be placed on the floor, not on a table. Babies can wriggle quite a lot and may cause the bouncing cradle or rocker to move and fall off the table.

Bouncing cradles and rockers are suitable for babies under 6 months of age and weighing less than 7 kg. They should only be used for short periods of time, and the baby should not be left unattended.

Baby chair

When the baby is able to sit upright, at the age of about 6 months, a baby chair can be used. High chairs have the advantage that the baby is at table level and can be part of the family at mealtimes. Low chairs are safer because, being less top-heavy, they do not topple over so easily.

Whichever type of chair is used, it needs to have a broad base and be very stable so that it will not easily topple over. The baby needs to be firmly harnessed to the chair so that he cannot fall or slip out.

Baby chairs often have trays in front which can be used at mealtimes or for toys. The best type of tray is large with rounded corners which are easy to clean.

Car seats

In many parts of the country, it is possible to rent an infant car seat so that a newborn baby leaving hospital can travel home safely. It is illegal for a child to travel in the front seat of a car on an adult's lap. Child car seats are dealt with more fully on p. 306.

FOR BATHING

Baby bath

This is not an essential item of equipment because a young baby can be bathed in the wash basin. Care must then be taken to ensure that the baby does not knock himself on the taps. There is also the danger that the baby could receive burns from touching the hot tap. Some parents therefore prefer to use a baby bath.

After a few months, babies reach the stage when they love to splash the water. The best place then is the ordinary adult bath. A rubber bath mat in the bottom of the bath will help prevent the baby from slipping.

Bouncer

Exerciser – the wheels are
hidden by the bumper

FOR PLAYING

Bouncers and exercisers

Although not essential, these are popular with babies, and provide exercise for the legs, which helps to strengthen them. They are recommended for babies at 8–10 months who have learnt to take their weight on their legs and are starting to stand. They should stop being used as soon as the child can walk unaided.

Bouncers can be suspended from most doorways and can be used for babies weighing up to about 12 kg. The babies bounce gently up and down and are able to move their legs and arms freely.

Exercisers of the type shown here have a wide base which gives them stability, speed-restricting wheels which prevent the baby from going too fast, and a tray on which toys can be placed. They are suitable for babies weighing up to about 13 kg and who are no taller than 85 cm.

Play-pen

A play-pen is useful when the baby begins to move around. It will keep the baby safe while the parent is busy or out of the room for a short time. Most babies will play happily in a play-pen until they start to object to their freedom being restricted. A baby in a play-pen will learn to pull himself into a standing position and to walk while holding on to the edge for support.

Accidents may happen with play-pens if a child climbs out and falls, or gets trapped in the bars.

It is an advantage if the play-pen folds up easily for storage. Both of the types shown here do this. A square play-pen fits more easily into a corner. The plastic mat, which is tied in position in **A**, protects the floor and makes it more difficult for the child to push the play-pen around or escape underneath. The raised floor of play-pen **B** keeps the baby off the ground. This playpen has mesh sides and a padded top rail.

A

B

BUYING EQUIPMENT: CONSUMER LAW

The *Sale and Supply of Goods Act 1994* gives customers (**consumers** of goods and services) certain rights. Any goods which you buy must be:

- **of satisfactory quality** – this means they must be fit for their normal purpose, bearing in mind the price which was paid
- **as described** on the package, on a display sign or by the seller
- **fit for any particular purpose** made known to the seller.

If these conditions are not met, the customer may be entitled to a refund.

The *Consumer Protection Act 1987* covers:

- **product liability** – if damage or injury has been caused by faulty goods, the consumer can claim compensation
- **misleading price indications** – it is an offence to give any misleading indications to consumers about the price of goods or services.

The *General Product Safety Regulations 1994* make it an offence to sell unsafe goods.

If you wish to make a complaint:

- stop using the item
- tell the shop at once
- take the item back with the receipt.

Advice on consumer matters can be obtained from your local Trading Standards or Consumer Protection Department.

QUESTIONS

1 a Name two advantages of using a carry-cot as a bed for a young baby.

b Give three advantages of a cot when the baby reaches the age of about 6 months.

c Name three safety features to check when choosing a cot.

d Why is a firm mattress safer than a soft one?

e Give an advantage of **(i)** a ventilated mattress, **(ii)** acrylic blankets.

f Why are cot quilts not recommended?

g How should a baby be placed in a cot for sleeping?

h (i) Should a baby have a pillow for sleeping?
(ii) Give a reason.

2 (i) What is the function of a baby monitor? **(ii)** Why is the device in two parts?

3 a List six points to check when choosing a pram or pushchair.

b From the list 'Points to consider' when choosing a pram or pushchair, give the three points which you think are most relevant for each of the types A–D. Give your reasons.

c At what stage does a baby require a safety harness?

d When is a walking rein or wrist strap useful?

4 a Describe a baby nest.

b For what purpose is a baby nest designed?

c Why should a baby never be left alone to sleep in a baby nest?

5 Describe two types of baby carrier.

6 a Name some safety features desirable in a baby chair.

b Name one advantage of a high chair and one advantage of a low chair.

c Why should a bouncing cradle or a rocker not be placed on a table when in use?

7 a When may a play-pen be useful?

b (i) For what stage of development are bouncers and exercisers recommended?
(ii) When should they not be used?

c (i) What can be used instead of a baby bath?
(ii) What care has to be taken?

d What helps to stop a baby from slipping when in the bath?

8 a Name three Acts or Regulations which give consumers certain rights.

b When may customers be entitled to a refund?

FURTHER ACTIVITIES

EXTENSION

1 Find photographs of the pieces of equipment mentioned in this topic to accompany your notes.

2 Make a concept keyboard overlay of pieces of nursery equipment. Provide data about the cost of each of them, its use and safety features.

INVESTIGATION

What other equipment can be bought for young children? For each item, say what age group it is designed for, and whether you consider it to be useful or unnecessary.

DESIGN

IT2.3 Design (see p. 358) and, if possible, make a cover suitable for a cot, pram or young child's bed. Use a graphics program to design the item. Experiment with different colours to find those you think will look best. Present your design to your class, giving information on the materials you will use and why you chose them.

CHILD STUDY

Discuss with the child's mother or father the items of nursery equipment mentioned in this topic. Which were used, and were these found useful, well designed or a waste of money?

EXERCISES

Exercises relevant to Section 3 can be found on p. 346.

Revision
Exercise
25

SECTION

4

DEVELOPMENT

26 WHY EACH CHILD IS DIFFERENT

No two children are exactly alike, and each can be recognised as an individual with his or her own unique appearance and character (personality). The way a child grows and develops depends on three main factors:

- the **genes** inherited from the parents (p. 120)
- the **environment** in which the child grows up
- the child's **health**.

Each child differs from all others because each (except identical twins) has a different set of genes, each has a different environment, and each has a different health record. From the moment of conception onwards, these factors interact continuously to produce a person who is unlike anyone else.

Identical twins have identical genes. Nevertheless, they will develop differently because the environmental factors will differ. For example, they will be in different positions in the womb and are likely to have different birth-weights; they will have different friends, different accidents and illnesses, and so on.

EFFECTS OF ENVIRONMENT ON DEVELOPMENT

Environment means surrounding conditions. Environmental factors which affect a child's development include the following:

Home conditions
The influences of family and home on a child's development include:

- the place where the child lives
- who looks after the child
- whether or not the child is loved and wanted
- the child's companions
- whether the child is encouraged to learn, or is ignored, or is prevented from learning by over-protection.

The results of these influences are unpredictable, and they help to produce a rich variety of personalities.

Culture
The cultural life of the family to which a child belongs will affect his or her upbringing. So too will the national culture of the country in which the family is living, and the ethnic group to which it belongs (see pp. 12–14).

Education
Development will be affected by the family's attitude towards education, the availability and use made of different types of pre-school groups, and the teachers and pupils the child meets throughout school life.

EFFECTS OF HEALTH ON GROWTH AND DEVELOPMENT

Health is physical and emotional well-being. Good health helps to ensure proper development of a child. The following factors affect a child's health.

Food

A child needs a balanced diet in order to grow properly.

Malnutrition (poor diet) stunts growth, and may be the result of poverty, famine, or simply lack of parental care or knowledge. The brain grows fastest during the last weeks of development in the uterus and the first three years of life, and malnutrition during this time may affect brain development and reduce the level of intelligence. On the other hand, over-feeding a child leads to obesity (fatness) and the possibility of health problems.

Illness

Severe long-term illness may slow down growth, and the younger the child, the greater the risk of illness having a permanent effect. If a child's rate of growth is only temporarily slowed down by illness, he or she will afterwards adapt with a period of 'catch up' growth. Severe or prolonged illness may also affect emotional development.

Exercise

Exercise strengthens and develops muscles. Lack of exercise makes muscles flabby and, when it is coupled with over-feeding, encourages the growth of fatty tissue.

Stress

Happy healthy children flourish. But those who are under severe stress for a long period of time may not grow to reach their potential height and often become very thin, or over-eat and get fat. Stress may result from unhappiness, worry, loneliness, illness or abuse.

Parents and carers who smoke

There is evidence that heavy smoking by parents and carers may slow down their children's rate of growth and development both before and after birth. One investigation found that 7-year-old children whose mothers were smokers were, on average, shorter in height and three to seven months behind in reading ability when compared with children of non-smoking mothers.

Children who spend much time in a smoky atmosphere may be more prone to lung disorders (such as asthma and bronchitis) than children who do not live in a smoky environment.

POSITION IN THE FAMILY

The position of a child in the family may have an effect on the development of his or her character.

Children in a large family
These children are likely to be influenced by:

- learning to share and 'give and take' at an early age
- having little privacy
- in the case of the older children, being involved in the care of the younger ones
- in the case of the younger children, receiving less individual attention from parents
- having fewer material benefits because the family income has to support more people, possibly resulting in hand-me-down clothes and toys
- always having someone to play with
- interaction with siblings (brothers and sisters).

An only child
The only child in a family is likely to have:

- less opportunities for sharing
- considerable privacy
- little involvement in the care of younger children
- a great deal of adult attention
- a greater proportion of material goods
- much time in which he or she plays alone
- no siblings to interact with.

The middle child of three or more
Such a child lacks the status of being the eldest, and any special treatment of being the youngest. How a middle child reacts will vary greatly, and may be a factor in the development of character.

Twins
Twins may have to fight to be recognised as individuals, especially if they look alike, are dressed alike, treated the same, and are always referred to as 'the twins'. The early language development of twins can sometimes be slower than that of other children because they may develop their own private means of communicating with each other which does not require real words. Also, there may be less individual attention from adults.

Me!

DEVELOPMENT OF SELF-IMAGE (SELF-CONCEPT)

As a baby grows and develops, she gradually becomes conscious (aware) of her:

- own name
- own body
- own family
- own home
- age, and of growing up.

The child gradually forms a mental image (concept) of herself and becomes aware that she is unlike anyone else. As the child begins to relate to a wider environment, she comes to understand her:

- physical capabilities and limitations
- intellectual (mental) capabilities and limitations
- dependence on others – and to realise that others depend on her
- place in the family and community – where she 'fits in'.

By the time adulthood is reached the child should:

- know how to receive and give love
- have learnt self-discipline
- be self-reliant and feel confident to take charge of her life
- have experience of coping with success and failure. These are both part of life. Being successful enhances self-esteem. Being unable to cope with failure can lower self-esteem.

QUESTIONS

1 a Name the three main factors on which a child's development depends.

 b Give examples of environmental factors which enable identical twins to develop into different individuals

2 a What does the term 'environment' mean?

 b Give examples of environmental factors which affect a child's development.

3 Give five factors which affect the health of a child, and say what effect these have on the child's development.

4 a Compare, using two columns, the effects of being a child in a large family with those of being an only child.

 b Give two reasons why the early language of twins can sometimes be slower than that of other children.

5 Describe the development of self-image.

Revision Exercise 26

FURTHER ACTIVITIES

EXTENSION

1 Suggest ten situations, both in and outside the home, which could give rise to stress in a child.

2 How do you see yourself? Using the section 'Development of self-image' as a guide, describe your own self-image.

DISCUSSION

C2.1a Discuss ways in which environmental influences can affect development. Give examples of environmental influences on physical, social, emotional, and intellectual aspects of development.

CHILD STUDY

1 Look back at your description of the child's appearance and personality. Can you add anything now that you know the child better? What influences do you think have been important in the child's development?

2 In what ways do you think that the child's own self-image is developing?

27 GENETICS

Genetics is the study of genes and their effects. Children inherit genes from their parents and this is why they resemble their parents, their brothers and sisters, grandparents and other relatives.

CHROMOSOMES

The human body is composed of vast numbers of tiny cells, each normally containing 46 chromosomes. Of the 46, 23 are exact copies of the chromosomes which came from the mother (in the egg); the other 23 are exact copies of the chromosomes which came from the father (in the sperm). They can be matched together in 23 pairs.

The only cells in the body which do not contain 46 chromosomes are the sex cells (eggs and sperm) – they contain only 23.

Sex chromosomes

The sex of a baby is determined by one pair of chromosomes – the sex chromosomes. One of the sex chromosomes is called **X**, the other is called **Y**. A female has two **X** chromosomes (**XX**). A male has an **X** and a **Y** chromosome (**XY**).

Boy or girl?

Each egg contains an **X** chromosome. Some sperm contain **X** and some contain **Y**. Whether the child is a boy or a girl depends on whether the egg is fertilised by a sperm containing an **X** or a **Y** chromosome.

GENES

Each chromosome contains thousands of tiny units called genes. Each gene contains an instruction that affects a part of the body. Together, the genes provide a set of instructions for growth and development of the whole body. For example, the baby's genes decide:
- the shape of the body
- the colour of skin, hair and eyes
- blood group
- the age at which teeth appear
- the size of hands and feet
- the maximum height to which the child will grow.

Dominant and recessive genes

Genes can be dominant (strong) or recessive (weak). Dominant genes mask the presence of recessive genes. For example, if a child inherits a gene for black hair from the father and a gene for blonde hair from the mother, the child will have black hair because the gene for black hair is dominant to that for blonde hair. However, the child will be a '**carrier**' for blonde hair and may pass the gene on to his or her own children. Recessive genes can only have an effect when they are inherited from both parents; for example, two genes for blonde hair are necessary to produce a blonde-haired child.

INHERITED DISEASES

Genetic disorders

A few diseases are caused by abnormal genes which can be passed from one generation to the next. Examples are:

- **cystic fibrosis** – Abnormally thick mucus is produced which blocks the air passages of the lungs and is very difficult to cough up.
- **haemophilia** – The blood is unable to clot properly and this results in severe bleeding from minor wounds. This disease only affects boys, although girls can be carriers for the faulty gene.
- **thalassaemia** – A disorder of the red blood cells; this type of anaemia is found mainly in countries bordering the eastern Mediterranean, the Middle East, India and Asia, or in people who have originated from these areas.
- **sickle-cell anaemia** – The red blood cells change to a sickle shape when there is a shortage of oxygen; this type of anaemia is more common in West Africa and in people of West African descent such as Caribbean people.
- **muscular dystrophy** – See p. 325.
- **PKU** (phenylketonuria) – See p. 63.

Chromosome disorders

These occur when the chromosomes fail to divide properly during cell division. If this happens when eggs or sperm are being formed, it can produce an individual with more, or less, chromosomes than is normal. For example, a person with **Down's syndrome** (p. 325) has 47 chromosomes instead of the normal 46. **Turner's syndrome** develops in girls whose cells contain only 45 chromosomes because one of the X chromosomes is missing. Girls with Turner's syndrome fail to grow normally in height.

GENETIC COUNSELLING

Genetic counselling is the giving of expert advice on the likelihood of disease being passed from parents to children by inheritance. People may ask for genetic counselling:

- when there is a history of inherited illness or abnormality in their family
- when the father and mother are closely related – for example, cousins – because if there are harmful recessive genes in the family, both may be carriers. Any children they have may then inherit a recessive gene for the same disease from each parent, allowing these genes to become effective and cause disease.
- when there is a possibility of an abnormal condition affecting an unborn child and the parents are considering terminating the pregnancy by abortion.

DETECTING DISEASE IN UNBORN CHILDREN

When there is a chance that an unborn child may have a genetic disorder, tests such as amniocentesis, chorionic villus sampling or cordocentesis may be carried out (see p. 51). These tests can be used to detect, for example:

- faulty genes – the cause of cystic fibrosis
- the number of chromosomes in the cells of the fetus – important in detecting Down's syndrome
- the sex of the child – important when there is a high risk that a male child may inherit haemophilia or the Duchenne type of muscular dystrophy.

PRE-IMPLANTATION GENETIC DIAGNOSIS (PGD)

PGD is a procedure which can be used for couples who want to have children but are known to carry a serious genetic disorder. IVF (see p. 32) is carried out and the embryos are examined to find those which are not carrying the genes for the disorder and are suitable to be placed in the uterus.

TWINS

Twins are either identical or non-identical depending on whether they come from one egg or two.

Identical twins (uniovular twins)

These develop when a fertilised egg splits into two parts (diagram **A**) and each develops into an individual. These twins are very much alike in appearance and are always of the same sex as they have inherited identical genes. Identical twins are more likely to be born to a younger mother.

Non-identical twins (binovular or fraternal twins)

These develop when two eggs are released instead of one. Each egg is fertilised by a different sperm (diagram **B**), so the twins will be no more alike than any other two children in the same family. They can be either the same sex or a boy and a girl.

The chance of having non-identical twins increases with the age of the mother, the number of pregnancies and when there is a history of twins in the mother's family.

Sextuplets: which two are the identical twins?

1 a Where do a child's genes come from?

b (i) How many chromosomes do the sex cells contain? **(ii)** How many chromosomes occur in all other cells?

c (i) What does each chromosome contain? **(ii)** What does each gene contain?

d Give at least six examples of the effects of genes on the growth and development of the body.

e What is the difference between 'dominant' and 'recessive' genes?

2 a Which sex chromosomes are possessed by **(i)** females, **(ii)** males?

b (i) What decides whether a child is a boy or girl? **(ii)** Draw a diagram to illustrate this.

3 a Name three inherited diseases of the blood.

b How many chromosomes are present in the cells of people with **(i)** Down's syndrome? **(ii)** Turner's syndrome?

c (i) Name three tests which are carried out to detect disease in unborn children. **(ii)** Describe three conditions that these tests can detect and name a disease which is linked with each

d (i) What is PGD? **(ii)** For whom may it be used? **(iii)** Describe the procedure.

4 Twins can be of two types – identical or non-identical. Which twins:

a develop from one egg

b are also called 'fraternal' twins

c are also called 'uniovular' twins

d are always of the same sex

e are more likely to be born to a younger mother

f are more likely to occur with a fourth pregnancy than a first one?

FURTHER ACTIVITIES

INVESTIGATION

Study one family you know well, perhaps your own family or the family of the child you are studying. From your observations, list the ways in which a child in the family resembles each of the parents. Which of these resemblances do you think are likely to be due to the genes the child inherited from the parents?

DISCUSSION

C2.3 **Nature-nurture?** There is a continuing debate about the relative influence of genes (nature) and environment (nurture) in determining a child's total development. For example, if a child in a musical family grows up to be a good musician, is it because he inherited his musical ability or because he was in the right environment? Is obesity inherited or due to living in a family where hearty eating is the usual pattern? Write a report of at least three pages on the difference between nature and nurture, and include examples of each. Say which you think is more important, giving examples to support your argument.

Revision Exercise

27

28 GROWTH AND DEVELOPMENT

Growth is an increase in size, and **development** is the process of learning new skills. Growth and development go hand in hand and it is often difficult to separate one from the other.

All babies follow the same general pattern of growth and development, and the stages in which they learn to do things generally follow in the same order. This is because they need to reach one 'milestone' in development before they can progress towards the next. For example, their legs have to become strong enough to bear their weight before they can stand, they have to be able to stand before they can walk, and to walk before they can run.

EACH BABY GROWS AND DEVELOPS AT HIS OWN PACE

Although all babies follow the same general pattern, each baby grows and develops at his own pace. The rate of development depends on a number of factors which include:

- the genes which the baby has inherited
- the amount of encouragement and interest shown by the parents
- the baby's state of health.

When a baby is said to be 'slow' or 'late' in doing something, for example walking, it is often because he is concentrating on some other aspect of development such as talking, in which he is said to be 'forward'.

MEASURING GROWTH

Growth can be measured in terms of **weight** and **height** (or **length** in the case of children under 3 years of age). Generally, as children grow taller they also become heavier, but not always, because weight also depends on how fat or thin the child becomes.

Gain in weight
This varies from child to child and from week to week. A weekly gain of 150–220 g is to be expected in the first 6 months. As the baby grows older, the rate of gain in weight decreases. From 6 to 9 months it is about 90–150 g per week, and it then slows down to 60–90 g per week from 9 to 12 months, and for the second year is about 40 g a week. Some gain more, some less.

As these figures show, a baby's increase in weight is greatest in the first 6 months and then gradually slows down. This is also true for increase in height. As a rough guide, the average baby doubles its birth-weight in the first 6 months and trebles it by one year.

Finding the average rate of growth
The average is worked out from measurements of a large number of children of the same age but differing body build and social background. Graphs showing the average weight and height of children up to 8 years can be found on pp. 130–131.

A B C D E

Individual variation

The photograph shows how greatly children of the same age can vary. These boys are all aged 5 years 9 months. Their measurements are spread over a wide range on either side of the average (see table).

Name	Weight in kg	Height in cm	Birth-weight in kg
A Ali	28.0	119.5	3.5
B Kenny	19.5	114.0	1.0
C Troy	20.0	118.0	3.0
D Ashley	22.0	119.0	3.5
E David	16.5	105.0	2.25

HOW TALL WILL A CHILD GROW?

The most important factors which affect growth in height are the genes and chromosomes inherited from the parents. Generally, short parents have short children and tall parents have tall children. It is usual for a child's adult height to be somewhere between the height of his mother and that of his father. This is called the child's **potential** or **target height**. If a child is not growing normally and is not as tall as he ought to be, this could be due to one of the factors in the diagram overleaf.

125

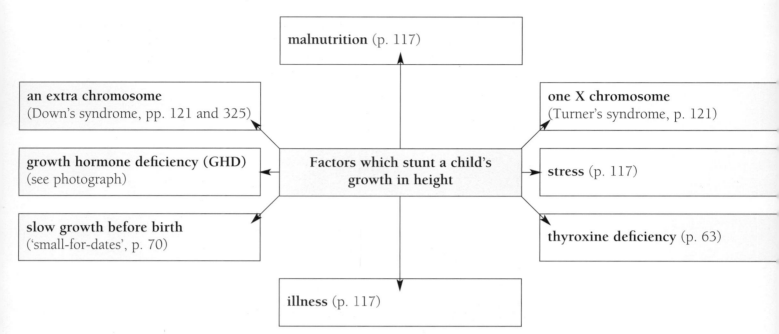

malnutrition (p. 117)

an extra chromosome
(Down's syndrome, pp. 121 and 325)

one X chromosome
(Turner's syndrome, p. 121)

growth hormone deficiency (GHD)
(see photograph)

Factors which stunt a child's
growth in height

stress (p. 117)

slow growth before birth
('small-for-dates', p. 70)

thyroxine deficiency (p. 63)

illness (p. 117)

Which sister is the older?
The girl on the right is 4½ years old. Her sister, who is 6 years old, has growth hormone deficiency. Children who are given doses of growth hormone before the age of 6 years may catch up and reach their full potential height

Is the child's height normal?
It is possible to find out if a child is growing normally in height by using the 'centile' growth charts on pp. 130–131. To do this:

1. The child's height is measured, and the height plotted on the chart.
2. Preferably once a year (perhaps on every birthday) the height is again measured by the same person in the same manner. This measurement is also plotted on the chart.

3. The plots on the chart will show whether the child is growing normally. If the child's height is not increasing as it should, this may indicate a growth problem which needs to be investigated. Many growth problems (as with the girl in the photograph with growth hormone deficiency) can be corrected if treated early.

Advice on height problems

Children who differ in height from their companions of the same age may have problems. Those who are much taller than average for their age may be expected by adults to behave older than their age, and they may fail to live up to adults' expectations. Those who are shorter than average may worry that they are not growing normally, and be upset when treated as being younger than their age. Parents may be able to obtain advice on growth problems from their family doctor. Assistance can also be obtained from the Child Growth Foundation (see p. 340).

PROPORTIONS CHANGE WITH GROWTH

As a child grows, the different parts of the body alter in shape as well as increasing in size. Some parts grow more quickly than others. This has the effect of changing the proportions of the body as the child gets older. For example, at birth the head is about 1\4 of the total length of the body, but by the age of 7 years it is only about 1\6 (see below).

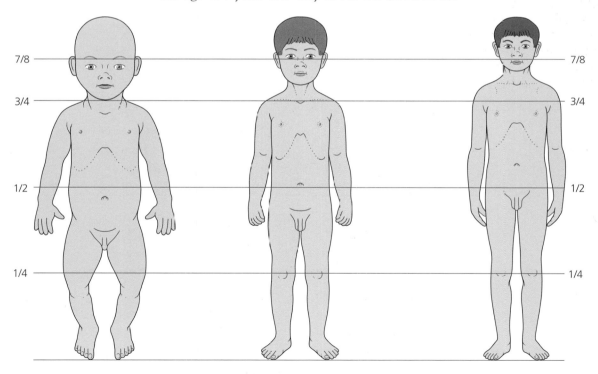

newborn 2 years 7 years
Source: Medical College of St Bartholomew's Hospital, London

DEVELOPMENT

Growth and development of the legs
In the early stages, a baby is bow-legged. This condition gradually disappears and is often followed by knock-knees at the toddler stage. By the age of 6–7 years, the legs have usually straightened.

18 months 3 years 6 years

QUESTIONS

1 Explain the difference between growth and development.

2 Find the average weight and height of the children in the photograph on p. 125.
 a Make a table to record the name, weight and height of each child.

Name	Weight in kg	Height in cm

 b To find the average weight of these children, add all the individual weights together, then divide by the total number of children, i.e. five.
 c In the same way, find the average height.
 d Name the child whose (i) weight, (ii) height is nearest the average.

3 a (i) Which of the factors in the diagram on p. 126 was responsible for the slow growth of the smaller girl in the photograph below? (ii) Is there any treatment she could receive?
 b (i) How can parents check that their child's growth in height is normal? (ii) If they are worried, who can they go to for advice?

4 Study the diagrams on p. 127 showing the proportions of the body.
 a Why do the proportions of the body change as the child grows?
 b At what age is the neck very short and not visible in front view?
 c At birth the head is about ¼ of the total length of the body. Is the head proportionately larger or smaller at 7 years?
 d On the newborn, the eyebrows mark ⅙ of the body. What marks ⅙ of the body at (i) 2 years, (ii) 7 years?
 e (i) At 7 years, what proportion of the body is that part of the leg from the knee to the foot? (ii) At 2 years, is the same part proportionately shorter or longer than at 7 years?
 f At 2 years, the navel is at the mid-point of the body. Is the navel above or below the mid-point (i) when newborn, (ii) at 7 years? (iii) What has grown more quickly than the rest of the body to cause the level of the navel to rise?

FURTHER ACTIVITIES

EXTENSION
1 Add pictures of children to your notes to show the three stages of leg development.
2 Growth charts can be used to compare the growth pattern of an individual child with the normal range of growth patterns typical of a large number of children of the same sex.
 ■ The **50th percentile** is the **median** – it represents the middle of the range of growth patterns.
 ■ The **91st percentile** is near to the top of the range (the greatest weight or height). If, for example, the height of an individual child was on the 91st percentile, in any typical group of 100 children, there would be 90 who were shorter and 9 who were taller.
 ■ The **10th percentile** is near to the bottom of the range. If a child was on the 9th percentile, 8 children would measure less and 91 would measure more.

continued

Revision Exercise 28

FURTHER ACTIVITIES

Table 1	Weight in kg	
Age in years	Boys	Girls
Birth	3.5	3.25
1	10.0	9.5
2	12.25	11.75
3	14.5	14.0
4	16.5	16.25
5	18.5	18.25
6	20.5	20.5
7	23.0	23.0
8	25.5	26.0

Table 2	Weight gain (kg) per year	
Period	Boys	Girls
1st year	6.5	6.25
2nd year		
3rd year		
4th year		
5th year		
6th year		
7th year		
8th year		

N2.1 Table 1 shows the 50th percentile weights for boys and girls. This information comes from the graphs on pp. 130 and 131.

a Use Table 1 to calculate how much weight is gained each year, then copy and complete Table 2.

Table 3	Height in cm	
Age in years	Boys	Girls
Birth	51	50
1	76	73
2		
3		
4		
5		
6		
7		
8		

Table 4	Height increase (cm) per year	
Period	Boys	Girls
1st year	25	23
2nd year		
3rd year		
4th year		
5th year		
6th year		
7th year		
8th year		

b Copy and complete Table 3 using the 50th percentile information from the height charts on pp. 130 and 131.

c Use Table 3 to calculate how much height is gained each year, then copy and complete Table 4.

3 Copy the table on p. 125 onto a spreadsheet. Use the spreadsheet to draw charts to compare the weight, height and birth-weight of the group of boys. Include data on the median height and weight for this age group taken from the graphs on p. 130. What can you say about the height and weight of each boy? **IT2.2**

4 Use the weights given in Table 1 to convert kilograms into pounds with 1 kg = 2.2 lb. Use your results to draw a graph showing the average weight of boys and of girls from birth to 8 years in pounds weight.

CHILD STUDY

N2.2a Measure the height and weight of the child. How do the child's measurements compare with the percentiles on the growth charts on pp. 130–131?

EXERCISES

Further exercises using the growth charts can be found on p. 348, questions 7 and 8.

BOYS' GROWTH CHARTS

Height (length) and weight charts for boys from birth to 8 years – showing 9th, 50th and 91st percentiles

Body Mass Index (BMI) is used to assess fatness. To find BMI, the body's weight in kilograms is divided by height in metres squared.

Example A child weighing 21 kg and who is 1.16 m tall:

$$\text{BMI} = \frac{\text{weight in kg}}{\text{height in m}^2}$$

$$= \frac{21}{1.16 \times 1.16}$$

$$= 15.61$$

When the child's BMI is plotted on a paediatric BMI chart it will indicate if the child is underweight or overweight.

Although in the majority of adults a BMI of between 18.5 and 24.9 is defined as being ideal, this range varies for children throughout their growing years. The adult definition of underweight, overweight and obese should never be applied to children.

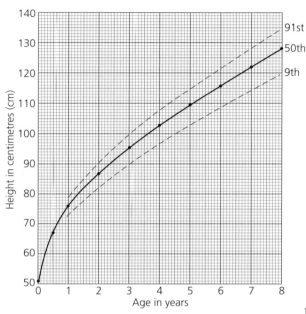

Height (boys)

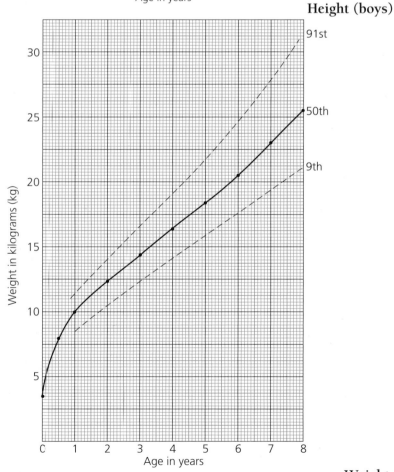

Weight (boys)
Source: Child Growth Foundation

GIRLS' GROWTH CHARTS

Height (length) and weight charts for girls from birth to 8 years – showing 9th, 50th and 91st percentiles

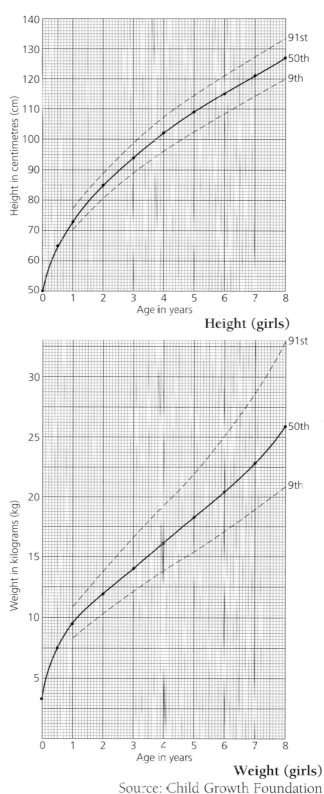

Height (girls)

Weight (girls)

Source: Child Growth Foundation

29 PHYSICAL DEVELOPMENT

Topics 29 to 39 are concerned with different aspects of a child's development. All these forms of development are taking place at the same time, but it is easier to study them one by one.

This topic deals with **physical** development, that is development of the body. Each of the diagrams is related to the average age at which the stage shown occurs. It is usual for most children to pass through the different stages of development within a few weeks either side of the average age. But it should be remembered that the age at which children sit up, walk and talk can vary a great deal.

MOTOR SKILLS

As physical development proceeds, the child acquires various physical skills – **motor skills** – which require co-ordination between brain and muscles. These skills often require a great deal of practice before becoming automatic. **Gross motor skills** use the large muscles of the arms, legs, hips and back such as when sitting, walking, catching, climbing, kicking a ball, throwing etc. **Fine manipulative skills** involve the co-ordination of the smaller muscles of the hands and fingers for pointing, drawing, doing up buttons, using a knife and fork, writing etc.

HEAD CONTROL

Movement of the head is controlled by muscles in the neck and in a newborn baby these are undeveloped and weak. Muscles need time to grow and develop. Also, the baby has to learn how to use them before gaining control over head movements.

Always support a newborn baby's head

Newborn When the baby is picked up or lifted into a sitting position the head falls backwards because the neck muscles are very weak. (**A**). This is why the head must always be supported when the baby is being lifted, as shown in the photograph.

3 months The baby is beginning to control her head (**B**): there is much less head lag when the baby is pulled into a sitting position. When the baby is held upright, the head is still liable to wobble.

6 months The baby now has complete head control. There is no head lag and the baby is able to raise her head when lying on her back (**C**). When in a sitting position the baby can hold her head upright and turn it to look around.

132

LEARNING TO SIT

Newborn When a newborn baby is held in a sitting position she appears to roll up into a ball (**A**). The back curves over and the head falls forward because, as yet, the muscles of the neck and back are not very strong.

3 months The baby still has to be supported when in a sitting position but the back is much straighter (**B**). Although the head is still rather wobbly, she can hold it steady for a short while.

6 months The baby is now able to sit upright but still needs support from a chair or pram. She can also sit for a short while on the floor with her hands forward for support (**C**).

9 months The baby can pull herself into a sitting position and sit unsupported for a short while (**D**).

1 year The baby is now able to sit unsupported for a long while and is able to turn sideways and stretch out to pick up a toy (**E**).

THE PRONE POSITION (LYING ON THE STOMACH)

Newborn When a newborn baby is placed on her front, she lies with the head turned to one side and with the knees drawn up under the abdomen (tummy) (**A**). By 1 month old her knees are not drawn up so much and she is beginning to be able to lift her head.

3 months The baby now lies with her legs straight, and she can raise her head and shoulders off the ground by supporting the weight on her forearms (**B**).

6 months The baby uses straight arms to lift her head and chest off the ground (**C**). Usually by 5 months, the baby is able to roll over from her front on to her back. It takes about another month before she can also roll over from her back on to her front, and then she can easily roll off a bed.

9 months The baby can now move over the floor either by pulling or pushing herself with her hands or by rolling.

1 year The baby crawls rapidly either on hands and knees, or like a bear on hands and feet (**D**), or shuffles along on her bottom. Although most children crawl before they can walk, some miss out this stage altogether.

LEARNING TO WALK

The legs of a newborn baby need time for further growth and development before they can be used for walking. The muscles of the legs, hips and back have to strengthen. In addition, the baby has to learn how to co-ordinate all these muscles and also how to keep her balance. All babies love the opportunity to kick, and kicking is an essential exercise in the development of the muscles of legs and feet.

Newborn When a newborn baby is held upright with her feet touching a firm surface, she automatically makes walking movements, especially if her head is pushed back a little by holding a finger under her chin. This is known as the walking reflex (see p. 72). It disappears after a few weeks and it will be quite a while before the baby learns to make true walking movements.

3 months When the baby is held in a standing position, the legs are beginning to be strong enough to take a little weight although they tend to sag at the knee and hip (**A**).

6 months The baby can take her weight on her legs when being held (**B**), and enjoys bouncing up and down.

9 months The baby can pull herself into a standing position. From now onwards the baby will start to walk, either sideways holding on to furniture (**C**) or when both hands are held by an adult.

1 year The baby can walk with one hand held (**D**). At this stage she walks with feet apart and with steps of varying length, and her feet have a tendency to go in different directions.

15 months The baby can by now walk alone. The average age at which babies first walk on their own is 13 months, but some walk much earlier and others much later. At first they are unsteady on their feet and tend to hold their arms up in order to keep their balance; they cannot stop easily or turn corners, and if they look down they fall down.

Once a child has learnt to use her legs for walking, she can acquire other skills. By 15 months the child is likely to be able to kneel and to crawl upstairs on all fours, but she does not yet understand that if she leans backwards she may fall down the stairs.

18 months The child can walk upstairs by holding on to the rail and putting both feet on each stair.

2 years The child can walk up and down stairs, two feet per stair, and can kick a ball without falling over. At 2½ years she can walk on tip-toe and jump.

3 years The child can walk upstairs with one foot to each stair, but still places both feet on the same stair when coming down, and will often jump off the bottom stair. At this age the child can also stand on one leg.

4 years By now the child places one foot on each stair when coming downstairs as well as when going up, and is also able to hop.

5 years The child can skip.

USING THE HANDS

Newborn A newborn baby keeps her hands tightly closed for most of the time. The baby also shows a grasp reflex – if anything is put in the hand, it is automatically grasped tightly (see p. 72). The automatic grasp reflex disappears after a few weeks and the baby will be able to grasp again only when she has learnt to control the muscles of her hands.

3 months The hands are held open for most of the time now that the grasp reflex has gone. If the baby is given a rattle, she holds it for a few moments only. If her hands accidentally touch her clothes she pulls at them. This is the stage when the baby spends a long time looking at her hands (**A**).

In about another month the baby is able to clasp her hands together and play with her fingers; she learns what they look like, what they can do, and how to get them where she wants.

6 months The baby can now grasp an object without it having to be put in her hand, and she uses her whole hand to do so (**B**).

At this age, she picks up everything in her reach with one hand or two, passes it from hand to hand, turns it over, and takes it to her mouth. When lying on her back, she likes to play with her toes. She loves to crumple paper, and to splash water in the bath.

9 months The baby is able to use fingers and thumb to grasp an object (**C**). She can also open her hands when she wants, and deliberately drops things on the floor.

By the tenth month she goes for things with her index finger and pokes at them, and can now pick up small objects between the tip of the index finger and the thumb (**D**).

1 year The baby can use her hands to throw things, and can point with the index finger to objects she wants.

15 months The child can take a cup or spoon to her mouth – but her judgement is not yet very good. She is likely to tilt the cup too far when about to drink and to turn the spoon over before the food gets to the mouth. When playing with bricks, she can place one brick on top of another to make a tower.

18 months The child can feed herself completely, and make a tower of three bricks.

2 years The child puts on shoes, begins to draw, turns door handles and unscrews jars. She can build a tower with six bricks.

2½ years The child begins to be able to undress, builds a tower with eight bricks, and can thread large beads.

3 years The child begins to dress herself but needs help with the buttons.

4 years The child eats skilfully with spoon and fork.

5 years The child dresses and undresses without help, and can use a knife and fork for eating.

RIGHT-HANDED OR LEFT-HANDED?

When babies start to use their hands, they use both hands equally. Many show some preference for using one hand or the other by the age of 18 months, and most have a clearly defined preference by the age of 3 years. Some are not obviously right- or left-handed until they are 4 years or older.

Most children are right-handed, but a few can use both hands with equal ease (they are **ambidextrous**). Others use one hand for some types of activity and the other hand for the rest, and about 10% of boys and slightly fewer girls are left-handed. Left-handed children have more difficulty in learning to write, in opening doors, and in using equipment designed for right-handed people.

Handedness is controlled by the part of the brain which also controls language – speaking, reading and writing. If a left-handed child is forced to use the right hand, it may result in stuttering and in difficulties in learning to read and write.

LEARNING TO SWIM

Young children love playing in water and having fun with other people, and most enjoy being taught to swim. Swimming is excellent exercise as it develops muscles and co-ordination, and improves breathing. Being able to swim gives the confidence which comes from acquiring another skill, and is an important safety skill to learn.

Swimming for children with special needs Swimming is high on the list of popular activities for these children. It gives them a sense of achievement in being like other children, develops courage and self-reliance, and improves stamina. Regular swimming sessions in a warm pool and with guidance from a qualified physiotherapist can be of particular benefit to those with certain disabilities, for example:

- learning disabilities – swimming encourages concentration and perseverance
- Down's syndrome – swimming firms up the floppy muscles, which aids digestion and breathing
- cerebral palsy – swimming relaxes tight muscles, enabling a fuller range of movements
- arthritis – the buoyancy and warmth of the water encourages movements of painful joints. Failure to move joints can affect growth and development.

QUESTIONS

1 What is meant by **(i)** physical development, **(ii)** motor skills, **(iii)** gross motor skills, **(iv)** fine manipulative skills?

2 Why should a newborn baby's head be supported?

3 Although the legs make walking movements, a newborn baby cannot walk. Why is the baby unable to walk?

4 What is the usual age at which babies become able to **(i)** roll off the bed, **(ii)** walk alone, **(ii)** play with their fingers, **(iv)** pick up small objects using the thumb and first finger?

5 a By what age do most children show clearly whether they are right- or left-handed?

 b Name two possible consequences of forcing a left-handed child to use the right hand.

6 a Besides having fun, what other benefits are gained by learning to swim?

 b (i) Why is swimming popular with children with special needs? **(ii)** Give examples of disabilities for which swimming is of particular benefit.

Revision Exercise 29

FURTHER ACTIVITIES

EXTENSION

C2.2 Describe the stage of physical development which will have been reached by a newborn baby in:

a head control
b the sitting position
c the prone position
d use of the legs
e use of the hands.

Draw pictures or find photographs from at least two different sources to illustrate each stage. Describe the progress made in a–e at 3 months, 6 months, 9 months and 1 year.

INVESTIGATION

N2.2d Carry out some research into left-handedness in children. For example, observe children in a playgroup or classroom. What percentage are left-handed? Are any of the children ambidextrous? Present your results in a pie chart. Does being left-handed cause any difficulties?

CHILD STUDY

Describe the child's stage of physical development. If a baby, what stage has been reached in head control, the prone position, sitting position and use of the legs and hands? If older, is the child right-handed or left-handed?

Babies have some ability to see from the time they are born. As their eyes grow and develop and with experience, babies become able to:

- **understand** what is seen
- **alter the focus** of the eyes to see things more clearly at different distances
- **control the movements** of the eyes and use both of them together
- **recognise colours**.

STAGES OF DEVELOPMENT

Newborn

When newborn, a baby is probably only aware of vague shapes, darkness, light and movement. Babies of this age are very short-sighted because their eyes have a fixed focus of about 20–25 cm. They therefore see most clearly those things which are at this distance, with objects further away appearing blurred. When an object is placed about 20 cm in front of even the youngest baby, he will look at it for about two seconds. Babies look longer at patterns than solid colours – which indicates that they find patterns more interesting.

When a mother holds her baby in her arms, the distance between the eyes of mother and baby is the distance at which the infant can best focus. Babies are particularly interested in faces, and a few days after birth a baby is able to recognise his mother's face. Within a week or two, he will gaze at her face as she feeds or talks to him.

A newborn baby is sensitive to the intensity of light, and will shut his eyes tightly and keep them shut when a bright light is turned on. The baby also notices movement and will follow an adult or other large object for a moment. When an object, for example a bunch of keys, is dangled close to the baby, he will stare at it and will follow with short, jerking movements of his eyes if it is slowly moved from side to side.

3 months

Although still short-sighted, the baby now has a greater focusing range and therefore can see further. There is also much more control over the movements of the eyes. The baby is very interested in looking at everything around him and is able to follow people who are moving nearby. At this age, a baby spends much time in watching his own hands as he lies on his back.

6 months

The eyes now work together and the slight squint commonly shown earlier has disappeared (unless the baby has an eye defect).

1 year

The baby is able to focus on objects which are quite a long way away, and he can easily recognise people at a distance. The eyes are also able to follow a rapidly moving object.

2 years

The child can now see everything which an adult can see.

2½–5 years

A child begins to show sense of colour from the age of about 2½ years. From then onwards there is gradual improvement in the ability to recognise different colours. Red and yellow are usually the first colours to be known, and blue and green are the next. Most 5-year-olds know at least four or five colours.

EYE DEFECTS

The baby's eyes are examined soon after birth to make sure that there are no cataracts or major eye problems. At 6 weeks of age they are checked for squint and other defects, and again when the child starts school. Eye checks may also be given at 18 months and 3½ years of age.

Short sight

A short-sighted child can see near objects clearly but everything further away appears blurred. Short-sightedness develops most often between the ages of 6 and 10 years, and it can develop quite rapidly. Short sight interferes with school work; for example, a child who is unable to see what is written on the board at the front of the class may seem to be restless or slow.

Long sight

This makes objects near to the eyes appear blurred and fine details are missed. It is less common in children than short sight and may be more difficult to recognise. Long-sighted children have difficulty with writing and other close work and so they may seem to lack interest and be lazy.

Squint

A child has a squint when the eyes look in different directions. This means that the child is unable to use both eyes to look at the same object, so only one eye is used for seeing. If the squint is not treated, the child could go blind in the other eye (the 'lazy' eye).

139

A mild squint is normal in the first few weeks of life. Babies who have a persistent squint after the age of 6 weeks, or who develop a squint when older, should be seen by an eye specialist. Treatment for squint includes the wearing of glasses and exercises for the eye muscles. The photographs show a young child with a squint, and the same child wearing glasses to make him use his weaker eye to correct the squint.

Before and after correction of a squint

Colour blindness

This is much more common in boys than girls. About 8% of boys are affected to some degree compared with about 0.4% of girls. The usual form is red-green colour blindness; people with this defect cannot distinguish red from green.

Astigmatism

This defect of the eye makes things look blurred or out of shape. It can be corrected by glasses.

VISUAL IMPAIRMENT

The term **visual impairment** includes:

- **blindness** – the inability to perform any task for which eyesight is essential (very few blind people can see nothing at all)
- **partial sight** – vision is poor enough to be a substantial disability.

Blindness

Babies who are born blind, or who have become blind in early life, will grow in the same way as other children but their development will be hindered. Their lack of sight reduces opportunities for making contact with people and for play. This in turn reduces their opportunities for learning. Blind children will not be able to:

- make eye-to-eye contact with people (important in the emotional development of young children)
- gradually gain experience by seeing things and remembering what they look like
- reach out for objects which look interesting in order to play with them
- watch people and learn from watching
- seek out people – they will always have to wait for people to come to them
- move around on their own without being frightened or in danger
- understand the meaning of a green field, or red shoes, or a rainbow.

Blind children learn mainly through touch and hearing. They therefore need specialist help and training from the earliest possible moment to reduce, as far as possible, the effects of their disability. Parents also need to be taught how best to help their blind children develop.

QUESTIONS

1 a When a newborn baby uses his eyes, what will he be aware of?

 b As he gets older and gains experience of using his eyes, what will he become able to do?

2 a When does a baby become able to recognise his mother?

 b How can you tell that a baby is **(i)** sensitive to a bright light, **(ii)** aware of a movement?

3 a Give two ways in which a baby's vision develops between birth and 3 months.

 b By what age can the eyes **(i)** work together, **(ii)** follow rapidly moving objects, **(iii)** see everything which adults' eyes can see?

4 a Which colours are usually the first to be recognised?

 b Which is the most usual form of colour blindness?

 c Is it more common for boys or girls to be colour blind?

5 a **(i)** Why are babies' eyes not checked at birth for squint? **(ii)** When are they first checked for squint? **(iii)** Can a squint develop later?

 b **(i)** Why is the boy shown opposite said to have a squint? **(ii)** What treatment is he being given, and what effect can you notice? **(iii)** Why is it important for the squint to be treated?

6 a Give two examples of ways in which eye defects can interfere with school work.

 b What is astigmatism?

 c At what age does short sight most commonly develop?

7 a What is meant by visual impairment?

 b Give reasons why the development of blind children will be hindered.

FURTHER ACTIVITIES

INVESTIGATION
Devise an experiment (pp. 356–357) to discover what a baby finds most interesting to look at.

DESIGN
Design (see p. 358) a mobile which you could make to hang above a baby's cot or in a 2-year-old's room.

CHILD STUDY
Use a graphics program to make an outline picture of an object with which the child is familiar, e.g. a train, car or teddy bear. Print several versions, each filled in with a different colour. Find out which colours the child recognises.

Revision
Exercise
30

31 DEVELOPMENT OF HEARING

By about the fifth month of pregnancy, babies' ears have developed sufficiently for them to hear, and they respond to a wide variety of sounds. While in the uterus, they can hear the mother's heartbeat and noises from her intestines. They also react to noises outside such as the slamming of a door or loud music. High-pitched sounds tend to make babies more active, and they are soothed by repetitive low-pitched sounds.

After the baby is born, the mother tends to hold her baby on her left arm. The baby can hear the mother's heartbeat, which is the same type of rhythm that was heard in the uterus, and which appears to have a calming effect.

CHECKLIST FOR DEVELOPMENT OF HEARING

The following checklist gives some of the general signs which show that the baby's hearing is developing normally.

Newborn
The baby is startled by a sudden loud noise (e.g. a door slamming) and blinks or opens his eyes widely.

1 month
The baby begins to notice continuous sounds (e.g. a vacuum cleaner) and pauses and listens to them when they begin. Young babies are often soothed by particular types of music and singing (e.g. lullabies).

4 months
The baby quietens or smiles at the sound of his mother's voice, even when he cannot see her.

7 months
The baby turns immediately to his mother's voice across a room, or to very quiet noises made on either side of him (if he is not too occupied with other things).

9 months
The baby looks around for very quiet sounds made out of his sight.

1 year
The baby responds to his own name and to other familiar words.

HEARING IMPAIRMENT (DEAFNESS)

Some children are born with hearing impairment. Others may become permanently deaf through meningitis or other causes. Temporary deafness can be due to 'glue ear' – a build-up of sticky fluid in the middle ear caused by infection. Glue ear can be treated by medicines or by surgery.

Hearing loss can be total or, more often, partial. Partial deafness means that some sounds are heard but not others. Sometimes only low notes are heard, and not those of a higher pitch. A baby cannot then make sense of the sounds people make when they talk to him. In other cases only loud noises or angry voices can be heard, but not normal speech or gentle voices. So these babies link noise with unpleasantness.

When deafness is unrecognised, a child may be wrongly labelled as lazy, difficult to manage, or as having a learning disability. In fact the child is confused and frustrated. He has great difficulty in understanding what is said to him and any slight changes or new instructions are a cause for worry.

Deafness prevents a child from learning to talk

Up to the age of 5 months, a deaf baby uses his voice to gurgle and babble in the same way as other babies. The parents may not realise that their baby has a hearing problem because the baby is responding in other ways. Babies respond to the vibrations of a slammed door as well as to the loud noise it makes. They respond to what they can see – facial expressions, gestures and the movement around them.

After about the first 6 months, speech development of a deaf baby does not progress any further. A child needs to listen to meaningful sounds in order to copy them, and a deaf child does not hear sounds which have any meaning. So he is unable to learn to talk. Instead of using his voice more and more like other children, a deaf child uses his voice less and the variety of sounds decreases.

Discovering deafness

It is extremely important to recognise deafness in children at an early age, preferably in the first year. The right training and treatment can then be given to reduce the effect of the disability. A child who does not hear sounds until the age of 3 years will be slow in learning new sounds. If he cannot hear them by the age of 7, it will be very difficult or impossible to teach him the sounds.

Parents are often the first to notice that something is wrong with their child's hearing. They can obtain advice from their family doctor or the Child Health Clinic.

Deafness should be discovered if the child is taken regularly to the clinic. Routine tests carried out there include the **startle reflex** to sound at 6 weeks.

In some areas, children are given more thorough **screening tests**, usually carried out by health visitors. The first screening tests take place at between 6 and 9 months old. By this age, the average child is able to sit up and has control over the movements of his head. He is tested for response to a low-pitched sound, a high-pitched sound, the 's' sound, and quiet speech. If the child can hear the sound he will turn his head in that direction. Children are usually screened again at 3½ years, and later on when they go to school.

It is now possible to test new babies (neonates) for deafness. The **neonatal audiological screen test** is used by most hospitals for babies at high risk of deafness, for example if the parents are deaf or if the baby was born very prematurely.

Screening test at 6–9 months

DEVELOPMENT

QUESTIONS

1 a When is a baby first aware of sounds?

b **(i)** Name four sounds which an unborn baby can hear. **(ii)** Which type of sounds are soothing?

2 a How does a baby indicate that he can hear **(i)** when newborn, **(ii)** at 1 month, **(iii)** at 4 months, **(iv)** at 7 months, **(v)** at 9 months, **(vi)** at 1 year?

3 a Why may parents not realise that their baby has a hearing problem?

b Although a deaf baby can use his voice, why can't he learn to talk?

c What can parents do if they are worried about their child's hearing?

d When a child's deafness is unrecognised, what may he be wrongly labelled?

e When a young child is tested for deafness **(i)** what sounds will his hearing be tested for, **(ii)** how will he respond if he can hear the sound?

f What is glue ear, and what effect can it have on hearing?

g Is it more common for deafness to be total or partial?

h How does partial deafness affect hearing? Give two examples

FURTHER ACTIVITIES

EXTENSION

Suggest some of the difficulties which a deaf child will have to overcome and which a child who can hear well does not. Try to get some idea of what it is like to be deaf by **(i)** wearing ear plugs for a while, **(ii)** turning the sound off when watching television.

INVESTIGATION

Find out about the types of treatment and training that can be given to deaf children.

Revision Exercise 31

32 DEVELOPMENT OF SPEECH

Speech is an important means of communication. Talking enables people to exchange information, tell others about their feelings and discuss problems.

COMMUNICATION WITHOUT WORDS (NON-VERBAL COMMUNICATION)

Babies have an inborn desire to communicate with other people. Long before they are able to talk, they use other means of getting messages across, such as:

- using the eyes – contact with another person can be made in this way
- tone of voice – a cry, scream or gurgle all carry different messages
- expression on the face – this can indicate pleasure, anger, contentment etc.
- using the hands – babies try to make their wishes known by pointing, clinging, throwing, pushing away, pulling etc.

Before they have learnt to talk, some babies become very cross and frustrated when they cannot make adults understand what is in their mind or what they want to do. Much of this bad temper disappears when they can use words. Being able to talk also makes life much more interesting for the child.

HOW CHILDREN LEARN TO TALK

In order to be able to talk, children have to learn how to make the right sounds and to put them together in a meaningful way. This ability comes with lots and lots of practice over several years. The following activities all play a part in learning to talk.

1. **Other people talking to them** Most mothers, fathers and other adults seem to know instinctively that it is important for them to talk to a young baby. When they hold or look at a baby who is awake, they nearly always speak or 'coo', often using a high-pitched tone of voice. It does not matter if the adults talk sense or nonsense at this stage. What is important to the baby is that someone is speaking to her.
2. **Listening** A baby is very aware of voices. She likes being spoken to, gazing up at the speaker and keeping quite still as she listens. As the child gets older she learns to make sounds which mean words. She does this by copying the sounds made by adults when they speak to her. A child cannot learn to talk merely by listening to the radio or television. She needs to be spoken to in a way that a young child can understand.

A

I'm not tired

B

Goo-goo-goo

C

Mum-mum

D

Bye-bye

3. **Practising making sounds** Babies get pleasure out of using their voices and often spend hours making noises (babbling) to themselves. They also make noises to attract attention, and they enjoy holding 'conversations' (without words) with anyone whose attention they can capture.

4. **Copying sounds made by other people** Babies make a great variety of different sounds as they babble. Only some of these sounds are used when they reach the stage of copying the language of the people around them. If they are spoken to in English, they will copy English sounds and words. If they are spoken to in Chinese, Spanish or any other language they will copy the sounds and words of that particular language. If children hear a lot of swear words, then they will learn those too. If no one bothers to talk to them, then they will not be able to speak very well at all.

5. **Learning what the sounds mean** Young children understand the meaning of words long before they can say them.

PATTERN OF SPEECH DEVELOPMENT

Speech development follows a general pattern. However, there are great differences in the speed at which individual children learn to talk – greater than in any other field of development. Some children will be in advance of, and others much behind, the average ages mentioned here. Girls tend to talk earlier than boys.

Newborn
The baby uses her voice to cry. She also makes other noises when she hiccups, sneezes and 'burps'.

By the age of 1 month, the baby is making little sounds which come from the throat (**guttural** sounds). At 5–6 weeks she is beginning to use her voice (**vocalise**) to coo and gurgle in response to someone speaking to her.

3 months
The baby can make more sounds now that she is beginning to learn to control the muscles of her lips, tongue and **larynx** (voice box). She gurgles and babbles to herself, and also likes to hold 'conversations' with other people. A 'conversation' takes place when the baby makes a noise and then waits for the other person to make a noise.

6 months
A great variety of sounds can now be made such as 'goo', 'der', 'adah', 'ka'. Much time is spent practising these sounds. The baby also laughs, chuckles and squeals in play, and screams when annoyed.

9 months
The baby may say 'dad-dad', 'mum-mum' and 'bab-bab', often repeating the same sound many times. She also begins to copy the sounds made by adults.

1 year

The baby is beginning to understand that some sounds have definite meanings. It is usual, at this age, to say two or three words with meaning, for example, 'dad-dad', 'mum-mum', 'bye-bye'. As the baby comes to understand the meaning of words she can obey simple instructions, like 'Give it to Daddy'.

Babies' first words are nearly always labels for people, animals or things. For example, 'dog' can be used for all animals. The next words are likely to be for food and clothes.

During the next year the child continues to learn more words. She practises making the sounds by talking to herself, at times continuously. At this stage a child may use a language of her own (**jargon**), which no one but her parents can understand.

18 months

The child says 6–20 words.

2 years

She uses 50 or more words and may be able to put two or three together to form a simple sentence.

2½ years

She uses pronouns – I, me, you – and is continuously asking questions. (See also Topic 39.)

3 years

She can carry on a simple conversation and talks incessantly.

4 years

A child's speech is usually easy to understand at this age because most of the basic rules of grammar have been acquired.

PRONUNCIATION

Young children make many mistakes as they learn to speak. They may mispronounce words (say them incorrectly) because they have difficulty in making the correct sounds. They may substitute easier sounds. For example:

- th for s (yeth for yes) – this is called **lisping** and it is quite common in young children
- f for th (fin for thin)
- v for th (fever for feather)
- w for r (wed for red)
- l for y (lellow for yellow).

Difficulties in pronunciation have usually disappeared by the age of 5 or 6 years.

STUTTERING (STAMMERING)

Children aged 2–4 years may sound as though they are beginning to develop a stutter. Sometimes words or parts of words are repeated, almost as if the child is filling in time as she sorts out her thoughts. At this age there is much that children want to say, they are in a hurry to say it and they stumble over words as they try to do so. This is not a true stutter. It is a temporary stage that children pass through as they learn to speak.

Most children pass through this stage quite quickly. It is only likely to become a problem when parents make a fuss about it and try to correct the child's speech. The child then becomes self-conscious about talking and a real stutter may develop. A child who develops a longer lasting stutter may need the help of a speech therapist.

SLOWNESS IN LEARNING TO TALK

Slowness in learning to talk has many causes including:

- **inherited pattern of development** – it may be the family pattern to be late in talking.
- **concentrating first on other aspects of development** – learning to walk or use the hands may come first.
- **not enough individual attention from adults** – children learn to talk from adults rather than other children. A young child in a large family may not get enough attention from adults. This can also happen to twins and in families where young children are close in age.
- **lack of encouragement** – if no one shares the baby's pleasure in the sounds she is making, then the baby will not be encouraged to produce different sounds.

BARRIERS TO COMMUNICATION

Some children have great difficulty in communicating by speech for reasons which include:

- **deafness** (see p. 142)
- **a speech disorder** – this can be caused by a defect in any part of the body concerned with speech such as mouth, vocal cords, or damage to the part of the brain concerned with language
- **emotional** – reluctance to speak due to shyness, fear etc.
- **cultural** – differences in language, background, or accent.

The radio hearing aid worn by this deaf boy amplifies sounds and enables him to hear them. Working with a therapist, he learns what the sounds mean and how to use his voice to repeat them.

COMMUNICATION THERAPY

This is treatment for people with communication difficulties, mainly problems with speech. **Speech and communication therapists** give advice and help to children and their parents in cases of:

- **delayed language development** – slowness in learning to talk
- **speech defects** – the child does not speak clearly, because of physical or emotional barriers to communication.

QUESTIONS

1 Explain the meaning of these words:
 a babbling
 b guttural
 c vocalise
 d larynx
 e jargon.

2 (i) Give four ways in which babies communicate with people before they have learnt to talk. **(ii)** In what way is the baby in the photograph on p. 145 communicating?

3 Name five activities that must take place so that children can learn to talk.

4 a What is lisping?
 b Give four other examples of the ways in which children substitute easy sounds for ones they find more difficult.

5 a Give a reason why some babies become very frustrated at times before they have learnt to talk.
 b Which comes first, a young child's understanding of a word or the ability to say it?
 c **(i)** Why may a 3-year-old appear to be developing a stutter? **(ii)** When is it likely to become a real problem?

6 a Do girls or boys tend to be slower in learning to talk?
 b Give four other reasons for being slow to talk.

7 a Even when children know how to talk, they may have difficulty in communicating by speech. Explain why.
 b For what conditions are speech therapists consulted?

FURTHER ACTIVITIES

EXTENSION
The drawings A–H on pp. 146–147 show children at different stages of speech development. Place the eight stages in the correct order of development, giving the average age at which each stage occurs.

DISCUSSION
Discuss 'Placing a child in front of the television for hour after hour is no substitute for a real live person to talk to'.

INVESTIGATION
 1 Observe (see pp. 354–355) a group of small children playing, and note the ways in which they communicate non-verbally.
 2 Talk with children of different ages and stages of speech development. Tape-record the conversations. Discuss and compare the results.
 a How many different words did each child use?
 b Set up a database of different phrases of **(i)** two words, **(ii)** three words, **(iii)** four or more words.
 c Sort out the words in your lists into nouns, verbs and pronouns.

CHILD STUDY

IT2.1 Talk to the child, listen carefully to what is said, then describe the stage which has been reached in learning to talk. Give some examples of what is said. Make a list of the words the child uses, adding more examples during the course of the study. Note any surprising statements the child comes out with.

Revision Exercise 32

149

33 SOCIAL DEVELOPMENT

Social development – **socialisation** – is the process of learning the skills and attitudes which enable individuals to live easily with other members of their community.

Social development follows similar patterns all over the world although social customs vary in different countries and even between different groups in the same country. Variation can be seen in eating habits, standards of hygiene, forms of greeting, attitudes to dress, religion and morals.

Activities which encourage social development are those which bring a child into the company of other people both inside and outside the home, for example:
- family outings
- parent and toddler groups
- playgroups and nursery schools
- opportunities to play with friends.

SOCIAL SKILLS

Children (and adults) are happier and healthier if they get on well with the people around them. It will be easier for them to do this if they are trained in **social skills**. These are skills which make a child's behaviour more socially acceptable to other people. They include:
- the ability to meet, mix and communicate with others
- knowing how to share, take turns, and accept rules
- having standards of cleanliness acceptable to others, e.g. washing, using the toilet
- eating in a manner which does not offend others.

Children are not born with a knowledge of these social skills. They gradually acquire them as they copy parents, carers and others with whom they come into contact. Parents and carers have an important part to play in guiding and encouraging them to develop acceptable social skills.

PATTERN OF SOCIAL DEVELOPMENT

Newborn babies are social beings right from the start. They have an inborn need for the company of other people. They cry if they are lonely and can be comforted by being held close to another person. The following stages occur in a baby's social development:

1. The baby begins to interact with other people

2 weeks The baby watches his mother's face as she feeds and talks to him and he soon comes to recognise her.

4–6 weeks The baby begins to smile. He will then smile to show pleasure when people look at him.

3 months When an adult speaks to the baby, he will respond by making noises, and he likes holding 'conversations' with people.

6 months The baby is beginning to understand how to attract attention, for example, by a cough. He learns how to make people do what he wants – at least on some occasions.

2. The baby learns that he is part of a family

9 months He distinguishes strangers from people he knows, and needs the reassuring presence of a familiar adult to overcome shyness and anxiety.

3. The child learns to co-operate as a member of a group

1 year He understands and obeys simple commands.

15 months He copies and 'helps' adults in the house and garden.

2 years He likes to play near other children, but not with them, and defends his possessions with determination. He will show concern for other children in distress.

3 years He plays with other children and understands sharing.

4 years He needs other children to play with but his behaviour is alternately co-operative and aggressive.

5–7 years He co-operates with his companions and understands the need for rules and fair play.

LEARNING TO SAY 'THANK YOU'

When people say 'thank you' they are expressing their gratitude for something which has been done for them. Young children have no understanding of the efforts of others and it is not natural for them to say 'thank you'. But if they are taught to be grateful for what other people do for them, and to say 'thank you', it will make them more pleasant to live with.

LONELINESS

The child who does not have sufficient social contact, that is, does not have enough people and friends to talk to and play with, will feel lonely. There are also children who feel lonely even when they are being looked after with other children. Feeling lonely over a long period of time can make a child unhappy and slow down development.

DEVELOPMENT

A

B

Adults who are cut off from sufficient contact with other people can also feel lonely and perhaps depressed. This sometimes applies to mothers of young children. The remedy is for the mother to find ways in which she can meet and mix with more people. If these people also have young children, then her own child will benefit from more company as well as from a happier mother.

DEVELOPMENT OF SOCIAL PLAY

Between the ages of 1 and 5 years, children show gradual development from simple to more complicated forms of social play. Most children pass through the following stages as they learn to play together in groups.

1. **Solitary play** – playing alone.
2. **Parallel play** – playing alongside others but not with them (**A**).
3. **Looking-on play** – watching from the edge of the group as other children play (**B**).
4. **Joining-in play** – playing with others by doing the same thing as everybody else, for example, running around together, or playing with dolls as in **B**.
5. **Co-operative play** – belonging to a group and sharing in the same task, for example, doing a jigsaw together, or cooking, or playing with a rope, as in **C** and **D**.

C

D

FURTHER ACTIVITIES

EXTENSION
1 List, in two columns, remarks which adults might make which would **(i)** bolster a child's self-esteem, **(ii)** discourage self-esteem.
2 a Use a camcorder to make a film of children playing (make sure you get their parents' permission first).
 b Study your film. Can you identify **(i)** some or all of the stages in the development of social play listed above? **(ii)** some of the social skills mentioned on p. 150?

IT2.1

DISCUSSION
Discuss:
 a 'How do children learn the necessary social skills?'
 b 'The effects of loneliness on a child's development' (see also Topics 18 and 35).

CHILD STUDY
Describe the stage of social development which the child has reached. What social skills has the child already learnt?

QUESTIONS

1 a What is meant by social development?
 b What is meant by social skills?
 c Give some examples of the social skills which children need to learn.

2 List the stages which come under the heading 'Pattern of Social Development'.

3 List the five stages in the development of social play.

Revision
Exercise

33

EMOTIONAL DEVELOPMENT

Emotions are feelings such as fear, excitement, affection, happiness, worry, sadness, anger, contentment, pride, jealousy, shyness, frustration, distress and disgust. Young children show all these emotions and many more. **Emotional development** – development of a child's ability to recognise and control her feelings – is influenced by the child's inborn temperament (effects of her genes), her environment and her state of health.

Inborn temperament

This depends on the genes the child inherits. Children vary considerably in the strength of their emotions. For example, some children are naturally very excitable, others less so. Some children are very shy, others are rarely shy. Some are great worriers, others seem almost carefree.

Environment

This means the surroundings and conditions in which the child grows up. Environmental factors which have a marked effect on emotional development include:

- **the home** – This includes the home conditions, the behaviour of the people in the house and the effects of the fortunes and misfortunes which occur as a child grows up.
- **training** – The type of training children receive from adults will affect the amount of control they develop over their emotions (**self-control**). For example, control over temper; whether they are able to overcome feelings of jealousy; how they learn to deal with worry and frustration.
- **children and adults outside the home** who influence the child.

State of health

There is a strong link between a child's state of health and her feelings. When a child is ill, she will have different feelings from when she is well. Long-term illness or handicap can have a marked effect on a child's emotional development. What sort of effect it will have depends on the child's inborn temperament and the care and training she receives.

BONDS OF ATTACHMENT

Emotional development will be affected by the extent to which infants form **bonds of attachment**, that is, strong feelings of attachment for the people who have the most meaning to them.

Being held close to another person gives a baby feelings of comfort and security. These feelings are strengthened by:

- **skin-to-skin contact** – as happens when the baby breast-feeds
- **eye-to-eye contact** – when the baby gazes into her parent's eyes
- **familiar smells** – a baby learns to recognise the smell of her mother's breast within a few days of birth
- **familiar sounds** – a baby soon learns to recognise the voice of her mother and responds more readily to it than to other voices.

As the infant becomes familiar with a person who stimulates feelings of comfort and security, a bond of affection develops. The baby's first emotional bond will be with her mother or the person who looks after her most of the time. The more the baby is cuddled and loved, the stronger the bond is likely to be.

LOVE

Love is one of the basic needs of every child (and indeed every adult). Babies thrive on an abundance of love. Parents who truly love their child accept her for what she is. They let her know they love her by cuddling and talking to her and by giving her their time, attention and companionship. Their love is continuous and undemanding.

Not all babies are loved and wanted. Lack of love and interest makes a child feel insecure and unhappy. Often, such children do not thrive physically or learn to deal satisfactorily with their emotions.

A loving family affects a child's emotional and social development because it allows strong bonds of attachment to be formed between her and other members of her family. She will not then be afraid to show affection for other people. Whereas a child who is not loved by her family may not learn how to love others because she is unable to form long-lasting bonds of attachment with them.

We buy her everything she wants and she's still not happy

'Smother' love

All children need plenty of love. They also need to be allowed to do things in their own way and to make mistakes so that they can learn from them. When they are over-protected and prevented from becoming independent as soon as they are ready, then the love becomes 'smother' love. Smother love may show itself in the following ways:

- not letting her play as she wants and always interfering
- being over-anxious about every movement
- constantly worrying about the child's bowels and toilet-training
- constantly worrying about the amount she eats and sleeps.

SHYNESS

Children have phases of shyness, often for no apparent reason. At 6 months old, a child is usually still friendly with strangers but occasionally shows some shyness. By 1 year old she is likely to hide behind her mother when a stranger speaks to her, or cover her eyes with her arm (**stranger anxiety**). Even when older, some children may become silent and shy in the presence of people they do not know.

Some children are by nature much more shy than others. The shyness is increased when they are in a strange place with new people, whereas the presence of a parent helps them to feel much less shy.

Giving the child plenty of love and security and many opportunities to meet other children helps to prevent excessive shyness. Saying to a child 'Don't be shy' or 'Have you lost your tongue?', or teasing her about it, will make her more shy. Shyness usually disappears with time.

EMOTIONAL REACTIONS TO STRESS

Children often react very strongly to stress. Events which may cause stress in children include:

- starting at playgroup or school
- a new baby in the family
- moving house
- separation from a parent
- break-up of their family
- death of a relative or a pet
- child abuse (pp. 332–334).

They do not understand what is happening and they have not yet reached a stage in emotional development which enables them to control or express their feelings. They may react by showing signs of distress in some of the following ways:

- regression (p. 159)
- jealousy (p. 159)
- nightmares (p. 161)
- aggression (p. 207)
- temper tantrums (p. 206)
- bed-wetting (p. 172)
- refusal to speak ('elective mute').

The stress can be reduced, and is less likely to be prolonged, when parents discuss the stressful event with their child or children in a way which helps them to understand.

SELF-ESTEEM

Self-esteem (self-respect) means valuing yourself as a person. You know that you are like other people in being able to do some things well, but not everything. Children with self-esteem have a positive self-image and this gives them:

- **self-confidence** – They know that they can cope easily with the people they meet and the situations in which they find themselves.
- **self-reliance** – They want to be independent. This comes when children are encouraged to do things for themselves, e.g. babies who are allowed to feed themselves, toddlers who choose what clothes to wear etc.

Factors affecting self-esteem

A child's self-esteem is affected by many factors:

most importantly:

- by the way the child is encouraged and supported by parents and other adults who care for him

other factors are:

- the child's environment, e.g. poverty and deprivation
- discrimination because of race, gender, religion
- the child may be 'different', either because of:
 - disability, e.g. deafness, lameness
 - infection, e.g. HIV positive.

Encouraging self-esteem

Self-esteem develops more strongly in children who are:

- praised for what they can do, not criticised for what they cannot do
- encouraged to develop new skills
- given choices – perhaps about the clothes they wear or toys they prefer to play with
- encouraged to discuss their feelings and express their ideas
- given minimum assistance, so allowing them to feel that they have control over their own activities.

Growing up to be emotionally healthy/unhealthy

Emotionally healthy

Emotionally unhealthy

praised and encouraged ← → faced with years of criticism

supported and encouraged ← → believing she is worthless; getting into trouble at home; getting into trouble at school

feels valued by family and friends, and more able to form long-term relationships ← → feels of little value to anyone and has difficulty in forming long-term relationships

Low self-esteem (low self-image)

Signs of low-esteem may show as:

- often expressing dislike of herself
- trying too hard to please
- constantly belittling herself
- often saying that her wishes do not matter
- lack of pride in her origins
- trying to change her appearance.

A child with low self-esteem may need to be helped by social workers or others specially trained in this field to help prevent her from becoming emotionally damaged. When adolescent, low self-esteem can result in personality difficulties and problems with developing adult relationships.

QUESTIONS

1 a The six faces A–F on p. 153 show the emotions of happiness, fear, sadness, anger, contentment, and shyness. Sort out which face shows which emotion.

b Other emotions are mentioned in this topic. Can you find ten more?

2 a Name three factors which influence emotional development.

b What does the inborn temperament depend on?

c Name three environmental factors which have a marked effect on emotional development.

d What effect does the child's state of health have?

3 a With whom will a baby form her first bonds of attachment?

b **(i)** What feelings are produced in a baby by being cuddled and held close to another person? **(ii)** What strengthens these feelings?

4 a How can parents let their child know they love her?

b How may a child who lacks love be affected **(i)** physically, **(ii)** emotionally, **(iii)** in learning how to love?

c Name four ways in which 'smother love' may show itself.

5 What may help to prevent excessive shyness in a child?

6 a Give some examples of events which may cause stress in a child.

b Give examples of ways in which children react to stress.

c What action may help to reduce the stress?

7 a What is meant by **(i)** self-esteem, **(ii)** self-confidence, **(iii)** self-reliance?

b **(i)** What is the most important factor affecting self-esteem in a child?
(ii) Give three other factors that can affect self-esteem. **(iii)** Suggest four more examples of disabilities that can cause a child to feel or be considered 'different'.

c Give five actions by parents and carers that encourage the development of self-esteem in children.

d **(i)** Give six signs of low self-esteem. **(ii)** What help can be given to children with low self-esteem, and for what purpose?

8 Describe in your own words why a child might grow up to be **(i)** emotionally healthy, **(ii)** emotionally unhealthy.

FURTHER ACTIVITIES

EXTENSION

1 Draw or find photographs of children showing different emotions.

2 Look through this book and list illustrations showing situations which help a bond of affection to develop between **(i)** a child and her (or his) mother, **(ii)** a child and her (or his) father.

DISCUSSION

C2.1a Consider the picture on p.154 and discuss 'Can money buy love?'.

CHILD STUDY

What different emotions (feelings) have you noticed in the child? For each emotion mentioned, describe the occasion when you noticed it. Suggest something which, in your opinion, may have produced the emotion. Describe ways in which the child is being helped to control his or her emotions.

Revision Exercise 34

35 SECURITY AND INSECURITY

A child's feelings may affect his development in many ways, and of special importance are the feelings of security and insecurity.

SECURITY

A secure child is one who **feels safe**. He knows that there is always someone who cares and always a place where he belongs. He feels safe not only from being hurt but also from being lonely, unhappy, rejected and afraid. Knowing that all is well with his world helps him to continue to develop normally.

INSECURITY

An insecure child is one who **feels unloved** and **unwanted**. In general, children who feel insecure will either become timid and withdrawn or (more likely) indulge in 'bad' behaviour in order to attract attention. Children soon learn that such inappropriate behaviour makes people notice them, while to be 'good' often results in being ignored.

Insecurity in children will be reflected in their behaviour. It may be expressed as (**list A**):

- jealousy
- fear
- rudeness
- spitefulness
- aggression
- destructiveness
- bad temper
- nervousness
- extreme shyness
- stuttering
- clinging to the mother
- stomach ache, headache, or other symptoms of illness
- toileting problems (e.g. wetting and soiling).

Insecurity may have many causes. The list below gives some suggestions (**list B**):

- loneliness and boredom
- excessive discipline and punishment
- too little discipline
- a new baby in the family
- the mother feeling depressed because she is unhappy or unwell
- fear of starting school
- too much worry on the part of the parents over such things as feeding, cleanliness, tidiness and toilet-training
- fears which an adult has passed on to the child
- low self-image (p. 156).

REGRESSION

Reverting to an earlier stage of behaviour is called **regression**. It is particularly likely to happen when a child feels insecure. For example, a child who is toilet-trained may revert to wetting his pants. It is no good scolding or smacking the child. What is needed is extra love and attention until he feels secure enough to go back to his normal behaviour.

JEALOUSY

Jealousy is a natural human emotion common to all children, but it is not a happy feeling. It can show in many ways including:

- hitting and biting another child
- snatching toys away from another child
- demanding attention
- moping (listlessness)
- reaction to a new baby in the family.

Learning about babies

A new baby in the family

Jealousy is often a problem when a new baby comes into the family. The feelings of an older brother or sister are likely to be a mixture of affection for the baby and jealousy arising from fear that the new baby is a rival for the parents' affections. Thus, the older child feels insecure. This type of jealousy is known as **sibling rivalry** (**sibling** means brother or sister).

The jealous feelings of the older child cannot be prevented. But, if the parents handle the situation well, jealousy can be kept to a minimum. It will gradually disappear when the older child no longer fears that the baby is a rival.

How parents can help

Parents can help to reduce the amount of jealousy in the older child by:

- preparing him for the new baby's arrival
- reassuring him often that he is loved and wanted (even when behaving badly)
- encouraging him to feel more grown-up and independent
- avoiding comparisons with the new baby in his hearing.

Preparing for a new baby

It is a good idea to prepare the child for a new baby's arrival. He will notice that his mother's tummy is getting bigger, and she can tell him that there is a new baby inside. She may let him pat her tummy and feel the baby kicking, but should explain that the baby needs to grow a little bigger before it is ready to come out. The mother should tell him that she will have to go into hospital for a little while when the baby comes. It will also help if the child knows what a new baby looks like and that he cannot expect a playmate.

Before the new baby comes, the parent should tell the child that when the baby arrives, it will need to be fed on milk, will cry sometimes, and will need to be looked after very carefully. The child can help to collect all the things the baby will need. The parents should try to make sure that the child knows and likes the people who will look after him while the mother is away.

FEAR

Fear is a natural response to danger, or to the thought of danger. Therefore it is quite normal for children to become frightened from time to time.

Young babies show fear by crying when there is a sudden noise or when they feel they are falling. Around 9 months old they may cry when strangers take notice of them. Between the ages of 2 and 3 years they develop particular fears, such as fear of the dark, thunder, dogs, spiders, 'nasty men', noisy machines, or even the plug hole in the bath.

These fears are very real to them. They come about because the child's imagination is developing and he is not yet old enough to understand. The natural fears of childhood can be increased when adults:

- **talk carelessly** in front of children about fires or burglars
- **make threats** – 'I will lock you in the cupboard', or 'I will run away and leave you'
- **let the child know that they themselves are afraid** – of the dark, thunder, or spiders.

NIGHTMARES

Some children have nightmares quite often, others rarely do. They may occur when an infection is just beginning, when the child is particularly tired, or following a heavy meal just before going to bed. The frightening dreams either wake the child up or the child appears to be terrified while still asleep and cries out with fear. An adult needs to go promptly to the frightened child to comfort, reassure and give security. Nightmares are no cause for worry unless they happen nearly every night. Then they are likely to be due to unhappiness or insecurity at home or school. The cause should be looked for and dealt with.

QUESTIONS

1 a What might an insecure child be trying to obtain by inappropriate behaviour?
b List some of the ways in which insecurity may show in a child's behaviour.
c Suggest reasons why a child may feel insecure.

2 a What is a sibling?
b (i) When may sibling rivalry be a problem in the family? (ii) When will the older child's jealousy disappear? (iii) How can parents help to reduce this form of jealousy?

3 a Why is it normal for children to have fears?
b Suggest a reason for the development of fears in a 2-year-old.
c Suggest three ways in which other people may increase a young child's fears.

4 a (i) What is regression? (ii) Give an example.
b (i) What can parents do to help a child return to his normal behaviour?
(ii) What reaction by parents and carers is likely to be unhelpful?

FURTHER ACTIVITIES

EXTENSION

1 How many types of behaviour in list A (p.159) have you noticed in children? Choose four from the list. For each:
a name the behaviour.
b describe how the child behaved.
c in your opinion might the reason have been any of the suggestions in list B? If not, make your own suggestion.

CHILD STUDY

Have you noticed the child behaving in any of the ways in list A (p.159)? How do you, or the parents, react to the behaviour? Does the child have nightmares?

Revision Exercise 35A

Revision Exercise 35B

36 DISCIPLINE

Discipline (or the lack of it) will affect the ways in which children behave and their social and emotional development.

THE NEED FOR DISCIPLINE

Children need sufficient discipline to help them to understand:

- what is safe and unsafe to do, and
- what their parents and carers consider to be an acceptable standard of behaviour
- that there are consequences for misbehaviour.

The form of discipline will need to vary according to the stage of the children's development with the object of ensuring that, by the time they have become adults, they have learnt to control their own behaviour by self-control (**self-discipline**). Children show that they have self-discipline when they behave properly because they understand that they should, and not because they have been told or forced to do so.

Parents do not always find it easy to get children to co-operate with them, and children often resent being told what to do. But parents who provide a certain amount of the right kind of discipline can make life happier for all.

GOOD DISCIPLINE

Discipline which is **firm**, **kind**, **reasonable** and **consistent** benefits children because it:

- **makes them feel secure**, since they know what is expected of them
- **helps them to behave in a way acceptable to others**, who will like them better for it
- **teaches them what is safe and unsafe**
- **helps them to develop self-control**.

LACK OF DISCIPLINE

Insufficient discipline is often harmful. It results in a child who is likely to be:

- **insecure** – because no limits are placed on her behaviour
- **greedy** – she expects to get everything she wants
- **disobedient and unco-operative** – she never wants to do as she is told
- **rude** – she does not consider other people's feelings
- **selfish** – she always expects to get her own way
- **accident-prone** – she is not taught to be aware of dangers.

No child is perfect

EXCESSIVE DISCIPLINE

Too much discipline is also harmful because, although it may stop a child from some types of poor behaviour, it can lead to others. Excessive discipline:

- **gives rise to continuous nagging** by the parent – 'Don't do this', 'Don't do that', 'Do as you are told'
- **demands too much of a child** – too much obedience, tidiness, good table manners
- **makes a child miserable** – there are so many things the child seems not to do right even when she tries.

Excessive discipline makes it difficult for a close and loving relationship to develop between child and parent.

No child is perfect. A parents' efforts to try to make a child perfect are likely to lead to two types of behaviour. Either the child becomes timid and withdrawn; or the child rebels, in which case she will behave very badly by displaying one or other forms of antisocial behaviour, for example temper tantrums, biting, stealing, aggression.

WHEN SHOULD DISCIPLINE BEGIN?

There is no point in trying to discipline children until they are old enough to understand what is wanted of them. Discipline can only be applied gradually as their understanding develops and they come to realise that their parents are pleased by some things and not by others.

Young babies simply do not understand instructions. By 1 year old, most children have begun to understand the meaning of 'NO'. However, it will be quite a while before they understand what is meant by words like 'hurry', 'wait', 'tidiness' or 'quiet'. By 2 years of age they have more understanding of what they are being asked to do. By 3 years, they should have quite a good understanding of what they are expected to do and not to do, but there will still be times when they do not appreciate what is required of them.

Never mind, you were a good girl to use the potty

You should be able to tie your laces by now

No, no more sweets today

HOW TO DISCIPLINE?

It is the parents' responsibility to discipline their young children. They may sometimes find it a difficult job. To make this task easier, parents and carers should try to:

1. **Set a good example**. Children learn a great deal by imitating adults, and copy both good *and* bad behaviour.
2. **Praise rather than criticise**. Rewarding good behaviour by a hug, a smile, or by showing interest in what the child does, is more effective than criticising bad behaviour.
3. **Be reasonable in what they expect**. A child needs time to learn, and if parents expect too much too soon it will only make them all unhappy.
4. **Be consistent**. When a rule is made, every effort should be made to keep to it. The child will then know whether she is doing right or wrong.
5. **Mean what they say**. A child will learn the rules more quickly when 'NO' means 'NO'. If parents do not mean what they say, then the child will be confused about the limits allowed. This can make the child feel insecure.
6. **Avoid battles they cannot win**. A child cannot be forced to eat or sleep or use the toilet, no matter how much parents shout and threaten.
7. **Say sorry when they have behaved badly**. All parents are at times short-tempered and unreasonable. If the parents can say sorry afterwards, it helps the child to learn to say sorry.

QUESTIONS

1 a Why do children need discipline?
 b (i) What type of discipline benefits children?
 (ii) Give four ways in which children benefit.

2 How may lack of discipline show in a child?

3 a Give three harmful effects of excessive discipline.
 b Give four examples of antisocial behaviour which may result from parents' efforts to make their child perfect.

4 a Why is there no point in trying to discipline a young baby?
 b (i) Name one word which a 1-year-old will have begun to understand.
 (ii) Name four words which the baby will not yet know the meaning of.

5 a Whose responsibility is it to discipline young children?
 b Give seven suggestions which make it easier to discipline.

Revision Exercise 36

FURTHER ACTIVITIES

EXTENSION
The drawings A–E on pp. 163–164 illustrate points made in the section 'How to discipline?' For each drawing, choose the point which you consider it illustrates best.

DISCUSSION
'Some parents consider discipline is harmful because it limits a child's freedom to develop in his or her own way.' Use information from at least two other different sources to answer the following:
 a What is your opinion of this attitude?
 b Give other reasons why children may not be disciplined.

CHILD STUDY
C2.2 Give examples of occasions when the child was disciplined. How does the child react to discipline? Does the discipline have the desired effect?

During childhood, children need to learn the skills and behaviour necessary for adult life. Praise and correction will both have a part to play in this.

PRAISE

As mentioned in the previous topic, praise and encouragement are likely to be more effective than correction. For example, a baby who gets praised when he feeds himself learns faster than one who is scolded for making a mess. A toddler who is praised when he uses the potty will learn to be clean and dry more quickly than if he is told off for soiling his pants.

CORRECTION

Although praise is most important, children need occasional correction in order to learn that:

- antisocial behaviour results in unpleasantness
- parents and carers mean what they say
- some actions are unsafe.

At what age should correction start?

There is no point in correcting children until they are old enough to understand why they are being corrected. Otherwise they will learn nothing, and only become confused and insecure and more difficult to deal with.

For this reason, babies under the age of 1 year should not be corrected. When a baby is doing something that the parents or carers do not like, then it is up to them to prevent it. They can do this either by turning the baby's attention to something else (distraction), or by removing the cause of the trouble.

During the second year, children will begin to understand when they have done something wrong, although this stage is unlikely to be reached until at least the age of 18 months. If the right sort of correction is given now, it will help the child to be obedient. By the age of 3, children should be well aware of whether they are being 'good' or 'naughty'.

HOW TO CORRECT A CHILD

Showing displeasure Often all that is necessary is for parents to show children that they are not pleased with what they are doing. Children who are given plenty of praise and encouragement when behaving well will soon notice when their parents are not pleased with them.

Parents can show that they are not pleased in a number of ways. For example, they can ignore the child for a little while. Or they can insist that the child has 'time out' by making him sit on the 'naughty' chair in the corner of the room (perhaps for about three minutes for a small child), or by sending the child out of the room for a set time.

Correction should be immediate If it is necessary to correct a young child, then it should be done immediately so that the child knows what the correction is for. A young child will not remember what all the fuss is about if he has to 'Wait until Daddy or Mummy comes home'.

Linking correction with misbehaviour For example, if a child scribbles on the wall then the crayons should be taken away. If a child deliberately hurts another child, he should be sent away to be on his own in a corner or another room for a short while. If a child will not stop playing to come for his dinner then it should be cleared away. The child will not starve, but he will be ready for the next meal.

Threats Threats should not be made unless the parent actually intends to carry them out. Empty threats will not teach a child to be obedient. Such a situation is shown in the drawing below.

I tell him every day to tidy his toys or he won't get an ice cream

PHYSICAL PUNISHMENT

Some parents believe that children should not be smacked under any circumstances. Others feel that giving a child a light tap on the hand occasionally helps to emphasise their displeasure at what the child has done. But it is **never** necessary to correct children by smacking them hard, shaking them or by other forms of physical punishment. The other ways of correcting a child which have already been mentioned are much more effective, and less harmful.

Smacking Sometimes parents hit out in anger or frustration, particularly if the child cries a lot or has problems with feeding or sleeping. Such smacking can damage the child, especially when the child is hit on the head.

Shaking It is always dangerous to shake a baby. The baby's head is big and heavy compared to the rest of its body and, unless supported, flops around because the neck muscles are not yet strong enough to hold it steady. Shaking makes the head move backwards and forwards very quickly and with great force. This may cause tiny blood vessels in the baby's brain to tear and bleed, which can result in blindness, deafness, fits, learning difficulties, or even death. The danger is greatest for babies under 12 months, but shaking can cause the same serious injuries in toddlers.

List A

Children behave badly more often when they are:

- hungry
- worried
- tired
- unwell
- bored
- lonely.

EFFECTS OF CORRECTION OR PUNISHMENT

The less often correction or punishment is given, the less severe they need to be in order to have an effect. The opposite is also true – the more often they are given, the more severe they have to be to have any effect. Also, constant correction and criticism can destroy a child's confidence and self-esteem (see pp. 155–156).

Frequent punishment disturbs a child and can lead to troublesome behaviour – temper tantrums, bed-wetting, disobedience and so on. When parents are frequently punishing the child, they should ask themselves why.

List B

Parents tend to punish more often when they are:

- cross and upset
- worried
- tired
- unwell
- too busy.

- Are they asking too much of the child before he is able to understand?
- Is the child being punished frequently because he is copying the parents' behaviour? Do the parents often lose their temper, shout, argue, hit each other, or damage things?
- Is the child behaving badly because of any of the factors in list A?
- Are the parents punishing frequently because of any of the factors in list B?

MORAL DEVELOPMENT

This is the development of moral values and standards of behaviour based on respect for other people. Babies are not born with a moral sense and have no understanding of 'right and wrong'. For example, they do not understand that hitting people is wrong.

By the age of 3–4 years, children begin to have some understanding and sympathy for the feelings of others. They learn that other people consider that some actions are 'right' and others are 'wrong'. As they gain more experience of life and become able to reason, they will judge for themselves what is right and wrong and this will lead to the development of their own moral values and standards of behaviour.

QUESTIONS

1 Is praise or correction likely to be more effective in training a child
 a to feed himself, as in the picture on p. 166
 b not to wet his nappy?
 Explain each answer.

2 a **(i)** Why should babies under 1 year old not be corrected? **(ii)** Name two ways by which parents can stop the baby from behaving in a way to which they object.
 b **(i)** By what age should children be well aware of being 'good' or naughty'? **(ii)** Give three reasons why children need occasional correction.
 c Why should correction be immediate for young children?

3 a Describe three ways of correcting a child.
 b When should threats not be made?

4 a When may parents or carers be tempted to smack a child?
 b Why is smacking undesirable?

5 When a baby is shaken **(i)** what happens to the head, **(ii)** why does it happen, **(iii)**, in what way can the brain be damaged, **(iv)** what can such damage to the brain result in?

6 a What effect is frequent punishment likely to have on the child?
 b What questions should parents ask when they find they are punishing their child often?

7 a What is moral development?
 b Why do babies not understand that hitting people is wrong?
 c By what age do children begin to learn right from wrong?
 d When will they begin to develop their own moral values?

FURTHER ACTIVITIES

EXTENSION

1 a From your own experience, describe some occasions when a child has been corrected (perhaps yourself as a child). In each case, say what effect the correction had.
 b For each, do you consider that any of the factors in **(i)** list A, **(ii)** list B, had any connection with the behaviour or punishment? You may consider that other factors were involved, in which case describe them.

DISCUSSION

C2.1a Contribute to a class discussion on one of the following:

Do you agree or disagree that:
 a 'Encouragement and praise are more effective than punishment in the training of children.'
 b 'Children are most in need of love when they are behaving badly.'
 c 'Smacking is never necessary.'

CHILD STUDY

What punishment is the child given, and what are the effects?

Revision Exercise

37

38 BLADDER AND BOWEL CONTROL

The body produces waste matter which is stored in the bladder and bowel before being discharged. The **bladder** stores liquid waste called **urine**. The solid waste which comes from the **bowel** has the technical name of **faeces**. Faeces are often called 'stools', 'the motion', or 'bowel action'. At intervals the outlet from the bladder or bowel opens and waste matter is released.

BABIES

When in the uterus, the baby's intestines contain a sticky, greenish-black substance called **meconium**. The baby gets rid of this during the first few days of life by passing greenish-black stools. The stools gradually change to a yellow colour as milk is taken and the baby's digestive system gets into working order.

It is common for babies to go red, grunt and strain when passing a stool, even a soft one. The stools of a baby fed entirely on breast milk are always soft. Bottle-fed babies have stools which are firmer, browner and more smelly.

Young babies are not able to control the outlet of either the bladder or the bowel, and the bladder in particular opens many times a day.

USING THE POTTY

Some parents try to teach their baby to use a potty when the baby is a few months old. Usually they do not have any success because a baby of this age is still far too young to learn. However, a few babies will perform regularly on the potty. This is not because the baby has learnt what to do; the reason will be either that the cold rim of the potty triggers the outlet of bladder or bowel to open, or the baby has regular bowel or bladder movements at particular times of the day.

Babies who use the potty in the early months may refuse to do so at 9–12 months old. A parent who then tries to force the baby to sit on the potty runs a real risk of starting a 'battle'. A baby of this age is not yet old enough to have any voluntary control over the bowel or bladder outlets. The parent should wait for a few months and then try again.

Who is likely to become potty-trained first?

WHEN SHOULD TRAINING BEGIN?

There are no hard and fast rules. Some parents want their child to be toilet-trained as soon as possible, others don't mind how long the nappy stage continues (within reason).

There is nothing wrong in putting a baby on a potty after the age of about 12 months, and if successful it saves a wet or dirty nappy. Problems will only result if the baby is forced to sit on the potty against her will. This is the commonest cause of later difficulties.

Toilet-training can only start properly when the child begins to learn how to control the muscles which open the bladder and bowel. This rarely happens before the age of 15–18 months and often not until 2½–3 years old. There is great variation in the speed at which normal children develop; even children of the same family become clean and dry at quite different ages.

Some pre-school groups insist on children being potty-trained before attending. Putting the child under stress to speed up the potty-training process is likely to be much less effective than gentle encouragement.

Stress can also be avoided when a child starting at a playgroup or nursery school is aware that an accident in bladder or bowel control is natural and will be dealt with sympathetically and without embarrassment or reprimand.

DEVELOPMENT OF CONTROL

Bladder control
The usual stages of development of bladder control are as follows:

1. It begins when the child is aware of passing urine, and indicates to her parents she **has** a wet nappy (**A**).
2. She indicates when she **is** wetting her nappy (**B**).
3. Next, she indicates when she is **about to** do so (**C**).
4. Shortly after this stage is reached, she is able to tell her parents **in time** to be put on the potty or lavatory (toilet, loo, or whatever it is called) (**D**).
5. She becomes dry **during the day**. Most children are dry during the day by the time they are 2½ years, but a few may not be so until 4–5 years or even older. Girls tend to acquire control earlier than boys.
6. She becomes **dry during the night** as well.

Bowel control
This is likely to be learnt before bladder control, and is acquired in the same way.

RELAPSE OF CONTROL (REGRESSION)

It is quite common for a child who has learnt to control her bladder and bowel to stop doing so for a while, and to return to wetting and soiling her pants. The cause may be teething, illness, change of surroundings, insecurity due to the arrival of a new baby, or there may be no obvious reason.

The relapse is likely to be short if the matter is dealt with in a way which does not undermine the child's self-esteem and if she is given praise and encouragement on the occasions when she is clean and dry. But it will usually last for a much longer time if she is smacked or punished and made to feel unloved and insecure.

FORCING A CHILD TO SIT ON THE POTTY

Children who have been forced to sit on the potty against their will are those who in later months refuse to use it. They may:

- deliberately soil or wet their pants as soon as they get off
- withhold the motion and become seriously constipated
- become bed-wetters.

These problems are not likely to arise if the child is taken off the potty as soon as she wants to get off, whether she has passed anything or not. A child who comes to associate the potty with smacking and scolding will not want to use it.

USING THE TOILET

Some children may be afraid of the toilet, and special child seats help them to feel more secure on it.

BED-WETTING

Some children take much longer than others to learn control of the bladder. By the age of 5 years, one in ten children still wets the bed occasionally. They will eventually grow out of it.

How parents can help

Restricting the amount of liquid which the child takes before bedtime is not likely to make any difference to the problem. This is because the bladder tends to adjust to less fluid, and therefore holds less before feelings of fullness occur. But there are other ways in which parents can help:

- They should remain calm and patient so that the child does not feel worried or under stress about bed-wetting.
- They could have a star chart with small rewards for a certain number of dry nights (such as a treat at teatime or an extra bedtime story).
- Children should not be given fizzy drinks or drinks containing caffiene such as cola and tea before bedtime as these stimulate the kidneys to produce more than average amounts of urine.

- A detector mat can be useful for children over the age of 7 years. The mat is placed under the sheet and it triggers a buzzer as soon as it becomes wet. Usually, with continued use the amount of urine passed before the child wakes becomes smaller, and many children are cured within two to three months.
- Some medicines can be helpful. They are very powerful, are best used for children over 7 years, and should be used for short periods only, e.g. when away from home.
- Waking the child during the night so that she can empty the bladder can be helpful if the child is fully woken up and at a different time each night. Night-time waking should be stopped if the bed-wetting has not lessened after two months of this treatment.

QUESTIONS

1 a What is the liquid waste from the body called?
 b Give three names for solid waste.

2 a **(i)** Do babies have any voluntary control over the bladder and bowel? **(ii)** Give reasons which may explain why a baby may perform regularly on the potty.
 b At about what age do most children begin to learn to control the muscles which open the bladder and bowel?
 c By what age are most children dry during the day?
 d Is bowel or bladder control likely to be learnt first?

3 a List six stages through which children usually pass as they learn to control the bladder.
 b Give four reasons for relapse of control.
 c What type of treatment of the child is likely to increase the length of time of the relapse?

4 Name three possible conditions which may arise in children when they are forced to sit on the potty against their will.

5 a Give seven ways in which parents can help a child to cope with the problem of bed-wetting.
 b Why is restricting the amount of liquid the child takes before bedtime not likely to be of much help?

FURTHER ACTIVITIES

DISCUSSION
Discuss problems which can arise in training children to be clean and dry, and how to deal with them.

CHILD STUDY
What stage has the child reached in bowel and bladder control? Describe the child's progress in 'potty-training'.

Revision Exercise
38

39 INTELLECTUAL DEVELOPMENT

Intellectual development (mental development; cognitive development) is development of the mind. The **mind** is the thinking part of the brain – the part which is used for recognising, reasoning, knowing and understanding.

A child's mind is active from the time he is born. Day by day, as the child grows, the mind develops as he:

- learns about people
- learns about things
- learns new skills
- learns to communicate
- acquires more memories
- gains more experience.

As a child's mind develops, he becomes more **intelligent**. How intelligent the child becomes will depend on two main factors:

- **genes** – these control the amount of natural intelligence he has
- **environment** – the use the child makes of his intelligence will be very much influenced by the environment in which he grows up.

Throughout childhood, the genes and environment continuously interact to produce people whose minds develop in a great variety of ways. For example, children vary in their ability to remember, their artistic or musical talents, skill at languages or mathematics, academic ability (ability to study), cleverness with the hands, and whether they have a good understanding of people and their problems.

HOW TO ENCOURAGE INTELLECTUAL DEVELOPMENT

In the first year
Development of a baby's mind is helped when parents:

- talk to the baby
- play with him
- place him in a position where he can see what is going on around him
- provide toys and objects which he can handle and investigate, and which encourage him to concentrate
- allow him to practise new skills as soon as he is ready – e.g. feeding himself
- from the age of about 9 months, start to read to him, tell him stories and show him pictures.

After the first year

Development of a child's mind is helped when the child is encouraged to:

- talk
- practise new skills – dressing himself, drawing, playing games
- be curious and ask questions
- explore new places
- play with other children
- play with toys which stimulate his imagination
- be creative and make things
- listen to stories
- look at books, and eventually learn to read.

CONDITIONS WHICH HINDER INTELLECTUAL DEVELOPMENT

The following conditions can slow down the rate of development of a child's mind:

- lack of enough opportunities for talking and playing
- nothing of interest for the child to do
- constant nagging or bullying from other people
- deafness
- poor eyesight
- poor concentration
- frequent illness
- frequent absence from school.

If these adverse conditions persist for too long, they may prevent full development of the child's natural intelligence.

HOW CHILDREN LEARN ABOUT THE WORLD AROUND THEM

Using their senses

Young babies are far more aware of their surroundings than was once thought. From their earliest days, they use their senses to develop an awareness and understanding of the world around them. They are aware of stimuli from the environment in the form of light, sound, touch and smell, and they learn as they **look, listen, feel** and **smell**. Babies take most interest in what is new or different. They are more likely to be kept alert and happy by changing patterns of stimulation, whereas the repetition of sounds and movements will often send them to sleep.

Exploring at the seaside

DEVELOPMENT

Investigating and exploring

From the age of 3 months onwards, they want to touch objects and to handle them and put them in the mouth. They come to recognise an object by its shape, what it feels like, how it looks and behaves when turned in all directions, and how it sounds when it is moved or banged. They are gaining information all the while, and new objects interest them more than familiar ones.

When children are able to move around, they approach objects or places to explore them. Places which they find interesting will encourage exploration and will increase their information about the environment.

Asking questions

When children are able to talk, they start to ask questions. At 2½ years they ask 'What?' and 'Who?'. At 3 years they ask 'Where?'. At 4 years they want to know 'Why?', 'When?' and 'How?'. Their questions are continual and demanding as they try to make sense of their world. Children who have their questions answered find out a great deal of information. They are now at an age when they can begin to understand about places and people they have never seen, and about events which have happened in the past or will happen in the future.

Using books

When adults encourage children to use books, they are helping to increase the children's knowledge and awareness. **Looking at pictures** with an adult helps in understanding pictures as representations of real things, and helps develop awareness of colours, shapes, sizes and numbers of objects. **Hearing stories** helps in learning to listen and to concentrate. When children can **read** (see Topic 43), they have the means of exploring a vast store of knowledge.

Acquiring basic concepts

Concepts are general notions or ideas. Children get ideas as they play, they test them out, and they ask questions. Gradually they come to understand more and more about how the world works, and they begin to understand basic concepts such as heat, light, gravity, living and non-living things, the change of state from solid to liquid to gas and back again, time (yesterday, today, tomorrow), distance, and the meaning of right and wrong.

Learning by imitation (by copying)

Children learn a great deal by imitating the behaviour of others. For example, they learn to:

- speak by copying sounds
- write by copying letters and words
- help in the house and garden by copying adults
- know the difference between right and wrong (provided that the people around them set a good example).

THE ROLE OF ADULTS IN EARLY EDUCATION

Children are naturally curious, showing great interest in new things and getting excited about new activities. They have a great deal to learn in order to acquire the knowledge and skills which they will need as they grow up and become adults. These are gradually acquired through ordinary daily activities and through play. The greater the child's ability to cope with life, the greater will be the child's self-esteem, self-reliance and self-confidence (see p. 155).

The early education of children is helped when they experience many different learning activities. These can be provided by the parents and carers, by childminders or by any of the pre-school groups mentioned on p. 217. Children also depend on adults for their moral development; they need to be taught about right and wrong, good and bad, sharing, helping others, and being considerate towards others.

Children learn best when adults:
- **provide plenty of opportunities** to learn skills and reinforce the patterns of learning at the appropriate stage of development
- **give them support and encouragement** when they need it, but **do not disrupt their play** by telling them how to do things – it is better to let children have the fun of finding out for themselves
- **help them to understand** the information they receive through their sense organs, e.g. eyes, ears etc. (The interpreting of information received through the senses is called **perception**.)
- **tell them what is happening** and let them help in the planning of activities
- **help them to recall** (remember) and predict
- **set a good example** and show a strong sense of right and wrong in their dealings with the child and with others.

QUESTIONS

1 a The intelligence of a child depends on two main factors. Name them.
 b How does each of these factors affect a child's intelligence?

2 a How can development of the child's mind be encouraged **(i)** in the first year, **(ii)** after the first year?
 b List eight conditions which may hinder this development.

3 a **(i)** How do young babies learn about the world around them? **(ii)** How will they investigate things when they are 3 months old or more?
 b How do children find things out when they can talk?
 c Name three ways in which children can use books and say how each way helps to increase the child's knowledge and awareness.
 d **(i)** What is meant by a concept? **(ii)** List at least seven basic concepts of which a child gradually becomes aware.
 e Give some examples of what children learn by copying other people.

4 a What role can adults play in early education?
 b Give six types of action which adults can take to create conditions in which children learn best.

Revision
Exercise
39

FURTHER ACTIVITIES

EXTENSION

1 **(i)** Find pictures to illustrate both of the lists under the heading 'How to encourage intellectual development' on pp. 174–175. **(ii)** For each of the illustrations on p. 176, suggest a second question.

2 From your experience of child's play, describe one incident which illustrates each suggestion for how adults can best help children to learn (p.177).

3 **a** Copy and complete the chart below.

 Column 1: contains a list of some of the skills and knowledge which are learnt during childhood.

 Column 2: for each of the items in column 1, select an example from drawings A to L opposite which provides a learning opportunity.

 Column 3: explain why you chose each example.

 Column 4: give another example not shown in the drawings which also illustrates each item in column 1.

 b Describe the safety aspects which would need to be considered for three of the activities shown in the drawings A to L opposite.

ACQUIRING SKILLS AND KNOWLEDGE			
1 Skill	**2 Example**	**3 Explanation**	**4 Your own example**
Learning to ■ co-ordinate muscles ■ concentrate ■ remember (recall) ■ be self-reliant ■ exercise self-control **Learning about** ■ heat and cold ■ floating and sinking ■ solid to liquid ■ gravity ■ distance ■ living things and growth **Learning the meaning of** ■ time ■ right and wrong ■ consideration for others			

Note: more Further Activities can be found on page 180.

FURTHER ACTIVITIES

DISCUSSION

C2.1a Discuss the importance to a child's intellectual development of the example set by parents in their conversations, reading, choice of television programmes and hobbies.

INVESTIGATION

Obtain some books intended for young children. List each title and:

 a say what age group it is suitable for
 b state briefly your opinion of the book
 c give ways in which you think it would help a child's mind to develop, e.g. in imagination, general education, improving reading ability.

DESIGN

Tape-record a story for children which will help their imagination to develop. You can use several voices and include sound effects.

CHILD STUDY

 1 Encourage the child to tidy a kitchen drawer – check beforehand that it holds a selection of cutlery of different types and sizes for comparing, sorting and counting, and make sure there are no very sharp implements. Observe and record what the child knows about numbers, shapes, sizes, colours, names, purposes, safety etc.
 2 What has the child recently discovered about the world around him or her? Give some examples.
 3 List ten of the child's activities and, for each, name a concept which is being learnt.
 4 Describe aspects of the child's behaviour that he or she has learnt by copying other people.

EXERCISES

Exercises relevant to Section 4 can be found on pp. 347–348.

SECTION **5**

EARLY CHILDHOOD

Children play because it gives them pleasure. They do not play when it is not enjoyable or if they are bored with the game. Play is also an essential part of their education because while they are playing they are learning. It is an important part of socialisation.

Children need opportunities both to play with other children and to play on their own. When two or more children are together, many different games are possible. Whatever the game, the children will be learning how others behave and how to mix easily with them. At other times, children need to play on their own and without interference in order to learn how to amuse themselves. If adults spend too much time playing with a child, the child will feel bored and miserable when left on her own. Then, instead of playing happily, the child will spend her time trying to demand attention.

BENEFITS OF PLAY

1. **Play enables children to find out** about themselves and the world. It allows them to:
 a discover
 b experiment
 c create
 d concentrate
 e express ideas
 f develop speech
 g develop muscles
 h invent
 i learn new skills
 j learn how other people behave
 k role-play (pretend to be someone else)
 l share possessions
 m use the imagination
 n co-operate with others
 o show off (children like to let others know what they can do)
 p act protectively towards someone less powerful than themselves.

2. **Play helps towards happiness**. A child who is absorbed in play is likely to be a happy child, as play produces feelings of satisfaction and achievement.
3. **Play helps prevent boredom**. Preventing a child from being bored is very important, as boredom can quickly lead to bad temper, irritability and destructiveness.
4. **Play can help reduce stress**. The acting out of stressful situations can help them to seem more familiar and therefore less frightening. For example, by playing 'schools' a child becomes familiar with the idea of going to school. This will help to reduce any nervousness about school which the child might have. In the same way, playing 'doctors and nurses' can help prepare a child for a stay in hospital.

5. **Play can help divert aggressive instincts**. Using a hammer to nail pieces of wood together to make a 'boat' is preferable to using the hammer to hurt someone or destroy property.

DIFFERENT TYPES OF PLAY

Children like variety and during the day will change from one type of play to another. Sometimes they use the same toy. More often they use different toys because changes stimulate different types of play. Six types of play can be recognised and each forms part of a child's total development.

- **Discovery play** (exploring play) enables a child to find out about things: what they are like – their size, shape, texture, colour; how they are made; what she can do with them, for example playing with water or sand. The child will also discover that things can be broken, and this can help to teach her to take care of her possessions.
- **Physical play** (exercise) takes place when a child is actively moving around – running, jumping, climbing, crawling, balancing, swinging, throwing a ball, and so on.
- **Creative play** is when a child expresses her own ideas and feelings to make something which is original, for example, a picture, an animal in modelling dough, a house in building blocks, and so on. A young child is able to express feelings and ideas more easily by painting and drawing than by using words. As the child becomes more skilled with words, she may then be able to write a story, poem or play.
 - **Imaginative play** is 'pretend' or fantasy play. The child imagines that she is someone else or an animal such as a rabbit or dog. Children imitate the ways of adults when they play in a Wendy house or play 'shopping'. Attempting to behave like someone else helps the child to understand more clearly the ways other people behave.
 - **Manipulative play** involves skilful use of the hands. During manipulative play the hands, eyes and brain are being trained to co-ordinate, that is, to work smoothly together. Babies become increasingly skilful with their hands as they play with rattles, soft toys and other objects. Later on, they benefit from playing with such things as modelling dough.
 - **Social play** takes place when children play together. It teaches them to co-operate, to share, and to be honest. It also teaches them that antisocial behaviour, like cheating, leads to isolation and loss of friendship. Children often quarrel and in doing so learn about each other's reactions.

At any one time, a child may be involved in more than one type of play. For example, when a baby plays with a rattle, she discovers what it is like as she learns to use her hands – this is both discovery and manipulative play. When a group of children play with bricks it could involve all types of play.

QUESTIONS

1 a Why is play considered to be an essential part of education?

b Give a reason why children need to play
(i) with other children,
(ii) on their own.

c List briefly five benefits of play.

2 What does play allow children to find out about themselves and the world? Give at least ten suggestions.

3 Play can be classified into six different types. Name and describe each type.

Revision Exercise

40

FURTHER ACTIVITIES

EXTENSION

Study the six pictures A–F in this topic.

1 Each of the six pictures is intended to represent a different type of play. Decide which type of play each picture best represents. Give a reason why you consider it represents that type of play.

2 Take each picture in turn and say which of the items in the list on p. 182 are involved in that particular play situation.

3 (i) Some of the toys used by the children in the pictures are objects which have been found around the house and garden. Make a list of the objects which are being used as toys. **(ii)** Suggest other everyday objects which could be used as toys.

4 Make a database file on toys which can be bought for children aged 7 years and under. This could be a group activity. Here is a suggested layout for one record.
Name: Bricks *Cost:* £12.99 *Type:* Imaginative, manipulative
Age: 1, 2, 3, 4, 5, 6, 7 *Comments:* Can be added to, very versatile.

IT2.2 Use the file to find out **(i)** Which toys are suitable for children under 2 years? **(ii)** Which toys are suitable for creative play for children under 2 years? **(iii)** Which toys are suitable for more than one kind of play? **(iv)** Which toys for 5-year-olds cost less than £10.00? **(v)** Then think of some more questions you could ask.

INVESTIGATION

Investigate the outdoor play facilities in your district, then write a report for your local council. Do you consider that children's needs are being met?

CHILD STUDY

C2.3 Observe (see pp. 354–355) the child in a variety of play situations, for example when playing:

a on his or her own
b with another child of the same age
c with an older child
d with a younger child
e with a group of children
f with an adult.

State the occasions when you were able to identify each of the six types of play mentioned in this topic.

As we saw in the previous topic, children play happily with many different objects which they find around the house and garden. They use these objects as toys. Nevertheless, toys which are specially made for children will also give them much pleasure and help to increase the variety and interest of their games.

CHOOSING A TOY FOR A CHILD

Toys come in many forms. Those which give pleasure will be used. Because they are used, they will give the opportunity to learn. Toys sold as 'educational toys' will only be played with if the child finds them either fun or interesting.

A successful toy is one which a child both likes and uses often. Such a toy:

- **is right for the age of the child** – the child is old enough to enjoy it, but not too old for the toy to seem babyish. It can be dangerous for younger children to play with toys for older children
- **is strong enough for the child to use**
- **provides more than temporary interest** – it may:
 - give scope for the imagination
 - give scope for learning new skills
 - make the child think
 - have special appeal for the child
- **is safe to play with** – for example, the eyes of soft toys are firmly fixed and cannot be pulled out; there are no sharp edges or points; toy cars and tricycles are stable and will not easily tip over.

SAFETY REGULATIONS

CONFORMS TO B.S. 5665

Toys are governed by safety regulations. The 'CE' symbol on a toy shows that it meets the requirements of the European Union's Toy Safety Directive and is safe for children to play with. Those with the 'Lion Mark' of the British Toy Manufacturers Association (BTMA) meet the legal safety requirements. A 'Lion Mark' on a toy shows that it has been made by a member of the British Toy Manufacturers Association (BTMA) and meets the legal safety requirements.

TOYS FOR CHILDREN OF ALL AGES

Many toys are used only during a particular stage of development. However, a few seem to appeal to children of all ages and are used over a long period of childhood. These include bricks, climbing frames, dolls and soft toys, and toys for bathtime.

Bricks

Bricks probably have the longest life of any toy. Building with bricks encourages children to concentrate, be patient, to invent and to be skilful with the hands.

When a young child first plays with bricks, he has difficulty in placing one brick on top of another. He has to learn:

- **to use the hands and eyes together**
- **to develop fine control** over the muscles which move the fingers
- **to concentrate** as both time and effort are needed to achieve a satisfactory result
- **to persist** and keep on practising until the bricks can be placed where they are wanted.

As the child gets older, more use is made of the imagination to arrange the bricks in different ways. There are a large number of games in which bricks can be used. For example, bricks can be made into walls, towers, steps, houses, roads, tunnels and patterns. They can keep one child amused or occupy a group of children playing together.

For bricks to be a really useful toy, there need to be enough of them. A few bricks are not much use except to a baby. Older children need many more, probably over 100. Hundreds of bricks require quite a lot of space, both for storage and when they are being played with. Parents must be prepared to have half-finished games left over a large part of the table or floor.

Interlocking bricks like Lego®, Duplo® or Sticklebricks® keep children happily occupied for many hours throughout childhood. Children can start to play with them as soon as they have the skill to lock them together *and* when they have grown out of the stage of wanting to put small things in the mouth. If a collection of bricks is begun when the child is young, then added to from time to time, it can be made to keep pace with his developing skills and imagination.

Climbing frame

This large and expensive toy takes up a great deal of space and, once put up, has to be left in place. The advantages of a climbing frame are that it can be used throughout childhood both for physical play and for many other activities. It can be erected wherever there is enough space, either inside or outside.

A climbing frame is particularly useful for children who do not have a large garden or nearby adventure playground in which to play. It gives opportunity for children to use their muscles, gain control over their movements, test their skills and use up energy. A young child using a climbing frame has to decide where to put his hands and feet, how far to climb and how to hold the body to stay in balance. As experience is gained in moving around, the child will become more confident and adventurous. Adding objects to the climbing frame such as a rope, plank, hammock or blanket increases the interest and provides ideas for many imaginative games.

Dolls and soft toys

The favourite doll or teddy or cuddly animal becomes a sort of 'person' to whom the child can turn for companionship or comfort. Unlike people, they are always ready for play, do not make demands, can be talked to in confidence and then left alone until wanted again. Sometimes children prefer to share their grief, anger or pleasure with dolly or teddy rather than with people. Many children rely on them for comfort throughout childhood. Dolls come in many shapes and sizes. Some are elaborately dressed and often appeal to grown-ups. However, children usually seem to prefer a simple doll or soft toy as there is more scope for the imagination and less to go wrong.

Toys for bathtime

Children love playing with water and have fun with toys which float, sponges for squeezing, and containers for scooping up water. One way of getting children to wash themselves all over or to have their hair washed at bathtime is a promise to give them time afterwards to play in the water, perhaps bathing a doll or washing its hair. Supervision of children in a bath continues to be needed at all times for safety reasons.

Sponge blocks float and can be squeezed; when wet they will stick to a flat surface

TOYS IN THE FIRST YEAR

Babies begin to play at 3 months or earlier. They love having objects to handle and to look at. They find new objects more interesting than familiar ones. It is therefore best if their toys are given to them a few at a time, then changed around for variety. They will then show renewed interest in a toy which has not been played with for a few days.

In general, babies prefer toys which are brightly coloured and which make a noise. Toys for this age group should be attractive, manageable, fun, unlikely to break, washable and safe. **Safe** means that the toy can be handled and put in the mouth without causing harm. It must have no sharp edges, or points, or small pieces which could be swallowed. Also it should be splinter-proof. Stuffing should be clean, and paint should not contain lead.

3 months

The baby's first toy is likely to be a rattle, which has to be placed in the baby's hand. The rattle should be light and with a handle or ring which is the right size for a baby to grasp.

4 months

The baby will get pleasure from waving a rattle about. He will also enjoy beads on his pram and a mobile above his cot. 'Baby gyms' provide a lot of fun and discovery – the baby handles and kicks the hanging mirrors, rattles and beads.

5 months

Now that the baby is able to pick up objects, a wide variety of toys will give him pleasure – in the pram, on the tray of his chair, on the floor, in the bath and in the garden. When the baby is able to sit up unaided, the range of toys that can be enjoyed is increased.

10 months

Babies of this age have better co-ordination. They can easily reach for, grasp and pick up objects. They enjoy putting things into containers (bags, boxes, tins etc.) and taking them out again.

1 year

Babies now begin to take an interest in books. Those shown at the bottom of p. 195 are suitable for this stage.

Baby gym/activity centre

TOYS FOR CHILDREN AGED 1–2 YEARS

Most of the toys for children under 1 year old will still be used between 1 and 2 years. In addition, the children can now stack bricks and play with other toys requiring similar co-ordination skills. They like picture books with simple stories or nursery rhymes. 'Push and pull' toys are popular with children who can walk. Towards the age of 2, they are able to thread large beads, play with a ball, enjoy a paddling pool, and like 'helping' with the cleaning, cooking and other jobs with mum and dad.

TOYS FOR CHILDREN AGED 2–3 YEARS

Children now have sufficient skill with their hands to manage large interlocking bricks, toys which unscrew, the 'posting box' with holes of different shapes, peg boards with pegs to hammer, blackboard and chalks, coloured crayons and poster paints, and modelling dough. They also like books with pictures and books in which they can draw and colour. Towards the end of the third year, they are able to use scissors to cut out shapes and pictures.

The big whale swam in the deep blue sea. He sang a song as he went along.

TOYS FOR CHILDREN AGED 3–5 YEARS

Children of this age group appreciate toys for imaginative play – drawing and painting materials, coloured paper to make patterns, and dressing-up clothes. They enjoy being active outdoors with toys like balls, climbing frames and tricycles. Their interest in books will be increasing, which helps in learning to read.

FROM 5 YEARS ONWARDS

Children are now ready for jigsaws, card games, board games, computer games, sewing kits, and books which they are able to read for themselves.

TOYS FOR SPECIAL NEEDS

Children with special needs (see Topic 73), like all other children, learn through play. They therefore need plenty of toys which they can use and which they find interesting and fun. When selecting toys for children with disabilities, some important points to note are:

this toy is operated by a switch in a 'touch box' which responds to a light touch by the elbow, foot or nose

- Toys should match the child's ability; those which are too easy have little play value, those which are too difficult can lead to frustration and anger or withdrawal.
- Toys intended for use in training to overcome or lessen a disability will be more successful if they are also toys which the children enjoy.
- The right toy can produce an active response from an otherwise inactive child.
- Children who are physically disabled must be comfortably positioned for play.
- Children who cannot use ordinary toys may be able to use switch-operated toys, such as the rabbit illustrated here.

Musical rabbit

Toys useful for children with particular disabilities

Sound-sensitive computer game – the child has to make sounds in order to keep the game going. The sensitivity can be adjusted to encourage the child to speak louder. Deaf children with electronic hearing aids, or autistic children, may be encouraged to speak by using computer games such as this

Activity mat – offers a range of activities which can be explored. It includes squeakers, rattles, beads, and pockets in which various items can be placed. Children with **visual difficulties** (those who cannot see very well) can enjoy this toy. It has patterns with **high visual contrast** (large shapes and bright colours), can be explored with the hands, and makes noises

Ball pool – is useful for children with physical disabilities because it encourages movement, which strengthens muscles and improves co-ordination

Magnet blocks – encourages hand-eye co-ordination and therefore useful for children with **poor manual dexterity** (difficulty in using the hands)

TOY LIBRARIES

These are places which parents can visit with their young children in order to look at toys, play with them, and borrow them for a short time. Toy libraries may be found in a variety of premises such as nursery and primary schools, Child Health Clinics, family centres and day nurseries, and also on mobile buses. They provide:

- opportunities for children, including those with special needs, to play with a wide variety of toys
- a friendly meeting place for parents and carers – there is often someone who will listen to worries and concerns and, perhaps, offer guidance
- informal support networks for parents who may be under stress
- information about other services
- support from visiting professionals.

QUESTIONS

1 a Give four points which make a toy successful.

b Give four reasons why a toy might be of more than temporary interest.

c Although illegal, unsafe toys can still be found on sale. To avoid buying unsafe toys, what two labels indicate that a toy meets legal safety standards?

2 a Name four types of toy which are used over a long period of childhood.

b What are young children learning when they play with bricks? Give four suggestions.

c Suggest four reasons why at times children prefer the favourite doll or teddy to people.

d (i) What treat might be offered to a child who objected to being bathed?
(ii) Describe the bath toys on p. 187 and how they could be used.

3 a (i) For which children is a climbing frame particularly useful? **(ii)** Name four opportunities it gives to such children.

b When parents are thinking about buying a climbing frame **(i)** name some advantages of such a toy, **(ii)** name three points which may be considered as disadvantages.

c Name four objects which can be added to a climbing frame to make it more interesting.

4 a At what age do children start to play?

b When choosing a rattle for a baby, name six safety factors to be considered.

5 What is the average age at which children become able to:

a enjoy beads on the pram

b pick up toys

c put toys in containers and take them out again

d take an interest in books

e walk along pushing a toy

f unscrew the pieces of a toy

g use scissors

h enjoy dressing up

i enjoy card games?

6 a For each of the toys on pp. 189–190, suggest one way in which a child could find it fun to play with.

b Describe a toy which could be used **(i)** to help strengthen muscles, **(ii)** to encourage hand-eye co-ordination, **(iii)** to increase attention span.

c Which toy would you select for a child **(i)** who has difficulty using his hands, **(ii)** with visual difficulties, **(iii)** who is being taught to speak?

Revision Exercise 41

FURTHER ACTIVITIES

EXTENSION

1 Make a collection of pictures of toys which you consider will give children long-term fun and are value for money.

2 Where is your nearest toy library? If possible, try to arrange a visit. Find out more about toy libraries, for example the history of the organisation, and their importance to both parents and children.

INVESTIGATION

Write a report on one of the following activities:

a Watch a child playing with bricks. Then read the section on bricks in this topic. Comment on how the points mentioned in the topic relate to what you saw.

b Observe (see pp. 354–355) children playing on a climbing frame – many parks and schools have them. Describe how the climbing frame was being used and note the approximate age of the children.

c Compare (see p. 357) the way in which boys and girls play with the same kind of toy. Do they use the toy differently?

DESIGN

Design (see p. 359) a toy for a child. What age is it most suitable for? What would the child learn by playing with it? Have you considered the safety of the toy?

CHILD STUDY

1 The child will almost certainly have a favourite doll or soft toy. Describe it, and observe when and how the child plays with it.

2 Play with the child. Describe the way he or she plays with different toys. Which are the favourite toys and which are never used? Where are the toys kept? Who puts them away when the child has finished playing with them?

42 LEARNING TO DRAW

DEVELOPMENT OF THE IMAGINATION

From an early age, a child begins to form pictures (images) in the mind. These pictures involve himself and the world about him, and also include other people and the way he sees them.

By 2 years of age, the imagination has developed enough for the child to be able to use **symbols** to represent real things. For example:

- dolls represent people
- small toy cars represent real cars
- words are used for objects and actions
- drawings describe events and express feelings.

At times, it is very hard for young children to separate the real world from their imaginary world.

DRAWING

Drawing is important as it helps children to express their feelings and imagination and to record their experiences.

Children love to draw. They are ready to do so as soon as they can hold a pencil or crayon, which is between the age of 12 and 18 months. The first drawings are scribbles. This is followed by 'big head' figures. The drawings gradually become more realistic as the child develops more control over the pencil, and as he comes to notice and understand more about the world.

Stage 1

Stage 2

STAGES IN LEARNING TO DRAW

Children pass through most or all of the following stages as they learn to draw. These stages often overlap, so when looking at a drawing made by a child, it may be difficult to place it in any one particular stage.

Stage 3

Stage 1	The child's hand moves backwards and forwards to produce a scribble.
Stage 2	The child becomes able to lift the pencil from the paper and move it in different directions.
Stage 3	He begins to scribble in circles.
Stage 4	He becomes able to draw round and round in circles.
Stage 5	He now starts to draw people and uses a circle to represent a face. Marks are put inside for eyes, nose, mouth.
Stage 6	Lines are added all round the circles as well.
Stage 7	The lines are arranged in bunches to represent hair, arms, legs.
Stage 8	The arms come straight out at the sides of the face. The legs come from a smaller circle which is drawn below for the body.
Stage 9	The body becomes much more important and the legs have feet.
Stage 10	Clothes are added. The drawings also have trees, houses, animals, cars and other objects in the child's world.

Stage 4

Stage 5

Stage 6

Stage 7

Stage 8

Stage 9

Stage 10

WHEN A DRAWING IS FINISHED

Children generally like to have their drawings admired and sometimes pinned on the wall for everyone to see. However, sometimes after completing a drawing, they scribble or paint over it so that it can no longer be seen. This often seems to give them pleasure similar to that which they get from knocking over a pile of bricks or a sand-castle.

QUESTIONS

1 Name four ways in which children use symbols.

2 a When are children ready to start drawing?
b What are the first drawings like?
c What type of drawings follow next?
d When do the drawings become more realistic?

3 Describe the ten stages which children pass through as they learn to draw. Accompany each stage with a simple drawing.

Revision Exercise 42

FURTHER ACTIVITIES

EXTENSION

The three pictures shown below were drawn by children – Laura Brend, aged 5; Claire Williams, aged 6; Elisabeth Cottam, aged 8. Which girl do you think drew which picture? Give your reasons.

ACTIVITY

IT2.3 Find some different types of drawing, colouring and puzzle books available for children of different ages. In what ways do they help children to learn about colour and shape? Use this information and a graphics program to design an outline drawing for children to colour in. Print several copies, or make a few designs which can be made into a colouring book.

CHILD STUDY

If the child is old enough, encourage him or her to draw a picture, but without saying what to draw or showing how to do it. When the picture is finished, ask the child to tell you about it. Have you learnt anything about the child's imagination or feelings?
Repeat this exercise every few weeks. Make a collection of the drawings and compare them.

Children have to be taught to read and write by adults. These skills take years to learn. Some children learn more quickly than others, but they all make better progress when the learning process is an enjoyable experience.

PRE-READING ACTIVITIES

Parents and carers have an extremely important part to play in preparing children for the early stages of reading. Learning to read is made so much easier if children:

- have had stories read to them
- have had the chance to talk about stories, pictures and what happens
- know some nursery rhymes
- know that books are fun.

BOOKS FOR BABIES

From the age of about 9 months, or even earlier, children begin to enjoy books when they share the activity with an enthusiastic adult. They soon learn to:

- hold the book the right way up
- point to pictures
- listen attentively
- help to turn the pages.

BOOKSTART

Bookstart is the first national books programme for babies in the world, and was introduced in Birmingham in 1992. Librarians and health visitors worked together on this project. Librarians constructed the pack, which contained a book, nursery rhyme card, information about book clubs and the local library. Health visitors gave the packs to parents at the 9-month hearing test, explained its purpose and encouraged parents to share the book with their baby. You can find out more about it at: www.bookstart.co.uk

Board book – sturdy and can withstand being put into the baby's mouth

Texture book – encourages a child to be aware of the sense of touch

Flap book – encourages a child to explore and predict

Cloth book – washable and strong

Bath book – waterproof

Sam enjoys

- looking at pictures with his mum
- recognising objects
- talking about what is seen
- having his questions answered.

Cara enjoys

- the comfort of being near her dad
- listening to the stories she likes over and over again
- following the words (she is learning that the words go from left to right across the page).

LEARNING TO READ

Each child learns to read at his or her own speed. Starting to learn may be left until the child attends school at the age of 5, or the child may be ready to begin earlier. It is important for parents to encourage a young child's natural interest and ability without trying to force the pace. If a child is made to learn too soon, reading will not be an enjoyable experience, and the child may resist learning and begin to fail. Learning to read involves learning:

- to recognise letters and link them with sounds (**A**)
- that groups of letters or sounds make words that have meanings (**B**)
- that strings of words make phrases or sentences that have meanings (**C**).

Parents can encourage a child to follow the words as stories are being read out loud, and to begin to say the words at the same time as the reader. Gradually the child will learn to recognise words and even phrases, gaining clues from the context of the story and from pictures.

The child should be praised and encouraged, and not corrected every time a mistake is made. It is essential that the child does not get frustrated and lose interest.

When the child goes to school, a large part of each day will be concerned with reading and writing for several years, because the child has many essential skills to learn.

Local libraries welcome babies and young children, and the librarians will be able to recommend suitable books for borrowing

LEARNING TO WRITE

Before a child can write easily, a number of skills have to be mastered which require a great deal of practice:

- holding and controlling a pencil
- forming the letter shapes
- writing in a straight line with letters and words spaced neatly
- learning to spell
- 'joined-up' writing (a quicker way to write)
- using correct punctuation and grammar.

It is helpful if a child can at least hold a pencil correctly before starting school. Left-handedness should not be discouraged if it comes naturally to the child (see p. 136).

READING AND WRITING DIFFICULTIES

There are a number of reasons why some children have more difficulty than others in learning to read and write. These include:

- **lack of motivation** – no one is interested in the child's progress
- **the child is discouraged by repeated correction** when reading
- **the child's experience of language is limited** – the child has a small vocabulary and little practice in using it. (This may apply to children of ethnic groups who are being educated in a different language from the one they speak at home.)
- **poor eyesight**
- **poor hearing**
- **poor hand-eye co-ordination**, which makes writing difficult
- **dyslexia**.

Dyslexia

Dyslexia means 'word blindness'. Children who suffer from this condition find reading, writing and spelling difficult even though they are able to talk well and have none of the other difficulties listed above. These children may say that the letters are confused, or they are the wrong way round, or they move around on the page. Children who are dyslexic often have to work very hard indeed to overcome this condition, and they may need a great deal of individual help from specialist teachers and parents.

QUESTIONS

1 What pre-reading activities help to make learning to read easier for children?

2 Describe Bookstart and the part played by **(i)** librarians, **(ii)** health visitors, **(iii)** parents.

3 (i) From about what age do children start to enjoy books? **(ii)** What can they learn? **(iii)** What types of books are suitable for babies?

4 (i) What does Sam enjoy about books? **(ii)** What does Cara enjoy about books?

5 a At what age do children start to learn to read?
 b Why is it important to encourage a child's natural interest in reading, but not to force the pace?
 c What does learning to read involve?
 d (i) What is Tracey learning about letters? **(ii)** What is Ben learning about words? **(iii)** What is Jane learning?

6 What skills are involved in learning to write?

7 a List seven reasons why learning to read and write is more difficult for some children.
 b What is dyslexia?

Revision Exercise 43

FURTHER ACTIVITIES

EXTENSION

1 If a child has a story read to her every day before she starts school, from her 2nd to her 5th birthday, how many stories would she have heard?
 If another child, who did not have any stories read to him until he started school on his 5th birthday, then listened to the teacher read the same number of stories at the rate of one per day, 5 days a week, 40 weeks of the year, how old would this child be before he had had the same number of stories read to him as the first child had heard by the age of 5? In what ways do you consider the second child to be disadvantaged?

N2.3

2 Make a series of 'flash cards' to help letter recognition, e.g. a card with an apple and the letter a. Use a computer for the letters and/or the graphics.

DISCUSSION

C2.1a Do you think that correct spelling is important? Give your reasons for and against this.

INVESTIGATION

Select three or more books for a particular child. Read each book to the child. Compare (p. 357) their suitability, for example:
 a What was the story like – exciting, funny?
 b Did the child understand the words?
 c Did the language sound like the spoken language with which the child is familiar?
 d Was the child's interest level high?
 e Did the illustrations relate closely to the text?
Give a short illustrated talk to explain your findings.

DESIGN

C2.1b Use a word processor to write a short story for children which could be used to teach road safety. Indicate the age range of children for whom the story is intended. Include illustrations and present it in the form of a book taking into account the following requirements:
 a appropriate content for the age range
 b attractive appearance
 c originality of text and illustrations
 d a suitable style of print
 e care taken with suiting illustrations to text.

C2.3 Use the book with a child of an appropriate age, and write a report on its success or failure.

LEARNING ABOUT NUMBERS

Numbers are part of a child's world. They are heard in

■ conversation

> You can have two biscuits

> 3 years old today!

■ stories, rhymes and jingles.

> Round and round the garden like a teddy bear. One step, two steps . . .

> Two-four-six-eight Mary shut the garden gate

STAGES IN THE DEVELOPMENT OF NUMBER CONCEPTS

Children gradually acquire the ability to put numbers in the right order and to use them to count, to compare and to measure. Various stages can be recognised in this development, which usually occur more or less in the order listed here:

1. **Repeating numbers** Many children are able to repeat numbers at 2 or 3 years, but the words mean very little and they are often said in the wrong order.
2. **Matching number words to objects**
3. **The correct order of numbers** The child learns that numbers have a definite order, for example, 1 is followed by 2, and then by 3.

> One, two, seven, four.

> There are three cars

> One, two, three . . . four!

Stage 1 Stage 2 Stage 3

First stair, second stair . . .

Stage 4

4 Learning the meaning of 'first', 'second', 'third', . . . 'last' These are called 'ordinal' numbers.

5 Comparing numbers The child comes to understand the meaning of 'more than' and 'less than' as applied to numbers. For example, understanding that with 5 toys here and 3 much larger toys over there, 5 is still **more than** 3, and 3 is **less than** 5.

Stage 5

6 Understanding that the number of things is constant regardless of size or position For example, 9 things are still 9 regardless of how they are placed. Before this important concept has been reached (usually between 4 and 7 years), a child may agree that there are 9 cubes on the table (**A**), but if these cubes are spread out (**B**), without re-counting he may say there are now more than 9, and if they are heaped up (**C**), he may say there are less than 9. This concept cannot be taught, but comes from many experiences.

Stage 6

7 Learning to recognise and write numbers Children learn the figures (symbols) that are used for numbers, and how to write them.

8 Manipulating numbers (doing sums) Once it is understood that a certain number of things is always the same number (stage 6 above) the child is then ready to . . .

Stage 7

Two and two makes four

If I take one there are four left

Stage 8 . . . add numbers together take them away . . .

. . . share . . .

. . . measure

QUESTIONS

1 In what ways are numbers part of a child's world? Give examples.

2 List eight stages in the development of the concept of number.

3 a When children first start to repeat numbers, how may they do it?

 b Give an example of: **(i)** matching the right number to a given set of objects, **(ii)** understanding the meaning of 'more than' and 'less than' when applied to numbers, **(iii)** use of ordinal numbers.

 c Name four ways in which numbers can be manipulated.

Revision Exercise

44

FURTHER ACTIVITIES

INVESTIGATION

1 Find some **(i)** songs and rhymes, **(ii)** games, which involve numbers and are suitable for young children. Use some of them with a small child and note the child's interest and understanding.

2 Carry out this problem-solving exercise with a group of three to five children aged 5 years. Using a heap of about nine toys, put the following questions, and note how the children tackle them: **(i)** How many toys are there? **(ii)** How many children are there? **(iii)** Are there enough toys to have one each – and another one each?

DESIGN

1 Make a simple 'matching number-to-number' game for 5-year-olds. For example, each child has a picture of a clown and six separate numbered pieces of clown. A die (1–6) is thrown in turn and the child who covers his clown correctly first is the winner.

2 Use a graphics or desk-top publishing program to design a booklet to encourage a child to count. Hint: use the 'copy' feature to make identical repeats of objects, e.g. two cats, five dogs.

C2.3

CHILD STUDY

Observe the child playing and note any occasions when number words are used. What stage in the development of number concepts do you think the child has reached?

45 LEARNING THROUGH MUSIC

Rock-a-bye baby . . .

A

Children can enjoy music in many ways even when they are very young. From birth, babies seem to be comforted when parents sing to them in a soothing and rhythmical way (**A**). From a very young age they show an interest in objects which make pleasing sounds, for example a musical mobile (**B**). When they are a little older, they want to join in songs, or to clap their hands to music (**C**). From about 3 years onwards, they can play their favourite tapes or CDs on players specially designed for young children (**D**).

Tinkle, tinkle, tinkle . . .

B

Pop goes the weasel

C

D

SINGING

From about 2 years of age, children begin to be able to imitate tunes more accurately and to sing with other children. Singing becomes more interesting for children when:

- they sing in groups
- the songs relate to what they know, e.g. daily activities, weather, time of year
- they do actions to accompany a song
- they are allowed to choose some of the songs
- words of a familiar song are adapted for a particular purpose
- new songs are introduced
- songs are accompanied by percussion instruments
- adults play the piano or guitar to accompany the songs.

As they sing, children learn:

- new words
- to develop their memory for words, sounds and music, e.g. 'Old Macdonald had a farm'
- about festivals, e.g. Christmas
- about past times, e.g. 'London's burning'
- about different cultures, e.g. folk songs, dances, rituals
- that other people sing in different languages, e.g. 'Frère Jacques'.

LEARNING ABOUT SOUNDS

Children can have difficulty in distinguishing between different sounds, for example between 'high' and 'low' notes and between 'loud' and 'soft' sounds. One way of overcoming this is to play a game in which the children respond to changes in the music by using different actions.

high notes

low notes

Pitch

soft sounds

loud sounds

Volume

slow

fast

Tempo (speed)

MUSIC AND MOVEMENT

Dancing and exercises to music help children to:

- develop movement skills (motor skills)
- listen and respond with actions
- extend their range of movements
- improve posture and balance
- learn about dances in other cultures
- use their imagination when they mime to music
- keep fit
- have fun.

Home-made instruments

Shaker
plastic food pot with
lid – rice, split peas,
paper clips etc. inside

saucepan and
wooden spoon

Drums
wooden spoon

three layers of
greaseproof
paper or a
layer of cling-
film

elastic band

MAKING MUSIC

Young children enjoy producing sounds with percussion instruments such as the home-made ones shown here. A percussion instrument is one which is used to produce sounds when it is hit, shaken or banged, such as bells, tambourines, cymbals, triangles, maracas and drums.

Music-making is usually a social activity and the children learn to co-operate with other players. At the same time, they are developing listening skills and co-ordination of movement.

LEARNING ABOUT MUSIC

When children are ready, they can start a more formal training in music. For many children, early encouragement can lead to very satisfying hobbies and careers, for example playing the piano, violin or trumpet, singing in a choir, or being a member of a steel band or jazz group.

MUSIC FOR SPECIAL NEEDS

Children with special needs enjoy music and music-making as much as other children, and most of them can use the same instruments, including a keyboard. Those children with **poor manual dexterity** (poor control over their hands and fingers) may need specially adapted equipment or instruments, for example larger handles or touch boards.

QUESTIONS

1 a When are babies first aware of music?
 b In what ways are the children in drawings A–D on p. 202 enjoying music?

2 Give six things which the children in the drawing at the bottom of p. 202 are learning.

3 Describe three home-made percussion instruments.

4 In what ways can early encouragement in music be of benefit to children as they get older?

Revision
Exercise
45

FURTHER ACTIVITIES

DESIGN
Make an audio-tape of a selection of songs for playing on a car journey with a young child.

EXTENSION
Suggest at least one song or piece of music for **(i)** lulling a baby to sleep, **(ii)** having fun with a toddler, **(iii)** singing with a group of children. Explain why you selected each of the songs or pieces of music.

CHILD STUDY
Describe the part which music plays in the life of the child.

46 BEHAVIOUR IN EARLY CHILDHOOD

Bedtime, John

No!

All children behave 'badly' or are 'difficult' from time to time. This is a normal part of growing up. At one time or another they are all likely to show some of the types of behaviour discussed in this topic – saying 'No!', seeking attention, having temper tantrums, telling lies, hitting, and stealing. They behave in these ways because they have not yet learnt to control their emotions or are frustrated that they cannot make adults understand their feelings. Helping children to behave in a more acceptable way can best be done as part of a loving relationship rather than through strict discipline.

The point at which such behaviour will cause the parents concern varies from family to family. What seems 'very bad' behaviour in one family may be regarded as normal in another. The types of behaviour mentioned above only become real problems when they persist or are carried to excess and regarded as anti-social behaviour. Children then need to be helped to grow out of them or the behaviour may continue into adolescence or adult life.

THE NEGATIVE ('NO!') PHASE

It is normal for children between the ages of 9 months and 3 years, and especially at 1½–2½ years of age, to go through a stage of saying 'No!' to anything they are told to do. They want to do the opposite. Being tired, hungry or unwell tends to make them worse. Active, determined children are likely to be more troublesome in this respect than placid ones.

Children can be very difficult to manage at this stage. It helps parents to be more patient and tolerant when they realise that this negative phase is a normal part of a child's development and not just naughtiness, and that it will pass. Although there will be good days and bad days, the bad days get fewer as the child gets older. On the other hand, if the parents are determined always to make the child 'do as she is told', then long-term behaviour problems are very likely to develop, for example frequent temper tantrums or persistent bed-wetting.

ATTENTION-SEEKING BEHAVIOUR

It is normal for a child to want to be the centre of attention, especially between the ages of 1 and 3–4 years. Children of this age group feel important when they are noticed. As a result, they will do many things to show off and attract other people's attention, including:

- making lots of noise
- coughing
- refusing to eat
- eating earth
- holding their breath until blue in the face
- spitting
- biting
- head banging

- refusing to sit on the potty
- passing urine in the wrong place at the wrong time
- having temper tantrums.

All these tricks are aimed at making the child the centre of attention. If the tricks succeed, they are likely to be done repeatedly and to become habits.

Ignoring the habit (if possible) is usually the best way to stop it. Sometimes however, when the habit persists, it indicates that the child's basic needs are not being met – not enough notice is being taken of the child, or the child is not being loved and praised enough. So the child finds that the only way to get attention is to do something naughty.

TEMPER TANTRUMS

A temper tantrum is a period of uncontrolled rage. The most common age for tantrums is between 18 months and 3 years. This is the stage at which a child wants to do things her way, and loves to say 'No!'. Tantrums are more likely to happen in determined children with abundant energy, and not to be a problem in those who are placid and easy-going.

When in a tantrum, the child screams and kicks and may deliberately throw things in order to damage them. She pays no attention when told to stop, and will not listen to reason. The reaction of parents may be to smack the child, but this rarely helps and is much more likely to make matters worse (see p. 168). The child is punished by no one appearing to take any interest in the outburst, although it may be necessary to prevent the child from hurting herself or others, or from damaging things.

Possible causes
A temper tantrum once in a while can be considered normal behaviour. But when a child has frequent temper tantrums the cause may be:

- **frustration** at being unable to do what she wants or to tell other people what she wants or feels. Often a child's feelings develop faster than the ability to use words to express them.
- **imitation (copying)** of older children or adults. She sees them lose their temper and does the same.
- **emotional needs** – The tantrum draws attention to the child's need for love and stimulation.

Trying to understand why a child has temper tantrums will help in knowing how to deal with them.

STEALING

Young children have a natural desire to take what they want and they have to learn that they cannot take things which belong to other people without asking first. A simple way of teaching this lesson is to allow children to have their own possessions and a place to keep them. A child will then know what it feels like if they are borrowed without permission. The good example of the parents is also very important in teaching children not to steal.

Stealing is not usually a problem during the first five years. It occurs more amongst school-age children.

TELLING LIES

It is natural for young children to use their imagination to play pretend games and to make up 'tall stories'. It takes time for them to understand the difference between what is real and what is make-believe. Therefore, truthfulness can only develop slowly. A child's greatest help in learning to be truthful is having parents who set a good example.

By the age of 5 years, most children understand that unless they speak the truth, people will never know when to believe them. One danger of punishing young children for untruthfulness is that they may continue to tell lies in order to escape punishment.

HITTING AND BITING

The occasional hitting and biting of others is normal behaviour in young children. It must be expected when they are at the stage of learning to play together and do not yet fully understand the consequences of their actions.

A child who is **often** extremely quarrelsome and frequently attacks others by hitting, biting, kicking or shouting, is said to be **aggressive**. The cause of this aggressive behaviour needs to be found. It can then be dealt with in a way which will be of most help to the child in overcoming the problem. Causes for the aggression may include jealousy, a means of attracting attention, or imitation – if a parent frequently hits a child it will be natural for the child to hit others, especially someone smaller. The harmful effects of frequent physical punishment are discussed on p. 168.

SLEEP PROBLEMS

Children, like adults, vary in their need for sleep. Some children regularly sleep for 12 hours, others seem to need much less. Some children continue to need a sleep in the middle of the day for several years, others do not. The amount of time a child sleeps becomes a problem when:

- it results in the child being tired and irritable during the day
- the parents are woken frequently during the night, and they themselves become short of sleep
- the parents expect their child to sleep much longer than the child needs
- the parents try to force a sleep pattern on to the child which is not natural to the child.

Getting to sleep Sleep may not come easily if the child is:

- not tired, possibly because the child has not had sufficient exercise
- too hot or too cold
- thirsty or hungry
- uncomfortable – if the nappy needs changing, clothing is too tight, or the bed is not comfortable
- unwell
- not given a regular bedtime routine
- afraid of the dark – some form of night light may help
- worried
- wanting attention (p. 205)
- over-excited.

Broken nights These may occur because the child:

- has developed the habit of waking up
- is hungry – some children are unable to go for a long stretch of time unless they are well fed beforehand
- is cold or too hot

- has nightmares (p. 161)
- wets the bed (p. 172).

Sometimes there seems no obvious reason – it might be a stage through which the child is passing. If the problem seems to be loneliness, there is no reason why a young child should not sleep in the parents' room – provided both parents agree.

Waking early The natural pattern is for young children to wake early, and they want to begin the new day as soon as they are awake. If this is earlier than the parents would like, interesting toys or books placed by the bedside may help to keep the child occupied for a while.

OVERACTIVITY

A healthy child is an active child. Many young children (18 months to 5 years) are described by their parents as being overactive, and this is often only because the child's level of activity is so different from the adults'. Young children:

- **can concentrate for only a short time**, 10–15 minutes perhaps, and they then need a new activity – a different toy or game, or a change of scene.
- **may find it difficult to sit still** for more than about 10 minutes – this makes them appear restless. For example, eating a meal consisting of main course, pudding and drink may take too long for some young children.
- **can become troublesome when they are bored** – they are too intelligent to be satisfied with an uninteresting life.
- may rush around as a means of **seeking attention**.

Older children who are overactive may not have learnt, or had the opportunity, to spend some of their time quietly. Overactivity in children of school age interferes with learning and social development at home and at school.

Hyperactivity

This is a condition in which the affected child is overactive to a degree that is inappropriate to the child's age, and which interferes with family life and other relationships, and with learning.

Very few children are truly hyperactive and have an **attention deficit hyperactivity disorder** (ADHD). It is more likely to occur with boys who have had a difficult birth, who are slow to learn to talk, and who may have difficulties with reading, writing and tasks involving co-ordination of eyes and hands (tying shoe laces, playing ball games etc.).

FOOD-LINKED BEHAVIOUR

There is a growing understanding that some children are intolerant to certain foods which can affect their behaviour. Reactions to foods and additives (see p. 238) have, in some cases, been linked with aggressiveness and hyperactivity.

Most foods cause most children no problems when they are eaten in moderation. Problems are more likely to arise when there is excessive intake of a particular type of food, for example four cans of cola a day (cola contains caffeine) or six packets of crisps (these can contain additives). Any type of food (including citrus fruit, dairy foods, eggs and cheese) can be the cause of health and behavioural problems.

QUESTIONS

1 List the first six types of behaviour discussed in this topic and say at which age or stage each is most likely to occur.

2 a What is meant by the 'negative phase'?
b What may help parents to be more patient in dealing with a child who is passing through such a phase?

3 a Name some ways in which children attract attention to themselves.
b When may these ways become habits?
c Give two reasons why a child may want to attract attention.

4 a Describe a temper tantrum.
b Name three possible causes of frequent temper tantrums.

5 a Why does truthfulness in a young child develop only slowly?
b (i) What does a young child have to learn about other people's belongings?
(ii) Describe one way of teaching this lesson.

6 a Why can occasional hitting and biting be considered normal behaviour in young children?
b When is such behaviour said to be aggressive?
c Name three possible causes of aggression.

7 a How much sleep do children need?
b Give four reasons for a sleep problem.
c Give ten possible reasons why a child may have difficulty in getting to sleep.
d Why may broken nights occur?
e (i) Is it natural for children to wake early?
(ii) How can parents try to keep them occupied?

8 a Give four reasons why adults may describe their young children as overactive.
b (i) Give a reason why an older child may be overactive. **(ii)** How may overactivity affect such children?
c What is meant by hyperactivity?
d (i) What is ADHD? **(ii)** In which children is it most likely to occur?

FURTHER ACTIVITIES

DISCUSSION
Discuss 'Children need to be helped to grow out of behaviour problems or the problems may continue into adolescence or adult life'.

C2.1a

INVESTIGATION
a Carry out a survey, based on a questionnaire (see p. 356) to find **(i)** the average number of hours per day that children of different age groups spend sleeping, e.g. 0–6 months, 6–12 months, 1–2 years, 2–3 years, 3–4 years, 4–5 years, 5–7 years, **(ii)** whether the parents think that their children have sleep problems, and what these are.

N2.2a

b (i) Use a spreadsheet program to calculate the average hours of sleep for each of the above age groups.

IT2.2

(ii) Draw a bar graph to compare the averages.

CHILD STUDY
1 Describe an occasion when you have noticed any of the types of behaviour mentioned in this topic, either in the child you are studying or others. Say
a what may have caused the behaviour
b how adults deal with it
c what the child's reaction was.
2 Observe the child for one hour. How many different activities did you observe, and for how long did the child concentrate on each?

Revision Exercise
46

47 MANAGING DIFFICULT CHILDREN

The term **difficult child** applies to those children who are very hard to manage because they often show some or all of the following types of **antisocial behaviour**:

- persistent refusal to do as they are told (unco-operative behaviour)
- verbal abuse (shouting, swearing)
- physical aggression (pushing, hitting, biting, spitting)
- damaging property and other children's work
- frequent temper tantrums
- endless teasing or bullying
- deliberate disruption of activities and games
- self-inflicted damage, e.g. head banging
- unwillingness to be involved in new situations.

A difficult child often breaks the rules for behaviour at home and at school, and this makes adults cross. Adults who are often cross can make the child feel unwanted and unhappy. His difficult behaviour can lead to **social isolation** – other children will not want to play with him, and adults do not enjoy looking after him.

POSSIBLE CAUSES OF A DIFFICULT CHILD

Inborn temperament
Some children seem to be born with more determination to question and challenge than others. They need more careful handling than those who are placid and easy-going by nature.

Being 'extra special'
A child who is considered 'extra special' by his parents (perhaps because he was difficult to conceive, was premature or delicate as a baby, has been seriously ill etc.) can develop behaviour problems.

Lack of parental control and guidance
The reason for this may be one of the following:

- The parents do not know how to deal with their children in a way which encourages good behaviour.
- Stress caused by unemployment, lack of money, or cramped housing can make caring for children very difficult.
- A crisis in the family (e.g. the death of a relative or a divorce) has a very unsettling effect on the whole family.
- Most of the parents' time is spent on caring for a child or relative with disabilities, and the other children in the family feel neglected.

Wrong type of diet
Parents could try changing the child's diet to find out if there could be a link between food and behaviour. See also p. 209.

MANAGING A DIFFICULT CHILD

A young child who is very difficult to control will be feeling very frightened and insecure because he does not know how to behave. Such behaviour is a cry for help – the child needs adults to take charge and take control. To do this, they are advised to behave in the following ways:

1. Give praise and encouragement when the child is behaving well (he will soon learn that when you become quiet and show no interest in him that you disapprove of his behaviour). See the illustrations below.
2. Cut down on commands (do not keep telling the child what to do – only give instructions when really necessary).
3. Decrease the number of times you say 'No' (reserve this for big issues involving safety and health).
4. Do not criticise (this gives rise to angry feelings of rejection).
5. Give the child a balanced diet and cut out additives (to help to find out if there may be a link between food and behaviour).

Ways of showing approval of good behaviour

smiling

cuddling and giving friendly touches

enthusiastically describing out loud what the child is doing

praising

asking to play with the child or asking him what he would like to do next

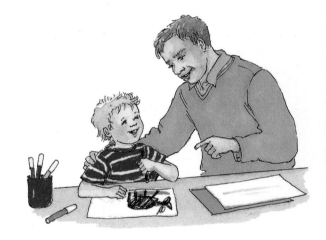

Ways of showing disapproval of naughty behaviour

looking away from the child's face

not speaking to him

looking disinterested

not touching the child, except to keep him, or yourself, safe

WHERE TO OBTAIN ADVICE

- The family doctor (GP) or health visitor.
- Child Guidance Clinics and Child Psychiatric Clinics are run by the Health Service. Some are drop-in, others need a doctor's referral letter.
- The local library should have a list of all the local self-help groups – many people find it useful to share their feelings and ideas with other parents who have similar problems.

QUESTIONS

1 a What is meant by **(i)** a difficult child, **(ii)** social isolation?

b (i) Give nine examples of antisocial behaviour. **(ii)** Why is a difficult child likely to be an unhappy child?

2 a Give four reasons why children may lack parental control and guidance.

b Give three other possible causes of a child being difficult.

3 a Complete the table below, giving five actions which can be taken to help manage a difficult child, and an explanation for each.

Managing a difficult child	
Action which can be taken	**Explanation**
1. Give praise and encouragement when . . .	He will soon learn that . . .

4 Describe how the father shown opposite **(i)** encourages good behaviour, **(ii)** shows disapproval of naughty behaviour.

5 From where can advice on managing difficult children be obtained?

Revision Exercise 47

FURTHER ACTIVITIES

EXTENSION

'The Family Game' video is about a 5-year-old boy whose behaviour had turned family life into a misery. It shows the family receiving therapy sessions at the Maudsley Hospital in London with the aim of restoring normal family life. Watch the video, then answer the following questions:

1 Explain why Andrew was considered to be 'out of control', giving examples of his disruptive behaviour.

2 What did each of the four people in the family say when they were interviewed separately?

3 What is meant by child-centred behaviour?

4 What is meant by child-directive behaviour?

5 The parents were advised to play differently with Andrew. What was suggested?

6 What method was suggested for dealing with Andrew when he was being difficult?

7 What was recommended as a punishment for Andrew? Explain why you think this was appropriate.

8 Was the six weeks course at the Maudsley Hospital successful in helping the family?

The video is available only to educational and business customers from BBC Videos for Education & Training, 80 Wood Lane, London W12 0TT.

DISCUSSION

C2 1a Why are children naughty? Consider possible reasons and the different ways the naughtiness can be dealt with.

48 HABITS IN EARLY CHILDHOOD

Habits are regular actions which are carried out without any, or with very little, thought. Examples of habits commonplace in children include the sucking of a thumb or dummy, nail biting, and the need for a 'comforter'. Habits of this kind are often used by children to comfort themselves when they are tired or unhappy. They are sometimes called 'comfort habits'.

As children grow older, these habits often fade away. In other cases, a great deal of willpower is required to break the habit. Occasionally, some habits persist into adult life.

THUMB AND FINGER SUCKING

All babies suck their thumbs or fingers, sometimes even before they are born. Some babies do this more than others. Many will stroke a doll, blanket or other material at the same time, or twiddle a piece of hair. They may do it when they are feeling sleepy, shy, bored, in trouble, or when a tooth is coming through. The skin on the thumb or finger may thicken or become sore or blistered by the sucking.

Thumb sucking is a harmless habit in a young child, and as it is harmless, no attempt need be made to stop it. If it is ignored, the child will be very likely to grow out of the habit naturally by the age of 4 years. On the other hand, if the parents try to stop the habit, the child will object strongly when her thumb is removed from her mouth. If they make a great deal of fuss, the child will do it all the more.

When thumb sucking continues after the age of 5, it may prevent the front teeth growing properly into place when the permanent teeth come through. Thumb sucking may need to be stopped for this reason, and by now the child should be old enough to understand.

SUCKING A DUMMY

Some parents have strong opinions about dummies. Some say that a dummy stops a baby crying because it soothes and keeps her contented. Others think that a dummy is a poor substitute for the love and attention that should be given when the baby cries. Another point of view is that dummies should not be used because they are difficult to keep clean and can pass on germs to the baby.

It is generally considered that dummies do not do much harm – unless they contain sweet substances for the baby to suck, which will encourage the front teeth to decay. Most children give up their dummy between 1 and 2 years of age – if the parents do not continue to encourage its use.

THE NEED FOR A COMFORTER

Most children have one favourite cuddly toy or piece of material which gives comfort and security, especially at bedtime. The child loves it however scruffy it gets, and will be very upset if it is lost. A child may even be very upset if it smells different after it has been washed. Some children need their comforters for several years.

NAIL BITING

So many children over 3 years old bite their nails that it can be considered a normal thing to do. These children bite their nails without realising what they are doing. It often happens when they are nervous or tense or deep in thought. The only harm it does is to make the nails look unsightly. Probably the only thing the parents can do is to ignore it. Nagging or punishing the child does not usually stop the habit because the child seldom realises when she is doing it. Some children just seem to grow out of the habit of biting their nails. For others it is an effort to stop, and a few still continue to bite their nails as adults.

HEAD BANGING, HEAD ROLLING AND BODY ROCKING

Some babies have the following rhythmical habits:

- **Repeatedly banging the head** against something hard, perhaps the end of the cot. This may make a lot of noise but it does not seem to hurt the child. Padding the end of the cot, or using a cot bumper, helps both to reduce the noise and the possibility of bruising.
- **Rolling the head from side to side**. The hair on the back of the head becomes rubbed off in the process.
- **Rocking their bodies to and fro**. When a young child in a cot does this, the rocking action usually moves the cot across the room and it then bangs repeatedly against the wall. The cot may need to be fixed in some way to stop it from moving.

Babies are at least 6 months old before these types of habit appear. If ignored, the habits rarely continue after the age of 3 years. Efforts to stop them are likely to make the habits continue for a longer time. Some parents are worried by these habits. If seriously worried, they should discuss the matter with their doctor or health visitor.

HANDLING THE GENITALS

Babies discover their genitals in the same way as they discover their toes, and they will touch and explore in the same way. Because handling the genitals is a natural thing for young children to do, there is no reason why they should be made to feel naughty or guilty. After all, parents also touch these areas when the child is bathed.

A child is likely to play with the genitals less often if the parents ignore it or gently divert the child's attention to something else. Gradually, children come to understand that parents disapprove. From the age of 6 until puberty, children become less interested in sexual matters anyway.

Masturbation

This is handling the genitals for pleasure and only becomes a problem when done to excess. Excessive masturbation may be a sign that a child is deeply unhappy, bored, lonely, worried, afraid, or is being abused. Telling children that it is naughty or wrong to do it only makes them more unhappy – and guilty as well.

QUESTIONS

1 a What is meant by a 'habit'?
b What habits are shown by the illustrations in this topic?
c Why are habits of this type sometimes called 'comfort habits'?
d As a child grows older, what may happen to these habits?

2 a Why is there no need to stop a young child from sucking her thumb?
b If parents do try to stop the habit, what may be the result?
c If a 6-year-old still sucks her thumb, why should the parent try to stop the habit?

3 a Give one reason for and one against the use of a dummy.
b When might the use of a dummy encourage tooth decay?
c **(i)** By what age will most children give up their dummy? **(ii)** What may encourage its use after that?
d Give one reason why a child may be upset when her comforter is washed.

4 a Why may nail biting be considered a normal thing to do?
b When are children more likely to bite their nails?
c Is nail biting a harmful habit?
d Why does nagging or punishing the child rarely stop the habit?

5 a Name three rhythmical habits of young children.
b What is the usual age at which these habits occur?

6 a Are young children being 'naughty' when they touch their genitals?
b **(i)** What is masturbation? **(ii)** When may it be a problem?
c Give six possible causes for the problem.

FURTHER ACTIVITIES

DISCUSSION

C2.1a Should parents try to stop comfort habits and if so, how?

INVESTIGATION

Choose one of the habits mentioned in this topic. Carry out a survey (see pp. 355–356) to find out how common the habit is in different age groups. If the habit has been discontinued, at what age did it stop?

CHILD STUDY

Describe any comfort habits the child may have.

Revision
Exercise
48

49 PRE-SCHOOL GROUPS

Pre-school groups include playgroups, nursery schools, nursery classes, and parent and toddler groups. Attendance is voluntary, so the parents can decide whether their child goes to a pre-school group or not.

A pre-school group does not take the place of home, but adds to it by providing a wider circle of people to mix with and a wider range of activities. A good pre-school group helps with a child's early education by providing:

- opportunities to socialise and learn how to mix with other children and adults and to enjoy their company
- facilities which include space to run around, apparatus to climb, toys, paints, paper, modelling dough etc.
- activities such as stories, music, dancing, singing and games
- activities which encourage early familiarity with letters and numbers, to help children acquire pre-reading and pre-counting skills.

Children who benefit most

A pre-school group is useful for almost all children, but it is particularly valuable for those who:

- are the only child in the family
- have little chance to play with others of their own age group
- live in a small flat
- live in a high-rise block
- have parents who find them difficult to manage
- have few toys at home
- are from overcrowded homes
- are neglected children – those whose parents do not talk or read to them or play with them.

When to start

A fairly independent 2-year-old may settle into a pre-school group without any trouble. However, at this age many children are still very dependent on their parents and timid with other adults and children. By 3 years of age,

most children benefit from mixing with others of about the same age. This is a good time for a child to start attending a playgroup or nursery school. Many children will want their parents to stay with them for the first week or two, until they become used to being in a strange place and with a large group of people.

PLAYGROUPS

A playgroup is a group of young children aged from about 2½ to 5 years, who play together regularly under supervision. Many different play activities are provided for the children so that they can learn through play at their own speed.

Playgroups take place in hired halls or private houses. They may be run by parents who act as playgroup leaders or helpers, with one adult to every eight children. At least half of the staff should hold a relevant qualification – they may be teachers, nursery nurses, or mothers (and sometimes fathers) who have attended playgroup training courses.

Playgroups usually take place in the mornings for two to three hours, sometimes not every morning, and sometimes in the afternoon. The children attend on a regular basis, perhaps once or twice a week, perhaps every day. It is necessary for playgroups to charge fees to cover the cost of hiring a room, paying the helpers and buying equipment. Sometimes the Social Services Department pays the fees for children in need.

Many playgroups and parent and toddler groups are members of the Pre-School Learning Alliance (p. 342).

PARENT AND TODDLER GROUPS

Parent and toddler groups may be held in the same halls as playgroups, or in people's homes. They usually take place in the afternoons for about a couple of hours. Unlike playgroups, the parents must remain with their children, and young babies can be taken. A small fee may be charged to cover the cost of hiring the hall and for the equipment and refreshments.

This type of group is an ideal situation for parents to meet and chat while their children play. The youngsters can have fun exploring a world which is wider than home, and with different toys. At the same time, they have the opportunity gradually to get used to playing with other children. As the children get older and become happy to play without their parents, they may be at the right stage to attend a playgroup.

NURSERY SCHOOLS

These are schools for children aged 3–5 years, and the staff are trained nursery teachers or nursery nurses. Nursery schools are open on the same days as other schools and keep to the same term times.

Although the school day is from about 9.30 a.m. to 3.30 p.m., most children attend for only half the day, either in the mornings or the afternoons. There are not enough nursery schools for all children and some of the schools have long waiting lists. Nursery schools provide the same kind of activities as playgroups.

NURSERY CLASSES

A nursery class is a class for 3- to 4-year-olds in an ordinary school. It gives children the opportunity to begin school before the compulsory age of 5.

QUALITY OF CHILD CARE

The quality of care which children receive in a pre-school group will depend on a number of factors, including the size of the group, the resources available, whether the carers are trained or untrained and, most importantly, their attitudes. Children start to develop their own attitudes and opinions early in life and they will be influenced by the attitudes and prejudices of their carers – parents, relations, playgroup staff, teachers, etc. Children will receive high quality, sensitive care when they are treated with tolerance and consideration. Carers of children need to be aware of the following:

- **The multicultural nature of society** – Children attending pre-school groups will mix with children who have different abilities and disabilities, and may come from different racial, religious and cultural backgrounds. Children need to be encouraged to respect and value differences in other people, and discouraged from making racist, sexist and antisocial remarks which are hurtful and upsetting.
- **Avoidance of stereotyping** – All children have their own likes and dislikes, manner of speaking, family customs and social background. A child should not be expected to conform to a **stereotype** – a pattern of behaviour which the carer considers to be standard for the particular group to which the child belongs (nationality, ethnic group, social group or gender). Meeting and mixing with others from different backgrounds widens children's knowledge and experience of people and is part of their education.
- **Equal opportunities** – Boys should not be expected to behave in different ways from girls, and both sexes should be given the same opportunities to play with the full range of toys and to take part in all types of activities (see also p. 10). Treating boys and girls differently is known as **gender stereotyping**.
- **Language and accent** – It is important to make sure that the children can understand what is said to them, particularly when a child comes from a different background from the carer. It is also important that the language which is spoken in the child's home is respected. Children who speak one language at home and another at school, and who move easily from one to the other, often seem to benefit and show increased creativity and flexibility of thought.
- **The importance of self-image** – Each child is an individual and should be encouraged to develop a positive self-image (self-esteem, p. 155). This applies to all children, particularly to those who, for example, belong to a minority group or are socially disadvantaged or are disabled.

QUESTIONS

1 a Give four examples of different types of pre-school group.
 b What does a good pre-school group provide for young children?
 c Which children are likely to benefit most from attending a playgroup?

2 a Why are many 2-year-olds not ready to attend a playgroup?
 b What is generally a good age to start?

3 a What is a playgroup?
 b What do playgroups provide and for what purpose?
 c Which other type of pre-school group provides the same kind of activities as a playgroup?
 d Explain the difference between a nursery school and a nursery class.

4 Give the following information about playgroups and parent and toddler groups:
 a Of which organisation are these groups likely to be members?
 b Is attendance voluntary?
 c Which of the groups has to be registered, and with whom?
 d At which of these groups do parents remain with their children?

5 a When children start to form their own opinions, what will they be influenced by?
 b In what ways should child care workers be aware of **(i)** the multicultural nature of society, **(ii)** avoidance of stereotyping, **(iii)** equal opportunities, **(iv)** language and accent, **(v)** the importance of self-image?

Revision Exercise
49

FURTHER ACTIVITIES

EXTENSION
 a Describe what the children are doing in the photograph on p. 217.
 b List other activities that are likely to be available.

INVESTIGATION
 1 Find out more about the Pre-School Learning Alliance. Information can be obtained from a local playgroup or parent and toddler group, or from the headquarters (see p. 342).
 2 a Find out the whereabouts of pre-school groups in your area. Try to arrange to visit or help at one or more groups.
 b Observe (see pp. 354–355) the children at play at a pre-school group. **(i)** Draw a plan of the play area and mark in the various activities which have been set out for the children to use. **(ii)** Observe one child for a time (say half an hour). Map the child's movements on your plan, noting how long was spent at each play activity and what the child did. **(iii)** Observe another child in a similar way. Compare your results from the two children. Can you suggest reasons for any differences in the ways the two children played?
 c Compare (see p. 357) differences in stages of development and skills between two children in a playgroup, for example a 3-year-old who has just started and a child of 4½ who has been at the playgroup for a year or more.
 3 Research the pre-school groups in your area. Prepare a series of data presentation screens to inform parents about each of the pre-school groups you have researched. Explain where and how your screens may be used. This could be a group exercise.

 IT2.3

CHILD STUDY
If the child attends a pre-school group, talk with the child to try to discover what happens there and how the child feels about it.

50 STARTING SCHOOL

Education in Britain is compulsory from the age of 5 years. Children are legally required to attend school full-time from the beginning of the term after their fifth birthday, or to receive a suitable education elsewhere, for example to be educated at home. Some schools take them earlier, either full-time or part-time.

CHANGES TO THE CHILD'S LIFE

For a child, starting school is the next stage in becoming independent and building up a separate personality. Children enter a new world alone and soon come to know more about it than their parents. They can decide what to tell them about it and what to keep to themselves. They find themselves in a large building with lots of unknown people. They join classes with other children of about the same age and they all share the attention of one adult. They are expected to keep to a timetable. New friends are made. The playground is shared with larger and older children. Some stay to dinner and must get used to school meals. All must abide by the rules and codes of behaviour necessary for the smooth running of large organisations. These are great changes to a young child's life, apart from the necessity of being away from home and parents for a large part of the day.

PREPARING A CHILD FOR SCHOOL

How can parents help?

Parents can help by talking to their child about school, and telling him what to expect, and by making it sound exciting. If the mother is sad at the thought of losing her child's companionship and of being left alone in the house, she should not show it. It may worry the child and make it difficult for him to settle at school. The child who is happy and secure at home is less likely to have difficulties at school.

Whatever the size of the class, the teacher will not be able to give continuous attention to one particular child. Therefore, children who have been encouraged by their parents to 'stand on their own feet' are likely to find it easier to adjust to school than those who are used to the continuous attention of their parents.

Attending a pre-school group can help
A child who has been to a playgroup or nursery school will be used to:

- being away from home
- being separated from his parents
- mixing with other children
- sharing the attention of an adult with other children
- the noise and movement created by a large number of children.

Schools can help
Infant teachers are well aware that all children, to a greater or lesser degree, worry about starting school. They understand the big step that children take when they move from the small social world of home to the much larger social world of school. At school, they have to face all sorts of new situations without the support of their parents.

Many schools try to help new children settle into school life easily and happily, and they do this in a variety of ways. For example, they may:

- invite new children to visit the school in the term before starting
- arrange 'staggered' starts so that only a few new children start on the same day
- allow half-day schooling in the first few weeks
- let parents stay in the classroom for a while
- encourage parents to talk to the teacher about matters which affect the child. It helps the teacher to know about the other members of the child's family and any health or behaviour problems. It is also helpful for the teacher to know if the child is left-handed.

USEFUL SKILLS
When children start school it helps them to fit into the new environment more easily if they have already acquired certain **self-care skills**. For example, the ability to:

- say their name and address clearly
- put on clothes
- do up buttons, zips and other fastenings
- tie shoe laces and fasten buckles
- blow their nose
- go to the toilet without help
- wash their hands
- eat with a knife, fork etc.

Children in this age group like to be able to do the same things as others in the class. If they have already acquired the skills listed above by the time they start school, it will help them not to feel inferior or different from the other children. It also gives a degree of independence as they do not continuously have to seek the help of the teacher.

HELPING CHILDREN TO DO THEIR BEST

Before starting school

Parents and carers help children to get a good start at school by:

- encouraging them to concentrate on activities for more than a few minutes
- encouraging them to share and join in activities with other children
- reading and talking about books with them
- encouraging them to look at books by themselves
- giving them plenty of opportunities to use pencils and crayons. If they are ready to write their name, show them how to use a capital letter followed by lower case letters (e.g. Peter).
- introducing them to as many new words as possible
- helping them count and use numbers in everyday situations.

When at school

Children do better at school when their parents:

- give them lots of love and security at home
- are interested in what they do and talk to them about it
- encourage them to enjoy all the activities
- understand and support them when they have difficulties.

BASELINE ASSESSMENT

When children first start school at the age of 4 or 5 they will undergo a **baseline assessment** which has two aims:

- to find out what children know, understand and can do. This enables teachers to plan effectively for each child's learning needs
- to help schools measure and monitor children's progress from the time they start school.

BULLYING

Although bullying takes place most often amongst school-age children, it may also occur in pre-school groups. By the age of 3 or 4 years, some children have already learnt that being aggressive helps them to get what they want. The bullying can take the form of:

- **verbal abuse** (name-calling, teasing, racial insults)
- **physical abuse** (punching, kicking, jostling, pinching)
- **extortion** (demanding money etc.)
- **threats**.

Bullying may be a sign that the child himself (or herself) is being bullied or neglected at home, or there may be other reasons. Whatever the cause, it needs to be stopped for the benefit of both the victim and the bully. Victims need to be comforted and helped to develop a sense of security and self-esteem. Bullies need attention and help in order to learn not to hurt other people or their feelings.

'GIFTED' CHILDREN

These are children with very high ability in many subjects or who are talented in a particular area, for example, music, mathematics or sport. If their ability is not recognised or catered for at school, they may become bored and frustrated. This can lead to a complete lack of interest in school work, or to disruptive behaviour or the development of social or emotional problems. Educational approaches for gifted children could be

- individual work at a more advanced level
- being placed in a higher ability group that follows a specalised curriculum
- moving up a year at school; this can be a disadvantage if the gifted child has not reached the same level of social and emotional development as the other children in the year group.

QUESTIONS

1 a At what age are children in Britain legally required to attend school?
 b Name five ways in which children can be helped to settle into school life.

2 Name five ways in which attending a playgroup will help prepare a child for school.

3 Name eight useful skills to have learnt before starting school.

4 In what ways can parents help their children to do their best at school **(i)** before the child starts school, **(ii)** when at school?

5 **(i)** What are the various forms which bullying can take? **(ii)** Does bullying occur in pre-school groups? **(iii)** What type of help do the victims need? **(iv)** Why do bullies also need to be helped?

6 a Which children are regarded as gifted?
 b How may these children behave if they are bored at school?
 c Suggest three educational approaches for gifted children.
 d When can being moved up a year at school be a disadvantage?

FURTHER ACTIVITIES

EXTENSION

1 a Give ten examples of how a child's life will change when he starts school.
 b How would you suggest that parents prepare their child for these changes?

2 Compare the photograph on p. 221 with that on p. 217. How many differences do you notice between school and playgroup?

3 Answer the following questions using the leaflet STOP BULLYING from Kidscape (see p. 341) or other source of information.
 a What signs may indicate that a child is being bullied?
 b What factors may cause children to become **(i)** temporary bullies, **(ii)** chronic (long-term) bullies?
 c Give some ways in which parents can help a child who is being bullied.
 d Give some suggestions for dealing with bullies.

INVESTIGATION

Visit an infant school (first school), if possible as a helper.
 a Write an account of your visit.
 b Watch the children arrive at school, leave school, and when they are in the playground. Observe their behaviour and note any interesting points. How did the children react when they were reunited with their parents after school?

51 CHILDREN'S CLOTHES

Clothes for young babies were discussed in Topic 24. Once babies begin to move about, different types and a greater variety of clothes become desirable.

A list of requirements for baby clothes is given on p. 101. The same list applies to clothes for children of all ages, together with additional requirements.

Additional requirements for children's clothes
Children's clothes should be:

- loose enough for movement but not so big as to get in the way
- hard-wearing
- easy for a child to put on
- easy for the child to take off for toilet needs.

Shoes are required from the toddler stage onwards.

Different types of clothes are needed for daytime, night-time, and to wear outside in cold, hot and wet weather.

DIFFERENT TYPES OF CLOTHES
The following are some examples of different types of clothes for children.

Nightwear
A **sleepsuit** (**A**) keeps the child warm even when not covered by blankets. It may have feet attached, sometimes with soles made of a material which can be easily wiped. Then the child does not need a dressing-gown or slippers.

Pyjamas (**B**) have a tendency to part in the middle, but are easier to remove for the toilet than a sleepsuit.

A **nightdress** (**C**) does not keep the child as warm as a sleepsuit or pyjamas, but this can be an advantage in hot weather.

D

E

Points to note:

- Children's nightdresses, nightshirts, dressing-gowns and bathrobes (except bathrobes made from 100% terry towelling) ***must*** all pass a test for slow burning fabrics. These garments therefore do not need to carry a LOW FLAMMABILITY label.
- Children's bathrobes and pyjamas made from 100% terry towelling must carry a permanent label showing whether or not the garment passes the low flammability test for slow burning.

If the garment has passed the LOW FLAMMABILITY test it will be slow to burn and be labelled:

LOW FLAMMABILITY TO BS5722	or	LOW FLAMMABILITY TO BS5722 KEEP AWAY FROM FIRE

If the garment probably has not passed the low flammability test and is not slow burning, it will be labelled.

KEEP AWAY FROM FIRE

Daytime clothes

Romper suits (**D**) and **dungarees** (**E**) are practical for the crawling and toddler stages. They help to stop nappies from falling down and ensure that there is no gap between trousers and top.

Clothes for active children (**F**) need to be easy to wash and comfortable to wear.

For **outdoors**, a warm washable **jacket with a hood** (**G**) is a useful garment for wet or cold, windy weather. It needs to be loose enough to go over other clothing and still give freedom of movement.

F

G

LEARNING TO DRESS

When children are very young, they do not mind what they wear. By the time they reach the age of 3 years, they take an interest in their clothes, and often make a great fuss about what they want, or do not want, to wear. They are also starting to dress themselves. At this stage, dressing is a slow job, and the clothes are often put on inside out and back to front. Adults know they can do the job easily and quickly and will be tempted to do so. However, the children are likely to get very cross if adults interfere as they want to do it themselves. Battles can rage between parent and child!

Making it easier

Parents can make it easier for children to dress unaided by providing clothes that are simple to put on. This gives children the satisfaction of being independent and self-reliant at an earlier age. Dressing dolly or teddy gives practice in using the fingers to do up buttons, velcro fastenings, zips, hooks and eyes, press fasteners, laces, toggles and bows.

'Learning to dress' doll

DRESSING FOR PLAY

It is natural for children to get dirty. They easily spill food or drink, and they love playing with water, or in a muddy garden or with paints. Parents will be happier if they accept that it is natural for children to get dirty, and the children will be happier if they are dressed in hard-wearing clothes which can be easily washed. Children who are nagged too much about keeping clean are likely to react by worrying. The worry will result in them getting far less enjoyment out of their play.

SHOES

Shoes and other types of footwear are a very important part of clothing and need particular attention.

Children do not need shoes until they are walking. They then only need them when it is necessary to protect the feet against damage, or to keep them warm. Going barefoot as much as possible allows the bones and muscles to develop in the natural way to produce strong, healthy feet.

Although we shall be talking mainly about shoes, much of what is said applies to other types of footwear.

Damage caused by ill-fitting shoes

The need for well-fitting shoes

Children's shoes need to be the right shape and size to allow the bones and muscles of the feet to develop properly. The bones in a young child's foot are very soft and rather like rubber. These bones can be easily deformed by badly fitting shoes. The bones harden as the child grows. If the foot is kept in perfect shape, the bones will harden in a perfect shape. If the feet are crushed into shoes which are too small, the bones harden into an imperfect shape, and the muscles will be poorly developed. The child rarely feels any pain when wearing tight shoes and therefore will not complain. Pain may come later, because many of the foot and back troubles which develop in later life are caused by ill-fitting footwear in childhood.

The photograph on p. 227 shows how the toes and toenails may be damaged by the pressure of ill-fitting shoes. Corns, callouses and hardening and thickening of the skin are also caused by pressure. All these problems are avoided by wearing shoes that fit properly.

Rate of growth of feet

Feet grow about 2–2½ sizes each year until the age of 4 years. As a result, young children usually outgrow their shoes every 3 months. New shoes should be fitted to leave 12–18 mm growing space between the end of the longest toe and the end of the shoes, but not so loose that the shoes rub the heels and make them sore. The shoes also need to be wide enough to allow the toes to move.

The most suitable shoes for children are those which are made in whole and half sizes, and in several different widths to suit thin feet, fat feet and those in between.

Choosing shoes for a child

- **Measuring the feet** – When buying shoes for children, it is best that their feet are measured by a trained fitter in a shoe shop. Children should always wear socks and stand upright when having their feet measured and shoes fitted, as feet alter a little in shape when the full body weight is placed on them.
- **Uppers** – The upper part of a shoe may be made of leather or plastic. Leather is hard-wearing and stretches to take the shape of the foot. It also allows moisture to pass through. This means that sweat from the feet can escape and the shoes will be more comfortable to wear for a longer time. Shoes with plastic uppers are often cheaper and need less cleaning, but they do not stretch in the same way as leather or allow moisture to escape.
- **Soles** – Soles which are light and flexible bend with the foot. This encourages a natural springy step which makes for easier walking. Soles which are anti-slip are safer. They also give greater confidence to a child who is learning to walk.

Type of shoe considered to be suitable for young children

- **Points to check** – Shoes for children should:
 - give support and protection to the feet
 - be smooth inside and with no hard seams
 - be wide enough to allow the toes to move
 - have room for growth
 - have an adjustable fastening
 - have flexible uppers which bend as the foot bends
 - have soles which are light and flexible
 - have a firm fitting heel
 - have a low heel so that the foot does not slide forwards.

Other types of footwear

- **Pram shoes (A)** are not meant for walking. They are sometimes worn when a baby is dressed for special occasions.
- **'Padders' (B)** keep a baby's feet warm and give some foot protection when crawling or toddling. Those with an antislip sole help to keep toddlers steady on their feet.
- **Sandals (C)** are useful for wearing in hot weather as they allow air to get to the feet, which reduces the unpleasant effects of sweating.
- **Plimsolls (D)** are lightweight canvas shoes with rubber soles which are useful for energetic games because they bend easily. As plimsolls are not usually made in half sizes or a variety of widths they are not usually a good fit.
- **Trainers** or sports shoes **(E)** are sturdy shoes made of leather, canvas or plastic, with rubber soles.
- **Wellington boots (F)** are made of rubber or plastic to keep water out. Water from sweat is also kept inside. When the boots are worn in hot weather, the feet quickly become hot and sweaty. This makes the feet uncomfortable if the boots are worn for a long period of time. When the boots are worn in cold weather, the feet quickly become cold unless warm socks are worn inside. The size of the boots should allow for this.

A

B

C

 D

 E

 F

Socks and tights

These should be big enough to give a loose, easy fit at the toes. If too tight they can cause foot troubles in the same way as tight shoes. On the other hand, over-large socks or tights can be very uncomfortable to wear.

QUESTIONS

1 a What are the requirements for children's clothes in addition to those required for the layette?

b What label shows that a garment **(i)** has passed the low flammability test, **(ii)** has not passed the slow burning test?

c Why do children's nightdresses not need to have a low flammability label?

2 List the different types of clothing worn by the children in the drawings A–G on pp. 225–226, giving one reason why each type of garment is useful.

3 a By what age do children take an interest in what they wear?

b How can parents make it easier for children to dress themselves?

c **(i)** Name four situations when children are likely to get dirty.
(ii) What clothes are most practical for children?

4 a Give two reasons for wearing shoes.

b Why is it important that shoes are the right shape and size?

c Why are the bones in a child's foot easily deformed?

d Why do children usually not complain when their shoes are tight?

e What caused the twisted toes in the photograph on p. 227?

5 a How much growing space needs to be left at the end of new shoes?

b What is the advantage of having a choice of shoes in a variety of widths?

c Give two advantages of having the uppers made of **(i)** leather, **(ii)** plastic.

d Why are light and flexible soles considered to be an advantage?

6 a Name the types of footwear A–F shown on p. 229, and say when each would be of use.

b Give reasons why socks and tights should not be **(i)** tightly fitting, **(ii)** over-large.

FURTHER ACTIVITIES

EXTENSION

1 Copy the drawing of the shoe on p. 229 and match each of the numbers with one of the 'Points to check'.

2 Make a collection of pictures of different types of children's clothing, including shoes. Give your opinion of the usefulness of each garment.

DISCUSSION

 C2.1a Discuss the advantages and disadvantages of dressing identical twins in the same clothes.

INVESTIGATION

Devise and, if possible, carry out an experiment (see pp. 356–357) to test the flammability of various materials commonly used for children's clothes. Only a small sample of each material needs to be tested. Say what safety measures were taken during this experiment.

DESIGN

1 Design (see p. 358) an item of clothing for a child.

2 Use a graphics program to design a motif for a child's T-shirt. Print it out using a colour printer. Transfer the design onto a T-shirt.

CHILD STUDY

1 Measure the child's feet. Are they both the same size?

2 Discuss children's clothes with the mother. What are her views on the way children should be dressed? Has the child any views on the clothes which he or she wears?

EXERCISES

Exercises relevant to Section 5 can be found on p. 349.

Revision Exercise **51**

FOOD

People take in food to satisfy feelings of hunger and because they enjoy eating and drinking. The body uses this food to provide:

- material for growth
- material to replace worn out or damaged tissues
- energy for the wide range of chemical activities that take place inside the body
- energy for physical activities
- heat to keep the body warm.

FOOD SUBSTANCES

All foods consist of one or more of the seven types of substances in the table below:

proteins carbohydrates fats minerals vitamins fibre water	**nutrients** (substances derived from foods that are essential for life)

A few foods, for example sugar, contain only one of the substances (sugar is 100% carbohydrate). The great majority of foods are a mixture of several substances.

A variety of foods needs to be eaten to provide the body with sufficient of each of the nutrients in order to grow and develop properly, to be active, and to keep healthy.

PROTEINS

Proteins are used to build the body and keep it in good repair. They are particularly important in childhood for building the brain, muscles, skin, blood and other tissues in order to make a strong healthy body. Protein foods can be obtained from both animals and plants.

Animal proteins

Plant proteins

CARBOHYDRATES

Carbohydrates provide energy. Starch and sugar are both carbohydrates. Some of the more common carbohydrate foods are shown below. They have been grouped according to whether they contain mainly starch, mainly sugar or are a mixture of both. When more carbohydrate is eaten than the body can use, the remainder is changed into body fat and is stored until needed.

Starchy foods Sugary foods Foods rich in both starch and sugar

FATS

Fats may be in solid form like butter, or in a liquid form like oil, depending on the temperature. Generally, at room temperature animal fats are solid and plant fats are liquid and called oils. Margarine differs because, although made from oils, the oils are processed in such a way as to make a solid fat.

Fats provide energy. They have a much higher energy value than carbohydrates. That means, weight for weight, they contain more calories (see pp. 235–236). Some foods consist almost entirely of fats, and many popular foods contain large amounts.

The body needs a certain amount of fat but when more is eaten than is used, the extra becomes stored as body fat.

Fats and oils Foods which contain fat

MINERALS

Minerals are substances like calcium and iron which occur naturally in the earth. Fifteen minerals are known to be essential for various chemical activities which take place in the body and to build and repair the tissues. Minerals are obtained from:
- foods derived from plants which absorb minerals from the soil
- foods derived from animals which have eaten plants
- drinking water in which the minerals are dissolved.

Nearly all foods contain one or several minerals. The only minerals which are sometimes in short supply are calcium, iron and fluoride.

Calcium is essential for strong bones and teeth. Chief sources include milk, cheese, white bread, yoghurt, green vegetables.

Iron is essential for the formation of red blood cells. Chief sources are red meat, liver, eggs, green vegetables, wholemeal bread. It is added to some breakfast cereals.

Fluoride helps to produce strong, healthy teeth. If it is not present in the water supply, it can be given to children in tablet form and in toothpaste.

Phosphorus has a wide variety of essential functions in cells and, together with calcium, is needed for strong bones and teeth. It is present in nearly all foods.

Other essential minerals include **potassium**, **magnesium**, **phosphorus**, **zinc**, **sodium** and **chlorine**. Sodium and chlorine are both obtained from **salt** (sodium chloride).

VITAMINS

Vitamins are complex chemical substances made by plants and animals. Generally, the human body cannot manufacture vitamins so they have to be obtained from food. They are needed for various chemical activities. Only a very small quantity of each vitamin is required for the body to keep healthy and active. Vitamins so far discovered include the following:

Vitamin A

This is found mainly in foods containing fat, for example, milk, butter, margarine, fish liver oils. Carrots and green vegetables also provide it. Vitamin A is essential for being able to 'see in the dark' and for a healthy skin.

The B vitamins

Vitamin B is now known to be not just one vitamin but a number of vitamins including **thiamin** (B_1), **riboflavin** (B_2), B_6, **folic acid** (folate), and **niacin** (also called **nicotinic acid** but nothing to do with nicotine). These vitamins occur in foods like wholemeal bread, oats, milk, cheese and liver, and they are often added to processed breakfast cereals. An exception is B_{12} which occurs only in animal products and never in food from plants. Generally, the B vitamins enable the body to obtain energy from food.

Vitamin C

This is found in fresh fruits and vegetables. Small amounts occur in milk, particularly breast milk. This vitamin easily disappears when fruit and vegetables are kept for a long time or when they are cooked. Vitamin C keeps gums healthy and helps wounds to heal.

Vitamin D

This is obtained mainly from foods containing fat such as margarine, butter, oily fish, eggs. It can also be made in the skin when the skin is exposed to sunlight. Vitamin D is essential for healthy bones and teeth.

Vitamin E

Most foods contain vitamin E and, as it can be stored in the body, it is never in short supply except possibly in premature babies.

Vitamin K

This vitamin helps the blood to clot. Vitamin K is never in short supply in a healthy person because it is made by bacteria in the large intestine (the bowel). It also occurs widely in green vegetables. As there are no bacteria in the intestines of newborn babies, they are given vitamin K to protect them from a rare bleeding disorder.

Foods which contain vitamin C

DIETARY FIBRE

Dietary fibre (roughage) consists of plant material which cannot be digested. It is present in vegetables, fruit, wholemeal bread, pulses such as peas, beans, lentils, and cereals such as oats, wheat, bran. Fibre is an important part of the diet because by increasing bulk it encourages the movement of food through the intestines, which helps to prevent constipation.

WATER

Water is the main substance in the body and accounts for about two-thirds of the body's weight. It forms part of all the body tissues and is the liquid in which the chemical activities in the body take place.

Water is continuously being lost from the body in sweat, breath and urine. The water that is lost needs to be replaced. It enters the body as part of solid food as well as in drinks.

ENERGY FROM FOOD

The body needs a continuous supply of energy to keep alive. Energy is used for breathing, circulation, growth and keeping warm, as well as enabling the body to move. The more active (energetic) the person, the more energy will be used. This energy all comes from food.

The amount of energy a particular food contains can be measured in either kilocalories (kcal) or kilojoules (kJ):

$$1 \text{ kcal} = 4.2 \text{ kJ (approx)}$$
$$1000 \text{ kJ} = 1 \text{ MJ (megajoule)} = 239 \text{ kcal}$$

In everyday language the 'kilo' part of kilocalorie is often left off. So, when the word **calorie** is used it usually means kilocalorie. The same often happens to the word kilojoule. It is technically inaccurate to use calorie and joule in this way and can be confusing.

Different foods contain different amounts of energy per unit weight, that is, they have different **energy values**. Foods which have a high energy value are those which contain little water and a high proportion of fat or sugar.

Daily intake of energy
The estimated average energy requirements for children are shown in the table below. These figures apply to boys; girls require slightly less. The average daily intake for an adult woman is 8.1 MJ (1940 kcal), which increases by 0.8 MJ (200 kcal) per day during pregnancy. When breast-feeding, a woman requires, on average, an extra 1.9 MJ (450 kcal) during the first month, 2.2 MJ (530 kcal) during the second month, and 2.4 MJ (570 kcal) during the third month.

Age	MJ per day	kcal per day
0–3 months	2.28	545
4–6 months	2.89	690
7–9 months	3.44	825
10–12 months	3.85	920
1–3 years	5.15	1230
4–6 years	7.16	1715
7–8 years	8.24	1970

Source: *Dietary reference values for food energy and nutrients for the United Kingdom.* Dept. of Health

GENETICALLY MODIFIED FOODS

Genetically modified (GM) foods are foods that contain ingredients from genetically modified crops. **GM crops** are plants that have had their genes artificially altered in a laboratory. It is possible to alter a plant's genes to produce foods with new tastes and flavours, more protein, a longer shelf-life or a higher yield. Plants can also be designed to be poisonous to insects, which means that fewer pesticides are needed to grow the crop.

One of the most common GM ingredients in food is soya flour made from GM soya beans. GM tomatoes are also available. Soya flour and tomatoes are used in a wide range of convenience foods and ready-made meals. When a manufacturer knows that foods contain GM ingredients, the pack is usually labelled.

GM technology is still so new that any long-term effects (beneficial or disadvantageous) of GM crops on the environment, or GM foods on people's health, are still unknown.

QUESTIONS

1 a Give five ways in which the body uses food.
b (i) Name seven substances found in food. **(ii)** Which are nutrients?

2 a What are proteins used for?
b (i) Name some foods which contain animal proteins. **(ii)** Name some which contain plant proteins.

3 a What type of substance are starch and sugar?
b (i) Name another type of food besides carbohydrate which provides energy. **(ii)** Which of these substances has a higher energy value? **(iii)** What happens to these substances when more is eaten than is used?

4 Of the following eight foods – olive oil, pastry, sweet biscuits, sweets, rice, butter, bacon, lentils – name one which is **(i)** liquid fat, **(ii)** solid fat, **(iii)** mainly sugar, **(iv)** mainly starch, **(v)** contains fat and protein, **(vi)** contains fat and starch, **(vii)** contains starch and protein, **(viii)** contains starch, sugar and fat.

5 a Name nine minerals.
b Briefly, what is the difference between minerals and vitamins?
c (i) Name three minerals which are sometimes in short supply in the diet. **(ii)** Why is each essential? **(iii)** From what sources can each be obtained?

6 a Which two vitamins are found mainly in foods containing fat?
b Which vitamin is only found in animal products?
c Which vitamin can be made in the skin?
d (i) Which vitamin is found in fresh fruit and vegetables? **(ii)** Why do they have to be fresh?

7 a Why does the body need energy?
b Where does this energy come from?
c Name two units in which energy in food can be measured.

8 a What are **(i)** GM foods, **(ii)** GM crops?
b For what purposes may a plant's genes be genetically modified?

FURTHER ACTIVITIES

EXTENSION

1 Draw or find pictures to add to your notes of two or more examples of foods containing:

a	protein	**f**	iron
b	fat	**g**	vitamin A
c	starch	**h**	B vitamins
d	sugar	**i**	vitamin C
e	calcium	**j**	vitamin D.

2 Study the information given on the right, taken from a packet of cornflakes.
a Give the weight of an average serving in **(i)** grams, **(ii)** ounces.
b Give the average energy value of an average serving in **(i)** kilojoules, **(ii)** kilocalories.
c (i) Name the five vitamins of the B group listed in the ingredients. **(ii)** Give a function of these vitamins.
d (i) Name the other vitamin in the cornflakes. **(ii)** Why is it important in the diet?
e What reason is given for adding iron?
f (i) How much dietary fibre is present in an average serving? **(ii)** Why is fibre important in the diet?

3 From the information on the cornflakes label:
a Draw a bar chart on graph paper or by using a spreadsheet program to show the typical amounts of protein, carbohydrate, fat, fibre, and sodium per 100 g of cornflakes.

N2.1

b What percentages of these cornflakes are sugar and sodium? Why do you think that sugar and sodium are added? Do you think they are necessary?

4 a For each of the essential nutrients mentioned in this topic, use a dietary analysis program or other data to find a selection of foods containing high amounts of the nutrient.

IT2.1

b Find the recommended daily intake of energy for a 5-year-old boy in the table on p. 236. Using the food list which accompanies a dietary analysis program (or other data), plan meals for the boy for one day to give him food with the recommended amount of energy.

CORN FLAKES

NUTRITION INFORMATION Per 100g		
ENERGY		1550kJ 370kcal
PROTEIN		8g
CARBOHYDRATES		82g
of which sugars		8g
starch		74g
FAT		0.8g
FIBRE		3g
SODIUM		1g
VITAMINS:		(%RDA)*
THIAMIN (B1)	mg	1.2 (85)
RIBOFLAVIN (B2)	mg	1.3 (85)
NIACIN	mg	15 (85)
VITAMIN B6	mg	1.7 (85)
FOLIC ACID	µg	333 (165)
VITAMIN B12	µg	0.85 (85)
IRON	mg	7.9 (55)

*Recommended Daily Allowance

Revision Exercise 52

Additives are substances that are added to food to preserve it or to change it in some way. They can be:

WHOLE ORANGE DRINK

NO TARTRAZINE OR SIMILAR ARTIFICIAL COLOURS

INGREDIENTS: WATER, GLUCOSE SYRUP, ORANGES, CITRIC ACID, FLAVOURINGS, PRESERVATIVES (SODIUM BENZOATE, SODIUM METABISULPHITE), STABILISER (E466), ARTIFICIAL SWEETENER (SACCHARIN), VITAMIN C, COLOUR (BETACAROTENE).

- **natural** (obtained from nature), for example:
 salt is obtained from salt mines or from sea water
 sugar is obtained from sugar beet or sugar cane
 carotene comes from green plants, carrots and egg yolk
 vinegar and alcohol are produced by yeast
 vitamin C (ascorbic acid) obtained from fresh fruit and vegetables
- **synthetic** (man-made by a chemical process), for example:
 tartrazine and sunset yellow (artificial colours)
 saccharin (artificial sweetener)
 vitamin C (ascorbic acid); this natural additive is also produced synthetically

Additives are controlled by Government Regulation and it is illegal to put anything in food which is known to injure health. However, research indicates that a few additivies can cause changes in children's mood and behaviour, making them hyperactive. These are commonly found in foods popular with children. They include the colours tartrazine (E102), sunset yellow (E110), carmoisine (E122), ponceau (E124), and the preservative sodium benzoate (E211).

All manufactured foods are required to have a label showing the ingredients contained in the food, listed in order of the quantity (by weight) present, starting with the largest. The additives can be identified by name or number, or both. Those with an 'E' (**E-numbers**) have been approved for use in food by the European Union (EU).

Additives are usually grouped according to their function. Some examples are given below.

PRESERVATIVES

These protect food against microbes (bacteria and fungi). They prevent microbes from spoiling the food, which increases its storage life and also helps protect against food poisoning. Examples are:

- sugar, salt, vinegar and alcohol
- sodium benzoate (E 211)
- sulphur dioxide (E220)
- sodium metabisulphite (E223)
- potassium nitrate (E252).

ANTIOXIDANTS

These stop fatty foods from becoming rancid, and also protect vitamins contained in the food from being destroyed. Examples are:

- synthetic alpha-tocopherol (E307)
- lecithin (E322)
- L-ascorbic acid (vitamin C; E300).

EMULSIFIERS AND STABILISERS

Emulsifiers enable ingredients to be mixed together that would normally separate, for example fat or oil with water.

Stabilisers prevent substances which have been mixed together from separating again. Examples of substances which are both emulsifiers and stabilisers are:

- locust bean gum (E410), from carob beans
- gum arabic (E414), from acacia trees.

COLOURINGS

These are used to make food more colourful and attractive, or to change its colour. Examples are:

- tartrazine (E102) – yellow chemical
- curcumin (E100) – yellow extract of turmeric roots
- caramel (E150) – burnt sugar
- carotene (E160a) – orange-yellow colour obtained from carrots; becomes vitamin A in the body
- annatto – a yellowish-red dye.

FLAVOURINGS, FLAVOUR ENHANCERS AND SWEETENERS

Flavourings

There are about 3000 flavourings, but only tiny amounts are used compared with other additives. They are not at present required to be individually named on the packaging of foods. Flavourings include herbs and spices.

Flavour enhancers

These stimulate the taste buds and make food taste stronger. An example is:
- monosodium glutamate (MSG, E621).

Sweeteners

These are used in low-calorie food products and in diabetic foods. Examples are:
- saccharin (E954)
- sorbitol (E420)
- aspartame (E951).

ANTI-CAKING AGENTS

These stop lumps forming in powdery foods. An example is:

■ silicon dioxide (E551; silica).

VITAMINS AND MINERALS

These replace naturally occuring vitamins and minerals that are removed by processing.

QUESTIONS

1 a What are additives?

b Explain the difference between natural additives and synthetic additives, and give four examples of each.

c Are additives subject to any form of control?

d Give examples of additives that can cause changes in children's mood and behaviour.

e (i) How can additives be identified?
(ii) Which additives have an E-number?

f In which order are the ingredients in a food required to be listed on the label?

2 a Why are colours added to food?

b (i) About how many different flavourings are there?
(ii) Is it essential for them to be named on the packaging of food?

c (i) What type of additive is monosodium glutamate?
(ii) Why is it added to food?

d Which types of food might contain an additive such as E551 and why?

3 The label from a bottle of orange drink is shown on p. 238. What additives does the drink contain?

Revision Exercise 53

FURTHER ACTIVITIES

EXTENSION

1 Look at the information given here, which comes from a margarine carton.

> Sunflower oil; Vegetable oils; Whey; Salt; Emulsifier E471; Lecithin; Colours (Curcumin, Annatto); Flavourings; Vitamins A, D & E

a (i) The ingredients include 'whey' – find out what whey is.
(ii) Which vitamins does this margarine contain?

b (i) What type of additive is lecithin? **(ii)** Give two reasons for adding lecithin to margarine. **(iii)** Is lecithin a natural or artificial substance?

c (i) Which emulsifier has been added to the margarine? **(ii)** Why are emulsifiers added to food? **(iii)** Name three ingredients in this margarine which can be combined together by an emulsifier.

d Name the two colours which have been added to the margarine, and the colour each gives.

2 a Why does the orange drink label on p. 238 state 'No tartrazine'?

b (i) Which stabiliser has been added to the orange drink? **(ii)** What is the function of stablisers?

c Name an ingredient other than sugar which gives the drink sweetness.

d Name the two preservatives in the orange drink and give the E-number of one of them. **(ii)** What is the function of preservatives?

INVESTIGATION

Study the labels on a variety of different foods commonly eaten by young children. List the additives and try to identify their purpose.

54 DIET

Parents and those who care about children will want to feed them well to give them a good start in life. Sensible feeding begins during pregnancy when the expectant mother eats sufficient protein, fresh fruit and vegetables, to supply enough nourishment for herself and the developing baby. After the birth, the baby is fed entirely on milk for the first few months, then is weaned on to other foods. The child will then get nourishment from a variety of foods containing different types and amounts of nutrients. A child who is to grow into a healthy adult needs a balanced diet.

A BALANCED DIET

The word diet means the usual type of food that is eaten. For example, a young baby has a diet of milk, whereas the diet of an older child is a mixture of foods. 'Going on a diet' is rather different. When, someone 'goes on a diet' that person is restricted to eating certain foods, perhaps because of a disease such as diabetes, or in order to lose or gain weight.

A **balanced diet** is one which contains enough of all the necessary food substances. This does not mean that every meal has to be 'balanced', or that the right amounts of each of the seven substances listed on p. 232 have to be eaten each day. It means that over the course of several days, the body needs to take in enough of the right kinds of food substances to grow and to stay healthy.

A diet made up from suitable proportions of these food items would be balanced

Children who eat a balanced diet are more likely to:

- develop a strong, well-formed body
- have energy to keep warm and active
- keep healthy
- grow to their full potential height (the height which their genes will allow)
- maintain a suitable weight for their height and age.

A rough guide to a balanced diet

Parents do not need to worry too much about giving their child a balanced diet. If they offer a variety of food during the day, the child will eat what his or her body needs. Generally speaking, a child should have each day:

- some milk
- protein foods, e.g. meat, poultry, fish, cheese, an egg, beans
- vegetables – raw or cooked
- fruit
- bread, wholegrain cereals, potatoes, pasta, or rice.

Variations – likes and dislikes

The list given above is only a rough guide. A good diet can be obtained in a number of ways. For example:

- A child who doesn't eat meat or fish can get sufficient protein from milk, eggs, cheese, beans, peas and nuts.
- Some children do not like vegetables. They will come to no harm as long as other foods containing minerals, vitamins and fibre are eaten.
- Other children do not like fruit, but they may like fruit juice drinks such as blackcurrant or orange.
- Children who do not like drinking milk can be given it in the form of milk puddings, custard, yoghurt, cheese etc.

The cost of good food

Good eating does not have to be expensive. Nourishing foods are often less expensive than the high-calorie foods mentioned (p. 245). When a parent knows which foods are nourishing (i.e. supply proteins, vitamins and minerals), good meals can be served which may well cost less than meals of poorer quality.

AN UNBALANCED DIET

The diet can be unbalanced because of shortage of food, too much of certain kinds of food, or lack of essential substances in the food. Children whose health could be improved by more food or better food are suffering from **malnutrition**. Such children fail to thrive, lack energy, and are less able to resist infections.

CULTURAL AND RELIGIOUS PRACTICES

The food which a child thinks is the 'normal' diet depends on the part of the world in which the child lives and the cultural background to which the family belongs. For example:

- Most children in Britain will be used to bread and potatoes as their main source of carbohydrate, whereas in Italy it will be pasta and in Asia it will be rice.
- Orthodox Jews do not eat pork or shellfish. Meat must be 'kosher' (prepared in accordance with Jewish religious law), and milk and meat are not eaten at the same meal.
- Muslims do not eat shellfish or pork, and other types of meat must be 'halal' (prepared in accordance with Muslim religious law).
- Hindus are mostly strict vegetarians.
- Sikhs do not eat beef.
- Asians living in Britain who retain their traditional diets may have a low intake of vitamin D. The amount of this vitamin made in the skin may also be low, especially in women and children due to customs of dress. To prevent rickets in childhood and softening of the bones in adults, the inclusion in the diet of foods rich in vitamin D, or vitamin supplements, will be necessary.
- **Vegetarians** do not eat meat or fish, but their diet can contain milk, milk products and eggs. Care should be taken to provide young children on a vegetarian diet with enough energy, protein, iron, calcium, vitamin B$_{12}$ and vitamin C.
- **Vegans** do not eat any food that comes from animals. A vegan diet consisting mainly of cereals, fruit, vegetables, peas and beans can be very bulky. Young children on a vegan diet may have difficulty in eating enough of these foods to obtain the energy and nutrients they need for growth. These can be provided by the foods shown below. Soya-based infant formula can be given to babies in place of milk, and should be continued until the age of two years to ensure the child's diet contains enough protein.

Foods which can provide energy and nutrients suitable for children on a vegetarian or vegan diet	
protein	Quorn® and other foods made from pulses
energy	vegetable oils, and nut or seed butters
iron	fortified breakfast cereals, tofu, dried apricots, figs, prunes
calcium	soya mince, soya drink, tahini paste (made from sesame seeds)
vitamin B$_{12}$	fortified breakfast cereals, vitamin B$_{12}$ supplement
vitamin D	sunlight or vitamin drops

MEDICAL DIETS

Certain medical conditions require a special type of diet, for example:

- diabetics need a regular amount of carbohydrate in meals and snacks
- those with coeliac disease need a gluten-free diet (see p. 249).

DEFICIENCY DISEASES

When particular items in the diet are absent or in short supply (are deficient), illnesses called **deficiency diseases** develop.

Shortage	Deficiency disease
Iron or Vitamin B_{12}	**Anaemia** The lack of red pigment (haemoglobin) in the blood results in a shortage of oxygen throughout the body and feelings of 'no energy'.
Calcium or Vitamin D	**Rickets** Children's bones do not form properly, are soft and weak and bend under pressure.
Vitamin C	**Scurvy** The gums become soft and bleed. Teeth become loose, and wounds fail to heal properly.
Vitamin A	**Night blindness** (not being able to see in a dim light). There is also reduced resistance to diseases, especially those affecting the skin.
Protein and calories	**Kwashiorkor** (pronounced (quosh-ee-or-kor). This is a disease of severe malnutrition. The starving children have pot-bellies which are swollen with water.

Nourishing snacks

HIGH-CALORIE FOODS AND DRINKS

High-calorie, less nourishing snacks

There are some foods which are high in calories but have very little other nutritional value. They contain a great deal of sugar, starch or fat and include sweets, chocolate, cakes, biscuits, pastry and crisps. Children often love them because they like the taste and find them easy to eat. Many children also love high calorie drinks. These include squash, cola, some fruit juices, and many of the drinks marketed specially for children.

There is no reason why these foods and drinks should not be part of the diet in small amounts, but, when consumed in large quantities, a child has less appetite for more nourishing foods. Too much high-calorie food may also cause a child to put on too much weight, and sugary food can help to cause tooth decay.

OBESITY (FATNESS)

Being overweight is usually caused by eating more food than the body needs. Overeating is a habit which, once acquired, is difficult to break. Children (like adults) vary in the amount of food they can eat before getting fat and some seem to put on weight very easily. The tendency to be overweight often seems to run in families. So also does the tendency to give children lots of high-calorie foods.

Fat babies and children are often not healthy. They take less exercise and are more likely to suffer from tiredness, backache, headaches and joint problems. They are also more likely to suffer from infections such as bronchitis.

FOOD

QUESTIONS

1 a What is the difference between 'diet', a 'balanced diet' and 'going on a diet'?
 b Give five reasons for giving a child a balanced diet.

2 a Suggest a rough guide for a balanced diet.
 b If a child does not like drinking milk, in what other forms can milk be given?
 c **(i)** What is the difference between a vegetarian and a vegan diet? **(ii)** What may be in short supply in these diets? **(iii)** What foods can supply extra energy and nutrients?
 d What can children who do not like fruit be given instead?

3 Give three ways in which a diet may be unbalanced.

4 a What causes a deficiency disease?
 b What items in the diet are in short supply when the following deficiency diseases develop **(i)** anaemia, **(ii)** rickets, **(iii)** scurvy, **(iv)** night blindness, **(v)** kwashiorkor?

5 a List **(i)** some nourishing snacks, **(ii)** some high-calorie, less nourishing snacks.
 b What are the disadvantages of giving a child large amounts of high-calorie food?
 c Name some possible effects of obesity on health.

FURTHER ACTIVITIES

EXTENSION

1 Copy and complete the chart below to show the types of food substances present in the eight meals illustrated. Information about the foods can be obtained from Topic 52. Place a tick in the appropriate column if the food substance is present.
2 Record all the items of food you ate or drank yesterday. Do you consider that your diet for the day was balanced or unbalanced? Give reasons.

INVESTIGATION – Find out more about kwashiorkor and the effects of starvation on children.

DESIGN – Make up five menus for packed lunches for a 5-year-old for one school week, each providing a balanced meal.

CHILD STUDY – Describe the child's diet. What types of food does the child like and dislike?

Revision Exercise 54

Description of meal	protein	carbohydrate	fat	calcium	iron	vitamin A	B vitamins	vitamin C	vitamin D	fibre
A Cheese sandwiches, ice-cream										
B										

'Weaning' is the gradual changeover from a diet of milk to a diet containing a variety of foods, both solid and liquid.

Milk is the perfect food for the first few months of life. As babies get older, they begin to need foods containing starch and fibre. They also need more vitamins and minerals, particularly iron, than are present in milk alone in order to continue growing and developing properly.

Salt should not be added to weaning foods as it can be dangerous to young babies (see p. 83).

WHEN TO START WEANING

It takes several months for a baby's digestive system to develop fully. For example, starch cannot be readily digested until the baby is a few months old. There is, therefore, no point in weaning a baby until she is able to make proper use of the food. The danger of weaning too early is that the baby may become too fat, develop allergies to food, or suffer from indigestion.

The time to begin weaning is when the baby is about 6 months old and still seems hungry and restless after a good milk feed, or wakes early for the next feed and starts to suck her fists.

WEANING SHOULD NOT BE A BATTLE

New foods should be introduced one at a time. Even at this young age, babies make it clear whether they enjoy the taste or not. Babies are like adults in preferring some foods to others. If they are forced to eat a particular food it can easily lead to a feeding problem (see pp. 254–255). When a baby appears not to like a food, it is wise to wait for a week or two before offering it again. By this time there might be a change of mind.

STAGES IN WEANING

Starting to wean

Young babies cannot yet chew. They also have difficulty in swallowing and digesting lumps. So solid food such as cereals, fruit, vegetables and meat needs to be liquidised to a purée, to remove the lumps. It is then mixed with baby milk or other suitable liquid to make a thickened liquid which can be given to the baby on a spoon.

A small amount of such food once a day is enough to start with. Soon the baby comes to expect a little with each milk feed and the amount gradually increases. Different sorts of food should be given so that the baby gets used to a variety of flavours. Examples are 'baby rice' mixed with baby milk, mashed potato with a little gravy, mashed banana, boiled or steamed vegetables or stewed fruit which have been made into a purée, or meat stew which has been put through a blender.

Ways of removing lumps from food:

rub through a sieve

mash with a fork

use an electric blender

Giving solid foods

Most babies learn to chew at about 6 months, whether they have teeth or not. It is then important for them to be given hard foods such as crusts and low-sugar rusks on which to chew. A baby who is not encouraged to chew at this age may find it difficult do so a few months later.

A baby who is able to chew can be given solid foods such as sandwiches, toast, cheese, whole banana and a wide variety of other foods. There is no need to wait until the baby has a mouthful of teeth before giving such foods. However, the tougher foods such as meat should be cut into small pieces first.

Babies should never be left alone when eating or drinking, especially when they are learning to feed themselves, because of the danger of choking.

Reducing the amount of milk

As the amount of solid food increases, the need for milk decreases. Usually, by the age of 9 months to 1 year, babies have given up the breast or bottle (at least during the daytime) and are weaned on to a diet of mainly solid foods. They can then be eating food that is not very much different from the rest of the family. Milk is still needed each day, but it can be given in different forms such as milk puddings. Current medical opinion advises that babies should be given infant milk (formula) or follow-on milk to drink until 12 months old, and then they can have cow's milk (see p. 83).

Cow's milk given to children should be pasteurised whole milk until they are at least 5 years of age. Skimmed and semi-skimmed milks are not recommended because of their low energy and vitamin A content.

Drinking from a cup

Although breast- or bottle-feeding may continue until the baby is 9 months or older, the number of feeds becomes less and eventually stops. Cup-feeding usually begins about 5–6 months of age. Milk from a cup gradually replaces that from the breast or bottle.

It is quite common for babies suddenly to refuse to take any more milk from breast or bottle. Other babies are reluctant to give up the bottle. They may drink readily from a cup during the day, but still like a bottle of milk at bedtime. After the age of 1 year, the older the baby gets, the more difficult it becomes to give up the bottle.

Commercially prepared weaning foods

WEANING FOODS

Tins, jars and packets of baby foods can be very useful for weaning. They are quick and easy to prepare, convenient when only small quantities are required, and very useful when travelling. These commercially prepared foods provide adequate nourishment and come in an increasingly wide variety, but are more expensive than home-prepared foods.

Commercially prepared foods should not replace fresh foods and home-prepared foods altogether. Babies can try most foods served to the rest of the family. This provides a greater range of tastes and textures than is found in the commercially prepared foods and so makes eating more interesting. More important, the baby gets used to eating the same food as other members of the family.

Gluten is a type of protein found in some cereals. A few babies are unable to digest gluten and this only becomes apparent when they are being weaned. These children have a condition called **coeliac disease**. They need to have a gluten-free diet, and cannot have foods containing wheat, rye, oats or barley. Alternative foods are rice, millet, potato flour and corn flour.

Unsuitable drinks for young children

can damage teeth contains artificial sweeteners contain caffeine

QUESTIONS

1 a What is meant by 'weaning'?

b When is the right time to begin weaning, and what signs does the baby give?

c Name two food substances that babies need as they get older.

d What other food substances are needed in greater amounts than milk alone can supply?

e Name three possible dangers of weaning too early.

2 a Give two reasons why young babies should not be given lumpy food.

b Describe ways of removing lumps from food.

c **(i)** What is the advantage of giving babies a variety of foods? **(ii)** Name some suitable foods.

d **(i)** When may it be convenient to use the weaning foods in the photograph on p. 249 **(ii)** Give reasons why such foods should not replace fresh food altogether.

3 a By what age can most babies chew?

b Name foods that babies may be given when they can chew.

c Do babies need to have teeth before they are given the foods mentioned in **b**?

4 a At what age does cup-feeding usually begin?

b By what age is it usual for babies to be weaned on to a diet of mainly solid foods?

c At what age can babies be given cow's milk?

5 a **(i)** A few children need to be on a gluten-free diet; why? **(ii)** Which foods must be avoided? **(iii)** Name some alternative foods.

6 Give examples of unsuitable drinks for young children.

Revision
Exercise
55

FURTHER ACTIVITIES

EXTENSION

The table lists some do's and don'ts for parents weaning their babies. Take each item in the lists in turn and give reasons why it can be considered sensible advice.

Do	Don't
Give your baby a variety of foods for a variety of tastes.	Don't add salt or sugar to feeds.
Mash or sieve all your baby's food at first.	Don't give cereal at more than one meal a day.
Feed at your baby's pace rather than yours.	Don't give your baby food that's too hot.
Give extra water, especially in hot weather. There's no need to sweeten it.	Don't give sweet foods or drinks between meals.
	Don't leave your baby alone when eating or drinking.

Source: *Starting Your Baby on Solid Food*, Health Education Authority

INVESTIGATION

N2.1 Investigate the range of varieties of baby foods – those sold specially for babies. Choose at least three varieties of baby foods of a similar type, for example savoury foods or puddings. Compare (see p. 357) their contents (for protein, fat, energy, sugar, salt, gluten, additives etc.) and taste. Present the information in a table.

Mealtimes are more than just times when food is eaten. They should be social occasions as well.

FOOD AND EMOTIONS

A young baby is unhappy when hungry and happy when fed. When parents feed their baby they are providing happiness and love, so the baby comes to link food with happiness and love. These feelings help towards the development of a bond of attachment between parents and child.

Gradually, during weaning, babies want to feed themselves and, later, to decide what they eat. Children who are allowed to feed themselves and to eat as much or as little as they want, will continue to enjoy mealtimes and to link them with love and affection. However, if every mealtime is a battle over what is eaten or how it is eaten, then food will become linked with bad temper, wilfulness and fussiness. This can create a problem which may last throughout childhood and even longer.

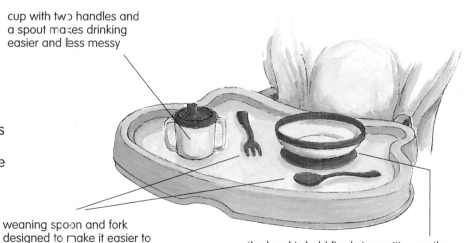

cup with two handles and a spout makes drinking easier and less messy

Equipment which makes self-feeding easier and encourages self-reliance

weaning spoon and fork designed to make it easier to get the food to the mouth

the bowl is held firmly in position on the table by a suction pad

Happy mealtimes

When mealtimes are happy occasions, children eat the food without a fuss, the parents and children will enjoy being together at this time, and they will have the opportunity to talk and listen to one another. Parents can encourage a young child to enjoy mealtimes by:

- serving food attractively
- varying the food
- serving small portions, with more to follow if wanted
- ensuring that the food is neither too hot nor too cold
- avoiding foods with very strong flavours
- setting a good example by eating proper meals themselves
- making mealtimes happy social occasions by all members of the family sitting at the table whenever possible.

'Fussy about food'

Encouraging a child to eat a variety of foods and not be fussy has three advantages:

- he is likely to have a balanced diet
- he will find it much easier to eat the food provided when away from home
- mealtimes will be happier occasions.

No one, apart from his parents, will have much sympathy for a child who is fussy about food and difficult to feed. He will be regarded as a nuisance.

TABLE MANNERS

When babies start to feed themselves, they have no understanding of table manners. At this stage, hands are used as well as spoons to get the food to the mouth. Food is also regarded as something to play with. Babies will undoubtedly make a mess.

During their second year, children learn how to use spoons and cups without spilling the contents. At this stage, they also come to understand that parents do not approve when they get food all over the place. They are now old enough to learn how to behave at the table. They will begin to copy the table manners of those around them, chiefly the manners of their parents and carers. These are the manners they will have throughout childhood and often for the rest of their lives.

SOME HINTS ABOUT FEEDING

- **Babies like to be with the family** at mealtimes. They enjoy company and they also learn how to behave with food.
- **Babies like to feed themselves**. It is messy, but much more interesting for the baby.
- **When everything is washable, there is no need to worry** about the mess. The chair, harness and tray should be easy to wipe and, if necessary, a plastic covering should be placed on the floor.
- **Bibs** save a great deal of mess.
- **Babies need to eat at their own pace**. This might be very slow and the parents need a great deal of patience!
- **Babies know when they have had enough** to eat, so never try to persuade or force the baby to eat more.
- **Young children may not want to eat large main meals**. They are happier to have smaller main meals with a snack between meals.

Bibs with sleeves are useful when babies start to feed themselves

useful for older children who are eating at the table rather than in a high chair

A 'catch-all' bib is designed to catch any spills

QUESTIONS

1 How can parents encourage their child to enjoy mealtimes?

2 Give seven hints about feeding.

3 Name three advantages of encouraging a child not to be fussy about food.

4 a Why do babies make a mess when feeding?
b When children become old enough to learn table manners, how do they learn?

Revision Exercise 56

FURTHER ACTIVITIES

EXTENSION
Make a list of as many different table manners as you can think of. For each, decide whether you consider it to be 'good manners', 'bad manners' or whether it 'does not matter', and why.

DISCUSSION
Are mealtimes social occasions or just the time for eating food?

DESIGN

C2.1a Use a graphics program to make a design to be used on a young child's bowl or plate.

CHILD STUDY
Describe the child's behaviour at mealtimes. Comment on any examples you have come across where you think food and the child's emotions are linked.

The commonest feeding problem in healthy children is **food refusal**. The child refuses to eat as much food as the parents think is needed. Consequently they become very worried about the child's 'poor appetite'.

Although this is a common problem in Britain, it does not occur in countries where food is scarce. Even in Britain, it is rarely a problem in homes where there are lots of children, nor in homes where no fuss about eating is made.

Children with this problem are usually between the age of 9 months and 4 years. It arises from a combination of factors including the following:

- Children of this age love fuss and attention and have a strong desire to feel important.
- The baby's rate of growth slows down during the first year and so does the rate of increase of appetite. This is the time of weaning and the mother is probably expecting the child to eat larger and larger quantities of food.
- Children go through a stage when it is natural for them to refuse to co-operate, and they have learnt to say 'no'.
- Children tend to dawdle over their meals and like to play with food. They have no sense of time and will not hurry so that the meal can be cleared away.
- Appetites vary. Some children (like some adults) have small appetites. The size of the appetite also depends on whether the child has been very active out of doors, or has spent time quietly indoors.

Do not try to force feed.

It is unnecessary to try to force a child to eat and attempts will not succeed. No healthy children ever starve if left to please themselves how much they eat, but they will enjoy making a great deal of fuss if forced to eat.

Ways of trying to make a child eat may include:
- pushing food into the mouth
- coaxing
- nagging
- bribing
- threatening.

A

B

C

D

E

EXAMPLES FROM A DOCTOR'S CASEBOOK*

Worried parents consulted the doctor about the following feeding problems:

- A 10-month-old baby whose mother, father, aunt and two uncles crept about the room after him with spoonfuls of food, trying to get him to eat something.
- The child who would eat only when his father's car passed the window. As a result, the father had to drive the car backwards and forwards so that each time it passed the window, the mother could put a spoonful of food in the baby's mouth.
- One boy refused to eat unless he was given a toy motor car, and his mother said he had acquired nearly 300 cars in that way.
- A mother who said she never went anywhere without a bag of biscuits in her handbag, so that if her son ever said he would eat something she could give him one.

Advice to parents

In all the above cases, similar advice was given.

1. There is nothing wrong with the child's appetite. The problem lies with the parents.
2. When the child is given food, the parents must not appear to show that they care whether it is eaten or not. There should be no anxious looks at the plate, and no remarks about it.
3. A child who refuses to eat at mealtimes should not be given any food in between meals.
4. Healthy children never let themselves starve; they will quickly learn to eat if left alone to decide for themselves.

*These examples are from the book *Babies & Young Children*. Illingworth & Illingworth (Churchill Livingstone).

QUESTIONS

1 a In Britain, what is the commonest feeding problem in healthy children?
 b What is the usual age of children with this problem?
 c In what type of homes is this problem unlikely to exist?

2 Name five factors commonly involved in food refusal.

3 What advice was given to worried parents who consulted the doctor about feeding problems?

FURTHER ACTIVITIES

EXTENSION
Which of the ways of trying to make a child eat listed under the heading 'Do not try to force feed' is illustrated by each of the pictures A–E on p.254?

CHILD STUDY
Have you come across a food refusal problem in a young child? (Do not confuse 'food refusal' with 'fussy eating'). Describe the problem. In your opinion, how many of the factors given in this topic, if any, were the cause of the problem you described?

Revision Exercise

57

58 FOOD HYGIENE

Food hygiene is concerned with the care, preparation and storage of food in order to prevent food poisoning. Most food poisoning is due to eating food which has been contaminated by bacteria to such an extent that it upsets the stomach and intestines, causing gastro-enteritis. Gastro-enteritis is particularly serious in babies and young children (see p. 93) and food hygiene is therefore of special importance in child care. Four golden rules of food hygiene are:

- **keep food clean**
- **keep fresh food cold when being stored**
- **cook food thoroughly**
- **do not eat if past the 'Use by' date.**

HOW BACTERIA GET INTO FOOD

Bacteria are too small to be seen with the naked eye and food which contains them may look, smell and taste good enough to eat. Bacteria get into food as a result of contact with:

- dirty hands
- dirty sinks and draining boards
- dirty work surfaces
- dirty dishcloths and sponges
- dirty towels and drying-up cloths
- dirty utensils – pots, pans, crockery, cutlery, glassware
- uncooked meat and poultry
- coughs and sneezes
- fingers or spoons which have been licked when preparing food
- flies
- septic cuts and sores
- rats, mice and their droppings.

Bacteria thrive in warm, moist foods particularly those containing protein, for example, both cooked and uncooked meat and poultry, gravy, egg dishes and milk. When such food is kept warm, any bacteria present quickly grow and multiply to become a possible source of food poisoning.

Bacteria multiply by dividing into two, and when conditions are right they can do so about every 20 minutes. The new bacteria grow quickly and 20 minutes later they are ready to divide again to produce more bacteria. After several hours, very large numbers will have built up in the food.

FOOD POISONING

The symptoms of food poisoning are diarrhoea, pains in the abdomen, and sometimes vomiting. Illness usually starts sometime between two hours and two days after eating contaminated food, although it can be almost immediate if the food is badly contaminated. The illness usually lasts for one to two days, but sometimes a week or more.

Treatment

Babies with food poisoning need medical attention quickly. Older children need medical attention if they are not recovering after 24 hours.

PREVENTION OF FOOD POISONING

1. **Keep food cold** Low temperatures slow down the rate at which bacteria grow and multiply.

Refrigeration – The temperature at which refrigerators are usually kept is between 1°C and 5°C, which is too low for food-poisoning bacteria to grow. Some other types of bacteria and fungi are able to grow at temperatures as low as this, but only slowly. This is why food left in a refrigerator for a long time gradually turns bad.

Cooked food which is to be kept for the next day should be cooled as quickly as possible and then placed in a refrigerator. Any bacteria present will not then have a chance to grow and multiply to dangerous levels.

Freezing – When food is frozen, any bacteria it contains are unable to grow. However, they are not killed by the cold and when the food warms up they become active again. The recommended temperature at which freezers should be kept is minus 18°C (−18°C).

2. **Keep food covered** Food needs to be covered to protect it from dust, dirt and flies. Dust and dirt are quite likely to contain food-poisoning bacteria. Flies can carry bacteria in their saliva and droppings as well as on their feet and hairy bodies, especially when they come from rubbish dumps and manure heaps in which they breed.

3. **Hands should be washed and then dried on a clean towel before preparing food** Particular care to do this thoroughly should be taken after using the lavatory or dealing with nappies, because large numbers of bacteria capable of causing food poisoning live in the bowel.

4. **Keep the kitchen clean** Floor, work surfaces, sink, cooking utensils, waste-bin, dishcloths, drying-up cloths etc. should all be cleaned regularly. Remember, food-poisoning bacteria can exist in dirt, and bits of leftover food lying around attract flies, mice and rats.

5. **Cover any boils or septic cuts** Germs which cause these can also cause food poisoning. Cover them with a waterproof dressing.

6. **Do not sneeze or cough over food** Food-poisoning bacteria and other germs often live in the nose and throat.

7. **Do not lick your fingers or smoke when handling food**
This will prevent germs from the mouth reaching the food.

Bacteria thrive in dirty kitchens

8. **Keep raw meat separate** Uncooked meat, especially poultry, may contain food-poisoning bacteria. It therefore needs to be kept away from other foods to prevent them from being contaminated.

9. **Cook food thoroughly** When cooking or reheating food, make sure that it is heated until it is piping hot all the way through in order to kill any food-poisoning bacteria. This applies in particular to 'cook-chill' meals (ready-cooked meals prepared in a factory and then kept cold but not frozen) and to frozen poultry (which should be thoroughly defrosted before cooking).

10. **Keep pets away from food and food-preparation surfaces** Pets can be a source of dirt and food-poisoning bacteria.

11. **Keep rats and mice away** Food-poisoning bacteria live in the intestines of mice and rats, and are present in their droppings.

12. **Keep away from the kitchen when suffering from diarrhoea or sickness** The cause may be food poisoning and the bacteria could easily be passed on to other people if you handle food or utensils.

13. **Check 'Use by' dates** It is not always possible to tell if food is safe to be eaten by its look or smell. Therefore, foods labelled with a 'Use by' date should be used by that date or thrown away.

14. **Check labels for storage instructions** If foods are not stored properly they may not keep as long as the 'Use by' date.

FOOD-POISONING BACTERIA

Several types of bacteria can cause food poisoning including the following.

Salmonella

These bacteria usually live in the bowel. They get into food from the excreta of humans or animals or from water which has been polluted by sewage. Illness is caused by eating large numbers of these bacteria. If food containing them is thoroughly cooked, the bacteria are killed and will not be harmful.

Staphylococcus

Bacteria of this type are found in many places including the nose, throat, boils and the pus from an infected wound. These bacteria produce **toxins** (poisons) as they grow and multiply in food. It is the toxins and not the bacteria which cause food poisoning. The bacteria are readily killed by cooking but the toxins are only gradually destroyed.

Clostridium

Spores of these bacteria are frequently found in human and animal excreta and they thrive when they get into the right types of food.

When conditions become unfavourable for the bacteria (for example, they become short of water) they produce **spores**. The spores are very hardy and can survive for long periods of time in dust, dirt and soil. They may even survive normal cooking processes. When they find themselves in warm, moist food, the spores turn into active bacteria again and multiply rapidly.

Clostridium welchii gives rise to a common type of food poisoning. Bacteria of this type produce toxins when they get inside the intestines. If the food is cooked thoroughly before eating, the bacteria will be killed and there will be no food poisoning.

Campylobactor

These bacteria can be found in milk, uncooked and undercooked poultry. The main symptom of this common form of food poisoning is diarrhoea containing blood. The bacteria are killed by thorough cooking and then do not cause harm.

E. coli (Escherichia coli)

These bacteria live in the intestines of humans and other animals and are usually harmless. However, some strains, for example, *E. coli 157* can cause food poisoning when they contaminate food or drinking water.

QUESTIONS

1 a What are the four golden rules of food hygiene?
 b Why may food-poisoning bacteria be eaten accidentally?

2 a Name some types of food in which bacteria thrive.
 b What happens when these foods are kept warm?
 c What are the recommended temperatures at which refrigerators and freezers should be kept?

3 a What are the symptoms of food poisoning?
 b What is the treatment?

4 Name 14 ways of helping to prevent food poisoning, giving one reason for each.

5 Name five types of food-poisoning bacteria.

FURTHER ACTIVITIES

EXTENSION

1 A collection of 1000 bacteria is just visible as a tiny speck. If a speck of dirt containing 1000 food-poisoning bacteria got into a feeding bottle, and the feeding bottle was kept in a warm place, how many germs would be present after **(i)** 4 hours **(ii)** 8 hours?

N2.2a

2 Find some actual cases of food poisoning from newspaper reports or other sources. Then, using a desk-top publishing program or graphics program, make a poster or leaflet to explain to parents how food poisoning can be caused and prevented.

C2.3

Revision Exercise

58

Although the teeth of a newborn baby cannot be seen, they are already developing inside the gums. They usually start to appear some time during the first year, the average age being 6 months. The parents need not worry if their baby is late in teething. The teeth will come through when they are ready and there is nothing that can be done to hurry them up.

ORDER OF APPEARANCE

Milk teeth

There are 20 teeth in the first set which are called the milk teeth or baby teeth. The first to come through are usually the two teeth in the front of the lower jaw. A month or two later they are followed by the two teeth at the front of the upper jaw. All the milk teeth will have appeared by the age of 2½–3 years. The diagram below shows the order in which the milk teeth generally appear.

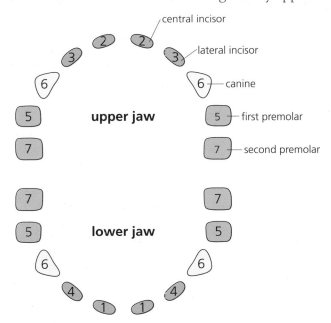

The usual order in which the milk teeth appear

Occasionally, a baby is born with a tooth that has already come through. It may need to be removed if it is so loose in the gum that it is in danger of falling out, being inhaled, and becoming stuck in the baby's windpipe. If the tooth is removed, there will be a gap in that position until the second set of teeth appear several years later.

From the age of 5 onwards, the milk teeth begin to fall out. Before they do this, their roots disappear.

Permanent teeth

The milk teeth are replaced by the permanent teeth. They start to come through when children are about 6 years old. The 20 milk teeth are replaced by larger teeth of the same type. In addition, there are 12 molars – 3 on each side of each jaw. When complete, the permanent set contains 32 teeth.

The first permanent teeth to appear are usually the lower incisors and the first molars. The latter are often called the '6-year molars'. Although the new teeth may appear looking crooked, they usually right themselves in time. Otherwise they may need to be corrected by dental treatment, e.g. the wearing of a brace.

 The milk teeth can be seen developing inside the jaw.

 The milk teeth are all through. The permanent teeth are developing underneath.

 The milk teeth at the front of both jaws (the incisors) have been replaced by permanent teeth, and the first molars are also through. The roots of the remaining milk teeth are beginning to disappear.

The milk teeth are replaced by the permanent teeth

TEETHING

Some babies cut their teeth with no trouble at all. Other babies may be cross and irritable at such times. Babies may show one or more of the following signs that their teeth are cutting through the gums:

- **sore gums** – As a tooth grows, it has to pass through the gum. This process may cause the gums to become sore and painful, making the baby refuse food.
- **increased dribbling** – Babies seem to dribble more than usual when a tooth is about to come through.
- **increased fist-chewing** – Some babies seem to chew their fists and fingers more than usual when they are teething.
- **red cheek** – A bright red patch on one cheek is often a sign of a new tooth.

Help for teething babies

A baby who is troubled by teething needs to be cuddled and comforted. Efforts should be made to divert the baby's attention, for example, by giving her something different to play with, going for a walk, playing some music or, if old enough, telling her a story.

The baby may get relief from chewing something hard. For this reason, babies who are teething are given teething rings, crusts or rusks on which to chew. Teething jelly is unnecessary. It quickly washes off and, if too much is used, may poison the child.

The advice of a doctor is needed for a child who is in severe pain or very fretful at nights.

Teething does not cause illness. Although teething may make a baby feel wretched, it will not cause illness such as bronchitis, rashes, diarrhoea, fever or convulsions. If any of these conditions appear at the time that the teeth are coming through, they will not be due to teething and need the prompt attention of a doctor.

EFFECT OF DIET ON TEETH

Substances in the diet which build strong, healthy teeth are **calcium**, **fluoride** and the **vitamins A, C and D**.

Fluoride combines chemically with the enamel of the teeth, making them stronger and more resistant to decay. Children living in areas where the water supply contains fluoride have only about half as much tooth decay as those living in other areas.

When the water supply lacks fluoride, many doctors and dentists recommend that children should be given fluoride daily. Under the age of 3 the fluoride should be given in the form of drops. Older children can be given tablets, crushed if necessary. The use of toothpaste containing fluoride also helps to protect the teeth.

Chewing helps to keep the teeth and gums healthy. Therefore the diet should include foods which need chewing such as crusts, apples and carrots.

Eating sweet and sticky foods in large amounts encourages tooth decay. This is especially so when sugary foods are eaten between meals and in a form which sticks to the teeth. Tooth decay is also encouraged by the frequent sipping of sugary drinks.

TOOTH DECAY

The mouth always contains bacteria. However well the teeth are cleaned, some bacteria are always left in the mouth. The bacteria themselves do no harm, and indeed, they are essential to keep the mouth healthy. But

<div align="center">

bacteria + sugar = tooth decay

</div>

When the bacteria in the mouth come into contact with sugar they produce acid. It is the acid which dissolves away the enamel and makes holes in the teeth. Sugar remains in the mouth for about half an hour after eating something sweet or even longer if a piece of food such as sticky toffee becomes caught up in the teeth. The longer the time that sugar is in the mouth the greater the chances of tooth decay.

The chances of tooth decay are reduced if sweets, chocolates, iced lollies and other sugary foods and drinks are given to a child only at mealtimes or on special occasions. It is also important for them to be eaten all at one go and not nibbled at over several hours.

CLEANING THE TEETH

Children can be taught to clean their teeth from the age of 1 year. They should learn to brush them up and down and not across. Also, the inner side of the teeth and the biting surface of those at the back need to be cleaned. The teeth should be brushed before going to bed and preferably after meals as well.

Although the milk teeth are only temporary, it is important to care for them because:

- tooth decay causes pain
- painful teeth may prevent a child from eating properly
- caring for teeth will become a good habit which will continue throughout life
- if milk teeth are lost prematurely, the permanent teeth may come through in the incorrect position.

VISITING THE DENTIST

Mothers are entitled to free dental care for a year after giving birth, and they can take their babies with them then. The baby can be registered with the dentist at this time, who can also give advice about the need for fluoride drops. If taken to the dentist regularly from an early age, children get used to the idea. They are then more likely to go happily when they are older and their permanent teeth have come through. Regular check-ups enable any problem to be treated before it becomes serious. Two words often used by the dentist are:

- **caries** – the name for tooth decay
- **plaque** – an almost invisible layer that is forming on the teeth all the time. Plaque is composed mostly of bacteria and materials from saliva. Cleaning the teeth removes plaque and leaves the teeth looking white and shiny.

QUESTIONS

1 a What is the average age at which teeth start to appear?

b How many milk teeth are there?

c By what age have all the milk teeth appeared?

d Using information from the diagram on p.260, complete and extend the following chart to show the usual order in which the milk teeth appear.

1 Central incisors of lower jaw
2

2 a At what age do the milk teeth begin to fall out?

b What part of a milk tooth disappears before the tooth falls out?

c What are the '6-year molars'?

d How many permanent teeth are there?

3 a Name four signs of teething shown by some children.

b Name five types of illness which are not due to teething.

c Describe ways in which a baby who is troubled by teething can be helped.

4 a Name two minerals and three vitamins which help to build strong, healthy teeth.

b How does fluoride strengthen teeth?

c If the water supply lacks fluoride, name two ways in which this mineral can be given to children.

5 a How is acid produced in the mouth?

b What effect does acid have on the teeth?

c How long does sugar remain in the mouth after eating something sweet?

d How can the chances of tooth decay be reduced?

6 a How should children be taught to brush their teeth?

b Why is it important to care for the milk teeth?

c What are the advantages of taking young children to the dentist?

7 What is meant by **(i)** caries, **(ii)** plaque?

FURTHER ACTIVITIES

EXTENSION

1 The photograph shows the milk teeth of a 3-year-old girl who was very fond of sweetened blackcurrant juice. Every time she was thirsty or needed comforting, day or night, she was given this drink.

a Describe the appearance of the teeth.

b What might account for their condition? Give your reasons.

c What advice would you give to parents to prevent this from happening to their children's teeth?

d Are the teeth in the photograph incisors, canines or premolars?

2 Use a dietary analysis program or other data to:

a calculate and compare the amount of sugar in drinks commonly given to children.

b find foods which are major sources of calcium in the diet.

CHILD STUDY

IT2.1 Find out about the child's teeth. How many are there? Has there been any teething trouble? Does the child clean his or her own teeth? Does the child go to the dentist?

EXERCISES

Exercises relevant to Section 6 can be found on p. 350.

Revision Exercise
59

HEALTH AND SAFETY

GERMS

Infectious diseases are caused by certain microbes, called germs (or **pathogens**) – mainly harmful **bacteria** and **viruses**. Some types of germ affect people of all ages, examples being those which cause the common cold, influenza, bronchitis, tetanus and tuberculosis. Other diseases occur mainly in children – nine infectious diseases of childhood are given in the chart on pp. 268–269.

Germs can only be seen with the aid of a powerful microscope. They are usually either bacteria or viruses, but a few fungi and other microbes are also able to cause disease. The chart of infectious diseases indicates which are caused by bacteria (*B*) and which by viruses (*V*).

Bacteria

Bacteria are found almost everywhere – in the air, soil, water, food, and both on and inside the bodies of plants and animals. There are many different types of bacteria and each has its own special shape, size, and conditions in which it can live and grow. Only a small proportion of the total number of bacteria are able to cause disease in humans.

Each tiny bacterium consists of a single cell. After growing to its full size, it reproduces by dividing into two. In the right conditions, this may take place about every 20 minutes, so large numbers of bacteria can be built up very quickly.

Bacteria cause disease when they damage the tissues of the body in which they are living, or when they produce **toxins** (poisons). The toxins may travel in the blood stream to harm other parts of the body.

Viruses

Viruses are even smaller than bacteria. They only become active when they get inside the living cells of plants or animals. There are many different types of virus including those which can live inside human cells. When the virus gets inside the right type of cell, it feeds, grows and multiplies. The cell then bursts and the virus particles are released to infect other cells. As the virus spreads, it damages the cells and causes disease.

HOW DISEASES SPREAD

All the diseases in the chart on pp. 268–269 except tetanus can be spread by droplet infection and by contact. Passing a disease from one person to another is known as **cross infection**.

Droplet infection

Very tiny drops of moisture containing germs come from the nose or throat of an infected person when breathing, sneezing, coughing, singing and talking. If they enter the nose or mouth of another person they may give rise to infection.

Mumps is a contagious disease

Contact

It is possible to pick up infection by kissing or touching an infected person (direct contact), or by using towels, toys, or other equipment which have been in contact with the disease (indirect contact). Diseases that are spread by contact are called contagious diseases.

Tetanus germs are 'caught' in an unusual way. They can cause disease only when they enter the body through cuts or grazes in the skin. Some other types of germs, for example food-poisoning bacteria, can be transferred from one person to another in food, milk and water.

WHEN GERMS GET INSIDE THE BODY

The body reacts in various ways to try to destroy any germs which may get inside it. If these fail, the germs grow and multiply and eventually produce fever and other symptoms.

Incubation is the time between the entry of the germs into the body and the appearance of symptoms. **Symptoms** are changes in the body which indicate disease. The **onset** of the disease is the point at which symptoms appear.

The **infectious stage** is the time during which germs can be spread from one person to another. The patient becomes infectious either during the incubation period or at the end of it. Quite often, a child is infectious before anyone realises that he or she has the disease.

IMMUNITY

Immunity is the ability of the body to resist infection. Generally speaking, the infectious diseases of childhood are less severe in children than in adults. One attack usually gives long-lasting immunity to that disease, so it is rare to catch it for a second time.

When a person 'catches' the infectious disease, the body produces **antibodies** of the right type which eventually destroy the germs. The antibodies also give immunity against that disease and help to prevent the person from catching the same disease again. Another way to obtain immunity against some infectious diseases is by immunisation.

IMMUNISATION (VACCINATION)

Vaccines are available for certain diseases. A specific vaccine is required for each disease. One or more doses of vaccine make the body produce the right type of antibodies to destroy the germs which cause the particular disease.

The diseases for which immunisation is readily available are those marked with an asterisk on the chart on pp. 268–269.

The risk of harmful complications from any of these vaccines is extremely small – very much smaller than the risk of harmful effects from the disease itself. There are very few genuine reasons why a child should not be immunised.

Disease	Symptoms	Incubation in days	Infectious stage
*Diphtheria B	A white layer forms on the throat, which may block the airway; it also produces a powerful poison which damages heart and brain.	2–5	Usually for about 2 weeks after onset.
*Tetanus (Lockjaw) B	Muscles in the neck tighten and lock the jaw.	4–21	Cannot be passed directly from one person to another.
*Whooping cough (Pertussis) B	Long bouts of coughing which may end with a 'whoop'.	7–12	A few days before onset to 4 weeks after onset.
*Polio (Poliomyelitis) V	Infection of the spinal cord causing fever which may result in paralysis.	3–21	From 2 days after infection to 6 weeks or longer after onset.
*Hib (*Haemophilus influenzae* type b) V	Vary depending on the part of the body which is infected.	Varies	Varies.
*Meningitis *Various B and V* See also Hib above	Some/all of: fever (possibly with cold hands and feet), vomiting, rash. Also in **babies**: high-pitched moaning cry, blank expression, arched back, bulging fontanelle, difficult to wake. **Children and adults** may complain of severe headache, stiff neck, drowsiness, painful joints, dislike of bright lights, and have fits.	2–10	Continuous. Meningitis bacteria commonly live in the back of the nose and throat, only causing disease when they overcome the body's defences. Many viruses, for example Hib, can cause meningitis and they are widely spread.
*Measles V	Fever, severe cold, cough. 4–5 days later a red rash appears on the face and spreads downwards.	10–15	From onset of cold symptoms until 5 days after rash appears.
*Mumps V	Painful swellings near the jaw on one or both sides.	12–28, usually about 18	Until the swelling goes down.
*Rubella (German measles) V	A mild disease with a red rash and usually with swollen glands.	10–21	From onset to end of rash.
*Tuberculosis (TB) B	Fever, sweating at night, cough with phlegm containing blood, loss of weight, continuous ill health.	28–42	Variable.
Chicken pox (Varicella) V	Small red spots which turn to blisters then scabs.	10–21	2 days before the spots appear until the last spot has formed a scab and flaked off.
Scarlet fever B	Sore throat, fever, bright red rash.	2–4	Up to 2 weeks after onset.

*Immunisation is available to protect against these diseases B = Bacterial infection V = Viral infection

Other information	Immunisation
Although now uncommon, it is still liable to occur in children who have not been immunised.	
Germs exist in soil, dirt and animal droppings, including those of horses and humans. They enter the body through cuts and scratches.	Vaccines against five diseases – diphtheria, tetanus, whooping cough (pertussis), polio and Hib – are given together as a single injection at 2 months old, 3 months and 4 months. This injection is known as DTaP/IPV/Hib or 'five in one'.
Can be very dangerous in babies up to 1 year old. Whooping-cough vaccine does not always prevent the disease, but it makes it much less unpleasant and the coughing less severe.	Before the child starts school, between the ages of 3 years 4 months to 5 years, there is a single injection containing booster doses of vaccines against diphtheria, tetanus, whooping cough and polio (pre-school booster).
Immunisation has almost eliminated this disease from Britain.	Between the ages of 13 and 18 years, a single injection is given containing booster doses of vaccines against diphtheria, tetanus and polio.
Hib causes a range of illnesses including a dangerous form of **meningitis**. The disease is rare in children under 3 months, rises to a peak at 10–11 months, declines steadily to 4 years of age, after which infection becomes uncommon.	
Meningitis is inflammation of the lining (meninges) of the brain and spinal cord. The disese develops rapidly and can be confused with flu. Viral meningitis is the most common. Bacterial meningitis is more serious, with three strains – groups, A, B and C.	Three injections of vaccine (Men C) against Group C are given at 2, 3 and 4 months and at the same time as the five vaccines above (the 'five in one'). Group A vaccine does not work on young children, and lasts for only 3–5 years in adults. When outbreaks of meningitis occur, students in schools and colleges may be offered vaccination against Groups A and C.
Dangerous to the fetus in the first 4 months of pregnancy.	A single injection of combined measles, mumps and rubella vaccine (**MMR vaccine**) is given at around 13 months with a pre-school booster at 3 years 4 months to 5 years old.
More serious in infancy than in older children.	
Mumps in males over the age of 11 may damage the testes and result in sterility.	
Most people who are infected by TB germs do not develop the disease. They do, however, develop natural immunity to the disease. BCG vaccine does not give complete protection against the disease.	Between the ages of 10 and 14 years, children are given a sample skin test to find out if they are immune to TB. If not, they are given one dose of **BCG vaccine** (Bacillus Calmette-Guerin) so that they can develop immunity. BCG vaccine is given at birth to those with infected, or previously infected, family members.
A mild disease in children. The virus can remain in the body and cause shingles in later life.	
Scarlet fever causes **tonsillitis** and a rash. Usually clears up quickly with antibiotics.	

Before an immunisation takes place, the situation should be discussed with the doctor or health visitor if the child:

- has a fever
- has had a bad reaction to any previous immunisations.

In most cases, there will be no reason to delay immunisation.

Benefits of immunisation
1. Almost all children get long-lasting protection from these diseases.
2. The more children who are immunised, the rarer the diseases become. This protects young babies and other children and adults as well. Polio is an example. Polio vaccine was introduced in 1957, and within five years the disease was almost wiped out.

EFFECTS OF IMMUNISATION

Usually there are no side-effects from immunisation. Occasionally, redness and swelling may develop where the injection was given, and then slowly disappear. A few children may be unwell and irritable and develop a temperature. Allergic reactions rarely occur and, if treated quickly, the child will fully recover.

IMMUNITY OF BABIES

Very young babies rarely catch the infectious diseases common in childhood because they are protected by antibodies obtained from the mother. When the baby is in the uterus, antibodies pass across the placenta from the mother's blood to the baby's blood. Because of this the baby is born with protection against the same diseases that the mother has had or has been immunised against. If the baby is breast-fed, the baby will continue to get supplies of these antibodies.

Antibodies from the mother survive in the baby for several months. All that time, the baby is growing stronger and becoming more able to withstand infection. The age of 2 months is the recommended time to begin immunisation. The baby will then begin to develop antibodies to take over from those of his mother, which gradually disappear.

Whooping cough is an exception. A newborn baby has no antibodies from the mother against this disease (whooping cough antibodies are too big to pass across the placenta). It is a very dangerous disease in babies and they should, therefore, be kept well away from anyone who is infectious. Even if the baby has been vaccinated against whooping cough it takes several months for the vaccine to become fully effective. It is useful to know that the cough lasts much longer than the infectious stage.

THE HENLEY COLLEGE LIBRARY

QUESTIONS

1 From the chart on pp. 268–269
 a What is the technical name for **(i)** German measles, **(ii)** polio, **(iii)** whooping cough, **(iv)** lock-jaw, **(v)** TB, **(vi)** Hib?
 b Why is mumps a risk to boys?
 c Which disease may cause shingles in an adult?

2 a Which of the diseases in the chart are caused by **(i)** bacteria, **(ii)** viruses?
 b Name two ways in which bacteria can cause disease.
 c How do viruses damage cells and cause disease?

3 a The DTaP/IPV/Hib injection contains vaccines against five diseases. Name them.
 b Which three diseases do the initials DTP stand for?

4 a How can disease be spread by droplet infection?
 b What is the difference between catching a disease from an infected person by **(i)** direct contact, **(ii)** indirect contact?
 c What is a contagious disease?

5 Give the meaning of the following terms when used to describe an infectious disease: **(i)** symptoms, **(ii)** incubation, **(iii)** onset, **(iv)** infectious stage.

6 a **(i)** What is the meaning of immunity? **(ii)** Name two ways in which immunity can be obtained.
 b For which of the diseases in the chart is immunisation available?
 c Before an immunisation takes place, what reasons might there be for discussing a possible delay with the doctor or health visitor?
 d Give two benefits of immunisation.
 e Are side effects from immunisation likely?

7 a **(i)** Why do very young babies rarely catch the infectious diseases common in childhood? **(ii)** Why is whooping cough an exception?
 b When is the recommended time to begin immunisation?

Revision Exercise	Revision Exercise	Revision Exercise
60A	**60B**	**60C**

FURTHER ACTIVITIES

EXTENSION

1 Use graph paper or a spreadsheet to produce a bar chart to show the duration of incubation of the infectious diseases of childhood mentioned on pp. 268–269 (excluding Hib).

N2.1

2 Copy the timetable below and complete with the name of the disease for which the vaccine is given.

Timetable for immunisation

1 2 3 4 5 6	3 injections by the age of 4 months
7 8 9	1 injection at around 13 months
10 11 12 13 14 15 16	a booster injection by the age of 5 years
17	for children of 10–14 years with no immunity
18 19 20	a booster injection at 13–18 years

INVESTIGATION

Since the year 1900, the infant death rate in Britain has been reduced from about 25% of all deaths in the whole population to about 2%. This dramatic reduction has been due to the control and treatment of measles, diphtheria, whooping cough and other diseases. Find out:
 a why each of the three diseases mentioned above is dangerous
 b when the method of control became generally available. Give a short talk to your class about your findings.

C2.1b

CHILD STUDY

1 Has the child had any of the diseases mentioned in this topic? If so, how did they affect the child?
2 Has the child been immunised? If so, make out a timetable. If not, perhaps the parents would be kind enough to discuss the reasons with you.

61 PARASITES

The parasites discussed in this topic are head lice, itch mites (which cause scabies), fleas, threadworms and roundworms. These parasites obtain their food from humans and one or more are likely to affect all children at one time or another. There is no reason for parents to feel ashamed if their child 'catches' any of these because they so easily pass from one child to another. The treatment to remove them is simple and advice can be obtained from the doctor, health visitor or clinic.

HEAD LICE

Head lice are tiny insects (each is called a **louse**) which live amongst the hairs of the head and look rather like dandruff which moves. The lice crawl around fairly rapidly and five times a day they pierce the skin for a meal of blood, leaving little red bite marks which itch.

The eggs (**nits**) are about the size of a pin head. Live eggs are grey/brown and are found glued to the hair, usually close to the scalp. They take seven to ten days to hatch, leaving empty egg shells. These are white and shiny and are found further away from the scalp, having grown out with the hair.

How lice spread
When heads come into contact for a minute or more, lice can crawl quickly from one head to the other.

head with sucking parts to obtain blood

legs for crawling

claws for hanging onto hairs, etc.

Louse (×20)

egg

cement — hair

Nit (×15)

Treatment
Washing hair will not get rid of head lice. They are not affected by the water as both lice and nits are waterproof. Nor do they get washed away – the nits are cemented to the hair, and the lice have claws which enable them to cling very tightly. There is a choice of treatment:

- **wet combing** After washing the hair with an ordinary shampoo, apply lots of conditioner to make the hair slippery. The wet hair is then combed with a **detector comb** (fine tooth comb) to remove the lice. This process needs to be repeated every three to four days for two weeks to remove the lice as they hatch.
- **chemical shampoos**. These kill the lice but not the nits.
- **chemical treatments**. These kill both lice and nits and are considered safe, but should only be used in moderation. If more than two treatments are needed, advice should be sought from a pharmacist, nurse or doctor.

SCABIES

Scabies is also called 'the itch' as it causes extreme irritation, especially at night, and keeps the sufferer awake. It is caused by mites which burrow into the outer layer of the skin (the keratin layer) where they spend most of their life feeding on the skin and laying their eggs.

Itch mite (×50)

Scabies on the foot
of a child

An irritating rash appears on the skin three to four weeks after infection. It looks like a scaly area with pimples and it may be possible to see the burrows of the mites. The rash makes the sufferer scratch, which can result in septic spots and boils. Scabies is most likely to occur on the palms, between the fingers, on the wrists, and sometimes armpits, groin and other places.

How scabies spreads

The main way that scabies spreads is by direct skin-to-skin contact for some minutes. This gives time for the mites to crawl from one person to another.

For this reason, scabies spreads easily between members of the same family, especially if they sleep in the same bed.

Scabies mites do not survive very long away from the body and so do not spread easily in playgroups and schools.

Treatment

The doctor will prescribe a lotion which must be applied to all parts of the skin from the neck to the soles of the feet. The bed-linen and underclothes must be washed. The treatment only works if all the members of the family are treated at the same time so that all the mites can be killed.

FLEAS

Fleas are small wingless insects with long legs adapted for jumping. It is easy to become infested with fleas as they can jump long distances from one person to another. The type of flea which feeds on human blood lives in clothing next to the skin. The human flea does not carry disease, but when it pierces the skin to suck blood it leaves small red marks which irritate. Fleas lay their eggs in dirt in buildings, furniture, bedding or clothing.

Treatment

Cleanliness is important in the control of fleas. They do not live for long on clean people or in clothes which are regularly washed. The eggs will not survive for long in clean buildings or bedding.

ANIMAL FLEAS

When young, children are often very sensitive (allergic) to fleas which live on dogs, cats, or birds. The fleas may be the cause of spots which persist for a long time. Pet animals with fleas need to be treated with a special insecticide available from pet shops and vets.

thin body which enables flea
to move easily amongst hairs

mouth parts for piercing skin
and sucking blood

long legs for jumping

Flea (×25)

273

Threadworm (×2)

THREADWORMS

Threadworms are small white worms about 1 cm long. They look like small pieces of thread that wriggle. They live in the large bowel (large intestine), feeding on the contents and can sometimes be seen in the stools. It is quite common for children to have threadworms from time to time. They do little harm but are a nuisance as they cause itching around the anus (back passage). The itching occurs mainly in the evenings because this is the time that the female worms crawl out of the bowel to lay their eggs and then die.

Threadworms live for 5–6 weeks but before they die, the female lays about 10 000 tiny eggs. These stick to the skin and clothes or are caught in the finger nails. They become part of the dust of the room, and can survive for up to two weeks outside the body. If the eggs enter the mouth of a child on the fingers or in food, they pass down to the bowel where they hatch. The worms cannot multiply in the bowel, so the number of worms depends on the number of eggs that are eaten.

Treatment
A doctor or pharmacist will prescribe medicine to clear the worms from the bowel, but they will die out in time anyway – unless the child eats more worm eggs. It is therefore important for the home to be thoroughly cleaned and clothes, bedding and toys washed to remove all the eggs. The medicine should be given to all members of the family.

Helping to prevent infection
It is almost impossible to make sure that children's hands are washed before they put their fingers into their mouth or handle anything that they are going to eat or suck. But it helps to prevent infection if:

- children are taught to wash their hands every time they use the lavatory, and before meals
- the hands of the person who prepares and serves the food are washed before doing so
- fruit and raw salad vegetables are washed thoroughly before they are eaten.

ROUNDWORMS (TOXOCARA)

These are the most common worms which infect dogs and cats, puppies and kittens. An adult worm is like a very thin, white earthworm about 15 cm in length. The worms lay large numbers of eggs in the intestine of the animal in which they are living. The eggs are then passed out in the animal's droppings (faeces) and can survive for two to four years in the environment.

Roundworm (× 0.5)

Being sticky, the eggs can cling to fingers and if swallowed, particularly by a child, can hatch out and develop into worms, causing **toxocariasis**.
Symptoms include fever, vomiting, and pain in muscles and joints. In some cases, eyesight can be damaged. Treatment is similar to that for threadworms.

274

Helping to prevent infection

- Encourage children always to wash their hands before eating and after playing with pets.
- Clear up dog droppings immediately, especially in places where children play.
- Fence off childrens' play areas from dogs and cats, and cover sandpits when not in use.
- Give dogs and cats regular doses of medicine to ensure that their intestines remain free from worms.

QUESTIONS

1 Copy and complete this chart.

	Head lice	Itch mites	Fleas	Thread worms
Where they live				
What they feed on				
Where they lay eggs				
How a child becomes infected				

2 a What is the difference between lice and nits?
 b Why is it impossible to get rid of lice and nits by washing the hair?

3 a Where on the body is scabies most likely to occur?
 b Why is scabies also called 'the itch'?
 c Describe the rash.

4 Why should pets with fleas be treated with an insecticide, particularly in a household with young children?

5 a What can be done to help prevent infection by **(i)** threadworms, **(ii)** *toxocara* worms?
 b What are the symptoms of toxocariasis?

FURTHER ACTIVITIES

EXTENSION

1 For each of the five parasites:
 a draw a diagram of the parasite
 b describe treatment to remove them.
2 Use the data available in Topics 60 and 61 to start a database of children's diseases and infections. This could be a group activity. A suggested layout of a record for measles is given below:

Name:	Measles
Part of body affected:	Respiratory system, skin
Symptoms:	Fever, cold, cough, red rash
Cause:	Virus
How it spreads:	Droplet infection, contact
Prevention:	Immunisation

INVESTIGATION

Find out information about other parasites, for example bed bugs, tapeworms, malaria, bilharzia.

Revision
Exercise

61

62 SKIN PROBLEMS

There are many different disorders of the skin. Some have already been mentioned. These include nappy rash (Topic 22), infectious diseases (Topic 60), and parasites (Topic 61). Other causes are dealt with in this topic and in Topic 63.

ITCHING AND SCRATCHING

The skin usually itches (irritates) when something is wrong with it. The natural thing to do is to scratch. If the itching persists, it makes a child irritable, restless and upsets sleep. There is also a chance that scratching will damage the skin and allow germs to enter and cause infection.

RASHES

Rashes of one sort or another are extremely common in children. If a rash is not a symptom of one of the usual diseases of childhood, a parent will want to know what caused it. Is it caused by an infection? Is it caused by something the child ate? Has the child been in contact with something she might be allergic to? Whatever the cause, if it worries the child and makes her scratch, or if she is obviously unwell, then prompt treatment by a doctor is required. It is much easier to deal with a rash at an early stage than later when it has spread and caused more trouble.

Urticaria ('nettle rash'; hives)
The rash is lumpy and usually white, with either lots of small spots or fewer, larger ones. It itches severely, but usually does not last long, and can be soothed by calamine lotion. It may be blamed on 'overheated blood', 'too rich food' or 'acid fruits', but these will not be the cause.

The rash indicates that the child is particularly sensitive (allergic) to something (see also Allergy p. 285). A number of substances are known to cause urticaria including:

- certain medicines such as aspirin or penicillin
- a particular food such as strawberries and shellfish
- sensitivity to insect bites such as those from the fleas of dogs or cats, or from bed bugs.

Urticaria is not dangerous, but if it occurs regularly, or persists for a long time, it needs to be investigated to discover the cause so that it can be avoided.

Heat rash

When babies get too hot, a rash may appear, particularly around the shoulders and neck. It is understandable for a rash to appear in hot weather or in hot countries – where it is known as **prickly heat**. It may also develop in cold weather if the baby is wrapped in too many clothes and kept in an overheated room.

Bathing the baby will remove the sweat – which is the cause of the rash. When the skin is quite dry, calamine lotion applied to the rash may be soothing.

Dressing the baby according to the weather will help to prevent heat rash. When it is very hot there is no reason for any clothes to be worn at all except a nappy.

Eczema

Eczema in varying degrees of severity is a fairly common complaint in babies. It tends to come and go during the early years, and most sufferers grow out of it by the time they begin school. It usually starts with patches of dry, scaly skin which become red and slightly inflamed and may weep. Eczema makes children want to scratch the sore places and it is very difficult to stop them.

Eczema is neither contagious nor caused by poor hygiene. Although the exact cause is unknown, there is often a family history of eczema, allergies, asthma or hay fever, and it tends to be worse when the child is emotionally upset.

SKIN INFECTIONS

Ringworm

This is caused by a fungus which infects the skin and grows outwards to form a reddish patch with a ring of little pimples at the edge.

When it affects the scalp, the hairs break off to leave a bald, round patch. Treatment with anti-fungal cream destroys the fungus, and the hair will grow again.

Athlete's foot

This is the name for ringworm which grows on the skin of the feet. It likes the warm damp conditions encouraged by shoes and socks, especially between the toes, where it makes the skin turn white and peel off.

Athlete's foot

Impetigo

Impetigo

This is a skin disease caused by bacteria. It starts as little red spots which develop watery heads and then brownish-yellow crusts. It spreads quickly to other parts of the skin, and can easily infect other people when, for example, they use the same towel. Impetigo can usually be cleared up quickly by antibiotics.

Warts

Although these do not cause itching and scratching, they are included here because they occur on the skin. Warts are caused by a virus infection which may spread to form a crop of warts. They are harmless and will disappear eventually without treatment.

A wart on the sole of the foot is called a **verruca** or **plantar wart**. Verrucas need to be removed because they are painful and contagious, being easily picked up in the warm, moist conditions of bathrooms and swimming baths. They can be treated by a chiropodist or with over-the-counter preparations sold in pharmacies. Like all warts, if left untreated, verrucas should disappear with time.

QUESTIONS

1 a Give four ways in which persistent itching may affect a child.
b When is prompt medical treatment for a rash desirable? Why?

2 a Give two other names for urticaria.
b Suggest some substances which might be the cause of urticaria.
c Name a substance which can soothe the rash.

3 a Under what conditions may heat rash develop in cold weather?
b What is the cause of eczema?
c Is eczema catching?

4 Which of the skin infections mentioned in this topic is:
a caused by a virus
b caused by a fungus
c caused by bacteria
d called athlete's foot when it grows on the feet
e called a verruca when it occurs on the sole of the foot
f treated with antibiotics?

FURTHER ACTIVITIES

EXTENSION

1 There are many different disorders of the skin. A number have already been mentioned in this book. How many can you remember? The first paragraph of this topic gives some clues. What **IT2.2** treatment, if any, was recommended for each disorder?

2 Add to the database file of children's diseases and infections started in Topic 61.
Use the file to find out:
a Which diseases and illnesses are caused by bacteria?
b Which are caused by viruses? Then think of some questions of your own.

Revision
Exercise
62

63 FIRST AID

This topic gives a list of equipment which should be kept in a first-aid box, and a brief description of treatment for the more common mishaps.

FIRST-AID BOX

Children often cut themselves or fall over, burn or scald themselves or get stung. Parents and carers have to deal with these first-aid problems and it is helpful to have all the necessary equipment handy in a special box. Suggested contents for the first-aid box are:

- **antiseptic wipes** – for cleaning wounds
- **plasters (low allergy)** – to cover small wounds
- **gauze dressing**, either in individual packs or a long roll – to cover wounds
- **bandages** of different widths ⎫
- **adhesive tape** ⎬ to hold dressings in place
- **safety pins** – to hold bandages in place
- **scissors** – to cut bandages and tape
- **crêpe bandage** – to support a sprained ankle or other joint
- **triangular bandage** – to make a sling to support a damaged arm
- **tweezers** – to remove splinters
- **eye dropper or eye bath** – for washing the eye
- **sterile eye pads** – to cover an injured eye
- **calamine lotion or cream** – for sunburn, chapped skin
- **anti-sting cream** – for insect bites
- **plastic gloves** – to prevent spread of disease through contact with blood
- **disposal bag** – for safe disposal of used dressings etc.

adhesive tape

bandage

gauze dressing

crêpe bandages

CUTS AND GRAZES (ABRASIONS)

Small cuts and grazes should be washed with clean water or soap and water and dried by patting with a clean towel. If necessary, they should be covered with a dry dressing, and the dressing held in place with a bandage.

Bleeding from a small wound soon stops of its own accord, and the scab which forms prevents infection. There is no need for a plaster unless the wound keeps opening up. Also, there is no need for antiseptic ointment as a child's natural resistance deals with nearly all infections, and the ointment makes the scab soft and delays healing.

Wounds with severe bleeding

When there is severe bleeding, the aim should be to stop the bleeding immediately and to obtain medical help urgently. To stop the bleeding, pressure should be applied to the wound with the fingers. A doctor may decide that a large or deep wound needs stitches. An injection against tetanus may also be necessary.

BRUISES

A bruise is caused by bleeding beneath unbroken skin. Firm pressure on the affected area will help to stop a bruise from developing. A bad bruise may be eased by a **cold compress** if it is applied at once. This is made by soaking some suitable material, e.g. cotton wool, in cold water and placing it on the bruise.

NOSE BLEEDS

These are common in young children. They are more of a nuisance than a danger – the sight of blood makes them appear worse than they really are.

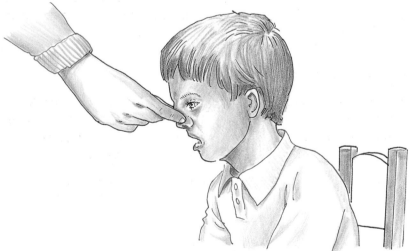

There are many causes, but the treatment is always the same. Sit the patient upright and leaning slightly forward. Pinch the soft part of the nose for 10 minutes, then release the pressure. If the bleeding has not stopped, reapply the pressure for another 10 minutes. Repeat if necessary. If the nose is still bleeding after 30 minutes, the child should be taken to hospital. Once the bleeding has stopped, the nose should not be blown for several hours.

CHOKING

When a hard object gets stuck in the throat, it interferes with breathing, and the child chokes. In the case of a baby, lay him along your forearm, keeping his head low, and pat his back, four or five times.

For an older child, hold him over your knee, head downwards, and slap four to five times between the shoulder blades. If the choking continues, put both arms around the child's waist from behind, interlocking the hands. Then pull sharply upwards below the ribs, telling the child to cough at the same time.

If the blockage is not completely cleared, or the patient continues to have trouble breathing, seek urgent medical help.

lay the baby along
your forearm

give five sharp pats
on the baby's back

keep the baby's head
low and support the chin

bend the child over
your knees

give five sharp slaps between
the child's shoulder blades

How to deal with choking

ELECTRIC SHOCK

If a child is receiving a continuous electric shock, do not touch him with bare hands, or you will receive a shock too. Switch off the power if possible. If you cannot do this, push the child clear using a broom, cushion, or wooden chair – avoiding anything made of metal which would conduct electric current.

BROKEN BONES (FRACTURES)

Generally, the bones of a young child bend rather than break. If a bone does break, it is likely to crack on one side only. This is called a 'greenstick' fracture because it behaves rather like a bent green twig which refuses to break off. An X-ray may be necessary to discover whether a bone is broken or not.

If a bone is obviously broken, it is important to keep the injured part still, stop any bleeding, and call an ambulance. Do not give anything to eat or drink in case a general anesthetic is needed.

Greenstick fracture
in the forearm

SOMETHING IN THE EYE

When a particle of dust, an eyelash or other small object gets into the eye it can be removed with the corner of a clean handkerchief from the eyelid but *not* the eyeball. The eyeball itself should never be touched because of the danger of damaging the delicate surface. Rubbing the eye can also cause damage.

Dust or other small particles on the eyeball are best removed by washing the eye. Tilt the child's head so that the good eye is uppermost. Then pour some water into the inner corner of the affected eye so that it washes over the eyeball. If a little salt is added to the water (a teaspoonful of a salt to ½ litre water), the water will soothe rather than sting the eye (tears are salty). If the object cannot be removed easily, it needs to be dealt with by a doctor, or at the hospital. After the object has been removed, it will still feel as though something is there if the eyeball has been scratched.

When a chemical substance such as bleach gets into the eye, it should be washed out immediately by holding the face under cold running water from the tap.

BURNS AND SCALDS

A **burn** is caused by dry heat, for example from a fire or touching a hot cooking pan. A **scald** results from contact with moist heat such as steam or hot fat.

The skin of young children can very easily be damaged by heat and the scars may last for a lifetime. Burns and scalds are also very painful. Therefore, every effort should be made to prevent them from happening (see Topic 68). In young children, especially infants, even small burns or scalds should be regarded as serious and be given immediate treatment.

Small burn or scald

Hold the burnt area under running cold water or put in a bowl of cold water containing ice cubes to remove the heat and reduce the pain. It is important to do this for at least ten minutes. Pat dry and cover with a gauze dressing, cling-film or a clean plastic bag, but **not** a plaster. If the burn is on the face, or is larger than the size of the patient's hand, or has caused severe blistering or broken the skin, the child should be taken to hospital immediately.

- **NEVER** put ointment, cream, jelly, oil or butter on a burn – they delay healing.
- **NEVER** prick a blister – this lets in germs and encourages infection.

Severe burn or scald

Wrap the child in a clean sheet and rush to hospital without waiting to call a doctor.

SUNBURN

The sun's rays can easily burn the skin, so a child's skin should be exposed to the sun gradually, starting with a few minutes on the first day. The time can be slowly increased as brown pigment (melanin) develops in the skin to protect it. Those with fair skin burn very easily and need particular care, especially at the seaside, as the sun's rays are reflected from the water and this makes them extra strong. Babies and young children should always be protected by sun protection lotion (factor 30 for young babies) and should wear a suitable hat to shade the face and neck.

Sunburn only begins to hurt several hours after the actual burning has taken place. Severe burning needs medical attention. In other cases, cold water may help to soothe, as may calamine lotion or special creams or lotions sold for the purpose.

Excessive exposure to sun, particularly in those with fair skins, can cause skin cancer.

STINGS

Calamine, anti-sting or anti-histamine creams give relief when rubbed on to stings from insects and nettles. They help to reduce itching. If the sting is in the mouth, sipping cold water or sucking an ice cube or ice lolly helps to give relief while medical advice is sought. Medical advice is also required if:

- there is a known allergy to bites and stings
- shortness of breath or fever develop
- infection sets in.

sleeping pills

pain killers

contraceptive pills

tranquillisers

Common causes of poisoning in young children

POISONING

If a child has swallowed something poisonous

- **keep calm** – poisoning is rarely fatal in a matter of seconds or even minutes
- **do not try to make the child sick**
- **telephone your doctor or take the child to the nearest hospital**
- **take a sample of the poison with you** so that it can be quickly identified.

FURTHER ACTIVITIES

EXTENSION

Make a leaflet to fit inside a first-aid box giving emergency instructions for dealing with common accidents, such as the ones in this topic.

C2.3 Include a contents check-list to place inside the box.

INVESTIGATION

Check the contents of a first-aid box. Perhaps you have one at home. There will certainly be at least one in every school and college. Compare the items in the box with the list on p. 279. What items are missing? If there are any extra items, what are they there for?

QUESTIONS

1 List the items shown in the photograph of the first-aid box on p. 279. Give a purpose for each item.

2 a How does first-aid treatment for a graze differ from that for severe bleeding?
b Are sticking plasters or antiseptic ointments necessary for a small cut?

3 a What is the cause of a bruise?
b What treatment is necessary?

4 Describe how to stop a nose bleed.

5 What treatment is advised for **(i)** a baby who is choking, **(ii)** an older child who is choking?

6 If you have to deal with someone who is receiving a continuous electric shock, **(i)** what should you not do, **(ii)** what should you do?

7 How should a broken bone be dealt with?

8 How can something be removed from a child's eye?

9 a Give two reasons why every effort should be made to prevent children being burnt.
b Describe the first-aid treatment for **(i)** a small burn, **(ii)** a bad burn.
c What should never be put on a burn and why?
d Why should blisters never be pricked?
e How can sunburn be **(i)** prevented, **(ii)** treated?

10 When is medical advice required for a sting?

11 a List the causes of accidental poisoning in young children shown above.
b What action should be taken when a child has swallowed something poisonous?

Revision Exercise **63A**

Revision Exercise **63B**

64 COMMON ILLNESSES

This topic gives a brief description of some of the more common illnesses from which children may suffer. They are placed in alphabetical order and not in order of seriousness or frequency.

An illness can be **acute** (short-term) or **chronic** (long-term). Depending on the severity of the illness it can be **mild, moderate** or **severe**. Details of illnesses should be recorded in the child's Health Record (see p. 66).

ADENOIDS

Adenoids consist of lymphatic tissue behind the nose which sometimes grows so large that it blocks the back of the nose. When this happens, the child has to breathe through the mouth. It may cause nasal speech, deafness, and sometimes a persistent cough. Common problems with large adenoids are a night cough, snoring and disturbed sleep. In such cases, the adenoids may need to be removed.

ALLERGY

Having an allergy means being unduly sensitive to a particular substance which is harmless to most other people. That substance may affect the body through the skin (e.g. detergent), or when eaten (e.g. strawberries, cow's milk, eggs, peanuts), or when breathed in (pollen, house dust etc).

The allergy may show itself in one or more of the following ways: hay fever, asthma, eczema, urticaria ('nettle rash'), stomach upset, or other unpleasant symptoms.

Many people (adults and children) have allergies of one sort or another. A tendency to suffer from allergies often runs in families, although it may take different forms in members of the same family. For example, a parent with asthma may have a child who suffers from hay fever.

> Little Paul Land is nuts about his granny but every time he gave her a cuddle he burst into tears and came out in blotches.
>
> For months doctors were baffled but now allergy experts have discovered the cause.
>
> Two-year-old Paul of Harlington, near Mexborough, South Yorks, is allergic to peanuts – and his granny, 63-year-old Mrs Ann Land, works in a nut factory.

This news item appeared in the *Eastern Daily Press*

APPENDICITIS

Appendicitis is inflammation of the **appendix** (a worm-like extension of the large intestine about 8 cm long). It starts with pain in the abdomen (tummy) which becomes localised in the lower right side within a few hours. The pain is usually accompanied by fever and vomiting. An operation is necessary to remove the appendix and prevent peritonitis and the spread of the infection in the abdomen.

ASTHMA

This is difficulty in breathing caused by tightening (spasm) of the muscles surrounding the small air tubes in the lungs. It may be due to infection, allergy, or emotional upset, and may run in families. An asthma attack starts with a feeling of tightness in the chest and often a troublesome cough. This leads to 'shortness of breath' and noisy, wheezy breathing, which can be distressing to both the child and the parents.

Asthma is usually treated by inhalers (puffers) and tablets. In serious cases, a few days in hospital may be necessary to stabilise the condition.

COLDS

The common cold is caused by a virus infection. It spreads easily, either by droplets in the air that come from an infected person, or by contact with handkerchiefs, cups, spoons or other objects recently used by an infected person. It is difficult to stop the germs from spreading between members of the same family. Colds are caused by a very large number of different viruses and as yet there is no known way of preventing them.

Young babies are more seriously affected by colds than older children. They are also more likely to suffer from complications such as chest infections. Therefore, it is wise to try to prevent anyone with a cold from coming into contact with a young baby. Babies have difficulty in feeding when the nose is blocked because they are unable to breathe and suck at the same time.

Children are particularly likely to catch colds in the first few months at playgroup or school. This is because they come into contact with a greater variety of different types of cold germs. By the time they are 6 or 7, they have usually built up more resistance to these germs.

CONJUNCTIVITIS ('PINK EYE')

This is caused by an eye infection. The eye looks red and there is usually a yellowish discharge which sticks the eyelids together. The infection easily spreads when other members of the family use the same towel or face flannel as an infected person. The eyes can be cleaned by wiping gently with cotton wool soaked in water, from the inner corner of the eye outwards. A fresh piece of cotton wool should be used for each eye. A doctor may prescribe antibiotic eyedrops or ointment.

CONSTIPATION

Constipation is the infrequent passing of very hard, dry stools. It is a common problem in children due mainly to not enough fibre in the diet and not enough fluids taken. Left to themselves, the bowels open when necessary, and usually according to a pattern. With some people (adults and children), the bowels may open once or more a day, or every other day, or once every three

or four days, and any of these patterns is normal. There is no need for the bowels to open every day, or for the child to be given laxatives to make this happen. It is common for babies who are being breast-fed to go for several days without having a motion, and the stools are always soft.

Laxatives can be harmful if they are given regularly, as they interfere with the normal working of the bowels. Bowels should be kept open by **diet** not laxatives:

- for young babies – more water
- for babies being weaned – fruit purée
- for children – foods containing fibre such as wholemeal bread, cereals, fruit, vegetables.

COUGHS

It is essential to cough from time to time to remove phlegm from the windpipe or lungs, especially following a cold. There is no need to consult a doctor whenever the child coughs a little more than usual. If the child coughs a great deal, it can be due to a number of possible causes and needs a medical opinion.

Cough medicine will not cure a cough, but it might comfort the back of the throat. The instructions should be read before any cough medicine is given to a child, because some are not suitable for young children.

CROUP

Croup is a harsh, barking cough accompanied by noisy breathing and a hoarse voice. It occurs in children up to the age of 4 years, and is caused by **laryngitis** (inflammation of the larynx – the voice box). If it develops suddenly, a doctor needs to be consulted as soon as possible.

DIARRHOEA

Diarrhoea is the frequent passing of loose watery stools. To prevent dehydration (see p. 93), children should be given plenty to drink, either water with a little sugar, or weak squash or weak fruit juice. A rehydration mixture available from a pharmacy can also be given. This will replace the essential salts lost during diarrhoea.

If the diarrhoea continues for more than 12 hours, or if it is accompanied by vomiting, medical advice should be sought.

EARACHE

Pain in the ears may be due to teething or a cold. If the earache persists, or if it keeps recurring, it needs to be investigated by a doctor in case an infection is present in the ear itself, e.g. 'glue ear' (see p. 142).

FEVER

Fever is when the body temperature is higher than normal. (Taking the temperature is discussed on p. 294.) A child with a fever will feel hot and sweaty. She needs to be allowed to cool off to reduce her temperature – not to be smothered in blankets. This can be helped by sponging the skin with tepid water, and lowering the heating in the room. Simple medicines such as infant paracetamol (e.g. Calpol®) may also help to reduce the fever.

Fever is usually a sign of infection, but not always. A high temperature on its own is not normally a reason for asking a doctor to call. However, if it remains high or is accompanied by other symptoms (such as headache), it is wise to ask the doctor for advice.

FITS (CONVULSIONS)

When a child has a fit, her eyes roll upwards, she loses consciousness and her limbs make jerking movements. Fits are caused by a wide variety of ailments, but not by teething. In many small children they are due to a high fever that occurs with infections such as tonsillitis or bronchitis.

Once the convulsion has stopped, lay the child on her side in the recovery position. This prevents the airway to the lungs from becoming blocked by the tongue or by vomit. The doctor should be informed.

Should the fit continue for more than 10 minutes, or if the child remains unconscious for longer than this time, and a doctor has been unable to reach you, the child should be taken to hospital.

Recovery position

HEADACHES

Headaches are common in children and may be due to tiredness, worry, infection (e.g. tonsillitis), or migraine. On the other hand, pretending to have a headache can be used as an excuse for not doing something, for example not going to school. If having a headache is found to be an easy way of avoiding a difficult or a worrying situation it can quickly become a habit.

Whatever the cause, headaches need investigation so that the right treatment can be given to stop them.

INFLUENZA

Influenza ('flu') is caused by a virus. It is a more serious infection than the common cold. Symptoms include fever, chill, headache and dry cough. A runny nose and sneezing may also occur.

SORE THROAT

There are various causes of sore throat. Often it is the beginning of a cold. Sometimes the child may have tonsillitis. It is not necessary to consult a doctor every time a child has a sore throat. If it is accompanied by earache, a rise in temperature, or if the sore throat is still getting worse after two days, a doctor should be consulted.

STICKY EYE

A yellowish discharge from the eye sometimes gums the eyelids together. It may result from a blocked tear duct or an infection. To clean the eye, wipe gently with cotton wool and water; always wipe from the inner corner of the eye outwards, and use a fresh piece of cotton wool for each eye. A doctor needs to be consulted if the discharge persists.

STYE

Inflammation at the base of an eyelash caused by infection.

SWOLLEN GLANDS

There are many reasons why the glands in the neck swell, and a doctor should be consulted.

THRUSH

This is a fungal infection which causes white patches on the tongue and mouth. It occurs mainly in babies and makes them scream when feeding because the mouth is sore. Thrush can also occur in the nappy area as red patches with spots. The infection can be cleared up by antifungal cream or drops.

TONSILLITIS

Tonsillitis is an infection of the tonsils. The throat is sore, the tonsils are inflamed and it may be possible to see yellowish-white spots on them. Antibiotics prescribed by the doctor usually cure the infection.

There are two tonsils, one at either side of the back of the mouth. They normally enlarge at the age of 5–6 years and shrink after the age of 10 or so. Tonsils do not need to be removed just because they are large, but only if there are frequent bouts of tonsillitis which cannot be prevented by medicines.

VOMITING (BEING SICK)

It is quite usual for young babies to bring up a little milk after a meal. This is often curdled, and it smells sour as it has been mixed with the acid in the stomach. It is not a cause for worry.

Vomiting has to be taken seriously when a child is repeatedly sick. This applies to older children as well as babies, and the advice of a doctor is needed. Vomiting and diarrhoea are often symptoms of food poisoning (p. 256).

WHEEZING

A child with a wheeze should always be seen by a doctor. The wheeze may be caused by asthma, an infection, or by inhaling something. It can be very much helped by medical treatment.

QUESTIONS

1 Link each of these words with the correct description below:
adenoids, asthma, conjunctivitis, constipation, croup, diarrhoea, fever, sticky eye, thrush, tonsillitis.
 a body temperature higher than normal
 b spreads easily when others use the same towel
 c noisy breathing with a harsh cough
 d white patches on the tongue and mouth
 e tissue which sometimes blocks the back of the nose
 f inflamed tonsils
 g yellow discharge which sometimes gums the eyelids together
 h loose, watery stools which are passed frequently
 i the infrequent passing of very hard, dry stools
 j difficult breathing.

2 What is the difference between acute and chronic illness?

3 a When a person has an allergy, what does this mean?
 b Name some substances which are known to cause allergies, and say how they get into the body.
 c What form may an allergy take?

4 a What causes the common cold?
 b How does it spread?
 c What particular difficulty do babies have when they suffer from a cold?
 d When children start attending playgroup, why are they particularly likely to catch colds?

5 a When can constipation become a problem in children?
 b When and why are laxatives harmful?
 c Give ways of encouraging the bowels to open regularly without the use of laxatives.
 d What should be given to children with diarrhoea, and why?

6 a Why should a child with earache be taken to the doctor?
 b What action is recommended when a child has a fit?
 c **(i)** What can cause headaches in children?
 (ii) Why may children have 'pretend' headaches?
 d What symptoms may indicate appendicitis?

FURTHER ACTIVITIES

EXTENSION
 a Use data from this topic to add to the database started in Topic 61.
 b Use the database to find all the diseases that can affect the respiratory system.

IT2.2

CHILD STUDY
Has the child had any illnesses mentioned in this topic? If so, describe how the child was affected.

Revision
Exercise
64

6 5 THE SICK CHILD

Parents can usually tell when their child is ill by changes in the child's normal pattern of behaviour. It is probable that the child will show one or more of the following symptoms:

- fever (looks flushed and feels hot)
- loss of appetite (will not eat)
- rash (spots or blotches on the skin)
- dark rings around the eyes, or the eyes look sunken
- vomiting or diarrhoea
- fretfulness
- unnaturally quiet and limp and shows no interest in anything
- unusual paleness.

With a baby, they will also notice that he cries differently.

CONSULTING THE DOCTOR

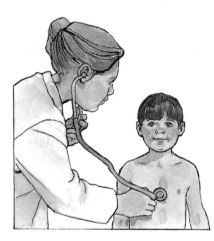

When parents feel that there is something wrong with their child, they have to decide whether to consult a doctor. There is no need to call the doctor every time the child coughs, or vomits, or has a raised temperature. These symptoms commonly occur in childhood and are often followed by a quick recovery. If the child does not recover quickly, or is more unwell than usual with these symptoms, or they recur frequently, then a doctor should be consulted.

When parents need the advice of a doctor, they should phone or call at the surgery or health centre, preferably before 10 a.m. They will then be given advice, or asked to bring the child to the doctor, or told that the doctor will be calling to see the child.

EMERGENCIES

A child needs urgent treatment either from a doctor or the accident and emergency department of a hospital for:

- severe bleeding
- severe burns
- severe pain
- severe blow on the head
- severe diarrhoea or vomiting (especially babies)
- broken bone
- electric shock

- swallowing poison
- unconsciousness
- glazed eyes which do not focus
- difficulty in breathing
- any type of fit or convulsion
- swallowing a dangerous object like a button, battery or a safety pin

CARING FOR A SICK CHILD

There is no good reason for keeping a child in bed unless he is happier there. The child will get better just as well in the living room as in the bedroom, so long as he is kept warm and comfortable. He is also likely to be less bored and feel less neglected if he is near other people in the family, and it is easier to care for him and keep him amused.

When a child has to stay in bed he needs to be kept clean, comfortable and occupied.

- Washing the face and brushing the hair and teeth help the child to feel fresh.
- A daily bath is unnecessary unless he is sweating a lot.
- The hands need to be washed before eating and after using the toilet.
- The bedclothes and nightclothes should be changed as often as necessary.
- The bed should be straightened several times a day and remade morning and evening.
- The room should be kept warm.
- The room should be kept ventilated to prevent it from becoming stuffy, especially when there is paraffin or gas heating. If the window is opened, the child should not be in a draught.
- A child who is old enough needs:
 - plenty of pillows so he can sit up comfortably
 - to be prevented from sliding down the bed by a pillow placed under the foot of the mattress
 - a bed-side table or tray for toys and play-things.

AVOIDING BOREDOM

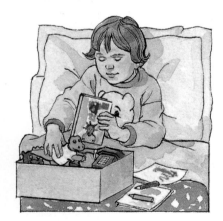

Keeping a child happy and occupied throughout the day can be difficult at the best of times, but it requires extra thought and patience when the child is unwell. It can be helpful if parents keep some toys and play materials tucked away, ready to bring out when the child is ill or convalescing (getting better). Some of these things may have been given as birthday or Christmas presents, and then put aside for just such an occasion. The box in the drawing is kept by the family and taken out when a child is sick.

In addition to having new or different toys to play with, a child always loves having someone who will play with him, or will read or tell stories to him.

WHEN A CHILD HAS TO GO INTO HOSPITAL

Being a patient can be a big shock to children, especially if they have to be separated from their parents and are too young to understand. When children go into hospital they:

- will find themselves in strange surroundings
- will meet many people who are strangers to them
- may not understand what is happening to them
- may be ill or in pain
- may have to undergo unpleasant treatments or procedures.

In addition, they will have:

- a changed routine
- different food
- different bed, bath etc.

When ill, children need more love and support from their parents than usual. All hospitals now have some provision for parents so that they can stay with their babies or young children and help to nurse them.

When children are old enough to understand, then it should be explained to them what is going to happen, perhaps with the help of books, videos or pre-visits to hospital. They may even look forward to the event if told that:

- they can take some of their toys with them
- there will be more toys in hospital to play with
- there will be other children to play with
- their parents will be able to visit them or stay with them
- the doctors and nurses will look after them.

QUESTIONS

1 a How can parents usually tell when their child is ill?
b What symptoms may the child show?
c When is it advisable to consult a doctor?

2 Name 13 emergencies when the child needs urgent medical treatment.

3 How should a sick child be cared for at home?

4 a Name some changes which take place in a child's life when he goes into hospital.
b How may hospitals make life easier for a young child?

FURTHER ACTIVITIES

EXTENSION

1 Look at the photograph of a child in hospital with a broken arm. How would the scene differ if a child was being cared for in bed at home?

2 Suggest a list of suitable items for the box in the drawing on the opposite page.

INVESTIGATION

Try to arrange to visit the children's ward of your local hospital. You may be able to do something useful like play with a child who does not have any visitors. Write an account of your visit and what, if anything, you were able to do for the patients or the staff.

C2.3

DESIGN

Find out the kinds of toys which are useful in hospitals for keeping sick children amused. With the aid of a suitable graphics program, design and, if possible, make an item to keep a sick child amused.

IT2.3

Revision
Exercise
65

TAKING THE TEMPERATURE

It is natural for the temperature of the body to vary (see also pp. 75–76). Most people have an average temperature in the mouth of about 37°C (98.6°F); in the armpit it is a little lower and in the rectum a little higher.

A high temperature may be an indication of illness, but a child can be seriously ill and yet have a temperature which is only slightly raised, or normal, or below normal.

There are different types of thermometer for measuring body temperature.

Ear thermometer

Ear thermometer
A safe and easy way to take a child's temperature is by using an ear thermometer. A small probe inserted into the ear accurately records body temperature. This type of thermometer is powered by a battery.

on/off switch tip
 (sensitive to
 temperature)

display flexible probe

Digital thermometer

Digital thermometer
This is safe to put in the mouth, simple to use, easy to read, accurate, and has a fast response. It is also battery operated.

Forehead thermometer
This is an easy and quick way to take a child's temperature. This type of thermometer is made of thin, flexible plastic containing liquid crystals. It is held against the forehead, and discs or stripes change colour to indicate the level of body temperature.

One for teddy, then one for you

GIVING MEDICINE

Medicines need to be used with care. When giving medicine to a child (or anyone else):

- **Make sure it is the right medicine**. Before giving medicine, check that it is right for the patient.
- **Follow the instructions exactly**. The right dose needs to be given, at the right frequency. Most medicines have side-effects which can cause considerable harm if too much is taken.
- **Ask the doctor for advice** if the medicine does not seem to be doing any good, or if it seems to be causing troublesome side-effects.
- **Store the medicine in a cool place and out of reach of children**, preferably in a locked cupboard.

Medicine taken by mouth

Every effort should be made to get a child to take medicine willingly. Ways of persuasion include:

- making it into a game, e.g. by giving some to teddy
- pretending to have some yourself
- disguising the taste with jam or yoghurt.

When force is used to get the medicine into the mouth, the child will be certain to fight against it every time. It is dangerous to force medicine down a child's throat when she is crying in case she inhales it.

For babies, medicine can be trickled into the side of the mouth using a dispensing syringe instead of a spoon. They may find flavoured medicines easier to take.

Generally, children under the age of 5 years are unable to swallow tablets, in which case they need to be crushed first and then given in a teaspoonful of milk, fruit juice or jam.

ANTIBIOTICS

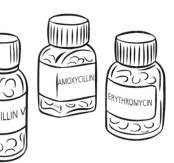

The drawing shows three of the many different kinds of antibiotic. **Antibiotics** are medicines used for treating diseases caused by bacteria and fungi. It is particularly important to follow the instructions that come with this type of medicine. It is also important to complete the course of treatment even if the symptoms have disappeared, as not all the germs may have been killed and the disease can start up again.

Antibiotics must never be stored and used later as they lose their effectiveness with time.

PREVENTING THE SPREAD OF INFECTION BY CROSS INFECTION

If a child is suffering from an infectious disease, the parents should try to prevent it from spreading by:

- general cleanliness
- keeping babies and other vulnerable people away from the infection.

A few serious infectious diseases may also require:

- **isolation** of the person suffering from the disease so that germs cannot spread to others
- **quarantine** of people who have been in contact with the infected person, because if they have caught the disease they may be infectious before the symptoms appear.

FOOD AND DRINKS

Children who are not feeling well often do not want to eat. It will do them no harm to go without food for two or three days. When better, they will make up for it by eating more than usual.

While there is no point in forcing food into children who are ill, they should be given plenty to drink, especially if feverish, to prevent dehydration. This might mean offering favourite drinks, or making special fruit drinks, iced lollies, using a drinking straw, or flavouring milk to make it into a milk shake.

ATTITUDES TO ILLNESS

Much of an adult's attitude to illness is learnt in childhood. Children learn:

- by how their parents deal with them when they are ill
- by the parents' attitude to their own health.

All children, at one time or another, have spells of not feeling very well – when they have a cut knee, a sore throat, a cold, a headache, and so on. If the mother or father becomes worried over every ache and pain, and keeps talking about it and making a great deal of fuss, the child will think it very important and learn to worry in the same way. If, instead of worrying too much, the parents put their energy into keeping the child happy and occupied, then she is unlikely to grow up to be over-anxious about her health.

QUESTIONS

1 a Describe in words or by diagrams three types of thermometer suitable for children.
 b Do children who are seriously ill always have a high temperature?

2 a What care should be taken when giving medicine?
 b Suggest ways of persuading a child to take medicine willingly.
 c What may result from forcing medicine into the child's mouth?
 d What is the usual age at which children become able to swallow tablets?

3 a What is an antibiotic?
 b List the different kinds of antibiotic shown on p. 295.
 c Why is it important to complete a course of antibiotics?

4 How can parents try to prevent the spread of an infectious disease?

5 Is food or drink more important for a sick child? Explain why?

Revision Exercise 66

FURTHER ACTIVITIES

EXTENSION

What should a child who is unwell be given to eat and drink? Describe different ways of making drinks attractive.

DISCUSSION

Do you agree or disagree that much an adult's attitude to illness is acquired in childhood? Give your opinion, backed up by examples, from your own experience.

C2.1a

67 PREVENTION OF ACCIDENTS

Accidents are the biggest cause of injury and death of children over the age of one year. It is estimated that every year more than 1 million children in the UK require hospital treatment. Many more are treated by GPs and by carers.

TRAINING FOR LIFE IN A DANGEROUS WORLD

The world is a dangerous place and children have to learn to cope with the hazards.

Parents and carers are responsible for the safety of their children. At the same time, they are responsible for training them to become independent people who can take care of themselves. Throughout childhood, parents and carers have to judge between the amount of protection their child needs for safety and the amount of freedom the child needs and wants. Children *need* to be given freedom so that they can learn to make judgements for themselves. Children often *want* more freedom than is safe for them because it is a natural part of growing up to react against parents' and carers' wishes.

Learning about danger

During the first 18 months of life, babies have no understanding of danger and therefore need complete protection. However, during this time they are beginning to learn what is unpleasant and can hurt, for example a child will remember for a while touching a particular object which was hot.

By the time they reach the age of 18 months, children understand simple instructions. They can now start to be taught that there are some things that should not be done.

Between 18 months and 2 years, children are beginning to understand a great deal of what their parents and carers say and their memory is improving. They start to realise that certain actions have certain consequences. For example, if anything hot is touched it will hurt. They still need a great deal of protection but they are just beginning to learn to protect themselves.

The amount of supervision can be gradually relaxed as the children acquire more sense about what is dangerous and how to avoid it. At times, parents and carers have to take calculated risks when they allow children a little more freedom. But if complete protection continues too long, children suffer the consequences of over-protection.

The type and amount of supervision changes as the children get older. It gradually becomes less and less, but even as adults they will need to be protected by the *Health and Safety at Work Act* and other regulations.

Fire resistant – the covers and filling of the goods meet fire resistance regulations. Fire safety labelling must, by law, be attached to all new and secondhand furniture sold in shops

Low flammability – the garment has passed the test for low flammability, that is, it is slow to burn

Keep away from fire – garments carrying this label have not passed the test for low flammability. Extra care must be taken when anywhere near a flame or a fire

Labels to indicate fire-resistance qualities

WHEN ACCIDENTS ARE MORE LIKELY TO HAPPEN

Accidents and injuries to children are more likely to happen:

- **at times of stress** – These are the times when people (both adults and children) are more careless and forgetful. For example, when in a hurry, when afraid, during an argument, or when very worried, perhaps about health, friendship, jobs or money.
- **when parents and carers are less alert** – Their senses may be dulled by medicines such as tranquillisers, or by alcohol, or by drugs, or perhaps because they are just very tired.
- **to children who are under- or over-protected** – Children who are under-protected are not made aware of dangers, so fail to take care. Children who are over-protected may either be made so aware of danger that fear makes them nervous and unsure and therefore unsafe, or may rebel against their parents or carers by taking more risks than would otherwise be the case.
- **to children who are neglected or abused** – See Topic 75.

REDUCING THE RISK

All children have accidents, however safe the home and however careful the parents and carers. It is neither possible nor desirable to watch a child every minute of the day. Nevertheless, adults can help to reduce the possibility of accidents by the following means.

1. Set a good example – children copy the behaviour of adults.
2. Make the home and gardens as accident-proof as possible.
3. Teach children to be aware of dangers and how to cope with them.
4. Never leave children alone in the house.
5. Where possible, buy goods which have the appropriate mark or label showing that they have been approved for safety. Some of the marks are shown here.

Labels which show that equipment meets safety standards

Kitemark – the goods have been made to the correct British Standard

LOW FLAMMABILITY TO BS 5722

BS number – the number of the British Standard (BS) to which the goods conform

CE

CE mark – shows that the goods comply with European regulations

Samples of appliances bearing this label have been subjected to rigorous tests for SAFETY

BEAB APPROVED YOUR ELECTRICAL SAFEGUARD

BEAB mark of safety – the goods meet government safety regulations for domestic electrical appliances (BEAB = British Electrotechnical Approvals Board)

Markings on containers of substances which can have harmful effects

Harmful/irritant – the substance is not a serious health risk, but may cause some ill health if inhaled or consumed or if it penetrates the skin; some of these substances will irritate the skin and the eyes

Toxic/very toxic – the substance causes a serious risk to health if swallowed, and in some cases if inhaled or spilt on the skin

Corrosive – the substance may cause painful burns and destroy living tissue

QUESTIONS

1 Why are accidents more likely to happen:
 a at times of stress
 b when parents and carers are less alert
 c to children who are under-protected
 d to children who are over-protected?

2 Name five ways that adults can help to reduce the possibility of accidents to their children.

3 a During what stage of life do children need complete protection?
 b When can the amount of supervision be gradually relaxed, and why?

Revision
Exercise
67

FURTHER ACTIVITIES

EXTENSION

1 Collect or draw some labels that are used to indicate that goods or materials meet recognised safety and other standards.

 N2.1

2 Tables 1 and 2 show some statistics for home accidents to children under the age of 5 years. Answer the following questions.
 a Describe in words the figures shown in Table 1 and suggest reasons for them.
 b **(i)** Compare the types of injury of the two age groups shown in Table 2. **(ii)** For the age group 0–8 months, suggest one reason for each type of injury, and suggest an action which might have prevented it. Do the same for the types of injury to the older children.

3 Use a spreadsheet program with a graph-drawing facility to draw two graphs of the data in Table 2. Suggest reasons for the different shapes of the graphs.

IT2.3

TABLE 1 The age groups of the children (under 5 years) who attended hospital because of a home accident

Age group	Number per 1000 children who attended hospital
0–8 months	40
9–12 months	44
1 year	278
2 years	288
3 years	199
4 years	151
	1000

TABLE 2 Types of accident of the children taken to hospital

Type of injury	For every 1000 children 0–8 months	For every 1000 children 9 months–4 years
Cuts	100	373
Bruises	213	115
Dislocation/fractures	48	59
Burns	76	38
Scald	94	52
Poisoning	22	73
Concussion	57	21
Suffocation	5	0
Electric shock	0	2
No injury found	251	103
Others	134	164
	1000	1000

Homes are for people of all ages to use and to live in and it is impossible to make them completely safe for children. Nevertheless, much can be done to prevent accidents:

■ Dangerous objects should be kept away from children.
■ Children should be kept away from dangerous situations.
■ Those items with which the child can have contact should be made as safe as possible.

Similarly, every reasonable precaution must be taken to ensure the safety of children in playgroups, nurseries and schools.

DANGEROUS OBJECTS

The following objects should be kept from children until they are old enough to use them sensibly.

Plastic bags
There is the danger of suffocation if a plastic bag is put over the head. Plastic material is airtight and clings to warm surfaces, therefore a plastic bag over the head will be very difficult to remove.

Small, hard objects
Sweets, peanuts, small pieces from a toy etc. can cause choking if swallowed. Choking is one of the commonest accidents of infancy because babies put everything into their mouths.

Medicines
These can be poisonous and should be locked in a cabinet which needs adult hands to open it. Pills and tablets in child resistant containers are difficult for a child to get at. Blister or strip packs make it less easy for a child to swallow a lot of pills at once. On the other hand, children may find these packs attractive to play with, especially if they see adults using them.

Poisons
Poisonous substances include cleaning materials, alcohol, weedkillers and other garden chemicals, and berries of a number of plants. Empty drink bottles should never be used to store poisonous liquids to avoid them being drunk by accident.

Sharp objects
There are quite a number of these in the average home, for example sharp knives and scissors, razor blades and needles. They should be kept out of reach of young children.

Inflammable items
Matches, lighters, petrol, paraffin, methylated spirits and fireworks should be stored where children cannot reach them.

DANGEROUS SITUATIONS

This section applies particularly to toddlers. At this stage, children are able to move around but are not yet old enough to understand about safety.

Safety barriers or gates prevent young children from wandering to a part of the house the parents or carers consider dangerous. Safety barriers are often fitted across the top and the bottom of the stairs and across the kitchen doorway (the kitchen is the most dangerous room in the house).

A safety barrier should have locks which children cannot undo and bars in which they cannot get their head, hands or feet trapped. It should be too high for a small child to climb over. If a child should climb over a barrier at the top of the stairs, the fall can be more serious than a simple fall down the stairs.

Electricity

Young children should be kept away from electrical equipment and supplies because of the risk of:

Socket cover

- **electric shock** – If electrical equipment is damaged or live wires are touched, it can give rise to a shock. So too can a worn or damaged flex. Modern electricity supply sockets are designed to prevent tiny fingers or small objects from being poked inside, and safety socket covers are also available. Electrical equipment should never be touched when the hands are wet, as this increases the likelihood of an electric shock. Trailing flexes can be dangerous; coiled flexes are safer as they do not trail, and a child's pull is less likely to cause the electrical equipment to become disconnected from the live supply. (See also p. 281.)
- **injury from moving parts** – Items such as electric mixers can cause nasty accidents.
- **fire hazards** – Electric irons are examples of equipment which, if misused, can be the cause of fire.
- **burns** – Electric cookers, heaters, kettles and irons can cause very severe burns or scalds.

Fire

There are two good reasons for keeping children away from fires. There is the danger that:

- they may burn themselves
- some action by them, either accidentally or in play, may cause the furniture and the building to catch fire.

Fireguards should be put in front of open fires. A good fireguard:

- is strong and sturdy and has a cover on top
- has no sharp edges
- is firmly fixed to the wall by hooks which cannot be undone by a small child
- has mesh small enough to prevent a baby pushing his arms or toys through
- has a door (if there is one) that fastens securely.

When a fireguard is in front of a fire, it should never be used as a clothes dryer.

Objects on the mantelpiece tempt children to reach for them. This can be a danger if there is a fire underneath. A mirror over the mantelpiece may also tempt children to go too close to a fire.

MAKING THE HOME SAFE

There are some parts of any home which it is impossible to keep children away from or to keep out of their reach. The only thing to do is to try to make them as safe as possible.

Floors

Children can hurt themselves when they slip. To reduce this danger:

- always wipe up spilt grease or liquid
- it is safer to have a heavy mat than a lightweight one
- if floors have to be polished, use non-slip polish
- never polish under mats.

Windows

To prevent children falling out of windows:

- Young children should not be left alone in a room with an open window through which they could fall, unless there are safety bars.
- Catches need to be securely fastened on all windows that children can reach.
- Keep chairs and tables away from windows to help prevent children from climbing on to the window sills.

Toddlers have accidents with glass – windows and drinking glasses – because young children are unsteady on their feet and fall over easily. Older children are at risk when they play rough games. Ordinary glass is very brittle and breaks with sharp, jagged edges which can cause serious cuts. Therefore, in houses with children, it is safer to have toughened glass (safety glass) in any windows or glass doors which are in danger of being broken. Another way to make glass safer is to cover it with a film of clear plastic specially made for this purpose.

Cookers

Ideally, a cooker should have controls which are difficult for a child to reach and switch on. When the hob is in use, it can be made safer by a cooker guard. Turning the handles of pans inwards makes them more difficult to reach and tip over.

Tablecloths

These can be a danger; for example, the young child in the picture pulling at the tablecloth could be badly scalded by hot tea. Liquids do not need to be very hot to damage the skin of a young child.

cooker guard

QUESTIONS

1 Name objects which should be kept away from children because of the danger of
 a suffocation **c** poisoning
 b choking **d** injury.

2 a Name four possible dangers when children touch electrical equipment.
 b Give two reasons for keeping children away from fire.
 c What safety features will a good type of fireguard have?
 d Name three features which are essential for a good type of safety barrier.

3 a Give four ways of making floors safer.
 b Name three safety precautions which help prevent dangerous situations involving windows.
 c Name two ways of making the glass in windows and doors safer.

4 a Name three ways of making the cooker safer if there are young children in the home
 b When can tablecloths be a danger?
 c Give one advantage and one disadvantage of having pills in a blister pack.

Revision
Exercise
68

FURTHER ACTIVITIES

EXTENSION

1 List the safety points you can remember from previous topics (or look them up), particularly the topics which dealt with clothing, nursery equipment and toys.

2 If a young child came to stay in your home, what would need to be done to make your home safer?

DESIGN

1 Design (see p. 358) a fireguard or safety barrier suitable for use in your own home when a small child is present.

2 Use a graphics program or a desk-top publishing program to design a leaflet or poster to point out to parents particular dangers to a child at home.

 C2.3

Children love to be independent, to explore and to experiment. This makes it difficult to foresee all the dangerous situations which might occur, especially when outside the home. However, there are precautions which parents and carers can take.

PLAYING OUTSIDE

Parents and carers can help to prevent accidents by making sure that:

- children never play on the road
- young children, when playing outside, are supervised by an adult or a responsible older child
- children do not play with gardening or other equipment, e.g. tools, lawn-mowers, chemicals
- children are discouraged from eating plants, as many are poisonous to a greater or lesser degree
- children do not play in gardens where chemicals such as slug pellets, weedkiller, or rat poison have been put down
- dog droppings in the garden are cleared away, and avoided elsewhere, as they can spread worm infections (see also p. 274)
- children do not have dangerous toys such as bows and arrows, air guns and catapults until they are old enough to understand the dangers and behave responsibly

- children do not run around with sticks or other sharp objects in their mouths – if they fall, they may perforate the palate (a hole may be made in the top of the mouth)
- children do not play with fireworks.

Tetanus

When children play, they are likely to graze their skin occasionally. Those children who have been immunised against tetanus will be in less danger from tetanus germs in the soil.

SAFETY NEAR WATER

Special care is needed when children are near or on water because of the risk of accidental drowning. Parents and carers should make sure that:

- paddling pools containing water are not left unguarded – babies have been known to drown in as little as 2.5 cm of water
- garden pools or swimming pools are completely fenced off or emptied when young children are around
- children are taught to swim as soon as they are old enough
- children always wear a life jacket when in a boat or canoe
- inflatable boats and Lilos® used on lakes or at the seaside are secured to the shore by a line to stop them floating away.

SAFETY IN CARS

A number of steps can be taken to help keep children safe in cars. These include:

- shutting doors with care to avoid trapping a child's fingers
- having child safety locks on the doors
- not letting children sit behind the rear seats of an estate car or hatchback
- keeping children under control so as not to distract the driver.

SEAT BELT LAW

- The driver is responsible for seeing that a child in the car wears an appropriate child restraint.
- A child **must not** sit on the lap of an adult travelling in the front of the vehicle.
- Rear-facing child seats should not be used on a front passenger seat if the car is fitted with a passenger airbag.
- All child restraints must conform to either British or European Safety Standards and carry the Kite Mark or the European 'E' mark.

Children under 3 years of age
When travelling in the front of the car, an appropriate restraint must be worn. When travelling in the back of the car an appropriate restraint must be worn if one is available.

Children between 3–11 years old and under 1.5 m in height
In the front of the car, an appropriate child restraint must be worn if available. If not, an adult seat belt must be worn. An appropriate child restraint must also be worn in the back of the car if available. If not, an adult seat belt must be worn if available.

Children aged 12 or 13 or a younger child 1.5 m or more in height
If available, an adult seat belt must be worn in both the front and the back of the car.

handle allows a sleeping baby to be lifted in or out of the car undisturbed

harness is adjustable to allow for growth and thicker clothing

Baby carrier (baby car seat) Child seat Booster seat

CHILD RESTRAINTS

An appropriate child restraint may be a:

- **baby carrier** (baby car seat). This can be used in the front or back seats of most cars. The baby is held in the carrier by a harness, with the carrier being held in place by a seat belt. When fitted to the front seat as shown on the opposite page, the driver and baby can see one another. This type of car seat is available for babies from birth and until they weigh up to 13 kg (about 12–15 months).
- **child seat**. This is suitable for a child weighing between 9–18 kg (about 9 months–6 years). It can be used in the front or back seat of the car and is held in place by a seat belt.
- **booster seat**. This is suitable for children weighing 15–36 kg (about 4–11 years). It raises the child so that the seat belt is in the correct position, and also allows the child to see out of the window.

SEAT BELTS DURING PREGNANCY

Pregnant women, like everyone else, are required by law to wear seat belts. The correct way to wear a seat belt (whether pregnant or not) is for the strap to be flat and tight, going diagonally across the body and then over the thighs (**A**) When the lap belt is worn too high during pregnancy (**B**) there is the danger of injury to the unborn baby in the event of a crash.

Correct way of wearing a seat belt Dangerous way of wearing a seat belt

ROAD SAFETY OFFICER

Each Local Authority has a Road Safety Officer who can be consulted about the use of seat belts, child seats, or any other problems.

QUESTIONS

1 Give ways in which parents can help prevent accidents to children playing outside.

2 What five precautions can be taken against accidental drowning?

3 Name four ways of helping to prevent accidents to children in cars.

4 When travelling by car, describe a type of restraint suitable for a child weighing **(i)** 6 kg, **(ii)** 16 kg, **(iii)** 26 kg.

5 Are there any occasions when a child can travel in a car without using a child restraint or a seat belt? If so, describe them.

6 a Who is responsible for seeing that a child travelling in a car is restrained: the child, the parent, or the driver?

 b Is it legal for a child to sit on the lap of an adult who is travelling in the front seat of a car? Suggest a reason for this rule.

 c When should a rear-facing seat not be used on a front passenger seat?

 d What shows that a child restraint conforms to safety standards?

7 Compare drawings A and B on p.307. **(i)** Apart from the black cross, what is the difference between them? **(ii)** Why is B dangerous?

> **Revision Exercise 69**

FURTHER ACTIVITIES

EXTENSION

1 How would you change the numbered items shown in the garden scene below in order to make it a safe place for children, and why is each action necessary?

2 Look outside your own home and make a list of the hazards for a young child. How would you recommend dealing with each if a young child came to stay?

INVESTIGATION

 a Using information from the Internet, CD-Roms, newspapers, and experiences of family and friends, carry out a survey about accidents which have happened to children aged 7 years and under. This could be a group exercise.

 b Use the information from the survey to create a database file. An example of a record for the file could be:

Time:	Morning
Age of child:	2 years
Place:	Kitchen
Article 1:	Cup
Article 2:	Hot water
Injury:	Scald
Body part:	Arm
Description:	Pulled cup of tea from table, hot tea spilt onto arm

 c Use the database file to find out: **(i)** What types of injury happened in the garden? **(ii)** During what part of the day did most accidents happen? Then make up some more questions.

Accidents on the roads are the most common danger outside the home. In 2002, 23 children under the age of 8 years were killed or seriously injured every week on roads in the UK. Many more were injured to a lesser degree.

HOW PARENTS CAN HELP

Parents and carers can help prevent their children becoming involved in road accidents when they follow these instructions:

- Set a good example by always crossing roads in a careful way.
- Use walking reins or wrist straps for toddlers – never rely on holding a toddler's hand as he can pull free in an instant.
- Do not let young children out on the roads by themselves.
- Insist that a young child holds the hand of an adult when crossing a road.
- Make sure the child can be seen – when out in the dark, children should always wear light-coloured or reflective clothing, or carry a reflective bag.
- Make sure their child knows the Green Cross Code – go through the code every time the road is crossed until the child knows it.

WHY CROSSING THE ROAD IS DIFFICULT FOR YOUNG CHILDREN

Young children cannot cross safely because:

- being small, they cannot see over parked cars etc.
- they do not remember instructions for very long
- they have not yet learnt to be good judges of distance or of the speed at which the vehicles are travelling
- they do not yet understand how traffic behaves
- their minds may be occupied with other matters, e.g. running after a ball.

LEARNING ABOUT ROAD SAFETY

Road safety education needs to begin at an early age. The majority of serious accidents to child pedestrians and cyclists occur on roads where the children live.

The under-5s

From the time that children can walk, they need to be taught that pavements are for people and roads are for traffic. Adults with children set a good example when they cross roads correctly. While doing so, they should talk to the children about stopping at the kerb, and looking and listening for traffic before crossing the road.

5–6 years

The risk of a road accident increases when children start school. They are not yet old enough to be out on the roads by themselves and should be taken to and collected from school. They have reached the stage when they can begin to learn how to cross quiet roads on their own. They will need to be taught and then be frequently reminded of the **Green Cross Code**.

Stand near the kerb but not at the very edge

GREEN CROSS CODE

1. **Find a safe place to cross, then stop.** Safe places include Zebra and Pelican ('green man') crossings or where there is a traffic island or school crossing patrol (lollipop lady or man). If it is necessary to cross near parked cars, stop at the outer edge of the cars and look and listen carefully before continuing across.
2. **Stand on the pavement near the kerb.** Do not stand at the very edge of the pavement; traffic often passes closer than you think.
3. **Look all around for traffic and listen.**
4. **If traffic is coming, let it pass. Look all around again.**
5. **When there is no traffic near, walk straight across the road.** If you are not sure, do not cross. Always walk, do not run.
6. **Keep looking and listening for traffic while you cross.**

Walk straight across the road and keep looking and listening for traffic

7–9 years

Children over the age of 7 should be able to cross quiet roads alone. They should now learn, understand and remember the Green Cross Code. When they have done so, they will be better able to cross busy roads safely.

SAFETY FOR CYCLISTS

Children need both the experience of riding a bicycle and training in road safety before they cycle on roads. It is therefore recommended that a child under 9 years of age should not ride on the road unless supervised by a responsible adult. Children over 9 years of age should be accompanied until they have successfully completed a cycle training course.

When cycling a child should:

- keep both hands on the handlebars except when signalling
- keep both feet on the pedals
- ride in single file on cycle tracks and lanes, and when in traffic
- not carry anything which may affect balance or get tangled up with the wheels or chain
- not carry a passenger unless the cycle has been adapted to carry one
- use front and back lights and a red reflector at nights and in poor visibility
- use a bell when necessary as a warning.

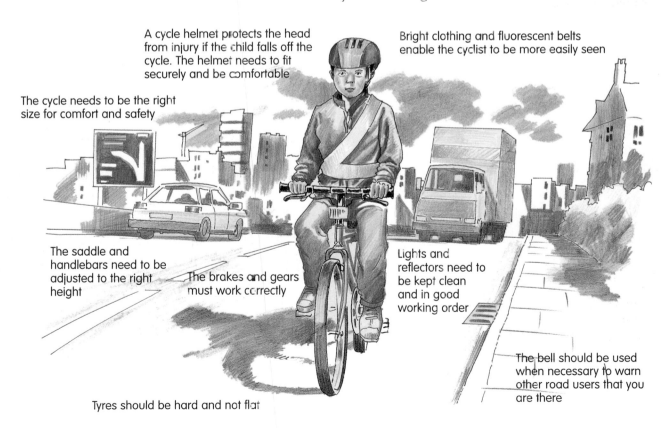

A cycle helmet protects the head from injury if the child falls off the cycle. The helmet needs to fit securely and be comfortable

Bright clothing and fluorescent belts enable the cyclist to be more easily seen

The cycle needs to be the right size for comfort and safety

The saddle and handlebars need to be adjusted to the right height

The brakes and gears must work correctly

Lights and reflectors need to be kept clean and in good working order

The bell should be used when necessary to warn other road users that you are there

Tyres should be hard and not flat

QUESTIONS

1 Calculate how many children under the age of 8 years were killed or seriously injured on the roads of the UK in 2002.

2 Name six ways that parents can help to prevent their children from being involved in road accidents.

3 Give five reasons why it is difficult for young children to cross roads safely.

4 Describe how a child under 5 can learn about road safety.

5 Read through the six rules of the Green Cross Code. Then close the book and see if you can write out the main points from memory, in the correct order.

6 a Before the boy on the bicycle on p. 311 cycles on the road, what advice should he be given?

 b Give two items of clothing he can wear for safety.

 c Name three conditions of his bicycle which should be checked.

FURTHER ACTIVITIES

EXTENSION

a Study the picture below showing Sally and her father waiting to cross the road. **(i)** What can Sally see? **(ii)** What can her father see? **(iii)** Suggest possible reasons for the flashing indicator on the car. **(iv)** Are Sally and her father standing in a good position for crossing the road? Explain your answer.

b Sally's father is making crossing the road into a game by letting Sally tell him when it is safe or unsafe to cross. Imagine a conversation between them.

INVESTIGATION

What can be done to prevent accidents? Carry out a media search (see pp. 357–358) in one particular area, for example, baby safety, design of nursery equipment, child safety in the kitchen, safety at playgroup, cycling safety, safety on local roads, water safety. Information can be obtained from RoSPA (see p. 343) and from safety officers of your local council. You could then make a display of good safety advice.

DESIGN

Use a camcorder to make a short film about crossing the road safely which could be shown to young children.

CHILD STUDY

If the child is old enough to talk to you, find out what he or she knows about road safety.

WEBSITE ANALYSIS

Visit the Road Safety Website www.hedgehogs.gov.uk. Print out the Home Page or list all the facilities that the website offers. Investigate the website then give your opinion, with reasons, on its usefulness in helping to teach children about road safety.

Revision Exercise 70

EXERCISES

C2.2 Exercises relevant to Section 7 can be found on p. 351.

THE FAMILY IN THE COMMUNITY

People who look after children have an influence on the way they develop. It is therefore important for parents to choose with care the people they ask to care for their children.

Different types of care are available run by local authorities (councils), voluntary organisations, private companies or individuals. Children may be cared for full-time or part-time and, generally, parents pay for the services they use.

Why child care is needed

Families use child care services for a variety of reasons, such as:

- the parents are working or studying
- one parent is ill and the other is working
- they are one-parent families and the parent goes out to work
- the parents need a break from the demands of child care
- the children benefit from more contact with other children and adults
- children need to be cared for out-of-school and during school holidays.

TYPES OF CARE

Parents may use one or more of the following for the care of their children:

- relatives
- childminders*
- nannies/mothers' helps
- day nurseries*
- playgroups*

- crèches*
- out-of-school care schemes*
- holiday care schemes*
- respite care schemes*
- baby-sitters.

RELATIVES

A child who is looked after by a relative will usually be in the care of a person the child knows well. As a result, there are less likely to be problems of getting used to strangers and to different surroundings and ways of doing things.

Nowadays, grandparents or other relatives are often not able to help. They may be very busy people with jobs, or may live too far away. So the parents have to find someone else to look after their child.

CHILDMINDERS

A **childminder** is a person who cares for children 0–8 years and who is not a close relative. They care for children:

- in the childminder's own home
- for more than two hours a day
- and receive some reward.

*Must be registered and regularly inspected by OFSTED (Office for Standards in Education).

Close relatives are grandparents, aunts and uncles, brothers and sisters. If a friend acts as a childminder without registering, the friend will be breaking the law.

How many children?

Childminders may be registered for a maximum of six children under the age of 8 years, of whom:

- not more than three children may be under the age of 5 years and
- not more than two children under the age of 2 years.

The childminder may care for additional children over the age of 8 years but the total number must not exceed 8 children under 14 years of age. In all cases the childminder's own children must be included in these numbers.

Choosing a childminder

Parents should:

- consider whether the childminder needs to live near their home or work, or on their way to work.
- go to see several childminders before selecting one
- always choose registered childminders.

Registration

Childminders are required by law to be registered with their Local Authority and OFSTED (Office for Standards in Education). They will be inspected at least once every 24 months to ensure that acceptable standards of childminding are being maintained. Many childminders also belong to the National Childminding Association (see p. 341).

A registered childminder will have a document to show that OFSTED considers her (or him) to be a suitable person to look after children. As well as registering and inspecting childminders, OFSTED is also responsible for investigating any complaints made.

The childminder is expected to:
- like children and give them the love and care that all young children need
- be healthy
- have a clean home
- have a safe, warm place for children to play
- have adequate toilet and kitchen facilities for the children
- take them outside regularly, or have a garden in which they can play.

People who enjoy childminding find that it gives them:
- the pleasure and interest of working with children
- the satisfaction of doing important work
- the chance to meet other families
- the opportunity to earn some money.

When a child is unwell

Before sending a child who is unwell to a childminder, the parents need to take into account the nature of the illness, how serious it is, whether it is infectious, and how much attention the child needs. Children who are ill may well need to stay at home.

NANNIES/MOTHERS' HELPS

These are employed by parents to care for children, usually in the children's own homes. Nannies and mothers' helps may or may not have relevant child care qualifications.

DAY NURSERIES

Nurseries provide all-day care for children under 5 whose parents work or who are otherwise unable to care for the children themselves. Children attend on a regular basis, either full-time or part-time.

CRÈCHES

A crèche is a place where children are cared for while their parents are occupied. It may provide all-day or part-day care. Large factories, hospitals, colleges and offices sometimes run a crèche for the children of their employees. A crèche can also be a place where parents can leave their children while they are temporarily away, for example shopping or attending a meeting or religious service.

OTHER CARE SCHEMES

Out-of-school care schemes These offer care to school-age children from the end of the school day until their parents can collect them. They might also offer care before school starts.

Holiday care schemes These offer full-day care to school-age children during the school holidays, and may include playwork schemes.

Respite care schemes Day and overnight care is provided for families with children with special needs, particularly those with severe learning difficulties. This allows the parents a break (respite) from the demands of care.

BABY-SITTERS

Baby-sitters are people who look after children in the children's own homes while the parents are out. Although called 'baby-sitters', they may be required to look after children of any age. The parents are usually only happy to leave their child or children when they feel that the baby-sitter can cope with any situation which may arise. A sitter for a young baby needs to be able to comfort a crying child, change a nappy and give a bottle. However, for an older child, it is better if the sitter is someone the child knows and likes, who understands the behaviour of the child's age-group, and is agile enough to cope.

Baby-sitters provide a useful service. They allow parents to have a break from their children for a short while. This helps to remind them that they are partners as well as parents. They are able to do things together and to go to places where children would not be welcome. Having a break from their children now and then often helps parents to enjoy their children all the more. The children can also benefit from meeting new people, especially when they enjoy the baby-sitter's company.

Instructions for the baby-sitter

It helps baby-sitters to look after children if they are given information which includes:
- the child's usual routine
- the words the child uses when asking for a drink, or a special toy, or to go to the toilet
- where to find the first-aid kit
- what to do in an emergency – how to contact the parents, the neighbours, and the telephone number of the doctor
- where to find refreshments such as milk, fruit juice, biscuits
- how to use the television etc
- the approximate time the parents are expected back.

Most baby-sitting is done in the evenings, so the baby-sitter will need to know the **bedtime routine**:
- the time for bed
- whether a light is to be left on or off
- whether the bedroom door is to be left open or shut
- the need for a favourite cuddly toy, a drink, a biscuit, cleaning the teeth, and perhaps a bedtime story.

During the daytime, the baby-sitter needs to know about meals, the rules about watching television, where the children are and are not allowed to play, bathtime, and so on.

QUESTIONS

1 a Give some reasons why families use day-care services.

b Ten types of day care are mentioned on p. 314. Place them in two groups, those which are, in most cases, required to be registered with OFSTED and those which are not.

2 a (i) What is the meaning of the term 'childminder'?

(ii) How many children is a childminder permitted to look after?

b What points should parents consider when choosing a childminder?

c What is expected of a suitable childminder?

d What do parents need to consider before sending a child who is unwell to a childminder?

3 a For which children are day nurseries intended?

b Who may run a crèche?

4 Describe a type of care scheme which operates **(i)** after school, **(ii)** during school holidays, **(iii)** for children with special needs.

5 a What is the meaning of the term 'baby-sitter'?

b Give three requirements for a baby-sitter for **(i)** a young baby, **(ii)** an older child.

c In what ways may the parents benefit from leaving their children in the care of a baby-sitter?

6 a What useful information can be given to a baby-sitter?

b When the baby-sitting is done in the evenings, what may the baby-sitter need to know about the bedtime routine?

Revision Exercise **71**

FURTHER ACTIVITIES

EXTENSION

1 A mother is looking for a childminder for her 3-year-old daughter Jane. Below is a list of questions the mother will ask herself.

C2.3

- Is the childminder a warm, welcoming person?
- Does she have a stable routine so that Jane will quickly get used to new surroundings?
- Will she give Jane nourishing food?
- Will the discipline be firm but kind?
- Are there toys to play with?
- Is the place clean?
- Are the home and garden safe for young children?
- Is the childminder registered?

In your opinion how many of the answers to these questions need to be 'Yes' for the mother to be able to leave Jane with confidence? Give your reasons in each case. Add to the list some more questions that Jane's mother could ask.

2 Describe any baby-sitting that you have done. Say why you were needed to baby-sit. What information were you given? What problems did you have and how did you deal with them? Give a short talk on your baby-sitting experiences.

C2.1b

DISCUSSION

C2.1a It is said that children of working mothers do not suffer provided that the child has a stable, continuous and happy relationship with the person who cares for the child during the mother's absence. In what ways do you think that (i) the child can benefit, (ii) the mother can benefit?

INVESTIGATION

Visit a day nursery, crèche, or day-care scheme to watch how new children settle in. What difficulties do they have? How are they helped to overcome these difficulties?

72 LOCAL AUTHORITY CARE, FOSTERING AND ADOPTION

In certain circumstances children do not live with their natural parents but are looked after by other members of their family, foster carers, adoptive parents, or in special children's homes.

CHILDREN LOOKED AFTER (ACCOMMODATED) BY THE LOCAL AUTHORITY

Under the *Children Act 1989* the main duty of the authority (through the Social Services department) is to keep families together. If it is not possible to keep the children with their parents, the possibility of the children being cared for by relatives will be explored. If this is also not possible, the local authority will make arrangements for the children to be accommodated in foster homes or special children's homes. Any arrangements which are made will take into account the wishes of the child (when possible) and the parents. Responsibility for the child will be shared between the parents and the local authority.

The local authority is given the right to look after children in one of two ways:

- by **voluntary agreement with the parents** – The child is placed in accommodation as part of a plan which all interested parties agree is in the best interests of the child.
- by a **court order** (statutory care) – A court compels the parents to hand over their child to be looked after by the local authority.

Why children are looked after

There are a number of reasons why children may be looked after by the local authority. These include:

- the parents are unable to look after their children because of illness, family problems or difficulties with housing
- the children have been neglected or ill-treated and are likely to suffer serious harm if they continue to live at home.

The length of time that children are looked after by the local authority depends on the reason for them being separated from their families.

FOSTERING

Fostering is an arrangement for children to live in other people's homes. It is usually on the understanding that the children will return to their own homes to live as soon as possible. The foster carers are paid an allowance for food, clothing and general care, but they do not have any legal parental responsibility for the children.

Children stay with foster carers for varying amounts of time. It may be only for a few weeks while the mother is in hospital, or it may be for many months or even years. In some cases it may be considered appropriate for children to remain in their foster homes until they are grown up. When the children are with foster carers for a long time they can become very attached to the family.

It may then be hard for them to part when the time comes for the children to return to their own homes.

The Children Act requires Local Authorities to be mindful of children's needs in respect of race, religion and culture when placing them in foster care or for adoption.

ADOPTION

Adoption is a legal process by which adults become parents of children not born to them. In all cases, adoption must be because it is in the best interests of the child, not the adults involved. The adoptive parents gain parental responsibility for the child, whom they are expected to support completely, although, in special cases, financial support is available through an Adoption Allowance. The natural parents relinquish all parental responsibility.

It is becoming more common for adopted children to continue to have some contact with their natural parents and siblings even after they are adopted. Adoption agencies may act as a 'post box' so that letter-contact between adoptive and birth families can be facilitated but, at the same time, remain confidential.

Children offered for adoption

Few newborn babies are available for adoption these days, the reasons being:

- wider use of contraception and of termination of pregnancy mean that fewer unplanned babies are born
- changes in attitudes and increased help from the state have made it easier for single parents to bring up children on their own.

Most children available for adoption are the result of a Care Order. Children in these circumstances are from a few months old up to about 12 years. They may be placed for adoption on their own, or with their brothers or sisters. Some children have significant physical or learning difficulties. Many carry emotional scars from the abuse and neglect they suffered at home, or from the experience of having had many different carers. The effect of these experiences may be long-lasting and some children will not be easy to bring up. For this reason, many adoption agencies have Post Adoption Services that can help, advise and support adoptive families.

Why adults adopt

People may wish to adopt because:

- they are unable to have children of their own
- they have children of their own but wish to enlarge their family and to help a child needing adoption
- they are the grandparents or other relatives of a child whose parents are unable to bring them up because of death or other reasons
- the mother marries a new husband and they jointly adopt her child so that all the family share the same surname
- they are foster carers who apply to adopt a child they are fostering.

Adoption agencies

People who wish to adopt usually do so through an adoption agency. There are a number of different agencies, and they each operate slightly differently and with their own priorities. It is possible that if one agency is unable to help, another might. Most agencies are part of the local authority's Social Services department but some are run by voluntary organisations.

How adoption takes place

People who adopt must be over 21 years of age. They must also be able to show that they can give the children all the help, encouragement and practical support they will need throughout childhood and into adult life. Adoption orders are granted jointly to married couples. A single person may also adopt. If a couple are not married to each other, only one partner can become the adoptive parent. People who apply to adopt are interviewed by the adoption agency:

- to make sure that they are healthy, happy, have a stable relationship, and can manage financially
- to ensure that they really *want* to adopt a child and have the personal resources and support to do so successfully.

An application to adopt has to be considered and recommended by the agency's Adoption Panel, as does the match between the adopting parents and a child.

When a suitable child becomes available, he or she lives with the adoptive parents for a probationary (trial) period of at least 13 weeks. A social worker from the adoption agency visits the home from time to time to make sure the arrangement is working well. The probationary period cannot start until the child is 6 weeks old. This is to give the natural mother time to be sure of her decision to part with her child.

During the probationary period, the prospective adopters do not have legal parental responsibility (see p. 338), and the natural parents can claim the child back.

If the probationary period has been satisfactory, the adoption can then be made legal. This is done either in a magistrates court, a county court or in the High Court. From that moment, the adoptive parents have parental responsibility for the child. The natural parents no longer have any claim to the child.

Adopted children are entitled, if they wish, to see their full birth certificates when they reach the age of 18 years (or 17 years in Scotland). They may seek to make contact with their natural parents, but this is not always possible; for example the natural parents may refuse to have any contact, or their whereabouts may be unknown or they may have died.

Information about adoption
This can be obtained from the local Social Services department, or from British Agencies for Adoption and Fostering (p. 340), or from any of the adoption agencies.

QUESTIONS

1 a If it is not possible to keep families together, who may take care of the children?

b Give the difference between a voluntary agreement with the parents and a court order.

c Why may children need to be looked after by the local authority?

2 a What is the difference between fostering and adoption?

b Which is a temporary arrangement?

c Which involves legal rights over the child?

d Which provides payment for the child's care?

3 a Give five reasons why people may wish to adopt a child.

b Can a single person adopt?

c How old must people be in order to adopt?

d Give two reasons why there are fewer babies for adoption these days.

4 a Why are people who wish to adopt interviewed first?

b What happens during the probationary period?

c What happens when the probationary period has been satisfactory?

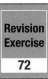

Revision Exercise 72

FURTHER ACTIVITIES

DISCUSSION
Discuss the 'tug-of-love' case below from the point of view of
a the child
b the foster parents **C2.1a**
c the natural parent.

Tearful Debbie aged 7 clung to her foster parents Joan and Geoff Taylor before being taken by car from the house in Balesham Road which has been her home for the last four years. 'We are heartbroken – it's so cruel,' said Geoff, 'especially as we were hoping to adopt her soon, and this came out of the blue a month ago.'

Debbie was taken to her new home with her mother Sue Neil who had to give up Debbie when she lost her job and became ill. 'It was a very sad time, but all that's in the past,' she said. 'I'm now in a steady job and have a nice flat. Having Debbie back completes my happiness, and I think I can be a mum she will be proud of.'

The social worker dealing with Debbie's case said, 'We are confident Sue Neil can give her a good home and upbringing. It is her legal right to have Debbie back.'

Yesterday evening Mr and Mrs Taylor contemplated life without Debbie: 'She was such a joyful child, we can only hope she doesn't lose that. We're keeping her room just as she left it.'

73 CHILDREN WITH SPECIAL NEEDS

Children with special needs are those who suffer from disabilities which handicap their development by interfering with growth or the normal functioning of the body or the ability to learn. Disabilities can be the result of accidents or infections, or they can be congenital.

CONGENITAL ABNORMALITIES

A **congenital abnormality** is a disability which is present at birth. In some cases the disability is obvious from the moment the child is born, for example Down's syndrome or spina bifida. In other cases such as deafness or mild cases of cerebral palsy, the abnormality becomes apparent only when the child fails to develop in the normal way. Congenital abnormalities can be due to:

- **abnormal genes or chromosomes** which the child inherits from the parents or which occur in the fetus for the first time. Examples include Down's syndrome, haemophilia and muscular dystrophy.
- **abnormal development** in the uterus. Examples include 'hole in the heart', cleft palate and cleft lip, damage caused by the rubella virus, or by the effects of drugs, smoking or alcohol taken by the mother.
- **brain damage** during development in the uterus or during birth. This may be caused by insufficient oxygen (**anoxia**) or a number of other reasons. The disability which results depends on the part of the brain which is damaged. For example, if the part controlling movement is damaged the result is cerebral palsy (spasticity). If the part controlling intelligence is damaged, this results in learning difficulties.

DEVELOPMENTAL DELAY

Disabilities can delay development. For example, children who lack mobility will not be able to explore their environment to the same extent as they would if they could move around freely. Those who cannot communicate easily will fail to receive and understand the necessary information for their mental development.

A child with special needs may have one particular disability which handicaps development, e.g. deafness. More often, there is a combination of conditions which include physical disabilities and learning difficulties.

PHYSICAL DISABILITIES

A physical disability affects the body. Normal growth and development are prevented and the result is a physical disability, for example:

- cerebral palsy (p. 326)
- muscular dystrophy (p. 325)
- spina bifida (p. 325)
- cleft palate and cleft lip (p. 325)
- 'hole in the heart'

- congenital deformities involving the limbs such as a dislocated hip (p. 63) and club foot
- communication difficulties due to deafness
- damage to the body caused by accidents
- dyspraxia – clumsiness due to imperfect co-ordination of muscle movements by the brain.

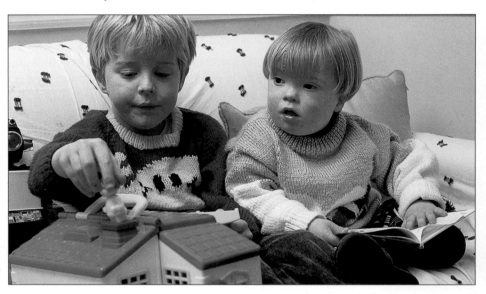

Thomas* and his friend Jack* (who has Down's syndrome) enjoy playing together

LEARNING DISABILITIES

Children with learning difficulties are those whose brain fails to develop normally or is damaged by accident or infection. The condition results in a level of intelligence which is lower than average, and the child has difficulties in learning. The disability can be mild, moderate, severe or profound and may be due to:

- Down's syndrome (p. 325)
- brain damage in the uterus by rubella or other viruses (p. 40)
- brain damage during birth
- brain damage caused by a blow to the head
- infection in childhood, e.g. meningitis (p. 268).

Intelligence Quotient (IQ)

One way of measuring people's intelligence is by their IQ. This is worked out from the results of intelligence tests. The average IQ is 100. People with an IQ of less than 70 will have learning difficulties.

Training

Much can be done to help people with learning difficulties by proper care and training. The training is aimed at developing as much independence as possible. Those with a mild or moderate disability can learn to lead independent lives. The more severely affected will always need to be cared for to some degree by the community.

*The names of these children have been changed.

SENSORY DISABILITIES

A sensory disability affects the sense organs, principally the eyes and ears. For example:

- visual impairment (see p. 140)
- hearing impairment (see p. 142).

LESSENING A DISABILITY

Most babies are born perfectly healthy and with no serious problems, but disabilities do occasionally occur. It is important to know about them because it may be possible to:

- **prevent them** – e.g. rubella damage, Rhesus damage (p. 48)
- **have surgery to repair them** – e.g. 'hole in the heart', cleft palate and cleft lip (at birth the top of the mouth and lips are not joined together in mid-line)
- **have treatment to improve the condition** – e.g. some cases of spina bifida
- **control the condition** – e.g. epilepsy
- **lessen the effects of the disability by early intervention** – e.g. Down's syndrome, cerebral palsy
- **prevent the development of a secondary disability** – e.g. early treatment of children with hearing loss will make it possible for them to speak.

CHILDREN WITH DISABILITIES

Down's syndrome Jack has Down's syndrome. He is very small for his age and, although he is growing slowly, he will not reach full adult size. His intelligence is limited and learning is a slow process. Jack is much loved by his family. The care and training they give him means that he will learn to do far more than if he was in a family where they had no time or love for him.

Spina bifida Chloe is now almost 4 years old and was born with spina bifida. Her backbone did not develop properly, so part of the spinal cord was left unprotected and became damaged. This means that Chloe can walk only with the aid of crutches.

Muscular dystrophy Michael Gibson has Duchenne muscular dystrophy – a severe type that only affects boys, although girls can be carriers of the faulty gene that causes the disease.

Autism Michael Hines is autistic. People with this condition see the world in their own way, and enjoy being absorbed in activities that capture their imagination. This may make them withdrawn with difficulties in communication and social relationships. **Asperger's syndrome** is a less severe form of autism. There is often a limited ability to communicate orally, a lack of common sense, and the persistence in following a particular routine (**obsessive behaviour**). Although people with this condition are usually aware of their disability, they often find it very difficult to make friends.

*The names of these children have been changed.

Chloe*

Michael Gibson

Michael Hines

Joanne

Cerebral palsy Joanne has cerebral palsy. This condition is a result of damage at birth to the part of the brain which controls muscle co-ordination. The problems which it causes depend on the extent of the damage. They range from very mild stiffness (spasticity) of one arm and leg to severe movement problems in all four limbs together with learning difficulties, vision and hearing difficulties.

EFFECTS ON THE FAMILY

Most children with special needs are cared for at home by their families. Generally, this is the best place for them as they have the same need for a happy family life as other children. They need to be treated in the same way – that is, cuddled, smiled at, talked to, played with, taken for outings, given opportunities to meet people, and so on.

When there is a child in the family with a disability it can mean a great deal of extra work and expense for the parents, especially if the child is unable to eat without help, unable to be toilet-trained, or unable to move around unaided, or requires special equipment. Other children in the family will be less likely to feel neglected if they themselves are involved in helping to care for the special needs of their brother or sister.

SUPPORT FOR FAMILIES

Families with a child with disabilities may need outside help including:

- practical advice for day-to-day care
- advice on helping the child from babyhood onwards to lead as full a life as possible
- advice on education
- contact with other families with similar problems – to find out how they overcome difficulties
- financial support for special equipment and other necessary expenses
- help with the ordinary domestic jobs
- child-minding help so that the parents can have a break
- transport for outings
- help with holidays
- respite care.

The help can come from relations, friends, neighbours, health visitors, the family doctor, social workers, schools and teachers. There are also a large number of voluntary organisations which help both the disabled and their families. A list of some of them is given on pp. 340–343.

Special educational needs (SEN) means a child has learning, physical, sensory or speech difficulties that make it harder for that child to learn than most children of the same age.

CHILDREN WITH SPECIAL EDUCATIONAL NEEDS

These children have specific learning difficulties that are significantly greater than those of their **peers** (other children in the same age group). The 1996 *Education Act* states that children with special educational needs should be educated within mainstream schools wherever possible. This allows all children to have contact with each other, and for those with disabilities to be accepted as part of the community.

Each child has to be assessed and a Statement of Special Education Needs is produced. This indicates whether a child's needs can be met in a mainstream school, or in a special unit or a special school.

Special schools These are for those children who require more individual care than is available in a mainstream school, or who require specialised teaching. Special schools differ from mainstream schools in that they have:

- **teachers specially trained** to teach children with disabilities
- **assistants specially trained** to care for children with disabilities
- **a higher ratio of teachers to children** so that the children can have more individual attention
- **physiotherapists** to help children with physical disabilities to make as full a use of their muscles as possible – this helps mobility and increases independence
- **occupational therapists** to help with training in the skills for daily living activities – dressing, feeding, personal care and hygiene
- **speech and language therapists** to help those with speech and hearing difficulties
- **suitable buildings** – corridors and doorways wide enough for wheelchairs, no stairs, specially designed chairs, lavatories, washing facilities and so on.

QUESTIONS

1 Who are children with special needs?

2 a A disability which is present at birth is called a – – – abnormality.
 b Give three ways in which such disabilities can arise, and name one example of each.

3 a Give two examples of the ways in which disabilities can delay development.
 b Can a child with special needs have one or more than one disability?
 c **(i)** Describe the difference between physical disabilities and learning difficulties. **(ii)** From the list of physical disabilities on pp. 323–324 choose at least five and say which parts of the body they affect. **(iii)** What is the aim of training those with learning difficulties? **(iv)** Name two sensory disabilities.

4 Name three types of disability which can be **(i)** prevented, **(ii)** treated, **(iii)** lessened by early training.

5 Describe the types of help which families with a child with disabilities often need.

6 In what ways will a special school differ from a mainstream school?

FURTHER ACTIVITIES

EXTENSION

1 For each of the five children with disabilities in the photographs on pp. 324–326:
 a Describe the disability.
 b Is the disability a physical disability or a learning disability or both?
 c Do you think the child will benefit more from attendance at an ordinary school or a special school? Give your reasons.

2 a Use a telephone directory and other sources of information to find out which of the voluntary organisations listed on pp. 340–343 have a branch in your district. If not, find the nearest branch.

C2.2 Say what each organisation does.
 b Add any other voluntary organisations that you know of to your list.
 c Which of the voluntary organisations you have listed aim in particular to help people with disabilities?

INVESTIGATION

Where are the special schools in your district? Find out as much as you can about one of them. Comment on the ways in which the special school differs from a mainstream school which you know.

A great deal of help is available to parents in the form of advice, assistance and money from many different sources. Therefore, parents may have difficulty in knowing where to go and whom to ask. In addition, government departments, policies and the rules by which they work tend to change quite frequently. Current rules and regulations can be found on government websites, such as the Inland Revenue and the Department for Work and Pensions.

SOURCES OF HELP AND SUPPORT

1. **Social Security benefits** – government-funded financial help, administered by the Inland Revenue.
2. **National Health Service (NHS)** – health care, administered and funded by the Department of Health.
3. **Social Services** – advice and assistance, but not money (except in rare cases), administered by local authorities (councils).
4. **Voluntary organisations**, which work independently of the government and local authorities, but often co-operate with them. Some of these organisations are listed on pp. 340–343.

SOCIAL SECURITY BENEFITS FOR FAMILIES

Child Benefit
This is a cash payment for people bringing up children. It is paid for each child under 16, or under 19 if still in full-time education. It is also paid for those aged 16–17 if they have left school and have registered for work or training. The benefit is paid to the person with whom the child lives (it does not have to be the parent), usually every four weeks.

Guardian's Allowance
If one or both of the parents have died, the person bringing up their child and receiving Child Benefit for that child may also be able to get Guardian's Allowance.

Income Support
This benefit is given to those aged 16 and over who are on a low income and are either unemployed or working less than 16 hours per week on average, e.g. lone parents and those caring for a child with disabilities.

Disability Living Allowance
This is a benefit for disabled people. Until a disabled child reaches the age of 16 it is paid to the parent or guardian.

MATERNITY BENEFITS

Statutory Maternity Pay (SMP) Pregnant women who have worked for the same employer continuously for six months up to and including the 15th week before the baby is due can claim SMP, even if they are not intending to return to their job after the baby is born. To qualify they must earn enough to pay National Insurance (NI) contributions. SMP is paid for a maximum of 26 weeks, starting at any time from the 11th week before the baby is due right up to the baby's birth. The employer must be informed at least 4 weeks before the mother plans to stop work.

Statutory Paternity Pay (SPP) and Paternity Leave (SPL) may be available to employees who take time off work to support a new mother and baby, for example the biological father, a partner or husband who is not the biological father, or a female partner in a same-sex couple.

Maternity Allowance (MA) Working pregnant women may be able to claim this allowance if they do not qualify for SMP.

Sure Start Maternity Grant If the mother or her partner are on a low income they may be able to claim this grant to help with the costs of things for the new baby.

OTHER TYPES OF BENEFIT

Housing Benefit and Council Tax Benefit These are paid by local councils to people on low incomes who need help to pay their rent and council tax.

Help with NHS costs Free dental treatment and doctors' prescriptions are available to women who are pregnant or whose babies are less than 1 year old. Children under 16, and those under 19 who are still in full-time education, are entitled to free dental treatment, prescriptions, eyesight tests, and vouchers towards the cost of glasses (spectacles) or contact lenses. Families on low incomes may also be entitled to some help.

Jobseeker's Allowance (JSA) This benefit is for unemployed people over the age of 16 who are looking for a job.

Free milk Free milk is available to:
- pregnant women, if the family is receiving Income Support or Jobseeker's Allowance
- children under five, if the family is receiving Income Support or Jobseeker's Allowance
- children with disabilities who are unable to go to school.

Free vitamins If the family is receiving Income Support or Jobseeker's Allowance, these are available to:
- pregnant women
- children under five
- mothers breast-feeding a child under 1 year old.

NATIONAL HEALTH SERVICE (NHS)

The NHS is a government-funded service which aims to help people keep well and to care for them when they are ill. The NHS provides a number of services specially for parents and children, for example:

- antenatal clinics (p. 48)
- preparation classes (p. 52)
- midwives (p. 55)
- maternity hospitals or wards
- Child Health Clinics (p. 65)
- Family Planning Clinics (p. 24)
- genetic counselling (p. 121)
- school health service.

School health service

Children may be given a medical examination during their first year at school. Parents are asked to be present when this takes place. A doctor or nurse tests eyesight, hearing and speech. Checks are also made on general health and development – height, weight, posture and co-ordination of movements when walking, using the hands etc.

Any child who is found to have a particular problem which affects health or learning can expect to be checked regularly and, if necessary, referred to a specialist for treatment.

SOCIAL SERVICES

Every local authority has a Social Services department which provides a range of services for children and families both directly, or with voluntary organisations or private individuals. For example, they:

- advise on the various types of child care
- provide information about out-of-school care
- provide fostering and adoption services
- supervise children in care
- deal with child safety and protection
- provide services for children with disabilities.

SURE START

Sure Start is a government programme that aims to achieve better outcomes for children, parents and communities. Under this scheme, multi-purpose **Children's Centres** are being set up to integrate services for the under-fives and their parents, for example health services, child-minding networks, early education integrated with childcare, and family support.

QUESTIONS

1 a Name four sources of help for parents.
 b What is the main difference between the help given by the Social Services and by Social Security?
 c Which two sources of help are the responsibility of government departments?
 d Who is responsible for the Social Services?
 e How are the voluntary organisations financed? See p. 340.
 f For each of these six sets of initials: CGF, CPAG, NSPCC, RoSPA, RNIB, SCF, give **(i)** the full name of the organisation, **(ii)** a purpose of the organisation, **(iii)** a drawing or description of the organisation's logo. See pp. 340–343.

2 a Who can claim the following benefits? **(i)** Child Benefit, **(ii)** Income Support, **(iii)** Guardian's Allowance, **(iv)** Working Families Tax Credit **(v)** Disability Living Allowance, **(vi)** Housing Benefit, **(vii)** free dental treatment (two answers), **(viii)** free doctors' prescriptions (two answers), **(ix)** vouchers for glasses, **(x)** milk tokens, **(xi)** vitamin tablets, **(xii)** vitamin drops.
 b Give the meaning of **(i)** SMP, **(ii)** NI, **(iii)** NHS, **(iv)** JSA.
 c Which of the maternity benefits could be claimed by a woman who had paid NI contributions but had changed jobs within the last six months?
 d **(i)** Who is entitled to SMP? **(ii)** For how long is it paid?
 e Who is entitled to **(i)** MA, **(ii)** Sure Start Maternity Grant?

3 a List eight services which the NHS provides specially for parents and children.
 b What happens during a school medical examination?

4 List six ways in which Social Services can help children and families.

5 What is (i) Sure Start, (ii) a Children's Centre?

Revision Exercise
74

FURTHER ACTIVITIES

EXTENSION

1 The names of some of the different places where parents may go for advice are shown in the drawings in this chapter. For each of these places, suggest at least two types of advice that parents might receive.

2 Read the extract below from a report of one case dealt with by the NSPCC.
 a What does NSPCC stand for?
 b Suggest reasons why (i) Mary was dejected, (ii) her children demanded constant attention.
 c What advice might the inspector have given Mary and Joey about applying for help from (i) Social Security benefits, (ii) Social Services, (iii) National Health Service?
 d Can you suggest any other voluntary organisations (see pp. 340–343) which might be able to help this family?

When the local inspector first called on Mary, he met a dejected young woman, seven months pregnant and who could not have weighed more than 6 stone.

Her three young children (aged 4, 3 and 2) by a much older man, demanded constant attention – something Mary just could not give them.

Help was desperately needed – for Mary's sake as well as the children's. The father of her next child, a man named Joey, was serving a six month jail sentence. Meantime, Mary had just moved into a house for which she was paying an exorbitant rent even though it was very damp and in poor repair. She had no friends or relations nearby and lived in constant fear of eviction.

Though the odds were very much against the family staying together once they were reunited, their trust in the inspector in helping them build up a home and plan for the future was such that after two years all is well. Joey has not returned to prison, and the children are all fit and happy. Mary has put on some weight and smiles once more.

WEBSITE SEARCH

Use the website www.surestart.gov.uk to search for Sure Start activities in your area. Print out the programme and highlight the different activities available for parents and children locally.

Although most children grow up in happy, loving homes, a few children are abused – harmed – by their parents or other adults. Child abuse may happen in any kind of home and any type of family, but the abusers are often young and inexperienced parents, or step-parents, or adults who were themselves abused as children, or those under the influence of alcohol or drugs.

TYPES OF CHILD ABUSE

There are various types of child abuse:

- physical abuse
- sexual abuse
- emotional abuse
- neglect.

The degree of abuse ranges from mild to severe, and an abused child usually suffers from more than one of the types listed above. For example, a child may suffer from harsh physical punishment (physical abuse) accompanied by neglect or indifference (a form of emotional abuse). Sexual abuse will undoubtedly involve emotional abuse.

PHYSICAL ABUSE

Physical abuse is also called **non-accidental injury (NAI)**. It may take the form of bruising, burns, bites, abrasions (grazes), or damage to the mouth region. It may also include broken bones or internal injuries caused by severe shaking.

Physical abuse occurs most often to children who cannot defend themselves – mainly babies and pre-school children, and also to older children with disabilities. Babies may be abused because they cry continually. The adult, unable to stand the noise any longer, loses self-control and shakes, beats or burns the baby. Toddlers may be attacked because they have been 'naughty' and are being 'taught a lesson'. For example, the adult suddenly loses control, lashes out and beats the child because she has wet her pants or got her clothes dirty.

Signs of physical abuse
- Delay by the parents in seeking medical help when it is clearly needed.
- Injuries to the child for which the explanation given by the parent does not make sense. For example, a baby with small round burns on her bottom who is said to have been burnt by a heater, when the burns are clearly inflicted by a cigarette.
- Injuries to areas of the body which are normally well protected, e.g. the armpits, behind the knees or on the inside of the thighs, may be signs of physical abuse.

SEXUAL ABUSE

Sexual abuse of children is usually carried out by males in the family, often the father or step-father, uncle, grandfather, or older brother, but it may be by a family friend or a stranger. Girls are more likely to be sexually abused than boys. The abuse can be in the form of fondling, sexual intercourse, or involvement in pornography.

Whatever form the abuse takes, the child is very often pressurised to keep quiet, perhaps by being offered sweets or money. The adult may say, 'It's our little secret, and if you tell anyone, I will get into trouble', or may threaten the child. The child may feel very guilty, and although anxious for the abuse to stop, is often afraid to tell anyone. She may fear that the family will break up, the abuser will be sent to prison, and she will be blamed and removed from the family by the local authority.

EMOTIONAL ABUSE

Emotionally abused children are those who lack love and security and the company of friendly people – sometimes described as conditions of **high criticism–low warmth**. Such children feel so rejected and unhappy that their health and development may be affected and they fail to thrive. Examples of emotional abuse are:

- **when children are constantly ignored** – the people around them show no interest in them
- **when children are in constant fear** because of:

It's always your fault

blame

threats of extreme punishment — *You will be locked in the cupboard all day*

You are not to have anything to do with them

being stopped from making friends

criticism — *You are no good at anything*

I'll have your cat put down

destruction of toys or pets

threats of rejection — *I'll go away and leave you*

Emotional abuse is difficult to detect, but it may be suspected when a child fails to grow and develop properly for no obvious reason. The child's behaviour may indicate emotional disturbance, for example when her behaviour towards other people, particularly adults, is unnatural for the child's age.

CHILD NEGLECT

Child neglect can be physical and/or emotional. Children are neglected when they are not fed adequately, or not kept warm or clean, or when they are left alone for long stretches of time. Child neglect can be deliberate, for example locking a child out of the house, or keeping the child locked in the house on her own. More often, it is due to ignorance of how to bring up children, for example a mother not realising that children need to be fed at regular intervals because she herself only eats when she is hungry.

WHERE TO GET HELP

Children who want to discuss their problems can contact:

- **an adult they can trust**, e.g. their teacher, or a youth leader
- **the NSPCC Child Protection HELPLINE** – Any person (child or adult) who is concerned about the safety of children can telephone for advice 24 hours a day, using the freephone number 0808 800 5000.
- **CHILDLINE** – Any child who is in trouble, or danger, or who has been abused, can telephone 0800 1111 (a freephone number) and talk to somebody who will listen carefully. The child does not need to give his or her name, and no action will be taken by CHILDLINE if the child does not wish it. The line is open 24 hours a day every day of the year.

Parents, relatives, neighbours or others who suspect that a child is being neglected or abused should contact:

- **the NSPCC HELPLINE or CHILDLINE** (see above)
- **the local Social Services** – social workers investigate cases which come to their attention
- **the police** – in cases of emergency where a child is in imminent danger.

ADVICE TO CHILDREN

Children should be warned not to go off with strangers, or to accept lifts or gifts from them. However, as most children who are abused already know their abusers, it is important for children to be taught to say '**NO**'. Children need to be made aware that their body belongs to them and not to anyone else, particularly the private parts covered by a swimsuit. If anyone tries to touch them in a way which confuses or frightens them, children should say '**NO**'. They should then tell an adult whom they trust about what has happened.

Various books, videos and publications are available from Kidscape (p. 341) and the NSPCC (p. 342) to help in teaching young children about self-protection against abuse.

QUESTIONS

1 a Name four types of child abuse.

 b Who are the abusers likely to be?

2 a **(i)** Which type of abuse is also called non-accidental injury? **(ii)** Describe the form which this abuse may take.

 b To which children does physical abuse most often occur?

 c Give an example of an occasion when a baby may be abused.

 d Given an example of an occasion when a toddler may be abused.

 e Name three signs of physical abuse

3 a **(i)** Who are most likely to be responsible when children are sexually abused? **(ii)** Are girls or boys more likely to be sexually abused? **(iii)** Name three forms which the abuse can take.

 b How may children who are sexually abused feel?

 c Why are they often afraid to tell anyone?

4 a **(i)** Describe emotionally abused children. **(ii)** How do they feel?

 b Give two main forms of emotional abuse.

 c Describe six things which a child may be in fear of.

 d When may emotional abuse be suspected?

5 a When may children be said to be neglected?

 b Give two reasons why child neglect may occur, with examples.

6 a Who can children contact to discuss their problems? Give three suggestions.

 b Who can parents or neighbours contact if they suspect that a child is being neglected or abused? Give three suggestions.

 c Describe the advice which children should be given to help protect themselves against abuse.

FURTHER ACTIVITIES

EXTENSION

Watch a video for teaching children about self-protection. Write a report (i) describing its contents, (ii) giving your opinion of its usefulness in getting its message across.

DISCUSSION

C2.1a The extensive publicity in recent years concerning child sexual abuse could make young children defensive against loving gestures from adults, and adults afraid of cuddling their children. To what extent do you think this is likely, and how can the correct balance of attitudes be achieved?

INVESTIGATION

C2.2 Study newspaper reports of at least two different cases of child abuse.

 a In what ways did it appear that the children involved were abused.

 b Who was the abuser(s)?

 c What judgments were reached, and do you think they were fair?

DESIGN

C2.3 Make an illustrated booklet for 4- to 7-year-olds to teach them about possible dangers from adults, and how to protect themselves. Use a suitable computer program to help, e.g. a word-processing and graphics program.

Revision
Exercise
75

There are some aspects of family life which are regulated by law. These include marriage, divorce and the legal duties of parents. In any 'domestic' proceedings which come before a court of law, the court's main concern will be the welfare of any child or children involved.

MARRIAGE

Marriage is a legal contract between two people of opposite sex. It seems to fulfil deep-felt human needs. This is shown by the fact that most people marry, and most of those who become divorced re-marry.

A marriage starts off with a ceremony – a wedding – during which a man and a woman are joined in a special kind of relationship – personal, legal, social, and sometimes religious.

Reasons for marriage

The reasons why people marry vary, but usually it is a combination of factors such as:

- love for each other
- the desire to share the future as a partnership
- the wish to have children within marriage
- financial benefits – two can live almost as cheaply as one
- legal considerations – marriage gives legal rights to the partners and their children, especially relating to property
- cultural reasons – to conform with the cultural pattern
- religious beliefs – to give the partnership a spiritual basis
- social status – to be recognised as a couple
- the romantic idea of a wedding
- because a baby is on the way.

Cohabitation

Some couples prefer to live together (cohabit) without going through a marriage ceremony. Such couples may marry later, possibly when they intend to have children.

Skills needed in marriage (or cohabitation)

When two people live together they need to be able to:

- communicate with each other – listen to what is said, understand what is meant, and respond
- co-operate and reach decisions together
- care about and consider their partner
- modify their own behaviour so that it is acceptable to their partner.

Stress in marriage

No two people will agree all the time, and every marriage has its times of disagreement and stress. When there is a strong clash of personalities or the stress is continuous, one or both partners may feel that they should separate.

Reconciliation

When a marriage is in difficulties, a couple may wish to discuss their problems with, for example, a marriage guidance counsellor, in an attempt to hold the marriage together.

CHILDREN ACT 1989

This Act brought together for the first time nearly all aspects of the law relating to children. It came into effect in 1991. The main principles of the Act are:

1. The welfare of the child is the most important factor (is paramount) when any decisions are made, including court cases.
2. Wherever possible children should be brought up and cared for within their own families.

3. Children should be safe, and be protected by effective intervention if they are in danger.
4. When dealing with children, courts should ensure that delay is avoided, and may make a court order only if it positively benefits the child.
5. Children should be kept informed about what is happening to them, and should participate when decisions are made about their future.
6. Parents continue to have parental responsibility for their children, even when their children do not live with them. They should be kept informed about their children and participate when decisions are made about their children's future. Where possible contact will be maintained between children and their parents.
7. Parents with children in need should be helped to bring up their children themselves.
8. This help should be provided as a service to the child and his or her family, and should:

- be agreed with parents
- meet each child's identified needs
- be appropriate to the child's race, culture, religion and language
- be open to effective and independent representations and complaints procedures
- be based upon effective partnership between a local authority and other agencies, including voluntary agencies.

Parental responsibility

This is defined as 'all the rights, duties, powers, responsibilities and authority which by law a parent of a child has in relation to the child and his property'. Examples of what is expected of parents include:

- not to harm, neglect or abandon their child (or children), i.e. to care for and show interest in the child
- to arrange appropriate education when the child is of school age
- to be financially responsible for the child
- to give physical and moral protection to the child
- to be legally responsible for the child's actions
- to maintain contact with the child.

Children without parents

If a child is left without parents, an official guardian will be appointed to take on the role of the parents. Sometimes parents will have nominated someone to take on this role in their wills. The official guardian may be a relative, a close friend of the family, or Social Services, and must comply with the legal responsibilities of parents listed above.

DIVORCE

Divorce is the legal ending of a marriage. One or both partners may have feelings of failure and regret because the marriage did not work, but it also allows them new opportunities.

Grounds for divorce

The divorce court must be satisfied that the marriage has broken down irretrievably, and that both husband and wife have had sufficient time to consider whether the marriage can be saved. Couples are actively encouraged to seek counselling if there is a possibility of the marriage continuing. If this is not possible, they are advised to use a mediation service to help negotiate a settlement.

Divorce settlements

When a couple with children divorce there are a number of matters which need to be settled legally, such as:

- with whom the children should live
- with whom the children should have contact. This includes arrangement for visits, and contact with grandparents
- division of property, including who should live in the marital home
- maintenance; financial support for the children is arranged, and financial support for the spouse is considered.

CHILD MAINTENANCE

Child maintenance is the amount of money that non-resident parents pay regularly as a contribution to the upkeep of their children. A **non-resident parent** (absent partner) means a parent who does not normally live with the child or children concerned. Child maintenance is administered by the Child Support Agency.

QUESTIONS

1 a Suggest ten reasons for marriage.
b What is meant by cohabitation?
c Suggest some skills needed in marriage or cohabitation.

2 a When did the Children Act 1989 come into effect?
b Of the eight main principles of this Act listed on pp. 337–338, select the four which you consider to be the most important.
c What is meant by parental responsibility?
d When is an official guardian appointed?

3 a **(i)** What is divorce? **(ii)** What are the grounds for divorce?
b When divorce takes place, which four matters need to be settled legally?

4 What is child maintenance, and who administers it?

FURTHER ACTIVITIES

DISCUSSION

C2.1a Discuss possible causes of stress in a marriage.

INVESTIGATION

Find out about the work done by the counselling organisation Relate (p. 342).

EXERCISES

Exercises relevant to Section 8 can be found on p. 352.

Revision
Exercise
76

LIST OF VOLUNTARY ORGANISATIONS

There are a large number of organisations dealing with particular aspects of child welfare; some of them are listed below. Each organisation has its own aims and rules and most are financed by voluntary contributions, although in some cases the government may give a grant or subsidy towards running costs.

The organisations listed here have indicated that they will provide further information on their work. When they have asked for a stamped addressed envelope (s.a.e.) this is mentioned.

Association for Spina Bifida and Hydrocephalus (ASBAH)
42 Park Road, Peterborough PE1 2UQ
Tel: 01733 555988 e-mail: info@asbah.org
Fax: 01733 555985 Website: www.asbah.org
A welfare and research organisation which gives support and advice to parents, families and individuals with spina bifida and/or hydrocephalus. For further information send s.a.e. (large).

British Agencies for Adoption and Fostering (BAAF)
Skyline House, 200 Union Street, London SE1 0LX
Tel: 020 7593 2000 e-mail: mail@baaf.org.uk
Fax: 020 7593 2001 Website: www.baaf.org.uk
Gives information and advice on adoption and fostering. For further information send s.a.e. (A5).

Child Growth Foundation (CGF)
2 Mayfield Avenue, Chiswick, London W4 1PW
Tel: 020 8995 0257 e-mail: cgflondon@aol.com
Fax: 020 8995 9075 Website: www.heightmatters.org.uk
An organisation which offers help and advice concerning children who do not grow or who grow too much. Please send a self-addressed envelope (A4) and two 2nd class stamps if you require a growth chart and basic background material. CGF will also supply an order form for additional leaflets on specific growth disorders.

CHILD GROWTH
FOUNDATION

Child Poverty Action Group (CPAG)
94 White Lion Street, London N1 9PF
Tel: 020 7837 7979 e-mail: staff@cpag.org.uk
Fax: 020 7837 6414 Website: www.cpag.org.uk
This organisation promotes action for the relief, directly or indirectly, of poverty among children and families with children. Applications for further information to be accompanied, if possible, by s.a.e. (A5).

ROYAL SCOTTISH SOCIETY FOR
PREVENTION OF CRUELTY TO CHILDREN

CHILDREN 1st (RSSPCC)
83 Whitehouse Loan, Edinburgh EH9 1AT
Tel: 0131 446 2300 e-mail: via their website
Fax: 0131 446 2339 Website: www.children1st.org.uk
For over 100 years, CHILDREN 1st, the Royal Scottish Society for Prevention of Cruelty to Children, has been working to give every child in Scotland a safe and secure childhood. The aims of CHILDREN 1st are: preventing harm to children in Scotland; assisting the recovery of children from abuse and neglect; building on the strengths of vulnerable children; enhancing the lives of children by supporting parents; championing the rights and interests of children. For further information, visit the CHILDREN 1st website or send a large s.a.e. (A4) to the Information Assistant.

ICAN

8 Dyer's Buildings, Holborn, London EC1N 2JT
Tel: 0845 225 4071 e-mail: via their website
Fax: 0845 225 4072 Website: www.ican.org.uk
ICAN is the national educational charity for children with speech and language difficulties. It provides specialist education and therapy services, and runs three specialist schools, four language resources and a network of speech and language centres nationwide. For further information send s a.e. (A4).

Kidscape

2 Grosvenor Gardens, London SW1W 0DH
Tel: 020 7730 3300 e-mail: webinfo@kidscape.org.uk
Fax: 020 7730 7081 Website: www.kidscape.org.uk
A registered charity which campaigns for children's personal safety. It offers a variety of resources (books, videos, posters etc.) dealing with bullying and child abuse, which are suitable for use by students, parents and child-care workers. For further information please send a large s.a.e. (A4) and six first class stamps. See also p. 334 re CHILDLINE.

Muscular Dystrophy Campaign

7–11 Prescott Place, London SW4 6BS
Tel: 020 7720 8055 e-mail: info@muscular-dystrophy.org
Fax: 020 7498 0670 Website: www.muscular-dystrophy.org
The Muscular Dystrophy Campaign is the only national organisation set up to help those with MD and other allied neuromuscular conditions. They fund scientific research into finding treatments and cures and offer support to those affected by the condition. Students wanting more information should send a s.a.e. (with two first class stamps) to the Head office in London.

The National Autistic Society (NAS)

393 City Road, London EC1V 1NG
Tel: 020 7833 2299 e-mail: nas@nas.org.uk
Fax: 020 7833 9666 Website: www.nas.org.uk
Aims to provide and promote day and residential centres for the support, education and training of children and adults with autism and to help parents by arranging meetings between them where they can exchange information. For further information send s.a.e. (large).

The National Childbirth Trust (NCT)

Alexandra House, Oldham Terrace, Acton, London W3 6NH
Tel: 020 8992 2616 e-mail: enquiries@national-childbirth-trust.co.uk
Fax: 020 8992 5929 Website: nctpregnancyandbabycare.com
Promotes informed choice for parents to make birth a satisfying experience. Provides antenatal classes, breast-feeding information, postnatal support, parents and babies to visit schools. For further information send s.a.e. (A5).

National Childminding Association (NCMA)

8 Masons Hill, Bromley, Kent BR2 9EY
Tel: 020 8464 6164 e-mail: info@ncma.org.uk
Fax: 020 8290 6834 Website: www.ncma.org.uk
Promotes quality registered childminding in England and Wales so that children, families and communities can benefit from the best in child care and education. Working in partnership with the Government, local authorities and other child care organisations, it aims to ensure that every registered childminder has access to services, training, information and support to enable them to do a professional job.

National Children's Bureau

8 Wakley Street, London EC1V 7QE

Tel: 020 7843 6000 e-mail: via their website

Fax: 020 7278 9512 Website: www.ncb.org.uk

Organisation for research, development and dissemination into the needs of children and young people. Links together the many organisations concerned with the welfare of children. Also publishes books, runs conferences and has an extensive library and information service. Requests for information must come from teachers, not students. Send s.a.e. (A4).

National Council for One-Parent Families

255 Kentish Town Road, London NW5 2LX

Tel: 020 7428 5400 e-mail: info@oneparentfamilies.org.uk

Fax: 020 7482 4851 Website: www.oneparentfamilies.org.uk

Free information and help given to lone parents and single pregnant women. For further information send s.a.e. (A5).

The National Deaf Children's Society (NDCS)

15 Dufferin Street, London EC1Y 8UR

Tel: 020 7490 8656 (voice & text) e-mail: ndcs@ndcs.org.uk

Fax: 020 7251 5020 Website: www.ndcs.org.uk

Information & Helpline: 0308 800 8880 (voice & text)

The NDCS exists to enable deaf children and young people to make the most of their skills and abilities. Practical support is provided through a number of advisers, regional staff, local representatives and local groups. For further information please contact the Information & Helpline.

The National Network of Playwork Education and Training

The Playwork Unit in Skills Active, Castlewood House, 77–91 New Oxford Street, London WC1A 1PX

Tel: 020 7632 2000

Fax: 020 7632 2001 Website: www.playwork.org.uk

This organisation aims to raise the level of understanding about the importance of children's play and to improve access to good quality play provision. It also aims to improve children's lives by setting standards of excellence in education, training and qualifications, and by developing opportunities for playworkers to access education, training and qualifications.

National Society for the Prevention of Cruelty to Children (NSPCC)

Weston House, 42 Curtain Road, London EC2A 3NH

Tel: 020 7825 2500

Fax: 020 7825 2525 Website: www.nspcc.org.uk

The NSPCC exists to prevent child abuse and provides immediate help for children in need. In nearly one third of the cases dealt with, it is the parents themselves who ask the Society for help and advice. An s.a.e. is not required for further information, but a stamp would be appreciated. See also p. 334 re HELPLINE.

Pre-School Learning Alliance

69 Kings Cross Road, London WC1X 9LL

Tel: 020 7833 0991 e-mail: pla@pre-school.org.uk

Fax: 020 7837 4942 Website: www.pre-school.org.uk

A registered national educational charity representing over 16,000 member pre-schools and nurseries providing a range of services, including: training, publications, grants, and the monthly magazine *Under Five Contact*. In addition, the charity provides advice and support to parents seeking pre-school provision. For further information, please send s.a.e. or telephone/fax/e-mail.

Relate (formerly Marriage Guidance)
Herbert Gray College, Little Church Street, Rugby CV21 3AP
Tel: 0845 456 1310 e-mail: enquiries@relate.org.uk
 Website: www.relate.org.uk
This organisation provides counselling, sex therapy, relationship education and training to support couple and family relationships throughout life. For further information send s.a.e. (A4).

Royal National Institute for the Blind (RNIB)
105 Judd Street, London WC1H 9NE
Tel: 020 7388 1266 e-mail: helpline@rnib.org.uk
Fax: 020 7388 2034 Website: www.rnib.org.uk
The RNIB is the leading charity working in the UK offering practical support, advice and information for anyone with a serious sight problem. It provides products and services to help blind and partially sighted people of all ages lead independent lives. It funds research and work with others to avoid preventable sight loss for people in the future. It also offers consultancy and training in this field. For further information send s.a.e. (A4).

The Royal National Institute for Deaf People (RNID)
19–23 Featherstone Street, London EC1Y 8SL
Tel: 0808 808 0123 e-mail: informationline@rnid.org.uk
Fax: 020 7296 8199 Website: www.rnid.org.uk
Textphone: 0808 808 9000
Advice and information is given on all aspects of deafness. For further information send s.a.e. (A5).

The Royal Society for the Prevention of Accidents (RoSPA)
Edgbaston Park, 353 Bristol Road, Edgbaston, Birmingham B5 7ST
Tel: 0121 248 2000 e-mail: help@rospa.com
Fax: 0121 248 2001 Website: www.rospa.org.uk
Involved in all aspects of safety. Welcomes specific enquiries from students. Please enclose s.a.e. (A4).

Save the Children Fund (SCF)
1 St John's Lane, London EC1M 4AR
Tel: 020 7012 6400 e-mail: supporter.care@savethechildren.org.uk
Fax: 020 7012 6963 Website: www.savethechildren.org.uk
SCF is the leading UK charity working to create a better world for children. It works in over 70 countries helping children in the world's most impoverished communities. Emergency relief runs alongside long-term development and prevention work to help children. their families and communities to be self-sufficient. SCF is part of the International Save the Children Alliance, which aims to be a truly international involvement for children. For further information send s.a.e. (A4).

SCOPE
PO Box 833, Milton Keynes MK12 5NY
Tel: 0808 800 3333 e-mail: cphelpline@scope.org.uk
 Website: www.scope.org.uk
Provides services for children and adults with cerebral palsy including care, education and training. Promotes public awareness of attitudes to disability. Enquiries for information must be specific. Send s.a.e. (A4).

EXERCISES

SECTION 1 Family and home

1 a In general, during the last 60 years families in Britain have become smaller. Suggest two reasons for this. [2]

b Suggest **four** factors which a couple should take into account before starting a family. [4]

c Give **two** ways in which watching television can help a child's speech development. [2]

d Give **two** ways in which watching television can hinder a child's speech development. [2]

e Explain the difference between kinship and friendship. [2]

f Give **four** reasons why a family may be unhappy. [4]

g Give **four** factors which can help to make family life happy. [4]

h List **five** responsibilities of parenthood. [5]

i List **five** rewards of parenthood. [5]

2 Children should be encouraged to have an appreciation and understanding of cultures and lifestyles other than their own. Suggest **three** reasons why this is important, and refer to **three** activities within the home and **three** activities outside the home which might help achieve this. [9] AQA

3 Contraception[1]: by method used

Great Britain	Percentages			
	1976	1986	1996	2003
Non-surgical				
Pill	29	23	25	25
Male condom	14	13	18	23
IUD	6	7	4	4
Withdrawal	5	4	3	3
Injection	–	–	1	3
Cap	2	2	1	1
Safe period	1	1	1	1
Spermicides	–	1	–	–
Surgical				
Female sterilisation	7	12	12	11
Male sterilisation	6	11	11	12
At least one method	68	71	73	75

1 By women aged 16 to 49, except for 1976 which is for women aged 18 to 44.
Source: Family Formation Survey and General Household Survey, Office for National Statistics

Use the information in the table to answer the following questions.

a Since 1976, which **two** methods have remained **(i)** most popular, **(ii)** least popular? [4]

b **(i)** What is meant by the 'safe period'? **(ii)** Give **one** advantage and **one** disadvantage of this method. [3]

c **(i)** What was the percentage increase between 1976 and 2003 in the use of contraception? **(ii)** What percentage was not using any method of contraception in 2003? **(iii)** Suggest **three** reasons for not using contraception. [5]

d Were more men using contraception in 2003 than in 1976? Explain how you arrived at your answer. [5]

e Give **four** possible problems caused by unplanned parenthood. [8]

4

'Our television programmes in this country are generally of very high quality, and those designed for under-fives will try to stretch their imagination, get them to think, extend their vocabulary and inspire them. All these can happen without a programme being obviously educational.

In the early days of television, people worried that it killed conversation in the home, but today, perhaps, it can actually give us more to talk about. It was thought, too, that it would stop people from reading, although research showed that it replaced comic-reading, and children who read books would continue to do so. Many programmes actually introduce children to books and probably encourage some parents to buy them who would not otherwise do so.

Watching a film telling a story can be excellent for increasing concentration, but it is not the same as looking at a book, turning the pages, hesitating over an interesting picture or joining in the funny bits with a loved adult. Nature films are always fascinating, but to a small child the discovery of his own worm or snail is probably better. How can television convey the sensation of frosty days or sunshine, of crunchy autumn leaves, or the smell of the forest? But if the child sees the programme and experiences the real thing for himself, the possibilities for enriching his experience are endless.' **(Reproduced by permission of Nursery World.)**

a According to the passage: **(i)** What do high-quality television programmes designed for the under-fives try to do? [4] **(ii)** In the early days of television what effects on children were feared? [2] **(iii)** What effect has television actually had on children's reading? [2] **(iv)** The passage compares watching a film with looking at a book. In what ways does the writer think that looking at a book is better? [2]

b From the passage **(i)** suggest ways in which television may be harmful to a young child. [8] **(ii)** Explain how adults can increase the benefits for young children of watching television. [5]. AQA

SECTION 2 Becoming a parent

1 a Name **two** early signs which might indicate that a woman is pregnant. [2]

b Give **two** reasons why an expectant mother needs a well-balanced diet. [2]

c State **four** minor health problems which often occur during pregnancy. [4]

d State **two** advantages of a mother having her baby in hospital. [2]

e What is an antenatal clinic? [1]

f State **two** reasons why a baby may need to be born by Caesarian section. [2]

g Give **two** functions of the umbilical cord. [2]

h Give **two** reasons for testing the blood of an expectant mother. [2]

i Why is regular testing of urine of an expectant mother necessary? [2]

j A pregnant mother is advised not to smoke. State **two** ways by which smoking can harm the unborn child. [2]

k What is the most likely sign of a threatened miscarriage? [1]

l How many chromosomes are there in **(i)** an unfertilised egg, **(ii)** a normal body cell? [2]

m What is the difference between 'baby blues' and postnatal depression? [2]

n Explain what is meant by **(i)** Rhesus factor, **(ii)** induction. [2]

o (i) When is the postnatal examination held? **(ii)** Give **two** reasons why this examination is important. [3]

p Name **three** ways in which the arrival of a baby changes the daily life of the parents. [3]

2 Describe how an egg from the ovary develops into a fetus in the uterus. [10]

3 a Name **four** benefits and services available to pregnant women. [4]

b Describe the roles of the midwife and health visitor in the care of mothers and babies. [8]

c In what ways can regular attendance at clinics benefit both the mother and her baby? [4]

4 a (i) Name parts 1–5 of the diagram below. **(ii)** State what happens to each of the parts during childbirth. [10]

b (i) Are the twins identical or fraternal? Give a reason for your answer. **(ii)** How do the twins obtain food and oxygen while in the uterus? [4]

5 Hormones play a very important part in controlling the menstrual cycle, pregnancy, birth and breast-feeding.

a (i) What are hormones? **(ii)** How do they move around the body? [2]

b (i) Name **four** hormones and give one function for each. **(ii)** Which two hormones help in controlling the menstrual cycle? [10]

6 Place each of the events listed below into the correct column in a copy of the table, showing the three stages of a normal labour and delivery. Use each phrase once only.

placenta delivered; contractions weak; umbilical cord cut; strong contractions; cervix dilates; baby's head passes through vagina; mother should push; mother should relax; baby takes first breath

Stages of labour		
First stage	**Second stage**	**Third stage**

[9] AQA

EXERCISES

SECTION 3 Caring for babies

1 a What is the usual cause of nappy rash? [2]

b State **two** safety checks which should be made before buying a second-hand pushchair. [2]

c How can a mother recognise 3-month colic? [2]

d **(i)** What is a suitable room temperature for a young baby's bedroom? **(ii)** Why is it important to maintain this temperature? [3]

e Select **four** fabrics which are suitable for baby clothes, giving a reason in each case. [4]

f Give **two** important points to remember in preparing for baby's bathtime. [2]

2 Compare the advantages and disadvantages of disposable and towelling nappies. [10]

3 **Preparing a feed** Add the following words to complete the instructions for preparing a bottle feed: boiled; cap; water; dissolve; hot; knife; milk powder; scoop; sterilising; teat; wash; wrist.

(i) – – – your hands. **(ii)** Remove the bottle from the – – – solution. Rinse with boiled – – – **(iii)** Measure the required amount of warm, previously – – – water into the bottle. **(iv)** Add the required amount of – – -to the bottle, levelling off each – – – of powder with a clean, dry – – – **(v)** Place the – – – on the bottle and shake well to – – – the powder. **(vi)** Place – – – on the bottle. **(vii)** Before feeding, shake a few drops of milk on to the inside of your- – – to make sure that the milk is not too – – – for the baby. [12]

4 a Study the graph below, which compares the nutritional content of breast milk and cow's milk. **(i)** Compare the sugar, protein and mineral levels of breast milk with cow's milk. [4] **(ii)** State the possible implications for the high percentage of casein in cow's milk. [2]

b The mother of a newborn baby has decided to breast-feed. Assess the likely benefits to the baby's health. [4] NICCEA

5 a Suggest **three** advantages of bottle-feeding a baby. [3]

Average weight of baby kg lb	Approx. age of baby from:	Level scoops of formula feed	Amount of water needed: ml fluid oz	Number of feeds in 24 hours
3.0 6½	birth	3	85 3	6
4.0 8½	2 weeks	4	115 4	6
5.0 11	2 months	6	170 6	5
6.5 14	4 months	7	200 7	5
7.5 16½	6 months	8	225 8	4

b The chart above is taken from a packet of formula milk powder. Use the information in the chart and on p. 91 to answer the following questions. **(i)** How many level scoops of formula feed are needed for a baby aged 2 months? [1] **(ii)** How much water is needed for a baby aged 6 months? [1] **(iii)** How many feeds in 24 hours should a baby aged 2 weeks be given? [1] **(iv)** What is the average weight of a baby aged 4 months? [1] **(v)** Give **three** reasons why it is important to measure formula milk powder accurately. [3] AQA

6 a What is meant by bonding? [1]

b Not all mothers bond with their babies immediately. Suggest **one** reason for this. [1]

c Suggest **two** ways in which a father can bond with his child. [2]

d All young babies cry from time to time. Give **four** reasons for a baby crying. Suggest what action should be taken in each case. [8]

e Many young children suffer from 'separation anxiety'. **(i)** What does this mean? [1] **(ii)** Suggest, with reasons, a suitable bedtime routine for a young child. [10] AQA

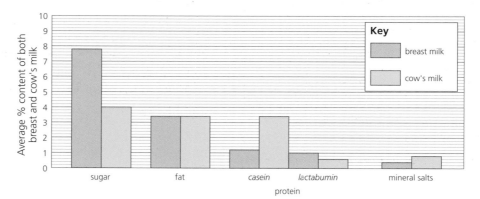

SECTION 4 Development

1 a Give the approximate age (in months) at which children usually become able to: **(i)** walk with help, **(ii)** turn their head to watch something of interest, **(iii)** get into a sitting position unaided, **(iv)** take delight in dropping toys and other objects from the pram, **(v)** prop themselves up on their forearms when placed on the floor, **(vi)** point to an object they want, **(vii)** smile at their parents, **(viii)** know when they have done something wrong, **(ix)** start asking questions. [9]

b By what age should it be noticeable whether a child is right-handed or left-handed? [1]

c Describe **two** ways in which babies may move around unaided before they begin to walk. [2]

d If a 4-year-old child is not yet talking, there must be a reason for it. Give **two** possible explanations. [2]

e Who would be the right person to help a child who has difficulty in speaking? [1]

f State any **two** causes of deafness in a young baby. [2]

g Give **two** reasons why fresh air is important to a child's health. [2]

h Give **two** reasons why it is sometimes more difficult for an only child to mix with other children. [2]

i What is meant by parallel play? At about what age might children play like this? [2]

2 a Describe a typical newborn baby, including the following information: **(i)** average weight in kg **(ii)** general appearance, **(iii)** reflex actions and abilities. [10]

b Describe **ten** ways, apart from changes in size, in which the baby would be expected to have changed by the time he is 3 months old. [10] AQA

In the homes of children who were developing well	In the homes of poorly developing children
The mother spoke frequently to the children	Children were kept out of the way of the mother
If play-pens were used, the children were confined to them only for brief periods	Play-pens were extensively used and for long periods of time
The children were encouraged to explore and there was a high degree of tolerance to infant clutter and disorder	Children were subjected to ready-made experiences in the form of television

3 One study on the effect of the home environment on the development of young children found the results shown in the table.
Discuss reasons why the points made in the first column helped children to develop well, and the points in the second column hindered development. [10]

4 It has been said 'Parents are a child's most important teachers'. Explain how parents can help language development during each of the following three stages: 1. early communication; 2. speech; 3. language.
[3×5] NICCEA

5 It has been claimed that one child in ten is hard of hearing and that many children are falling behind with their schoolwork when their only problems are minor hearing defects.

a Describe ways in which deafness in children can be detected. [4]

b Why may a child with a minor hearing defect be wrongly thought to be backward? [2]

6 Read the following story:
Jimmy is a busy, happy child who suffers from diabetes. For his third birthday he was given a large teddy bear. After the birthday party it was very difficult to get him to bed. He screamed and threw himself on the floor in quite a rage. His mother finally managed to quieten him down by following her usual routine, and because he said he was sorry she allowed him to take the toy to bed with him. Later that evening before his parents went to bed, they checked on Jimmy and not only found the bed was wet, but the eyes on the toy were missing.

a Suggest **three** toys suitable for children in this age group, giving reasons for choice. [3]

b **(i)** Give **one** reason for Jimmy's temper tantrum. [1] **(ii)** Suggest **two** ways to deal with a child's temper tantrum. [2]

c What would be a suitable bedtime routine for a young child of Jimmy's age? [3]

d Bed-wetting is very common in children of Jimmy's age. **(i)** Suggest **two** possible causes of bed wetting. [1] **(ii)** Discuss how Jimmy's parents could cope with this problem. [3] WJEC (part)

EXERCISES

7 a Using the information in Table 1 on p. 129, draw a graph of the 50th percentile weights of **girls** from birth to 8 years, like the one on p. 131. [3]

b On the same graph axes draw another graph to show the weight of a girl called Nina. To do this read the following and make a table of Nina's weight for each year, then draw the graph.

When Nina was born she was a strong, healthy baby of 3 kg. During the first year she gained weight steadily and on her first birthday weighed 9 kg. At 2 years she weighed 11.5 kg, 3 years – 13.5 kg, 4 years – 15.5 kg, and at 5 years – 17.5 kg. Then Nina started school and developed the habit of eating lots of sweets, chocolates, ice-cream and crisps. At 6 years her weight was 22 kg, at 7 years – 25 kg, at 8 years – 30 kg.

(i) Was Nina's birth-weight above or below the 50th percentile?

(ii) At what age did her weight equal the 50th percentile weight for girls?

(iii) By how much was her weight above the 50th percentile at 8 years? What may have been the cause of this? [12]

N2.1

8 a Complete Table 3 on p. 129, using the growth charts on pp. 130 and 131. Draw the graph of the 50th percentile heights of **boys.** [3]

b On the same graph axes draw two more graphs to show the growth in height of Ben and Terry, using a different colour for each boy. [8]

Height in cm at:								
	Birth	1 yr	2 yrs	3 yrs	4 yrs	5 yrs	6 yrs	7 yrs
Ben	56	79	84	88	103	113	118	125
Terry	43	68	82	91	100	109	112	117

c Study the three graphs you have drawn and answer the following questions: **(i)** Terry was born 6 weeks prematurely. At what age did his height reach the 50th percentile height for boys? **(ii)** Ben was unfortunate in being severely ill for about a year. How old do you think he was when this happened? Was it followed by a time of 'catch-up' growth? [3]

d Who could be asked for help and advice if a child has a growth problem? [1]

SECTION 5 Early childhood

1 a Give **two** reasons why play is vital to a child's development. [2]

b Suggest **two** ways in which parents can encourage their baby to learn to use his hands. [2]

c Suggest **three** suitable playthings for a 10-month-old baby, and give reasons for your choice. [6]

d Give reasons why water is good play material. [3]

e What is the value of a sand-pit in the garden to a 3-year-old child? [3]

f Suggest **two** ways in which a 4-year-old can be encouraged to play with other children. [2]

g The development of play follows a definite pattern starting with solitary play. Suggest, in order, **two** other stages through which play passes before group play occurs. [2]

2 a Suggest **two** hygiene rules to teach toddlers. [2]

b Give **two** reasons why new shoes for a toddler should be fitted correctly. [2]

c A child is likely to be jealous of a new brother or sister. Suggest **three** ways of helping the older child to accept the new baby. [3]

d Why should you not scold or make fun of a young child for sucking her thumb? Give **two** reasons. [2]

e Suggest **two** ways of encouraging kindness in young children. [5]

3 When choosing clothes for a 4- to 5-year-old child it is important to remember their growing need for independence. Explain how this might affect the choice of clothing and footwear for a child of this age. [8] AQA

4 'Play is much more than a fun leisure activity that passes the time.'

a Explain **how** and **why** play is important in helping to encourage all aspects of a child's development.

b Discuss ways in which parents can provide a range of learning opportunities for both indoor and outdoor play without having to buy expensive toys. [20] AQA

5 a Suggest **three** ways a parent could introduce the concept of numbers to children. [3]

b When used sensibly, television, videos and computers can help a child's development. Explain **how** they can help, and suggest **why** their use should be limited. [10]

c **(i)** Explain **why** it is important for parents to encourage their children to take an interest in books. **(ii)** Suggest ways in which this can be done. [10]

d Suggest what points a parent should consider when choosing books for young children. [5] AQA

6 It is generally agreed to be valuable for a child's father, together with the mother, to play the fullest possible part in his or her upbringing. Suggest suitable ways in which a father can become involved at each of the following times: **(i)** during the mother's pregnancy, **(ii)** at the delivery, **(iii)** during the early weeks of the baby's life, **(iv)** during the child's second and third year, **(v)** when the child reaches school age. [10] AQA

7 a Toys can help a child's emotional development.

(i) What is meant by emotional development? [1]

(ii) Give **two** examples of positive emotions. [2]

(iii) Give **two** examples of negative emotions. [2]

b Why is the age between 2 and 3 years sometimes called 'the terrible twos'? [2]

c All children misbehave from time to time and need to have their behaviour corrected. What guidelines should parents follow when trying to discipline their children? Give reasons. [6] AQA

EXERCISES

SECTION 6 Food

1 a Give **two** reasons why milk is good for growing children. [2]

b Suggest **three** ways in which milk can be made attractive to a 4-year-old. [3]

c At about what age do toddlers have all their milk teeth? How many of them are there? [2]

d At about what age will a child's second set of teeth begin to come through? How many of these will there be? [2]

e What is meant by a 'deficiency disease'? Give **two** examples. [3]

f Assuming that a child has not much appetite, what arrangements would you make for meals? [3]

g What is meant by **(i)** weaning, **(ii)** malnutrition, **(iii)** obesity? [3]

2 Study the food label below and answer the following questions:

Analysis per 100 grams	
Protein	9.7 g
Fat	6.7 g
Sucrose	18.0 g
Starch	48.0 g
Fibre	0.3 g
Minerals	7.0–9.0 g
Calcium	375 mg
Phosphorus	170 mg
Iron	12.5 mg
Sodium	185 mg
Vitamin A	1500 mg
Vitamin D	1.5 mg
Vitamin B_1	0.3 mg
Vitamin B_2	0.3 mg
Nicotinic acid	2.5 mg
Energy	412 calories (1729 kJ)

a (i) How much sugar is to be found per 100 g in the above product? [1] **(ii)** State **two** reasons why it is important to restrict the amount of sugar children consume. [2]

b From the above food label, identify the nutrients which are important for **(i)** forming blood cells, **(ii)** bone development, **(iii)** growth. [3]

c Why is fibre important in a child's diet? [1]

d (i) At what age is a child ready for mixed feeding? [1] **(ii)** Give **two** important reasons why mixed feeding should not begin before this time. [2] **(iii)** Explain how adults can deal with a child refusing to eat. [3]

e Discuss the differences between 'homemade' and commercial baby foods. [8] WJEC

3 Three feeding problems with young children are: **(i)** refusing to eat, **(ii)** spitting out food, **(iii)** throwing food around.

Possible causes of a feeding problem are that the child:
- does not like the food
- is not hungry
- is bored
- is tired
- is unwell
- has sore gums
- wants to play
- is being given food which is too hot
- is being given food in large pieces
- wants a change of flavour

a For each of the problems, give what you consider to be the **three** most likely causes from the list above. [9]

b Give one other cause of feeding problems not listed above. [1]

4 Study the following graph, which shows the effect of eating sugar on the acid level in the mouth.

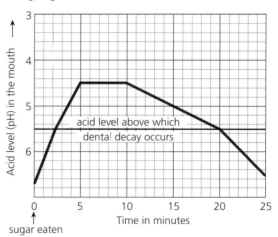

a (i) Explain what begins to happen to the acid level in the mouth after a sweet is eaten. [1] **(ii)** Name another item given to a child which can cause the acid level in the mouth to rise. [1]

b (i) After eating sweets, how many minutes does it take to reach the acid level in the mouth at which tooth decay can begin? [1] **(ii)** State the total number of minutes the acid level in the mouth remains at tooth decay level. [2]

SECTION 6 Food

c **(i)** If children are to be given sweets, explain why it is better to give them all at once rather than spread out at intervals during the day. [3]

(ii) Explain how sugar causes the acid level in the mouth to change. [4]

d Assess and evaluate the importance of establishing good dental hygiene habits in young children. [8]

WJEC

5 a The frequent occurrence of tooth decay in young children has caused much concern in recent years. Suggest ways in which a mother can improve her child's chances of having little tooth decay **(i)** during her pregnancy, **(ii)** during the child's first year, **(iii)** later in the child's life. [7]

b Many children are afraid of visiting the dentist. Suggest **three** ways in which a parent can help to overcome this fear. [3]

AQA

EXERCISES

SECTION 7 Health and safety

1 a Give **two** ways infection may enter the body. [2]

 b Give **two** ways in which infection can be passed on. [2]

 c Name **three** precautions which can be taken to prevent an infectious disease from spreading. [3]

 d Name a deficiency disease associated with shortage in the diet of **(i)** vitamin D, **(ii)** iron. [2]

 e Name **three** diseases for which protection is obtained by the **(i)** DTP vaccine, **(ii)** MMR vaccine. [6]

 f Name **two** diseases caused by **(i)** bacteria, **(ii)** viruses. [2]

 g Name a disease for which a diet low in both fat and sugar is recommended. [1]

2 a List **eight** items which you would expect to find in a first-aid box and give a reason why each is included. [16]

 b What treatment should be given for **(i)** a bad bruise, **(ii)** a baby who is choking, **(iii)** a nose bleed? [6]

3 Describe **five** types of accident which can happen to children under 1 year of age in the **(i)** home, **(ii)** garden. Suggest ways in which these accidents can be prevented. [20].

4 a Suggest **three** features you would look for when selecting which swimming pool to visit with a young baby. Give reasons for each feature. [3]

 b Suggest **three** situations when you would advise against taking a young baby to a swimming pool. [3]

 c Explain how each of the following might contribute to a child's ill health.

 (i) Poor food hygiene. [3]

 (ii) Cold, damp housing conditions. [3]

 (iii) A family pet. [4] AQA

5 Study the chart on the right and answer the following questions.

 a Identify the **two** blocks of time when road casualties involving children are at their highest. [3]

 b **(i)** Give the approximate number of children that are involved in accidents between 3 o'clock and 4 o'clock in the afternoon. [1] **(ii)** Suggest **one** reason for this. [1]

 c Suggest ways a parent might help children avoid road accidents. [3]

d Explain how you would **(i)** make a garden safe for a child to play, **(ii)** deal with a child who has a grazed knee. [2 + 2]

e Discuss how parents can help raise their children's safety awareness without frightening them. [8] WJEC

Child Casualties in Road Accidents: Great Britain 1998

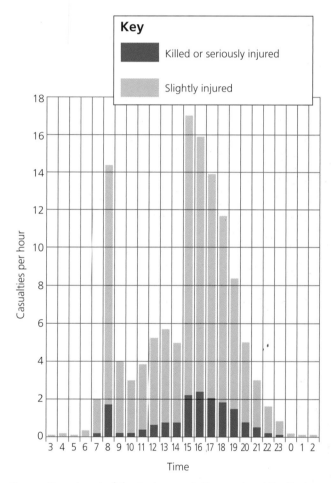

Source: Department of the Environment, Transport and the Regions (DETR)

SECTION 8 The family in the community

1 **a** Give **three** ways of securing babies and children in a car. [3]

b Suggest **two** causes of electrical accidents in the bathroom and ways of avoiding them. [2]

c The Green Cross Code has six rules. Write down those you can remember. [6]

d State **two** differences between fostering and adoption. [2]

e Name **two** ways in which the Social Services may provide for the care of babies of working mothers. [2]

f Name **one** disability known to be of genetic origin. [1]

g State **two** ways a child may become disabled after birth. [2]

h Give **three** ways in which a Special School differs from an ordinary school. [3]

2 **a** **(i)** What is meant by the term 'family'? [1] **(ii)** Name **three** types of family. [3] **(iii)** List **four** needs of a child which are provided by the family. [4]

b Name the department of the local authority which is responsible for the fostering of children. [1]

c Give **three** reasons why children might be looked after by the local authority. [3]

d Give **three** reasons why people may wish to adopt a child. [3] AQA

3 **a** Many working parents use childminders rather than 'a friend' to take care of their children. What are the safeguards in using a Registered Childminder? [3]

b Give details of special problems encountered by working parents. [3]

c Starting nursery school can be a stressful time for young children. Explain why this might be. How can parents prepare their child to cope with this? [12] AQA

4 **a** Explain what is meant by child abuse. [3]

b What would make you suspect that a child in the nursery was being physically abused? [6]

c What action should be taken in a case of suspected abuse? [6]

d Why might some parents abuse their child? [5]

5 Study the pictograms below and answer the following questions:

a **(i)** What are the main causes of lone mothers having to manage a family single-handed? **(ii)** What percentage of one-parent families are lone fathers? **(iii)** What percentage of one-parent families are lone mothers? [3]

b Briefly describe the main problems experienced by one-parent families. [3]

c Parents may need help and advice; describe **three** services available to them. [6]

d Discuss the responsibilities of family life. [8] WJEC

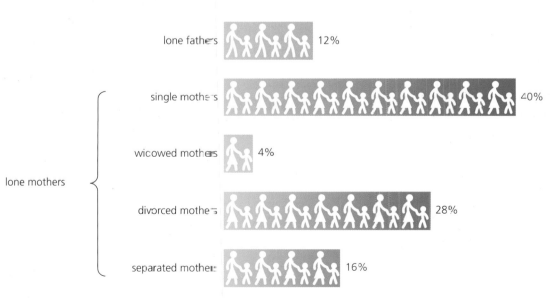

Different types of one-parent family in Great Britain, 2000–2001
Source: General Household Survey

Practical coursework is an essential part of any course in Child Care and Development, and may be required for assessment as part of an examination. Each examination syllabus has its own requirements, and needs to be consulted before you start on your coursework assignments.

Brief for a coursework assignment The starting point for an assignment is the brief. This defines the task and sets the limits within which you are expected to work. Before you start, make sure you know:

- the total amount of **time** you are expected to spend
- the **developmental area** of the child/children to be studied
- the **age range** of the child/children to be studied
- what **resources** are available both inside and outside school/college
- what **safety aspects** must be considered
- what **costs** are involved, if any
- whether you need to obtain **permission** to carry out the assignment
- the **date for completion** of the assignment
- the **form of presentation** acceptable for assessment
- the **length** of any written work required (pages or number of words)
- the **method of assessment** of the assignment.

Presentation Presentation of coursework may be in the form of one or more of the following:

- written account
- diary
- drawings or sketches
- graphs, tables or charts
- photographs
- talk or lecture
- display or demonstration
- audio-tape recording
- video recording
- an item you have designed.

Computers can be used in many ways to enhance presentation. The use of a word processor, especially with a desk-top publishing program, can make your work neater and more attractive. Spreadsheet programs help to analyse results of investigations and produce tables and charts. Graphics programs are particularly useful for assignments involving design.

Care must be taken to ensure that the presentation meets the requirements of the particular examination syllabus being followed.

Evaluation You should always assess your work when finished, or at intervals when working on a long assignment.

- Have you achieved what you set out to do?
- Could you improve
 - your interpretation of the brief
 - the way you carried out the assignment
 - your presentation?

Types of assignment A coursework assignment can take different forms, depending on your course. In this book, ideas are given at the end of each topic for the following types of practical work: **child study**, **investigation**, and the **design of an item** (which may also need to be made). These can form the basis of, or part of, a coursework assignment.

Suggestions are given below for ways in which these types of practical work can be carried out.

CHILD STUDY

A child study involves the systematic observation and recording of the behaviour and/or growth of a child, or group of children, over a period of weeks or months. You should comment on your observations and relate the information obtained to the theory of child development and to your general knowledge.

Examples

1. Study the growth and development of one child in the age range 0–5 years over a period of six months.
2. Study one child in relation to a single major area of development, e.g. development of physical co-ordination, language development.
3. Study the activities of a small group of children of about the same age for a total of 12 hours.
4. Study the development of number concepts in young children.
5. Study the social development of a small group of children during the three months following their starting at playgroup.

Suggestions for carrying out a child study

- **Set the parameters** (limits) of the area to be studied.
- **Decide when and where** to carry out the observation.
- **Obtain any permissions** required.
- **Decide what** is to be observed.
- **Decide how** to record the information – notebook, video, photographs, check-list, tape recorder, drawings.
- **Analyse the information** obtained from the study.
- **Compare** what has been observed with information in textbooks etc.
- **Give your conclusions** and your own views.

Extension

- Make a critical assessment of the way the study was carried out and suggest possible improvements.
- Suggest further studies in the same area.

OBSERVATION

Observations should be the 'fly-on-the-wall' type, that is, watching but not interfering.

Examples

1. Observe the foods selected by 5-year-olds in a school cafeteria.
2. Spend 10–30 minutes observing the activities of a young child in a particular situation, e.g. playing, at a party, having a meal, drawing.
3. Use a check-list similar to the one opposite to observe a small child at play, e.g. in a Wendy house, garden or sandpit.

Skill or emotion observed	What the child was doing
Example: Use of concept of shape Concept of colour Concept of size Concept of number Concept of time Used sense of taste smell touch sight hearing Used body to solve problem Used thinking skills to solve problem Control of finger and thumb Copied another child or adult Repeated what an adult had said Asked questions Looked at adult for approval Acted to gain attention Expressed feelings with face and gesture only Expressed feelings with words and gestures	Fitting shapes into posting box

From *Pupil Centred Learning*, June Scarbrough, *Modus* (NATHE)

INVESTIGATION

An investigation is a piece of research which may be carried out in one or more of the following ways.

1. SURVEY

A survey is made to seek out information about actual conditions or events.

Examples
1. Carry out a survey to find out how many children in a playgroup are left-handed.
2. Carry out a survey of playgroups in your district for type of premises, numbers of children, charges, facilities, waiting list etc.
3. Carry out a survey of the use of safety restraints for young children travelling in cars.

Suggestions for carrying out a survey
- **Decide**:
 - what information is required
 - the area to be covered
 - how to obtain the information
 - how to record it.
- Carry out the survey.
- **Draw conclusions** and present them in an appropriate way.

Extension
- Make a critical assessment of the way the survey was carried out.
- Suggest possible improvements.
- Give ideas for further investigations.

2. QUESTIONNAIRE

A questionnaire is a type of survey in which a specially prepared list of questions is used to obtain facts or opinions from a number of people. These people may be asked to complete the questionnaire themselves, or an interviewer may put the questions to them.

Examples
1. Question a number of mothers to find out what proportion of babies were breast-fed and for how long.
2. Carry out a survey to find out how much time children spend watching television and which is their favourite programme, or how much time they spend reading or being read to and which is their favourite book.
3. Design and use a questionnaire to find the average number of hours per day that children of various ages spend sleeping.

Suggestions for compiling and using a questionnaire
- **Decide** what information is required.
- **Design questions** to obtain the information.
- **Design a suitable form** on which to record the answers.
- **Select a sample** of people to be questioned.
- **Ask the questions** and record the answers.
- **Analyse the answers**.
- **Draw conclusions** and present them in an appropriate way.

Extension
- Make a critical assessment of the questionnaire. Were the right questions asked? Was the sample large enough?
- Re-design the questionnaire in the light of your experience.

3. EXPERIMENT

An experiment is carried out to test an idea in a practical way.

Examples
1. Devise and carry out an experiment to find out which of three brands of disposable nappy can absorb the most liquid.
2. Devise and carry out an experiment on the washability of baby clothes.
3. Devise and carry out an experiment to test the flammability of various materials commonly used in children's clothes.

Suggestions for carrying out an experiment
- **Decide** how the idea is to be tested to get a valid result.
- **Select appropriate equipment** for the test.
- **Carry out** the test.
- **Record your results** in a suitable manner – in a table, on audio tape, on video etc.
- **Draw conclusions** – relate the results obtained to the idea being tested.

Extension
- Write a method for the experiment so that it can be carried out by another person at another time and place.
- Suggest further experiments which could be carried out from the results obtained.

4. COMPARISON

A comparison is made in order to investigate similarities and differences, advantages and disadvantages.

Examples
1. Compare two or more brands of baby milk.
2. Compare the way in which boys and girls play with the same kind of toy. Do they use the toy differently?
3. Compare three brands of disposable nappy.

Suggestions for carrying out a comparison
- Construct a table of the points to be compared.
- Compare the items.
- Draw conclusions:
 - good points
 - bad points
 - best value for money.

Aspect compared	Brand 1	Brand 2	Brand 3
Shape			
Size			

Extension
- Give recommendations for improving the product.
- Suggest, or carry out, follow-up work in the form of investigations or experiments.

5. MEDIA SEARCH

This is the research of information about a particular topic in books, pamphlets, magazines, newspapers, television or radio programmes, videos, databases, websites etc.

Examples

1. What written advice can you find about how to deal with temper tantrums in young children?
2. What advice is given on bed-wetting?
3. Research the use of children in television advertisements. Comment on the way in which they are depicted and how you think this relates to reality.

Suggestions for carrying out a media search

- **Select** the books, pamphlets, magazines, newspapers, programmes, videos, databases or websites to be consulted.
- **Write a report**.
- **Compile a bibliography** (list of the resources consulted).

Extension

- Select from the report an area for further investigation.

DESIGN AN ITEM

Examples

1. Design a cover suitable for a young child's bed.
2. Design a mobile for the bedroom of a 2-year-old.
3. Design wall-to-wall storage units for a child's bedroom.
4. Make a tape-recording suitable for a young child to listen to while travelling by car.
5. Write and illustrate a story to help a young child understand the importance of caring for teeth.
6. Design a game to teach road safety to 6-year-olds.

Suggestions for carrying out a design brief

- **Suggest** two or more designs for the item.
- **Compare** them, e.g.
 - materials required
 - resources required
 - skills required
 - time required
 - costs involved
 - suitability for purpose.
- **Choose one** of the designs. A graphics program and a word processor could be used to prepare patterns. Write out a set of instructions for making the item.

Extension

- Make the item, following the written instructions. Evaluate the instructions – what problems were encountered? how were they overcome?
- Evaluate the item for suitability of purpose.
- Compare the item which has been designed with commercial products for durability (how long it will last), safety, cost etc.